Basic Visual Concepts and Principles

for Artists, Architects, and Designers

Charles Wallschlaeger

The Ohio State University
Department of Industrial Design

Cynthia Busic-Snyder

 WCB **Wm.C.Brown Publishers**

To my students and graduate teaching associates.

Editor *Meredith Morgan*

WCB **Wm. C. Brown Publishers**

President *G. Franklin Lewis*
Vice President, Publisher *Thomas E. Doran*
Vice President, Operations and Production *Beverly Kolz*
National Sales Manager *Virginia S. Moffat*
Group Sales Manager *Eric Ziegler*
Executive Editor *Edgar J. Laube*
Director of Marketing *Kathy Law Laube*
Marketing Manager *Kathleen Nietzke*
Managing Editor, Production *Colleen A. Yonda*
Manager of Visuals and Design *Faye M. Schilling*
Production Editorial Manager *Julie A. Kennedy*
Production Editorial Manager *Ann Fuerste*
Publishing Services Manager *Karen J. Slaght*

WCB Group

President and Chief Executive Officer *Mark C. Falb*
Chairman of the Board *Wm. C. Brown*

Cover and interior design by Charles Wallschlaeger.

Editing and production by Carnes-Lachina Publication Services, Inc.

The credits section for this book begins on page 515 and is considered an extension of the copyright page.

Printed in the United States of America by Wm. C. Brown Publishers, 2460 Kerper Boulevard, Dubuque, IA 52001

10 9 8 7 6 5 4

Contents

Chapter 7 The Visual and Physical Attributes of Form 193

Chapter 8 Color 237

About the Authors

Charles Wallschlaeger received his bachelor's degree in art from Albion College in Michigan. He was certified in art education at the University of Michigan and taught in the Ann Arbor public schools. He later received a master's degree in industrial design from the Cranbrook Academy of Art in Bloomfield Hills, Michigan.

Since the 1960s Wallschlaeger has taught in and chaired the Department of Industrial Design at The Ohio State University. He has been an active participant in developing and teaching courses in basic design studies, visual communication, interior space, and graduate studies in design education and design management.

Prior to teaching, Wallschlaeger was a professional designer in the fields of graphic design and interior planning in Chicago. From the late 1950s until 1975 he was involved in the partnership of a retail business that sold international quality design products. He is currently a professional member of the Industrial Designers' Society of America.

Wallschlaeger's recent visits to national and international art, architecture, and design schools to observe and study the different curriculum structures have provided additional knowledge and experiences relevant to this text.

Cynthia Busic-Snyder received her bachelor's degree in visual communication design and a master's degree in design education from The Ohio State University Department of Industrial Design. Her professional experiences include teaching at The Ohio State University and Ohio Wesleyan University. Ms. Busic-Snyder has worked as a graphic designer for an international retail design and consulting firm in Columbus, Ohio, and is currently an art director for a Columbus graphic design firm specializing in identity and print programs. She is a professional member of the American Institute of Graphic Arts.

Preface

The Context

Currently, there are a number of art, architecture, and basic design books being utilized by faculty and students in beginning visual studies. Many university instructors who teach foundation courses have difficulty selecting a supporting textbook because of the different approaches and emphases given to basic theories and concepts. These variations often present problems, because introductory subject matter is either too general or too specific to one subject area—the visual elements, principles of design, color, or visual organization, for example.

Many quality books are available that provide an overview of the basic visual theories and concepts and are appropriate within a specific context. Art, architecture, and design programs, however, vary in their educational goals, philosophy, course structure, time allocation, and subject emphasis. Some programs prepare students for professional fields such as graphics, printing, illustration, photography, television, visual communication, architecture, interior space design, and industrial design, each of which requires specific knowledge and skills. There are also schools of art that stress a general overview of the visual arts and a perceptual awareness of the visual elements. Still other programs emphasize visual concepts, theories, and problem-solving techniques as they relate to architecture, interior environments, visual communication, and industrial design, and also involve an appreciation of the visual arts.

To address these program variations, it is necessary to have a number of supporting textbooks in order to cover the basic visual subject matter two- and three-dimensionally and also to teach the techniques, approaches, processes, and skills germane to design. Although no single textbook can be all things to all faculty and all educational programs, this book attempts to eliminate the need for many supporting texts by presenting a wide range of information and study exercises to help faculty and students learn and utilize a common visual language. At the same time, it uses a simple, general approach so that lessons can be adapted to the required educational context.

The Intent and Use of the Text

The primary intent of this textbook is to actively involve art, architecture, and design students in a process-oriented approach to learning the visual language—that is, the theories, concepts, and skills used in creating form. These concepts, theories, and skills can be taught not only in foundation courses, but also in advanced courses in visual communication, product design, architecture, and interior space design; they can also be useful to artists on various levels.

Coupled with the primary intent is a model, the Problem-Solving Process/Form Generation Model, that orders and categorizes the visual elements used in form generation and identifies the basic concepts taken from visual perception and communication theory. This model also recognizes human factors and human dimensions; form configuration, structure, and materials; and processes and technology utilized by architects and designers. The model illustrates the interrelationship of the problem-solving process and the form generation process so that professionals, faculty, and students can relate to the comprehensive process for creating two- and three-dimensional forms.

In addition, the textbook and its approach to teaching the visual language provide the reader with varied subject matter. Lessons are reinforced with exercises that help the student apply the different concepts. The exercises are illustrated with actual student solutions to the problems. Some of the student exercises and examples are from national and international universities and design schools, providing insight into contrasting approaches. Students may do the exercises in class or as independent projects outside of class.

Acknowledgments

The recognition of the need to design and develop instructional materials that would take a more comprehensive view of the visual language and its concepts brought about the challenge and concept for this textbook. As with any text of this magnitude it is impossible to complete this task alone.

I am grateful to Cynthia Busic-Snyder who has complemented the text with her design skills and computer-generated illustrations essential to comprehending many of the visual concepts and principles. Cynthia also shared in helping formulate the design process and form generation model that is instrumental in relating and organizing the process of form generation within the text.

Many thanks to my family and to Cynthia's husband, who have supported this textbook from beginning to completion with only occasional complaint.

Special recognition and my indebtedness go to my wife, Jeannette, who has spent long hours assisting me in copywriting and proofreading the text and in encouraging me to maintain my energy in completing it.

Gratitude and thanks to my graduate teaching associates who have been an inspiration in my classroom in addition to assisting me in design instruction: Dennis Foley, Janet Muhleman, Tim Cook, Rainer Teufel, Jay Corpus, Deborah Singer, Yin Ian Chen, Karl Brugger, Hsuen Chung Ho, Attila Bruckner, Victor Leone, Laura Rolfe, Rod Johnson, Cynthia Busic-Snyder, Chi-Ming Kan, Eun Sook Kweon, and Louise Utgart-Konrath.

Special thanks go to Susan Hessler, Louise Utgart-Konrath, Alan Jazak, Anita Wood, Angela Canini, Robert Jennings, and Grace Greczanik for their help in photographing student work and preparing art for production.

I also give thanks and recognition to all my design students whose work is represented within the text. I have tried to give name recognition to student work when possible; however, there is illustrative work that I have not been able to identify because there was no name attached to it.

My gratitude to my friends and colleagues for their wholehearted support for this book, in particular to my dean, College of the Arts, Andrew Broekema.

My appreciation to Kennie Harris, production editor at William C. Brown Publishers, for being my advocate through difficult times, and to Pat Phillips, project manager at Carnes-Lachina Publication Services, who has tirelessly guided me through the last stages of preparing this textbook for publication.

Charles Wallschlaeger
April 23, 1991

To the Instructor: Developing a Structure and Terminology for Basic Visual Studies

The Need for a Formal Visual Language

Many authors, visual theorists, and educators have written and lectured on the visual elements and theories that comprise visual studies. Visual educators do not always agree about which basic theories are essential to foundation studies. Because this disagreement often leads to misinterpretation and misunderstanding, many visual educators, including ourselves, believe that the visual language and its structure needs to be formalized and clarified.

General agreement by visual educators on the body of knowledge in basic foundation studies could result in a unified visual language and would have equal application in general and professional (that is, discipline-centered) studies in art, architecture, and design. This is not to imply that regimentation is desired, however. Faculty need the freedom to present visual subject matter according to their various program structures. Formalizing and defining the body of knowledge and terminology offers a structure (as opposed to a rigid, regimental system) for the visual concepts and principles, thereby improving communication among educators in the fields of art, architecture, and design. This definition of terms also can be beneficial to visual educators in specifying, writing, and planning learning experiences.

Planning and Writing Educational Objectives for Basic Visual Studies

Art, architecture, and design educators continue to meet and exchange ideas about the need for emphasizing the basic visual studies within their educational programs. Visual foundation programs are structured differently according to the curriculum structure and variation in their teaching methods and background of the faculty. However, agreement can be reached about the development of a taxonomy for the basic subject matter. Benjamin S. Bloom and others, in *Taxonomy of Educational Objectives*, have outlined an approach for identifying and classifying educational goals and objectives that can be adapted to designing instruction for visual studies. Generally, this system is applied to curriculum development and setting instructional objectives for the classroom using three learning domains—**cognitive**, **affective**, and **psychomotor**.

The Cognitive Domain

The cognitive domain includes objectives and skills that make up "understanding" and "concept formation." Bloom has classified six categories: knowledge, comprehension, application, analysis, synthesis, and evaluation. Skills that involve creativity fall under the last two categories.

1. *Knowledge* consists of those behaviors that emphasize the remembering of material or events by the recognition or recall of ideas.
2. *Comprehension* includes objectives, behaviors, and responses that represent an individual's understanding of the literal message in a communication.
3. The *application* category requires students to know an abstraction well enough that they can correctly demonstrate its use. In order for this category to apply, it is necessary to comprehend the particular method, theory, principle, or abstraction.
4. *Analysis* deals with the separation of a whole into components, with an examination of the parts and their relationship to one another. Analysis is a commonly expressed objective in science, social studies, philosophy, and the arts.
5. *Synthesis* is the process of putting together elements to form an end product. In other words, students express their own ideas and experiences in order to produce a product, and each result will be unique because of the variances between ideas and experiences.
6. *Evaluation* is the process of formulating judgments about a particular idea, method, and so on. Evaluative judgments may be qualitative, quantitative, or both. Judgment formulation involves the use of criteria for appraising the accuracy, effectiveness, and satisfaction of the idea, method, end product, etc.

The Affective Domain

The affective domain includes those objectives that deal with the modes of behavior within an individual: interests, attitudes, appreciation, values, and emotional sets or biases. Affective objectives exist on a continuum ranging from simple attention to selected phenomena to complex qualities of character and conscience. The categories within this domain—receiving, responding, valuing, organization, and characterization—are arranged in hierarchical order from the lowest to highest level of internalization.

1. *Receiving* is the level at which the learner is sensitized to the existence of specific stimuli and becomes willing to receive or attend to them.

2. *Responding* refers to the responses by the learner that go beyond merely recognizing a phenomenon or concept. For example, the student becomes motivated to actively explore the phenomenon and its applications.

3. *Valuing* is an attribute of worth assigned by an individual to things, places, events, behaviors, and so on. The abstract value assessment is the result of a particular individual's criterion of worth.

4. *Organization* of a value system is achieved as a learner successfully internalizes values and encounters more complex situations for which more than one alternative may be relevant. The organization system categorizes the values, determines the interrelationships among them, and establishes which values are dominant and which values are pervasive.

5. *Characterization*, or personal judgment, of a value, or value complex, functions according to the internal value system. It develops with the addition and integration of personal and social values and philosophy.

The Psychomotor Domain

The psychomotor domain includes objectives that require acts involving neuromuscular or motor skill performance. The creative process in art, architecture, and design requires manipulative skills that are in the psychomotor domain. Despite the fact that physical development within young adults is fairly complete, differences in individual abilities should be realized and considered.

Developing Instructional Objectives

Developing instructional objectives is a basis for developing content and procedures. Writing specific objectives assists the instructor in (1) selecting learning experiences, (2) communicating to the student the learning experience and what is expected, and (3) giving both the student and the instructor standards for the evaluation process.

Although a course description and outline tells something about the content and procedures of the course, it usually lacks detailed instructional objectives—that is, what the student should be able to do once the course is complete. Robert F. Mager, author of *Preparing Instructional Objectives*, lists three characteristics of a useful objective:

1. Performance. An objective states what a learner is expected to be able to *do*.

2. Conditions. An objective describes the important conditions (if any) under which the performance is to occur.

3. Criterion. Whenever possible, an objective describes the criterion of acceptable performance by describing how well the learner must perform in order to be considered acceptable [Robert F. Mager, *Preparing Instructional Objectives* (Belmont, CA: Fearon Publishers, Lear Siegler, 1962), p. 21].

Following is an example of how to apply Mager's theory:

1. The student is instructed how to change a geometric shape to another shape in seven systematic steps.

2. The student must be able to scale the seven drawings on a 9" x 9" hot press illustration board. All seven drawing steps must be drawn with a no. 1 technical pen in black ink.

3. The student's performance is evaluated according to the performance and condition criterion; that is, did the student create a shape transformation from one geometric shape to another? Does the transformation utilize seven systematic steps? Were the technical specifications followed? Were the proper materials and tools used? How well or to what level were the criteria executed?

At this point the question may be asked, "Does writing instructional objectives take the spontaneity and creativity out of teaching?" Some instructors may believe that they shouldn't be limited by specific objectives but should feel free to take up whatever is of interest. The instructor may also think that the student should set the context, since this method may be considered more interesting and motivating. The use of these methods, however, affords the risk of the course/exercise objectives not being met or understood. It is ultimately the instructor's responsibility to plan and prepare the instructional objectives relating to the subject matter.

It should be emphasized at this point that a well-written objective states what theory, concept, or skill should be learned. The practice exercise experience is the vehicle by which to teach the objective. As suggested, instructors can write and develop useful objectives for exercises by incorporating Mager's three characteristics when preparing instructional objectives. It is

recommended that those new to formulating instructional objectives review books on preparing objectives, methods, and evaluation to support their subject matter. Walter Dick's and Lou Carey's *The Systematic Design of Instruction* is one such book.

Planning the Learning Experience

To structure a successful learning situation, it is necessary:

1. To be knowledgeable about the subject matter.
2. To know how to form and write the correct instructional objectives.
3. To know how to apply the appropriate instructional methods to motivate students.
4. To use appropriate testing and evaluation criteria relating to the written instructional objectives.
5. To recognize and understand the differences and capabilities of the students.

Evaluating the Learning Experience

Upon completion of the learning experience students should be aware of what they have or have not learned. Clear objectives allow both the instructor and the student to evaluate progress at any time through testing, one-to-one communication, or grading.

An important goal of the instructor should be to develop students' independence. At the foundation level the student is often too dependent on the instructor for learning direction. Students should be encouraged to learn from their mistakes. (Of course, this is not to say that they should be allowed to repeat them!) The instructor's role is to minimize misconception and misinterpretation, to help students plan and organize visual studies and to give direction to their work, minimizing the chance for error.

It has been the authors' personal experience that students have participated in class with an initial enthusiasm that later turned into disappointment simply because they didn't comprehend the instructional objectives described in the unit exercise. They didn't understand how their work was to be evaluated or the requirements of the unit. The more specificity brought to the knowledge and skills expected, the better the outcome for the student and the instructor.

Creativity in Visual Education

Creativity is the ability to attain a degree of originality in the perception of and creation of new things. It is an essential part of the problem-solving process in art, architecture, and design. Many books and articles are written about creativity; however, relatively little is understood about why some individuals possess the natural ability to synthesize in an imaginative way and others do not. One explanation is that, traditionally, education programs stressed and rewarded memorization of facts and tasks without adding a creative dimension, such as problem solving, to the cognitive processes. Now, however, educational systems and practices are changing, giving more emphasis to problem-solving creativity. Currently the educational system is beginning to recognize the importance of introducing creative instructional methods in order to experience visual thinking and problem solving at all levels.

One way to introduce students to creative thinking is to engage them in imaginative group game playing directed toward tearing down emotional and mental blocks that restrict creativity. Creative thinking can be encouraged through:

- Listening
- Speculating about "what if" questions
- Building onto ideas
- Value learning from mistakes
- Optimism
- Feedback/Direction
- Fantasy or fantasizing
- Not evaluating too early
- Being open to the new or novel

A list of reference books that assist in stimulating creativity and visual problem solving can be found on p. xv.

Creativity: A Student's Remarks

One student's concept of the creative process, shown on this page, is revealing. It defines the creative process and hints at the many feelings, frustrations, and other elements that occur within the process—fear, self-doubt, possible mistakes, and even a sense of humor.

To be creative, a positive and open attitude is primary. The artist, architect, or designer must be willing to attempt new ideas, experiment, and face the possibility of failure. Creativity involves a great deal of challenge, patience, and an inquiring interest or curiosity in the problem-solving process. It also involves an analytical, logical, but "free-thinking" approach to a given design activity.

It would seem quite apparent that there is no one creative process, and there may well be as many creative processes as there are creative people.
H. Herbert Fox
"A Critique on Creativity in the Sciences"

The stages of creativity are not stages at all, but processes which occur during creation. They blend together and go along concurrently.
John W. Haefele
"Creativity and Innovation"

SUMMARY:

As the stages of creativity were outlined at the start of Design 251, first comes acceptance of the project, "Variations of an object - 8 final plates to be handed in as a final exam, with all controls met. → Next comes analysis, a personal study of the project, followed by definition, which, with the problem statement already in hand are merely steps in clarification for the student. Ideation, ideally, comes next, the generation of ideas, spontaneous and original; well, John inserted a step before ideation — Incubation, a period of time when the problem soaks in (I was "becoming" garlic at this time, as it was to be my object... feeling it, looking, pulling cloves off, peeling them, cooking everything with garlic, eating and digesting it). The trouble with incubation is that if you are not careful, it can become stagnation, and I have noticed that this often happens in my personal creative process.

"Self-Discipline, my dear —
that is the thing you must learn!"
-Edith Gram, age 83 ... couturier (Denmark to France to Early Los Angeles society)

Once out of the pleasantly indulgent incubation stage, and having struggled with near stagnation, Ideation, Idea Selection (it really helped to see the titles of the eight projected plates); Implementation, the actual doing, as usual set into motion by the adrenalin generated by last-minute panic followed. And the Evaluation phase belongs to the teachers...

It is clear to me that, as a class, we are being taught to control our creative processes and that this lesson, well learned, is an invaluable tool to freeing the creative spirit in the individual, whether he is a student, a designer, a journalist or a brick mason; a cook, and everybody else who ever set an idea in motion or wished to try, must discipline himself to control his own creative thought processes. So there it is, and I forgot to say that although incubation is usually my favorite stage, implementation could well be the most rewarding, especially as the panic is gradually eliminated.

References and Resources

Education

Adams, James L. *Conceptual Blockbusting*. New York: W.W. Norton Co., 1978.

Bloom, Benjamin S., ed. *Taxonomy of Educational Objectives Handbook I: The Cognitive Domain*. New York: David McKay Company, 1956.

Dick, Walter, and Lou Carey. *The Systematic Design of Instruction*. 2d ed. Glenview, IL: Scott, Foresman and Co., 1985.

Gagné, Robert M., Leslie J. Briggs, and Walter W. Wager. *Principles of Instruction*. 3d ed. New York: Holt, Rinehart and Winston, Inc., 1988.

Krathwohl, David R., Benjamin S. Bloom, and Bertram B. Masia. *Taxonomy of Educational Objectives Handbook II: The Affective Domain*. New York: David McKay Company, 1964.

Mager, Robert F. *Preparing Instructional Objectives*. Belmont, CA: Fearon Publishers, Lear Siegler, 1962.

Parker, Cecil J. *Process as Content: Curriculum Design and the Application of Knowledge*. Edited by Louis J. Rubin. Chicago: Rand McNally, 1966.

Popham, James W., and Eva I. Baker. *Systematic Instruction*. Englewood Cliffs, NJ: Prentice-Hall, 1970.

Terwilliger, James S. *Assigning Grades to Students*. Glenview, IL: Scott, Foresman and Co., 1971.

Tyler, Ralph W. *Basic Principles of Curriculum and Instruction*. Chicago: The University of Chicago Press, 1949.

Vargas, Julie S. *Writing Worthwhile Behavioral Objectives*. New York: Harper & Row, 1972.

Creative Thinking

Arnheim, Rudolf. *Visual Thinking in Education*. Edited by György Kepes. New York: Braziller, 1965.

McKim, Robert H. *Experiences in Visual Thinking*. 2d ed. Pacific Grove, CA: Brooks/Cole, 1980.

————. *Thinking Visually*. Belmont, CA: Wadsworth, Inc., 1980.

Samson, Richard. *The Mind Builder: A Self-Teaching Guide to Creative Thinking and Analysis*. New York: Dutton & Co., 1965.

VonOech, Roger. *A Whack on the Side of the Head*. New York: Harper & Row, 1983.

————. *A Kick in the Seat of the Pants*. New York: Harper & Row, 1986.

Wilson, John. *Thinking with Concepts*. London: Cambridge University Press, 1963.

The Problem-Solving Process | **Project Planning and Research**

Problem Statement | **Research and Information Gathering** | **Problem Formulation and Delineation**

Problem-Solving Techniques:

Form Generation

Format

2 Dimensions
Pictorial Space or
Picture Plane

3 Dimensions
Physical Environment
and Products

Note: The actual
format or product
is composed of a
selected material
or materials.

Form

Form is the primary
identifying characteristic
of volume.

D

C

In

Vi

Fo

Po
co
No

Li

Pl

Vo
po
lin
pl

Chapter 1

Historical Influences on Visual Education

CHAPTER OUTLINE

- Historical Influences
- Art, Architecture, and Design Education
- Contemporary Trends in Design and Architecture Education
- References and Resources

CHAPTER OBJECTIVES

On completion of this chapter, readers should be able to:

- Understand and list the major historical influences on visual education.

- List some of the major art, architecture, and design schools or programs that have influenced visual education.

- Understand the evolution of curriculum structure as it relates to art, architecture, and design programs.

INTRODUCTION

There is little written about how visual language concepts, principles, and theories evolved, or about the evolution of visual educational patterns. The following is a brief synopsis of significant historical influences and events which have affected the evolution of art, architecture, and design education. It is important to know this historical information in order to understand where art, architecture, and design education are today, and why.

HISTORICAL INFLUENCES

Many of the early classical theories of order, harmony, proportion, and scale that we still draw upon today were originally recognized and utilized by practicing artists, architects/builders, and utilitarian craftsmen. These visual theories and concepts assisted in the creation of art forms, buildings, and commercial products.

Beginning in the Middle Ages, the artist, architect, or craftsman was taught professional skills and visual concepts by joining a guild system as an apprentice or by studying with a recognized master within a given area. The master taught the student through "hands-on" experience and imitating works of art and architecture. The phases in the education process were apprentice, journeyman, and, finally, after several years of study, master craftsman.

The Renaissance, or revival of classical art, literature, and science from the fourteenth to sixteenth centuries brought numerous new theories and concepts to the forefront, such as Brunelleschi's and Alberti's artificial or scientific perspective drawing, Fra Luce De

Pacioli's and Leonardo Da Vinci's proportional theories, Sir Isaac Newton's seven-step color theory, LeBlon's red, yellow, and blue theory of pigment colors, and Harris's color chart, to name a few; all of these are discussed in this text. Other significant cultural developments came about with the invention of the printing press and the production of books, which resulted in the spread of knowledge and information among the common man.

The Baroque period in painting, sculpture, and architecture can be described as dynamic, ornamental, and colorful. Artists and craftsmen aspired to create spectacular visual effects. Some of the great artists of this era were Annibale Carracci and Caravaggio (Italian), Diego Velázquez (Spanish), Peter Paul Rubens and Anthony Van Dyck (Flemish), Frans Hals, Rembrandt van Rijn, and Jan Vermeer (Dutch), and Nicolas Poussin (French). Well-known architects included Giacomo da Vignola, Gianlorenzo Bernini, and Guarino Guarini (Italian), Louis Le Vau, Jules Hardouin-Mansart, and Francois Mansart (French),

Inigo Jones and Christopher Wren (English). This period also brought about the establishment of academies within the areas of arts and letters, science, and philosophy. In 1635 the French academy, L'École des Beaux Arts was founded in Paris. In general, academies' curriculum included lecturing on drawing composition, proportion, color, and expression. Learning and copying from a master artist or craftsman was still widely accepted in education.

During the Industrial Revolution and through the Victorian era, Great Britain's economy was transformed by new manufacturing processes that facilitated production of inexpensive commercial products. Where in the past British manufacturers had merely reproduced imitations of hand-crafted products, as a matter of course they began to search for ways to improve production through improved designs. Modifications in educational patterns and practices followed and reflected society's increased demands for material goods and services. Many artists and craftsmen were intimidated by these changes because of the threat they posed to their

arts and crafts. As a result, members of the Arts and Crafts Movement, led by William Morris, refused to participate in the design and production of manufactured products.

The need to cope with industrial change led in two divergent educational directions. One direction, initiated by Henry Cole, addressed industrialization by reforming art and design curriculums; the result was a more formalized visual education. This attempt at reform failed because not enough emphasis was given to the design of objects for manufacture. The second direction was the Arts and Crafts Movement led by William Morris. Morris and his followers were convinced that industrialization would bring about the destruction of human purpose.

He encouraged his followers to continue the practice of creating one-of-a-kind, individualized objects and reject the movement toward industrialization of products. The Arts and Crafts Movement was not concerned with the reconciliation of art and the forces of industrialization. Henry Cole and his followers, however, contributed to the acceptance of the machine in the production of goods for mass consumption, and ultimately to the need for change in the educational curriculum of artists and craftsmen. This unrest resulted in a philosophical struggle as to a new formalization of design education and the acceptance or rejection of the machine and new technologies relative to professional areas of practice. This philosophical struggle culminated in the reforms formulated by twentieth-century pioneers of the design movement.

ART, ARCHITECTURE, AND DESIGN EDUCATION

It took approximately seventy years, from 1830 to the beginning of the 1900s, to begin to overcome the resistance of industrial mechanization. At this point in time, with the exception of those from England, many European artists, architects, and designers from the continent realized the inevitability of industrialization and accepted the challenge of the new technology, materials, and processes, as well as the desire to control the machine. This acceptance fostered yet another new direction in design education: the establishment in 1919 of the Bauhaus in Germany under the direction of Walter Gropius. Gropius was an architect from Berlin who helped bridge the gap between artists, architects, and designers and the industrial system.

The importance of the Bauhaus was in its development of new ideas in art, architecture, and design relating to a new perception of the world of technology and craft. One of the major influences of the Bauhaus was Johannes Itten's efforts to organize the first basic foundation course. This course was important in establishing a more formal educational approach to the study of the basic materials, principles, and elements of forms, and eventually led to the creation in 1923 of a syllabus for the Bauhaus. Thus, the model on which modern visual education is built was established. Since the closing of the Bauhaus in 1933, there has been a rich tradition of movements throughout Europe and the United States for the creation of formal programs in art, architecture, and design.

The United States has fostered the growth of art, architecture, and design schools and colleges in the twentieth century. In 1934 the Carnegie Institute of Technology (now Carnegie-Mellon University) established the first department of industrial design in a university or college in America when Donald R. Dohner, supported by Alexander Kostellow, established a degree-granting undergraduate program in industrial design. The curriculum presented a plan for educating designers to work for industry and eventually a theoretical structure for visual education was developed.

Also in 1935, a special school named the Design Laboratory was established through funding from the Works Progress Administra-

tion (WPA) in New York City. It was set up to provide professional training in industrial design for those who could not afford a private education. The curriculum was based on the Bauhaus educational concept and supplemented course work with training in manufacturing processes and merchandising. In 1936 funding from the WPA was withdrawn. The Federation of Architects, Engineers, Chemists and Technicians decided to support the Design Laboratory and the name was changed to the Laboratory School of Industrial Design. According to John McAndrew, curator of architecture at the Museum of Modern Art, this school was the first in the United States to devote its entire curriculum to the various professional fields within industrial design [cited in Arthur Pulos, *The American Design Adventure, 1940–1975* (Cambridge, MA: MIT Press, 1988), p. 164].

In 1936 Donald Dohner accepted an invitation to join the faculty at the Pratt Institute in Brooklyn, New York, to develop an industrial design program. In 1938 Dohner invited Alexander Kostellow and Rowena Reed Kostellow to teach at Pratt. Under the direction of Dohner, Kostellow, and other faculty, a new industrial design program was developed at the request of Dean James Boudreau. At this time, Pratt offered one of the most significant programs in art and industrial design. Kostellow's pioneering efforts in establishing a foundation program

has influenced many U.S. art and design programs.

In the late 1930s the Cranbook Academy of Art gained a national and international reputation because of its faculty, which included Walter Baermann, Charles Eames, Ray Kaiser, Harry Weese, Henry Bertoia, and Eero Saarinen. Their educational contributions led to significant changes that influenced industrial design in the post–World War II era.

In 1937–38 the New Bauhaus was established in Chicago under the direction of Moholy-Nagy. The instructional program at the New Bauhaus reflected the principles of the original Bauhaus, but further refined and broadened its aims; the program was well structured but too ambitious for immediate realization. During the period 1939–44 the New Bauhaus became the School of Design under the direction of Moholy-Nagy. Walter Paepcke provided financial support for the school, and György Kepes joined the faculty. Then in 1944 the School of Design became the Institute of Design and obtained college status. In following years there were numerous changes in the leadership and structure. Serge Chermayeff became the director in 1946, and in 1949 there was an incorporation of the Institute of Design into the Illinois Institute of Technology. As a result, the school obtained university status. In 1951 Serge Chermayeff resigned and the acting director was architect

Crombie Taylor until 1955, when Jay Doblin was appointed to head the Institute.

In Europe, meanwhile, the Hochschule für Gestaltung officially opened at Ulm, Germany, in 1955 under the direction of Swiss architect Max Bill. Bill followed the concepts of the Bauhaus and the philosophy of Serge Chermayeff at the Institute of Design in Chicago. Under the direction of Tomás Maldonado, Ulm modified its direction and gave greater emphasis to a methodical, scientific, social, and economic approach to solving problems. Like the Bauhaus, the Ulm School brought distinguished faculty and professional designers, architects, theoreticians, methodologists, technologists, sociologists, and historians together within one educational institution. The dynamics of this faculty and its graduates brought about a new philosophy and approach to design education, which has influenced many programs nationally and internationally since the 1960s. In addition to Max Bill, who served from 1954 to 1956, rectors of the Ulm School included a faculty administrative board from 1956 to 1963; Otl Aicher, 1963–64; Tomás Maldonado, 1964–66; Herbert Ohl, 1966–68. In 1968 the Ulm School closed.

The aforementioned institutions and their philosophies and approaches to visual education have influenced other evolving schools and departments within the United States, Europe, and Asia. Toward the end of the 1960s

and into the 1980s newly formed programs such as the Department of Industrial Design at The Ohio State University have continued to assess and rationalize industrial design as a profession, taking into consideration the dynamics of change within industry and education. These changes have emphasized traditional and nontraditional knowledge and interdisciplinary problem-solving, utilizing new methodologies and systems approaches to designing. Other important schools that have made significant contributions to art, architecture, and design education are the Art Center College of Design (California), the Massachusetts College of Art, the Rhode Island School of Design, the Rochester Institute of Technology, Syracuse University, the University of Cincinnati, and the University of Illinois at Urbana/Champaign.

CONTEMPORARY TRENDS IN DESIGN AND ARCHITECTURE EDUCATION

The United States has evolved from an industrial society into one that is primarily directed toward the creation and distribution of information. This dynamic change from an industrial to an information society has taken little more than two decades.

The visual arts, architecture, and design fields continue to increase in complexity due to the expansion of new technologies in production and the use of computers that assist in design and manufacture. With these technological and societal advances, emphasis is now placed on the acquisition and application of information toward new aesthetics within the visual arts professions. In the design and architecture professions, the major focus today is no longer on pure form generation, which has been the case in the past. A more comprehensive position relative to user needs and involvement, affordability, resources, environmental conservation, and the ability to produce through industrialized manufacturing methods has been established. This amelioration of emphasis in requirements has and will continue to affect design and architecture programs. Many national and international schools have already incorporated computer-aided design and graphics into the curriculum. These changes have resulted in the reorganization of some of the major subject matter on the undergraduate and graduate level, as well as changes in how students approach visual problems and solutions through the use of computer media. To draw a parallel, today's visual arts, architecture, and design educators are faced with an educational dilemma somewhat similar to the one that occurred during the Industrial Revolution. The evolving technologies challenge educators to promote technologically innovative solutions and to use the computer as a media and support tool.

REFERENCES AND RESOURCES

Banham, Reyner. *Theory and Design in the First Machine Age*. New York: Praeger, 1960.

Bayer, Herbert. *Bauhaus 1919–1928*. Edited by Walter Gropius and Ise Gropius. Boston: Branford, 1959.

Bayley, Stephen. *The Conran Directory of Design*. New York: Villard, 1985.

Bentley, Nicolas. *The Victorian Scene 1837–1901*. London: Weinenfeld and Nicolson, 1968.

Benton, Tim and Charlotte, with Dennis Sharp. *Architecture and Design 1890–1939*. New York: Watson-Guptill, 1975.

Boe, Alf. *From Gothic Revival to Functional Form*. Oslo: Oslo University Press, 1957.

Burckhart, Lucius, ed. *The Werkbund History and Ideology, 1907–1933*. New York: Barron's, 1980.

Burns, Tom, ed. *Industrial Man*. Baltimore, MD: Penguin, 1969.

Ferebee, Ann. *A History of Design from the Victorian Era to the Present*. New York: Van Nostrand Reinhold, 1970.

Friedman, Mildred, ed. *DeStijl: 1917–1931: Visions of Utopia*. New York: Abbeville, 1982.

Hartwell, R. M. *The Causes of the Industrial Revolution in England*. London: Metheuen, 1967.

Henderson, W. O. *Industrial Revolution on the Continent*. London: Cass, 1961.

Hillier, Bevis. *Art Deco*. London: Vista, 1970.

Hulten, Pontus K. G. *The Machine as Seen at the End of the Mechanical Age*. New York: The Museum of Modern Art. Distributed by The New York Graphic Society, 1968.

Kepes, György. *The New Landscape in Art and Science*. Chicago: Theobald, 1961.

Klemm, Friedrich. *A History of Western Technology*. Cambridge, MA: MIT Press, 1964.

Kouwenhoen, John A. *Made in America: The Arts in Modern Civilization*. New York: Doubleday, 1962.

Lindinger, Herbert, ed. *Hochschule für Gestaltung, Ulm*. Berlin: Ernst and Sohn, 1987.

Loewy, Raymond. *Industrial Design*. New York: Overlook, 1979.

Miller, R. *Design in America*. New York: Abrams, 1983.

Moholy-Nagy, Laszio. *Vision in Motion*. Chicago: Theobald, 1947.

Muller-Brockmann, Josef. *A History of Visual Communication*. New York: Hastings House, 1971.

Naylor, Gillian. *The Arts and Crafts Movement: A Study of Its Sources, Ideas and Influences on Design Theory*. London: Studio Vista, 1971.

Peter, John. *Masters of Modern Architecture*. New York: Bonanza, 1958.

Peusner, Nikolaus. *Pioneers of Modern Design from William Morris to Walter Gropius*. New York: The Museum of Modern Art, 1949.

Pulos, Arthur J. *American Design Ethic*. Cambridge, MA: MIT Press, 1983.

———. *The American Design Adventure 1940–1975*. Cambridge, MA: MIT Press, 1989.

Read, Herbert. *Art and Industry*. New York: Harcourt Brace, 1935.

Rowland, Kurt. *A History of the Modern Movement: Art, Architecture, Design*. New York: Van Nostrand Reinhold, 1973.

Rudenstine, Angelica Z., ed. *Russian Avant-Garde Art: The George Costakis Collection*. New York: Abrams, 1981.

Rykwert, Joseph. *The Necessity of Artifice*. New York: Rizzoli, 1982.

Schmutzler, Robert. *Art Nouveau*. New York: Abrams, 1962.

Selz, Peter, and Mildred Constantine. *Art Nouveau, Art and Design at the Turn of the Century*. New York: Museum of Modern Art, 1959; distributed by Doubleday.

Society of Industrial Designers. *Industrial Design in America*. New York: Farrar, Strauss, and Young, 1954.

Wallance, Don. *Shaping America's Products*. New York: Reinhold, 1956.

Willet, John. *Art and Politics in the Weimar Period*. New York: Pantheon, 1978.

Wilson, Richard Guy, Diane H. Pilgrim, and Dickran Tashjian. *The Machine Age in America 1918–1941*. New York: Abrams, 1986.

Wingler, Hans M. *The Bauhaus: Weimar, Dessau, Berlin, Chicago*. 2d ed. Cambridge, MA: MIT Press, 1968.

Wolfe, Tom. *From Bauhaus to Our House*. New York: Farrar, Straus & Giroux, 1981.

Chapter 2

The Problem-Solving Process and Form Generation Model

CHAPTER OUTLINE

- The Problem-Solving Process
- The Form Generation Process
- Using and Interpreting the Problem-Solving Process/Form Generation Model
- References and Resources

CHAPTER OBJECTIVES

On completion of this chapter, readers should be able to:

- Understand the relationship between the problem-solving process and the form generation process subject matter using the models presented.

- Understand the rationale for applying formal design concepts and principles to creative activities.

- Understand the rationale for the way subject matter is categorized and locate the different subject matter categories as they are presented in the form generation process model.

THE PROBLEM-SOLVING PROCESS

The problem-solving process is an activator assisting in the creative process which, in a general sense, encompasses a variety of activities with widespread applications in many structured and unstructured bodies of knowledge and disciplines. It can result in the generation of art forms, graphics, visual communication messages, products, architecture, or interior spaces. The problem-solving process utilized by artists, architects, and designers is also utilized in activities such as managing, marketing, engineering, manufacturing, teaching, research, and many other areas.

The process describes a series of events, stages, or phases that can be viewed in a variety of ways. It is a planning and organizational tool used to guide creative activities toward an end goal. Many variations of problem-solving models are used, since they can be arranged to organize specific problems, taking into account the various time and resource constraints in addition to differences in desired outcome. Individuals, teams, and organizations discover, adapt, and use those methods and organizational processes that best fit their design problem. Although the particular process can change in appearance depending on the emphasis placed on the aforementioned variables, it is still referred to as a problem-solving process.

Design practices may be carried out at a formal level for large-scale projects that involve a number of constraints and personnel, or at an informal, highly individualized, and seemingly simple level. In either case, a satisfactory solution requires that specific types of information be appropriately assembled and implemented. These practices, which make up the problem-solving process, form the core of the disciplines of architecture and industrial design.

Four different versions of the problem-solving process are shown to illustrate how the process can be altered for use in solving specific types of problems (see Figures 2.1–2.4). For example, short-term, well-defined problems may utilize the linear process, whereas more complicated, less well-defined problems may require several rounds of creativity and evaluation before the final solution is selected, implemented, and evaluated.

Figure 2.1 Linear model of the problem-solving process.

Figure 2.2 Circular model of the problem-solving process.

Figure 2.3 Branching model of the problem-solving process.

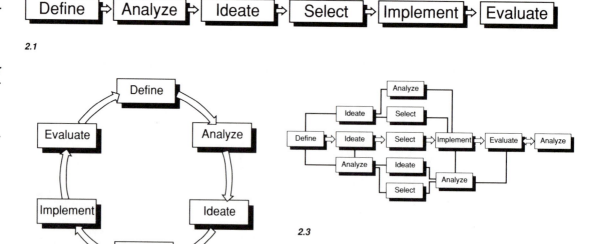

2.1

2.2

2.3

The Form Generation Process

At this point, readers should have an understanding of the evolution of art, architecture, and design, as well as how to structure and/or analyze creative learning experiences. The next question is "How do the subject matter, skills, and materials interrelate with the process of creating or organizing new forms?"

There are varied form generation models created by educators in the visual arts, some simple in structure and others more complex or comprehensive. The appropriate choice of model depends on the area of discipline.

Form Generation and Visual Ordering

Both two- and three-dimensional compositions and forms are created by combining the subject matter, meaning, or intent with materials or media; the result is a tangible figure or form. During the "generation" of a form, artists, architects, and designers manipulate components to devise and produce meaningful art forms, products, buildings, interior spaces, communications, and so on.

According to the model shown in Figure 2.5, form generation involves media, the elements of art, and the principles of organization, employing balance, movement, proportion, dominance, and economy to produce form unity. This model and the one developed for this

2.4

Figure 2.4 Feedback model of the problem-solving process.

Figure 2.5 Model outlining the components involved in form generation (from Ocvirk, et al. Art Fundamentals, Dubuque, IA: Wm. C. Brown Publishers, 1990).

Form
⇩
Is the Use of ———— **Media**
　　　　　　　　Art Tools
　　　　　　　　Art Materials
⇩
the Elements of Art
Line
Shape
Value
Texture
Color
⇩
according to
⌐ **the Principles of Organization** ⌐
Harmony　　　　　　　　　　　　Variety
involving rhythm-repetition　　involving contrast-elaboration
⇩
employing
⇩
Balance
Movement
Proportion
Dominance
Economy
⇩
and
Space
⇩
to produce
Unity

2.5

textbook (see the foldout preceding Chapter 1) are parallel in thought and use of terms. The terms are clarified by *Art Fundamentals* authors Ocvirk, Stinson, Wigg, and Bone:

Artists are visual formers with a plan. With their materials they arrange the elements (lines, shapes, values, textures, and colors) for their structure. The elements they use need to be controlled, organized, and integrated. Artists manage this through the binding qualities of the principles of organization:

harmony, variety, balance, movement, proportion, dominance, economy, and space. The sum total of these, assuming the artist's plan is successful, equals unity. *Unity in this instance means oneness, an organization of parts that fit into the order of a whole and become vital to it.*

Form is the complete state of the work. The artist produces this overall condition using the elements of art structure, subject to the principles of organization. [Ocvirk, et al., Art Fundamentals (Dubuque, IA: Wm. C. Brown Publishers, 1990), p. 17.]

Evolution of the Problem-Solving Process/Form Generation Model

The foldout preceding Chapter 1 illustrates a comprehensive model that outlines the knowledge, skills, materials, and processes involved in the creation or the organization of form. This problem-solving process/form generation model identifies the visual elements and theories utilized, drawing upon formal areas of knowledge and research such as perception and communication theory, human factors and dimensions, form configuration and structural physics, materials, and manufacturing processes.

This model was derived from an extensive review of art, architecture, and design materials, as well as texts and publications on visual perception, communication, and information theory. In addition, approximately thirty national and international art, architecture, and design programs were visited.

Information was gathered and reviews were structured with the help of a questionnaire. Faculty could select and communicate the theories, concepts, and principles that were applicable to their individual programs and areas of study. Of great significance, the practical experience and use of information derived from many years of teaching on the undergraduate and graduate levels are incorporated into the model.

USING AND INTERPRETING THE PROBLEM-SOLVING PROCESS/FORM GENERATION MODEL

Intent of the Model

The intent of the model is twofold. For the instructor in art, architecture, and design, it provides a foundation for structuring program curricula, courses, and learning exercises, and it is a means to describe and locate interrelating concepts, theories, principles, rules, and processes to bring about better awareness of interdisciplinary knowledge. Second, it helps students understand the educational contexts of course requirements, both general and specific.

The model can help instructors and students move through an exercise more efficiently and effectively, producing either a two- or three-dimensional end form, which could be a painting, sculpture, architectural structure, interior product, or a graphic communication.

In summary, the model may be used:

- To identify and organize into a comprehensive structure the basic visual elements, form attributes, and the various theories and phenomena that influence the form generation process in art, architecture, and design.

- To assist in reviewing and evaluating or modifying a visual program structure when needed; that is, its course content and instructional objectives.

- To help in identifying subject matter areas that need to be added to and reinforced at intermediate and advanced levels of art, architecture, and design.

- To help in teaching concepts, theories, and principles in art, architecture, and design.

Keep in mind that the model is not all-inclusive and that information or subject matter areas can be added to or subtracted from it. Both the problem-solving process and the form generation process, which parallel each other in the model, can be reviewed and interpreted in a variety of ways. The model is meant to be used only as a flexible planning and organizational guide to direct creative activities toward the desired goal. It can be arranged to accommodate the type of outcome desired, as well as the resource and time constraints involved.

Model Structure

The model reads both horizontally from left to right and vertically from top to bottom. The top portion of the model is the problem-solving process. Reading across from left to right are the major categories. The categories overlap one another in some in-

stances, just as the activities in the actual creative process may overlap.

The lower portion of the model is the form generation process. Again, reading from left to right are the major categories. The vertical columns list the subcategories and outline the general information, theories, concepts, principles, processes, and materials related to the particular category.

Model Subject Matter

The subject matter outlined in the problem-solving process/form generation model is located within the text as follows.

Unity of form, which is the physical shape or end result of the form generation process involves materials, tools, and techniques. Chapter 3 covers these items in a discussion of drawing as a means of communicating.

Chapter 4 supplies more in-depth knowledge about formal drawing systems. These formal systems are located under the Space, Depth, and Distance area of the model.

How well the artist, architect, or designer combines the various techniques and materials with visual elements and their surface attributes, visual perception concepts, form configurations, and structures determines the success of the outcome of the form. Form, and its generation on a two- or three-dimensional format or space through point, line, and plane, is covered in Chapter 5.

Structural concepts, as well as volumetric form or objects, are presented in Chapter 6. Readers are introduced to various ways to explore and create three-dimensional forms.

Chapter 7 focuses on the visual and physical elements of form and how they are used in the creation of two- and three-dimensional figures and forms. Attributes discussed are tone, texture, pattern, size, scale, dimension, and proportion.

Chapter 8 provides information on various color theories, concepts, and terminology, and poses a variety of exercises that assist in applying the subject matter.

Perceptual concepts and spatial cues as they relate to the perception of space, depth, and distance are dis-

cussed in Chapter 9. Among the concepts from the model presented are monocular and binocular cues, position, orientation, motion, and brightness constancy.

Chapter 10, Perception of Figure and Form, discusses concepts, laws, and principles of visual perception and how they relate to the visual form recognition process. Ambiguous figures, impossible figures, embedded figures, and figure/ground reversals are some of the phenomena discussed.

Organizational principles are concepts, theories, and rules that help guide artists, architects, and designers to organize and create shapes and forms; communication theory offers a process by which people can communicate with one another socially and culturally. Both of these areas are discussed in Chapter 11.

The final chapter, Symmetry and Dynamic Symmetry, outlines the prescriptive principles of organization, providing additional information on how to understand and learn to use a structural ordering system in form generation problems.

REFERENCES AND RESOURCES

Adams, James. *Conceptual Blockbusting*. New York: Norton & Company, 1978.

Archer, Bruce L. *Systematic Method for Designers*. London: Reprinted from *Design*. Published as a series of seven articles during 1963–64.

Christopher, Alexander. *Notes on the Synthesis of Form*. Cambridge, MA: Harvard Press, 1964.

Clark, Charles H. *Brainstorming*. New York: Doubleday, 1958.

De Bono, Edward. *New Think*. New York: Avon Books, 1971.

Gregory, S. A. *The Design Method*. London: Butterworths, 1966.

Jones, J. Christopher, and D. G. Thornley. *Conference on Design Methods*. Papers presented at the Conference on Systematic and Intuitive Methods in Engineering, Industrial Design, Architecture and Communications in London, September 1962. New York: Macmillan, 1963.

Kaufmann, A. *The Science of Decision-Making*. New York: McGraw-Hill, 1968.

Koberg, Don, and Jim Bagnall. *The Universal Traveler*. Los Altos, CA: Kaufmann, 1972.

———. *The Polytechnic School of Values*. Los Altos, CA: Kaufmann, 1976.

Ocvirk, et al. *Art Fundamentals*. Dubuque, IA: Wm. C. Brown Publishers, 1990.

Olsen, Shirley A. *Group Planning and Problem Solving Methods in Engineering Management*. New York: John Wiley and Sons, 1982.

Rowe, Peter. *Design Thinking*. Cambridge, MA: The MIT Press, 1987.

Sanoff, Henry. *Design Games*. Los Altos, CA: Kaufmann, 1979.

Starr, M.K. *Product Design and Decision Theory*. Englewood Cliffs, NJ: Prentice-Hall, 1963.

Chapter 3

Drawing as a Means of Communicating

CHAPTER OUTLINE

- Chapter Vocabulary
- Introduction to Drawing
- Intent of Drawing
- Types of Drawing
- Introduction to Drawing Exercises
- Beginning Approaches to Drawing
- Visually Representing an Object
- Sketching
- Drawing a Visual Set of Objects
- Introduction to Perceiving, Analyzing, Describing, and Drawing Natural Objects
- Denoting Surface Characteristics of Objects
- Practice Exercises
- References and Resources

CHAPTER OBJECTIVES

On completion of this chapter, readers should be able to:

- List the different purposes for using the medium of drawing.

- Determine what type of drawing is appropriate for communicating ideas to oneself, a specific audience, or a mass audience.

- Use the different finger, hand, and arm positions required in drawing.

- Use various drawing tools such as pencils, pens, and markers to create different visual effects within a drawing on a two-dimensional format.

- Use basic technical tools and materials such as technical pens, compasses, ruling pens, X-acto® knives, dry transfer lettering, film, self-adhesive tape, designer's gouache, brushes, paper, paper-board, and rubber cement.

- List the various characteristics of a good or interesting drawing in terms of media and technique.

- Utilize the four techniques of constructing and visually representing an object—that is, measurement, grid, axis, and motion.

- Utilize the different methods by which to perceive, analyze, describe, and draw natural objects.

- Use the different graphic techniques that develop descriptive detail in a drawing— that is, black and white contrast, point, line, and pure tone.

- Use sketching techniques to visually think and communicate about a person, place, or object.

- Use various methods, techniques, tools, and materials to create a visual story about an object.

- Interpret an object or form in different ways using various drawing techniques, tools, and materials.

- Represent an object or form with minimum line.

- Abstract an object or form into a simple archetype using point, line, plane, and tone drawing techniques.

- Denote surface characteristics of an object utilizing tone and texture.

- Develop interpretive fantasy drawings of objects using methods and techniques outlined in the chapter.

Figure 3.1 The gray areas (Visual Attributes of Form, Space, Depth, and Distance) denote the subject matter presented in this chapter.

Visual Elements of Form

Perception Theory

Form Generators

Visual and Physical Attributes of Form

Space, Depth, and Distance

Form Generators	Visual and Physical Attributes of Form	Space, Depth, and Distance
Point conceptual element **No** Dimension	Value/Tone Color	**2- and 3-Dimensional Form Perception** Light/Brightness contrast threshold
Line	Value/Tone Color Texture Dimension length Direction	Illusions Monocular Cues size partial overlap value color aerial perspective
Plane	Value/Tone Color Texture Dimension length width Shape direction visual stability Proportion	detail perspective linear perspective* texture gradient shadow blurring of detail transparency Binocular Cues muscular cues parallax cues Position Orientation Motion Time

Form

Form		Space, Depth, and Distance
	Form is the primary identifying characteristic of volume	
Volume is the product of: points (vertices) lines (edges) planes (surfaces)	Value/Tone Color Texture Dimension length width depth Shape direction visual stability Proportion	***Drawing/Projection Systems** Orthographic Paraline axonometric oblique Perspective

CHAPTER VOCABULARY

Drawing A graphic process that depicts or represents figures and forms on a surface by using either pencil, pen, or marker to produce points, lines, tones, textures, and so on, that illustrate an image.

Freehand drawing The use of hand-eye techniques for recording an image without the support of mechanical tools or instruments.

Projective drawing The utilization of conventional drawing systems such as orthographic, axonometric, oblique, and perspective projections.

Sketch or **sketching** A graphic process in which only those basic lines necessary to generally describe an object or form are used.

Technical drawing or **rendering** A drawing which depicts objects, human figures, or interior or exterior environments with great representational detail. This type of visual representation or drawing generally uses a projective drawing system and selected or mixed media.

INTRODUCTION TO DRAWING

In the fine and applied arts section of any bookstore or library, there are many books on drawing: freehand drawing, figure drawing, sketching, technical illustration, working drawings, and principles of perspective. *Joy of Drawing, The Easy Drawing Book, Freehand Drawing, Rapidviz, Pencil Sketching, Figure Drawing, A Studio Guide to Drawing,* and *Drawing on the Right Side of the Brain* are just a few. These are texts that present an overview and define abstract concepts of drawing and projection systems drawing. This illustrates the point that there can be many definitions, interpretations, and techniques of drawing that may confuse the beginning student. Thus, some time should be spent discussing the interpretations, systems, and techniques of drawing.

Perhaps the most important point here is that there are different purposes for using the medium of drawing. The artist most often considers drawing as an expressive medium, an end in itself. To the designer, drawing is analytical and is a means of developing form sensitivity, an awareness of visual relationships, and an ability to make a coherent graphic statement. The designer, architect, and engineer consider drawing as a means to communicate ideas about objects and spaces. Drawing becomes a visual thinking process, not an end in itself. (A valuable resource for design students is Hanks and Belliston's book, *Draw! A Visual Approach to Thinking, Learning, and Communicating.* This book gives an excellent overview of the purpose of drawing and how drawing can be used to express ideas and assist in visual communication. It also reinforces the ideas discussed in this chapter, since it concentrates on freehand drawing, media, and techniques.)

INTENT OF DRAWING

Drawing can express and represent ideas in numerous ways. Drawing should be considered an important mode of communication; it is as appropriate a method of communicating thoughts, ideas, and impressions as speaking or writing.

In art, architecture, and design, drawing has various intents. Drawing is a means to:

- Express impressions or views about the world we live in.
- Describe objects and environments.

- Understand, evaluate, and resolve design problems.
- Heighten visual awareness and detail of forms.
- Clarify ideas expressed by the written word.
- Develop form sensitivity and awareness of visual relationships.

- Retain and communicate what has been seen and understood.
- Visually explore and develop ideas.
- Understand concepts and pursue and develop ideas.

This list is incomplete; there are other ways that drawing is used in the communication process. However, the items listed do communicate the idea that it is necessary to begin drawing with an approach to see-ing and analyzing objects; the use of many different drawing tools and techniques can help in developing this approach.

TYPES OF DRAWING

Drawing, in the most general terms, involves putting marks on paper that visually describe forms, figures, and ideas. Two general categories of drawing presented in this chapter and in Chapter 4 are **freehand drawing** and formal drawing through projection systems, or **projection drawing**.

To determine what type of drawing is appropriate, it is necessary to establish the intended purpose, audience, and level of function of the drawing. Is the purpose of the drawing to help think about different problem solutions or to help present ideas to others? Should the drawing have meaning for the artist only, a small, specific audience, or a wide mass audience? Does the drawing represent a preliminary idea or a final design ready for print or manufacture? Asking these questions helps create a drawing or visual presentation tailored to the particular or specified communication need.

Figure 3.2 Hand/finger positions. (a) The most familiar position, used in writing. This position, with restricted arm movement, results in short, controlled strokes. (b) This position results in free, rhythmic strokes. (c) This position is commonly used for free, quick line and motion studies. (d) This position works well for most detail and tone drawing.

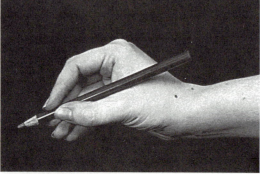

3.2a

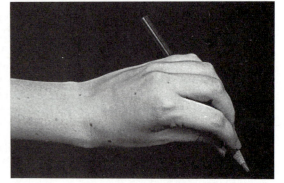

3.2c

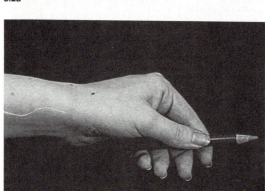

3.2b

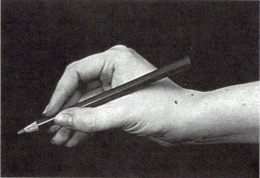

3.2d

INTRODUCTION TO DRAWING EXERCISES

The exercises in this chapter are designed to increase drawing abilities by helping readers learn to representationally draw objects and figures—in other words, to visually describe form that can be correctly interpreted and understood.

Beginning to Draw

A sketchbook is needed to begin. As various drawing techniques and skills with different media and tools are practiced, record the visual results in the sketchbook. Make notes about the processes and materials; this will become a personal log of the visual results for later use as a reference.

In starting the drawing process, it is important to understand that the wrist and finger movement commonly used in writing restricts dexterity and tends to produce tight, cramped drawings. In order to draw freely and to produce variations of line and stroke, it is necessary to use the whole arm and not just the fingers or wrist.

Hand Positions

The position of the drawing surface—horizontal, vertical, or sloped—influences the position of the hand. Hand positions are important in drawing because they influence the type and quality of the resulting line. Figure 3.2 illustrates some of the different hand positions. Practice these different hand/finger positions with a black, soft-lead pencil.

Pencils, Positions, and Graphic Techniques

In learning to draw, it is first necessary to become familiar with graphic tools and how to use them. The pencil is a tool and medium used in placing marks, lines, and images on paper. Select a few of the H and B leads (see Figure 3.3). Practice making different lines, line tones, and gray tones such as those illustrated in Figure 3.4.

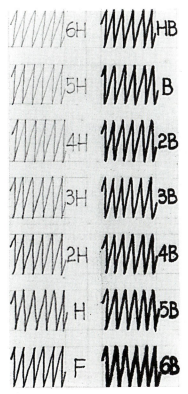

3.3

3.4a

3.4b

3.4c

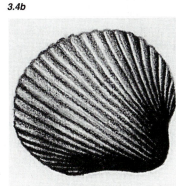

3.4d

Figure 3.3 Drawing leads are numbered according to the hardness of the lead. The higher the number used in combination with the letter H, the harder the lead. The higher the number used in combination with the letter B, the softer the lead. F lead is medium hardness (illustrated by Chi-ming Kan).

Figure 3.4 (a-d) Drawings of seashells using different types of lead (illustrated by Chi-ming Kan).

Figure 3.5 (a-c) The position of the pencil relative to the drawing surface creates different types of lines.The more vertical orientation of the pencil creates a thin, distinct line. The more angled or horizontal position creates a thicker, less distinct line (illustrated by Chi-ming Kan).

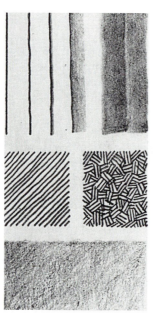

3.5a

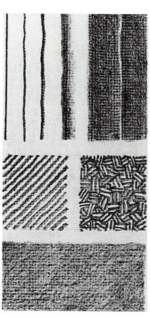

3.5b

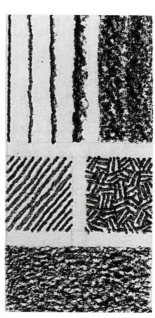

3.5c

As the pencil becomes familiar as a graphic tool, it becomes evident that the choice of the grade of lead (i.e., the hardness or softness), sharpness or bluntness of the tip, and position or angle of the pencil relative to the drawing surface influence the visual result of the drawing. Look at Figure 3.5 to see results obtained by different pencils, hand positions, and techniques.

✍Practice Exercise 3.1: Learning to Use Pencils

Select several pencils with different lead grades. Start with a sharp, hard-pointed pencil. Try to draw small texture areas (as in Figure 3.5), utilizing the pencil positions and graphic techniques illustrated. Progressively change to softer lead pencils. Continue this procedure until all four of the pencil positions and graphic techniques shown in Figures 3.6–3.9

have been tried. Compare the visual differences among the different texture areas.

At this point select a simple object. Draw the object using the four different pencils, positions, and graphic techniques illustrated (see Figures 3.6–3.9). Experiment with different combinations of pencils, positions, line/tone techniques, and papers. Note the differences in the results.

Pens, Positions, and Graphic Techniques

There is as wide a variety of pens available as there are of pencils. The choice of a pen depends on the graphic task or desired visual result. For example, technical pens are used for drafting and **technical drawings**, whereas fountain and felt-tip pens are used for freehand drawing and sketching, lettering, and writing. Many pen manufac-

turers offer pen systems that include a wide range of different points or nibs related to the resulting line width or style. A variety of inexpensive pens, such as the ballpoint, razor point, illustrator pen, or chisel art pen can be used to achieve specific graphic results or for specific drawing techniques.

✍Practice Exercise 3.2: Learning to Use Pens

Select one of each of the following pens: extra-fine point, medium-point (soft plastic tip), bullet-shaped point (fiber tip), and technical pen no. 1 (0.4 mm tip). Practice the pen positions and graphic techniques illustrated in Figures 3.10–3.13. Continue to experiment with the pens on an assortment of smooth and textured papers.

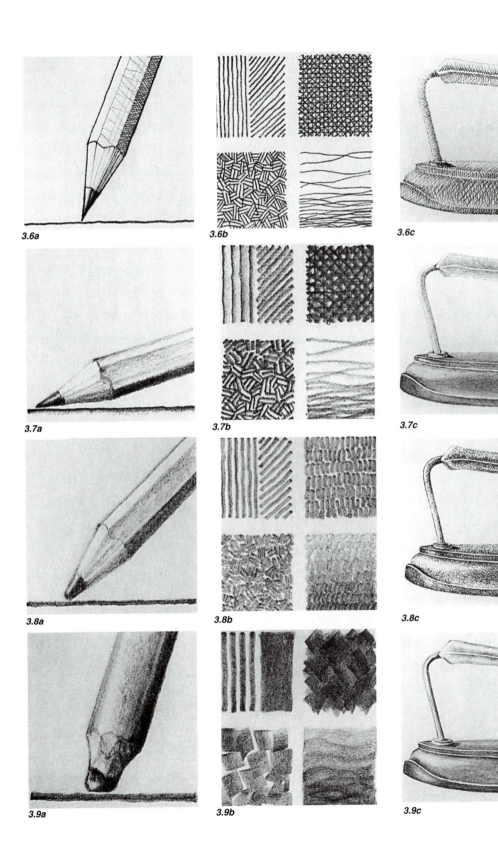

3.6a

3.6b

3.6c

3.7a

3.7b

3.7c

3.8a

3.8b

3.8c

3.9a

3.9b

3.9c

Figure 3.6 An illustration of an antique iron using an HB pencil in a relatively vertical position and a cross-hatching drawing technique (illustrated by: a, Chi-ming Kan; b, Mary Jo Sindelar).

Figure 3.7 An illustration of an antique iron using a 2B pencil in a relatively horizontal position using a less-defined, shading technique (illustrated by: a, Chi-ming Kan; b, Mary Jo Sindelar).

Figure 3.8 The texture or tooth of the paper creates a visual effect with the soft pencil. An illustration of an antique iron using a 3 or 4B pencil at approximately a 45° angle relative to the drawing surface (illustrated by: a, Chi-ming Kan; b, Mary Jo Sindelar).

Figure 3.9 An illustration of an antique iron using a large soft, flat pencil (illustrated by: a, Chi-ming Kan; b, Mary Jo Sindelar).

Figure 3.10 (a-b) An illustration of an Indian head nickel using an extra-fine-point pen and a cross-hatching technique (illustrated by Chi-ming Kan).

3.10a

3.10b

3.10c

Figure 3.11 (a-b) An illustration of an Indian head nickel using a medium-point, soft plastic tip pen (illustrated by Chi-ming Kan).

3.11a

3.11b

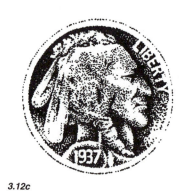

3.11c

Figure 3.12 (a-b) An illustration of an Indian head nickel using a bullet-shaped point, fiber tip pen (illustrated by Chi-ming Kan).

3.12a

3.12b

3.12c

FIGURE 3.13 (a-b) A line illustration of an Indian head nickel using a technical pen. Technical pens should be held at a 90° angle to the drawing surface for best results, and to avoid damage to delicate pen tips caused by exerting pressure at an angle (illustrated by Chi-ming Kan).

3.13a

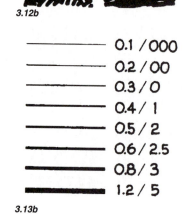

——	0.1 / 000
——	0.2 / 00
——	0.3 / 0
——	0.4 / 1
——	0.5 / 2
——	0.6 / 2.5
——	0.8 / 3
——	1.2 / 5

3.13b

3.13c

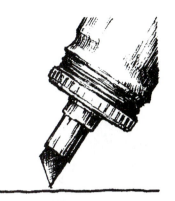

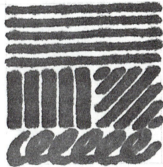

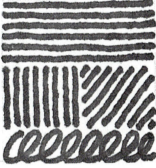

Figure 3.14 (a-c) Markers create different types of lines and surface coverage depending on which side or corner of the marker is used on the drawing surface. Shown are techniques using a broad chisel nib marker (illustrated by Chi-ming Kan).

3.14a 3.14b 3.14c

Markers, Positions, and Graphic Techniques

The marker is one of the most popular drawing tools used by architects and designers for quick sketching and illustrative drawing. The advantages of using the marker are the broad range of colors available and the fact that they are coded according to a prescribed color system. Markers are available in permanent and water-soluble inks and can be used in combination with pens and pencils. Markers come in a variety of tips: fine, medium, and broad or chisel-tipped. Some manufacturers also produce a double-ended pen having both a fine and a broad tip.

✍Practice Exercise 3.3: Learning to Use Markers

Select several markers with different types of tips. Try a variety of pen positions with each of the markers, as shown in Figures 3.14 and 3.15.

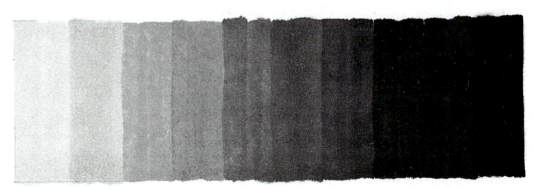

3.15

Figure 3.15 Marker colors can blend to create a gradation of value or color (illustrated by Chi-ming Kan).

Figure 3.16 Illustrations of several different drawing techniques using technical pens (illustrated by: a, Dale Greenwald; b, student work; c, Suzanne Abbati).

Drafting Tools, Technical Pens, and Materials

In order to visually communicate with others, the ability to select and use the appropriate materials and tools is necessary. Some basic visual tools and materials are technical pens, compasses, ruling pens, X-acto knives, dry transfer lettering, film, self-adhesive tape, designer's gouache, brushes, paper, paperboard, and rubber cement. The drawings in Figure 3.16 illustrate several techniques using technical pens. Figure 3.17 shows how various tip sizes and techniques can affect a drawing. The geometric constructions in Figure 3.18 illustrate the use of technical pens and other drafting tools.

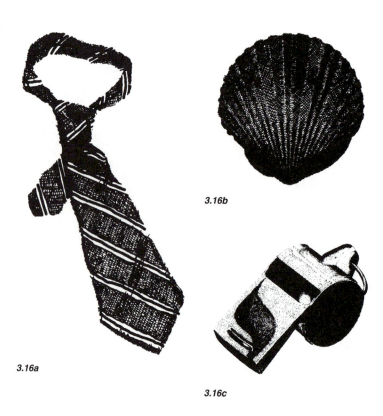

3.16b

3.16a

3.16c

Figure 3.17 Technical pens are available in different size tips. The graphic technique and tip size can alter the visual results of the illustration or drawing (illustrated by Dale Greenwald).

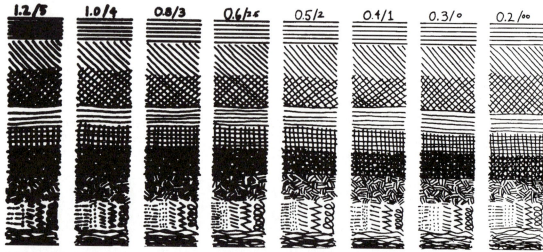

3.17

✍**Practice Exercise 3.4: Line and Point Graphic Techniques**

Select a simple natural or man-made object. Practice point or line graphic techniques using assorted technical pens. Pay attention to the tone variations (lightness or darkness) achieved by the different graphic techniques being used.

The recommended format for each of the following practice exercises is 10" x 10" hot press illustration board. Each design measures 5" x 5", and is centered on the 10" x 10" illustration board.

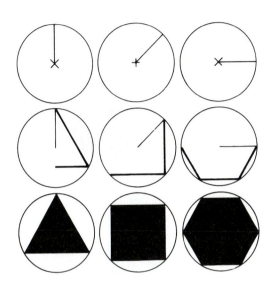

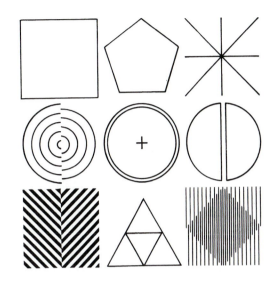

3.18a

3.18b

Figure 3.18 Geometric constructions using technical pens and other drafting tools (illustrated by Louise Utgard).

✎**Practice Exercise 3.5: Inking**

Tools and materials needed include a no. 0 or no. 1 technical pen, lead pencil, architect's scale, combination bow compass and ruling pen attachment, drafting tape, drawing board, triangles, and T-square, in addition to the 10" x 10" hot press illustration board. Design a simple geometric figure that includes straight, angular, and curvilinear lines (see Figure 3.19a). The figure should measure 5" x 5". Squarely place and mount the illustration board on the drawing board. Lightly draw the design on the illustration board in pencil, centering it within the 10" x 10" format. Practice using a technical pen to ink the figure. Evaluate the results according to line consistency, line connections or tangent points, and overall neatness.

Fig 3.19a

✎**Practice Exercise 3.6: Using Graphic Tape**

Materials needed include an X-acto knife and no. 11 blade, lead pencil, architect's scale, drafting tape, drawing board, triangles, T-square, metal cutting edge, two colors of 1/16" matte graphic tape, and a 10" x 10" piece of hot press illustration board. Design a simple geometric figure that includes straight and angular lines, such as the one shown in Figure 3.19b. The composition should measure 5" x 5".

Fig 3.19b

Squarely place and mount the illustration board on the drawing board. Lightly draw the design on the illustration board in pencil, centering it within the 10" x 10" format. Practice laying and cutting the tape on the constructed design. Miter the corners and cut the intersections of tape so that the tape doesn't overlap, but only appears to. Evaluate the results according to line consistency, precision of overlapping and corner cuts, and overall neatness.

Figure 3.19 (a) Example of inking with technical pens on illustration board. The curves are tangent with the straight lines; therefore they appear as if they were created in one continuous stroke. (b) Example of a composition using colored graphic tape. The corner intersections are mitered to avoid overlapping. The visual overlaps are trimmed so that all tape lies flat against the illustration board surface.

Figure 3.19 (c) Example of a self-adhesive film composition applied to hot press illustration board. First, curves are cut, then straight lines are cut to ensure neat tangent points. (d) Example of a gouache composition created by masking areas, painting them, and letting each dry before applying a second or third color.

3.19c

3.19d

✍Practice Exercise 3.7: Using Self-Adhesive Film

Tools and materials needed include an X-acto knife and no. 11 blade, bow combination compass and cutting blade attachment, lead pencil, architect's scale, drafting tape, drawing board, triangles, T-square, metal cutting edge, two different colored sheets of self-adhesive film, and 10" x 10" hot press illustration board. Design a simple geometric figure in a 5" x 5" format that includes straight, angular, and/or curvilinear lines (see Figure 3.19c). The design should include adjoining areas that will be covered with the two different colors of film. Squarely place and mount the illustration board on the drawing board. Lightly draw the design on the illustration board in pencil, centering it within the 10" x 10" format. Practice cutting and laying the film over the designated areas in the figure. Evaluate the results according to the smooth appearance of the film application (no bubble or dirt underneath), straight and smooth cuts between the adjoining color areas, and overall neatness.

✍Practice Exercise 3.8: Using Designer's Gouache

Tools and materials needed include a bow combination compass and ruling pen attachment, ruling pen, lead pencil, architect's scale, drafting tape, transparent magic tape or frisket film, drawing board, triangles, T-square, metal cutting edge, two colors of designer's gouache, paint mixing dishes, brushes (3/4" flat and no. 10 round), and a 10" x 10" hot press illustration board. Design a simple geometric figure that includes straight, angular, and/or curvilinear lines, as in Figure 3.19d. Create a design that measures 5" x 5" and has adjoining areas to be covered with the gouache colors. Squarely place and mount the illustration board on the drawing board. Lightly draw the design on the illustration board in pencil, centering it within the 10" x 10" format. Practice painting the designated areas with the gouache. Either outline the different color areas with the ruling pen and compass ruling pen attachment or mask the different areas with transparent magic tape or frisket film before painting. If you choose the latter, evenly apply transparent tape or frisket film to the illustration board, then with an X-acto knife cut out areas to be painted and peel the tape away before painting. Evaluate the results according to the smooth appearance of the gouache application, straight and smooth application between adjoining color areas, and overall neatness.

✍Practice Exercise 3.9: Using Cut Paper

Tools and materials needed include a bow combination compass and knife attachment, X-acto knife, lead pencil, architect's scale, drafting tape, drawing board, triangles, T-square, metal cutting edge, Bristol board, rubber cement, and white glue. Design a simple representation of a natural object (e.g., a seashell, a leaf, or a vegetable) that has concave and/or convex variations in its inherent structure or surface (see Figure 3.20). Cut out planar pieces of Bristol board that can be used to illustrate the physical characteristics of the object's shape. The object can be reconstructed as either a relief or a volumetric composition. To gain greater depth or volume, position spacers, foamcore, or chipboard between the planar shapes used to create the representation. Evaluate the results according to the likeness of the original object, particularly in terms of its scale and proportion. Also consider the quality of the cutting of the board, as well as the overall neatness.

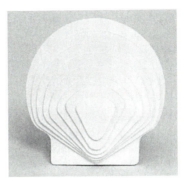

3.20a

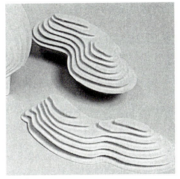

3.20b

Figure 3.20 (a-c) Examples of planar relief forms of natural objects constructed from cut paper and board: (a) sea-shell; (b) seashell and peanut; (c) two seashells, different constructions (student work).

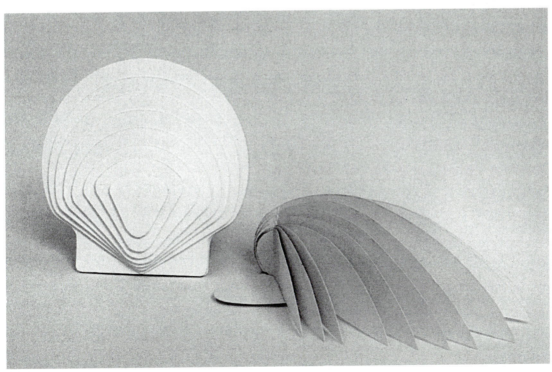

3.20c

BEGINNING APPROACHES TO DRAWING

What Are the Characteristics of a Good or Interesting Drawing?

This question is asked frequently. The primary characteristic of a good visual representation is that it maintains the proportion, scale, and descriptive characteristics of the original form or object. It is also important that the viewing angle or projection is complementary to the subject's structure and compositional intent. Visual interest is achieved through what are called surface treatments or visual techniques—variation in line width, tone, surface texture, and, often, the application of black and white contrast.

How Does One Begin?

When beginning to visually represent forms or objects, the first step is to carefully analyze the object. For the following discussion, a seashell (see Figure 3.21) is used as a study example. Look at its contour. The contour lines help define the structure and shape of the object. Although the lines don't actually appear on the real object, the contour outline is the most direct approach to simply representing the object. Consider shape, form, symmetry, size, proportion, and surface detail or characteristics before putting any lines on the sheet of paper. Once familiar with the object, begin the visual representation by using any of the four construction methods or

combinations, as outlined and illustrated in Figures 3.22– 3.25. Keep in mind that these particular construction methods relate to a single front or side view of the object. Formal drawing systems that cover three-dimensional drawing are reviewed in Chapter 4.

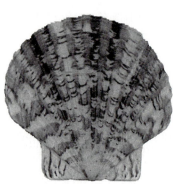

3.21

Figure 3.21 Photograph of a seashell used as a study example for the drawing.

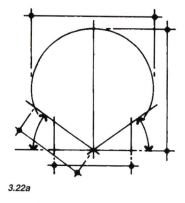

3.22a

3.22b

Fligure 3.22 (a-b) The measuring method offers the most accurate representation for the beginning drawing (illustrated by Chi-ming Kan).

3.23a

3.23b

Figure 3.23 (a-b) The grid method is similar to the measuring method, but does not use exact dimensions (illustrated by Chi-ming Kan).

VISUALLY REPRESENTING AN OBJECT

Relative to drawing in general, there are two ways to create visual representations: **drawing** and **sketching**. Drawing is the graphic process whereby one can represent figures, forms, products, or environments on a surface by using a medium such as a pencil, pen, or marker to produce the lines and tones that describe the desired idea or image with representative detail. A sketch is a drawing that lacks detail. Sketches consist only of the most basic lines needed to describe the object or form.

Four Ways of Constructing and Visually Representing an Object

Drawings and sketches can be constructed in four different ways: measurement, grid, axis, and motion. Each approach has advantages, depending on the shape and characteristics of the object being drawn.

Measurement

If it is difficult to perceive and interpret the contour, size, proportion, and surface detail of the object, begin by using the measurement method. This method reinforces, through the measuring process, perceptions of the actual characteristics of the object. Measure the different details and record them. Then use the measurements to draw the object (see Figure 3.22).

Grid

The grid approach is similar to the measurement method in that the grid is set to a size, scale, and proportion that represents the object. Once the grid is established, mark off the contour of the object onto the grid and connect the marks with a line (see Figure 3.23). Add the necessary detail to the surface to complete the sketch or drawing.

Axis

The axis method illustrated in Figure 3.24 is a quick and simple way of constructing the shape of an object. A visual ability to judge size, scale, and proportion is required in order to use this

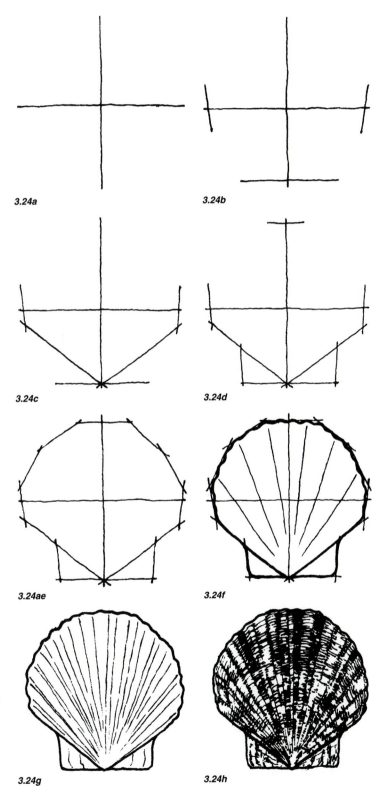

3.24a 3.24b

3.24c 3.24d

3.24ae 3.24f

3.24g 3.24h

Figure 3.24 (a-h) The axis method is used to quickly define the visual boundaries of the figure or form relative to the center (illustrated by Chiming Kan).

Figure 3.25 (a-h) The motion method of drawing requires visual understanding of the basic shapes that make up the figure or form (illustrated by Chi-ming Kan).

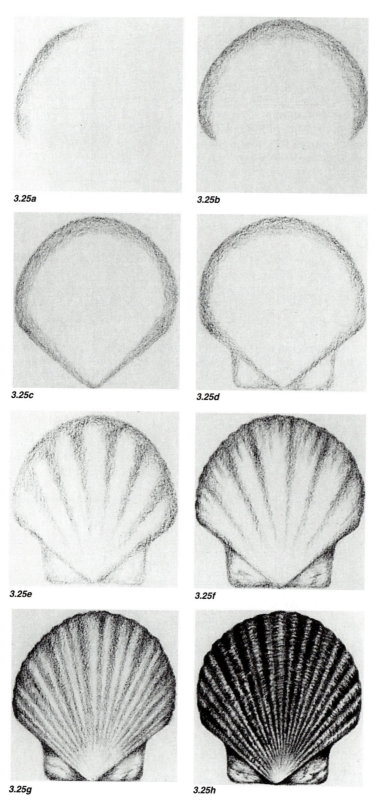

3.25a

3.25b

3.25c

3.25d

3.25e

3.25f

3.25g

3.25h

method effectively. This drawing approach works best with a symmetrical object and a single or side pictorial view. First, lightly draw vertical and horizontal lines, creating an axis. Then mark off the major points around the axis to establish the general shape contour. Connect the major points with lines to complete the contour and add the necessary descriptive detail to the surface of the object to complete the sketch or drawing.

Motion

The motion method requires a good visual sense of size, scale, and proportion along with a knowledge of how to use a free, rhythmic arm motion. Proper hand and finger positioning is also important. This method offers a freer, more expressive line/value approach to drawing and has many advantages for quick sketching.

Use quick sweeping motions to create the general contour of the object. The side of the lead, not just the point, should be used; this provides a soft wide line. Continue to add as much detail to the shape as desired (see Figure 3.25).

✍Practice Exercise 3.10: Four Basic Drawing Constructions

The objectives of this exercise are to help develop perceptual abilities, to assist in visually recording a natural object using basic construction methods, and to practice using the lead pencil as a graphic tool and medium.

Select a natural object (e.g., a fruit or vegetable). Practice the four drawing construction methods illustrated in Figures 3.27–3.30. Once these four methods have been attempted, make a tone drawing of the object (see Figure 3.26). A variety of wood/lead pencils, ranging from F to 2B, and an all-pur-

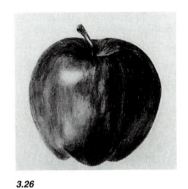

3.26

Figure 3.26 A tone drawing illustrating surface characteristics of an apple (student work).

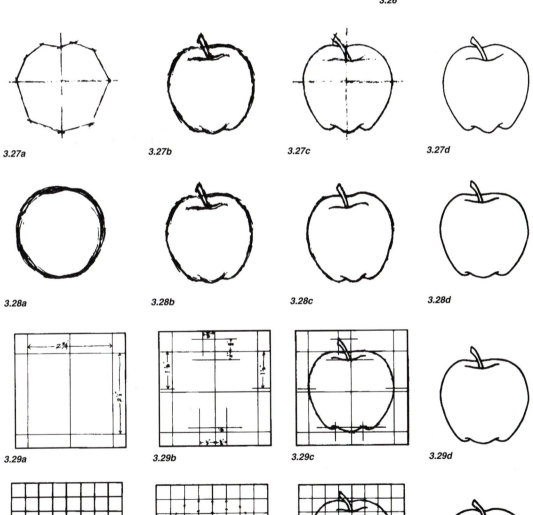

3.27a *3.27b* *3.27c* *3.27d*

3.28a *3.28b* *3.28c* *3.28d*

3.29a *3.29b* *3.29c* *3.29d*

3.30a *3.30b* *3.30c* *3.30d*

Figure 3.27 (a-d) The axis drawing method used to show an apple in four progressive steps of development (illustrated by Chi-ming Kan).

Figure 3.28 (a-d) The motion drawing method used to show an apple in four progressive steps of development (illustrated by Chi-ming Kan).

Figure 3.29 (a-d) The measurement drawing method used to show an apple in four progressive steps of development (illustrated by Chi-ming Kan).

Figure 3.30 (a-d) The grid drawing method used to show an apple in four progressive steps of development (illustrated by Chi-ming Kan).

pose bond paper are needed. Strathmore 400 series paper is recommended.

✎Practice Exercise 3.11: Construction and Application of Surface Techniques

Select a simple man-made object. An Indian-head nickel is used to illustrate the surface drawing process because it has a lot of detail, which complements the different techniques. It also has a flat, round shape that is easily constructed. After carefully constructing the contour and some internal characteristics of the chosen object using one of the previously illustrated methods, begin to experiment with the different graphic techniques shown in Figure 3.31: black and white contrast, point, line, and pure tone.

Figure 3.31 (a-d) The axis drawing method used to show an Indian head nickel in four progressive steps of development; (e) black and white contrast drawing; (f) point technique; (g) line technique; (h-i) pure tone drawings using different techniques and media (illustrated by Chi-ming Kan).

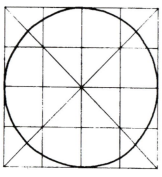

3.31a

3.31b

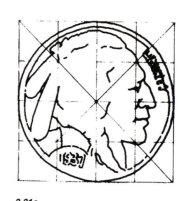

3.31c

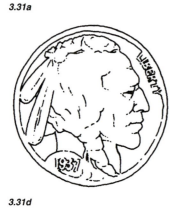

3.31d

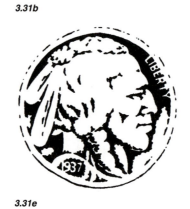

3.31e

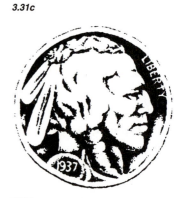

3.31f

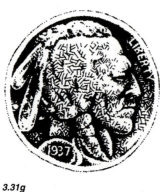

3.31g

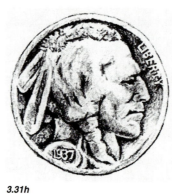

3.31h

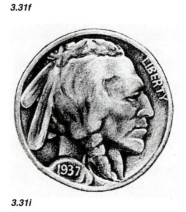

3.31i

SKETCHING

Sketching techniques can be used to think and communicate visually about a person, place, or thing. Preliminary doodles or thumbnail sketches graphically represent an artist's or designer's beginning thoughts about a problem. Sketching allows product designers to explore the use and function of new forms, while architects and interior space designers can explore the organization of spaces and the traffic flow through them. Quick sketching shows the compositional arrangement of a possible page layout, typographic compositions, paintings, illustrations, and sculptures.

3.32a

3.32b

3.32c

Figure 3.32 (a-c) A quick sketch study of drawing tools (illustrated by Anita Wood).

✐Practice Exercise 3.12: Quick Sketching

Select several different symmetrical and asymmetrical objects. Create quick pencil and pen study sketches of these objects using as few lines as possible to visually describe them. See Figures 3.32 and 3.33 for examples.

As sketching techniques become more detailed, it is necessary that the drawings remain identifiable and communicative (see Figures 3.34 and 3.35).

3.33a *3.33b* *3.33c* *3.33d*

Figure 3.33 (a-d) Quick sketching studies of a hand-held drill (illustrated by Mark Groves).

Figure 3.34 Quick sketching is used to indicate the image composition (illustrated by Susan Hessler).

3.34

Figure 3.35 Each image on the page is represented by a quick line sketch. The rough sketches give enough detail to allow others to understand the intent, placement, and position of the components (illustrated by Susan Hessler).

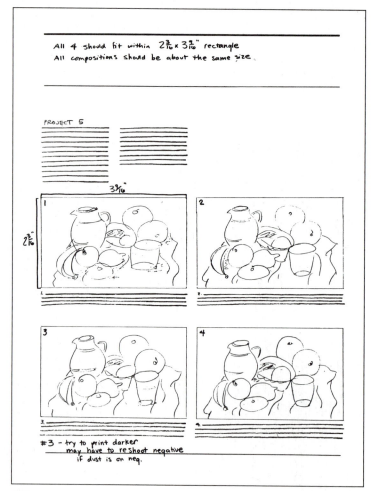

3.35

✍Practice Exercise 3.13: Self-Portraits Through Quick Sketching

It is a widely held belief that drawing the human face is one of the most difficult kinds of drawing. In order to dispel this belief, do several quick sketches of yourself from memory without a mirror. Set time increments—for example, thirty seconds, one minute, two minutes, five minutes, and so on, for each sketch. The resulting visual impressions, surprisingly, are often recognizable representations (see Figure 3.36). Note that the time allocation helps reinforce the understanding of quick sketching methods.

In continuation of the self-portrait study, develop quick sketch studies of yourself using a mirror. When you have become more confident in drawing the face, begin to develop tone and line detail studies using the previously mentioned drawing techniques, tools, and papers. For reference, many quality books are available on figure and portrait drawing. An interesting approach is the book *Drawing on the Right Side of the Brain* by Betty Edwards.

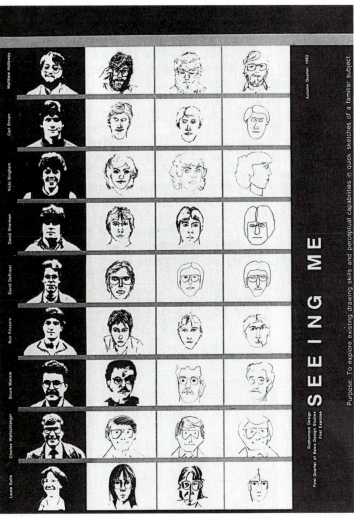

3.36

Figure 3.36 Basic drawing methods and techniques: quick sketching self-portrait studies compiled into an interesting poster sequence.

This self-portrait exercise emphasizes mental visual impressions of oneself, quick sketching techniques, and designated time allotments. To continue this drawing experience it is appropriate to do a more controlled study of a head and face. The learning objectives of the next exercise continue to emphasize observation techniques in order to develop perceptual abilities as well as practice drawing, construction, and manipulative methods. In addition, the exercise helps to develop an appreciation of and skill with various media.

✍Practice Exercise 3.14: A Graphic Study of the Human Head

The objective of this practice exercise is to help develop an understanding or sense for the three-dimensional form and proportion of the human head. This analytical study emphasizes the application of drawing systems for denoting information about the head.

Part 1
Part 1 of the exercise requires an orthographic drawing of a person's head—that is, top, front, and side views in a one-to-one-to-one scale (see Figure 3.37). (Chapter 4 explains more about orthographic drawing.) Measured dimensions of the head must be placed on the drawings. The measuring process is best achieved by pairing off into teams of two people. It is recommended that a large caliper be made from paperboard to assist in making measurements. Once the drawings are finished, trace the different views of the head and transfer them onto white paperboard. Cut out the shapes and use them as templates to create other drawings and compositions.

Part 2
Part 2 of the exercise emphasizes the transformation of the head by drawing a number of varying grid networks that modify coordinates about the X and Y axes to a new equation (see Figure 3.38).

Figure 3.37 (a-c) A dimensioned orthographic drawing of a head (illustrated by Kathryn Edelstine).

FIGURE 3.38 (a-f) Shape transformation of the head drawings using varying grid networks (illustrated by Kathryn Edelstine).

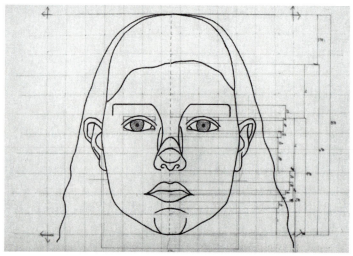

3.37a

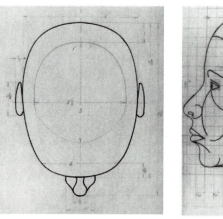

3.37b

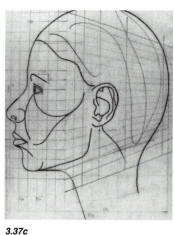

3.37c

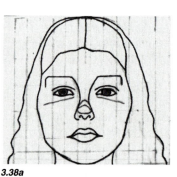

3.38a

3.38b

3.38c

3.38d 3.38e

Part 3

Part 3 involves graphic manipulation techniques, basic composition, and various media. For example, draw the head many times in a repetitive series and subtract or change the hair, the facial features, or both (see Figure 3.39). Another option is to construct or draw a self-portrait on posterboard, then cut it out to create a template. This template may be used as a compositional device. Move the template in different directions along an axis,

drawing along the edge of the template with different tools and media. Study the graphic illustrations in Figure 3.40 and then try to create a similar compositional study. Try a variety of media, such as pencils with various grades of lead, colored pencils, conté crayons, technical and ballpoint pens, brushes, ink, and designer's gouache. Different papers and boards can be used also, including marker bond, Strathmore 400, cold or hot press illustration board, and so on.

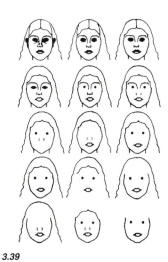

Figure 3.39 Drawing detail of the head, progressing from a significant amount of detail to a minimal amount of detail (illustrated by Kathryn Edelstine).

3.39

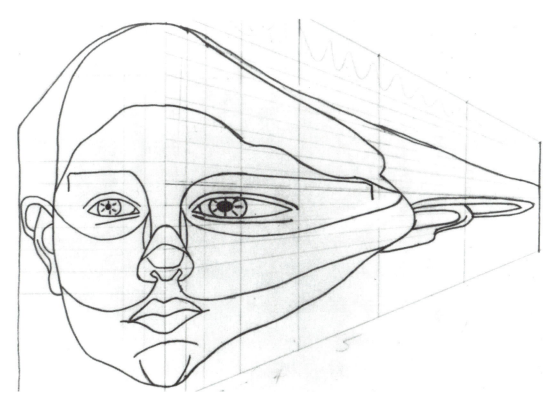

3.38f

Figure 3.40 (a-m) Illustrations of the human head. Tools used include pencil (various grades of lead); designer gouache; pen and ink; technical, felt-tip, and ballpoint pens; colored pencils; charcoal; and conté crayon (illustrated by Kathryn Edelstine).

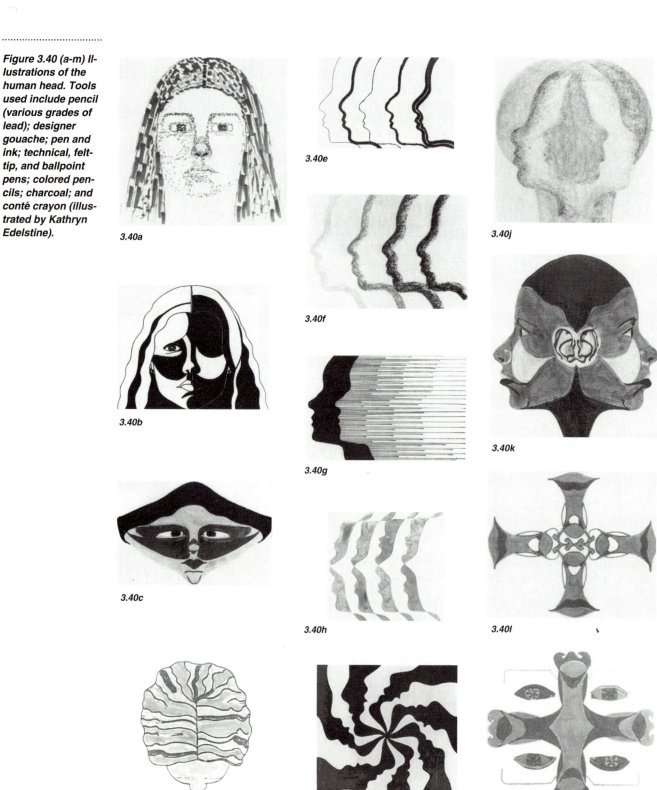

3.40a

3.40b

3.40c

3.40d

3.40e

3.40f

3.40g

3.40h

3.40i

3.40j

3.40k

3.40l

3.40m

DRAWING A VISUAL SET OF OBJECTS

A visual set is a group of objects that have some similarity in visual makeup, use, or function.

✍Practice Exercise 3.15: Drawing Visual Sets

Identify a category or set of objects that have similar visual makeup or structure, such as the gloves in Figure 3.41. List the objects and their uses, which can be visually reinforced by observing pictures or photographs of the objects. Draw the objects from memory. With another person, identify the different sketches to determine if they are visually interpretable.

✍Practice Exercise 3.16: Representing an Object with Minimum Line

This study explores ways of representing an object with as few lines as possible. The principle of *closure* is the dominant concept of this exercise. In Gestalt psychology, closure is described as the tendency, when looking at an illustration of an object, to perceive an incomplete shape as complete. The law of closure is discussed more completely in Chapter 10.

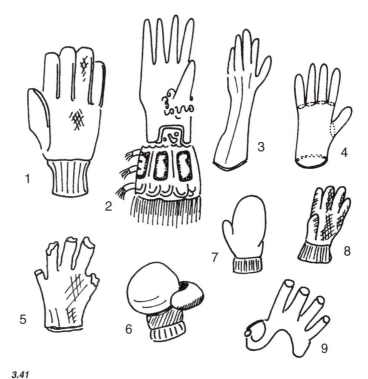

3.41

Figure 3.41 Examples of different types of gloves illustrating a visual set: 1. worker; 2. king; 3. formal; 4. surgeon; 5. pauper; 6. boxer; 7. mitten; 8. winter; 9. sports (illustrated by Eugene McHugh).

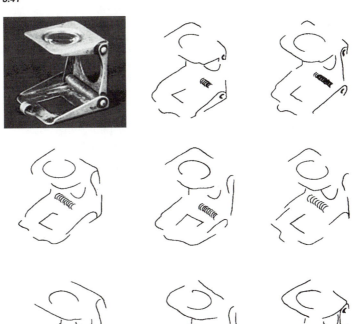

3.42a–i

Figure 3.42 (a-j) A photograph and a series of line drawings explore the minimum amount of visual information needed to perceive an object, in this case a loupe (illustrated by Susan McNulty).

3.42j

Select a simple object and either draw it in detail or photograph it. Then develop six to nine study drawings of the object in which parts of the contour are subtracted or dropped out from the figure (see Figure 3.42). In order to understand this principle, review the drawings, selecting the one that has the fewest number of lines and yet does not destroy the visual identity of the object.

INTRODUCTION TO PERCEIVING, ANALYZING, DESCRIBING, AND DRAWING NATURAL OBJECTS

In order to reinforce the process of seeing an object and being able to draw it on paper, a number of approaches can be utilized. Most people are more adept at describing an object verbally or in writing than drawing it. This verbal facility can be used to support the visual process by means of writing a description of an object and then using the written description to draw the object. The following exercise demonstrates this approach.

✍ Practice Exercise 3.17: Writing a Visual Description to Assist in Drawing an Object

Select a natural object that has a three-dimensional or volumetric form. Be sure that the object has a well-defined external and internal structure. Once the object has been selected, study the physical characteristics of the form. Next, describe the form by answering the following questions, and then write a description of the object.

1. What is the basic geometric shape of the object (i.e., rectangular, square, spherical, etc.)?
2. What is the object's contour (oval, broad, pointed, rough, etc.)? Describe it in detail.
3. What is the approximate size of the object?
4. How does the approximation compare to the actual measurements?
5. Is the object symmetrical or asymmetrical?
6. What is the color of the object?
7. Does the object have more than one color? If so, list them.
8. Does the object have visual contrast among its parts?
9. Does the object have concave and/or convex surfaces?
10. What is the tactile texture of the object? To determine this correctly, close your eyes and feel the object.
11. Does the object have a pattern? If so, describe it.
12. How many different sides does the object have?
13. Are there any other surface qualities of the object? If so, describe them.
14. What other details can be added?

Part 1: Written Description of a Pine Cone

"Petal-shaped protrusions emerge from a central core. These protrusions arch away from the core and overlap one another. They are sparse at one end and heavily concentrated at the opposite end, giving the object a triangular outline. The surfaces of the protrusions are fairly smooth and are made of a woodlike material.

"The core is approximately 2 inches long on a vertical axis. The top of the object is formed by two protrusions that are thinner than the rest. These two are joined where they enter the core but arch slightly away from each other at the top. The protrusions become larger toward the bottom and extend to 1-1/2 inches at the bottom."

Part 2: Drawing the Object According to the Written Description

Have another person draw the object from the written description (Figure 3.43). Then see how the written descrip-

tion and resulting illustration can be improved. Evaluate the written work according to how logical and accurate the description is and how easily others can visually interpret the description through drawing. Evaluate the drawings according to how well the construction and drawing techniques have been used.

At this point there should be a greater visual awareness of what an object looks like and how to represent the object through drawing. It is important to gain confidence in the ability to see and graphically represent objects. The following exercise is intended to continue and add to drawing experiences.

3.43

Figure 3.43 Illustration from written description of a natural object, in this case a pine cone (student work).

✍Practice Exercise 3.18: Creating Visual Variations of an Object

Either continue to use the selected natural form from the previous exercise, or select another natural object. The examples in Figure 3.44 demonstrate additional methods of creating visual variation.

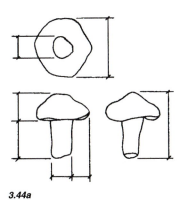

3.44a

3.44b

Figure 3.44 (a-h) Drawings that record and describe a natural object (a mushroom) and utilize the drawing techniques previously mentioned, adding line and tone techniques. (a) Orthographic representation shows more than one view of the object and actual dimensions; (b) overlaying the object's front view on a grid helps to determine a scale of equal units for later drawing studies; (c) use of a grid to distort and change shape; (d) cross section; (e) the axis method used to outline shape and characteristics; (f) motion technique defines the overall shape of the object; (g) line technique used to create tone, communicating a sense of dimensional depth; (h) point technique used to create tone and dimensionality (student work).

3.44c

3.44d

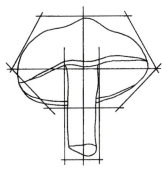

3.44e

3.44f

3.44g

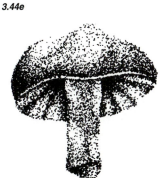

3.44h

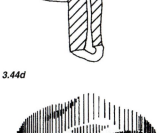

Figure 3.45 (a-l) Interpretive drawings of a pineapple using pen, ink, and a variety of other media (illustrated by Joyce Cook).

✍Practice Exercise 3.19: Interpretive Variations of a Natural Object

Select a natural object such as the pineapples shown in Figures 3.45. Draw many shape contours and internal surface variations of the selected object using the visual elements point, line, shape, and/or combinations of these elements. Select pencils in a variety of leads (soft and hard), colored pencils, pens and markers, technical pens, brushes, ink, or gouache. Create the illustrations on various smooth and textured papers. The final drawings may be mounted on hot press illustration board for presentation.

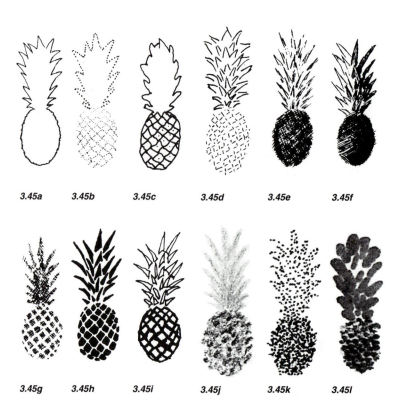

3.45a 3.45b 3.45c 3.45d 3.45e 3.45f

3.45g 3.45h 3.45i 3.45j 3.45k 3.45l

✍Practice Exercise 3.20: Creating a Visual Story About an Object

The previous exercises have emphasized the more basic skills and techniques of drawing. After becoming familiar with how to use the basic drawing methods, techniques, tools, and materials and developing visual perception, it is possible to approach the beginning process of visual communication in a more interpretive way. This interpretive visual study extends the process of seeing and reinforces the drawing experience by developing a short graphic story about an object.

Begin this exercise by selecting and studying an object's form, structure, and physical surface. Then cut it apart to analyze its internal makeup. This observation technique should provide an understanding of the object's overall physical characteristics. The next step is to sketch as many analytical and interpretive studies of the object's internal and external structure as possible. Note next to each drawing what is observed and thought about. The drawings of a carrot in Figures 3.46–3.49 on the following pages illustrate the thought and sketch process described. A variety of media such as pencil, pen, and colored paper were used. Once the observation was accomplished, more detailed studies were drawn using a variety of visual techniques and interpretive drawings that emphasized more interesting aspects of the object—that is, form, texture, color, and so on. The final step of this exercise is to plan the visual communication by selecting and ordering the best drawings into a visual story sequence. Develop an organizational grid to structure the layout and bring order to the drawing sequence.

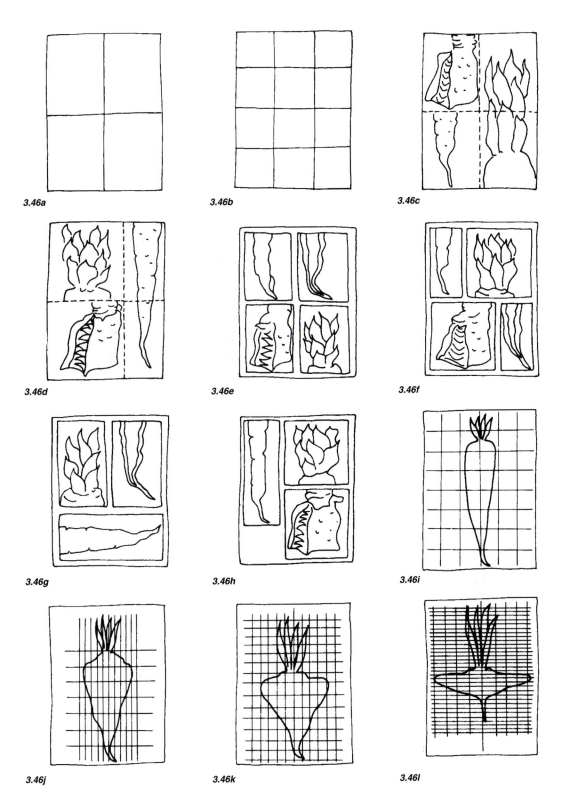

3.46a

3.46b

3.46c

3.46d

3.46e

3.46f

3.46g

3.46h

3.46i

3.46j

3.46k

3.46l

Figure 3.46 (a-l) A series of sketches of a carrot tells a visual story about the object through shape, detail, and form transformation studies. (a-b) Page layout is planned using a grid. (c-d) Carrot section drawings organized within the page layout grid. (e-h) Sketches showing internal and external sections of the carrot. (i-l) Transformation of carrot shape using varying grid networks (illustrated by Judith Reichel).

Figure 3.47 Internal cross sections of a carrot (illustrated by Judith Reichel).

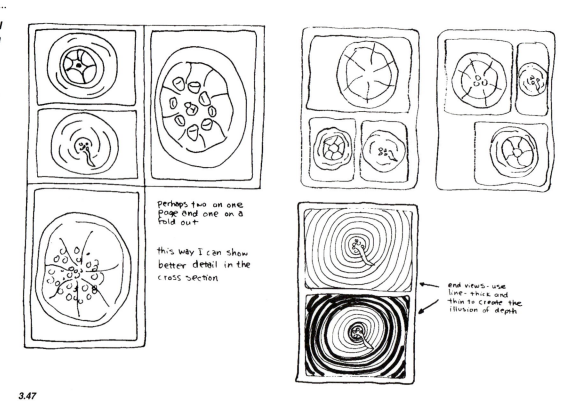

Perhaps two on one page and one on a fold out

this way I can show better detail in the cross section

end views- use line- thick and thin to create the illusion of depth

3.47

Figure 3.48 Visual interpretive studies of a carrot exploring shape, format, positive, and negative relationships (illustrated by Judith Reichel).

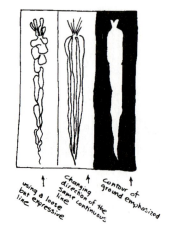

using a loose but expressive line

Changing direction of the same continuous line

Contour of ground emphasized

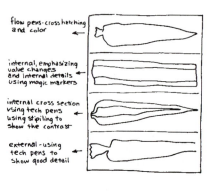

flow pens- cross hatching and color

internal, emphasizing value changes and internal details using magic markers

internal cross section using tech pens using stipiling to show the contrast

external- using tech pens to show good detail

3.48

detailed
value change
in leaves
using color
match paper
and inking
lines on it

internal detail
coloring with
pencils

use a
continuous
free line
on on
external
view

Show change in texture
with markers and cross
hatching

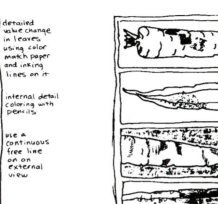

good detail
using pens also
concentrate on
leaf detail

cross section
detail with tech.
pens or pencil
stipling and line
value changes

external detail
with tech. pen or
pencil-cross
hatching and lines

internal detail
using flat color
and expressive
line movement

Figure 3.49 Visual interpretive studies of a carrot including internal section detail (illustrated by Judith Reichel).

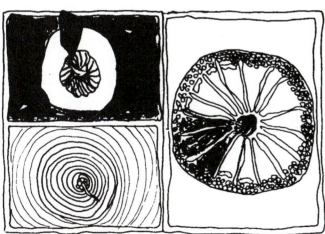

use a uniform spiraling line
for the carrot perhaps even
continuing it into the ground
but changing the grounds color.
The contrast of the direction
and type of lines used in the
tip will make the point of interest.

use as many techniques as
possible to render the
cross section as accurately
as possible and change
the paper it's on to lend
itself to preciseness and to
introduce a change of papers
in other sections.

Contour by
sourrounding
carrot with
orange or
black marker

Contour by
using
different
width lines

Contour by
silouette
with film
or paper

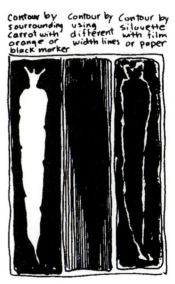

Figure 3.50 Visual interpretive studies of a paint tube using pen and ink (illustrated by Anne Baker).

3.50

✎Practice Exercise 3.21: Visual Interpretations of an Object

Refer back to the visual techniques, materials, and tools already mentioned in this chapter. Review the ways to change the visual interpretation of the object through the use of various tones, line, point, or black and white contrast techniques. Try a variety of lead grades, pens, markers, brushes, and ink or gouache. Use different smooth and textured papers to complement the different graphic interpretations (see Figures 3.50–3.52).

Figure 3.51 Visual interpretive studies of garlic using pen and ink (illustrated by Georgia Brown).

3.51

Figure 3.52 Visual interpretive studies of a flower using the visual elements point, line, and plane, drawn with a technical pen (student work).

3.52

✍Practice Exercise 3.22: Abstracting an Object

Graphic designers and artists are frequently involved in creating symbols or abstracting two-dimensional shapes or objects. The illustrations of the scallop seashell in Figure 3.53 show a graphic approach to the process of structuring a study to simplify and abstract an object. In order to abstractly draw an object it is important to first visually study its shape and physical characteristics. At the same time, it is helpful to record notes to determine those characteristics needed to describe the object accurately. Start by utilizing one of the drawing methods described in this chapter (the illustrated seashell is an example of an axis construction). Then add more descriptive detail to the interior surface by using line and tone. Once the object is visually represented in a realistic manner, begin to reverse the process by subtracting information, minimizing the internal detail, and simplifying the contour of the object.

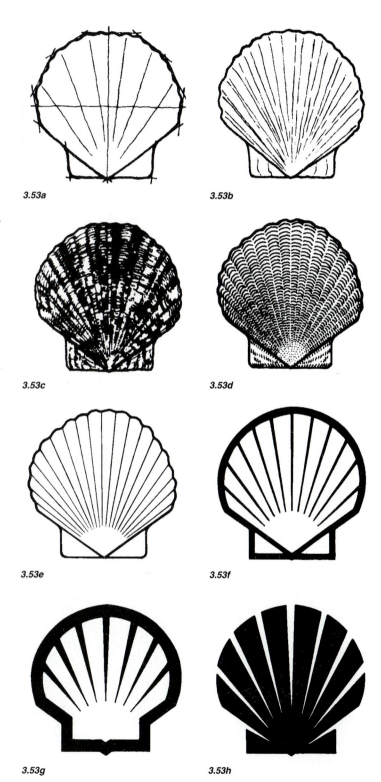

3.53a

3.53b

3.53c

3.53d

3.53e

3.53f

3.53g

3.53h

Figure 3.53 (a-h) A series of seashell drawings illustrates different drawing techniques and media used for varying results. (e-h) Drawings illustrating different levels of abstraction. Examples (g) and (h) show a positive/negative reversal, which complements symbolic representation (illustrated by Chi-Ming Kan).

DENOTING SURFACE CHARACTERISTICS OF OBJECTS

Tone and Texture in Drawing

Often those beginning to draw assume that a good drawing consists of highly rendered detail. Keep in mind that drawings can be representational or abstract representational—that is, an image representing a form, figure, or idea. The difference between a line contour draw-ing and a drawing with tonal values distinguishes different levels of representational abstraction. Tone brings clarity and dimension to a drawing but is not the only character-istic of a well drawn repre-sentation. Drawing tech-niques (as earlier discussed) used in combination with compositional concepts (scale, proportion, balance, orientation, etc.) also en-hance a drawing. These and other factors that help to dis-tinguish between figure and ground, such as the differ-ence between light and dark areas, help the viewer per-ceive and derive meaning and dimension from drawings (see Figure 3.54).

Figure 3.54 (a) Shape of a sphere drawn with continu-ous tone creates di-mensionality; (b) changing a vertical rectangle to a cylin-der shape by use of tone and texture; (c) light and dark tones create the illusion of a coffee cup, similar to that in a continuous tone photograph. At-tached and cast shadows define the direction of the light (illustrated by Bruce Brugge-mann).

3.54a

3.54b

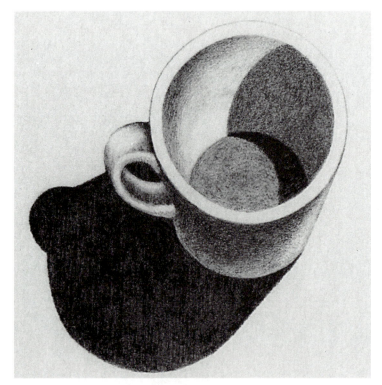

3.54c

✍Practice Exercise 3.23: Learning to Utilize Tone and Texture

Select a variety of media, tools, and drawing surfaces. Then select a series of objects that have different surface textures. The list of objects might include:

- An object that is shiny or metallic like a fork or spoon.

- An object that has an interesting texture and surface pattern like a sock or a glove.

- An object that is made of wood like a spoon or a match.

- An object made of paper like a playing card or a dinner napkin.

- A food object like a cracker or a cookie.

- An object that has bristles like a brush

- An object that is fuzzy like a tennis ball or a stuffed animal

The drawings in Figure 3.55 illustrate how to represent an object realistically with pen and pencil by using tone, light and dark contrast, and texture.

3.55a

3.55b

3.55c

3.55d

3.55e

3.55f

3.55g

3.55h

Figure 3.55 (a-h) Drawings illustrating the use of light and dark values to create the illusion of surface texture (illustrated by: a-b, James Guy; c-d, student work; e-f, Diana Ullman; g-h, Eric Brothers).

Figure 3.56 (a-b) Illustrations of a block plane using different drawing techniques and media (illustrated by Alan Jazak).

Figure 3.57 (a-c) Vegetable peeler illustrations using different drawing techniques and media to represent surface characteristics (illustrated by Tim Hershner).

Using Drawing Techniques to Create Representative Surface Characteristics of Objects

An object's surface characteristics can be illustrated using various drawing techniques and materials. The representation of an object can be made to appear old, new, shiny, dull, metallic, wooden, and so on. The drawings in Figures 3.56 and 3.57 illustrate some of the possibilities in representing the surface of an object.

3.56a 3.56b

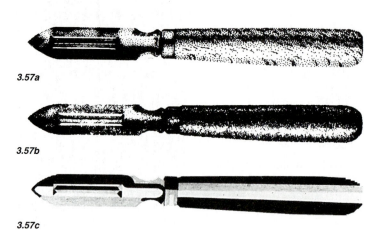

3.57a

3.57b

3.57c

✍Practice Exercise 3.24: Creating Analytical Drawings

This exercise requires the selection of a simple object for a series of interpretive drawings that are descriptive of the actual form, shape, and surface qualities.

Begin by creating a series of drawings that denote the physical characteristics of the object as was done with the ice cream cone in Figure 3.58 on the following page. Draw as many views of the object as necessary to represent its form accurately. The complexity of the object's shape helps determine how many views are needed. For example, simple symmetrical objects such as an apple or ball require fewer views than a complex object such as a mechanical toy.

Next, draw an internal section of the object. If the object comes apart easily, disassemble it and examine its internal pieces, then draw the pieces as accurately as possible. If the object is organic, cut it into two pieces through the center (i.e., an apple or orange would be sliced through the core or center point), revealing the internal structure. As before, draw it accurately.

Finally, create a series of drawings using the different drawing techniques already learned, such as point, line, and pure tone. Remember that softer pencil leads produce more opaque, black lines and dark areas. Review and select several of the best drawings and mount them on illustration board.

For more examples of analytical drawing, see Figure 3.59.

3.58a

3.58b

3.58c

Figure 3.58 Analytical drawing study of an ice cream cone. (a) Elevation drawing using the axis method; (b) contour drawing; (c) disassembled drawing; (d) cross-section drawing using technical pen and ink; (e) point creating tone drawing; (f) line creating tone drawing (illustrated by Catherine Melinis).

3.58d

3.58e

3.58f

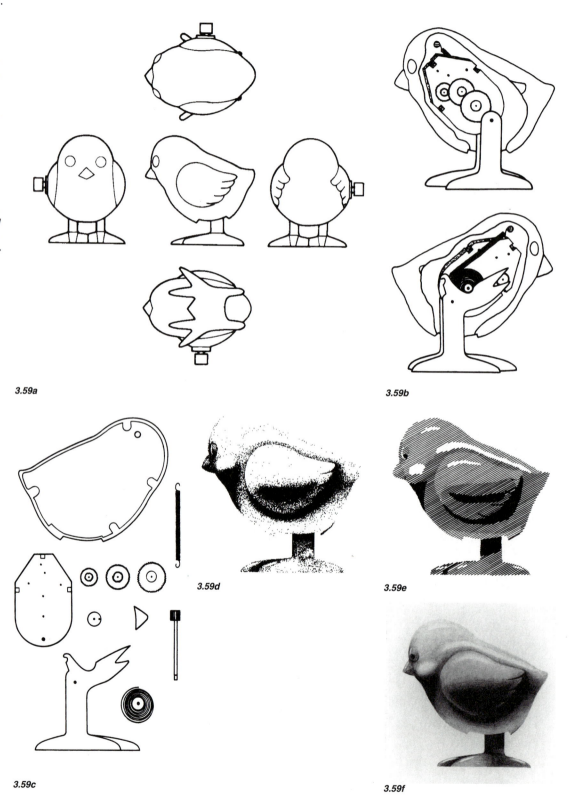

Figure 3.59 Analytical study of a wind-up toy chick. (a) Orthographic drawing using technical pen and ink; (b) cross section drawing using technical pen and ink; (c) disassembly drawing using technical pen and ink; (d) point creating tone using technical pen and ink; (e) line creating tone using technical pen and ink; (f) pure tone using pencil (illustrated by Lee Willett).

3.59a

3.59b

3.59c

3.59d

3.59e

3.59f

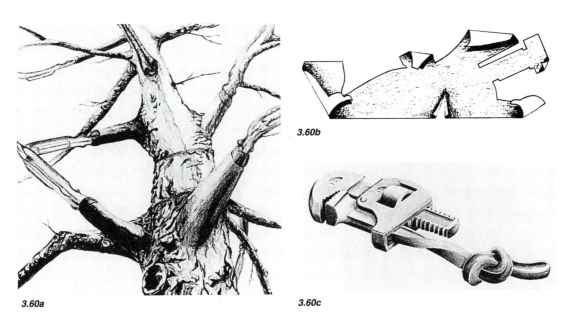

3.60b

3.60a

3.60c

Figure 3.60 Fantasy drawings. (a) A vegetable peeler transformed into a tree; (b) a block plane transformed into a thin, curled wood strip; (c) a pipe wrench tied into a knot (illustrated by: a, Tim Hershner; b, Alan Jazak; c, Paul Henninge).

✍️Practice Exercise 3.25: Creating Fantasy Drawings

Once an object is graphically represented in a variety of drawing techniques and media, a fantasy drawing can be created. Visual fantasy illustrations are a product of the imagination and can result from a humorous or whimsical state of mind. Examples of fantasy drawings are shown in Figures 3.60–3.63.

To begin a fantasy drawing, make a list of objects. Imaginative scenarios for these objects can begin by asking, "What if . . . ?" An object can be transformed in shape, texture, dimension, color, and so on. Create sketches of different fantasy ideas, using a variety of drawing techniques and media.

3.61a

3.61b

3.62a

3.62b

Figure 3.61 (a-b) Cheese cutter transformed into a moose's head (illustrated by Richard Stander).

Figure 3.62 (a-b) Toy bear with cymbals transformed into a melted figure (illustrated by Yolanda Jackson).

Figure 3.63 (a-d) Flower pot becomes a pig's snout, the ends of a telephone receiver, wheels on a vehicle, or an alien from another world (student work).

The fantasy drawings in Figures 3.60–3.63 are creative examples of different fantasies of objects and forms. This exercise is always fun as one begins to explore more creative applications for the previously learned drawing skills. Think about other possible solutions for the examples given.

3.63a

3.63b

3.63d

3.63c

Another type of fantasy drawing can be created by choosing a recognizable shape and using it in an unexpected application; examples can be seen in Figure 3.64.

3.64a

3.64b

3.64c

3.64d

Figure 3.64 (a-d) Pencil fantasized into a space rocket, a house plant, a banana, and a comb (student work).

✎Practice Exercise 3.26: Fantasy Drawing with a Typographic Form

Select a number or a letter. Using any or all of the tools, techniques, and media discussed, explore fantasy drawing possibilities of the letter or number, as in Figure 3.65. (Refer to the process presented in the previous student exercise.)

3.65a

3.65b

Figure 3.65 The letter M transformed. (a) The original M; (b) thin, flexible; (c) soft, fabric; (d) hard, metallic; (e) M made of metal chain (illustrated by Maria Palazzi).

3.65c

3.65d

3.65e

REFERENCES AND RESOURCES

Allen, Janet. *Drawing: A Complete Teach-Yourself Handbook*. New York: Van Nostrand Reinhold, 1980.

Arnheim, Rudolf. *Visual Thinking*. Berkeley and Los Angeles: University of California Press, 1969.

Bayer, Herbert. *Book of Drawings*. Chicago: Paul Theobald, 1961.

Blake, Wendon. *The Drawing Book*. New York: Watson-Guptill, 1980.

Bro, Lu. *Drawing: A Studio Guide*. New York: W. W. Horton Company, 1978.

Collier, Graham. *Form, Space and Vision: Discovering Design Through Drawing*. 2d ed. Englewood Cliffs, NJ: Prentice-Hall, 1967.

Edwards, Betty. *Drawing on the Right Side of the Brain*. Los Angeles: Tarcher, 1979.

Guptill, Arthur L. *Pencil Drawing: Step by Step*. 2d ed. New York: Van Nostrand Reinhold, 1959.

Hanks, Kurt, and Larry Belliston. *Draw! A Visual Approach to Thinking, Learning and Communicating*. Los Altos, CA: William Kaufmann, Inc., 1980.

Hayes, Colin. *The Complete Guide to Painting and Drawing Techniques and Materials*. New York: Mayflower Books, Inc., 1978.

McKim, Robert H. *Experiences in Visual Thinking*. Monterey, CA: Brooks/Cole, 1972.

Mugnain, Joseph. *The Hidden Elements of Drawing*. New York: Van Nostrand Reinhold, 1974.

Oliver, Robert S. The Sketch. New York: Van Nostrand Reinhold, 1979.

Orsini, Nicholas. *The Language of Drawing*. New York: Doubleday, 1982.

Paterson, Robert. *Abstract Concepts of Drawing*. New York: Van Nostrand Reinhold, 1983.

Schwarz, Hans. *Draw in Pencil, Charcoal, Crayon and Other Media*. New York: Taplinger, 1979.

———. *Draw Buildings and Cityscapes*. New York: Taplinger, 1979.

Seymour, Mary. *Draw Interiors*. New York: Taplinger, 1979.

Theil, Philip. *Freehand Drawing: A Primer*. Seattle: University of Washington Press, 1976.

Wang, Thomas C. *Pencil Sketching*. New York: Van Nostrand Reinhold, 1977.

Chapter 4

Formal Drawing Systems

CHAPTER OUTLINE

- Chapter Vocabulary
- Introduction to Formal Drawing
- Approaches to Pictorial Drawing and Sketching
- Orthographic Projection
- Axonometric Projection
- Oblique Projections
- Perspective
- Visually Communicating Information Through Drawing
- Practice Exercises
- References and Resources

CHAPTER OBJECTIVES

On completion of this chapter, readers should be able to:

- List the different projection systems used in formal drawing.

- Determine the type of drawing or drawings needed to visually communicate the appropriate information about an object, figure, form, or environment.

- List the advantages and disadvantages of the different projection systems and their pictorial effects.

- Use formal drawing systems as a means to analyze and create visual representations of objects and forms.

- Construct and use the formal projection systems presented.

- Determine the best pictorial view, or orientation, of an object or figure so that it may be easily perceived and interpreted.

- Relate geometric shapes to objects in the drawing process.

- Understand and utilize the components of perspective drawing.

Figure 4.1 The gray area (Space, Depth, and Distance) in the model denotes the information presented in this chapter.

Visual Elements of Form		**Perception Theory**

Form Generators	**Visual and Physical Attributes of Form**	**Space, Depth, and Distance**
Point conceptual element **No** Dimension	Value/Tone Color	**2- and 3-Dimensional Form Perception** Light/Brightness contrast threshold Illusions Monocular Cues size partial overlap value color aerial perspective detail perspective linear perspective* texture gradient shadow blurring of detail transparency Binocular Cues muscular cues parallax cues Position Orientation Motion Time
Line	Value/Tone Color Texture Dimension length Direction	
Plane	Value/Tone Color Texture Dimension length width Shape direction visual stability Proportion	

Form	**Form** is the primary identifying characteristic of volume	
Volume is the product of: points (vertices) lines (edges) planes (surfaces)	Value/Tone Color Texture Dimension length width depth Shape direction visual stability Proportion	***Drawing/Projection Systems** Orthographic Paraline axonometric oblique Perspective

4.1

CHAPTER VOCABULARY

Angle of vision The limited range of sight of an object from a stationary point.

Axonometric A general term for parallel projections that are isometric, dimetric, or trimetric.

Convergence The phenomenon of parallel lines seeming to come together at a point in the distance.

Coordinates Points that provide a precise reference framework to locate a point, line, or plane in two- or three-dimensional space.

Dimetric projection A parallel projection in which the two axes make equal angles with the plane of projection.

Diminishing forms The phenomenon of shapes that seem to become smaller as they recede into the distance.

Elevation A scale drawing of an object in vertical projection.

Horizon line The line of intersection between the horizon plane and the picture plane. In perspective drawing, the horizon appears at the viewer's eye height.

Isometric projection A parallel projection in which all the edges of a cube are of equal measure. The angles of the faces are 120° and 60°. Isometric is the most frequently used method in technical illustration.

Oblique projection A form of parallel projection in which one set of faces is parallel to the picture plane.

Orthographic projection A multiview drawing represented in two dimensions. It is a parallel projection of the planes

and elevations in which all angles remain the same and all dimensions are true to scale.

Perspective drawing A three-dimensional projection that shows an object as the eye sees it from one particular point of view. The types of perspective are one-point, two-point, and three-point.

Plan view A scale drawing of the object viewed from above.

Trimetric projection A parallel projection in which the three axes make different angles with the plane of projection. A trimetric projection requires three different foreshortened scales for measurement.

Vanishing point The point at which a set of converging lines meet; for example, convergence may be on, above, or below the horizon line.

INTRODUCTION TO FORMAL DRAWING

In Chapter 3 emphasis was placed on beginning approaches to drawing, techniques, tools, materials, and construction methods that keep the object's orientation parallel with the picture plane. This chapter introduces formal drawing systems that are used to create the illusion of three-dimensional space on a two-dimensional picture plane. Artists, architects, designers, and engineers use drawing projections and their constructions to represent figures, objects, and environments similarly to the way they are actually perceived.

There are different types of drawing methods (freehand and mechanical sketching) and technical drawing (rendering, architectural, and engineering). The projection systems presented in this chapter can be used to represent objects in all of these contexts.

APPROACHES TO PICTORIAL DRAWING AND SKETCHING

The three major divisions of pictorial drawing are:

1. Orthographic projections, which meet the picture plane at right angles. Plan elevations, section views, and axonometrics (transmetric, trimetric, dimetric, isometeric) are included in orthographic projections.

2. Oblique projections, in which lines are parallel to each other and at an oblique angle to the picture plane; transobliques, plan obliques, and elevation obliques belong to this group.

3. Perspective projections, which are drawn at various angles to the picture plane with lines converging at a common vanishing point; this group includes one-, two-, and three-point perspectives.

Models of these systems are shown in Figure 4.2.

Theoretically, axonometric projection is orthographic projection—that is, a multiview drawing represented in two dimensions, in which only one plane is used. In an axonometric drawing, the object is turned so that three faces show in the resulting view. Oblique projection is similar to isometric drawing in that it has three axes that represent three mutually perpendicular edges. Perspective drawing is based on the viewer being positioned at a particular point relative to the object and represents the object as it would appear to the eye. Note that in perspective drawing, lines cannot be measured directly for accurate description of the object as in orthographic projection; however, artists, architects, and designers more frequently use perspective in pictorial representation rather than axonometric projections.

Figure 4.2 (a-c) A model of the geometric projection systems and their pictorial views (continued next page) (illustrated by Chi-ming Kan).

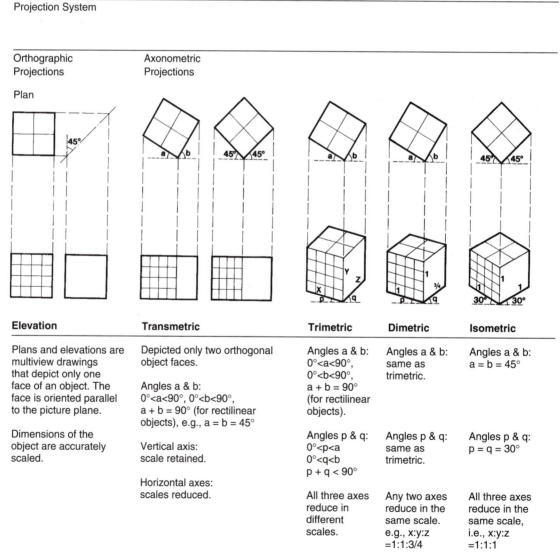

Projection System

Orthographic Projections	Axonometric Projections				
Plan					
Elevation	Transmetric		Trimetric	Dimetric	Isometric
Plans and elevations are multiview drawings that depict only one face of an object. The face is oriented parallel to the picture plane.	Depicted only two orthogonal object faces.		Angles a & b: 0°<a<90°, 0°<b<90°, a + b = 90° (for rectilinear objects).	Angles a & b: same as trimetric.	Angles a & b: a = b = 45°
	Angles a & b: 0°<a<90°, 0°<b<90°, a + b = 90° (for rectilinear objects), e.g., a = b = 45°				
Dimensions of the object are accurately scaled.	Vertical axis: scale retained.		Angles p & q: 0°<p<a 0°<q<b p + q < 90°	Angles p & q: same as trimetric.	Angles p & q: p = q = 30°
	Horizontal axes: scales reduced.		All three axes reduce in different scales.	Any two axes reduce in the same scale. e.g., x:y:z =1:1:3/4	All three axes reduce in the same scale, i.e., x:y:z =1:1:1

4.2a

Oblique Projections

Plan

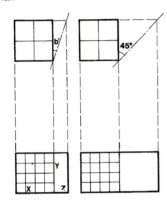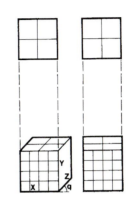

Transoblique

Depict only two orthogonal object faces.

Angle b': $0° < b' \leq 45°$

Vertical axis Y & horizontal axis X: scales retained.

Horizontal axis Z: scale variable, either in full or reduced.

(Note also conditions for plan and elevation transobliques on the right.)

4.2b

Plan Oblique

Plan view retains its size and shape.

Angles a, b, p & q: $0° < a < 90°$, $0° < b < 90°$ $a + b = 90°$ (for rectilinear objects) a = p, b = q

Angle r (direction of axis Y): $0° \leq r \leq 360°$ (note: becomes transoblique when r = 0°, 90°, 180°, 270° or 360°)

Vertical axis Y: scale variable, either in full or reduced.

Horizontal axes X & Z: scales retained.

Elevation Oblique

Elevation view retains its size and shape.

Angle q: $0° \leq q \leq 360°$ (note: becomes transoblique when q = 0°, 90°, 180°, 270° or 360°)

Vertical axis Y & horizontal axis X: scales retained.

Horizontal axis Z: scale variable, either in full or reduced.

Figure 4.2 (continued).

Perspective Projections

Plan

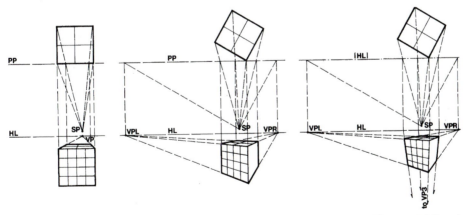

One-point Perspective

One face of a rectilinear object is parallel to the picture plane.

Locations of station point (SP), picture plane (PP), and horizon line (HL) variable.

Verticals remain vertical.

Horizontals converge to vanishing point (VP).

Scale of receding axis foreshortened.

4.2c

Two-point Perspective

One set of a rectilinear object's parallel edges is parallel to the picture plane, and no faces of the object are parallel to the picture plane.

Locations of SP, PP and HL are variable.

Verticals remain vertical.

Horizontals converge to left or right vanishing points (VPL/VPR) which are determined by SP, PP and HL.

Scales of horizontal axes are forshortened.

Three-point Perspective

No edges or faces of a rectilinear object are parallel to the picture plane, i.e., the picture plane is tilted at an angle.

Locations of SP, PP and HL are variable.

Verticals converge to vanishing point three (VP3).

Horizontals converge to VPL or VPR.

Scales of all axes are foreshortened.

ORTHOGRAPHIC PROJECTION

Orthographic projections are often called multiview drawings because two or more different views of the object are represented. Multiview drawings are used for production purposes, and each view shows only two dimensions (i.e., height and width, height and depth, or width and depth).

Orthographic projection uses graphic conventions or rules that provide a means to accurately describe the true shape and details of an object. Only two dimensions are shown in each view of the orthographic projection, in contrast to the three-dimensionality of the pictorial drawing projections.

Orthographic projections of an object are made by projecting perpendicular lines from two or more sides of the object to planes that are positioned at right angles to each other. The views on each of these planes describe the object in true shape and detail because each of the object's sides is shown as though the observer is positioned directly opposite, facing that side. No distortion or foreshortening results (see Figures 4.3 and 4.4).

The most commonly drawn orthographic views are the front, top, and right side of an object. The different views and the number of views selected are determined by the complexity of the object being drawn. More complex objects require more views to communicate important characteristics.

✎**Practice Exercise 4.1: Creating a Three-Dimensional Form Using an Orthogonal Grid**

The objective of this exercise is to introduce the process of visualizing a three-dimensional object through orthographic conventions. Begin by constructing an orthogonal grid (see Figure 4.5a). Make copies of the grid structure so that several different solutions can be developed. Darken lines in different sections of the grid; these lines indicate areas to be subtracted from a three-dimensional cube (see Figure 4.5b). In the margin of the paper, sketch some small three-dimensional views of the resulting form to help visualize what an actual cube would look like if the areas were subtracted (see Figure 4.5c). Continue to make a number of study drawings, keeping in mind that the final form should possess good balance and unity.

Select one of the best solutions and prepare an orthographic drawing of the final form (see Figure 4.6). Remember that if there is detail on the left, back, or bottom of the form, these views of the object also are needed in the final drawing.

Figure 4.3
A front elevation of an orthographic projection drawn with the face of the object parallel to the picture plane. The image is projected directly onto the picture plane and shows true dimensions.

Figure 4.4
An orthographic projection illustrating the six projected sides of a building.

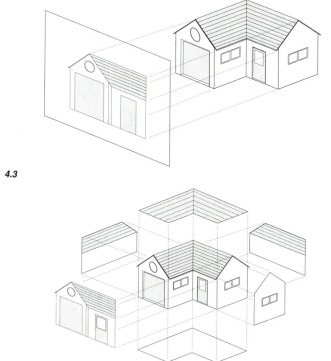

4.3

4.4

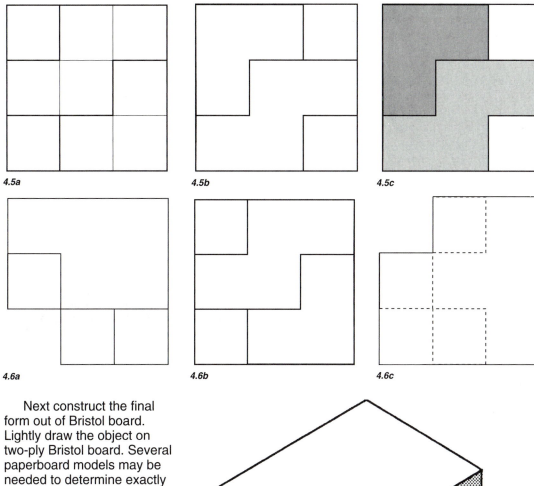

4.5a 4.5b 4.5c

*Figure 4.5 (a)
Dividing a square
figure using an
orthogonal grid; (b-
c) creating a front
view of a two-
dimensional form
using an ortho-
gonal grid.*

4.6a 4.6b 4.6c

*Figure 4.6 (a-c)
An orthographic
projection of
Figure 4.5c. (a) Top
or plan view;
(b) front elevation;
(c) right side
elevation.*

Next construct the final form out of Bristol board. Lightly draw the object on two-ply Bristol board. Several paperboard models may be needed to determine exactly how the planes are connected to each other in three dimensions. Add tabs where necessary to glue the sides of the form together. Figure 4.7 shows the final result of this exercise.

Evaluate the results according to the accuracy and neatness of both the drawing and the model. Make sure that the areas subtracted in the orthographic drawing are subtracted from the model. The same form can be drawn using axonometric and/or perspective projections.

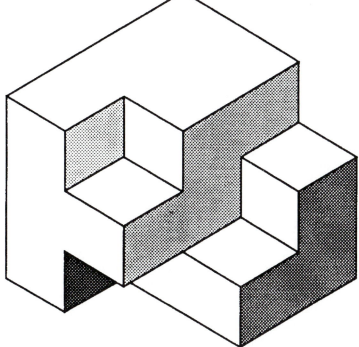

*Figure 4.7 An
isometric drawing
of the finished
three-dimensional
model.*

4.7

Figure 4.8 (a-b) An orthographic and axonometric projection.

Figure 4.9 (a-b) Transmetric projections of an object.

Figure 4.10 (a-b) Isometric projections showing how the orientation of the form in the plan view affects the resulting isometric view.

AXONOMETRIC PROJECTIONS

Axonometric projection provides a means to present all three orthographic dimensions (height, width, and depth) of an object in a single view (except for transmetric projections, discussed below, which show only two dimensions). See Figure 4.8 for an example of an orthographic and axonometric drawing. As the object is turned and/or tilted in three-dimensional space, one or more faces of the object appears foreshortened to the viewer which means that they appear smaller than they actually are. This gives the appearance of distance or depth to the object.

Transmetric Projection

A transmetric projection, also called a transparaline, is a type of axonometric projection that shows only two faces of an object in a single view. In this type of projection, the object is rotated about the vertical axis but remains perpendicular to the picture plane in the front or horizontal view. Both of the faces shown in the transmetric view are foreshortened, and the amount of foreshortening varies according to the amount of rotation in the plan, or top, view. Transmetric projection is illustrated in Figure 4.9.

Isometric Projection

Of the axonometric projections, **isometric** is the easiest pictorial view to construct.

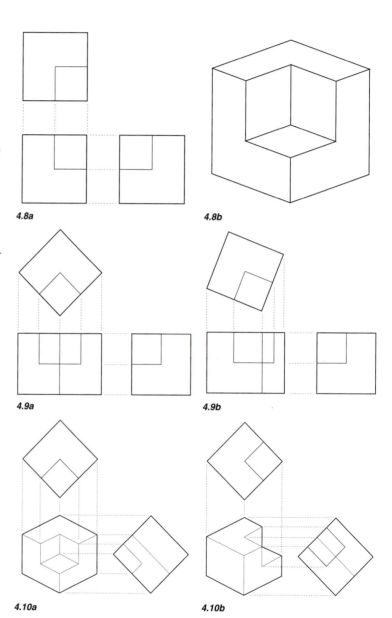

4.8a 4.8b

4.9a 4.9b

4.10a 4.10b

All three measuring axes (height, width, and depth) are foreshortened equally. The object orientation in an isometric projection is achieved by rotating the object about its vertical axis, then tilting the object forward until the diagonal axis appears as a point in the isometric view (see Figure 4.10). If the object is a cube, the diagonal axis can be found by drawing a line from the top, front center corner of the object to the bottom rear corner of the object.

The most evident disadvantage of isometric projection is that as the orientation of the object is rotated and tilted forward into the correct isometric position, the points located on the diagonal (top

front and bottom rear corners) become superimposed, which can create ambiguity or visual fluctuation. Figure 4.11 shows a completed isometric drawing.

Dimetric Projection

In **dimetric projection** (see Figure 4.12), only two of the axes are equal. The two equal axes of the dimetric projection are foreshortened the same amount because they are positioned at the same angle and distance relative to the picture plane and viewer.

The most common dimetric orientation is achieved by rotating the object 45° around its vertical axis, and then tilting the object forward 21°. The object's vertical faces (front, right, left, or back) are increased or decreased by selecting a vertical rotation angle other than 45°. The selection of other tilt angles increases or decreases the visibility of the object's top surface. If the vertical rotation angle is modified so that the two vertical faces are not equally visible, the top must be tilted to be equally visible to one of the vertical planes, so that two of the axes remain equal. Dimetric drawings have a more natural appearance than isometric, but usually require less time to draw than a perspective projection. Since there are two different axes, two measuring scales are required as the height is not the same measurement as the width or depth.

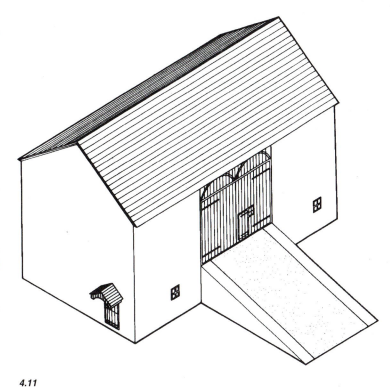

4.11

Figure 4.11 Isometric drawing of a Dutch barn (illustrated by William Faust).

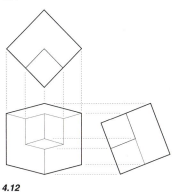

4.12

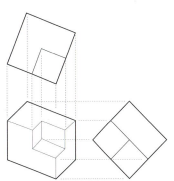

4.13

Figure 4.12 Dimetric projection of a cube.

Figure 4.13 Trimetric projection of a cube.

Trimetric Projection

In **trimetric projections** (see Figure 4.13), the object is positioned so that none of the faces of the object are equally visible. The object is rotated around its vertical axis to a point other than 45° so that the two vertical faces are not equal. Then the object is tilted forward a desired number of degrees so that the top surface is at a differ-

ent viewing angle from the other two faces. This object orientation results in three different axis measurements with each face foreshortened a different amount.

Trimetric drawings are more time consuming than any of the other axonometric projections. Since the three faces are shown at three different angles, three measur-

*Figure 4.14 (a-b)
Transoblique
projection of a
cube.*

ing scales are required. The primary advantage of the trimetric is that a more natural view of the object is achieved, similar to a perspective view. But, unlike the perspective, it is attained through the easier method of measuring directly on the axis lines.

OBLIQUE PROJECTIONS

Oblique drawings are similar to isometric because they have three mutually perpendicular axes upon which measurements can be made. Oblique projection lines are parallel to each other and at an oblique angle to the picture plane. Two of the axes (height and width) are perpendicular to each other, while the third axis (depth) is at another angle, seeming to

4.14a

4.14b

recede back into the picture plane. The measure of the depth angle can be varied for specific situations; no definite rules are given. The most common angles used are 30°, 45°, and 60°.

Transoblique

There is one irregular oblique called a transoblique (see Figure 4.14), which shows

only two faces of an object. The front or top face is drawn parallel to the picture plane. Then the side or top (depending on the selected front view) is drawn next to the front view. This can be true length or foreshortened, as shown.

*Figure 4.14 (a-b)
Transoblique
projection of a
cube.*

*Figure 4.15
Elevation oblique
projections
showing an extended Y (depth or
receding) axis for
continued depth
using different
measurement
scales. (a) Cabinet
oblique; (b) general
oblique; (c) cavalier
oblique.*

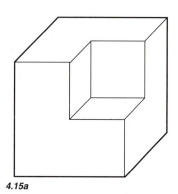

4.15a

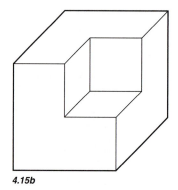

4.15b

4.15c

*Figure 4.16 (a-c)
Plan oblique
projections of a
cube illustrating
different views and
orientations of the
plan.*

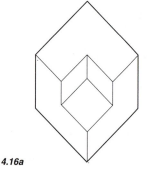

4.16a

4.16b

4.16c

Elevation and Plan Obliques

In an oblique, one face of the object is parallel to the picture plane, unlike the isometric, dimetric, and trimetric, in which no faces are parallel to the picture plane. If the front view is parallel to the picture plane, it is called an elevation oblique, and if the top view is parallel to the picture plane, it is called a plan oblique. The face that is parallel to the picture plane is shown without distortion. For this reason, the face that has an irregular outline or contour should be placed parallel to the picture plane for an oblique. Elevation oblique drawings are shown in Figures 4.15 and 4.17; plan oblique drawings are shown in Figures 4.16 and 4.18.

Plan and elevation obliques can be drawn in three ways: cabinet oblique, general oblique, or cavalier oblique. These classifications are determined by the measuring scale used on the third (depth or receding) axis. All the obliques use a one-to-one scale on the axes parallel to the picture plane. The cabinet oblique uses a 1/2 scale on the third axis; the general oblique uses a 2/3 or 3/4 scale on the third axis; and the cavalier oblique uses a full scale on the third axis. Some of the distortion can be avoided by placing the longest dimension parallel to the picture plane. However, any irregular face on the object should be oriented so that it is parallel to the picture plane.

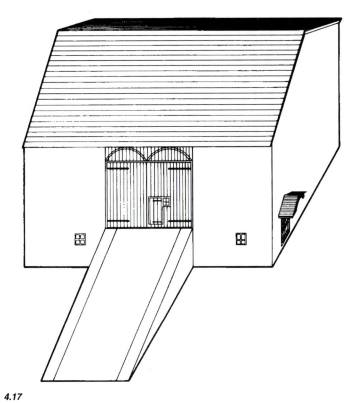

Figure 4.17 Elevation oblique projection of a Dutch barn (illustrated by William Faust).

4.17

Figure 4.18 Plan oblique projection of a Dutch barn (illustrated by William Faust).

4.18

PERSPECTIVE

There are two approaches to learning how to draw in perspective. One approach is drawing a geometric perspective, which is projected with drawing instruments onto a picture plane, from carefully arranged orthographic views of the object. This is the traditional method that engineers and architects use. The other method is a construction or freehand drawing that utilizes the components of perspective—that is, a horizon line, vanishing points, a station point, center of vision, picture plane, measuring line, visual rays, and so on. This type of drawing method does not project an object from orthographic views but is drawn as seen through the mind of the person drawing.

In beginning to draw in perspective, it is easier to learn the geometric projection method because there are object **plan** and **elevation views**, which are easy to comprehend. However, in freehand perspective drawing, it is also necessary to have a plan or side elevation (orthographic view) of the object in order to draw it correctly.

The differences between one-, two-, and three-point perspectives are based on orientation of the object relative to the picture plane. One-point perspective places one face of the object parallel to the picture plane. Two-point perspective positions one set of an object's parallel edges

parallel to the picture plane. No faces or sides of the object are parallel to the picture plane in a two-point perspective. Three-point perspective has no faces or edges parallel to the picture plane.

In theory, a perspective drawing of an object is the image experienced by viewing the object at the point where the picture plane intersects the viewer's field or cone of vision. Both the distance between the object and the picture plane (pp) and the distance between the viewer, or station point (sp), and the picture plane (pp) affect the resulting perspective image. If the viewer is close to the object, the perspective image appears larger than if the viewer were farther away. If the object is farther away from the picture plane, the perspective image created by the intersection of the visual rays from the object and the picture plane is smaller. To draw using this method, it is important to have an understanding of the theory of per-

spective and to comprehend its components and relationships (see Figures 4.19 and 4.20).

Components of the Perspective Drawing

Although each type of perspective (one-, two-, or three-point) varies in its particular object view and orientation, there are basic components germane to each. These include the station point, center of vision, cone of vision, picture plane, horizon line, ground line, vanishing points, visual rays, and measuring line.

Station Point (sp)
The station point is the location of the eye of the viewer. All of the projection lines from the object pass through the picture plane and **converge** at this point.

Center of Vision
The center of vision is the viewer's focal point. It is the point at which the viewer's line of vision intersects the horizon line.

*Figure 4.19
Diagram of a perspective drawing.*

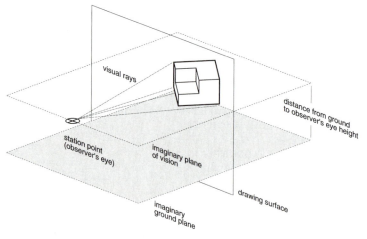

visual rays

distance from ground
to observer's eye height

station point
(observer's eye)

imaginary plane
of vision

drawing surface

imaginary
ground plane

4.19

Figure 4.20 Relating
the diagram of a
perspective drawing
to the perspective
theory.

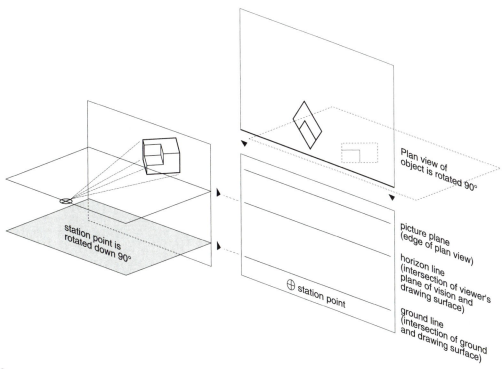

Plan view of
object is rotated 90°

picture plane
(edge of plan view)

horizon line
(intersection of viewer's
plane of vision and
drawing surface)

ground line
(intersection of ground
and drawing surface)

⊕ station point

station point is
rotated down 90°

4.20

Cone of Vision
The cone of vision is the viewer's **angle of vision**. This imaginary cone converges at the viewer's eye. The cone of vision angle varies as the viewer's distance from the object varies, narrowing as the viewer moves farther from the object. The cone of vision angle should measure between 45° and 60° to avoid a great deal of distortion in the resulting perspective view.

Picture Plane (pp)
The two-dimensional picture plane is perpendicular to the horizon plane, ground plane, and viewer's line of sight and is parallel to the viewer. The picture plane usually refers to the drawing surface or sheet of paper on which the object is drawn. In the figures that follow, however, picture plane refers to the line representing the edge of the plan view drawing.

Horizon Line (hl)
Imagine a plane that extends from the viewer's line of sight and is perpendicular to the picture plane. This plane is called the horizon plane. The line of intersection between the horizon plane and the picture plane is called the **horizon line**. If the horizon line is placed low, it is assumed that the viewer is seated on the ground; if the horizon line is placed high, it conveys a feeling of looking down, as though the viewer is above the object.

Ground Line (gl)
Imagine a plane that extends from the point where the viewer is standing, perpendicular to the picture plane and parallel to the horizon plane. This plane is called the ground plane. The line of intersection of the ground plane and the picture plane is called the ground line. The ground line provides a reference for the placement of the object on the picture plane.

Vanishing Points (vp)
The number of vanishing points in a perspective drawing determines the type (i.e., one-, two-, or three-point perspective) and view of the object, figure, or environment. Parallel lines on the object converge to the respective vanishing points creating the illusion of depth in the perspective view. All lines and planes on the object that are parallel to each other converge to the same vanishing point.

Figure 4.21 One-point perspective views of a cube above, on, and below the horizon line.

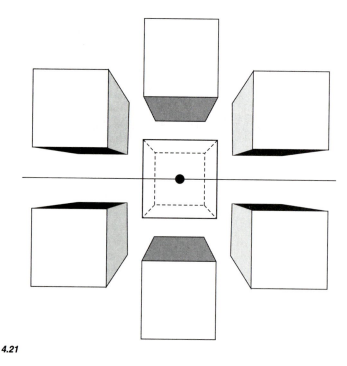

4.21

Figure 4.22 One-point perspective or "bird's-eye view" looking down into a barn (illustrated by William Faust).

4.22

Figure 4.23 One-point perspective looking into a barn (illustrated by William Faust).

4.23

Visual Rays (vr)

Visual rays are the imaginary lines leading from points on the object to the eye of the viewer. The visual rays are drawn from each of the object's identifying points to the station point (viewer's eye), passing through the picture plane. The intersection of the visual rays and the picture plane establish new points that are projected down to the ground line and station point. These new points give the correct placement of the vertical planes in the perspective view, creating the illusion of foreshortening as the object diminishes into space.

Measuring Line (ml)

The measuring line in the perspective view is considered true height. In the top or plan view, the measuring line is the place at which the object intersects or touches the picture plane and is extended down to the ground line or station point. All points on the measuring line must be projected to a vanishing point; they establish the contour of the planes that describe the object in perspective.

One-Point Perspective

One-point perspective is used commonly in architectural and interior space drawings. This type of perspective creates a feeling of depth and enclosure. A one-point perspective often called a "bird's-eye" perspective orients the viewer above the environment looking down into the space for example. This is effective in representing floor plan details.

As the name implies, in a one-point perspective drawing all the parallel lines on an object converge to a single vanishing point. It is not difficult to construct a one-point perspective, since one set of parallel planes remain parallel to the drawing surface, and the other set of parallel planes converge toward the vanishing point. Figures 4.21, 4.22, and 4.23 are one-point perspective drawings.

Two- and Three-Point Perspective

Two-point perspective is used commonly to draw products, building exteriors, landscapes, and so on. Figures 4.24 and 4.25 are examples of two-point perspective drawing.

4.24

Figure 4.24 Square forms drawn using a simplified two-point perspective method.

Figure 4.25 Two-point perspective of a Dutch barn (illustrated by William Faust).

4.25

Three-point perspective is not used as frequently as the one- and two-point methods. Three-point perspective is used in exterior architectural drawings to create the feeling of looking down onto or into an object or space, similar to one-point perspective, but also to show vertical planes as in two-point perspective.

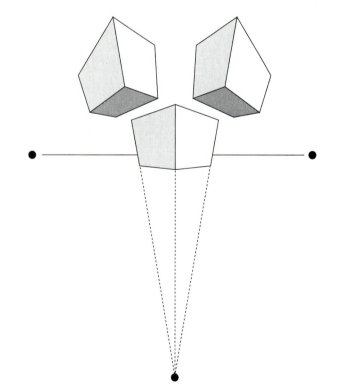

Figure 4.26 Square forms drawn using a simplified three-point perspective construction method.

4.26

The drawing conventions are the same as in two-point perspective, except that a third vanishing point is added above or below the horizon line. Instead of the vertical faces remaining completely vertical, their edge lines converge to the third vanishing point. An example of three-point perspective is shown in Figure 4.26.

Constructing a Two-Point Perspective

Figure 4.27 illustrates how to construct a two-point perspective. The first step in setting up the page for a two-point perspective is to determine the picture plane, horizon line, ground line, station point, and orientation of the object's plan view (see

Figure 4.27a). The distance between the picture plane and the horizon line will not affect the perspective view. The distance between the horizon line and the ground line affects how much of the object's top or bottom will show in the perspective view. The station point is found by drawing the cone of vision from the outermost points of the object's

Figure 4.27
(a) Begin the two-point perspective by locating the plan and elevation of the object relative to the picture plane (pp), horizon line (hl), and ground line (gl). (b-d) Draw visual rays from the object to the station point (sp), and from the elevation into the cone of vision. Where the visual rays intersect the picture plane (pp), draw lines straight down to the perspective view. (e) When the lines from the object elevation intersect the measuring line (ml), then draw the lines to the vanishing points. These vanishing lines will intersect other lines projected down from the plan view. (f) Darken the contour and internal detail lines to bring clarity to the object.

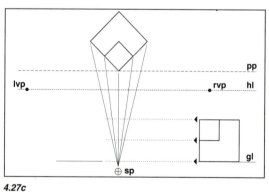

4.27a

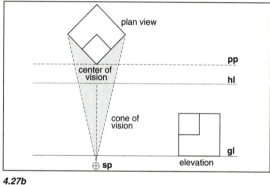

4.27b

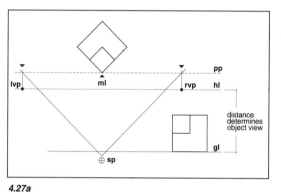

4.27c

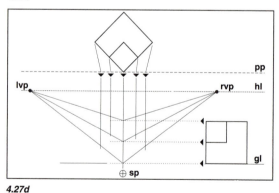

4.27d

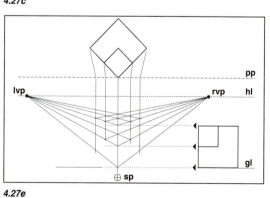

4.27e

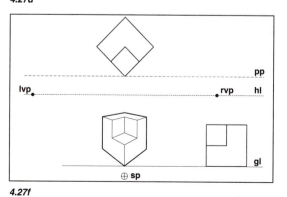

4.27f

plan (see Figure 4.27b). The cone of vision angle should be between 45° and 60°. The object's plan can be set at a 45° angle, or 30°/60° angle. If the 30°/60° angle is selected, the 30° side will show the most in the perspective view.

Determine the object's placement relative to the picture plane, and then find the vanishing points. The plan view can be in front of, intersecting, touching, or behind the picture plane. The point(s) of the object that intersects or touches the picture plane will be true height in the perspective view. To find each of the vanishing points draw a line through the station point to the picture plane, parallel to each side of

the plan view. This point found on the picture plane then is projected straight down to the horizon line, establishing the right (rvp) and left vanishing points (lvp) (see Figures 4.27c and 4.27d).

All the points of the object must be drawn from the station point to the object through or to the picture plane. If the object is in front of the picture plane, the lines must be projected from the station point (sp) through a point on the object onto the picture plane. The same points on the front or side elevation are projected to the true height or measuring line (ml) (see Figure 4.27e).

The points where the visual rays intersect the picture plane (pp) are projected straight down into the perspective view. These lines establish the vertical plane edges in the perspective view. Finally, the lines of the perspective view are darkened to show the perspective image clearly (see Figure 4.27f). This projected perspective image can be used as an underlay to develop more refined drawings of the object.

Orientation of an Object in Perspective

As discussed earlier, the vertical distance between an object (or the ground line) and the horizon line helps to determine how much of the top and bottom of the object shows in the perspective view. As an object approaches a midpoint on the horizon line, neither the top nor the bottom planes are seen. This view changes according to the type of perspective (one-, two-, or three-point) used to draw the object. The drawings of cubes in one- and two-point perspective in Figure 4.28 should help bring an understanding to object orientation in space. The cubes are constructed above, on, and below the horizon line. The two-point perspectives above and below the

line are oriented at 45°, showing both vertical faces of the object equally. The cubes to the right and left of center, above, and below the

horizon line are placed at the 30°/60° position, emphasizing one vertical face more than another.

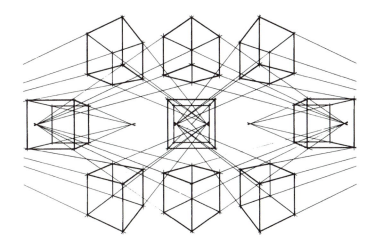

Figure 4.28 Cubes drawn in perspective as one-point and two-point constructions.

4.28

*Figure 4.29
Computer gener-
ated illustrations:
(a) One-point
perspective; (b)
side elevation;
(c-d) rotation of
stapler in space
(student work;
instructor Craig
Vogel, Institute of
Design, Illinois
Institute of
Technology).*

4.29b

4.29c

4.29d

4.29a

*Figure 4.30 (a-c)
Computer gener-
ated illustrations:
Example of a
cassette player
shown in different
perspective views
(student work;
instructor Craig
Vogel, Institute of
Design, Illinois
Institute of
Technology).*

4.30a

4.30b

4.30c

Computer-Aided Perspective Drawing

Many educational programs have introduced the use of the computer for mechanical drawing into the curriculum. The illustrations in Figures 4.29 and 4.30 demonstrate an approach to this. The figures emphasize how the computer can be used to vi-sualize pictorial views utilizing computer-aided design software for perspective drawing.

✍Practice Exercise 4.2: Determining and Drawing an Object's Position and Orientation in Perspective

The objective of this exercise is to understand how the position and orientation of an object will change in space. Begin by selecting an object such as the toy truck in Figure 4.31.

4.31a 4.31b 4.31c

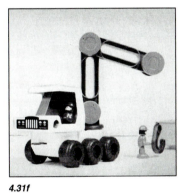

4.31d 4.31e 4.31f

Figure 4.31
Photographs illustrating varied object orientations on and below the horizon line. (a) Side elevation (orthographic view); (b) front elevation (orthographic view); (c) one-point perspective below the horizon line; (d) 45° two-point perspective below the horizon line; (e) 30°/60° two-point perspective on the horizon line; (f) two-point perspective on the horizon line.

4.32a

4.32b

4.32c

4.32d

Figure 4.32
Orthographic drawings of the toy truck components. (a) truck cab; (b) arm and bucket; (c) trailer bed; (d) trailer (illustrated by Ben Goodman).

.....................................

Figure 4.33
Toy truck drawn in
different perspec-
tive views. (a) One-
point perspective;
(b) two-point
perspective
(30°/60°); (c) two-
point perspective
(45°); (d) two-
point perspective (45°)
(illustrated by Ben
Goodman).

4.33a

4.33b

4.33c

4.33d

Figure 4.34
(a) Developmental
sketch of toy truck;
(b) refined sketch;
(c) developmental
sketch of toy truck,
cab, arm, and
bucket; (d)
developmental
sketch of toy
bulldozer
(illustrated by Ben
Goodman).

4.34a

4.34b

4.34c

4.34d

Place the object on a white backdrop, and use a dark-colored cord to represent the horizon line. The cord can be moved up and down to achieve different viewing positions of the object—above, on, and below the horizon line. Photograph the various positions of the object, noting the different angles and positions and how they change the representation of the object. This is an effective way of understanding the concept of position and orientation in perspective of an object in space.

Next, draw different perspective views of the selected object, beginning with a formal orthographic projection. Determine the number of orthographic views needed to accurately represent the object. An orthographic drawing of each of the object's component parts may be necessary for more complicated objects, as is the case with the toy truck in Figure 4.32.

After the orthographic drawings are completed, construct perspective drawings using one- and two-point perspective (45° and 30°/60°) construction methods, as shown in Figure 4.33.

Finally, use the completed construction drawing to develop underlays for freehand sketching. Draw the sketches over the existing construction in order to refine ideas of the object's form (see Figure 4.34).

COMMUNICATING THROUGH DRAWING

The organization of visual ideas into a drawing presentation requires considerable thought and planning. Essentially, the goal of a drawing presentation can be related to that of the goal of structuring a verbal message—that is, correctly conveying the chosen message to an audience through a drawing or set of drawings. Questions to consider are: What is to be communicated? How might it be communicated visually through drawing? To whom is the message directed? What response is desired from the audience?

Drawings for Presentation

The process of developing drawings for the presentation of ideas can go through a number of developmental phases depending on the complexity or requirements of the problem. Three drawing phases that may be used are quick sketches, overlay sketches or drawings, and final drawings or renderings.

Quick sketches consist of only the few lines necessary to represent the general idea or describe an object or environment. They are used to communicate key concepts and take little time; this allows for quick evaluation of thoughts and revision. Overlay sketches are created by drawing new sketches over the old by laying paper over the preliminary construction until the desired repre-

4.35

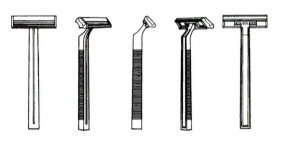

4.36

sentation of the object is achieved. This type of drawing process refines concept ideas, objects, and forms. Final drawings or renderings for presentation are carefully drawn and detailed, and clearly communicate visually detailed information.

Object Orientation

Selecting the best view of an object to visually describe it is an important aspect of the drawing process. The different views and object orientations should be studied through quick sketching to assist in the selection.

✍Practice Exercise 4.3: Exploring Object Orientation

Begin this exercise by selecting a simple object. View the

object from the front elevation. Now rotate the object about its vertical axis, observing each side. Notice how the object has several intermediate views between the front and side. Draw quick sketches of the object rotating in space, then select the drawings that best visually describe and define the object.

Finalize the drawings, and organize them sequentially into a visual presentation, starting with the object in a front elevation position. Draw one- or two-perspective views so that the object appears to turn through sequential drawings. Figures 4.35 and 4.36 illustrate this technique.

Figure 4.35 Sequence of drawings integrating perspective views so that the chisel appears to turn in space (illustrated by Robert Sheldon).

Figure 4.36 Sequence of drawings integrating perspective views so that the shaving razor appears to turn in space (illustrated by Robert Sheldon).

Object Analysis Through Sketching

Figure 4.37 illustrates a preliminary visual study of an antique iron, rendered in Practice Exercise 3.1 in Chapter 3. The visual analysis utilizes quick sketching techniques to determine what views, orientations, structural, and surface characteristics best represent the object before more detailed drawings are developed. The preliminary study also requires that the drawings be related to a specific page format and layout. At this stage, consideration of the actual size, shape, and proportion of the format should be considered. The shape and proportion of the picture plane will influence other relationships between the visual elements. The placement and size of each of the drawings will vary depending on its importance in communicating the intended message.

✍Practice Exercise 4.4: Analyze an Object Through Sketching

Select a simple object, such as the illustrated antique iron. Use quick sketching techniques and formal drawing systems to explore different views and structural and surface characteristics of the object. Use these sketches to develop a more formal drawing presentation of the object in pencil or pen and ink.

Figure 4.37 Illustrations of an antique iron exploring the different object views relative to its orientation (illustrated by Mary Jo Sindelar).

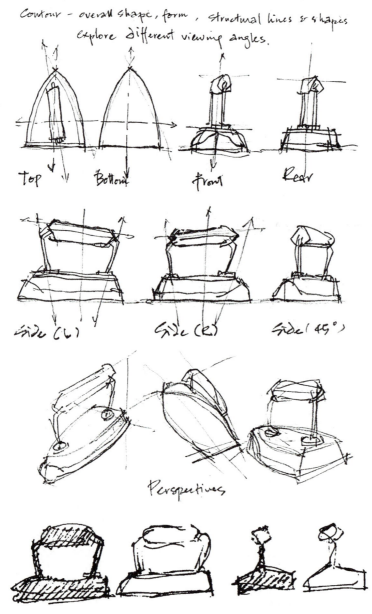

4.37

REFERENCES AND RESOURCES

Ballinger, Louise Bowen. *Perspective: Space and Design*. New York: Van Nostrand Reinhold, 1969.

Beakley, George C., Donald D. Autore, and David W. Hudgins. *Introduction to Technical Illustration*. Indianapolis, IN: Bobbs-Merrill, 1983.

Ching, Frank. *Architectural Graphics*. New York: Van Nostrand Reinhold, 1975.

Crowe, Norman, and Paul Laseau. *Visual Notes for Architects and Designers*. New York: Van Nostrand Reinhold, 1984.

Doblin, Jay. *Perspective: A New System for Designers*. New York: Whitney Publications, Inc., 1956.

Dubery, Fred, and John Willats. *Drawing Systems*. New York: Van Nostrand Reinhold, 1972.

Duff, Jon M. *Industrial Technical Illustration*. Monterey, CA: Brooks/Cole, 1982.

Forseth, Kevin, with David Vaughan. *Graphics for Architecture*. New York: Van Nostrand Reinhold, 1980.

French, Thomas E., and Charles J. Vierck. *Engineering Drawing*. 9th ed. New York: McGraw-Hill, 1960.

Gill, Robert W. *Creative Perspective*. London: Thames and Hudson Ltd., 1979.

Lockard, William Kirby. *Design Drawing*. Revised ed. Tucson, AZ: Pepper Publishing, 1982.

McHugh, Robert C. *Working Drawing Handbook: A Guide for Architects and Builders*. New York: Van Nostrand Reinhold, 1978.

Olivo, C. Thomas, Albert V. Payne, and Thomas P. Olivo. *Basic Blueprint Reading and Sketching*. New York: Van Nostrand Reinhold, 1979.

Poter, Tom. *How Architects Visualize*. New York: Van Nostrand Reinhold, 1979.

Ratensky, Alexander. *Drawing and Modelmaking: A Manual for Students of Architecture and Design*. New York: Whitney Library of Design, Imprint of Watson-Guptill Publications, 1983.

Thomas, T. A. *Technical Illustration*. 3rd ed. New York: McGraw-Hill, 1978.

Vero, Radu. *Understanding Perspective*. New York: Van Nostrand Reinhold, 1980.

Walters, Nigel V., and John Bromham. *Principles of Perspective*. New York: Whitney Library of Design, Imprint of Watson-Guptill, 1974.

Wang, Thomas C. *Projection Drawing*. New York: Van Nostrand Reinhold, 1984.

White, Edward T. *A Graphic Vocabulary for Architectural Presentation*. Tucson, AZ: University of Arizona, 1972.

White, Gwen. *Perspective: A Guide for Artists, Architects and Designers*. New York: Watson-Guptill, 1978.

Chapter 5

The Visual Elements of Form: Point, Line, Plane, and Shape

CHAPTER OUTLINE

- Chapter Vocabulary
- Introduction to the Visual Elements of Form
- Theoretical Model of Form Generation
- Introduction to Point
- Introduction to Line
- Introduction to Plane
- Practice Exercises
- References and Resources

CHAPTER OBJECTIVES

On completion of this chapter, readers should be able to:

- Distinguish between conceptual and representational definitions of the basic visual elements: point, line, plane, and shape.

- Understand, visually interpret, and define point, line, plane, and shape as they are used in art, architecture, and design.

- Be aware of the physical representations of point, line, plane, and shape within the environment.

- Use point, line, plane, and shape to represent realistic or abstract images in illustrations.

- Be aware of the ways in which professional artists, architects, and designers use point, line, and plane in their creations.

Figure 5.1 The gray area (Form Generators) denotes the subject matter described in this chapter.

Visual Elements of Form

Perception Theory

Form Generators

Visual and Physical Attributes of Form

Space, Depth, and Distance

Form Generators	Visual and Physical Attributes of Form	Space, Depth, and Distance
Point conceptual element **No** Dimension	Value/Tone Color	**2- and 3-Dimensional Form Perception** Light/Brightness contrast threshold Illusions
Line	Value/Tone Color Texture Dimension length Direction	Monocular Cues size partial overlap value color
Plane	Value/Tone Color Texture Dimension length width Shape direction visual stability Proportion	aerial perspective detail perspective linear perspective* texture gradient shadow blurring of detail transparency Binocular Cues muscular cues parallax cues Position Orientation Motion Time

Form

Form is the primary identifying characteristic of volume

Volume is the product of:
points (vertices)
lines (edges)
planes (surfaces)

Value/Tone
Color
Texture
Dimension
 length
 width
 depth
Shape
 direction
 visual stability
Proportion

***Drawing/Projection Systems**
Orthographic
Paraline
 axonometric
 oblique
Perspective

5.1

CHAPTER VOCABULARY

Abstract theoretical concept
An idea or thought having no tangible physical form as distinct from a tangible object within the environment; these concepts can be represented by images, however.

Complex Describes a composition, object, or building that is difficult to interpret visually, perhaps because it consists of a number of different elements, components, or attributes.

Concept An idea, thought, theory, or notion conceived in the mind.

Contour The outline or outermost edge of a plane that defines its shape.

Illusion An inaccurate or false perception; a contradiction between what is perceived through the senses and what actually exists.

Line Conceptually, a point in motion, having only one dimension, length. Line has both a position and a direction in space.

Location The exact position of something in space.

Mark A visible sign, such as a point or line, in a given space.

Perceive To distinguish or observe through the senses: to see, feel, hear, taste, or smell.

Perceptual Describes something understood through sensory stimuli, as opposed to an abstract concept.

Physical Describes materials, objects, products, or environments that actually exist tangibly in space.

Plane Conceptually, a two-dimensional expression of length and width. A plane is a line that is stretched in two-dimensional space in a direction other than that of its length.

Point The simplest and most minimal of the visual elements used in art, architecture, and design. It is considered the prime generator of all form and can be used to determine and define location in space.

Position Location of an element or image in space. Compositional elements can be positioned on a two-dimensional picture plane relative to the height and width of the format or in three-dimensional space with respect to the height, width, and depth of a defined area.

Precept A rule, principle, or axiom.

Represent To portray or symbolize a figure, form, or action.

Representation A figure or form that is recognized as representing a person, place, or thing known to the viewer.

Shape The specific surface configuration of a plane, figure, or object. Shape can be representational or abstract. Simple two-dimensional regular geometric shapes are called "squares," "rectangles," "circles," or "triangles" depending on their specific boundary configurations.

Simple Describes configurations, compositions, objects, or structures having few parts. Usually the shapes that make up a simple composition or form are uncomplicated and similar in shape, size, color, and so on.

Space A two- or three-dimensional area defined by the visual elements. For example, a two-dimensional space might be a picture plane or format, and a three-dimensional space might be an environment or building interior.

Surface The outermost boundary of any two-dimensional shape, or the outermost plane on a three-dimensional form.

System A group of related elements or interdependent elements that form a collective entity. In the example of form generation, the system might consist of a group of related shapes or forms.

Theory A knowledge or information base consisting of accepted assumptions, principles, and rules of procedure used to analyze or explain a specific phenomenon.

Transformation The gradual change of a figure or form from one structure or composition to another.

INTRODUCTION TO THE VISUAL ELEMENTS OF FORM

Within visual studies there is rarely sufficient time to study or visually explore the various uses, interpretations, and dimensions of the basic elements of form. An understanding of these factors is important and can bring structure and creativity to the visualizing or designing process.

The creating or designing of figures and forms involves the use of the basic visual elements—**point**, **line**, and **plane**—as well as the organizational rules and principles for "putting together" the composition or structure. In addition, point, line, and plane are part of the attributes of form that create tone and texture, imparting visual interest and meaning. This chapter is concerned with the elements involved, both conceptually and representationally, in form generation. The objective is to provide readers with a sense of the dynamics of these elements and their importance in adding visual interest and meaning to compositions and structures.

At this point, it would be advantageous to refer to the problem-solving process/form generation model in the foldout preceding Chapter 1. Figure 5.1 reviews the steps in the process and the relationships among the elements.

In visual studies, point, line, and plane are the most basic and primary of all the visual elements. Their impor-

tance becomes evident through their use in generating images and forms both two- and three-dimensionally. Defining and relating their application to visual studies is sometimes a challenge, however, because the terms can be interpreted and used in different ways, not only in art, architecture, and design, but in other disciplines such as mathematics, the physical sciences, and the humanities.

To illustrate, the mathematician may think about and define words such as "point," "line," "plane," and "volume" in abstract terms. In geometry, a point has no dimension and its only attribute is that of defining a **location** or **position**. A line is thought of as a point in motion within **space**, and it has only one dimension—length. A plane is a flat **surface** bound by lines that has the attributes of length and width, but no depth. Volume, in conceptual terms, is described as a plane in motion in a direction other than its inherent direction—a three-dimensional form derived from and enclosed by planes that has a position in three-dimensional space.

These definitions are conceptual in nature and are utilized in visual studies. However, in the visual arts, artists, architects, and designers must **represent** these elements visually by drawing them on paper, painting them on canvas, or forming them into three-dimensional models or structures using tangible materials

or media. This visualizing process is relational, meaning that both the conceptual and visual **representation** of these elements are finally brought together and interrelated in a dynamic way to produce a visual composition, object, or environmental structure. This method, then, can be thought of as the transforming of conceptual terms and ideas into tangible forms.

It is also important to note that the conceptual terms such as "point," "line," "plane," or "volume" can be referred to and implied within the environment. Examples will be presented in this chapter.

THEORETICAL MODEL OF FORM GENERATION

In the 1920s Paul Klee, artist and master teacher at the Bauhaus, developed his theory regarding pictorial dimensions of form generation starting with point as the generating agent. In his writings he described his theory in conceptual terms: "The point (as agent) moves off and the line comes into being—the first dimension [1]. If the line shifts to form a plane, we obtain a two-dimensional element [2]. In the movement from planes to spaces, the clash of planes gives rise to a body (three-dimensional) [3]. Summary of the kinetic energies which move the point into line, the line into a plane, and the plane into a spatial

dimension [4]." [Paul Klee, *The Thinking Eye* (New York: Paul Wittenborn, Inc., 1961) p. 24.]

Point is considered to have only one attribute, that of indicating position or location, because conceptually a point has no width or depth. However, in representational terms, a point must have a minimal width and depth, or it cannot be perceived.

As a point moves from its original position to another, a line is formed (see Figure 5.2a). Line has the attribute of length but no height or depth. As in the example of point, the representational line does have width, or it could not be perceived.

The movement of a line from one position in space to another creates a plane (see Figure 5.2b). The direction of movement must be in a direction other than the inherent direction of the line or the position change will only serve to extend the line, or make it longer. Planes are two-dimensional elements having height and width but no depth. Planes also have **shape**; the specific shape of a plane depends on its overall configuration of boundary lines.

Volume, or the body, as it is called by Klee, is the result of a plane that moves to a new position within three-dimensional space (see Figure 5.2c). As with a line creating a plane, the plane must be moved in a direction other than its inherent direction, or

it will only create a larger plane. The overall shape of the volumetric form depends on the direction and distance that the point moves from its original position in space (see Figure 5.2d).

Figure 5.2 (a-d) Steps in the form generation process, as outlined by Paul Klee. The point moves into a line, the line into a plane, and the plane into a volume.

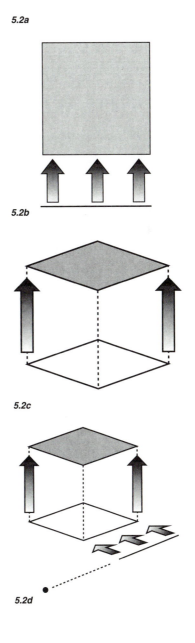

5.2a

5.2b

5.2c

5.2d

INTRODUCTION TO POINT

A point or dot is the simplest element in the form generation process. According to Euclidean geometry, "A point is infinitely minute and has no dimensions." However, a representational point on paper, no matter how small, must have shape, tone, and size if it is to be seen.

The perception of a point is determined relative to a frame of reference. For example, a point may appear fairly large when it is confined to a small format; however, the same point may appear to be very small when it is placed in a relatively large format.

The size of the point must be relative to the size of the viewing or picture plane and the distance of the viewer so that it is not misinterpreted as a circular disk or plane. The perceived point used to indicate position or location may be a shape other than circular. Figures 5.3, 5.4, and 5.5 provide visual examples for the application of point or dot in compositional studies.

Figure 5.3 A point can be: (a) a representational point; (b) a smaller point; or (c) a conceptual (idea) point with no dimension.

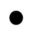

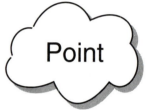

5.3a 5.3b 5.3c

Figure 5.4 Points are perceived relative to their size and format: (a) point in a small format; (b) point in a medium format; and (c) point in a larger format.

5.4a 5.4b 5.4c

Figure 5.5 Representational points must have shape, size, and value or color to be perceived: (a) a square point; (b) a triangular point; and (c) a typographic point.

5.5a 5.5b 5.5c

Point as a Visible Mark or Representational Element

A point is the smallest visible **mark** placed on a two-dimensional plane or within a three-dimensional space. The most common shape assigned to a point is circular. However, a point may be represented as a shape, such as a triangle, square, hexagon, and so on, relative to size (see Figure 5.6).

5.6

Figure 5.6 A small typographic element may be perceived as a point, drawing the viewer's eye to a specific location within the format. At second glance, however, it is recognizable as having a specific shape, as is the case with a typographic element.

Point Creating Line and Direction

A point used as a repetitive mark forms a line. The lines formed by points in Figures 5.7 and 5.8 are organized and positioned to give visual direction and the **illusion** of movement.

5.7

5.8

Figure 5.7 Sets of points creating five short lines. Their arrangement within the format creates a feeling of direction and movement (illustrated by Bill Weber).

Figure 5.8 Points creating an irregular, curvilinear line, such as the flying movement of an insect (illustrated by Bill Weber).

Point Creating Volume and Shape

As the point moves in space other two- and three-dimensional figures and forms are created. The resulting shape of the line, plane, or volume is changed as the direction and distance of the point moves from its original position (see Figures 5.9 and 5.10). The creation of three basic geometric figures and forms is illustrated. A tetrahedron is formed by projecting the original point in space, perpendicular to the planar surface (see Figure 5.11a). A cube is formed by projecting the square plane in a direction perpendicular to the original plane (see Figure 5.11b).

A sphere is created at the original point and line, and projected perpendicularly to the original circular plane (see Figure 5.11c).

Figure 5.9 (a-c) All basic geometric shapes begin by creating a line. As in Klee's model, the point moves in space from its original position.

5.9a

5.9b

5.9c

Figure 5.10 (a-c) The line moves to create a plane. The line may be rotated around an axis, or simply projected in space.

5.10a

5.10b

5.10c

Figure 5.11 (a-c) The use of point, line, and plane is the basis for a three-dimensional volume.

5.11a

5.11b

5.11c

Point Describing and Dividing Space

Points can be used to indicate shape **contours** and visual internal subdivisions of larger shapes. There is a tendency to mentally "fill in" images and attribute meaning to them in the **perceptual** process. For this reason, a square may be visually defined by placing four points,

one at each corner or vertex (see Figure 5.12). More complicated shapes require more points to describe their contours.

In the same way that the contour is described by points, the shape or form can be subdivided, using points as a reference to mark vertices of the subdivision areas (see Figures 5.13–5.15).

Figure 5.12 Square shape defined using four points at the corner vertices.

Figure 5.13 Points used as a visual referent to describe a square plane and its internal subdivisions (illustrated by Susan Hessler).

Figure 5.14 Points used as a repetitive mark forming a visual line. The line subdivides the original square into smaller units (illustrated by Susan Hessler).

Figure 5.15 Points used as a repetitive mark, filling space to create planes. Points are left out to create a visual line between each subdivision (illustrated by Susan Hessler).

FIGURE 5.16 Point grid pattern on which a design idea can be constructed.

FIGURE 5.17 In architecture, the point can represent a position in space relative to a scale (e.g., 1/4" = 1'-0"). Points can also be a notation symbol for a structural member, such as a column (illustrated by Susan Hessler).

5.12

5.13 5.14 5.15

Point Creating a Visual Plan

Points can be used to represent a position in architectural space relative to a scale or as a referent to form a grid on which the design idea is laid out (see Figures 5.16 and 5.17).

5.16 5.17

FIGURE 5.18 Points can be used to create a shape within a plane by altering the frequency or size.

Figure 5.19 Simple shapes created by using points: (a) star; (b) diamond shape; and (c) apple (illustrated by: a, Louise Utgard; b, Lee Willett; c, Louise Utgard).

5.18

Point Creating Shape

Points can be used to visually describe the contours of a shape, in the same way that lines can (see Figures 5.18 and 5.19). This is achieved through the phenomenon called closure. Refer to Chapter 10 for information on this subject.

The success of perceiving a shape defined by points generally is based on the viewer's previous association with the figure. The position of points, as well as their frequency, affects the shape's identity. For example, the fewer points used the more difficult it is to perceive the shape. When more points are used, it is easier for viewers to **perceive** the shape correctly.

5.19a

5.19b

5.19c

5.20a

...........................

Point Creating Movement and Gravity

Points can be arranged within a format to create clusters or groups, lines, and planes. Depending on the quantity, size, and configuration of the points, compositions can be created illustrating direction, movement, and gravity in a two-dimensional format (see Figure 5.20).

Figure 5.20 Compositions using point to create: (a) bounding motion; (b) a random configuration illustrating gravity (illustrated by: a, Lee Willett; b, Cyndi Allen).

5.20b

Point Creating Pattern

Points used repetitively in a regular configuration can be used to create various patterns. Patterns can be created by designing a simple shape or configuration called a cell. The whole pattern is then created by the translation (repetition) of the cell in both horizontal and vertical directions. Visual interest, such as movement or direction, is created by varying the size and location of the points relative to each other. The original cell can be translated or rotated to complement the pattern (see Figure 5.21). Additional information on the symmetry operations—translation, reflection, and rotation of cells—is presented in Chapter 12.

Figure 5.21 Pattern created by rotating four cells around a central axis. The size change creates a sense of movement and direction (illustrated by Cynthia Busic-Snyder).

5.21

Point Creating the Illusion of Depth

Points of varying sizes can be organized within the format to create the illusion of depth/distance and three-dimensional space (see Figure 5.22).

Point Creating Tone and Visual Texture

Tone is the intensity of lightness or darkness reflected from figures and forms. Tone makes possible the perception of dimension and depth. Points can be used to create tone on a two-dimensional plane by varying their size and interval; for example, a continuous tone image (such as a black and white photograph) can be translated into a series of points or dots that are transferred onto a plate, inked, and printed (see Figures 5.23 and 5.24).

Figure 5.22 The pattern of alternating large and small dots appears as though some dots are closer and some are farther away (illustrated by Susan McNulty).

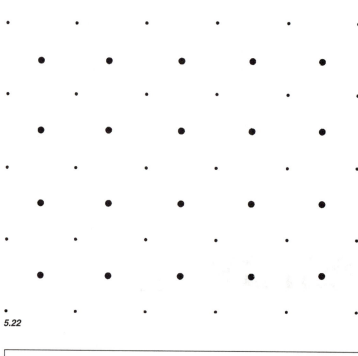

5.22

Figure 5.23 An enlarged section of a halftone image illustrates the technique of creating a transition from light to dark tones. Individual points increase in size to create dark areas. As the negative area reaches a midrange, the points become large and intersect (student work).

Figure 5.24 Points creating a tone image of an Indian head nickel. The increase and decrease in size and interval creates the illusion of dimension and depth (student work).

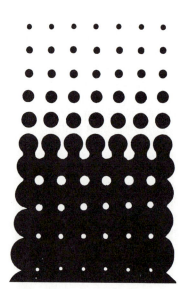

5.23

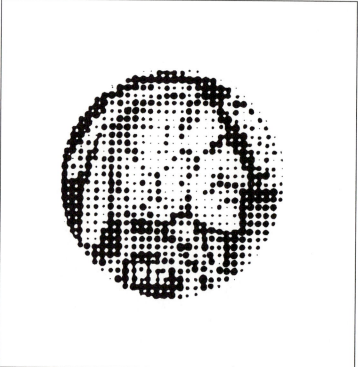

5.24

✍Practice Exercise 5.1: Using Point to Create Tone

Begin by selecting a photograph from a magazine. Lay tracing paper over the image and outline different light and dark tonal areas. Create a tone scale from one to five, one being lightest and five being darkest. Code each outlined area with a number to indicate its tonality.

5.25a

Before removing the tracing paper overlay, lightly construct an orthogonal grid in pencil, using a T-square and triangle for accuracy. The grid intervals will depend on the size and scale of the image and the amount of detail desired in the final illustration.

Create a tonal scale consisting of five different-sized points or dots to correspond to the different tonal areas on the photograph. For greater detail, a wider range of point sizes is needed. Use the larger points for dark tones and the smaller points for lighter tones. Prepare the final artwork on hot press illustration board. The grid should be lightly reconstruct-ed on illustration board using a nonrepro blue pencil. Dry transfer dots may be used to execute the design. See Figure 5.25 for exercise examples. (This exercise can also be done on a computer.)

✍Practice Exercise 5.2: Point Creating Tone and Dimension

The objective of this exercise is to visually represent a spherical object using point to create tone and the illusion of depth and dimension.

Begin by photographing a basic geometric volume, such as a sphere. Direct a single light source on the object to create highlights and dark areas. The photograph will help to determine the light and dark areas in the final illustration.

Within an orthogonal grid, represent the sphere first using one point size, then two, three, and so on. Divide the drawing into tonal areas by laying tracing paper over the photograph, coding these areas from light to dark, and devising a point tonality and size for each area, as in the previous exercise.

Sketch the final image onto hot press illustration board. Lightly draw a grid over the drawings, and apply dry transfer dots to create tone. Study the examples in Figures 5.26–5.30 to see how point size, interval, and quantity affect visual results.

Figure 5.25 (a-b) The point tone image becomes more legible when it is reduced in size or the viewing distance is increased (student work; exercise by Professor Peter Megert, Department of Industrial Design, The Ohio State University).

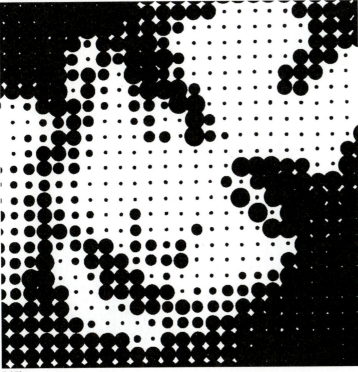

5.25b

Figure 5.26 (a-b) An illustration of the development of a sphere using point to create tone and dimension (illustrated by: a, Haidee Boyce; b, Richard Wancho).

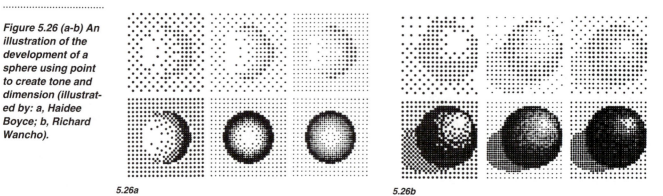

5.26a 5.26b

Figure 5.27 An image of the Liberty Bell created by grouping people and photographing them at a distance illustrates point and tone (designed for Davis-Delaney-Arrow, Inc., by George Tscherny, Inc., New York, NY).

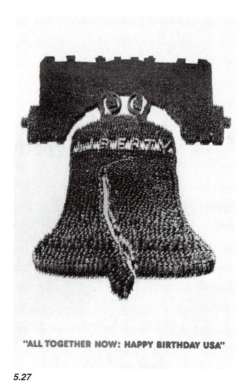

"ALL TOGETHER NOW: HAPPY BIRTHDAY USA"

5.27

Figure 5.28 Illustrations of a landscape using point to create tonal contrast (illustrated by Patricia Ingram).

Figure 5.29 An illustration of an apple using point to create tonal contrast (student work).

Figure 5.30 An illustration of a teacup using point to create tonal contrast (illustrated by Bruce Bruggemann).

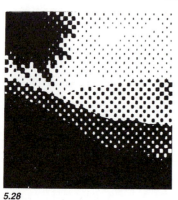

5.28 5.29 5.30

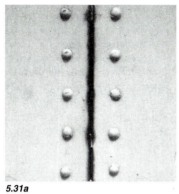

5.31a

5.31b

Point Implied in the Environment

Visual examples of the concept of point can be found within the man-made environment. Objects can be perceived as points relative to their distance from the viewer. The farther away the viewer is from a subject, the smaller the subject appears (see Figure 5.31).

Points also can create visual texture on surfaces of objects and structures. Many building materials have visual textures that may be perceived as points (see Figure 5.32).

5.32a

5.32b

Figure 5.31 Point is perceived relative to the viewing distance as illustrated: (a) rivets on a metal surface; and (b) holes in a wood surface (photos by Alan Jazak).

Figure 5.32 Square and circular shapes may be perceived as points or dots as illustrated: (a) bricks protruding from a wall; and (b) a drain in a concrete wall (photos by Alan Jazak).

INTRODUCTION TO LINE

5.33a

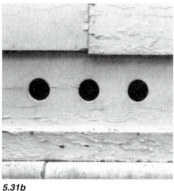

5.33b

As lines take on visible shape or form through drawing, they enable the artist, architect, or designer to visually communicate ideas, **concepts**, moods, expressions, and many types of information.

The visible line can be used for representation of shapes, forms, objects, and structures. Lines can bring meaning, symbolism, and expression to visual forms and their messages. Lines have a variety of applications. For example, they can be used to denote information such as that found in diagrams, maps, architectural and engineering plans, directional symbols, and measurement increments.

Line is an essential element used in creating and representing form. Lines can represent surface characteristics such as tone and texture. Lines can be bold, light, graceful, active, tight, or spontaneous (see Figure 5.33).

Figure 5.33 Examples of the use of line creating (a) facial expressions and (b-c) shape, movement, and spontaneity (illustrated by: a, Chris Hesch; b, Tim Karl; and c, Peggy Siu-Scott).

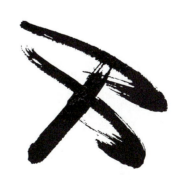

5.33c

Conceptually, a line is created as a point moves from one position to another in space. In theory, lines have no width or depth, only length. A line may be thought of as a set of points extending in two directions without end (see Figure 5.34). According to Euclidean geometry, a line segment is a set of points that lie between two distinct points. No matter how close together the end points of a line segment are, an infinite number of points still lie between them. Lines can represent the boundaries of a shape or plane or the edges of a volume. In this sense, lines can be seen as part of a larger whole figure or form (see Figure 5.35 and 5.36).

In visual studies, it is necessary to understand these **abstract concepts** and relate them to the form generation process: The mathematical idea of line must be rendered into a visible line in order to physically represent abstract concepts and their applications.

Figure 5.34 (a-c) Illustrations of the conceptual idea "line."

5.34a 5.34b 5.34c

Figure 5.35 Applications of line as a part of a larger whole are illustrated in: (a) contour line defining a shape boundary; (b) line creating pattern; and (c) line as a series of small visual elements.

Figure 5.36 (a-c) Illustrations showing that the concept of line can be found in familiar figures and forms, such as a sheet of paper.

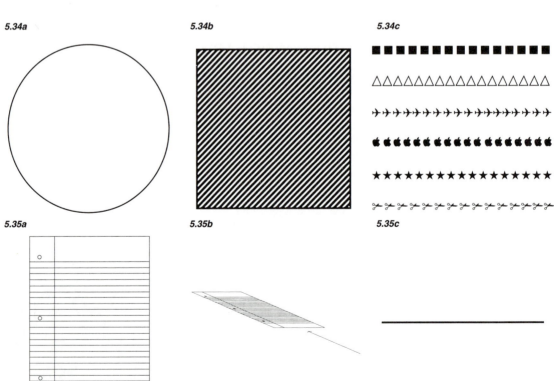

5.35a 5.35b 5.35c

5.36a 5.36b 5.36c

Characteristics of Visible Line

In addition to some degree of visible thickness, representational lines have shape and surface characteristics. Lines can be straight or curved, thick or thin, solid or broken (see Figure 5.37). Line surfaces may have tone, color, texture, or a combination of these characteristics. Line characteristics, such as the condition of being solid or broken, can be symbolic, signifying an action or a location of one object behind another (hidden lines).

5.37c

5.37a

5.37b

5.37d

Figure 5.37 (a-d) Examples of different types of lines and their characteristics—straight, curved, solid, broken, thick, and thin.

Figure 5.38 Stitching representing line and shape on pocket of blue jeans (illustrated by Amy Lieurance).

✍Practice Exercise 5.3: Line Compositions

Look for examples of lines with different characteristics in man-made products. Select one and develop a line drawing or composition representing that object. Using different media, create an interesting composition on hot press illustration board (see Figure 5.38 for an example of this exercise).

5.38

Figure 5.39 (a-d) Examples of line defining and dividing space.

Line Dividing Space

Line can be used as a visual referent to indicate and divide areas of space, both two- and three-dimensionally. The space areas indicated by line can be regular or irregular shapes (see Figure 5.39).

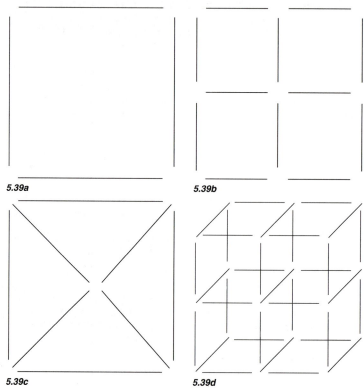

5.39a 5.39b

5.39c 5.39d

Line and Direction

Line can visually convey a sense of dynamic movement as illustrated in Figure 5.40. Line can also be visually interpreted as being static, active, or dynamic depending on position and orientation within a two- or three-dimensional format (see Figures 5.41 and 5.42).

5.40

Line Describing Shape

Line can describe the shape contour or edges of two-dimensional planes and three-dimensional volumes (see Figure 5.43). Lines can describe regular or irregular and abstract or representational figures as in Figure 5.44 on the following page.

Figure 5.40 Lines can convey a sense of direction and movement (illustrated by Bill Weber).

Figure 5.41 (a-c) Horizontal, vertical, and diagonal lines within a two-dimensional format indicate direction.

Figure 5.42 (a-c) Horizontal, vertical, and diagonal lines within a three-dimensional format indicate direction.

Figure 5.43 (a-c) Line describing a two-dimensional plane and three-dimensional forms.

5.41a

5.41b

5.41c

5.42a

5.42b

5.42c

5.43a

5.43b

5.43c

Figure 5.44 (a-c) Line describing representational figures and forms (illustrated by: a, Louise Utgard; b-c, Susan Hessler).

✐Practice Exercise 5.4: Using Line to Describe Shape

Collect pictures or photographs of figures and forms and practice representing the images in outline. Experiment with a variety of media and techniques on tracing paper. Analyze different line weights and types of line that describe and emphasize important parts of the composition. Each line drawing should communicate the original referent without internal detail such as tone, texture, or color.

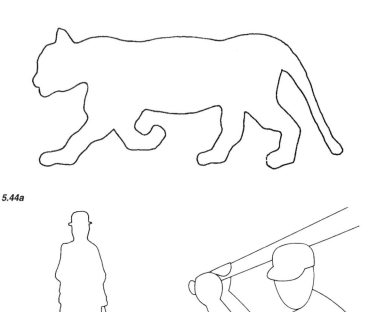

5.44a

5.44b 5.44c

✐Practice Exercise 5.5: Using Continuous Line or Contour Line to Describe Shape

The objective of this exercise is to use a single, continuous line or contour line to describe a complex figure or form.

Begin drawing on tracing paper with a soft lead pencil (B or HB). Sketch only the contour of your hands in a number of positions. Try not to overlap lines or lift the pencil lead off the paper.

Figure 5.45 Stamp design created by using contour line (German Postal Service).

Figure 5.46 Drawing of crossed hands using a single line (illustrated by Karen Wirtz).

5.45

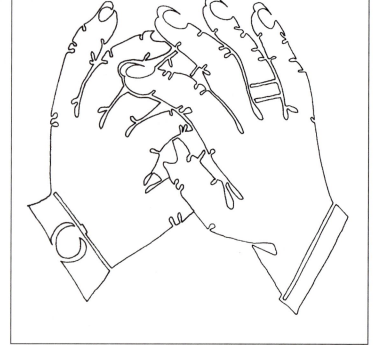

5.46

Select the best composition and redraw it on hot press illustration board. Use a no. 2 technical pen to ink the drawing (see Figure 5.46).

Line Representing Surface Characteristics

Lines can add to the recognition and interpretation of figures or forms and their shape characteristics. Internal shape contours, tone, and texture can be visually defined using line drawing techniques, which create visual interest and meaning (see Figure 5.47).

Line Forming Pattern

As visual awareness increases, there is a greater sense as to how line is used and implied in many man-made objects, materials, and building structures within the environment.

In visual studies, patterns can be organized from a set of lines into a configuration that can be repeated an infinite number of times (see Figures 5.48 and 5.49). Another technique, which allows line patterns to break away from stability or regularity, is the use of a progression or change in line weight to create the illusion of depth and movement (see Figure 5.50).

5.48

5.50

Figure 5.47 Line drawing of a pepper illustrating surface characteristics (illustrated by Fred Hunker).

Figure 5.48 Drawing of a zebra, using line to create pattern (illustrated by author).

Figure 5.49 Example of line and pattern shown in a lattice fence (photo by author).

Figure 5.50 Progression of lines of varying thicknesses and intervals create movement.

5.47

5.49

Figure 5.51 Lines can symbolize: (a) U.S. Postal Service code; (b) a street map; and (c) a UPC symbol (illustrated by Susan Hessler).

Figure 5.52 (a-b) Script and printing used to create linear compositions (illustrated by: a, unknown; b, Rocky Nutter).

Line as a Notation System

Lines can be used not only for drawing figures and forms, but also to notate technical facts, quantities, abbreviated expressions, or coded symbols (see Figure 5.51).

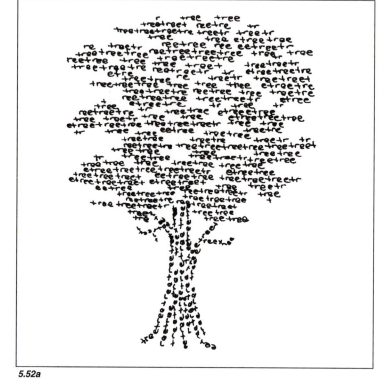

5.52a

5.51a

Lines Formed by Script and Typographic Letterforms

Typographic elements can be organized to imply a visual line and create images and compositions (see Figures 5.52 and 5.53).

5.51b

theselettersrepresentaline

5.52b

Figure 5.53 (a-b) Typographic examples incorporating line, enhancing the definition or meaning of a word (illustrated by: a, Laura Betts; b, A. Menges).

5.51c

SCRIBBLE

5.53a

UNRAVEL
nRAVEL
aVEL
L

5.53b

Line as a Visual Means of Expression

Lines can be used as a dynamic visual device to translate, evoke, and represent ideas and moods. Line has the graphic means and power to express happiness, sadness, spontaneity, gracefulness, boldness, or other feelings or concepts. Line also can be used to separate, outline, or infer movement or depth (see Figures 5.54 and 5.55).

5.54a

5.54b

5.55

Figure 5.54 Types of line illustrating expression and movement (illustrated by: a, Rocky Nutter; b, Peggy Siu-Scott).

Figure 5.55 Applied example of the use of expressive line in a poster for DAKO-TAH, Incorporated's tenth anniversary celebration (design by Richardson-Smith; design directors: Phil Gross and Tom Hamilton; DAKOTAH, Inc., Webster, South Dakota).

Line Creating the Illusion of Dimension, Depth, and Movement

Lines can be used effectively to create the illusion of dimension, depth, and movement in a two-dimensional format. Varying line weights, spacing, relative direction, and implied overlap are techniques used in line compositions to create a feeling of depth and distance (see Figure 5.56).

5.56a

5.56b

5.56c

5.56d

Figure 5.56 Line compositions using techniques such as: (a) series or progression of lines with varying thicknesses and intervals creating a cylindrical appearance; (b) lines with varying direction appear to create depth; (c) overlapping lines create depth and dimension; and (d) lines used to create a sense of movement or progression (illustrated by: a, Regina Vetter; b, Susan Hessler; c, Louise Utgard; d, Lee Willett).

Figure 5.57 Line composition created by varying the line thickness, illustrating minimum contrast (student work).

Line Creating Tone

Lines, like points or dots, can be used to produce tone. This visual effect can be achieved by varying the width of a set of lines and their proximity, or the space between them. A range of light and dark values or gradations can be achieved through this technique, creating the illusion of depth, surface modulation, and in some instances, a sense of movement (see Figures 5.57–5.59).

Figure 5.58 (a-b) Line used to create tone (illlustrated by: a, Chi-ming Kan; b, Harvo Miyauchi).

Figure 5.59 Poster for the Metropolitan Museum in New York, using line as a visual treatment of the letter M.

5.58a

5.57

5.58b

New York Metropolitan Museum

5.59

Line Implied in the Natural Environment

Line is often implied in natural forms, as a result of the form's structure or the influence of the environment (see Figure 5.60).

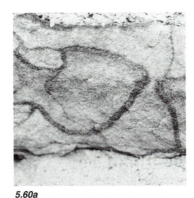

5.60a

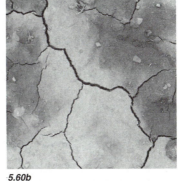

5.60b

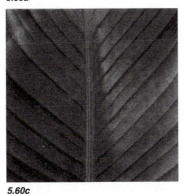

5.60c

5.60d

Figure 5.60 Line implied in the natural environment: (a) irregular lines on a stone surface indicating stages of sedimentary formation; (b) irregular lines produced as the earth dries and cracks; (c) structural ridges in a leaf; and (d) surface texture of a piece of wood (photos by Alan Jazak).

Line Implied in Manmade Products, Forms, and Environments

Line implied in man-made forms and environments are a result of dividing spaces, the inherent qualities of objects, use of materials, etc. (see Figure 5.61).

Figure 5.61 Line used or implied in man-made objects and environments: (a) bleachers in a stadium appear as a pattern of curvilinear lines; (b) lines dividing the lanes on a running track (photos by Alan Jazak).

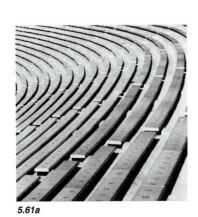

5.61a

5.61b

INTRODUCTION TO PLANE

A plane is defined in Euclidean geometry as formless, representing an infinite expanse of flat surface area that stretches two-dimensionally in all directions. For our purposes, a plane can be defined as a two-dimensional expression of length (or height) and width; it is the interior space defined by lines or sides, connecting three or more points (see Figure 5.62).

In art, architecture, and design, the plane is an important form-generating element because it is utilized in two-dimensional compositions as well as in the creation of three-dimensional configurations and for surface areas that make up volumetric forms (see Figure 5.63).

According to Klee's model of form generation, a plane is formed by a line in motion,

Figure 5.62 (a-c) As an idea, plane is formless; (b) plane illustrated conceptually as an infinite expanse of flat surface; (c) plane is an enclosed area of two-dimensional space having length and width.

5.62a

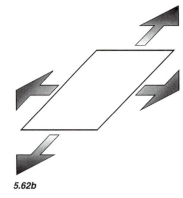

5.62b

5.62c

Figure 5.63 Planes are used to: (a) create two-dimensional configurations; (b) create three-dimensional configurations; and (c) enclose areas to create volume.

5.63a

5.63b

5.63c

Figure 5.64 (a-c) According to Klee's model of form generation, plane is formed by a line in motion.

5.64a

5.64b

5.64c

extending in a direction other than its inherent direction (see Figure 5.64).

Plane and Shape

Shape is the identifying characteristic of a plane and is determined by the configuration of the contour line or boundary of a plane. It is a means by which figures and forms are recognized. Many shapes have names based on their edge contour, **physical** attributes, and associations. Shapes may be categorized as geometric or abstract, representational or nonrepresentational, or symbolic.

Geometric shapes are distinguished as regular or irregular, and they can be two- or three-dimensional. Regular (two-dimensional) polygon shapes (see the discussion of polygons on page 110) or (three-dimensional) polyhedra shapes have equal interior angles and equal sides. Irregular polygon or polyhedra shapes can have equal or unequal angles, equal or unequal sides, or a combination of both (see Figures 5.65–5.68).

Shapes can be convex, having interior angles less than 180°, or concave, having interior angles greater than 180°. Shapes can also be congruent, meaning they have the same shape and size.

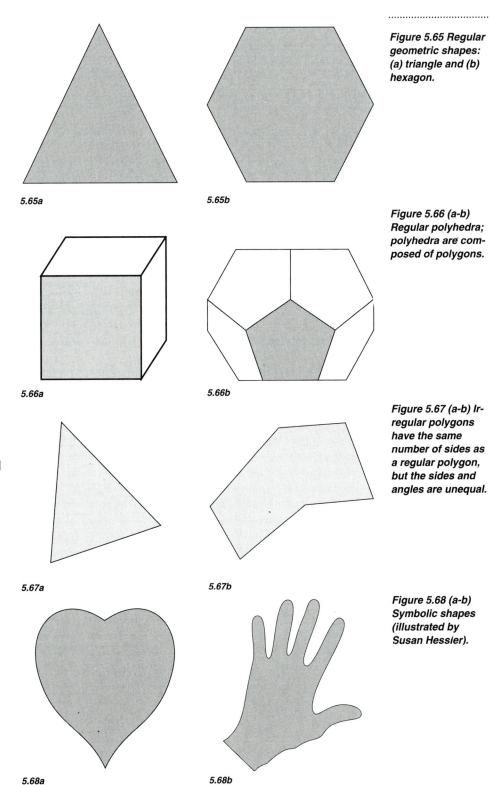

5.65a
5.65b

Figure 5.65 Regular geometric shapes: (a) triangle and (b) hexagon.

5.66a
5.66b

Figure 5.66 (a-b) Regular polyhedra; polyhedra are composed of polygons.

5.67a
5.67b

Figure 5.67 (a-b) Irregular polygons have the same number of sides as a regular polygon, but the sides and angles are unequal.

5.68a
5.68b

Figure 5.68 (a-b) Symbolic shapes (illustrated by Susan Hessler).

Figure 5.69 Compositional study of a Coca-Cola® bottle using point, line, and plane (illustrated by Mark Groves).

Plane and Tone

Like points and lines, planes can be used to create images with tone and texture. Planar compositions are created by delineating surface areas with different values or colors as separate planes.

✍Practice Exercise 5.6: Using Point, Line, and Plane to Create Tone

Select a simple, symmetrical object and photograph it using continuous tone (black-and-white) film. After a photographic print is made, lay tracing paper over the image and outline the different light and dark tones, dividing them into separate tonal areas.

Next, divide the image into three sections, each section to be rendered using points, lines, or planes. Transitions between sections, i.e., as points become lines and lines become planes, should be smooth.

Sketch a number of visual studies until there is a consistent transition between each visual element. See Figures 5.69 and 5.70 for an example of this exercise, and review the previous point and line tone exercises.

Figure 5.69 Compositional study of a Coca-Cola® bottle using point, line, and plane (illustrated by Mark Groves).

5.69

Figure 5.70 Sketch examples of a Coca-Cola® bottle using point, line, and plane in transition, creating tone (illustrated by Mark Groves).

5.70

*Figure 5.71 (a-b)
Concept sketches
of a tree using
point, line, and
plane (student
work).*

✍Practice Exercise 5.7: Designing a Holiday Shopping Bag

Begin the exercise by listing traditional symbols of the Christmas season. Draw quick sketches using points, lines, and planes to develop symbolic graphic images. For example, use triangular shapes to develop a symbol for an evergreen tree (see Figures 5.71 and 5.72).

The developed symbol sequence can be adapted and used as the graphic approach for designing a shopping bag. Take actual measurements of a shopping bag and use them as a guide for the format of the composition. Continue the exercise using point, line, and plane drawings.

*Figure 5.72 (a-f)
Concept sketches
of a tree using
point, line, plane,
and figure/ground
reversal techniques
(student work).*

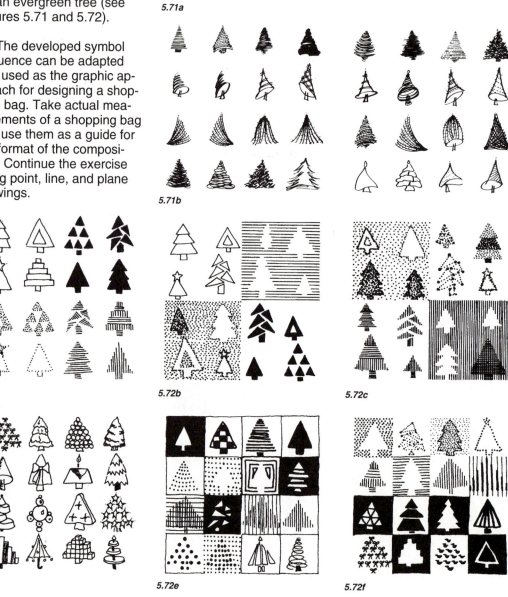

5.71a

5.71b

5.72a

5.72b

5.72c

5.72d

5.72e

5.72f

Once a composition is selected, prepare the final artwork and mock-ups. Determination of the appropriate media for creating and constructing the shopping bag will depend on the design (see Figures 5.73 and 5.74).

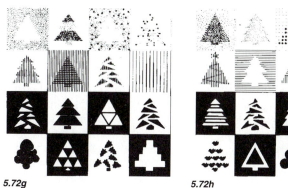

5.72g 5.72h

FIGURE 7.52 (g-h) (continued).

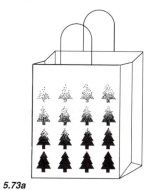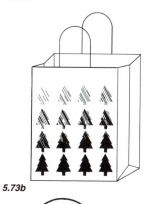

5.73a 5.73b

FIGURE 5.73 Compositional examples of the shopping bag design using (a) point to plane and (b) line to plane (student work).

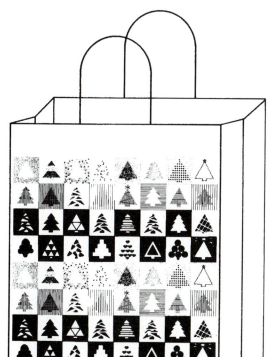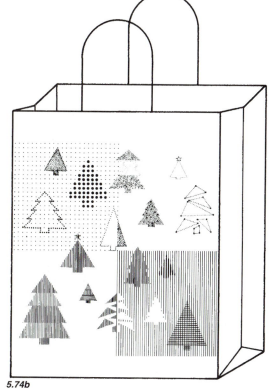

5.74a 5.74b

FIGURE 5.74 (a-b) Examples of an approach to organizing the tree images using an orthogonal grid, alternating figure and ground in the final design of a shopping bag (student work).

Polygons

A basic knowledge and understanding of polygons, or planar shapes, and their use can assist artists, architects, and designers in the creation of objects, structures, products, and art forms.

A polygon is defined as a flat. enclosed figure or plane.

It is called a polygon regardless of its shape configuration. In theory, a polygon is composed of points, line segments, and an interior plane. Each point represents a corner or vertex. Line segments are the sides of the polygon, connecting the vertices. The defining of the interior area of the polygon by points and line segments re-

sults in a specific shape (see Figure 5.75).

Polygons are identified according to regular, concave, or convex shape characteristics. These terms refer to the angle of each vertex (see Figures 5.76–5.78).

Figure 5.75 The combination of points and line segments results in a plane with a specific shape, called a polygon.

5.75

Figure 5.76 Regular polygons: (a) triangle; (b) square; and (c) hexagon.

5.76a 5.76b 5.76c

Figure 5.77 (a-c) Convex polygons.

5.77a 5.77b 5.77c

5.78a

5.78b

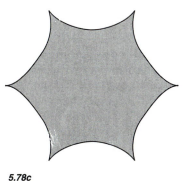

5.78c

Figure 5.78 (a-c) Concave polygons

The exterior and interior angle is important in defining the specific shape and name of a polygon (see Figure 5.79). Interior angles can be right, acute, or obtuse. A right angle equals 90°. An acute angle is greater than 0° and less than 90°. An obtuse angle is greater than 90° and less than 180°.

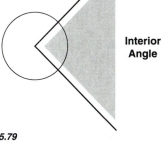

5.79

5.80

Figure 5.79 Location of the interior and exterior angles of a polygon.

Figure 5.80 Congruent triangles are identical in all respects.

Polygons can be congruent. Congruent describes two or more polygons that are identical, and if placed on top of each other, they appear as a single figure when viewed from the top or bottom (see Figure 5.80).

Naming Polygons

Polygon figures were studied by Greek mathematicians, who assigned names to the shapes; these are the names we use today. The name of each polygon begins with the number of sides and ends with the suffix *gon*. For example, a four-sided figure is a tetragon (*tetra*, meaning four, plus *gon*); a five-sided figure is a pentagon (*penta*, meaning five, plus *gon*); a six-sided figure is a hexagon (*hexa*, meaning six, plus *gon*); and so on. An exception to this rule, however, is the triangle (see Figure 5.81).

5.81a

5.81b

5.81c

Figure 5.81 (a-c) Regular polygons.

Figure 5.82 (a-b) Nonregular polygons.

Regular and Nonregular Polygons

Regular polygons have equal interior angles and equal line segments. Nonregular polygons (see Figure 5.82) can have unequal sides and equal interior angles, equal interior angles and unequal sides, or neither equal sides nor equal angles.

Figure 5.83 Square constructed within a circle.

Figure 5.84 (a-d) Regular 90° angles located around the circumference of a circle.

Constructing Regular Polygons

Illustrated in Figures 5.83–5.85 are mechanical constructions for several regular polygons. A consistent size is maintained by basing each shape construction on a circle and working around a constant center point and radius.

Figure 5.85 Geometric constructions of (a) triangle, (b) square, and (c) pentagon.

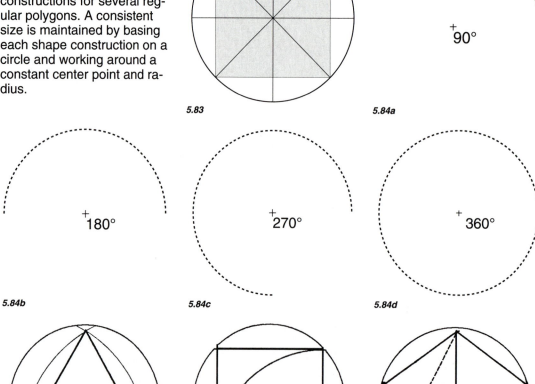

5.82a

5.82b

5.83

5.84a
+90°

5.84b
+180°

5.84c
+270°

5.84d
+360°

5.85a

5.85b

5.85c

Subdividing Regular Polygons

Regular polygons can be subdivided into smaller, equal units using various techniques. Subdividing techniques divide the figures into smaller, equal units (see Figures 5.86–5.88).

5.86a

5.86b

Figure 5.86 (a-b) Subdivision of a square into equal areas.

5.87a

5.87b

5.87c

Figure 5.87 (a-c) Subdivision of a square into smaller congruent squares.

5.88a

5.88b

5.88c

Figure 5.88 (a-c) Subdivision of a square into smaller similar squares by locating the center of each new, smaller square.

Regular polygons can be subdivided by constructing lines at equal angle intervals through the center of the shape. This results in a series of right triangles (see Figure 5.89).

5.89a

5.89b

Figure 5.89 Subdivision of (a) a triangle and (b) a square.

Polygons, Shapes, and Symmetry

Both regular and nonregular polygons and shapes can have symmetry. There are two types of symmetry: line (also called line axis, mirror, or bilateral symmetry) and rotational or point. A figure has line symmetry if, when folded along the center axis line, the two halves are congruent. A polygon can have more than one axis or line of symmetry (see Figures 5.90–5.92).

A polygon has rotational or point symmetry if it can be turned less than one single rotation about a point and match its original shape. Rotational symmetry also occurs when a figure repeats it-self an equal distance from an adjacent center point. The symmetry is defined in terms of "folds." One complete revolution about a center point equals 360°. If a figure repeats itself four times in a 360° rotation, it is said to be a "fourfold" rotation (see Figure 5.93).

Figure 5.90 (a-c) Shapes having line (mirror or bilateral) symmetry.

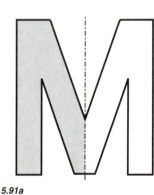

5.90a

5.90b

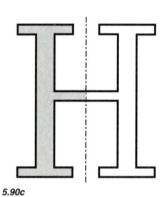

5.90c

Figure 5.91 (a-b) The letter M illustrates bilateral symmetry because when folded in half the two congruent halves coincide.

5.91a

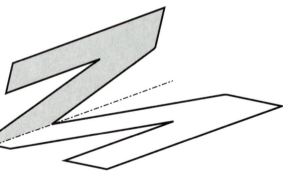

5.91b

Fligure 5.92 (a-c) Regular polygons have an inherent point symmetry that is recognizable when subdivided.

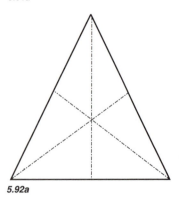

5.92a

5.92b

5.92c

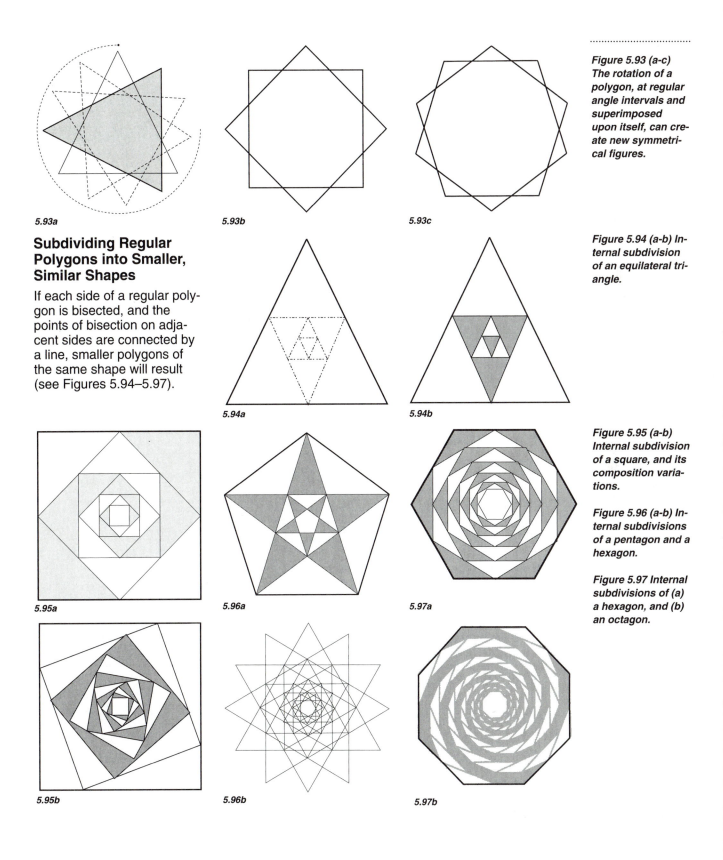

5.93a

5.93b

5.93c

Figure 5.93 (a-c) The rotation of a polygon, at regular angle intervals and superimposed upon itself, can create new symmetrical figures.

Subdividing Regular Polygons into Smaller, Similar Shapes

If each side of a regular polygon is bisected, and the points of bisection on adjacent sides are connected by a line, smaller polygons of the same shape will result (see Figures 5.94–5.97).

5.94a

5.94b

Figure 5.94 (a-b) Internal subdivision of an equilateral triangle.

5.95a

5.96a

5.97a

Figure 5.95 (a-b) Internal subdivision of a square, and its composition variations.

Figure 5.96 (a-b) Internal subdivisions of a pentagon and a hexagon.

Figure 5.97 Internal subdivisions of (a) a hexagon, and (b) an octagon.

5.95b

5.96b

5.97b

Figure 5.98 Regular tessellations are created by using either (a) squares, (b) triangles, or (c) hexagons.

Tessellations: Grouping Polygons

The word tessellation means to fit or join polygons into flat, continuous patterns, usually called mosaic tilings. Understanding tessellations helps in understanding how to combine regular and non-regular polygons to create different pattern configurations.

A tessellation is created by joining three or more sides of a set of polygons. The point where the sides meet is called a vertex; the sum of the angles around a vertex must equal 360°. Regular tessellations are created by combining regular, congruent polygons in a uniform manner. The only three regular, congruent polygons that can possibly be used in regular tessellations are the triangle, the square, and the hexagon, because only they have interior angles that divide evenly into 360° (see Figures 5.98 and 5.99).

A semiregular tessellation is uniform (i.e., all its vertices are congruent) and consists of more than one type of regular polygon (see Figure 5.100).

5.98a

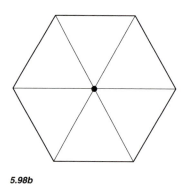

5.98b

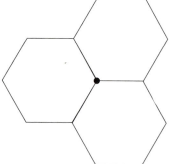

5.98c

Figure 5.99 (a-c) Examples of regular tessellation patterns.

5.99a

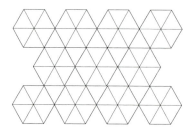

5.99b

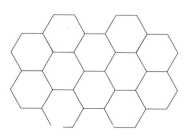

5.99c

Figure 5.100 (a-c) Semiregular tessellations created by using two or more polygons.

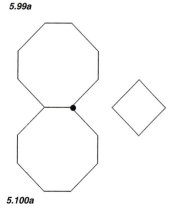

5.100a

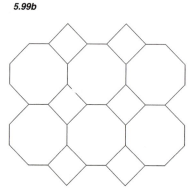

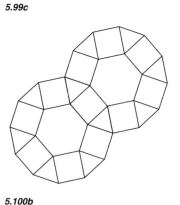

5.100b

5.100c

There are uniform or nonuniform, and periodic or nonperiodic tessellations. In a uniform tessellation all vertices are congruent and the organization of polygons around each vertex is the same. In a periodic tessellation a group of regular polygons can be moved to a new position within the tessellation, where it will fit together exactly with a similar group of regular polygons. Also, in a periodic tessellation, a group (configuration of polygons) may be moved in any direction, but may not be rotated. The polygon elements can be a combination of degrees—for example, three 60° and two 90° elements—as long as the sum is equal to 360°.

There are an infinite number of nonuniform periodic and nonuniform nonperiodic tessellations with regular polygons. However, nonuniform periodic and nonuniform nonperiodic tessellations are restricted to fourteen typical vertices with regular polygons because of the 360° requirement at each vertex (see Figure 5.101).

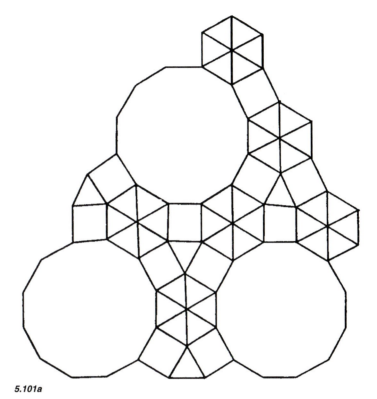

5.101a

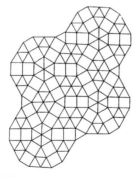

5.101b

✍Practice Exercise 5.8: Creating Tessellation Combinations

Six regular polygons are commonly used to create tessellation patterns (see Figure 5.102). Construct each shape using a T-square and triangles on lightweight posterboard or Bristol board. Cut out the shapes and explore

5.102

the various configurations they create in combination. On a separate sheet of paper, sketch the configurations and identify whether they are regular or semiregular, uniform or nonuniform, and periodic or nonperiodic tessellations.

Figure 5.100 (c) (continued).

Figure 5.101 (a) Nonuniform periodic and (b) nonuniform nonperiodic tessellations with regular polygons.

Figure 5.102 A series of six regular polygons that can be used to create tessellation patterns.

Figure 5.103 (a-c) Drawings of puzzle configurations and their combinations.

✍Practice Exercise 5.9: Designing a Wooden Puzzle Based on a Tessellation

Design a wooden puzzle based on a tessellation other than the three regular configurations previously discussed. The objective is to select two or more polygons that can be arranged into a variety of puzzle patterns. Through the visualizing process of quick sketching on tracing paper, explore ways of altering the shapes of two or more regular polygons (see Figure 5.103).

Select a number of ideas from the sketches, transfer them by drawing onto Bristol board, and then cut out the shapes. Manipulate the shapes, analyze the various combinations, and look for different patterns. Experiment with color in the sketches before finalizing the design, and then construct the puzzle pieces in wood (see Figure 5.104).

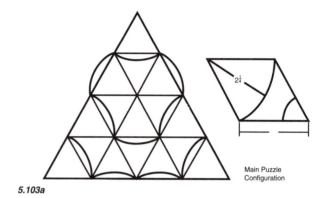

Main Puzzle
Configuration

5.103a

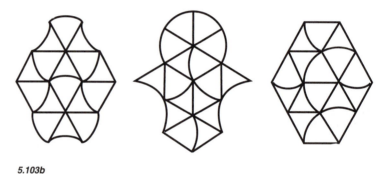

5.103b

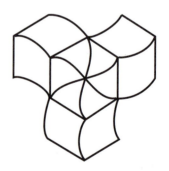

5.103c

Figure 5.104 (a-c) Puzzle solutions using several tessellation configurations to create combinations of different patterns (student work).

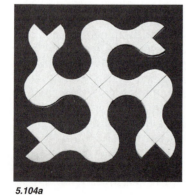

5.104a

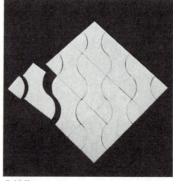

5.104b

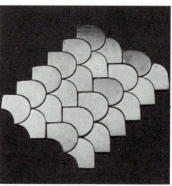

5.104c

✍Practice Exercise 5.10: Designing an Interlocking Puzzle Using Polygons

Review the different regular, semiregular, uniform, nonuniform, periodic, and nonperiodic tessellations developed from regular and nonregular polygons. Through quick sketching on tracing paper, explore a variety of ways to alter the contour of a shape so that when two or more are joined, they interlock as in Figures 5.105 and 5.106. Use a grid underlay to help visualize the pattern and to structure the sketching process. Develop a minimum of three potential pattern combinations and assess how they might be translated into a wooden puzzle.

Evaluate the solution according to the design and to how well the pattern pieces fit into a continuous interlocking **system** that resists displacement. Evaluation of the production process should also be emphasized.

5.106a

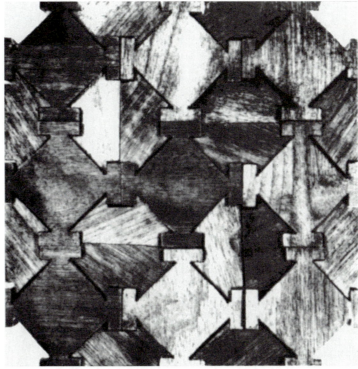

5.106b

Figure 5.105 Interlocking pieces create a puzzle configuration (student work).

Figure 5.106 (a) Plan drawing of the puzzle solution, and (b) the constructed wood model (student work).

5.105

✍**Practice Exercise 5.11: Creating Tessellations Using Transitional Tiling Patterns**

Arrange regular polygons into a four- or five-step transitional pattern (see Figure 5.107). Develop the transition from one polygon to another using a basic grid underlay consisting of regular poly-gons. Refer to Chapter 12, Symmetry and Dynamic Symmetry, for information regarding shape **transformation**.

5.108a

Figure 5.107 (a-b) Transitional tiling patterns (student work).

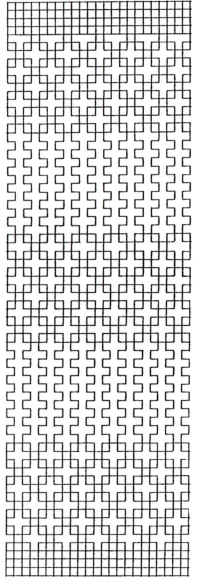

5.107a 5.107b

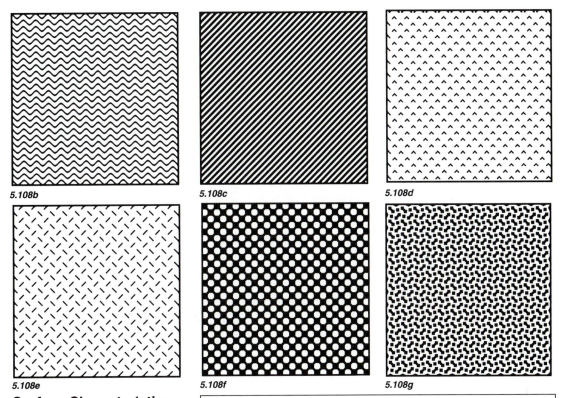

5.108b 5.108c 5.108d

Figure 5.108 (a-g) Examples of square planes with different surface treatments.

5.108e 5.108f 5.108g

Surface Characteristics of Planes

The surface area of a plane can be treated in different ways. It can be filled in with tones ranging from white to black, or with different patterns, textures, and colors (see Figure 5.108). Planes and shapes may be opaque or transparent and can overlap to create new shape and texture areas as in Figure 5.109. Overlapping patterns are called moirés.

5.109

Figure 5.109 Composition of overlapping, transparent planes with pattern.

Figure 5.110 (a-c)
Series of develop-
mental sketches of
a button using
achromatic planes
(student work).

Dividing Images and Objects into Achromatic Planes

Artists, architects, and designers often use the visual technique of dividing an image into flat value planes instead of using continuous tone photographs or illustrations. This technique produces a more stylized, abstract solution, but maintains an illusion of depth by the gradation of values applied to achromatic (colorless or gray) and chromatic (having color or hue) planes (see Figure 5.110).

5.110a

5.110b

5.110c

Figure 5.110 (a-c)
Series of developmental sketches of a button using achromatic planes (student work).

✍Practice Exercise 5.12: Dividing an Image into Value Planes

Select a photograph of a famous person, as in Figure 5.111. Sketching over the photograph using tracing paper overlays, convert the continuous tone image into a series of gray planes. Code

Figure 5.111 (a-c)
Image of Albert Einstein using points, lines, and planes to create value (exercise by Professor Peter Megert, Department of Industrial Design, The Ohio State University; illustrated by Mike Garten).

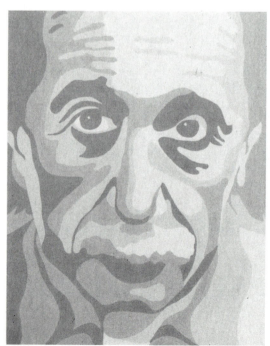

5.111a

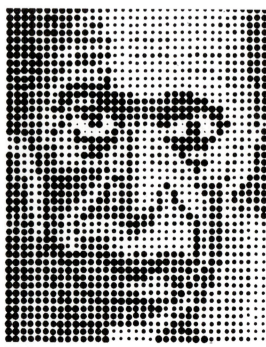

5.111b

each area according to a specific gray tone based on a five-step scale. Once the image has been divided into simple, tonal planes, compare the new image to the original photograph. Make sure the tonal areas coincide to create a recognizable, realistic representation. Transfer the sketch onto hot press illustration board. Fill each area with the appropriate gray using self-adhesive color film, Pantone® paper, Color-Match® paper, or gouache. For other applied examples, see Figures 5.112 and 5.113. (This exercise can also be created on a computer.)

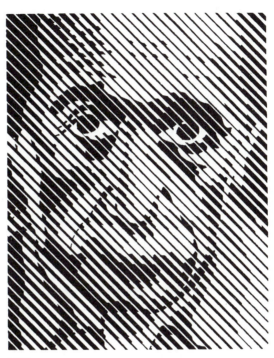

5.111c

*Figure 5.111 (c)
(continued).*

5.112

5.113

*Figure 5.112 A
stamp design for
the German Postal
Service to com-
memorate the 1972
Olympic games
using plane, value,
and color.*

*Figure 5.113 Poster
for the Mobil Corpo-
ration using plane,
value, and color (il-
lustration: Ivan
Chermayeff; de-
sign: Chermayeff &
Geismar, Inc.).*

Transforming Shapes

The ability to transform shapes can be an interesting, creative, and useful skill. The approach to transforming figures and forms varies; however, there often are similarities among different transformation solutions. Shapes may be transformed through an association of one shape to another, or through addi-tive and subtractive process-es. The transforming process begins with the selection of various products, art forms, or architectural structures that lend themselves to transformation changes with-in their design.

Identify the transitional process (additive or subtrac-tive) needed to alter or trans-form the selected shapes or objects. To further under-stand the visualizing pro-cess, observe and analyze the structural and physical attributes of the forms. List and sketch other shapes that may be associated with the object through form similari-ties or meaning (see Figure 5.114).

Figure 5.114 Shape transformed through the associ-ation of an artist's paintbrush to other figures and forms (illustrated by Eu-gene McHugh).

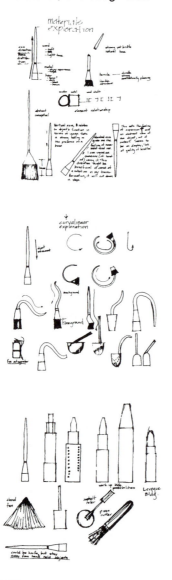

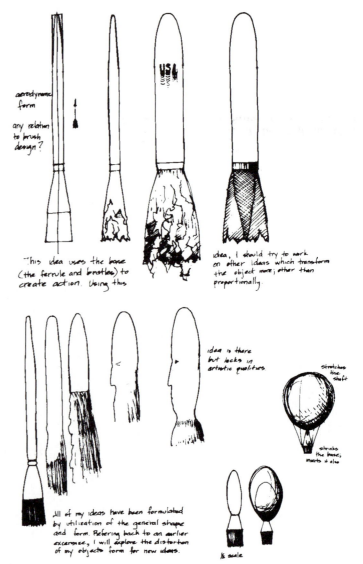

Chapter 5 **125**

Shape Generation Using the Transformation Process

The generation of figures and forms using points and lines can be a starting point for visually exploring the transformation process. A figure can begin with a single point or line; a recognizable form begins to emerge through the addition of more points or lines. The process illustrated in Figure 5.115 is similar to animation in concept; the resulting image communicates the form generation process.

✍Practice Exercise 5.13: Creating Shapes Using the Transformation Process

Explore the transformation of a point or line into a shape or figure through sketching. The number of steps in the transformation will vary according to the complexity of the idea or figure. Select one concept and prepare final artwork on hot press illustration board using pen and ink (see Figure 5.116).

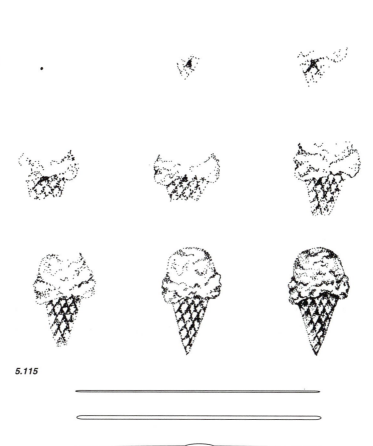

5.115

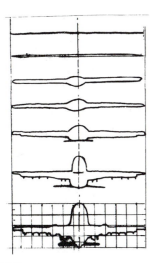

5.116a

5.116b

Figure 5.115 Shape generation beginning with a single point and adding more points to create the image of an ice cream cone (illustrated by Cathleen Waliga).

Figure 5.116 (a-b) A line increasing in width and shape detail until it is transformed into a jet airplane (illustrated by: a, Ed Maceyko; b, final transformation solution by the authors using Adobe® Illustrator 88 and an Apple® Macintosh SE).

Figure 5.117 (a-b) A nine-step transformation from a line to a Mickey Mouse balloon shape (illustrated by Edward Maceyko).

Figure 5.118 A complex shape transformed into a square in a five-step progression (student work; exercise by Professor Hans Reudi Buob).

Figure 5.119 Series of complex shape transformations (student work; exercise by Professor Hans Reudi Buob).

Figure 5.120 A shape transformation starting from a square and ending in a circle (illustrated by John Stralka).

✍Practice Exercise 5.14: Shape Transformation

Begin the shape transformation process with a single point or line. Add more points or increase the line thickness to achieve the desired shape or form. This exercise can also begin with one plane or shape, and through the systematic addition or subtraction of sections, new abstract or representational shapes can be created. The illustrations in Figure 5.117 are an example of shape transformations, from quick sketch ideas to more articulated, detailed drawings.

A shape transformation exercise (examples shown in Figures 5.118–5.120) called "Contrast and Metamorphosis" (from Schule für Gestaltung, St. Gallen, Switzerland) shows how contrasting elements can be created through shape transformation. "Progression establishes contrasts. Through stages of progression, contrasting forms are combined. **Simple** and **complex** elements are united" (Hans Reudi Buob, professor of graphic design, Schule für Gestaltung, St. Gallen, Switzerland, private conversation).

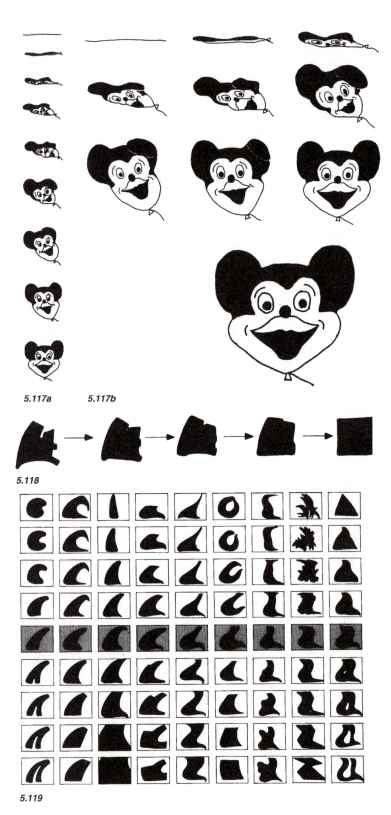

5.117a *5.117b*

5.118

5.119

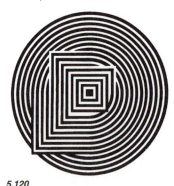

5.120

✍Practice Exercise 5.15: Plane to Shape Transformation

Select a symmetrical figure. It can be representational or abstract. Draw the figure on tracing paper. Place the paper on an orthogonal grid to help in the visualizing process (see Figure 5.121). Explore ways that the figure can be divided into smaller units. From this subdividing study, develop a shape transformation showing the subtractive steps from the original shape to the final shape. To illustrate the shape transformation, prepare final artwork on hot press illustration board, using self-adhesive film, ink, or gouache (see Figure 5.122).

The shape transformation can begin with regular polygons or representational shapes, as illustrated in Figures 5.123–5.127. (This exercise can also be created on a computer.)

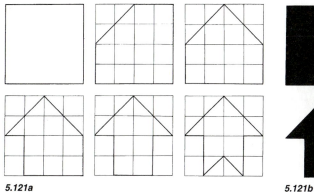

5.121a

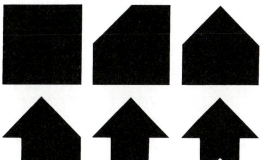

5.121b

Figure 5.121 (a-b) Shape transformation sequence using an orthogonal grid (student work).

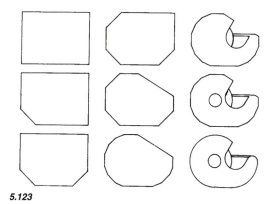

5.122

Figure 5.122 Shape transformation from an insect to a pair of scissors (illustrated by Mike Del Grosso).

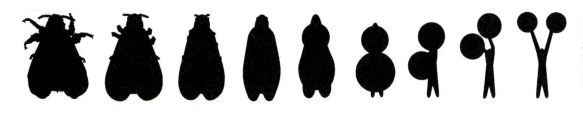

5.123

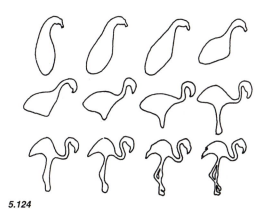

5.124

Figure 5.123 Shape transformation from a rectangular plane to a tape dispenser (student work).

Figure 5.124 Shape transformation from a summer squash to a flamingo (student work).

Figure 5.125 Shape transformation from a teapot to an elephant (Susan Hessler).

Figure 5.126 Shape transformation from an oval to a pig (illustrated by Jim Vargo).

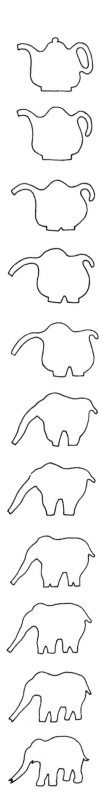

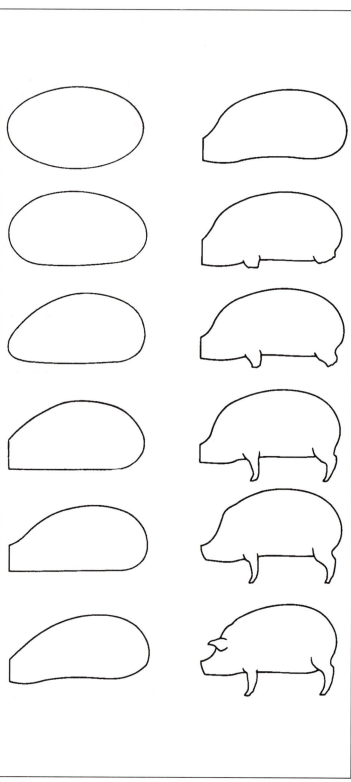

5.125

5.126

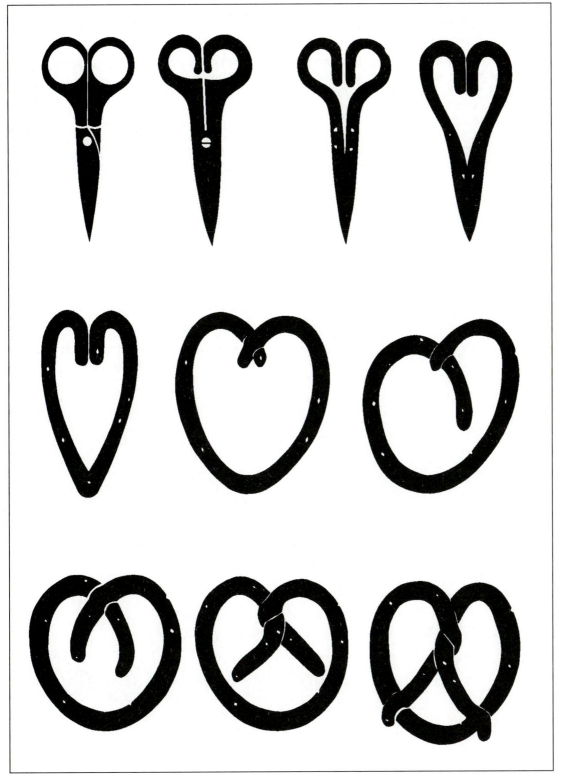

Figure 5.127 Shape transformation from scissors to a pretzel (illustrated by Ellen Richey).

5.127

Figure 5.128 A series of planes illustrating different configurations and orientations in space.

Two-Dimensional Planes Transformed into Different Configurations

Planes are usually considered quadrilateral in shape and are commonly organized perpendicular to the ground plane and parallel to the picture plane. However, two-dimensional planes can be transformed by bending, fold- ing, and stretching, and oriented to appear three-dimensional (see Figure 5.128).

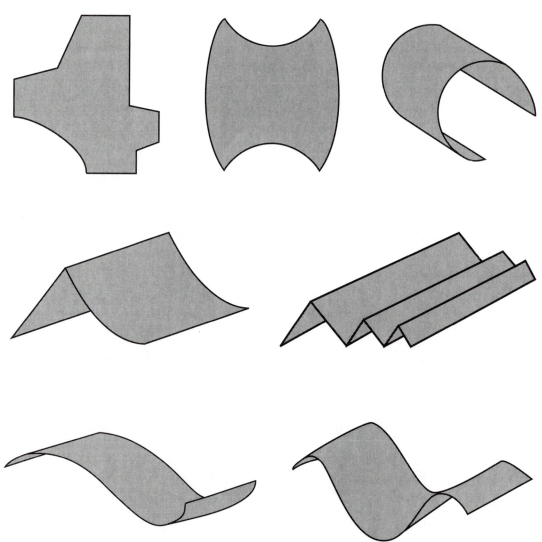

5.128

✍Practice Exercise 5.16: Identifying Planar Forms in the Environment

Identify and photograph examples of planar forms (architectural, sculptural, etc.) within the environment. Analyze the different structural and surface configurations in relation to their applied function (see Figure 5.129).

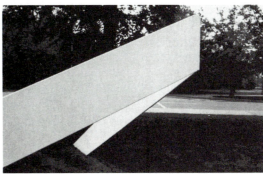

5.129

Figure 5.129 Sculptural form illustrating use of plane (photo by Alan Jazak).

✍Practice Exercise 5.17: Development of Free-Standing Planar Configurations

The objective of this exercise is to develop an understanding of planar spatial relationships with an emphasis on composition, proportion, scale, and visual balance. Through sketching and model building, develop a set of planar shapes that complement each other in size and proportion. Solutions to this problem are illustrated in Figure 5.130.

Develop three different rectilinear or curvilinear planes. Select and organize the planes into a balanced composition. Construct a final model of the composition in wood or metal painted flat white and mount on a black base. Each plane should be joined to another using a simple slot, dado, or rabbet joint.

5.130a

5.130b

5.130c

5.130d

FIGURE 5.130 Planar model solutions: (a-b) curvilinear; (c-d) rectilinear (student work; practice exercise by Craig M. Vogel, Institute of Design, Illinois Institute of Technology).

Figure 5.131 (a-h) Space defined by planes which may be perceived architecturally as ceilings, floors, and walls.

Planes Defining Architectural Structures and Their Interior Subdivisions

In architecture and interior space design, planes are used to define the boundaries of three-dimensional space, forming the ceilings, walls, and floors of buildings, and rooms within buildings (see Figure 5.31).

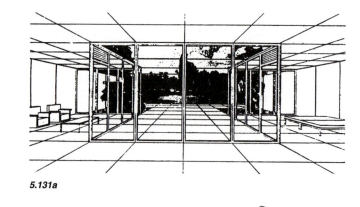

5.131a

5.131b

5.131c

5.131d

5.131e

5.131f

5.131g

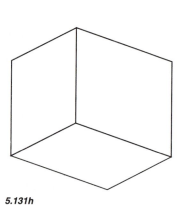

5.131h

Planar Configurations for Structural Support

Planar elements such as panels can be arranged to structurally support each other (see Figure 5.132). A panel by itself has no stability. Fixing a panel into a ground plane provides minimal stability; however, further stability is achieved by adding and joining additional planar panels. Both panels then support each other. It is not necessary that the panels are positioned perpendicular to each other, as long as they form an angle and meet along a common edge. If the panels do not come in contact with each other, another panel is required to provide structural stability.

Figure 5.132 (a-g) Planar panel configurations illustrating structural support.

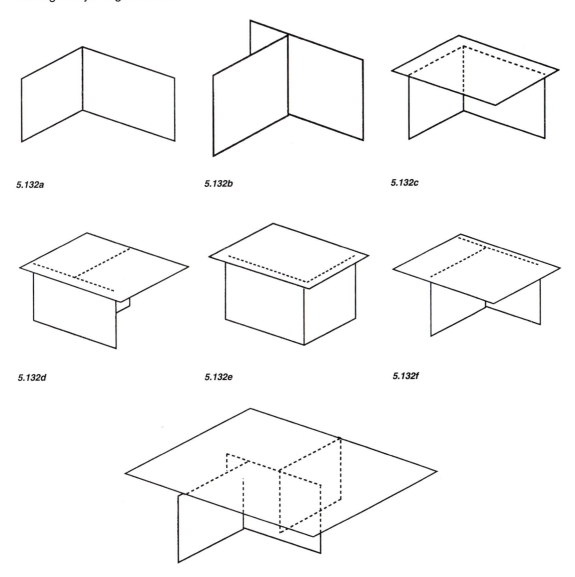

5.132a

5.132b

5.132c

5.132d

5.132e

5.132f

5.132g

Planes and the Illusion of Depth

In visual composition it is necessary to understand how to position or align planes in two-dimensional space in order to communicate the illusion of space and depth.

Various techniques and principles can be used to create the illusion of depth within a two-dimensional drawing, painting, or composition. By using the principles of perspective, the illusion of three-dimensional space and depth can be created on the two-dimensional picture plane (refer to Chapter 9, Space, Depth, and Distance, and Chapter 4, Formal Drawing Systems). Other visual techniques are size differentiation, overlap, tone or value differences between elements, color, line weight, and linear progression (see Figure 5.133).

Figure 5.133 (a-f) Organizing overlapping planes to create the illusion of three-dimensional space on a two-dimensional format.

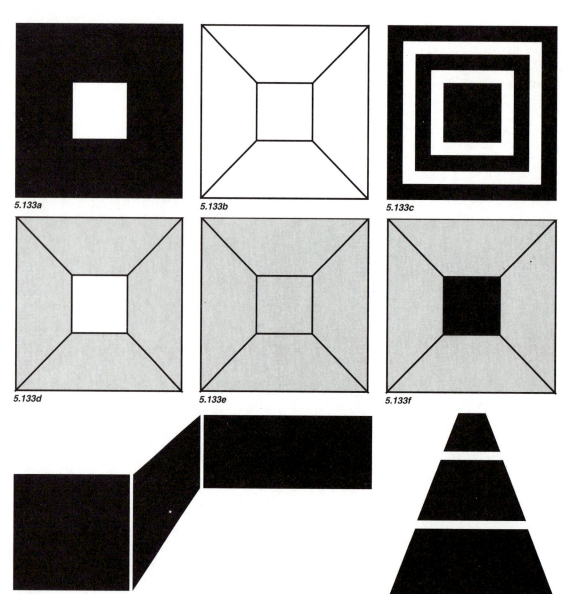

5.133a

5.133b

5.133c

5.133d

5.133e

5.133f

Figure 5.134 (a-c) Planes organized on a two-dimensional picture plane to create the appearance of three-dimensional space (student work).

5.134a

5.134b

✍Practice Exercise 5.18: Planes and the Illusion of Depth

Explore different methods of organizing planes on a two-dimensional format to create the illusion of depth and three-dimensional space (see Figure 5.134). Remember that the observer's view distorts the actual shape of the plane in perspective. Only the front elevation parallel to the picture plane is a true representation of the shape or form. Note value can affect the perception of three-dimensional space.

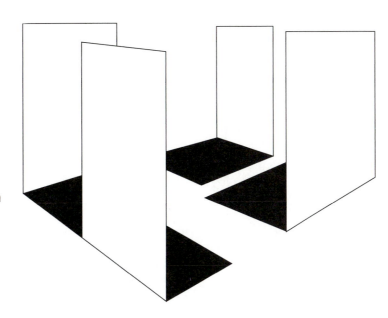

5.134c

Figure 5.134 (c) (continued).

Planes, Depth, and Movement

Planes positioned parallel to the picture plane can be organized to create an illusion of depth and movement by using overlap, size change, and varying line weights (see Figures 5.135 and 5.136).

5.135

5.136

Figure 5.135 Size and line width variation creates the illusion of depth and movement.

Figure 5.136 Planar composition illustrating the illusion of depth and movement (illustrated by Cynthia Busic-Snyder).

REFERENCES AND RESOURCES

Baker, Rachel. *All About Art: An Introduction to the Basics of Art*. New Haven, CT: Fine Arts Publications, Inc., 1981.

Bevlin, Marjorie Elliot. *Design Through Discovery: The Elements and Principles*. New York: Holt, Rinehart & Winston, 1985.

Ching, Francis D. K. *Architecture: Form, Space and Order*. New York: Van Nostrand Reinhold, 1979.

Collier, Graham. *Form, Space & Vision*. 2d ed. Englewood Cliffs, NJ: Prentice-Hall, 1967.

Dantzic, Cynthia Maris. *Design Dimensions: An Introduction to the Visual Surface*. Englewood Cliffs, NJ: Prentice-Hall, 1990.

Dondis, Donis A. *A Primer of Visual Literacy*. Cambridge, MA: MIT Press, 1973.

Garrett, Lillian. *Visual Design: A Problem-Solving Approach*. New York: Robert E. Krieger, 1967.

Grillo, Paul Jacques. *What is Design?* Chicago: Paul Theobald & Co., 1960.

Hofman, Armin. *Graphic Design Manual: Principles and Practice*. New York: Van Nostrand Reinhold, 1965.

Itten, Johannes. *Design & Form*. New York: Van Nostrand Reinhold, 1975.

Kepes, György. *Language of Vision*. Chicago: Paul Theobald & Co., 1944.

————. *The New Landscape*. Chicago: Paul Theobald & Co., 1961.

Kranz, Kurt. *Early Form Sequences, 1927–1932*. Cambridge, MA: MIT Press, 1975.

Lauer, David A. *Design Basics*. New York: Holt, Rinehart & Winston, 1979.

Maier, Manfred. *Basic Principles of Design*. Vol. 4. New York: Van Nostrand Reinhold, 1977.

Malevich, Kasmir. *The Non-Objective World*. Chicago: Paul Theobald & Co., 1959.

Martinez, Benjamin, and Jacqueline Block. *Visual Forces: An Introduction to Design*. Englewood Cliffs, NJ: Prentice-Hall, 1988.

McKim, Robert H. *Experiences in Visual Thinking*. 2d ed. Monterey, CA: Brooks/Cole, 1980.

Moholy-Nagy, L. *Vision in Motion*. Chicago: Paul Theobald & Co., 1947.

Ocvirk, Otto G., Robert E. Stinson, Philip R. Wigg, and Robert O. Bone. *Art Fundamentals: Theory and Practice*. 6th ed. Dubuque, IA: William C. Brown Publishers, 1990.

Pearce, Peter, and Susan Pearce. *Polyhedra Primer*. New York: Van Nostrand Reinhold, 1978.

Preble, Duane and Sarah. *Artforms*. 3d ed. New York: Harper & Row, 1985.

Scott, Robert Gillam. *Design Fundamentals*. New York: McGraw-Hill, 1951.

Taylor, John F. A. *Design and Expression in the Visual Arts*. New York: Dover, 1964.

Thiel, Philip. *Visual Awareness and Design*. Seattle: University of Washington Press, 1983.

Wong, Wucius. *Principles of Two Dimensional Design*. New York: Van Nostrand Reinhold, 1972.

Young, Frank M. *Visual Studies: A Foundation for Artists and Designers*. Englewood Cliffs, NJ: Prentice-Hall, 1985.

Zettl, Herbert. *Sight, Sound, Motion*. Belmont, CA: Wadsworth, 1973.

Chapter 6

Volume and Structure

CHAPTER OUTLINE

- Chapter Vocabulary
- Introduction to Volume and Structure
- Polyhedra
- Linear Configurations and Their Structural Strength
- Volumetric Transformations Using Planes
- From Plane to Volume
- Practice Exercises
- References and Resources

CHAPTER OBJECTIVES

On completion of this chapter, readers should be able to:

- Distinguish between conceptual and representational definitions of volume.

- Understand, visually analyze, interpret, and define volume as it is used in art, architecture, and design.

- Understand how professional artists, architects, and designers create volumetric forms and utilize structural concepts in their work.

- Interpret structural concepts and techniques and apply them in creating volumetric art forms, objects, and structures.

- Understand and construct polyhedra, prisms, and antiprisms.

- Relate prisms, antiprisms, and polyhedra to the design of packaging and other structural configurations.

- Create a three-dimensional transformation utilizing paperboard, styrene, or wood.

- List and describe the differences between regular and semiregular polyhedra.

Figure 6.1 The gray area (Form) denotes the subject matter described in this chapter.

Visual Elements of Form

Perception Theory

Form Generators

Visual and Physical Attributes of Form

Space, Depth, and Distance

Point
conceptual element
No Dimension

Value/Tone
Color

2- and 3-Dimensional Form Perception

Light/Brightness
 contrast threshold
Illusions
Monocular Cues
 size
 partial overlap
 value
 color
 aerial perspective
 detail perspective
 linear perspective*
 texture gradient
 shadow
 blurring of detail
 transparency
Binocular Cues
 muscular cues
 parallax cues
Position
Orientation
Motion
Time

Line

Value/Tone
Color
Texture
Dimension
 length
Direction

Plane

Value/Tone
Color
Texture
Dimension
 length
 width
Shape
 direction
 visual stability
Proportion

Form

Form is the primary identifying characteristic of volume

Volume is the product of:
points (vertices)
lines (edges)
planes (surfaces)

Value/Tone
Color
Texture
Dimension
 length
 width
 depth
Shape
 direction
 visual stability
Proportion

***Drawing/Projection Systems**
Orthographic
Paraline
 axonometric
 oblique
Perspective

6.1

CHAPTER VOCABULARY

Active force Weight.

Bending A force that involves both tension and compression.

Center of gravity A downward vertical force applied to a point on a structure. The center of gravity can be evenly distributed throughout the volume or concentrated in one area.

Compression The stress produced in a member by forces acting upon it.

Concurrent forces Forces that occur when force lines of action meet at a point.

Deformation A structural change to a form by the action of forces or stresses.

Equilibrium The state that occurs when a number of forces act upon a structure and the structure does not move, or if already moving, does not change its state of motion.

Force Pressure exerted by one body upon another. Force is measured in units of weight relative to a specific surface area (i.e., pounds/area or tons/area).

Force of gravity The natural attraction or pull of the earth.

Form A total three-dimensional whole such as an object, geometric solid, product, sculpture, or architectural structure.

Kinetic Describes motion caused by force in a volume or structure.

Mass A solid body or a grouping of visual elements that compose a solid, unified form.

Nonconcurrent forces Lines of force that do not meet at a single point.

Passive force The resistance or reaction exerted by structural members in an upward direction.

Shear A type of stress in which two contacting parts of a body slide upon each other in opposite directions parallel to their plane of contact.

Solid A definite form or volumetric shape composed of some type of material or substance.

Space Boundless or unlimited extensions in every direction.

Static Describes the condition that occurs when forces are prevented from causing motion by equal or opposite resisting forces.

Stress Any force acting on a volume. There are four types of stress: tension, compression, shear, and torsion.

Tension Type of stress produced in a member being stretched.

Torsion The stress exerted when the application of force results in a twisting action.

Volume A three-dimensional form that has length, width, and depth. Volumetric forms consist of points (vertices), lines (edges), and planes (surfaces).

Volumetric Of or relating to measurement of three-dimensional forms.

INTRODUCTION TO VOLUME AND STRUCTURE

Chapter 5 emphasized how the visual elements point, line, and plane can generate **form** and help create tone and texture. The objective of this chapter is to provide readers with an understanding of the elements of **volumetric** form—its generation, makeup, and terminology— and the various ways to explore and create three-dimensional forms.

Volume, in conceptual terms, is described as a plane in motion in a direction other than its inherent direction. It then becomes a three-dimensional form derived from and enclosed by planes, with a position in three-dimensional space.

The form generation model preceding Chapter 1 and excerpted in Figure 6.1 shows how volume is thought of conceptually as the product of points represented by vertices, lines represented by edges, and planes represented by surfaces. Volume or three-dimensionality is created by adding the dimension of depth to the length and width of objects or forms.

Artists, architects, and designers use terms such as shape, volume, and **mass** to designate the three-dimensional qualities of objects in space. In a broad structural definition, form is the sum of these terms in conjunction with media, techniques, and visual organization laws

which turn the three-dimensional compositional elements into man-made objects. The format in terms of three dimensions should be thought of as the outer boundary of any number of views of an object or structure that consists of spatial planes and their interrelationships (see Figures 6.2–6.4).

Representing Volume

A volume may be **solid** or enclosed by planar members, and can have negative space (subtracted area) within its boundaries. It may also be an open linear structure in which the outer contour and the internal subdivision are suggested by extending points and lines.

Figure 6.2 (a-c) Mathematically, volume is the concept of a plane in motion.

6.2a

6.2b

6.2c

Figure 6.3 Volume can be represented in a number of ways: (a) a linear model; (b) a planar model; or (c) a solid model.

6.3a

6.3b

6.3c

6.4a 6.4b 6.4c

Figure 6.4 Examples of basic geometric solids or volumetric forms: (a) tetrahedron; (b) cube; and (c) sphere.

Volume in the Environment

As illustrated in the applied architectural, structural, and sculptural examples in Figures 6.5–6.7, the concept of volume can be expressed as solid structures, planar structures, or open linear structures.

Figure 6.5 Front elevation of a building representing a surface plane.

6.5

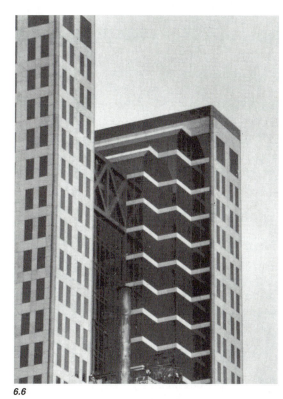

6.6

Figure 6.6 Architectural example of volume.

Figure 6.7 (a-b) Three-dimensional sculptures and sign structures representing volume.

6.7a

6.7b

Volumetric Forms

A volumetric form has three dimensions: length, width, and depth, as illustrated in Figure 6.8.

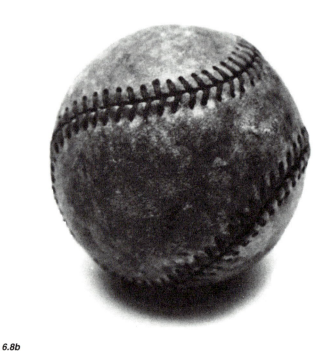

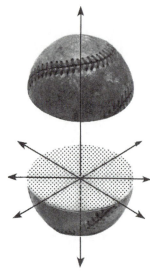

6.8a

6.8b

Representing Volume on a Two-Dimensional Format

The illusion of volume on a two-dimensional picture plane can be created using drawing projection systems, texture, tone, value, or color (see Figures 6.9 and 6.10). The drawing systems (orthographic, axonometric, oblique, and perspective) are covered in depth in Chapter 4.

Figure 6.9 (a-b) Paraline drawings of volumetric forms create the illusion of volume (student work).

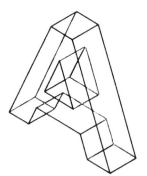

6.9a

6.9b

Volume and Shape

As with planes, shape is a primary identifying characteristic of volume. There is an association between volumetric forms and familiar objects, products, and structures within the environment.

Figure 6.10 Tone and texture drawing techniques used to create the illusion of volume (illustrated by Tim Hershner).

6.10

✍Practice Exercise 6.1: Volume and Visual Associations

Select two or three regular or nonregular volumetric forms and list articles or objects that have the same or similar shape. From memory, draw a series of sketches that represent the selected objects. For an example, see Figure 6.11.

In the final step of the exercise, collect and draw the actual objects, then compare the two sets of drawings to the object. If the visual representation is inadequate, redraw it until it is correct. Once the drawings have been rendered, organize them on hot press illustration board.

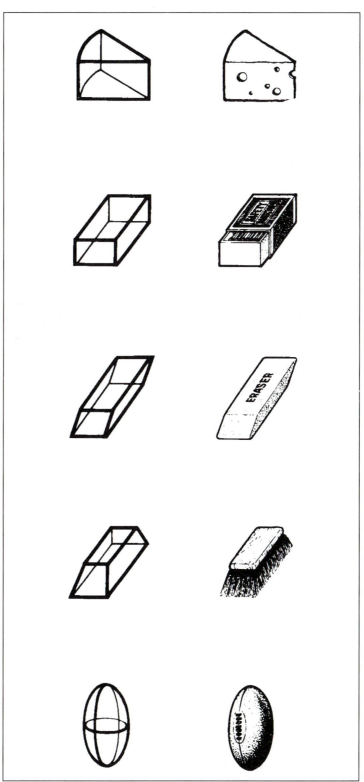

Figure 6.11 Volumes related to their associated representational forms (illustrated by Chi-ming Kan).

6.11

Relationships Between Two- and Three-Dimensional Shapes/Forms

The foundation for creating three-dimensional forms begins with simple two-dimensional planar shapes called polygons. From polygons, two-dimensional tessellations or planar nets can be developed (see Figures 6.12, 6.13a, and 6.14a).

A planar net can be folded into a polyhedron, regular prism, or antiprism, depending on the polygons used and the relationship between the face angles and vertices (see Figures 6.13 and 6.14). Tessellations, when projected into the third dimension, can result in the development of prismatic space-filling networks.

The prismatic polyhedra lattices create three-dimensional space-filling networks. Combinations of polyhedra also create space-filling networks and open-packing networks (see Figures 6.15–6.18).

Figure 6.12 (a) A polygon can be used singularly, or (b) combined to create regular tessellations or (c) semiregular tessellations.

6.12a

6.12b

6.12c

Figure 6.13 (a) Two-dimensional polygons forming a planar net, which results in a polyhedron. (b-c) Examples of polyhedra folded into a three-dimensional volumetric form.

6.13a

6.13b

6.13c

Figure 6.14 (a) Combinations of polygons combined into a planar net folded to create (b) a prism, or (c) an antiprism.

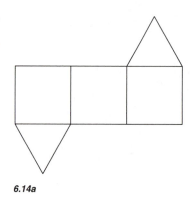

6.14a

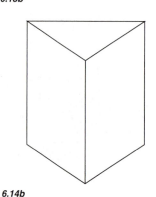

6.14b

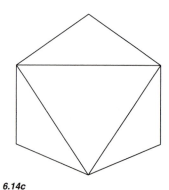

6.14c

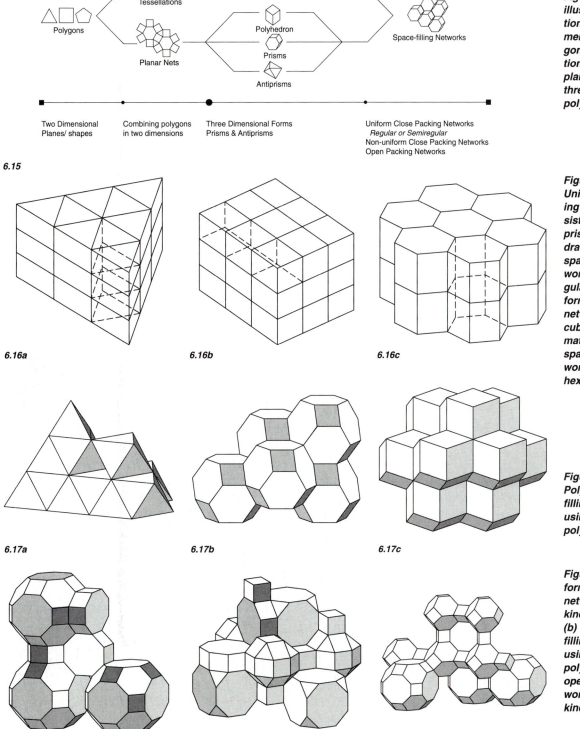

6.15

Figure 6.15 Model illustrating the relationships of two-dimensional polygons, their tessellation patterns, and planar nets creating three-dimensional polyhedra systems.

Figure 6.16 (a-c) Uniform space-filling networks consisting of regular prismatic polyhedra: (a) prismatic space-filling network using a triangular prism; (b) uniform space-filling network using a cube; and (c) prismatic uniform space-filling network using a hexagonal prism.

Figure 6.17 (a-c) Polyhedra space-filling networks using one or more polygons.

Figure 6.18 (a) Uniform space-filling networks using two kinds of polyhedra; (b) uniform space-filling networks using four kinds of polyhedra; (c) open-packing network using three kinds of polyhedra.

6.16a 6.16b 6.16c

6.17a 6.17b 6.17c

6.18a 6.18b 6.18c

Figure 6.19 Components of a polyhedron: (a) The vertex of a polyhedron is a point where three or more edges intersect. (b) The edge of a polyhedron is formed where the sides of adjacent polygons meet. A dihedral angle is formed by two polygons joined along a common edge. Conceptually, an edge is represented by a line. (c) The face of the polyhedra can be a regular or nonregular polygon.

Figure 6.20 Polyhedra constructed by laying out planar nets as illustrated: (a) a tetrahedron and its planar net; (b) a hexahedron, or cube, and its planar net; (c) an octahedron and its planar net; (d) a dodecahedron and its planar net; and (e) an icosahedron and its planar net.

6.19a

6.19b

6.19c

POLYHEDRA

A polyhedron is a volumetric solid made by combining polygons (see Figure 6.19). In order to form and construct a polyhedron, surfaces, or faces, of four or more polygons are needed. A regular polyhedron is a volumetric solid that has identical faces, edges, and vertices. There are five regular polyhedra, which are known as the *platonic solids*.

A polyhedron is named by the number of faces it has, in the same way that polygons are named by the number of sides they have: A tetrahedron has four faces, a pentahedron has five faces, a hexahedron has six faces, and so on.

A polyhedron is constructed by first laying out a planar net (sometimes called a development). The planar net is a two-dimensional version of the polyhedron, as it would appear before it is folded into a three-dimensional form. The relationship among the polygons in a planar net is based on the sides of the re-

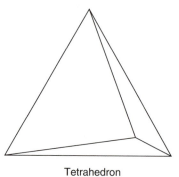

Tetrahedron Net

6.20a

Tetrahedron

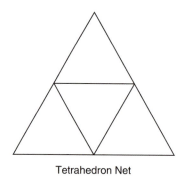

Hexahedron Net

6.20b

Hexahedron (cube)

Octahedron Net

Octahedron

6.20c

sulting polyhedron; that is, the location of the polygon shapes is relative to the adjacent faces on the polyhedron (see Figure 6.20.)

Semiregular polyhedra are solids that have more than one kind of regular polygon shape or face, maintaining consistent, equal vertices. There are thirteen semiregular solids, called Archimedean solids; however, only three are illustrated in Figure 6.21.

Dodecahedron Net

Icosahedron Net

Dodecahedron

6.20d

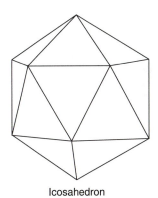

Icosahedron

6.20e

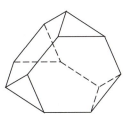

Truncated Tetrahedron Net

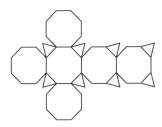

Truncated Hexahedron Net

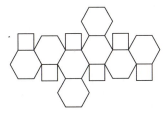

Truncated Octahedron Net

Truncated Tetrahedron

6.21a

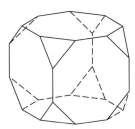

Truncated Hexahedron

6.21b

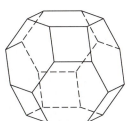

Truncated Octahedron

6.21c

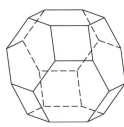

Figure 6.21 Archimedean solids have different-shaped polygon faces, but maintain congruent corners or vertices as indicated in: (a) a truncated tetrahedron net and its solid; (b) a truncated hexahedron net and its solid; (c) a truncated octahedron net and its solid.

Prisms and Antiprisms

Prisms are classified according to the number of sides in a base polygon and whether or not a lateral edge is perpendicular to the plane of the base. If the lateral edges are perpendicular to the base polygon, the resulting form is a regular prism. If the lateral edges are not perpendicular to the base polygon, the resulting form is an antiprism.

Prisms are named according to the shape of the base polygon. For example, if the base is triangular, the prism is called a triangular prism; if the base polygon is square, the prism is called a square prism, and so on. A prism that has square sides, congruent vertices, and is enclosed on the top and bottom by another polygon is referred to as semiregular. The same is true of any antiprism that has sides shaped as equilateral triangles and also has equal vertices (see Figures 6.22 and 6.23).

Figure 6.22 Various configurations of regular and semiregular prisms (open and closed).

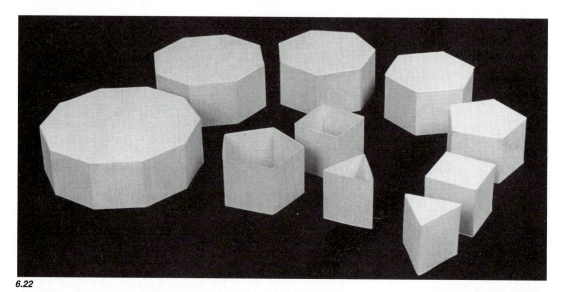

6.22

Figure 6.23 Various configurations of regular and semiregular antiprisms (open and closed).

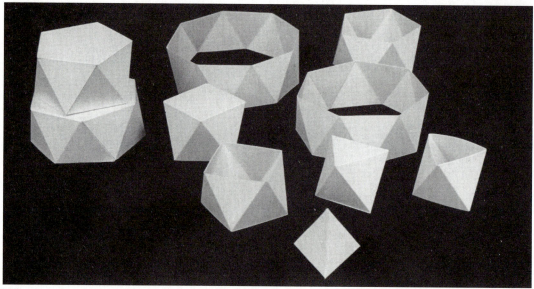

6.23

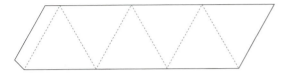

6.24a

✎Practice Exercise 6.2:
Folded Models of Regular Prisms, Semiregular Prisms, and Antiprisms

Carefully draw and cut out fifteen to twenty bands or strips, 1-1/4" wide, using 2-ply Bristol board. Score and fold them into square and triangular polygons. By folding and gluing these strips, explore the numerous cell configurations of regular prisms, semiregular prisms, and antiprisms. Note the various cell configurations and how they fit together (see Figures 6.24 and 6.25). Make a list of their structural attributes and include suggestions for their application in architecture and design.

Figure 6.24 (a-b) Examples of triangular and square planar nets that create prisms and antiprisms.

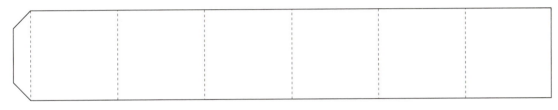

6.24b

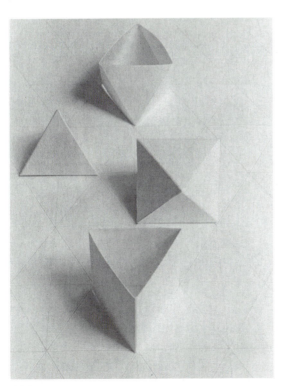

6.25a

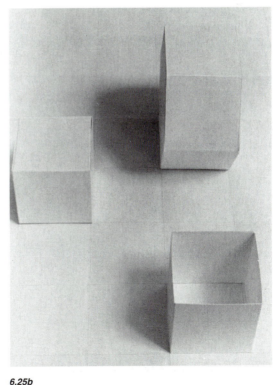

6.25b

Figure 6.25 (a-b) Examples of antiprism and prism configurations.

✍**Practice Exercise 6.3: Designing a Paper Sandal**

The purpose of this exercise is to explore and experiment with different prismatic cellular configurations to learn their inherent strengths and how they can add support to paperboard. From the prismatic cellular study, design and construct a pair of paper sandals using 2-ply Bristol board, taking into consideration structural strength of the prismatic cells.

The final sandal design should accept a live dynamic weight up to 200 pounds and be usable indoors. The cellular configurations may be constructed and assembled using slotting, folding, or both. The sandals should be attractive and fit well, and the cellular support structure should be covered by a lightweight paperboard material that forms an inner sole. The sandal must incorporate a device or strap by which to keep the sandal on the foot.

To begin, have another person trace around your feet to create a pattern for the basic sandal design. Experiment with at least three different cellular systems made up of prisms, semiregular prisms, antiprisms, or a combination. On tracing paper draw different cellular configurations and select what you feel is the strongest configuration. Plan and construct a Bristol board model. See Figures 6.26–6.28 for examples of this exercise.

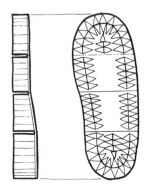

6.26b

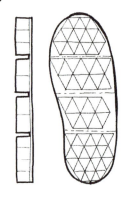

6.26c

Figure 6.26 (a-c) Study sketches of various cellular combinations and their positions on the sole (illustrated by Robert Jennings).

Figure 6.27 Person wearing a pair of prismatic sandals (student work).

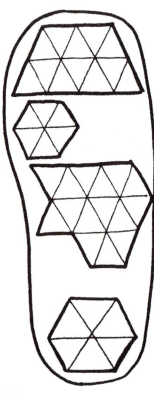

6.26a

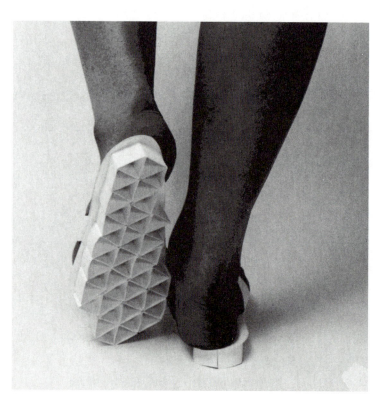

6.27

Evaluate the sandals according to the following criteria:

- Appearance (aesthetics and proportion)
- Comfort and fit
- Wearability
- Structural support of the specific weight

- Support location relative to the wearer's walking patterns
- Economy of material—that is, the use of the least amount of material
- Integration of the top surface and strap
- Geometric cell configuration

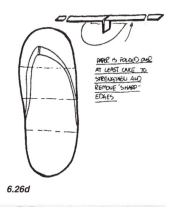

PAPER IS FOLDED OVER AT LEAST ONCE TO STRENGTHEN AND REMOVE "SHARP" EDGES

6.26d

Figure 6.28 (a-f) Examples of various cellular combinations used in the sandal designs (student work).

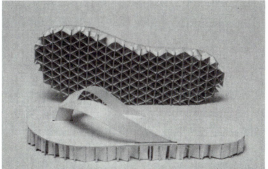

6.28a

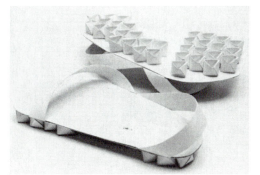

6.28b

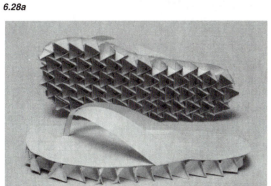

6.28c

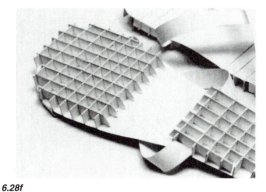

6.28d

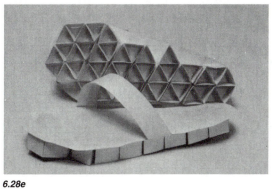

6.28e

6.28f

Figure 6.29 Eating
utensils made of
paper (designed
and tested by
William Wilkinson).

✍Practice Exercise 6.4: Designing an Eating Utensil Made of Paper

The purpose of this exercise is to learn more about paper and how to create strong, usable eating utensils by folding or twisting paper into an appropriate shape configuration.

Hypothetical problem: You have just survived a hurricane off the island of Bora Bora. The schooner you were crewing on was broken up by a twenty-foot wave, but fortunately you and the rest of the crew were washed ashore onto a small, uninhabited, sandy island.

Much to everyone's delight, a few provisions and materials washed ashore as well. One of the boxes found contains chocolate pudding cups. However, no one can find eating utensils.

The captain, Wally the Tough, discovers a tin box containing a package of 8-1/2" x 11" bond paper. "Ah ha! We have a material with which to construct eating utensils," Captain Wally exclaims with glee. He yells out, "Mates, within the next forty-five minutes, design a knife, fork, and spoon from the bond paper that I've found." He also adds that good design is necessary. "Just because we're stranded on this island doesn't mean we have to eat like heathens."

Each utensil will be tested by Wally the Tough—he will attempt to eat the pudding with each paper fork or spoon. He grumbles that if any mates fail the test, they will have their pudding cup confiscated and will not be permitted to eat for another twenty-four hours. Turning to gaze at the sea, he says, "Lots of luck, mates." (See Figures 6.29–6.31 for examples of this exercise.)

6.29

Figure 6.30 (a-c)
Eating utensils
made of paper (student work; tested
by Cynthia Busic-
Snyder).

6.30a

6.30b

6.30c

Figure 6.31 (a-c)
Eating utensils
made of paper (designed and tested
by Lori Reeder).

6.31a

6.31b

6.31c

✍️Practice Exercise 6.5: Using Wire as a Representative of Line to Explore Volumetric Forms

Line is a dynamic, descriptive element that can give a sense of direction, movement, action, and expression. Line can visually communicate numerous associations about a figure or object, such as stability, action, turning, **bending**, and so on.

This exercise affords an opportunity to work with wire material to create a linear volumetric form or representational object. It also presents the opportunity to explore the contours and transverse lines required for structural rigidity in a three-dimensional form.

Using wire as a representation of line, explore ways of forming three-dimensional figures and objects that utilize one or more of the associations mentioned.

Begin by sketching simple objects—for example, abstract or representational forms, such as animals, the human head, hands, and so on. Remember that volumetric forms can be viewed from 360°. To assist in the visualizing process, develop wire sketch models from the two-dimensional sketches. Work back and forth, drawing and modeling until a unique and successful solution evolves. Construct the final wire model using 18-gauge copper wire. Mount the linear model on a base so that it is stable and stands alone. Figures 6.32 and 6.33 show examples of wire models.

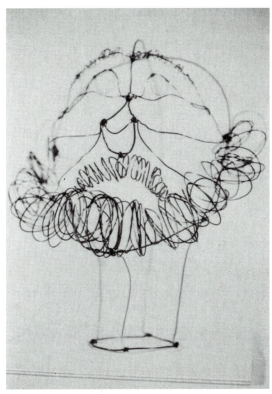

Figure 6.32 Linear wire model of a hand (student work).

Figure 6.33 Linear wire model of a head (student work).

6.32 6.33

LINEAR CONFIGURATIONS AND THEIR STRUCTURAL STRENGTH

Understanding linear configurations and their structural attributes involves exploring the relationships between structural configurations and the strength that they add to the material. Economy, i.e., avoiding overuse of material, but without decreasing strength and efficiency, is an important structural consideration in design. Note that the following exercises are not approached mathematically, but by making linear stick models and assessing the effectiveness or noneffectiveness of the various configurations by observing the reaction of linear members when **forces** are applied to them.

✍Practice Exercise 6.6:
Linear Bridge Configurations and Their Structural Attributes

Gather photos, drawings, and other visual examples of linear structures, such as bridges. Study their structural configurations and note how forces would move through the linear members, identifying **tension** and **compression** members.

Sketch ideas for the design of a minimal bridge structure that will be constructed of wooden linear members, will span 18", and will support a 15-pound hanging weight at the center. The bridge structure should not extend beyond 3" at the widest point. Record the quantity of material used by measuring the linear members during assembly. Test the model by applying a 15-pound force at the center of the suspended model (see Figures 6.34 and 6.35).

Figure 6.34 (a) Linear bridge structure (student work); (b) linear bridge structure being tested.

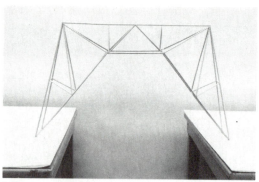

6.34a

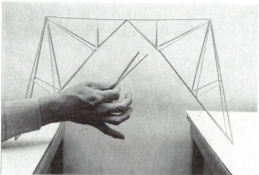

6.34b

Figure 6.35 (a-b) Linear beam structures being tested by hanging a 15-pound weight at the midpoint (student work).

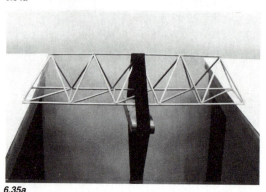

6.35a

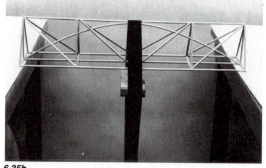

6.35b

✍Practice Exercise 6.7: Columns and Their Structural Attributes

The objective of this exercise is to learn how to optimize the strength of a linear column under compression. By exploring form configurations that add support to a vertical structure, a minimum amount of material will be utilized.

Design and construct a linear column from 6" applicator sticks. The column should measure 18" high and must be less than 3" wide on any side. The column must be able to withstand a minimum of 20 pounds of compression. Sparingly use white, water-based glue or contact cement to attach the linear members at each ver-

tex. Note: The structure should not be painted, and the glue should not be heavily applied, as too much glue can form large joints. Figures 6.36–6.38 show examples of this exercise.

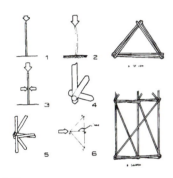

6.36a

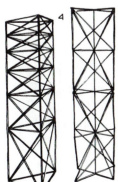

6.36b

6.36c

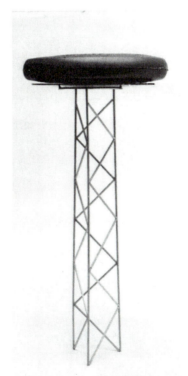

6.37a

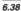

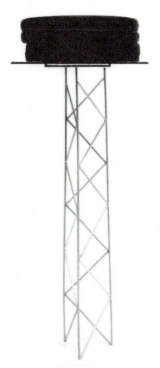

6.37b

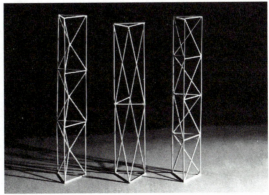

6.38

Figure 6.36 (a-c) Study sketches exploring various structural configurations (illustrated by William Faust).

Figure 6.37 (a-b) Column structure being tested by applying weights (student work).

Figure 6.38 Column structures and their configurations (student work).

Figure 6.39 Space-spanning linear structure (student work).

Using Linear Configurations to Produce Volumetric Forms

For architects and interior, product, and exhibit designers, linear structures have many applications. The illustrations in Figures 6.39–6.41 are just a few examples of how linear frames can be utilized in space frame structures, minimal shelters, and exhibition pavilions.

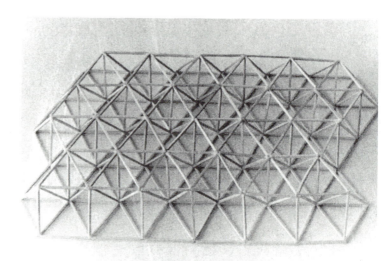

6.39

Figure 6.40 (a-c) Use of a linear tetrahedron structure to create an environment (student work; photographic examples from Kunstgewerbeschule Der Stat, Zürich, Switzerland; Schule für Gestaltung).

6.40a

6.40b

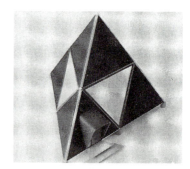

6.40c

Figure 6.41 (a-c) Developmental stages: designing a modular structure utilizing a panel system (student work; photographic examples from: Kunstgewerbeschule Der Stat, Zürich, Switzerland; Schule für Gestaltung).

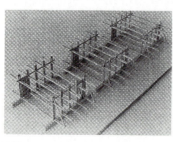

6.41a

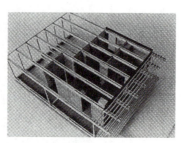

6.41b

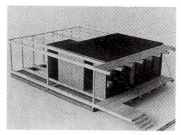

6.41c

✍Practice Exercise 6.8: Designing and Constructing a Double-Layer Linear Space Frame

This exercise introduces the concepts of tension, compression, distribution of force, line of action, and the balance of forces. Design and develop a linear model of a double-layer space frame that consists of two single layer grids spaced apart and interconnected by bracing members (see Figure 6.42 for examples).

The minimum size of the model is to be 15" x 15" x 2" or 2-1/4" in width, depth, and height. Economy of material is important; therefore, a minimum number of support members should be used. Use 1/8" applicator sticks and white glue or contact cement to assemble the model.

Consider the overall strength of the space frame as it relates to its configuration (shape and number of members), proportion, ease of construction, and overall appearance. Test the model by placing a 20-pound weight in the center of the structure. Record the actions of the different members under compression and tension.

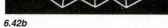

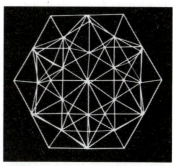

Figure 6.42 (a-e) Examples of double-layer space frame configurations (student work).

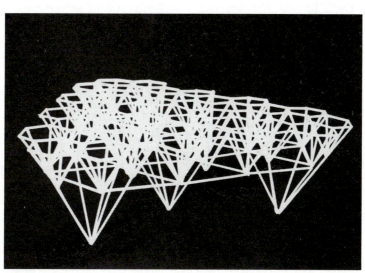

6.42b

6.42c

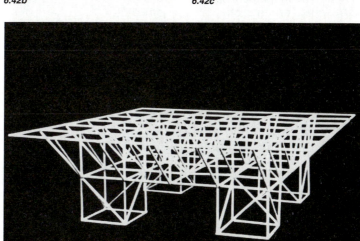

6.42d

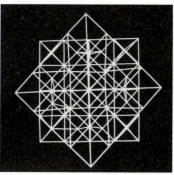

6.42a

6.42e

Figure 6.43 Study sketches and observation notes of linear prismatic frames held together by tension members (illustrated by William Faust).

✍Practice Exercise 6.9: Stabilizing a Linear Prismatic Frame with Cable and Turnbuckles

The emphasis of this exercise is the stabilization of a linear prismatic polyhedron using aluminum tubing, cables, turnbuckles, and wire inserts. The major concepts represented are tension, compression, **torsion**, resistance, stabilization, and **equilibrium**. Models should be tested for their strengths and weaknesses. Begin by drawing ideas for the model. The final model should be constructed of aluminum tubing, 1/8" steel wire rigging cable, and turnbuckles. The final model should be 8" tall. Test the model for stability, force resistance, and equilibrium (see Figures 6.43 and 6.44).

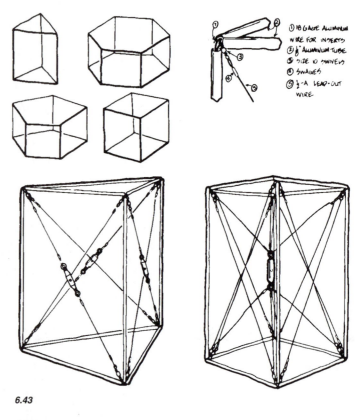

6.43

Figure 6.44 Concept development sketches of a minimal seating structure and table exemplifying the application of a prismatic frame (illustrated by William Faust).

THIS CONCEPT OF A MINIMAL SEATING STRUCTURE IS DEVELOPED DIRECTLY FROM THE CONFIGURATION OF THE RECTANGULAR PRISM. AFTER INVESTIGATION THE RECTANGULAR SHAPE WAS CHOSEN OVER A TRIANGLE FOR MAXIMUM SEAT AREA AND COMFORT. THIS STOOL CAN BE MANUFACTURED FROM ALUMINUM TUBING, A CANVAS SEAT/SLING AND SIMILAR CABLE RIGGING THAT WAS

USED IN THE CONCEPT MODELS. THIS CONCEPT IS ALSO APPLICABLE TO ANY SORT OF SUPPORT STRUCTURE SUCH AS A TABLE OR STAND. THIS CONCEPT IS TO DEMONSTRATE THE USE OF IDENTICAL MEMBERS THAT WOULD BE HELD TOGETHER STRICTLY BY TENSION AND INTRINSIC FORCE. NO GLUE OR PERMANENT JOINT WILL BE USED. IF THE TENSION CABLES BECOME LOOSE. THE PRISMATIC SHAPE WILL BECOME

WEAK AND COLLAPSE. A SYSTEM OF JOINING THE MEMBERS AT THE VERTICES MUST BE DEVELOPED THAT IS CAPABLE OF DRAWING THE MEMBERS IN TENSION TOWARDS THE CENTER. THE SCALE WILL BE CHOSEN RELATIVE TO THE APPROPRIATE ANTHROPOMETRIC INFORMATION. STRENGTH AND AVAILABILITY OF THE APPROPRIATE MATERIALS WILL BE INVESTIGATED AS WELL AS OVERALL COST OF PRODUCTION.

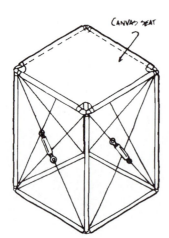

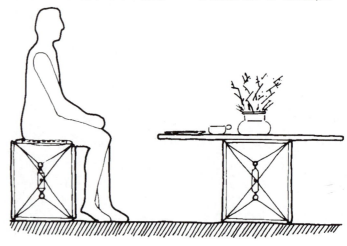

6.44

✎**Practice Exercise 6.10: Linear Tension Support Structures**

The preceding study emphasized the concepts of tension, compression, resistance, and stability through the construction of a linear prismatic model using aluminum tube, wire, and turnbuckles. This exercise exemplifies the above concepts through application and construction.

Design and develop a minimal support structure that will support one person when relaxing, reading, viewing television, or resting (see Figure 6.45).

The design requirements for the support structure follow:

- Apply the concepts in the previous exercise, basing the size and dimensions of the structure on average young adult human dimensions.

- The structure should be able to accept the force or weight of up to 225 pounds.

- Construct the support structure from lightweight aluminum tube, fabric straps, cinches, canvas, and wire.

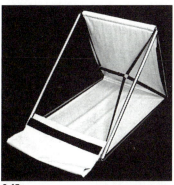

6.45a

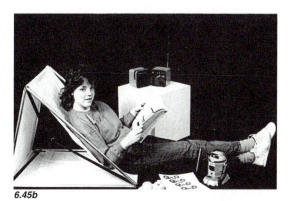

6.45b

Figure 6.45 (a-c) Different views of linear support structures (student work).

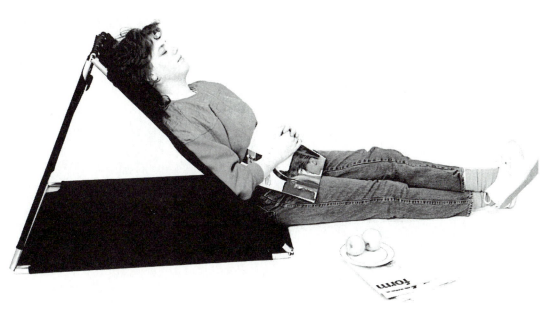

6.45c

Figure 6.46 (a-c) Different views of linear tent structures (student work).

✍Practice Exercise 6.11: Designing and Constructing a Linear Tent Structure

The major concepts used in this exercise are tension, compression, resistance, stability, and equilibrium. Begin by investigating the different tent structures available, recording their attributes and use through sketching and/or photographing. Study and analyze the tent structures, differentiating between configurations held in tension and those held in compression by linear configurations.

Develop sketches and mock-up models to illustrate tent structure ideas. The primary constraints are that the tent should house two adults comfortably and the structure should stand independently without being staked into the ground. Select the best idea from the sketches and models for final production. Construct a full-scale prototype model using aluminum tube or fiberglass rods, canvas or nylon, and a fabricated connector system (see Figure 6.46).

(Exercise concept by graduate research assistant Reiner Teufel, Department of Industrial Design, The Ohio State University.)

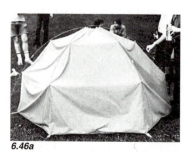

6.46a

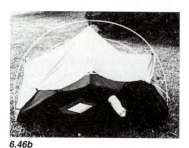

6.46b

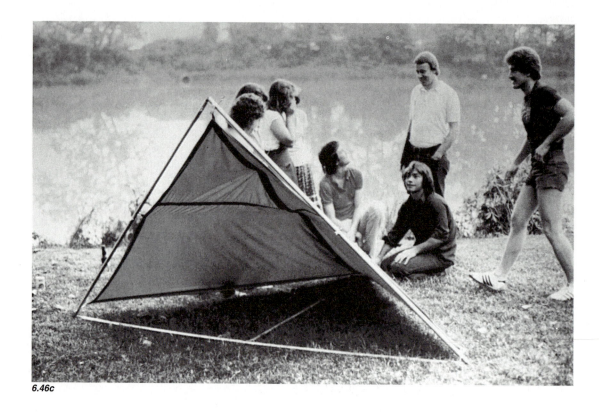

6.46c

VOLUMETRIC TRANSFORMATIONS USING PLANES

Industrial Design, The Ohio State University.)

Understanding how volumetric forms are generated and the various methods by which they can be transformed and manipulated is of primary importance to artists, architects, and designers. Volumetric transformation form studies assist in developing a sensitivity to the visual qualities used to create aesthetically pleasing art forms and architectural and interior designs and products.

Some of the visual qualities that forms should possess are good proportion and scale, symmetry, balance, graduated transitions from one shape to another, and proper use of materials.

✍**Practice Exercise 6.12: Creating Form Transformations Using Serial Planes**

Serial planes are units of form that represent planar sections of an overall volume or form. The emphasis of this exercise is on creating a form transformation with a series of planes (see Figure 6.47).

Terms important to this exercise are: *transition* or *gradation*, which refers to the phasing, or transforming in a gradual manner, of serial planes; *transformation*, which means a complete change from one shape or form to another; and *repetition*, which means repeating a basic shape within a unit of form.

Begin the exercise by se-

Figure 6.47 (a-g) Examples of transitional planar forms (student work).

6.47a

6.47b

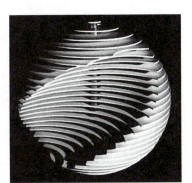

6.47c

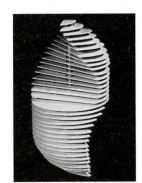

6.47d

6.47e

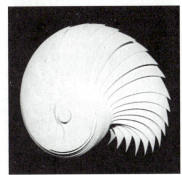

6.47f

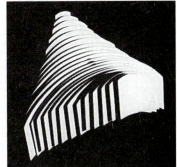

6.47g

such as a letterform and an animal. Examples might be a K and a kangaroo or an F and a frog. Create a volumetric unit that represents the transformation from one of the selected shapes to another. The transformation is created using a series of graduated plane shapes. The choices of variables in the transforming process are:

Gradation (select one):
- Change in size maintaining a consistent shape
- Change in shape maintaining a consistent size
- Combination of both

Position (select one):
- Parallel with consistent spacing or interval between each
- Parallel with varied interval between each
- Parallel with graduated interval

Direction (select one):
- Rotation on a vertical axis
- Rotation on a horizontal axis

Location of the axis (select one):
- Positioned with the axis on the center
- Positioned with the axis off the center

Selected constraints might be a gradation in shape and size with planes that are parallel and equally spaced, and a vertical axis located on the center.

Once the concept drawings have met the variables list, cut out the series of planes from white posterboard and place them in the correct order on a dowel rod. Analyze the overall unit form and its transitional steps. Make modifications if needed. The original selected shapes should be recognizable in the final model (see Figure 6.48).

Construct the final model using 1/16" styrene, 3/4" plexiglas rod for spacers, and 3/16" threaded plexiglas rod for the center axis. Using the posterboard mock-up planes as templates, trim the final model planes out of styrene and drill 1/4" holes for the axis rod. Cut the 3/4" plexiglas rod into the correct width for spacers, and drill 1/4" holes in the center. Assemble the model and evaluate the results.

Figure 6.48 (a-f) Transformation drawings and models using serial planes (illustrated and designed by William Faust).

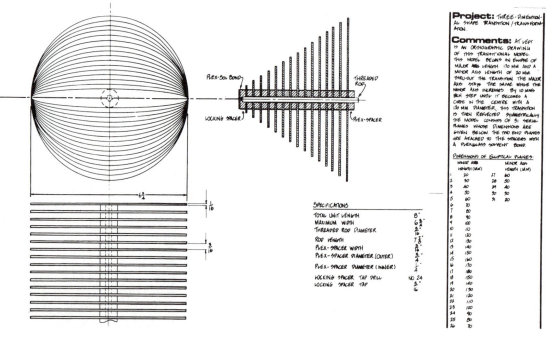

6.48a

PROBLEM STATEMENT

THE STUDENT IS TO CREATIVELY DESIGN, DEVELOPE AND FABRICATE AN AESTHETICALLY PLEASING VOLUME CONSISTING OF PLANAR ELEMENTS THE VOLUMETRIC FORM MUST DEMONSTRATE A GRADUAL TRANSITION OR TRANSFORMATION OF A GEOMETRICAL CONFIGURATION.

CONSTRAINTS

1 A 3-D MODEL MADE OF 1/16" STYRENE PLANES ON A 3/16"Ø THREADED STEEL ROD AND CLEAR PLEXIGLASS 3/4"Ø SPACERS EACH SPACER=3/16" THICK AND WILL HAVE A 1/4" HOLE DRILLED IN THE CENTER TWO OF THE SPACERS WILL BE DRILLED 3/16" AND TAPPED TO THE SAME SIZE TO SERVE AS TIGHTENING NUTS THE APPROXIMATE SIZE OF THE VOLUME IS 8"x8"

2 THE IDEA 3-D MODELS WILL BE MADE OF A LIGHTWEIGHT BOARD AND DOWEL ROD WITH SPACERS MADE OF THE DESIGNERS PREFERRED MATERIAL

3 THERE WILL BE AN 18"x24" STUDY NOTEBOOK IT WILL CONTAIN A STUDY PROJECTION CALENDAR FOLLOW A UNIFORM ORGANIZED FORMAT AND CONTAIN ALL CONCEPT SKETCHES PERTAINING TO THE PROBLEM AS WELL AS AN ORTHOGRAPHIC DRAWING OF THE FINISHED MODEL

BILL OF MATERIALS

1/16" THICK STYRENE PLASTIC
3/4" DIAMETER PLEXIGLASS ROD
3/16" (NO 10) THREADED ROD (STEEL)
1/4" DOWEL ROD
MEDIUM WEIGHT TAG BOARD
3/4" RUBBER-PLEX CLEAR TUBING
18"x24" VELLUM
BLACK COVER STOCK
18"x24" BLUEPRINT PAPER

PRESENTATION DATE

WEDNESDAY, APRIL 15, 1981 5:00 PM

CONSIDERATIONS AND VARIABLES

TRANSFORMATION - COMPLETE CHANGE
TRANSITION - PASSAGE FROM ONE STAGE OF DEVELOPMENT TO ANOTHER WITHOUT ABRUPTNESS.

REPETITION - THE UNIT FORMS ARE IDENTICAL IN SHAPE

GRADUATION - TRANSFORMATION OR CHANGE IN A GRADUAL ORDERLY MANNER.

REFLECTION - AN ISOMETRY IN WHICH THE INVARIANT POINTS CONSIST OF ALL THE POINTS ON A LINE OR PLANE CALLED THE MIRROR

ROTATION - AN OPERATION WHEREBY THE PLANAR ELEMENT IS REPEATED IN A 1:1 CORRESPONDENCE AT A SPECIFIED DISTANCE FROM AN INVARIANT POINT AT ANGULAR INTERVALS

SYMMETRY - THE CORRESPONDENCE IN SIZE, FORM AND ARRANGEMENT OF PARTS OF OPPOSITE SIDES OF A POINT, LINE OR PLANE

TRANSLATION - THE SIMPLE DIRECT ISOMETRY IN WHICH EVERY POINT ON THE PLANE MOVES THRU THE SAME DISTANCE IN THE SAME DIRECTION.

GRADUATION

1. SIZE + REPETITION OF SHAPE
2. SHAPE + REPETITION OF SIZE
3. SHAPE + SIZE

POSITION

1. PARALLEL + SIMILAR SPACING
2. PARALLEL + DIFFERENT SPACING
3. PARALLEL + GRADUAL SPACING

DIRECTION

1. ROTATION → VERTICAL AXIS
2. ROTATION → HORIZONTAL AXIS
3. ROTATION → CENTRAL AXIS

RELATIVE DATA

SERIAL PLANES

A VOLUME CAN BE REPRESENTED BY A SERIES OF PLANES WHEN A VOLUME IS REPRESENTED BY A SERIES OF PLANES, EACH PLANE BECOMES A CROSS-SECTION OF THAT VOLUME THUS TO CONSTRUCT A VOLUMETRIC FORM ONE CAN THINK IN TERMS OF ITS CROSS-SECTIONS OR HOW THE FORMS CAN BE SLICED UP AT REGULAR INTERVALS WHICH WILL RESULT IN SERIAL PLANES EACH SERIAL PLANE CAN BE CONSIDERED AS A UNIT FORM WHICH MAY BE USED EITHER IN REPETITION OR GRADATION REPETITION REFERS TO REPEATING BOTH SHAPE AND SIZE OF UNIT FORMS (FIG 1) GRADATION REFERS TO GRADUAL VARIATION OF THE UNIT FORM AND CAN BE USED IN 3 WAYS
A) GRADATION OF SIZE BUT REPETITION OF SHAPE (FIG 2)
B) GRADATION OF SHAPE BUT REPETITION OF SIZE (FIG 3)
C) GRADATION OF SHAPE & SIZE (FIG 4)

FROM PRINCIPLES OF 3 DIMENSIONAL DESIGN
BY W WONG PP 15

1.

2.

3.

4.

.................................

*Figure 6.48 (b)
Application of
problem-solving
process.*

PHASE ONE: CONCEPTUALIZATION

MARCH
30. MON: PROBLEM STATEMENT GIVEN DISCUSSION IN CLASS.
31. TUE: RESEARCH AND INVESTIGATION OF PROBLEM. COMPLETION OF ASSIGNED READING

APRIL
1. WED: GROUP DISCUSSION IN CLASS. SETTING UP THE STUDY
2. THURS: CONCEPTUALIZATION BEGINS FINALIZE RESEARCH AND APPLY IT TO PROBLEM. BEGIN TO SKETCH IDEAS. THUMBNAIL & CONCEPT
3. FRI: FURTHER DEVELOPMENT OF CONCEPTUAL IDEAS. CONTINUE SKETCHES ASK QUESTIONS IN CLASS PRESENT IDEAS FOR CRITIQUE
4. SAT: FABRICATION OF THREE-DIMENSIONAL CONCEPTUAL MODELS USING SEVERAL IDEAS
5. SUN: CONTINUATION OF FABRICATION OF THREE-DIMENSIONAL CONCEPTUAL MODELS CONSIDER IDEAS AS THEY TAKE THREE-DIMENSIONAL FORM REVIEW BRIEF AND RESEARCH MATERIAL
6. MON: STOP! REVIEW AND ANALYZE PROGRESS THUS FAR CONSIDER ELEMENTS MENTIONED IN BRIEF AND HOW THEY APPLY TO 3-D CONCEPT SKETCHES FROM CONCEPTUAL STUDIES. NARROW AND SELECT ONE IDEA FOR FINAL SOLUTION. DO DO WITH APPROVAL OF INSTRUCTOR IN CLASS PRESENT ALL PRELIMINARY IDEAS. BOTH IN SKETCH AND MODEL FORM IN CLASS DEMONSTRATION OF MODEL-BUILDING TECHNIQUES.

PHASE TWO: REFINEMENT

APRIL
7. TUES: REVIEW OF CONCEPT CHOSEN TO BE SOLUTION. CONSIDER POSSIBLE IMPROVEMENTS. VARIATIONS APPLY INITIAL RESEARCH AND BRIEF DATA TO THIS PARTICULAR CONCEPT
8. WED: FURTHER REFINEMENT OF CONCEPT BY ALTERATIONS ON 2D AND 3D SKETCHES ASK QUESTIONS IN CLASS AND ATTAIN INSTRUCTORS CRITIQUE
9. THURS: STOP! REVIEW PROGRESS THUS FAR CONSIDER HOW THE THE SOLUTION WAS ARRIVED AT BY CRITIQUING THE DESIGN PROCESS "IS THE SOLUTION READY TO BE CONSTRUCTED"
10. FRI: ORGANIZE THUMBNAIL AND CONCEPT SKETCHES IN A LOGICAL PROGRESSION ALSO. ORGANIZE NOTES AND RESEARCH DATA DEVELOP FORMAT FOR BOOKLET AND MAKE BLUE-PRINT COPIES FINISH PURCHASING MATERIALS

PHASE THREE: EXECUTION

APRIL
11. SAT: BEGIN FABRICATION OF FINALIZED CONCEPT. THIS WILL INVOLVE MODELING TECHNIQUES AND THE TOOLING OF STYRENE, PLEX-ROD & THREADED STEEL ROD
12. SAT: CONTINUE ROUGH CUTTING OF PLANAR ELEMENTS AND LATHE CUTTING OF SPACERS BEGIN WORK ON PRESENTATION BOOKLET INCLUDING CALENDAR AND RESEARCHED DATA
13. MON: FINISH ROUGH CUTTING AND BEGIN SANDING PLANES AND SPACERS BY SANDING TO SHAPE AND SIZE CONTINUE WORK ON BOOKLET WITH IDEA SKETCHES AND ORTHOGRAPHIC
14. TUES: TAP LOCKING SPACERS AND ASSEMBLE TRANSITION CUT THREADED STEEL ROD TO THE APPROPRIATE SIZE EXAMINE FINISHED SOLUTION "IS IT THE DESIRED RESULT?" SEARCH FOR MISTAKES OR PHYSICAL INCONSISTANCIES AND CORRECT THEM NOW EXPERIMENT WITH THE VARIABILITY AND COMBINATIONS OF YOUR MODEL AND RECORD YOUR OBSERVATIONS IN THE BOOKLET
15. WED: FINALIZE MODEL AND THE COVER BOOKLET AND REVIEW WORK TO PREPARE FINAL PRESENTATION GIVE PRESENTATION OF FINAL RESULT IN CLASS

Figure 6.48 (c-d)
Concept develop-
ment.

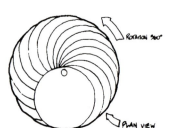

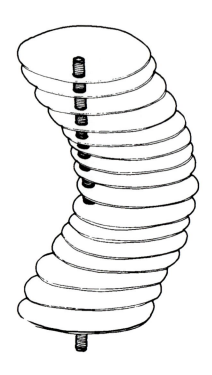

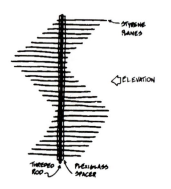

6.48c

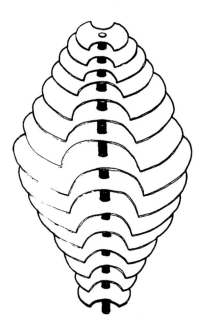

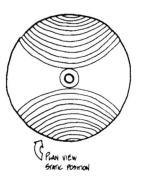

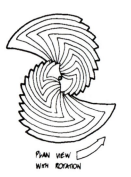

6.48d

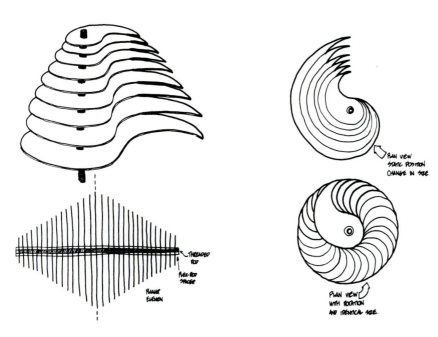

6.48e

Figure 6.48 (e-f) Concept development.

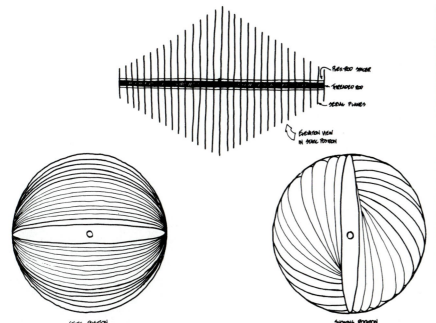

6.48f

Figure 6.49 (a-e)
Form transforma-
tion: sink stopper
to pig (student
work; exercise by
Professor J. Mon-
tague, School of
Design at Sydney
College of the Arts,
Sydney, Australia).

✍Practice Exercise 6.13: Five-Step Volumetric Transformation

This exercise helps in developing an understanding of and visual sensitivity to form transformation relationships with similarities and associations (see Figure 6.49 as an example).

Select two objects, and use them as end points in a five-step series to create a volumetric form transformation. Develop three intermediate steps at the quarter and halfway points in the transition from one form to the other. Determine the media appropriate for the final model.

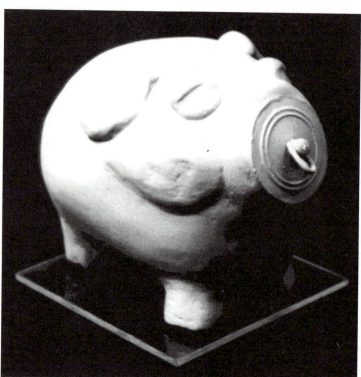
6.49d

6.49a

6.49b

6.49c

6.49e

✍Practice Exercise 6.14: Three-Dimensional Form Metamorphosis

The basic skills required for this problem include invention, visualization, and model building. Conceptualize and develop an object transformation or metamorphosis in a five-step series. Select two different objects or forms that are somewhat related in their physical shape to serve as the beginning and end points.

Through sketching, develop a series of forms illustrating the metamorphosis of the two selected objects. Select the five steps that best illustrate an even sequence from one form to another.

Accurately create the models using plastaline. Evaluate the models, placing emphasis on the creativity of the solution, accuracy in the degree of form development and detail, and modeling techniques used (see Figure 6.50).

Figure 6.50 Three-dimensional form metamorphosis changing: (a) a calculator into a tube of paint; (b) a box of crayons into a hand (student work; exercise by Professor Tom Kovacs, Foundation Program in Art and Design, University of Illinois, Urbana, Champaign).

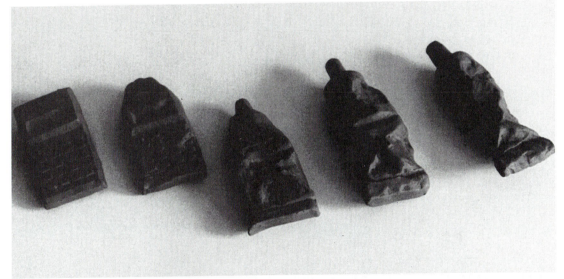

6.50a

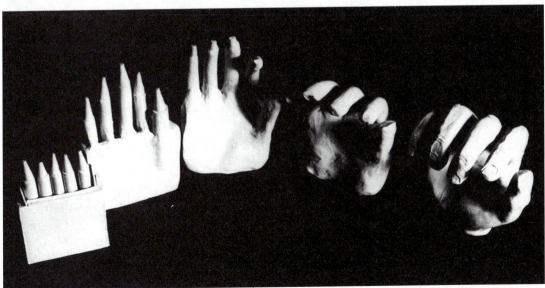

6.50b

Figure 6.51 Drawings illustrating the placement of slots into pentagonal and triangular elements creating an interconnecting system (student work).

Figure 6.52 Slotted volumetric model using triangular and hexagonal planes (student work).

Figure 6.53 Examples of planes creating volume: (a) square plane with slot placement; (b) an elevation of the unit configuration of an interconnecting system; and (c) completed volumetric slotted model (student work).

✍Practice Exercise 6.15: Using Polygons to Form a Slotted Volumetric Structure

This exercise explores the use of regular polygons, their structural characteristics, and the ways they can be combined to form a slotted volumetric structure. Emphasis is placed on determining the possible internal subdivisions of regular polygons in order to develop an interconnecting slotted system to join them, creating a planar volume or form in the process.

On tracing paper, develop concept drawings that explore basic geometric polygons and their possible volumetric configurations using the symmetry operations translation, rotation, and reflection (refer to Chapter 12, Symmetry and Dynamic Symmetry, for more information on these operations). From the concept drawings, create three-dimensional sketch models using white posterboard. Select the best idea from the model concepts. The polygon configuration should be interchangeable in design; that is, a variety of configurations should be possible from the single polygon planar element. The model should have strength, balance, and aesthetic merit. Construct the final model solution from white styrene. Figures 6.51–6.53 show examples of this exercise.

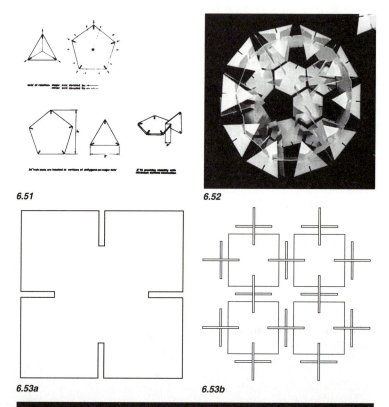

6.51

6.52

6.53a

6.53b

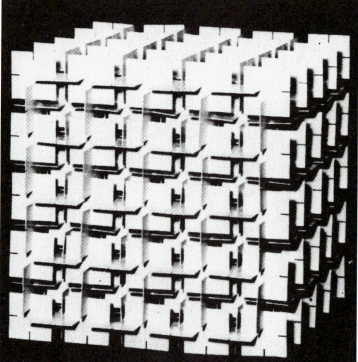

6.53c

Folded Paper Structures

The study of folded paper surfaces can be an effective means of exploring structural strength. Structural surfaces can be composed to form mechanisms that redirect forces—that is, surface-active structure systems. Structural continuity of the folded elements in two axes—that is, surface resistance against compression and **shear** stresses—are prerequisites of surface active structures as used in architecture.

✍Practice Exercise 6.16: Studying Regular and Semiregular Tessellation Patterns in Folded Structures

Through study sketches, modify the standard tessellation patterns previously presented (refer to Chapter 5). Explore ways to create folded paper structures derived from a two-dimensional plane. Be cognizant of the need to incorporate transverse and longitudinal axes. Use 2-ply Bristol board and double-sided tape or contact cement to construct the models (see Figures 6.54 and 6.55 for examples).

Variables can be:

- The shape of the polygon tiles in the tessellation
- Tessellation pattern configuration
- Size of the polygon tiles
- Size of the tessellation pattern

Note that the depth of score and folding affects the strength of the folded structure. Test the strength of the paper model by applying a force to the overall folded structure to analyze its strength.

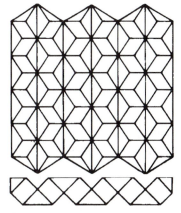

6.54a

6.54c

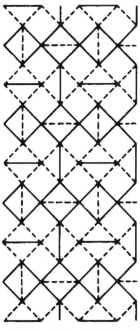

6.54b

Figure 6.54 (a) Orthographic drawing illustrating pattern configurations of a folded paper structure (student work). (b) Plan view showing fold lines. (c) Folded paper model.

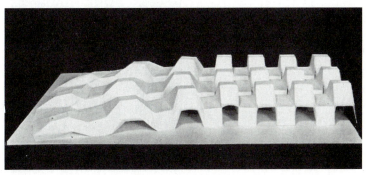

6.55

Figure 6.55 Folded paper model showing pattern configuration (designed by Jerry Kohli).

....................................

Figure 6.56 (a-b) Examples of folded paper columns (student work).

✍Practice Exercise 6.17: Hollow Paper Cylindrical Columns

This exercise is designed to transfer polygons and their tessellation patterns from the two-dimensional plane into a three-dimensional paper-folded hollow column. The exercise emphasizes the fact that paper can be made into a sturdy material by utilizing tessellation patterns. These patterns can be transformed into a rigid hollow cylindrical column when folded on transverse and longitudinal lines or axes. Note that the structural strength of a paper column is in inverse relationship to the number of faces it has.

Study the information on tessellations in Chapter 5. Develop a series of paper study models using 2-ply Bristol board. The models should be approximately 18" tall. The diameter will vary according to the size of the polygons in the tessellation pattern (see Figures 6.56 and 6.57).

Figure 6.57 Pattern construction created by cutting along selected lines of the column for interesting light modulation (student work).

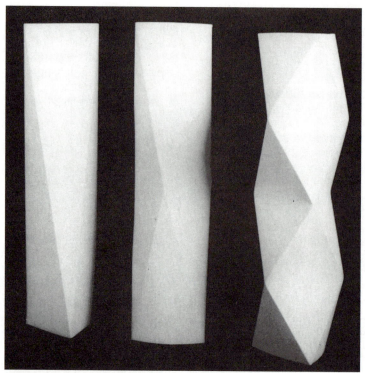

6.56a

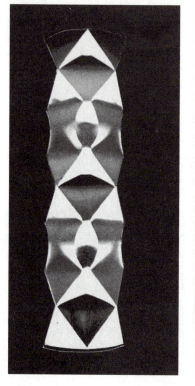

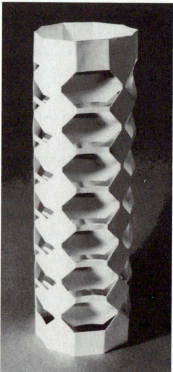

6.56b 6.57

✍️Practice Exercise 6.18: Constructing an Information Column Using Polyhedra and Pattern Transformation

Practice Exercise 6.17 provides insight into how polygon shapes and tessellation patterns can be used to add strength and rigidity to a vertical paper column. This exercise combines these study experiences into an applied context. The design requirements of these columns are modified from the previous exercise by using polyhedra that transform shapes through a series of steps. In this exercise the column structure dimensions are related to human scale and are freestanding and stable. The polygon surfaces at viewing height should accommodate typographic information in a legible size.

The specifications for the column are:

- Height of the structure measures 72"

- Base of the structure measures 18" to 20"

- Typographic information surfaces measure 15" wide

The design process steps are based on:

- Polyhedra studies and their surface relationships

- Form transformations

- Two- and three-dimensional concept development

- A final prototype model in full scale made from white foamcore or corrugated cardboard (see Figures 6.58 and 6.59).

6.58

Figure 6.58 Information column structure solution (designed by Ed Maceyko).

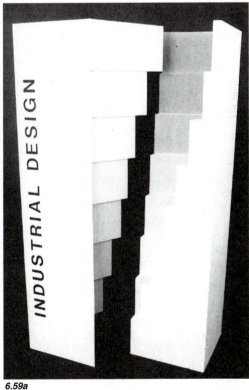

6.59a

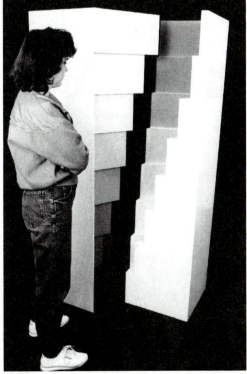

6.59b

Figure 6.59 (a-b) Two views of information column structure solution (designed by Raymond Kuhar and Kelly Horton).

Figure 6.60 (a-c) Polygon shapes used to construct enclosure models made of Bristol board and rubber bands (student work).

PLANE TO VOLUME

✍Practice Exercise 6.19: Polygon Planar and Dome Configuration Enclosures

Polygon shapes can be utilized in rnany ways. One way is to enclose space in a planar or dome configuration, which is applicable to this enclosure study. An interest in dome structures and their various configurations was stimulated by the work of Buckminster Fuller. The result is that there has been a great deal of research on dome structures, economy of materials, construction, and application.

To appreciate and become more familiar with how polygon shapes can enclose space, cut out ten to fifteen of each of the regular polygon shapes (triangles, squares, pentagons, hexagons, and octagons) from white 3-ply Bristol board. Develop a joining system using tabs and rubber bands to connect the polygons and build several different enclosure models (see Figure 6.60).

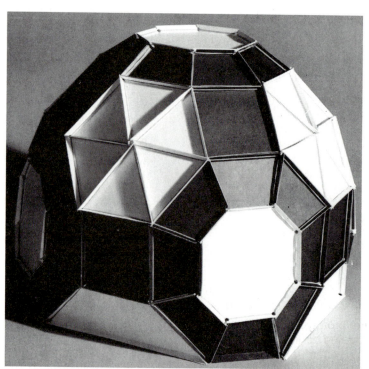

6.60a

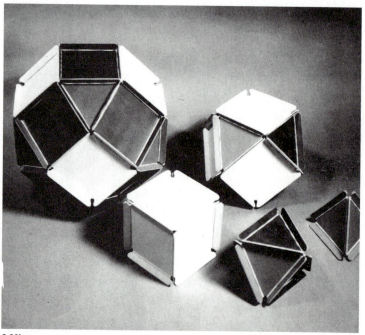

6.60b

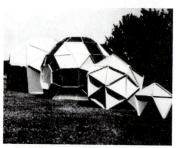

6.60c

✎Practice Exercise 6.20: Modular Play Structure

The purpose of this exercise is to design and build a full-scale prototype model of a play environment. Emphasis is given to the design and development of a component play structure that can be assembled and disassembled easily by young children with the help of an adult. The components should be interchangeable polygonal shapes that can be assembled in a variety of configurations (see Figures 6.61 and 6.62).

The materials used for the prototype model are corrugated board and a fastening system (e.g., bungy cords, snaps, and plastic connectors).

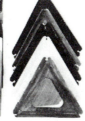

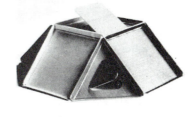

6.61a

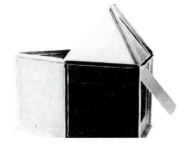

6.61b

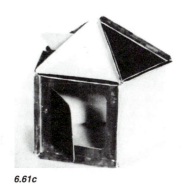

6.61c

6.61d

Figure 6.61 (a-d) Two sets of polygon shapes (squares and triangles) used to construct enclosure models (designed by Angelica Smith).

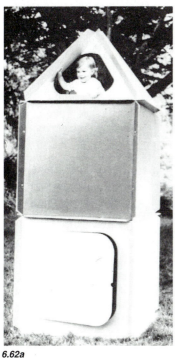
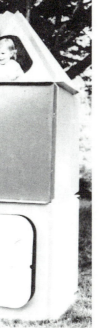

6.62a

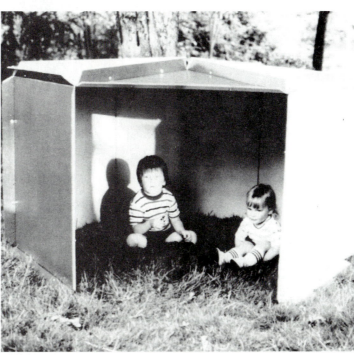

6.62b

Figure 6.62 (a-b) Prototype modular child's play structures (designed by Angelica Smith).

*Figure 6.63 (a-b)
Beginning assembly of a prototype
minimal enclosure
environment using
polygon shapes
(student work).*

*Figure 6.64 (a-d)
Full scale prototype
models, parts, and
assembly process
of minimal enclosure environments
(student work).*

✍Practice Exercise 6.21: Designing a Minimal Enclosure Environment

Design and construct a shelter system that accommodates one adult in a sitting position. The shelter should consist of a polygon panel system with interchangeable pieces. Base the size of the panels on the desired finished size of the shelter; keep in mind that the shelter should be easy to carry.

The design process steps are based on:

- Use of polygon shapes and enclosure configurations

- Human factors/anthropometric considerations

- Structural factors: force, stress, stability, and equilibrium

- Model-making techniques and results

See Figures 6.63–6.65, which show applications of this exercise.

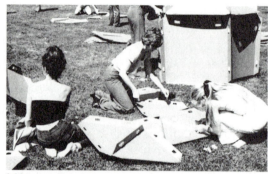

6.64a

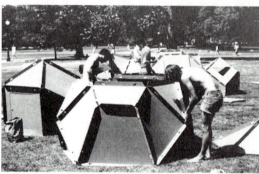

6.64b

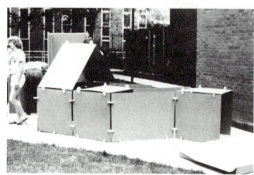

6.64c

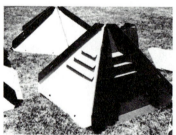

6.63a

6.63b

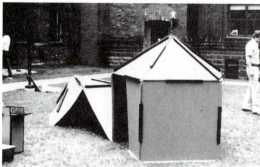

6.64d

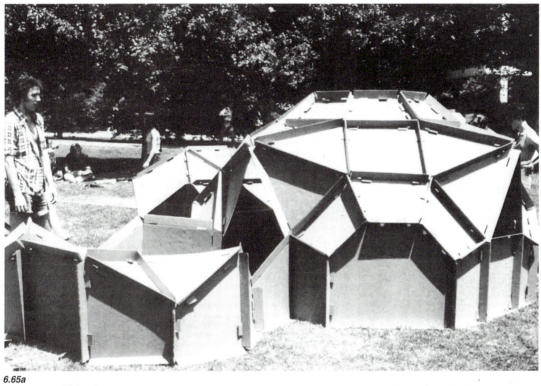

6.65a

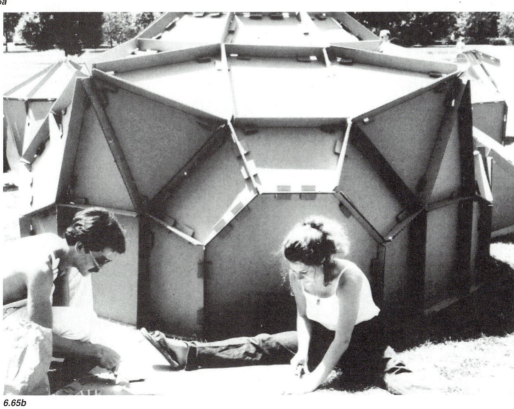

6.65b

Figure 6.65 (a-b) Examples of a minimal enclosure environment (student work).

✍**Practice Exercise 6.22: Designing a Minimal Seating Structure from Corrugated Board**

This exercise emphasizes how form configuration, structural principles, materials, and human dimensions affect the design of a simple seating product.

Emphasis is also placed on understanding forces and their effect on materials, form configurations, human dimensions, aesthetics of form giving, full-scale model building, and testing and evaluation procedures.

A corrugated cylindrical or prismatic form lacks the strength for a seating structure. By incorporating an internal or vertical support structure in the design, sufficient strength can be achieved to allow its use as a seating structure. The internal structure may be created by maximizing the structural qualities of the corrugated board, or by using a system of slotted or crossing members inside the seating unit for structural strength. The disadvantage of this type of structure is that it uses a considerable amount of material and does not allow the internal configuration to be seen or incorporated into the aesthetics of the design.

Semi-open seating structures are more difficult to create and design, but usually require less material and are as strong as the cylindrical or prismatic structures. They are more interesting because the internal structure is visible and can be used as part of the aesthetic appeal of the form.

Begin the exercise by exploring form configurations to be used in designing a seating structure. Review the information on polyhedra, prisms, and antiprisms already presented.

Figure 6.66 (a-c) Different views of closed prismatic and semi-open seating solutions (student work).

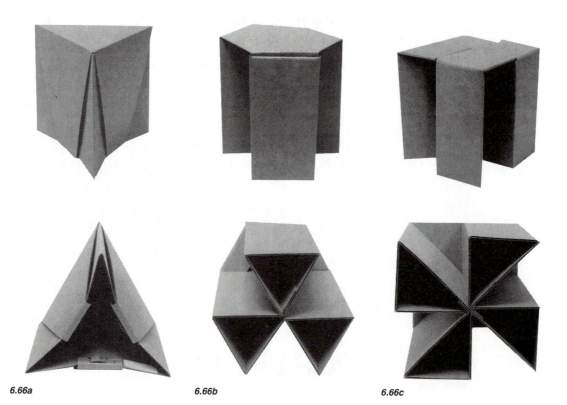

6.66a 6.66b 6.66c

The project constraints are:

- Only one 4' x 8' sheet of single-wall corrugated board may be used for each seating structure.

- No more than three independent pieces of corrugated board may be used.

- No commercial fasteners may be used.

- The seating structure must be able to accept a 250-pound downward force (compression), as well as torque (a force that produces **torsion**).

- The final form must be aesthetically pleasing.

The following steps are to be used in the creative design process:

- Study the problem requirements and learning objectives.

- Organize the problem into a time frame, listing the priorities and design process steps.

- Discuss the problem with others; brainstorm for innovation ideas.

- Collect the necessary information to solve the problem—information on human dimensions,

Figure 6.67 (a-b) Sketches illustrating problem-solving process used in building seating structure (illustrated by William Faust).

Problem

THIS PAGE INCLUDES THE BASIC REQUIRE-MENTS OF THE MINIMAL SEATING PROJECT INTRODUCED ON MAY 22 AND COMPLETED JUNE 8 OF 1981.
STATED ARE OBJECTIVES OF THE PROBLEM, SUGGESTED REFERENCES, CONCEPTS TO BE APPLIED, MATERIAL USED AND CONSTRAINTS TO FOLLOW.

TO EXPLORE, STUDY AND CREATE A MINIMAL SEATING STRUCTURE CAPABLE OF WITHSTANDING 250 POUNDS OF FORCE. THE MAJOR VERTICAL FORCE AND ALL RESULTING FORCES MUST BE CONSIDERED.

NO MORE THAN 3 SEPARATE PIECES, MADE FROM CORRUGATED CARDBOARD (SINGLE WALL). THE POSSIBILITY OF BUILDING THE STRUCTURE FROM ONLY ONE PIECE SHOULD BE EXPLORED.
THE DESIGN AND MATERIAL MUST ACT AS ITS OWN FASTENING SYSTEMS. TABS AND SLOTS WILL BE USED TO CONNECT SECTIONS WITHIN THE SEATING CONFIGURATION.
APPROXIMATE SIZE : 15 x 15 x 15 INCHES.
THE SEATING STRUCTURE MUST BE ABLE TO WITHSTAND THE TORQUE AND LATERAL FORCE OF LIVE MOVEMENT.
THE STUDENT WILL BE JUDGED ON THE AMOUNT OF AND EFFICIENT USE OF MATERIAL NEEDED TO COMPLETE THE PROJECT SUCCESSFULLY.

THE TOP SURFACE OF THE STRUCTURE WILL BE USED FOR SITTING. THE STUDENT MUST CONSIDER THAT TOP SURFACE RELATIVE TO HUMAN COMFORT AND VISUALLY IDENTIFIABLE AS A SEATING SURFACE.
APPEARANCE : ALL QUALITIES SHOULD VISUAL-

6.67a

LY COMMUNICATE SIMPLICITY AND APPLY TO A MINIMAL SEATING CONCEPT. INTEGRITY OF DESIGN, STRUCTURE AND MATERIAL IS ESSENTIAL. THE STRUCTURE MUST BE EASY TO ASSEMBLE AND DISASSEMBLE FOR CARRYING, TRAVEL AND STORAGE.

- STRUCTURE : THE ESSENCE OF ARCHITECTURE - FORREST WILSON
- NOMADIC FURNITURE — JAMES HENNESSEY AND VICTOR PAPANEK
- POLYHEDRA PRIMER — PETER AND SUSAN PEARCE
- DESIGNING WITH TYPE — JAMES CRAIG

Timetable

- MAY 22 - INTRODUCTION OF PROBLEM.
- MAY 23 - ACQUIRE MODEL MATERIALS, BEGIN SKETCH STUDIES, READ MINIMAL SEATING APPLICATIONS IN NOMADIC FURNITURE.
- MAY 24 - EXPLORE CHARACTERISTICS OF SKETCH MODEL MATERIAL (BRISTOL BOARD, 2-PLY STRATHMORE.
- MAY 25-29 - SKETCH MODEL RESEARCH.
- MAY 26 - ACQUIRE CORRUGATED CARDBOARD.
- MAY 30 - SELECTION OF PRIMARY PROBLEM SOLUTION ALTERNATIVES.
- JUNE 1 - BEGIN NOTEBOOK SUMMARIES OF OPTION STRENGTHS, WEAKNESSES. LAYOUT SKETCHES OF PRIMARY OPTIONS; DETAILS OF AREA MEASUREMENTS.
- JUNE 2-5 - CONSTRUCT CARDBOARD PROTOTYPES OF AS MANY LIKELY SOLUTIONS AS POSSIBLE.
- JUNE 6 - CONSTRUCT FINAL MODEL SOLUTION.
- JUNE 7 - CONSTRUCT PACKAGE AND DESIGN PRODUCT GRAPHICS. COMPLETE NOTEBOOK.
- JUNE 8 - FINAL PRESENTATION.

Options

I PICKED FIVE VARIABLES TO CONSTRUCT A PROBLEM SOLVING PROCESS WHICH WOULD EXPLORE AS MANY OPTIONS AS POSSIBLE FOR A STABLE, COMFORTABLE AND EASILY ASSEMBLED STRUCTURE. THEY WERE # OF PIECES, CURVED OR STRAIGHT PIECES, OPEN OR CLOSED CONFIGURATION, EXISTENCE OF AN INNER STRUCTURE OR NOT, AND # OF VERTICAL SIDES. THROUGH EXCHANGING THE VARIABLES WITH ONE ANOTHER, I WAS ABLE TO COME UP WITH A NUMBER OF ALTERNATIVES TO CONSIDER.
AFTER DESIGNING STRUCTURES TO FIT EACH COMBINATION, I NARROWED THE CHOICES DOWN BY ELIMINATING THOSE STRUCTURES WHICH WERE OBVIOUSLY IMPRACTICAL. MANY OF THESE USED A VERY HIGH AMOUNT OF MATERIAL. VERY FEW WERE ELIMINATED BECAUSE OF SUSPECTED STRUCTURAL INSTABILITY, SINCE I COULD NOT BE SURE OF THE STRENGTH FACTOR UNTIL AFTER BUILDING A SMALL MODEL, AND THEN EVEN, I COULDN'T BE POSITIVE.
I BUILT SMALL MODELS OF THE REMAINING OPTIONS TO TEST FOR STRENGTH AND FEASABILITY OF CONSTRUCTION. THE MODELS HELPED POINT UP PROBLEMS WITH THE TAB AND SLOT POSITIONS ON A FEW OCCASIONS AND ALSO AIDED ME IN SEEING MORE EFFICIENT SOLUTIONS SIMPLY BY HAVING A TANGIBLE STRUCTURE TO LOOK AT. LATERAL MOVEMENT AND TORTION WEAKNESSES BECAME MORE APPARENT AS WELL.

3 SIDED STRUCTURES -

① THIS STRUCTURE USES 1144 SQ. IN. AND IS CONSTRUCTED OF TWO PIECES. IT HAS NO INNER STRUCTURE BUT INSTEAD FEATURES WALLS WHICH PROTRUDE INWARD TO PROVIDE STABILITY.
THE DESIGN SEEMED TO LACK RESISTANCE TO TORTION. IT HAD A SIMPLE DESIGN WITH EASY CONSTRUCTION. THE SIDE WALLS OF THE STUDY MODEL DID NOT APPEAR STRONG ENOUGH TO STAND UP TO

ANY GREAT AMOUNT OF LATERAL FORCE. I DECIDED THAT SOME KIND OF INTERIOR STRUCTURE WAS NEEDED TO MAKE THE WALLS MORE RIGID.
①A I ADDED A SMALLER TRIANGE IN THE CENTER WHICH PROVIDED MUCH MORE STABILITY.

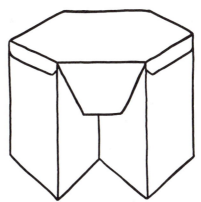

BUT ALSO ADDED 270 SQ. IN. OF AREA AND AN EXTRA PIECE. ALSO THE SIDES ON THE TOP PIECE LACKED SUPPORT. THE TOTAL AREA OF THE STRUCTURE WAS 1414 SQ.IN. THE RECOGNIZABILITY OF ① AND ①A AS OF ALL THE 3-SIDED STRUCTURES, AS A SEAT IS QUESTIONABLE. HOWEVER, TRIANGULAR STRUCTURES HAVE AN ADVANTAGE IN THAT A PERSON'S FEET CAN EASILY STRADDLE A CORNER, PROVIDING MORE COMFORT THAN SQUARE OR ROUND SEATS.
②B THIS DESIGN IS A ONE-PIECE CONSTRUCTION, JOINED AT THE CENTER OF ONE OUTSIDE WALL. THE TOP HINGES FROM ANOTHER OUTSIDE WALL. TOTAL AREA WAS 1180 SQ. IN.
A SORE POINT IN THIS DESIGN WAS STABILIZING THE TWO UNFASTENED POINTS OF THE INNER TRIANGLE WITHOUT EXPOSING TABS IN SOME WAY. I DECIDED THAT ALL THAT WAS NEEDED WAS TWO EXTRA SLOTS IN THE LID (ARROW) TO HOLD THE CORNERS IN PLACE.
STILL, THIS SOLUTION WAS NOT AS STABLE IN MODEL FORM AS WAS ①A WHICH USED INTER-LOCKING 7½ IN. SLOTS. THE TWO SIDE

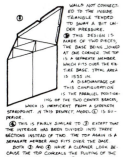

WALLS NOT CONNECTED TO THE INSIDE TRIANGLE TENDED TO SWAY A BIT UNDER PRESSURE.
② THIS DESIGN IS MADE OF TWO PIECES. THE BASE BEING JOINED AT ONE CORNER. THE TOP IS A SEPARATE MEMBER WHICH FITS OVER THE ENTIRE BASE. TOTAL AREA IS 1555 IN.
A DISADVANTAGE OF THIS CONFIGURATION IS THE PARALLEL POSITIONING OF THE TWO CENTER BRACES, WHICH IS INEFFICIENT FROM A STRENGTH STANDPOINT. IN THIS RESPECT, MODEL ① IS SUPERIOR.
④ THIS IS FAIRLY SIMILAR TO ③ EXCEPT THAT THE INTERIOR HAS BEEN DIVIDED INTO THREE SECTIONS INSTEAD OF TWO. THE TOP AGAIN IS A SEPARATE MEMBER AND FITS OVER THE BASE.
BOTH ③ AND ④ HAVE A CLEANER LOOK BECAUSE THE TOP CONCEALS THE FLUTING OF THE SIDE WALLS, AS OPPOSED TO ① IN WHICH THE LID FITS INSIDE THE WALLS. HOWEVER, BOTH ENCOUNTER

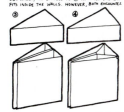

DIFFICULTIES OF CONSTRUCTION IN THE OPEN POINTS OF THE BASES. THIS OPEN POINT IS NOT EASILY FASTENED AND CAN APPEAR SLOPPY.

6.67b

FOUR-SIDED STRUCTURES -

⑤ THIS IS AN OPEN CONFIGURATION, WHICH DISPLAYS A TENSION MEMBER IN THE CENTER IT USES 1510 SQ. IN. OF CARDBOARD. THE MIDSECTION OF THE TOP TENDS TO SINK AND THE TWO POINTS AT THE BOTTOM SPREAD APART SLIGHTLY WHEN PRESSURE IS APPLIED.
THIS CONFIGURATION IS NOT PARTICULARLY COMFORTABLE OR SUPPORTIVE IN APPEARANCE IT USES A RELATIVELY HIGH AMOUNT OF MATERIAL, AS WELL, AND WAS SCRAPPED.
⑥ HERE IS AN UNUSUAL LOOKING DESIGN WHICH USED ONLY 1194 SQUARE INCHES. IT IS MADE OF THREE PIECES, TWO'X SHAPES ONE STACKED UPON THE OTHER WRAPPED BY THE THIRD PIECE.
THE MAIN DRAWBACK HERE WAS A LACK OF STRUCTURAL INTEGRITY BUT RATHER A TENDENCY OF THE STRUCTURE TO LOSE ITS BALANCE UNDER UNUSUAL LATERAL MOVEMENT. ALSO, THE SEAT DOES NOT LOOK STABLE EVEN THOUGH IT IS ACTUALLY QUITE SOLID AS A STRUCTURE.
ONE GOOD ASPECT FROM A HUMAN FACTORS STANDPOINT IS THE AMOUNT OF FREEDOM OF MOVEMENT FOR A PERSON'S FEET. THE SMALL BASE ALLOWS ANY RANGE OF POSITIONS.

The Winner

(large illustration of hexagonal seat)

THIS IS THE STRUCTURE I PICKED AS THE BEST COMBINATION OF OVERALL STRENGTH, UNIFIED AND INTEGRATED DESIGN, EFFICIENT USE OF MATERIAL AND ESTHETIC EFFECT. IT HAS TWO PIECES, USES 1395 SQ.IN. OF CARDBOARD AND MEASURES 15 IN. HIGH x 15 WIDE IN EACH DIRECTION. IT POSSESSES THE INHERENT STRENGTH OF THE HEXAGONAL FIGURE AND ALSO IS VERY EASY TO SIT ON. IT IS VERY EASILY RECOGNIZED AND READILY ACCEPTED AS A SEATING STRUCTURE.

.....................................

Figure 6.68 Development drawings illustrating the construction and assembly process of the final seating solutions (illustrated by Alan Jazak).

existing seating structures, materials, and so on.

- Consider production methods and model-building constraints relative to the materials.

- Generate concept sketches and models, taking notes where necessary to record the thought process.

- Finalize the design.

- Construct the final model.

- Prepare documentation of the project, compiling sketches and paperboard models into a coherent, informative package.

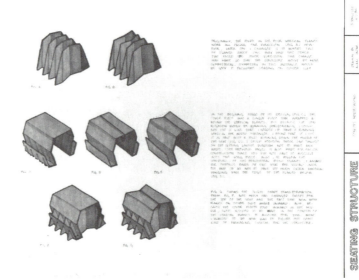

6.68

Use the following questions to evaluate the results of the project:

- Is the structure rigid enough to withstand a 250-pound downward force, as well as torque?

- Are there structural weaknesses? If so, how could the structure be improved to minimize or eliminate them?

- Is the construction economical?

- Is the form visually identifiable as a seating structure?

- Are the form configurations and aesthetics of the form innovative?

Prepare a documentation booklet for the project that includes structural, material, and anthropometric information and sketches. Documentation should also include:

- The designer's assessment of the problem requirements and constraints.

- Photographs of three-dimensional sketch models.

- Technical drawings showing how to produce the seating structure (patterns).

Figures 6.66–6.73 show examples of this exercise.

Figure 6.69 Paper scale models of seating structure showing development process before full-scale models are constructed (designed by Alan Jazak).

Figure 6.70 (a-b) Two views of the final corrugated cardboard seating model (designed by Alan Jazak).

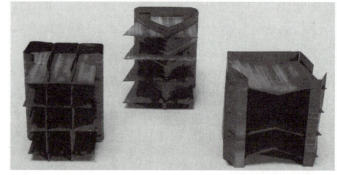

6.69

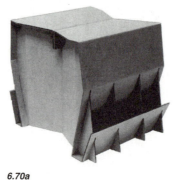

6.70a

6.70b

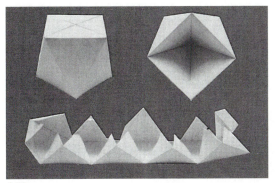
6.71a

6.71b

Figure 6.71 Assembled antiprism seating structure: (a) scale model; (b) with a mannequin (student work).

6.72a

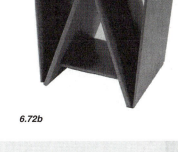
6.72b

Figure 6.72 (a-b) Assembly process resulting in a semi-open seating structure (designed by Scott Barton).

6.73

Figure 6.73 Photographic documentation of testing of seating structures.

Figure 6.74 Head protector: (a) front view; (b) side view (designed and constructed by Ed Maceyko).

Figure 6.75 Head protector: (a) front view; (b) side view (designed and constructed by William Wilkinson).

Figure 6.76 Head protector: (a) front view; (b) side view (designed and constructed by Andy Bartlett).

Figure 6.77 Head protector: (a) front view; (b) side view (designed and constructed by Ray Kuhar).

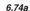

✍Practice Exercise 6.23: Designing a Head Protector

This exercise is designed to combine the study of polyhedral cellular forms, their inherent qualities, and how they can be combined to create strength. Select an activity or sport that requires some sort of head protection. Begin the exercise with information gathering and an analysis of existing head protection devices. From this review and analysis, outline specifications for a head protector.

Using polyhedral cellular configurations, develop a head protector or helmet designed to counteract possible forces to the wearer's head. The helmet should fit comfortably. It can be constructed from a series of polyhedra or can be folded from one piece of material using transverse, longitudinal, and/or latitudinal scores. The three-dimensional models should be constructed from 2-ply Bristol board; therefore, the problem is hypothetical as Bristol board does not lend itself to protecting against heavy force. Use caution to avoid injury when testing models.

In an actual study the models are valid as prototype models because final production of these structural configurations can be produced from a more durable, shock-resistant material (see Figures 6.74–6.80).

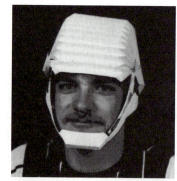

6.74a

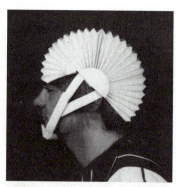

6.74b

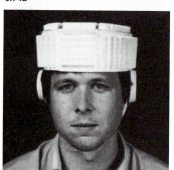

6.75a

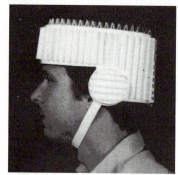

6.75b

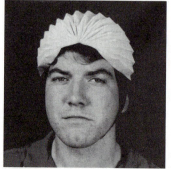

6.76a

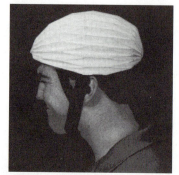

6.76b

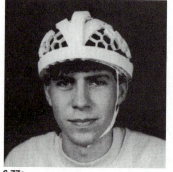

6.77a

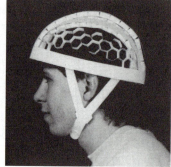

6.77b

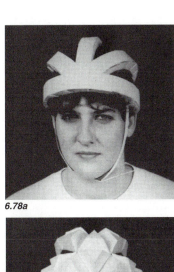

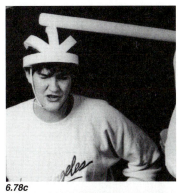

6.78a

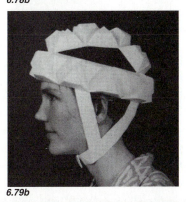

6.78b

6.78c

Figure 6.78 Head protector: (a) front view; (b) side view; (c) testing helmet (designed and constructed by Kelly Horton).

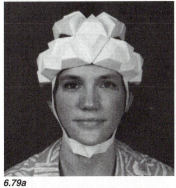

6.79a

6.79b

6.79c

Figure 6.79 Head protector: (a) front view; (b) side view; (c) testing helmet (designed and constructed by Lori Reeder).

6.80

Figure 6.80 Testing head protector solutions (designed by Ed Maceyko and William Wilkinson).

.....................................

*Figure 6.81 Transla-
tion of a planar net
into a polyhedron.*

*Figure 6.82 (a-b)
Two-dimensional
figures become
three-dimensional
forms by folding a
planar net into a
cube (student
work).*

*Figure 6.83 Exam-
ple of a hexagonal
pop-up promotional
package (designed
by Duane Rice).*

*Figure 6.84 (a-b) Ex-
ample of a fold-up
promotional pack-
age (designed by
Skip Stander).*

✎Practice Exercise 6.24: Designing a Folded or Pop-up Volume

As explained earlier in the chapter, the concept of moving from two to three dimensions can be represented by folding a two-dimensional planar net into a three-dimensional form (see Figures 6.81 and 6.82). The objective of this exercise is to design a three-dimensional pop-up promotional package that can be mailed or distributed as a flat, two-dimensional form. First, review prismatic and regular polyhedral nets and invent ways by which they may be modified or manipulated into a pop-up volume. Determine the promotional purpose of the form. It can be used in a number of ways, such as to advertise a special event or place, to publicize a business, or to serve as a personal promotion piece.

Apply graphic and typographic information to the flat planar surfaces. Construct the forms from Bristol board. Experiment with the weight of the board, since this affects the fold quality and structural durability. Tabs are required on some sides in order to glue planes together. Rubber bands may or may not be used to make the form pop up; however, the form must remain flat when packaged in an envelope or mailer (see Figures 6.83 and 6.84).

6.81

6.82a

6.82b

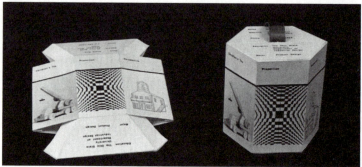

6.83

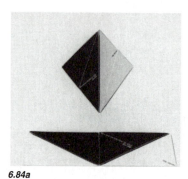

6.84a

6.84b

✍Practice Exercise 6.25: Designing a Three-Dimensional Promotional Package

This exercise concentrates on the different ways that regular, semiregular, and prismatic polyhedra can be repeated and combined to create a volumetric form. The overall volume must be conceived so that its component units create a number of different combinations and configurations. The planar surfaces of the units are used to display photographic examples of artwork. Typographic information such as name, address, education, and experience are integrated and applied to the surfaces of the volumetric units, making up the personal promotion package. The package could be used in addition to a traditional resume when applying for employment in a design or architectural office (see Figures 6.85–6.90).

Design process requirements of this exercise are as follows:

- The volume must be a close-packing system that can be manipulated into a number of different configurations.

- The shape of the planar surfaces should complement the typographic and visual information.

- The size and weight of the promotional package should meet postal codes.

- The form should be easy to construct and produce if several packages are needed.

- Production cost should also be a consideration.

6.85

Figure 6.85 Promotional package design using prismatic polyhedron (designed by David DePriest).

6.86a 6.86b

Figure 6.86 Manipulative promotional package (a) closed; (b) open (designed by Wally Mahn).

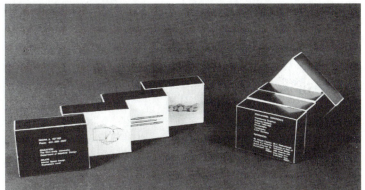

6.87

Figure 6.87 Promotional package showing two of its folded configurations (designed by Regina Vetter).

Figure 6.88 (a-b)
Promotional pack-
age showing two of
its folded configura-
tions (designed by
Kenneth Wood).

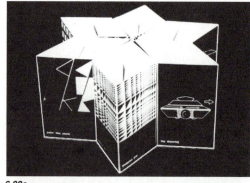

6.88a

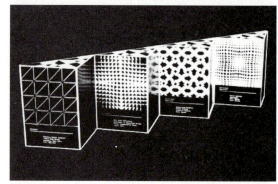

6.88b

Figure 6.89 (a-b)
Promotional pack-
age showing two of
its folded configura-
tions (designed by
Cornelia Lenander).

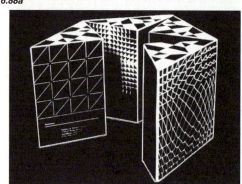

6.89a

6.89b

Figure 6.90 Promo-
tional package
showing two of its
folded configura-
tions (designed by
Susan Hessler).

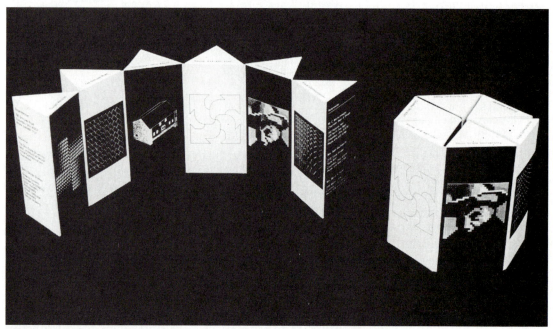

6.90

✍Practice Exercise 6.26: Close-Packing Forms

This exercise emphasizes greater awareness of the physical and visual attributes of natural forms and relates them to basic polyhedra and prismatic forms.

Select a natural object such as a fruit or vegetable. Study the form configuration through sketching, analyzing, and abstracting the basic volumetric form of the natural object. Experiment with subdividing the polyhedron into an internal structure that complements the natural internal and external configuration (see Figures 6.91–6.97).

Develop three-dimensional Bristol board models exploring the various ways the external polyhedron can be completely filled by internal polyhedral forms to create a close-packing system. Revise and refine the structure until all the internal polyhedra fit neatly into the external form package. Select the best solution from the sketches and paper models that visually and physically relate to the natural vegetable or fruit.

Construct the model of the final solution using Bristol board and colored paper, dry transfer patterns and dots, and self-adhesive film. The three-dimensional components may have shapes cut out to represent structural or visual characteristics.

Evaluate the final models, emphasizing the visual and structural likeness to the natural fruit or vegetable, the internal close-packing system, the surface colors and graphics, and the construction quality of scoring, folding, and assembling.

6.91

6.92a

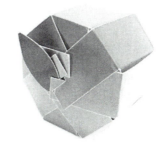

6.92b

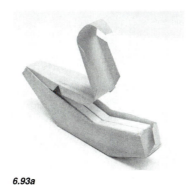

6.93a

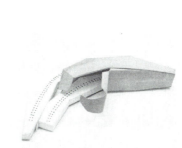

6.93b

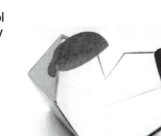

6.94a

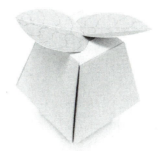

6.94b

Figure 6.91 Avocado illustrating the concept of close packing (designed by Fernando Rojas).

Figure 6.92 (a-b) Apple illustrating the concept of close packing (designed by Megan Cook).

Figure 6.93 (a-b) Banana illustrating the concept of close packing (designed by James Molloy).

Figure 6.94 (a-b) Pear illustrating the concept of close packing (designed by Doug Ritterling).

Figure 6.95 (a-b) Peanut illustrating the concept of close packing (designed by Jan Ostendorf).

Figure 6.96 (a-b) Cucumber illustrating the concept of close packing (designed by Molly Kestner).

Figure 6.97 (a-b) Artichoke illustrating the concept of close packing (designed by Natalie Trees).

6.95a

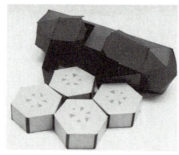
6.96a

6.97a

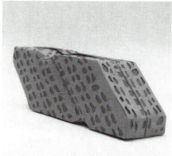
6.95b

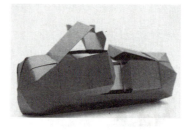
6.96b

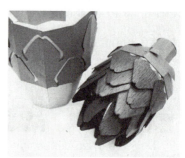
6.97b

Figure 6.98 Protective package for a flood lamp

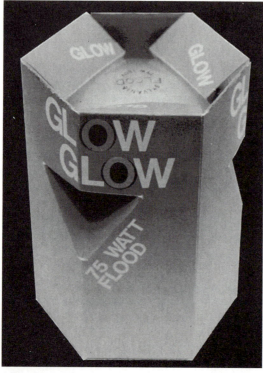
6.98

✍ Practice Exercise 6.27: Designing a Protective Package for a Flood Lamp Bulb

Apply the concepts learned in this chapter to create a package for a flood lamp bulb. The exercise integrates previously learned concepts in structure and close-packing polyhedra.

Analyze and record information on existing packages for light bulbs and flood lamp bulbs. Redesign an existing package to improve the visual and structural form, using prismatic volumes. (Note: A light bulb depends on a supporting structure to protect it during shipping and handling.) The surface planes must display information about the product such as product identification, manufacturer identification, size, electrical requirements, constraints, and use (see Figures 6.98–6.103).

Package requirements are as follows:

- Construct the package using 2- or 3-ply Bristol board.

- The bulb must be protected from breaking..

- Typographic information regarding the product should be clearly communicated.

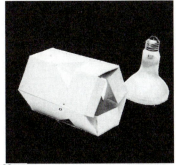

6.99a

6.99b

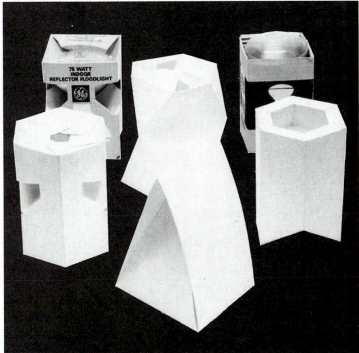

6.100

Figure 6.99 (a-c) Protective packages for a flood lamp (student work).

Figure 6.100 Examples of protective packages for a flood lamp (student work).

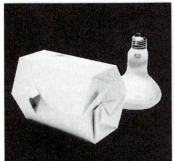

6.99c

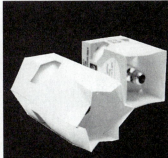

6.101a

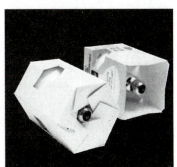

6.101b

Figure 6.101 (a-b) Existing flood lamp package and new design with a detail of the closure system (student work).

- Integrate a closure system that is sturdy but can be opened easily by the consumer.
- The package must be able to be close-packed in a larger corrugated container for shipping.
- The package must relate to the standard-sized products and corrugated shipping packages.

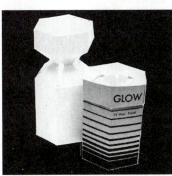

6.102

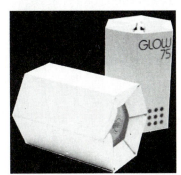

6.103

Figure 6.102 Protective package for a flood lamp (designed by Tim Hershner).

Figure 6.103 Protective package for a flood lamp (student work).

Figure 6.104 (a-d) Evaluating and testing bridge structures (student work).

✎Practice Exercise 6.28: Designing and Constructing a Corrugated Cardboard Bridge Structure

This exercise emphasizes team problem solving (two to four people) and the construction of a full-scale prototype model. It reviews structural concepts presented in this chapter.

Design, develop, and construct a load-bearing bridge structure for human use (see Figure 6.104a). The bridge should span 8' and be constructed of a minimal amount of corrugated cardboard. The bridge must accept 185 pounds of live, dynamic weight, and the walking surface should be approximately 12" wide. To test the bridge structure and to make the problem more interesting, place it on two cement block piers over an area of water. Persons from each team must walk across the bridge (see Figure 6.104b).

Develop a documentation booklet consisting of the design development drawings, and photographs of the three-dimensional models (see Figures 6.105 and 106).

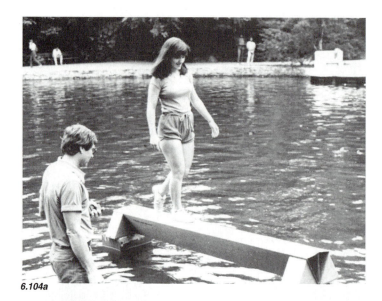

6.104a

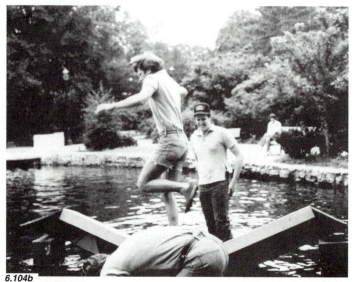

6.104b

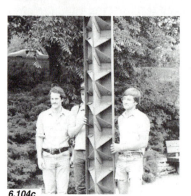

6.104c

6.104d

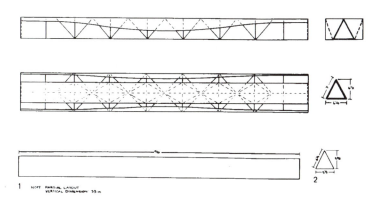

FINAL MODEL

AFTER THOROUGH TESTING AND EVALUATION A FINAL MODEL WAS CONSTRUCTED. THIS STRUCTURE MET THE REQUIREMENTS OF MAXIMUM STRENGTH AND STABILITY AND MINIMUM USE OF MATERIAL.

MODIFICATIONS WERE MADE IN OUR TEST MODEL. THE PROBLEM OF BUCKLING WAS SOLVED BY REINFORCING THE TRIANGULAR BEAM WITH ANOTHER LAYER OF BOARD. LENGTHENING THE SIDES (AND TAPERING TO REDUCE MATERIAL) ALSO REDUCED THE CHANCE OF BUCKLING. THE TRIANGULAR BEAM WAS ALSO MADE DEEPER, WHICH INCREASED THE AMOUNT OF MATERIAL ABOVE AND BELOW THE NEUTRAL AXIS. THIS SERVED TO STRENGTHEN THE BEAM.

Figure 6.105 Documentation of bridge project (student work).

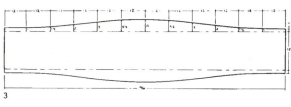

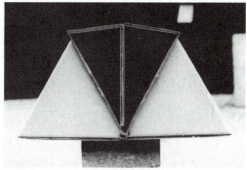
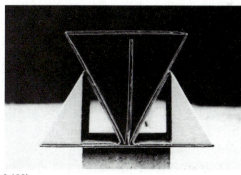

DESCRIPTION	AREA (sq.in.)	NO. OF PARTS	TOTAL AREA
1. TRIANGULAR BEAM	3180.0	1	3180.0
2. TRIANGULAR SUPPORT	15.4	10	154.6
3. WALKING SURFACE	1552.0	1	1552.0
4. VERTICAL SUPPORT	53.0	12	636.0
5. PIER SUPPORT	71.1	4	284.7
			TOTAL 40.32 h²

6.105

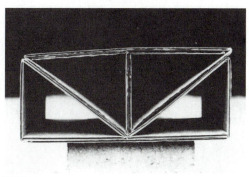

6.106a

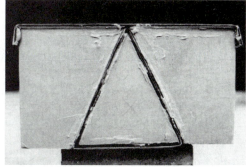

6.106b

Figure 6.106 (a-d) End views showing the construction configuration of completed beam structures for cardboard bridge (student work).

6.106c

6.106d

✍Practice Exercise 6.29: Designing and Constructing a Sleeping Support Structure

Explore, study, and create a sleeping support structure for human use. The sleeping support structure should be considered a minimal product, using as little corrugated cardboard as possible. The design must incorporate its own fastening system using tabs and slots. Materials used are 4' x 8' corrugated cardboard and cutting and drawing tools.

The top plane should be approximately 9" off the floor. The vertical support system must visually and aesthetically integrate with the horizontal plane. The structure should also be designed so that it can be easily assembled and disassembled, and so that it fits into a carrying or storage container.

The design procedure is as follows: Study corrugated materials. Observe the inherent strength of the cardboard due to its corrugated construction. Plan and lay out the design configuration on the sheet of cardboard. Maximize the support strength while minimizing the quantity of material used.

In addition to the structure, design an instructional pamphlet directing the user how to assemble and disassemble the structure. The format is determined relative to the amount of information that must be communicated. It should incorporate visual examples and written directions that are easily reproduced in one color.

Also included in the final presentation requirements is a design documentation booklet that includes developmental sketches, photographs of three-dimensional models, orthographic and paraline drawings of the final solution, and a scale layout of the pattern pieces as they were laid out on a 4' x 8' sheet of corrugated cardboard (see Figures 6.107–6.109).

Figure 6.107 (a-b) Design of assembly instructions (illustrated by Lori Reeder).

6.107a

6.107b

Figure 6.108 (a-d) Assembly process of sleeping support structure (designed by Lori Reeder).

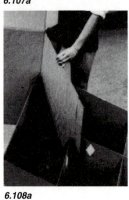

6.108a 6.108b

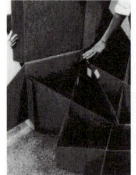

6.108c

6.108d

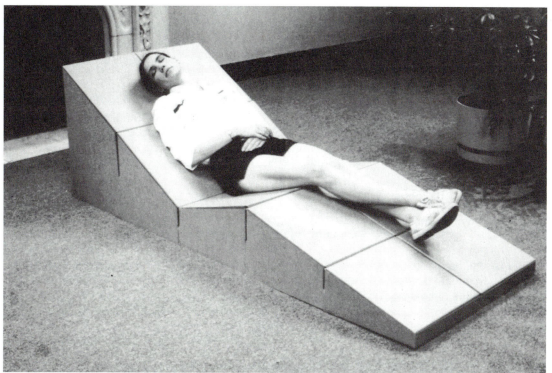

6.109

Figure 6.109 Testing sleeping support structure (designed by Lori Reeder).

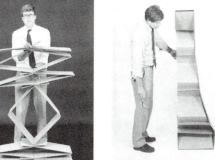

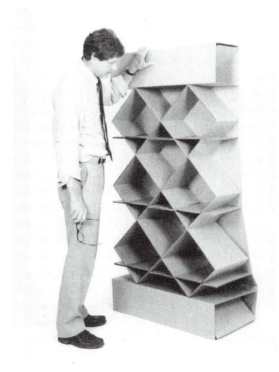

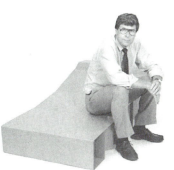

6.110b

6.110c

6.110a

6.110d

Figure 6.110 (a-d) Testing and evaluating other sleeping support structures (student work).

REFERENCES AND RESOURCES

Cowan, Henry J., and Forrest Wilson. *Structural Systems*. New York: Van Nostrand Reinhold, 1981.

Hennessey, James, and Victor Papanek. *Nomadic Furniture*. New York: Pantheon Books, 1973.

Holden, Alan. *Shapes, Space and Symmetry*. New York: Columbia University Press, 1971.

Mainstone, Rowland J. *Developments in Structural Form*. Cambridge, MA: The MIT Press, 1983.

Marks, Robert W. *The Dymaxion World of Buckminster Fuller*. New York: Reinhold Publishing, 1960.

Morgan, W. *The Elements of Structure*. 2d ed., revised by Ian G. Buckle. Marshfield, MA: Pitman, 1978.

Oka, Hideyuki. *How to Wrap Five Eggs*. New York: Harper & Row, 1967.

Palmer, Bruce. *Making Children's Furniture and Play Structures*. New York: Workman, 1974.

Pearce, Peter. *Structure in Nature Is a Strategy for Design*. Cambridge, MA: The MIT Press, 1978.

Pearce, Peter, and Susan Pearce. *Polyhedra Primer*. New York: Van Nostrand Reinhold, 1978.

—— *Experiments in Form (A Foundation Course in Three-Dimensional Design)*. New York: Van Nostrand Reinhold, 1980.

Prenis, John. *The Dome Builder's Handbook*. Philadelphia: Running Press, 1973.

Reuleaux, Franz. *The Kinematics of Machinery*. New York: Dover, 1963.

Salvadori, Mario. *Why Buildings Stand Up*. New York: W. W. Norton & Company, 1980.

Sandori, Paul. *The Logic of Machines and Structures*. New York: John Wiley & Sons, 1982.

Scott, Robert Gillam. *Design Fundamentals*. New York: McGraw-Hill, 1951.

Siegel, Curt. *Structure and Form in Modern Architecture*. New York: Reinhold Publishing, 1962.

Torroja, Eduardo. *Philosophy of Structures*. Berkeley and Los Angeles, CA: University of California Press, 1958.

Williams, Christopher. *Origins of Form*. New York: Architectural Books Publishing Company, 1981.

Wilson, Forrest. *Structure: The Essence of Architecture*. New York: Van Nostrand Reinhold, 1971.

Wong, Wucius. *Principles of Three-Dimensional Design*. New York: Van Nostrand Reinhold, 1977.

The Visual and Physical Attributes of Form

CHAPTER OUTLINE

- Chapter Vocabulary
- What Are the Visual and Physical Attributes of Form?
- Introduction to Tone or Value
- Introduction to Texture
- Introduction to Size, Scale, Dimension, and Proportion as Attributes of Form
- Anthropometrics
- Practice Exercises
- References and Resources

CHAPTER OBJECTIVES

On completion of this chapter, readers should be able to:

- Understand the visual attributes of form and how they are used in the creation of two- and three-dimensional figures and forms.

- Understand definitions of the basic terms discussed in the chapter and how they relate to visual studies.

- Know techniques for using the physical and visual attributes (tone, value, texture, etc.) in creating and representing figures and forms.

Figure 7.1 The gray area (Visual and Physical Attributes of Form) denotes the subject matter described in this chapter.

Visual Elements of Form

Perception Theory

Form Generators

Visual and Physical Attributes of Form

Space, Depth, and Distance

Point
conceptual element
No Dimension

Value/Tone
Color

2- and 3-Dimensional Form Perception

Light/Brightness
 contrast threshold
Illusions
Monocular Cues
 size
 partial overlap
 value
 color
 aerial perspective
 detail perspective
 linear perspective*
 texture gradient
 shadow
 blurring of detail
 transparency
Binocular Cues
 muscular cues
 parallax cues
Position
Orientation
Motion
Time

Line

Value/Tone
Color
Texture
Dimension
 length
Direction

Plane

Value/Tone
Color
Texture
Dimension
 length
 width
Shape
 direction
 visual stability
Proportion

Form

Form is the primary identifying characteristic of volume

Volume is the product of:
points (vertices)
lines (edges)
planes (surfaces)

Value/Tone
Color
Texture
Dimension
 length
 width
 depth
Shape
 direction
 visual stability
Proportion

***Drawing/Projection Systems**
Orthographic
Paraline
 axonometric
 oblique
Perspective

7.1

CHAPTER VOCABULARY

Dimension The actual size of figures and forms within the visual field measured in standard units such as picas, inches, or meters. The dimensions of a regular planar figure are measured according to height and width, whereas the dimensions of a regular volumetric form are measured according to height, width, and depth.

Pattern An emphasis on visual form relationships through the repetition of one or more visual elements. Many textures also have or create a specific pattern.

Proportion A comparison between size and quantity. Proportions are often expressed in terms of ratios, such as 1:2, or they can be expressed in more general terms, such as "twice as big as" or "darker than."

Relative scale A scale represented in painting, drawing, and photography through the inclusion of known objects. For example, if an adult person is shown next to a building in a composition, this gives the viewer a sense of the building size because the viewer has a general idea of the actual size of the person.

Scale Size and dimension of figures and forms relative to some unit of measure. Scale is presented in a formal drawing through a notation of dimension of the image as compared to the actual dimension in the physical world—for example, 1/2" = 1'-0".

Size Relative term used in comparing figures. For example, one figure can be "larger" or "smaller" than another. Size helps the viewer determine scale, depth, and distance within the visual field.

Texture The characteristics of a surface that are experienced through touch or vision, which can be represented on a two-dimensional picture plane through various drawing and media techniques.

Value and **Tone** Interchangeable terms that refer to the relative lightness or darkness created as light reflects off the surface of an object.

WHAT ARE THE VISUAL AND PHYSICAL ATTRIBUTES OF FORM?

As was discussed in Chapter 5, different elements are used in creating and representing two- and three-dimensional figures and forms. This chapter presents an overview of visual surface attributes of natural and manmade forms. These attributes include visual characteristics such as tone, texture, pattern, and color that help viewers identify and interpret objects, interior spaces, exterior structures, and visual messages. They can be represented through drawing, painting, printmaking, photography, or printed media.

It is important to recognize that natural and manmade forms have different surfaces. Surfaces can be smooth or rough, dull or shiny. Surface characteristics do not affect the structural configuration of the object or form. Tone or value, color, **texture,** and **pattern** are perceived visually; they are the visual attributes of form. **Size, scale, dimension, proportion,** and tactile texture can be both physical and visual attributes because they can be perceived through both visual and tactile means.

Artists, architects, and designers use these attributes in combination with each other in two- and three-dimensional compositions—it is almost impossible to illustrate one attribute without using another. It is important to understand this point so that the concepts and definitions presented in this chapter are not confused in the visual examples.

INTRODUCTION TO TONE OR VALUE

The terms **tone** and **value** are often used interchangeably to describe the degree of lightness or darkness within the visual field. A tone may be referred to as light, medium, or dark in value. Different tones are created and perceived as light reflects off the surface of an object.

Tone and **value** are achromatic terms that are defined along a continuum from white to black. These terms also are used to describe light and dark colors, but refer only to their relative lightness or darkness, not to the intensity of the hue. Theoretically, the range of gray tones along the white-to-black continuum is infinite; each tone depends on the varying amounts of white and black mixed together. Tone and value can be used to communicate depth and distance, visual texture, and pattern, as well as to define edges and shapes of figures and forms (see Figures 7.2–7.4).

Tone creates contrast between an object and its background or other figures or forms within the visual field. This contrast between light and dark communicates which forms are in front of others in the visual field, and how far apart the forms are positioned.

Figure 7.2 Tone or value can be represented on an achromatic scale called the "gray scale." The gray scale is represented as individual steps from white to black.

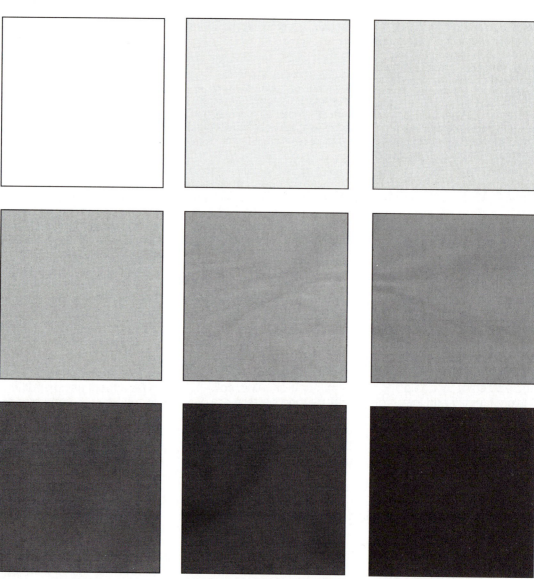

7.2

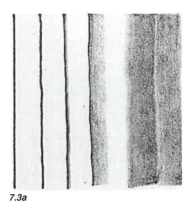

7.3a

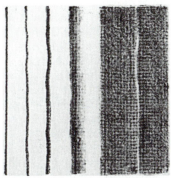

7.3b

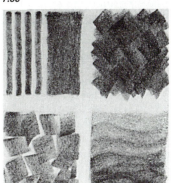

7.3c

7.3d

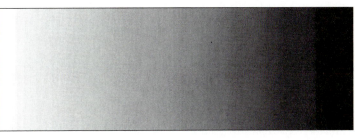

7.4

Figure 7.3 (a-d) Different pencil grades create contrasting values and line weights.

Figure 7.4 A gradual progression from white to black with subtle changes between each grey value or tone.

When tone is used to define the volumetric shape of a form, dark areas appear to exist farther from the light source and lighter areas appear to exist closer to the light source. The lightest area on the object, called the highlight, is the area closest to the light source.

Tone defines shade and shadow on three-dimensional forms as well as in two-dimensional compositions. Attached and cast shadows act as depth cues that communicate the position and distance of the object from the light source (attached shadows are the shadows cast by the contours of an object upon itself; cast shadows are the shadows cast on the ground or on other objects).

Tone is a basic and important attribute of form. Without differences in light and dark, it would be impossible to perceive figures and forms. Figures 7.5 and 7.6 illustrate objects using tone. The medium used is graphite pencil on illustration board, and the surface detail is represented using a variety of techniques.

Practice Exercise 7.1: Using Tone in Drawing

Select an object such as a fruit, vegetable, toy, or small hand tool. Use a number of different pencils of varying grades—for example, HB, 2B, and 4B. Make a tone drawing of the object. Represent the surface of the object as accurately as possible. Note that contrast is important in tone drawings. See Figures 7.5–7.9 for examples of tone drawings.

Figure 7.5 Tone drawing of X-Acto™ knife (illustrated by Pedro Alfonso).

Figure 7.6 Tone drawing of carpenter's pencil (illustrated by Robert Sheldon).

7.5 7.6

Figure 7.7 Tone drawing of scissors (illustrated by Mike Del Grosso).

Figure 7.8 Tone drawing of basket (illustrated by Pat Carleton).

7.7

Figure 7.9 Tone drawing of carrot, using HB, 2B, and 4B pencils (illustrated by Robert Sheldon).

7.9

7.8

✎Practice Exercise 7.2: Programmed Tone Study Using a Grid Structure

This exercise utilizes a square lattice or grid to divide the image area. The purpose of the exercise is to explore tone contrast when representing figures and forms within an organized image structure.

Part 1

Select a natural object such as a fruit or vegetable. After reviewing the tone drawings from the previous exercise, complete a detailed rendering of the object in tone. Once the drawing is complete, lay a sheet of tracing paper over the top. Lightly draw a square grid over the image area. In the examples illustrated in Figures 7.10 and 7.11, 1/16" and 3/8" grid squares were used.

Analyze the tone drawing, and create a five-step gray scale, including white and black, to use as a reference. Make sure that the different tones are evenly spaced.

7.10a

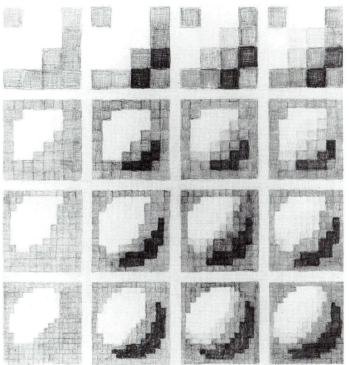

7.10b

7.11

Assign different pencil grades to the tones to achieve consistent contrast between values in the square grid areas. When the study on tracing paper is complete, transfer the grid onto quality bond paper or Bristol board.

Part 2

Prepare a more in-depth tone study by dividing the grid areas into smaller units. Experiment with the size of the grid areas and the number of gray values used. Repeat the steps in Part 1 (see Figure 7.12).

Figure 7.10 (a-b) Programmed tone drawings of a tangerine (illustrated by Pat Carleton).

Figure 7.11 Programmed tone series of spherical shapes with a single direct light source. On the horizontal axis, a darker tone is added to each image. On the vertical axis, the number of grid areas increases. The final image (bottom right) is more easily recognized because of gradual tone changes and greater detail (illustrated by Miriam Huber).

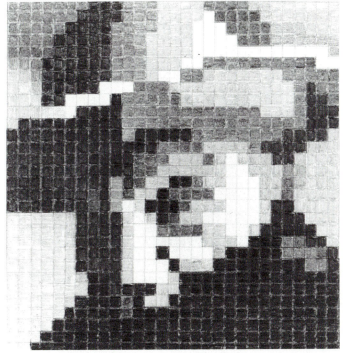

Figure 7.12 Programmed tone study portrait of Pablo Picasso (illustrated by Susan Hessler).

7.12

*Figure 7.13
Programmed tone
study of a woman's
face using a grid
(illustrated by
Susan Hessler).*

✍Practice Exercise 7.3: Using a Grid Structure to Distort a Programmed Tone Drawing

Begin this exercise by selecting an object or form, and draw it in tone. Using tracing paper, create a regular orthogonal grid. Place the tracing paper over the drawing and code the dark and light areas. Through sketching, experiment with at least three different grid variations, changing the size and shape of grid units to create distortions. Redraw the selected object or form on the grids and select the most interesting distorted image. Using a five-step gray scale to relate it to the first orthogonal study, reprogram the drawing within the distorted grids.

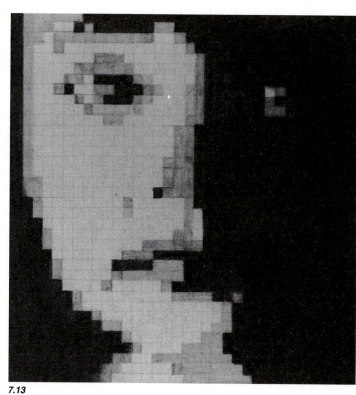

7.13

*Figure 7.14 (a-f)
Examples of (a) a
regular orthogonal
grid and (b-f) dis-
torted grid struc-
tures.*

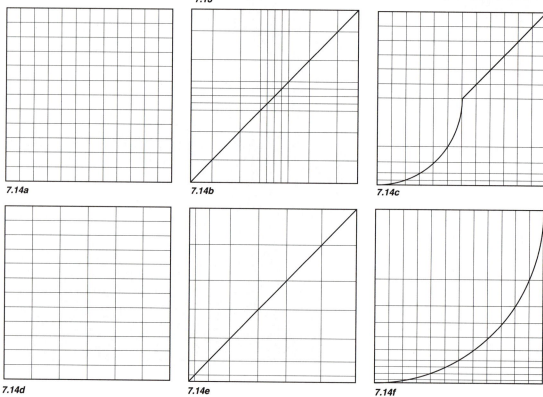

7.14a

7.14b

7.14c

7.14d

7.14e

7.14f

7.15a

7.15b

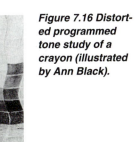

7.15c

Figure 7.15 (a-c) Using the programmed tone study of a woman's face, moving the image as it is photocopied (illustrated by Susan Hessler).

Evaluate the results, focusing on the drawing representation and tone contrast. Note that the image area can be expanded or condensed along the vertical and horizontal axes. Transfer the most interesting solution using pencil on hot press illustration board (see Figures 7.13–7.17).

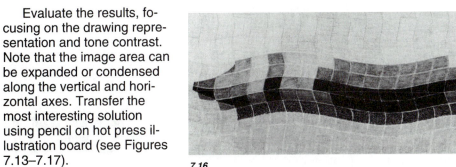

7.16

Figure 7.16 Distorted programmed tone study of a crayon (illustrated by Ann Black).

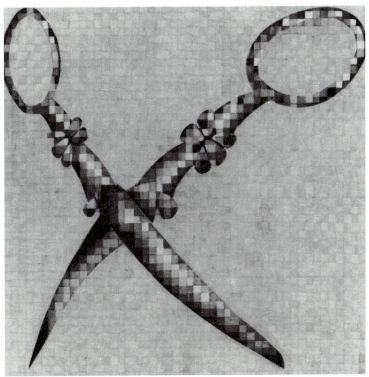

7.17

Figure 7.17 Distorted programmed tone study of a pair of scissors (student work).

Figure 7.18 A roll of paper towels viewed (a) at a distance and (b) close up. The close-up view emphasizes the surface texture (photograph by Alan Jazak).

INTRODUCTION TO TEXTURE

Since one of the objectives of this textbook is to define visual terms and relate them to the practice of visual form-giving, it is necessary to recognize that it is sometimes difficult to make distinctions between the terminology and its application. For example, in representing surface qualities on a two-dimensional picture plane, it is necessary to use one or more of the following attributes: tone/value, pattern, texture, color, and so on.

All natural and man-made materials have some type of surface texture that can be felt as well as seen. Textures can be described by such words as "rough," "smooth," "dull," and "shiny." Factors such as value contrast, color pigmentation, texture patterning, direction of the light source, reflectance of the surface, and the distance of the viewer affect the perception and representation of textures. The following pages provide examples, explanations of terms, and definitions involved in the perception and representation of textures.

Types of Texture

As previously mentioned, texture is perceived through either of two senses, touch or sight. *Tactile textures* are perceived through the sense of touch. Tactile textures are often also visual textures, since the light source creates contrast between the different surfaces of a texture, allowing them to be seen and differentiated. *Visual textures* are perceived through the sense of sight. Texture can be created by the artist, architect, or designer on a picture plane through the use of a variety of techniques and media.

Trompe l'oeil is a French term that means "fool the eye." It is used in reference to a drawing or painting that represents actual figures and forms and their surfaces and textures so realistically that the viewer believes the work is the real figure or form.

Decorative textures can be nonrepresentational, and can include rubbings, surface reliefs, or geometric patterns on the surface of an object or picture plane. This type of texture is used for visual or tactile decoration.

Observing Texture Close Up or at a Distance

Textures are an integral part of the environment. Texture is an important characteristic that can help distinguish between different objects within the visual environment. Through the sense of touch, people can feel surface irregularities and describe the "felt" textures as rough, smooth, bumpy, wavy, angular, or curvilinear.

Surface texture can be perceived through the sense of sight and described using the same words. The viewer is able to determine the shape, depth, contour, or color of the texture by the way light falls upon the surface. Surface and shape attributes become visually evident because of the differences in light wavelengths and the contrast between highlight and shadow perceived by the viewer. In addi-

7.18a

7.18b

tion, the intensity and direction of the illumination plays an important role in the visual perception of surfaces and their textures.

As more or less visual information is available depending on the viewing distance, the viewer's understanding and interpretation decreases or increases. Figures 7.18–7.22 emphasize how viewing distance affects the perception of textures. A distant and close-up view of the same object is illustrated in each example. Note how the two separate views affect the overall perception and interpretation of each object and its surface.

7.19a

7.19b

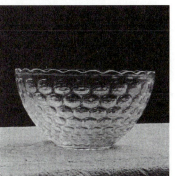

7.20a

7.20b

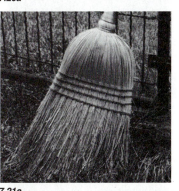

7.21a

7.21b

7.22a

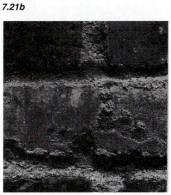

7.22b

Figure 7.19 Surface of a cardboard box: (a) viewed from a distance; the ridge-like texture is the result of the internal fluting structure. (b) A close-up view showing detail; a tactile sense of the surface is achieved by showing the inside flutes in a torn area (photograph by Alan Jazak).

Figure 7.20 Light reflecting from a glass bowl: (a) a view of the complete bowl; and (b) a close-up view emphasizing the smooth, hard surface and its bumpy pattern (photograph by Alan Jazak).

Figure 7.21 (a) A broom made of separate pieces of straw creates an overall texture. (b) When viewed close up, each straw has its own texture not visible at a greater distance (photograph by Alan Jazak).

Figure 7.22 (a) A brick wall viewed from a distance shows a regular pattern; (b) when viewed close up, the rectangular form and texture of the brick is visible (photograph by Alan Jazak).

.....................................

Figure 7.23 Close-up photographs show different materials and their textures: (a) concrete; and (b) particle board (photograph by Alan Jazak).

Figure 7.24 Photographs of a plant and one of its leaves: (a) at a distance, showing a grouping of the leaves that emphasizes an overall texture; and (b) in close-up, showing value changes, shade and shadow, which allow the viewer to perceive texture (photograph by Alan Jazak).

Texture in the Environment

Look at the photographs in Figures 7.23–7.25 and think about how textures actually feel. What characteristics help relate or associate the close-up images to the real objects? Mentally list and identify the different visual characteristics of the surfaces.

✍Practice Exercise 7.4: Observing Texture in the Environment

Collect different types of textures from the environment. Photograph or draw the various textured surfaces. While recording the visual surface characteristics, experiment with the viewing distances of these objects. What visual characteristics change when the viewing distance increases or decreases? Make a written list of the different characteristics.

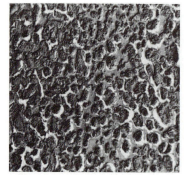

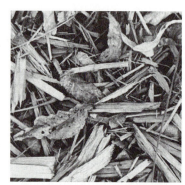

7.23a

7.23b

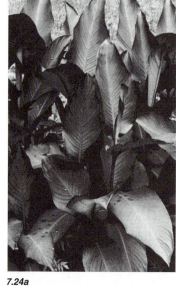

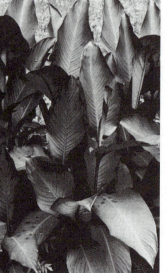

7.24a

7.24b

Figure 7.25 Photographs of a car roof and windshield (a) at a distance, and (b) close up. Weather and natural aging affects the texture as the roof material becomes brittle and cracked, producing an irregular, rough texture (photograph by Alan Jazak).

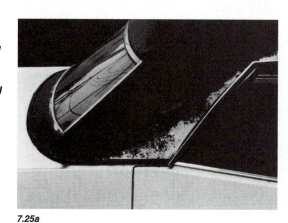

7.25a

7.25b

Representing Texture Through Drawing

Many interesting textures can be represented by combining different drawing media and techniques. Representational textures can be created through painting, drawing, rubbing, embossing, folding, and piercing. These can be tactile or visual textures simulated to look like real surface textures. To create imitated or fabricated textures, artists, architects, and designers also use value and color, utilizing various media.

Abstract and decorative textures can be created by repetition or patterns, lines, and planes. They are not necessarily representational.

Tactile textures can be represented through layering or collage techniques, embossing or debossing, or by producing a series of small pinholes or bumps in the paper surface. The overall configuration of the texture can be used to create larger compositional shapes or figures.

✐Practice Exercise 7.5: Representing Texture Through Drawing

Select an item that has an interesting visual and tactile texture. Carefully observe and record a smaller area of a texture of the selected item in a detailed representation using pen and ink. Using points, lines, and planes, draw an enlarged version of the surface (see Figures 7.26 and 7.27).

✐Practice Exercise 7.6: Creating Tactile Textures

Explore textures in the environment. Tactile textures can be created on paper through a variety of techniques, including embossing or debossing. To create an embossed or debossed surface, make a template of 4-ply Bristol board or chipboard. Design a pattern or composition and cut out the template areas to be embossed. Select a heavy, cold-pressed paper, such as watercolor paper, and place it over the Bristol board template (a cold-pressed paper usually "gives" more without tearing). Using a burnisher, rub on the cutout area to create the embossed composition.

7.26a 7.26b

7.26c 7.26d

Figure 7.26 Drawn textures: (a) sandpaper; (b) burlap; (c) chipstone; and (d) wood (illustrated by Chris Yost).

7.27a

7.27b

Figure 7.27 Close-up textures of (a) Chex® cereal (student work) and (b) corduroy fabric (illustrated by Cynthia Busic-Snyder).

✍**Practice Exercise 7.7:**
Transferring Surface Textures from an Object Through Rubbings

For the most part the visual examples in this unit have been representational photographs and drawings. Textures can also be transferred to a two-dimensional picture plane through rubbing techniques. Place a sheet of paper over a textured surface. Using charcoal, conté crayon, pastel, chalk, or pencil, rub over the sheet of paper to transfer the texture to the paper. Select five to ten differ-

ent surfaces and make rubbings. Experiment with different surfaces as well as different pencil and charcoal grades. Look at Figure 7.28 and try to identify each of the textures on the left without looking at the photographs of the objects on the right.

Figure 7.28 Visual textures created through rubbings: (a-b) racquetball racket and detail; (c-d) glass ball and detail; (e-f) screen door and detail; (g-h) wicker plate and detail; (i-j) porch blind and detail (photographs by Alan Jazak).

7.28a

7.28b

7.28c

7.28d

7.28e

7.28f

7.28g

7.28h

7.28i

7.28j

Figure 7.29 Close-up images of objects and their surface textures: (a-b) tennis ball and surface texture; (c-d) ball of yarn and surface texture; (e-f) piece of toast and surface texture; (g-h) cracker and surface texture (illustrated by: a-b, James Guy; c-d, Pat Carleton; e-f, Diana Ullman; g-h, Eric Brothers).

✍**Practice Exercise 7.8: Identifying Objects by Their Surface Texture**

Analyze the close-up detail drawings of the objects in Figure 7.29. What characteristics make the close-up drawings recognizable? Determine the media and drawing techniques used to create each image.

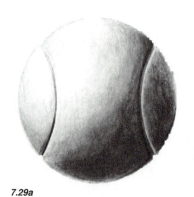

7.29a

7.29b

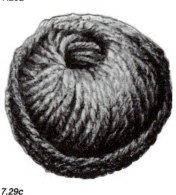

7.29c

7.29d

✍**Practice Exercise 7.9: Drawing Surface Textures Using Tone**

Select an object. Create two representational illustrations of the object in tone: a detailed, representational drawing of the entire object, and a close-up detail of the surface texture. For contrast, use different lead (H, HB, 2B, etc.), conté crayon, or pen and ink on hot press illustration board or quality bond paper (see Figure 7.30).

7.29e

7.29f

7.29g

7.29h

7.30a

7.30b

7.30c

7.30d

7.30e

7.30f

7.30g

7.30h

Figure 7.30 Tone drawings of surface textures: (a-b) carpenter's pencil; (c-d) push broom; (e-f) plastic comb; and (g-h) knit ski hat (illustrated by: a-d, student work; e-f, Fariba Farid; g-h, Robert Sheldon).

Figure 7.31 Close-up views of textures: (a) puncturing; (b) cut-out areas; (c) weaving; and (d) embossing (student work).

✍Practice Exercise 7.10: Exploring Surface Textures on Three-Dimensional Forms

Experiment with different papers or paperboards, utilizing embossing, scoring, weaving, and puncturing techniques on the paper surface (see Figure 7.31). Then fold the paper into a simple three-dimensional form, such as a cube or pyramid. Score the edges to be folded, then use glue or double-stick tape to secure the edges of the form (see Figures 7.32 and 7.33).

7.31a

7.31b

7.31c

7.31d

Figure 7.32 Three-dimensional pyramid and cube forms: (a) pyramid embossed; (b) cube pierced; and (c) pyramid woven (student work).

7.32a

7.32b

7.32c

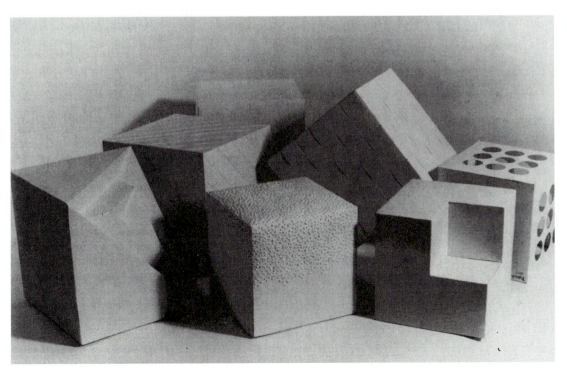

7.33

Figure 7.33 Three-dimensional cube forms illustrating different surface textures—pierced, embossed, and woven (designed by Denny Nordman, Esther Krams, Laura Gulasch, Dave Dubick, Angelika Peck, Joyce Cook, Dale Kanner, and Karen Shenker).

INTRODUCTION TO SIZE, SCALE, DIMENSION, AND PROPORTION AS ATTRIBUTES OF FORM

So far this chapter has examined the role of tone or value and texture in creating compositions, objects, and forms, but the attributes of size, dimension, scale, and proportion also relate to the form generation process.

It becomes evident in studying art, architecture, and design that an awareness of the terminology and visual application of size, dimension, scale, and proportion is necessary. These attributes affect the meaning, planning, visualization, and detailing of the final figure or form, and they can work together toward an aesthetic problem solution (see Figures 7.34–7.38).

Size

Size is a relative term; its determination requires comparing figures or forms to each other. Size helps the viewer determine scale, depth, and distance, or add meaning to visual forms or compositions.

Figure 7.34 Size relationships (a) comparing big and small, and (b) accentuating the format by enlarging the letterform.

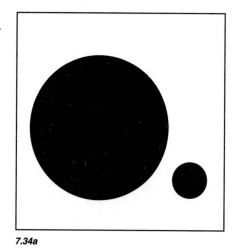

7.34a

7.34b

Figure 7.35 Example of size contrast using an architect's scale to illustrate the concept of extreme increase or decrease in size (illustrated by Cynthia Busic-Snyder).

7.35

7.36

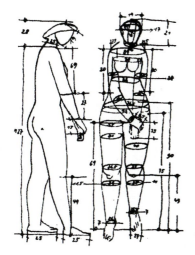

7.37

7.38

Figure 7.37 Dimension refers to the specific size of a figure or form, according to a unit of measure (illustration from Art: The Revealing Experience by Kurt Kranz; New York: Shorewood Publishers, 1964).

Figure 7.38 Scale relationship illustrated by exaggerating big and small.

Figure 7.39 In the word "banjo" the "o" is increased in size, emphasizing the phonetic sound of the letter and reinforcing the general iconic shape of the lower part of the actual musical instrument (typographic exercise by Professor Peter Megert, Department of Industrial Design, The Ohio State University; illustrated by Shari Cohen).

Figure 7.40 Magazine advertisement for Volkswagen using size to create a visual and verbal pun (from Graphic Design: Visual Comparisons © 1964 by Alan Fletcher, Colin Forbes, and Bob Gill; design by R. Levenson, J. Koenig, H. Krone, W. Paine, and D. Reider; U.S.A.).

Figure 7.41 (a-b) Size contrast of paper clip and spring (student work).

Within the design process, meaning can be reinforced by visual images or words, using size to contrast the visual communication (see Figures 7.39 and 7.40).

7.39

First you thought small.

7.40

✎Practice Exercise 7.11: Size Contrast

Select a number of small objects. Develop sketches that give new meanings or interpretations to the objects by altering their sizes and positions within the picture plane. The composition can be drawn or produced as a photogram. (A photogram is made by laying an object on light-sensitive paper and exposing it to light for a few seconds; this results in a black and white contour copy of the object.) Mount the final composition or photogram on hot press illustration board (see Figure 7.41).

7.41a

7.41b

Scale

Scale refers to the size and dimension of figures and forms relative to a specific unit of measure. Scale can be determined in two ways: through actual measurement or through visual estimates based on comparison. Figures 7.42 and 7.43 are examples of visual puns using size and scale contrast.

7.42

7.43

Scale is a learned and applied relationship. Architectural drawings and scale models are examples of the applied use of scale. Also, scale is used to specify or illustrate details based on the relative sizes of objects. For example, a drawing or three-dimensional model can be scaled up (made larger) or scaled down (made smaller) in comparison with the actual measurements of the real object forms or structures. Since there are specific relationships between the actual object or form and the model, it is necessary to ensure proper scale (relative dimensions) in the representation. This consideration is based on both a functional and aesthetic relationship. Substantial deviation from a normal scale relationship can create dramatic results and visual interest within the design or composition (see Figures 7.44–7.46).

Figure 7.44 A toy chicken model illustrating reverse of size, scale, and dimension between model and figure (student work).

7.44

Figure 7.45 Children's play structure model illustrating the size and dimension of the play structure relative to the children (designed by Louise Utgard).

7.45

Figure 7.46 Coin illustrating change of scale.

7.46

Dimension

Dimension refers to the actual measured size of figures and forms. Different standard units, such as inches, picas, and meters, are used to document dimensions. Any unit of measure can be used for dimensioning within a context as long as it is consistent throughout the entire measurement process.

Different units of measure are used in engineering, architecture, graphic arts, printing, journalism, and related professions. For example, engineers use an engineering decimal scale, whereas architects use an architectural scale with six different units of measure. Graphic artists, photojournalists, and printers use the point, pica, and agate scales (see Figure 7.47).

In the United States, measurements are usually specified in inches, feet, and yards; however, in many other countries measurements are specified using the metric system of millimeters, centimeters, and meters.

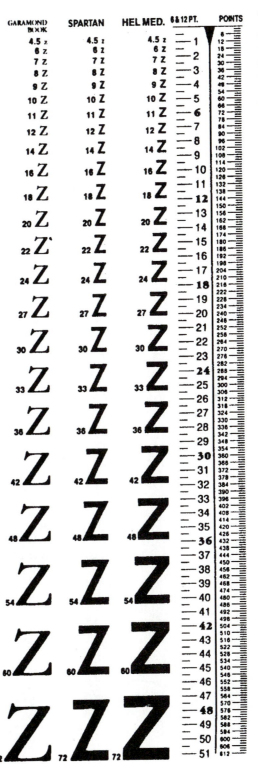

Figure 7.47 Types of measuring tools: (a) points and picas scale; (b) inches rule; and (c) type gauge.

7.47b

7.47c

7.47a

Three-dimensional forms and structures have three size dimensions: length, width, and depth. This means that in architectural and engi- neering specification draw- ings, more than one view is required to indicate true di- mensions for construction (see Figures 7.48–7.50).

Figure 7.48 Engi- neering drawing: orthographic view of a form, specifying its di- mensions in inches.

7.48

Figure 7.49 An architectural drawing of a win- dow detail indi- cates dimensions in inches.

7.49

Figure 7.50
**Dimensional work-
ing drawing of a toy
truck (designed by
Terry Birchler).**

7.50

Proportion

Proportion is a comparison between the size and quantity of parts as they relate to a total physical form. Proportion, as a concept, is considered an attribute of form because the ratio formulas are often used to determine visual order or visual balance. The three types of proportion are: geometric, arithmetic, and harmonic, as discussed in Chapter 12.

Proportions are expressed in terms of ratios such as a:b or 1 to 2; the basis of any proportional system is a constant ratio (see Figures 7.51–7.53).

Proportional systems establish visual relationships of size, shape, and quantity between the parts or elements of each form and its whole. Proportional systems for art, architecture, and design have been used throughout history.

Root Rectangles

Root rectangles can be used as a proportional device for organizing visual information or creating figures and forms (see Figure 7.54). For a more in-depth discussion of root rectangles, see Chapter 12.

Figure 7.51 Ratio is a comparison of any two quantities.

Figure 7.52 A continuous proportion is a comparison of two or more equal ratios.

Figure 7.53 A discontinuous proportion is the comparison of two unequal ratios.

Figure 7.54 The diagonal of the square provides the radius of an arc for the root rectangles. Each subsequent root rectangle radius arc is formed by striking a new diagonal on the previous rectangle.

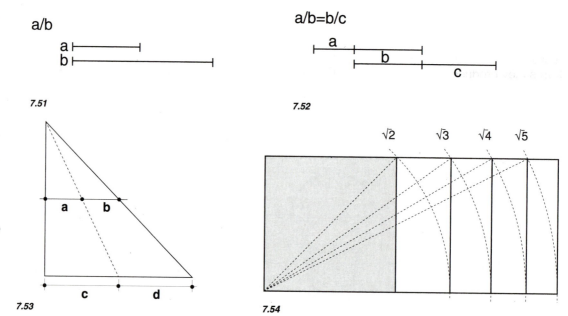

7.51

7.52

7.53

7.54

Golden Section

Historically, the golden section, also known as the golden mean, has been one of the most widely used proportional systems. The Greeks used this system as a means of achieving beauty and visual order in their temples and art forms. "Beauty" in this sense refers to order or visual organization, which the Greeks related to the natural environment and the higher order of the universe.

The golden section was also used by architects and artists during the Renaissance. For example, Palladio, da Vinci, Dürer, and, in more recent times, Le Corbusier, applied the golden section proportions to art forms, architectural structures, and sculptures.

The golden section is a geometric proportion system based on the equation of two ratios: a/b = b/a + b = 1.618 (see Figure 7.55).

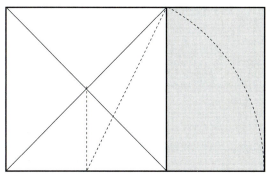

7.55

Proportion in Art or Utilitarian Objects

In the Renaissance, the artist's concern for aesthetics and visual harmony led to the formulation of proportional systems that would help the artist, craftsman, and architect to create beauty in the forms they produced.

The harmonic scale was used to generate proportional dynamic relationships through geometric ratios and progressions that related the elements of form to the object as a whole. In a harmonic scale the dimensions and proportions within the figure or form are submultiples of the whole. The use of proportion is evident in the drawings and analyses of Greek vases in Figures 7.56–7.58.

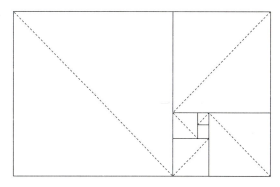

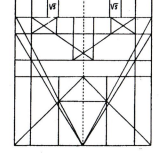

7.56

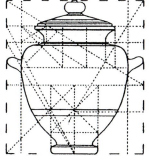

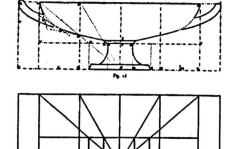

7.57

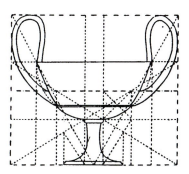

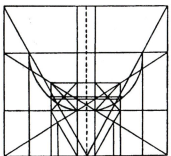

7.58

Figure 7.55 A golden rectangle constructed, beginning with a regular square, by drawing an arc from the center of the bottom line. A golden rectangle can be subdivided into proportional areas within the rectangle.

Figure 7.56 Harmonic analysis of a Greek vase "Stamnos" (from The Geometry of Art and Life *by Matila Ghyka © 1946, Sheed & Ward, Inc.).*

Figure 7.57 Harmonic analysis of a Greek vase "Kylix" (from The Geometry of Art and Life *by Matila Ghyka).*

Figure 7.58 Harmonic analysis of a Greek vase "Kantharos" (from The Geometry of Art and Life *by Matila Ghyka).*

Figure 7.59 Diagrams of the Parthenon proportional relationships: (a) according to subdivisions of a square (from **Discovery of the Square** *by Bruno Munari, Wittenborn); (b) illustrating the proportions of vertical and horizontal members (from* **The Geometry of Art and Life** *by Matila Ghyka); and (c) illustrating construction of analysis proportions (Jay Hambidge).*

Proportion in Architecture

The Pythagorean axiom that "Everything is arranged according to numbers" was influential in the evolution of the concept of geometry and proportion in art and architecture. The Pythagoreans stipulated number and proportion as the elements of an all-pervading harmony of the universe. These concepts were developed by followers of Pythagoras and Plato and laid the foundation of visual order and beauty during the Renaissance and within Western architecture.

Proportional systems are used to analyze and discuss historical works such as the Parthenon (built ca. 432 B.C., Athens, Greece). Few diagrams or construction drawings remain from the time of its construction, but many historians, mathematicians, archaeologists, and architects have speculated about and proportionally analyzed its visual, aesthetic, and structural characteristics. Many of these analyses are based on Greek thought that attempted to account for the harmonic order of the universe through proportion (see Figure 7.59).

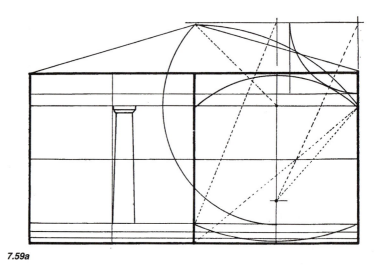

7.59a

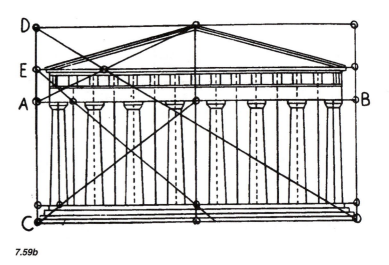

7.59b

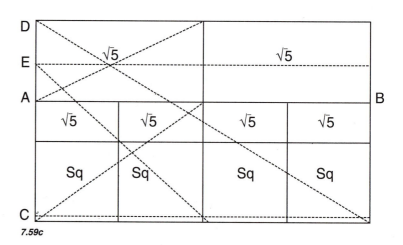

7.59c

The use of proportion is evident in classical architecture and its orders. The *orders* are styles of structure identified by the proportion and detailed ornamentation of structural columns. There are five orders: Tuscan, Doric, Ionic, Corinthian, and Composite. The Greeks and Romans believed that the proportions of the orders represented beauty and harmony.

The proportion of each order or column is carefully planned, and each detail has a proportional relationship to the module, or diameter, of the column. Since the orders are based on a system of proportion rather than on fixed dimensions, they could be scaled to accommodate the architectural requirements of a variety of situations. This use of proportion ensured that the individual architectural elements of a building were in proportion to each other and to the whole structure, thus creating visual harmony (see Figure 7.60).

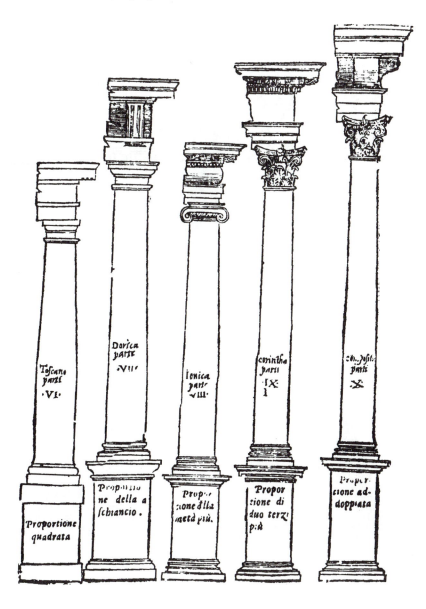

Figure 7.60 The classical orders of columns: Tuscan, Doric, Ionic, Corinthian, and Composite (from Proportion: A Measure of Order, Carpenter Center, Harvard University, 1965).

Proportion in Roman Letterforms

In 1463 a young Italian scholar/printer named Felice Feliciano developed the first manuscript setting forth rules governing the construction of a Roman capital alphabet using geometric means. The importance of using geometry as an aid to letterform development supported the growing demand for ornamental and elegantly printed books and manuscripts during the Renaissance. Also during this time, a number of other scholars, mathematicians, and painters developed their own proportional construction for Roman capital letterforms. In 1509 Luca Pacioli, an Italian mathematician and inventor, developed and published his treatise on the Roman capitals and the proportions of the human body. This well-known work was entitled *De Divina Proportione,* meaning "divine proportion."

Figure 7.61 The letter "A" by Luca Pacioli, derived from the square and circle.

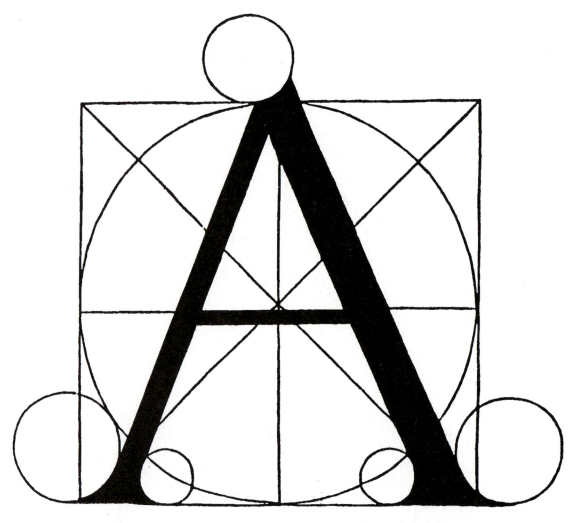

7.61

The proportions of the letterforms by Pacioli were based on relative measurements (see Figure 7.61). The right arm of the letter "A" is one-ninth as thick as the height; the left arm is half as thick as the right. The middle cross-stroke is one-third the thickness of the right arm and is located slightly below the center point of the square. The square center point is determined by crossing the two diagonals.

German artist Albrecht Dürer also developed a treatise on both a Roman and a Gothic alphabet as part of his book entitled *Unterweysung der Messung* published in Nuremberg in 1525. Although the letters developed by Dürer were well formed, they were considered too complex and impractical. Figure 7.62 shows various developments of the letter "A" from different time periods.

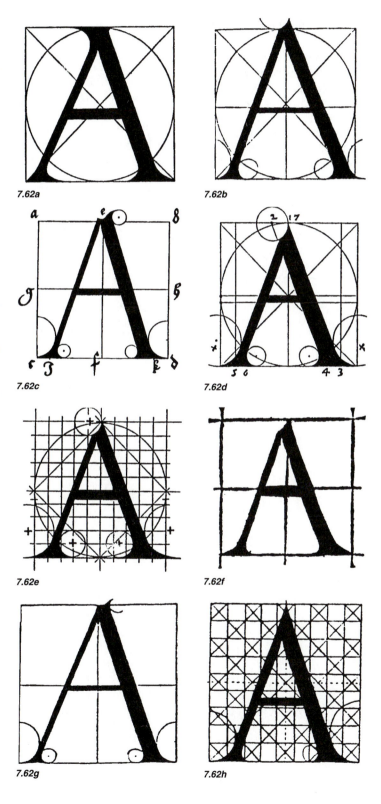

7.62a

7.62b

7.62c

7.62d

7.62e

7.62f

7.62g

7.62h

Figure 7.62 Chronological comparison of the development of the letter "A" by: (a) Hartmann Schedel, 1482; (b) Leonardo da Vinci, 1509; (c) Albrecht Dürer, 1525; (d) G. B. Verini, 1526; (e) Geoffroy Tory, 1529; (f) Serlio, 1549; (g) Juan Yeiar, 1550; and (h) Pierre LaBe, 1601.

Proportion in Paper and Print

Root rectangles and golden section proportions have been used to determine and standardize paper sizes for the graphics industry. Close to thirty countries use the standard DIN system, often referred to as "International Paper Sizes," set forth by the International Organization for Standardization (ISO).

Originally, Germany led the way in standardizing paper sizes. The primary reason for standardization was economy; that is, fewer standard sizes make mass production easier and require less storage space at paper mills. Within the graphics industry, it also brought about a standardization of printing press sizes.

The ISO proportions for sheet sizes are based on a square. The proportion of the short side of the sheet to the long side of the sheet is the same as the proportion of the side of a square to its diagonal. The DIN proportion of the short side of the sheet to the long side of the sheet is 1:1.414 (1:$\sqrt{2}$), which is the formula for the $\sqrt{2}$ rectangle (see Figure 7.63).

The DIN paper series is identified according to a letter and a number. For example, A is the largest sheet

Figure 7.63 (a-b) The DIN proportion is 1:1.414, the same as the $\sqrt{2}$ rectangle.

7.63a

7.63b

Figure 7.64 (a-b) In the DIN paper sizes, the sheet is halved to achieve the next sheet size.

7.64a

7.64b

size: the letters B, C, and so on become proportionally smaller. The number refers to the subdivision of the sheet size, beginning with zero. As the sheet is divided, it becomes A1; when it is halved a second time, it becomes A2, and so on (see Figure 7.64).

Historically, many manuscripts and books were based on proportional type and margin areas. In recent years the development of proportional grid systems has governed the areas to be filled with type and images.

The construction for the classical proportions of the page layout is as follows: The diagonals BC and AB across both pages establish

D. A vertical is drawn from D to the top of the page, creating E, then line EF is drawn. F corresponds to point D. Point G establishes the top

margin. H is where a horizontal line from G intersects diagonal BC, establishing the top margin (see Figures 7.65 and 7.66).

Figure 7.65 Construction of type and margin area for a publication: Diagonals YZ are drawn first. X is found by striking an arc from the bottom corner to the center margin. A horizontal line at X intersects YZ, and a vertical line is drawn to establish the top and outside margins. The inside margin (gutter) and bottom margins are determined by the printing press and binding equipment capabilities.

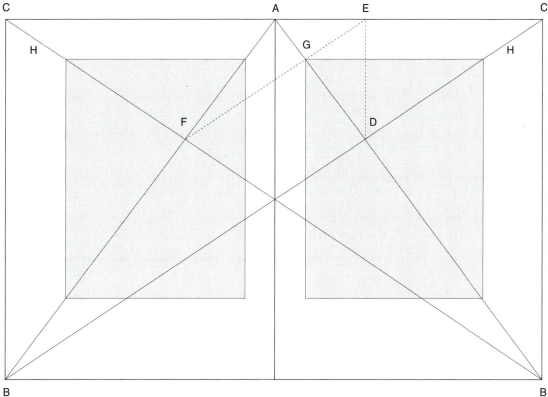

7.65

7.66

Figure 7.66 Classical proportions of the type area to the margin space based on the diagonals AB for a double-sided page layout.

✍Practice Exercise 7.12: Altering the Proportions of an Object

To understand proportional systems and how they affect an object visually, it is necessary to understand the application of different systems. As a study example, prepare a simple and accurate line drawing of a hand-held object such as a pencil, pen, compass, pushpin, hammer, or screwdriver. Construct a front view of the object using triangles, a T-square, and templates for accuracy. Ink the drawing using technical pens.

Next, select a proportional system that will allow change in the dimensions of the drawn object: an arithmetic proportion (1, 2, 3 . . .); a geometric proportion (1, 3, 9, 27, . . .); and a harmonic proportion (1, 2, 4 . . .). Translate the selected proportions onto an orthogonal grid. Plot the object drawing on a 1:1 orthogonal grid to determine the points of intersection. Then plot the drawing of the object on the proportional grid.

Figure 7.67 Grids can be based on proportional systems such as (a) regular orthogonal grid, (b) geometric grid along the horizontal axis, (c) geometric grid along the horizontal and vertical axes, (d) harmonic grid along the horizontal axis, and (e) harmonic grid along the horizontal and vertical axes.

7.67a

7.67b

7.67c

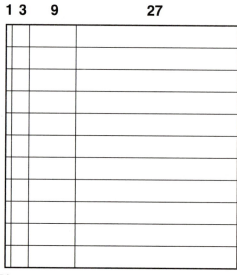

7.67d

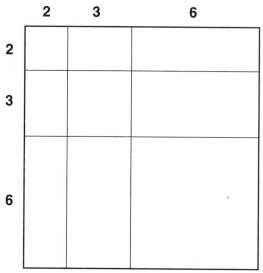

7.67e

After experimenting with different ratios and proportional types of grids, develop sketches of the selected object that illustrate contrasting proportional changes. Note the different variations and observe which proportional types are the most interesting. Redraw the best examples with ink on hot press illustration board (see Figures 7.67–7.69).

7.68

7.69a

Figure 7.68 Pushpin reproportioned along the horizontal axis (illustrated by Lawrence Krolak).

Figure 7.69 Ink bottle reproportioned along the: (a) horizontal axis and (b) vertical axis. (c) Normal (illustrated by Cynthia Busic-Snyder).

7.69c

7.69b

*Figure 7.70 Albrecht Dürer's "Holzschnitt aus der Proportionslehre" ca. 1528 (from **Dürers Gestaltlehre der Mathematik und der Bildenden Künste** by Max Steck; © 1948 Max Niemeyer Verlag).*

Human Proportion

The study of human proportional relationships has played an important role in art, architecture, and design throughout history. Artists, architects, philosophers, and mathematicians have attempted to give a personal rationalization to the proportional units and dimensions of the human figure. These human proportions have often been related to aesthetics and beauty rather than to the absolute measurements and functional structure of the human body.

During the Renaissance, there were different views as to how studies of human proportions were to be visually interpreted and adhered to in drawing, painting, sculpture, and architecture. P. H. Scholfield points out in *The Theory of Proportion in Architecture* that many studies were merely an exercise to explore the relationship between parts of the human anatomy and the whole body proportion. He backs up his point with the writings and drawings of some of the Renaissance masters. For

example, Vasari theorized in *On Technique* in 1550 that the eye should judge the representation of the proportions of the human body, deciding where to add and take away. Scholfield also noted that Leonardo da Vinci, despite his own drawings and recordings on human anatomy and proportion, did not bother to draw or paint with mathematical precision [P. H. Scholfield, *The Theory of Proportion in Architecture* (New York: Cambridge University Press, 1958), p. 41].

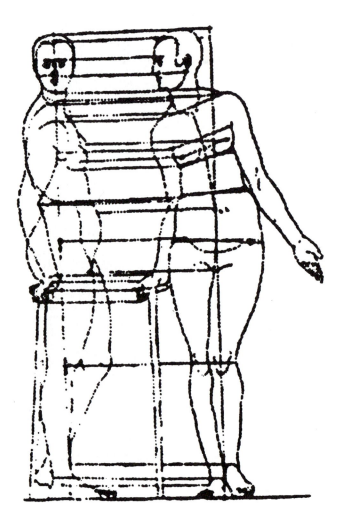

7.70

During the Renaissance, human proportions were thought to be submultiples of the whole figure or of the face, or multiples of the small division of the height of the human figure (see Figures 7.70–7.72). The two proportional theories emphasized during the Renaissance were the harmonic system and the arithmetic system. The harmonic system was developed from abstract mathematical laws of proportion; the arithmetic system was based on an empirical approach.

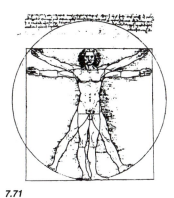

7.71

Figure 7.71 Leonardo da Vinci's drawing of the human figure based on the Vitruvian proportions for "normal" adult size male (from Dürers Gestaltlehre der Mathematik und der Bildenden Künste by Max Steck; © 1948 Max Niemeyer Verlag).

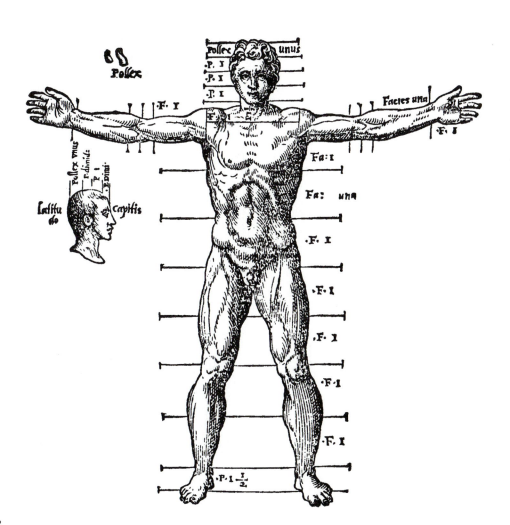

7.72

Figure 7.72 Barbado's "Vitruvius." According to the human proportions described by Vitruvius, the face is used as a module to determine the proportions of the rest of the human body (from Dürers Gestaltlehre der Mathematik und der Bildenden Künste by Max Steck; © 1948 Max Niemeyer Verlag).

The Modulor by Le Corbusier

In recent times, the search for proportional relationships has continued. During the 1940s French artist and architect Le Corbusier developed the Modulor, an important example of relating a system of proportion to architectural forms as a means for controlling the repetition of similar shapes. The Modulor (from the French *le modulor,* meaning standard or unit) is a system of dimensions intended to standardize the size of mass-produced building components, which complements the philosophies and practice of industrial design. The rationale behind the Modulor system was to incorporate the logic, function, and aesthetics of mathematical proportions (the golden section) and human proportions.

An important aspect of the Modulor scale is the relationship of the human figure to architecture. During the Renaissance, there was little interest in the relationship between proportion in architecture and proportion in the human figure. The Modulor was devised not only to assist in designing products with dimensions proportional to man, but also to relate human proportions to architectural elements and buildings in planning neighborhood spaces and cities (see Figures 7.73 and 7.74). The Modulor was an important discovery leading to Le Corbusier's involvement in many important architectural developments, such as the design of the United Nations building in New York City. It was also related to exhibition and furniture design, art, painting, and sculpture.

The Modulor system is composed of two scales, called the red scale and the blue scale. The red scale establishes the dimension 175.0 cm as the height of an average man (based on Le Corbusier's studies). The dimension 108.2 cm represents the height of a man's navel. If the navel height is doubled, it equals 216.4 cm, which is the height of the man with his arm raised

Figure 7.73 Le Corbusier's constructions illustrating modular proportions, which are similar to the golden section proportions (from The Modulor: A Harmonious Measure to the Human Scale Universally Applicable to Architecture and Mechanics by Le Corbusier *by Charles Edouard Jeanneret; © 1991 ARS, N.Y./Spadem).*

Figure 7.74 "Modulor" illustration by Le Corbusier (from The Modulor: A Harmonious Measure to the Human Scale Universally Applicable to Architecture and Mechanics by Le Corbusier *by Charles Edouard Jeanneret; © 1991 ARS, N.Y./Spadem).*

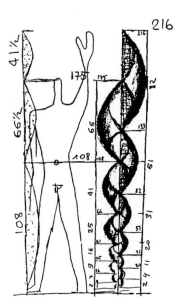

7.73

7.74

above his head. The divisions of the red scale are then doubled to create the blue scale and form a progression.

According to the measurements of man (175 cm), the Modulor grid was given the dimensions 175, 216.4, and 108.2. These measurements correspond to a series 1, 2, 3, 4, 5, 6 . . . so that 1 = 25.4 cm; 2 = 41.45 cm; 3 = 66.8 cm; 4 = 108.2 cm; 5 = 175.0 cm, and so on (see Figure 7.75).

Le Corbusier wrote: "The Modulor is a measuring tool based on the human body and on mathematics. A man with arm upraised provides, at the determining points of his occupation of space— foot, solar plexus, head, tips of fingers of the upraised arm—three intervals which give rise to a series of golden sections called the Fibonacci Series. On the other hand, mathematics offers the simplest and most powerful variation of a value: the single

unit, the double unit and three golden sections" [Le Corbusier, *The Modulor* (Cambridge, MA: Harvard University Press, 1954), p. 55]. (See Figure 7.76.)

The original concept of the Modulor was not of a continuous linear scale, but of proportions limited to a few dimensions within a grid. This proportioning grid was intended to provide practical measurements for designing and building products such as doors, windows, and furniture—allowing it to be applied to mass-produced housing and prefabrication technology

Le Corbusier's Modulor was originally based on the height of the average Frenchman at that time, 175 cm. By converting this to the average height of an Englishman, 6'0", a standard for both the metric measurements and the feet/inches measurement was achieved. (6' x 30.48 = 182.88 or 183

cm). The Modulor was then translated into measurements based on a height of 6'. Le Corbusier set forth tables describing the exact and practical values of the grid scale, in both the metric system and in feet and inches. This accomplishment was important to the whole concept of the Modulor: it meant that it could be applied to manufactured products around the world, bridging the communication problem created by the use of two different measuring systems.

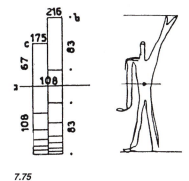

7.75

Figure 7.75 Relationship of the scales to the human proportion (from The Modulor: A Harmonious Measure to the Human Scale Universally Applicable to Architecture and Mechanics by Le Corbusier *by Charles Edouard Jeanneret; © 1991 ARS, N.Y./ Spadem).*

Figure 7.76 Le Corbusier converted the original dimensions based on a height of 175 cm to a height of 183 cm (from The Modulor: A Harmonious Measure to the Human Scale Universally Applicable to Architecture and Mechanics by Le Corbusier *by Charles Edouard Jeanneret; © 1991 ARS, N.Y./ Spadem).*

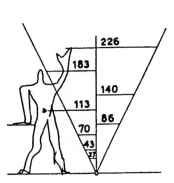

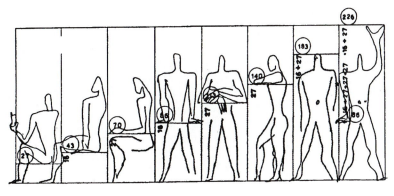

7.76

ANTHROPOMETRICS

Human Dimensions

By reviewing these historical theories of numbers and measurements we can see how man has searched for relationships within the universe, the natural world, and the physical forms he has created.

More recently, architects and designers have become involved with the concepts of human factor engineering, as it is called in the United States, or ergonomics, as it is called in Europe. Both include studies of measurements of the human figure, relating the figure to the new technology of man-machine interface, and the relationships between people and their environments based on a synthesis of human biology, anatomy, physiology, and psychology.

Architects as well as interior space designers, product designers, and visual communication designers are concerned about the formal and aesthetic qualities of their designs. However, they also must be concerned about how their designs complement the human use of space, products, or communications. Such concern takes into consideration the differences and similarities of body size, sex, race, handicaps, and occupational groups. The science that deals specifically with these factors is anthropometry. Anthropometry also deals with measurement of the body parts, their relationships, and their functions. From the introductory level of study, architects and designers should be sensitive to the need for and availability of anthropometric data, as well as to its application to the design of better products and spaces for people (see Figure 7.77).

Figure 7.77 (a-c) An example of using anthropometric data in the design of an office chair (designed by Delta Design of Stuttgart, Germany; manufactured by Wilkhahn of Badmunder).

7.77a

7.77b

7.77c

✍**Practice Exercise 7.13: Understanding Anthropometrics**

Human proportion can be understood by constructing a foamcore model of oneself, using one's own dimensions. Each person should have a partner to assist with measuring in this exercise.

Refer to *Human Dimension and Interior Spaces* by Martin Zelnik for visual examples of how to measure and record the body dimensions. Each pair of people requires a pair of calipers to take measurements; however, similar tools can be fabricated from cardboard, chipboard, or foamcore.

Using the dimensions obtained, make body parts from the foamcore, then slot and assemble them into a mannequin. Study the example in Figure 7.78 to determine how to slot and assemble the mannequin. Compare different results, relating the dimensions to available anthropometric data.

Figure 7.78 (a-b) Anthropometric study creating mannequins (exercise by Professor Rinehart Butter, Department of Industrial Design, The Ohio State University).

7.78a

7.78b

REFERENCES AND RESOURCES

Bevlin, Marjorie Elliot. *Design Through Discovery: The Elements and Principles.* New York: Holt, Rinehart & Winston, 1985.

Carpenter Center for the Visual Arts. *Proportion: A Measure of Order.* Cambridge, MA: President and Fellows of Harvard College, 1965.

Doczi, György. *The Power of Limits: Proportional Harmonies in Nature, Art and Architecture.* Boulder, CO: Shambhala Publications, 1981.

Dürer, Albrecht. *Of the Just Shaping of Letters.* New York: Dover, 1965.

Fletcher, Alan, Colin Forbes, and Bob Gill. *Graphic Design: Visual Comparisons.* New York: Reinhold Publishing, 1964.

Ghyka, Matila. *The Geometry of Art and Life.* New York: Sheed and Ward, 1946.

Graham, Donald W. *Composing Pictures.* New York: Van Nostrand Reinhold, 1983.

Harris, Ned. *Form and Texture.* New York: Van Nostrand Reinhold, 1974.

Larkin, David, ed. *Magritte.* New York: Ballantine Books, 1972.

Lauer, David A. *Design Basics.* New York: Holt, Rinehart & Winston, 1979.

Le Corbusier. *The Modulor.* Cambridge, MA: Harvard University Press, 1954.

Linn, Charles F. *The Golden Mean.* New York: Doubleday, 1974.

Maier, Manfred. *Basic Principles of Design, Vols. 1-4.* New York: Van Nostrand Reinhold, 1977.

Munari, Bruno. *Discovery of the Square.* New York: George Wittenborn, 1962.

Ocvirk, Otto G., Robert E. Stinson, Philip R. Wigg, and Robert O. Bone. *Art Fundamentals.* 6th ed. Dubuque, IA: William C. Brown Publishers, 1990.

Scholfield, P. H. *The Theory of Proportion in Architecture.* New York: Cambridge University Press, 1958.

Steck, Max. *Dürers Gestaltlehre der Mathematik und der Bildenden Künste.* East Germany: Kreuz-Verlag, 1948.

Zelnik, Martin, and Julius Panero. *Human Dimension and Interior Spaces.* New York: Whitney Library of Design, 1979.

CHAPTER OUTLINE

- Chapter Vocabulary
- Introduction to Color
- Light and Color
- The Dimensions of Color
- Historical Concepts of Seeing Light and Color
- Color Notation Systems and Theories
- The Munsell Color Sphere
- The Ostwald System of Color Notation
- Color Pigments and Products
- Color Mixing
- Color Harmonies and Major Types of Hue Relationships
- Figure/Ground Relationships and Color
- Color Balance and Proportion
- Psychology of Color
- Two-Dimensional Color Studies
- Three-Dimensional Color Studies
- Practice Exercises
- References and Resources

CHAPTER OBJECTIVES

On completion of this chapter, readers should be able to:

- Understand basic color theory and phenomena and how they affect the creation and perception of figures and forms.
- Understand basic color properties, dimensions, and terminology.
- Understand and discuss the basic color theories and historical color notation systems presented.
- Mix color according to a given system.
- Specify and mix colors according to how they can be perceived proportionally.
- Select colors that can reinforce meaning in visual messages, products, and interior environments.
- Create harmonious color compositions.

Figure 8.1 The gray area (Visual and Physical Attributes of Form) denotes the color subject matter described in this chapter.

Visual Elements of Form

Perception Theory

Form Generators

Visual and Physical Attributes of Form

Space, Depth, and Distance

Point
conceptual element
No Dimension

Value/Tone
Color

2- and 3-Dimensional Form Perception

Light/Brightness
 contrast threshold
Illusions
Monocular Cues
 size
 partial overlap
 value
 color
 aerial perspective
 detail perspective
 linear perspective*
 texture gradient
 shadow
 blurring of detail
 transparency
Binocular Cues
 muscular cues
 parallax cues
Position
Orientation
Motion
Time

Line

Value/Tone
Color
Texture
Dimension
 length
Direction

Plane

Value/Tone
Color
Texture
Dimension
 length
 width
Shape
 direction
 visual stability
Proportion

Form

Form is the primary identifying characteristic of volume

Volume is the product of:
points (vertices)
lines (edges)
planes (surfaces)

Value/Tone
Color
Texture
Dimension
 length
 width
 depth
Shape
 direction
 visual stability
Proportion

***Drawing/Projection Systems**
Orthographic
Paraline
 axonometric
 oblique
Perspective

CHAPTER VOCABULARY

Achromatic Refers to an absence of hue; white, gray, and black are considered achromatic.

Additive mixing A process in which equal amounts of light primaries are combined; the end result is white.

Chroma Brightness or dullness of a hue. The chroma range extends from neutrality (grayness) to the brightest, most intense color a pigment can provide.

Hue A specific color or light wavelength found in the spectrum, ranging circularly from red through yellow, green, blue, and back to red.

Kelvin Absolute scale of temperature that has an approximate zero point of –273°C. The Kelvin scale is used to measure degrees of electromagnetic radiation, including the visible or white light spectrum.

Luminous energy Radiant energy of electromagnetic waves in the visible electromagnetic portion of the spectrum.

Medial Refers to the gray color that results when equal amounts of the visual primaries are combined or spun on a color wheel.

Monochromatic Describes anything having a single hue; monochromatic compositions consist of variations of one hue, using tints and shades.

Pigment Substance or matter used as coloring. Many color pigments for paints and pencils are derived from natural minerals and plants.

Primary hues Hues that are considered absolute or completely pure because they cannot be obtained by mixing. Light primaries are red-orange, green, and blue-violet; pigment primaries are red (magenta), yellow, and blue (cyan). In visual perception, primaries are red, yellow, blue, and green.

Saturation The attribute that determines the chromatic color difference from a gray of the same intensity or brightness; vividness of chroma.

Secondary hues The result of a combination of any two pigment primaries in equal proportions. The secondary hues are orange, green, and violet.

Shade A hue combined with black.

Subtractive mixing A process in which equal amounts of pigment primaries are combined; the end result is dark brown or black.

Tint A hue combined with white.

Tone A hue combined with white and black.

Value Brightness; it is the relative degree of lightness or darkness of a color measured in relationship to a graded scale from black to white.

INTRODUCTION TO COLOR

An understanding of color, its attributes, dimensions, harmonies, and phenomena is an important part of the artist's, architect's, and designer's knowledge. Those who work with or use color creatively know that color affects the viewer's attitudes and responses to objects, visual messages, and environments. Through the use of color, viewer response can be manipulated and directed. Also, color can add dimensions of excitement, pleasure, restfulness, and so on, to an artist's, architect's, or designer's work. The increasing use of color in products and environments necessitates that a great deal of study and consideration be given to the subject of color.

There are chemical, physical, and psychological aspects to color. This chapter presents only some of the basic phenomena and theories, and their applications. The textbooks listed at the end of the chapter take a more in-depth approach to the various theories and phenomena.

LIGHT AND COLOR

Color is a property of light. Electromagnetic radiation is the form through which energy is transmitted. Natural white light or sunlight is energy composed of electromagnetic vibrations of different wavelengths. These electromagnetic vibrations are called wavelengths because they travel in all directions in an undulating motion.

All objects receive, absorb, and radiate electromagnetic waves that correspond to a particular wavelength of light. The known electromagnetic radiations are categorized as visible light, gamma rays, X-rays, ultraviolet radiation, infrared rays, radar, television signals, and radio waves. Human perception is limited to the small range of visible light wavelengths (violet to red) called the visible spectrum or color spectrum. The light waves are measured in units called angstroms. One angstrom (Å) is a unit of length equal to one ten-billionth of a meter (see Figures 8.2 and 8.3).

The Color Spectrum

The color spectrum is a series of color bands that is formed when a beam of sunlight passes through a prism and is rearranged according to light wavelengths. This is the only type of electromagnetic radiation that is visible to the human eye.

English scientist Sir Isaac Newton was the first to experiment with splitting sunlight into visible bands of color. In the mid-1660s Newton identified and named seven distinct hues: red, orange, yellow, green, blue, indigo, and violet. When the color spectrum

Figure 8.2 Green light wavelength measured in angstroms (Å). Each wavelength is measured from crest to crest.

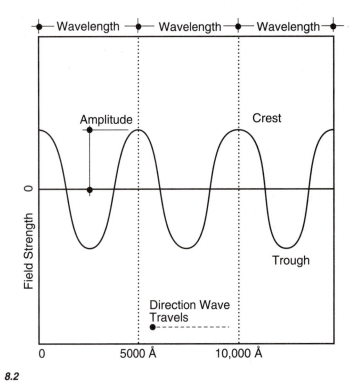

8.2

Figure 8.3 The electromagnetic spectrum includes all known types of electromagnetic radiation. White light or visible light is a small part of the whole range of light energy.

	10^4	10^6	10^8	10^{10}	10^{12}	10^{14}	10^{16}	10^{18}	10^{20}	10^{22}	10^{24}	
	Induction Heating		Radio Waves	Television Waves	Infrared Rays	**Visible Light**	Ultraviolet Rays		X-rays		Gamma Rays	Secondary Cosmic Rays
	10^{15}	10^{13}	10^{11}	10^9	10^7		10^3	10^1 (1A)	10^{-1}	10^{-3}	10^{-5}	10^{-7}

8.3

is projected back through another prism, the result is visible (white) light (see Figures 8.4 and 8.5).

The color spectrum is separated into colors, or hues. **Hue** is the specific name of a color. It is classified as either red, orange, yellow, green, blue, violet, or any intermediate hue between these depending on its light wavelength. Different light wavelengths can be mixed and separated indefinitely. The visible light wavelengths are: Red—7,000 Å; Orange—6,500 Å; Yellow—6,000 Å; Green—5,500 Å; Blue—4,500 Å; Violet—4,000 Å.

Light Sources and Color

Different types of light sources affect the way colors appear. The three common light sources are sunlight, incandescent light, and fluorescent light. White light or sunlight is a mixture of all spectrum colors, evenly distributed. The man-made light sources are not evenly dispersed hues; they emit more of one light color than the rest. The particular light color becomes visible in the immediate environment and affects the way that surface colors are perceived. Paintings and color drawings composed outdoors will look different when they are viewed indoors under man-made light sources; color photographs reflect the available light source in the final print, unless colored filters are used to compensate for these changes.

The energy from all light sources is measured in Kelvin degrees (K°), which is an absolute scale used in scientific measuring. Sunlight averages around 5,000° K, although it changes constantly during the course of the day from sunrise to sunset. The energy distribution from an incandescent lamp averages around 5,700° K; therefore, it appears more red than average sunlight. Fluorescent lamps vary according to the chemical mixture of phosphors used to make them, which allows for a wide range of colors.

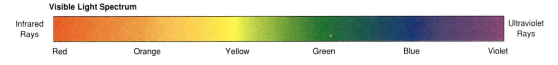

Visible Light Spectrum

Infrared Rays Ultraviolet Rays

Red Orange Yellow Green Blue Violet

Figure 8.4 Visible light spectrum.

8.4

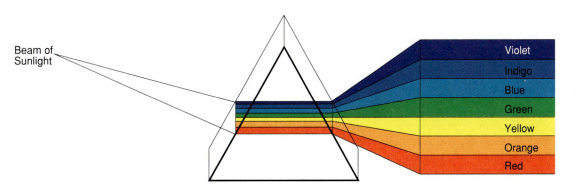

Beam of Sunlight

Violet
Indigo
Blue
Green
Yellow
Orange
Red

Figure 8.5 A prism separates a beam of visible light into its component wavelengths and displays them in a spectrum.

8.5

This explanation of the physics of light and color is to help beginning artists, architects, and designers understand that figures and forms do not have their own color, but do have the ability to reflect certain wavelengths of light, depending on their specific surface characteristics. Red objects appear red to the human eye because they absorb all visible light rays except red. The red light rays are reflected from the surface and are seen by the viewer. White objects reflect all of the visible light rays. The importance of this is that when light conditions change, the visible color perceived by the viewer changes also (see Figures 8.6 and 8.7).

Figure 8.6 Spectral energy curves are represented by the lines on the diagram as follows: A, incandescent light; B, noon sunlight; C, average daylight; and D, simulated "daylight" fluorescent light (adapted from Light and Color *by Clarence Rainwater).*

Figure 8.7 Light and color: (a) white is the total accumulation of all color so that all hue wavelengths in the immediate environment are reflected; (b) this square absorbs all the colors illuminating it, reflecting no color; therefore, it is seen as black.

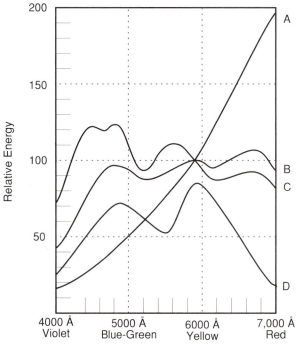

8.6

8.7a

8.7b

THE DIMENSIONS OF COLOR

There are three dimensions or attributes of color: hue; **value**, or brightness; and **chroma**, or **saturation**. Hue depends on the dominant visible wavelength of a color. The wavelength associated with the particular hue indicates that hue's position within the spectral range. Only the colors included in the spectrum are considered pure hues, and the seven spectral hues cannot be separated into simpler colors. Other visible hues are combinations of several different light wavelengths.

Value, or brightness, is the relative lightness or darkness of a color as it would appear in a black and white photograph. An image consisting of only values is called **achromatic**, meaning an absence of color. The value of a color depends on how much light the color re-

flects. Color values are referred to as **tints** or **shades**. Tints are lighter in value; shades are darker in value. The Munsell system of color notation, presented later in this chapter, specifies a nine-step value scale including black (1) and white (9). Other color notation systems divide values into different numbers of equal steps (see Figure 8.8).

Chroma, or saturation, refers to the amount of hue in a particular color or the relative purity of a color on a scale from a hue to gray. A color that has a high chroma

is said to be saturated with a **monochromatic** (one color) hue (see Figure 8.9).

Up to this point only the light spectrum colors have been discussed. There are several types of **primaries**, depending on the discipline or area of study pursued. Two are presented in this chapter: light primaries and pigment primaries. A light primary is a hue of a single dominant wavelength in its most pure state. It is unchanged by the impurities of other wavelengths. The light primaries are red (red-orange), blue (blue-violet) and

green. In **pigments**, primaries are red (magenta), blue (cyan), and yellow. **Secondary** colors or hues are created by mixing two primary colors. For example, in **additive color mixing** using light hues, the primaries of blue and green create cyan, red and green create yellow, and blue and red create magenta. In **subtractive color mixing** using pigment hues, the primaries blue and red create violet, blue and yellow create green, and red and yellow create orange.

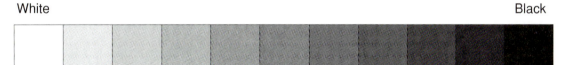

White Black

8.8

Figure 8.8 Value scale from white to black.

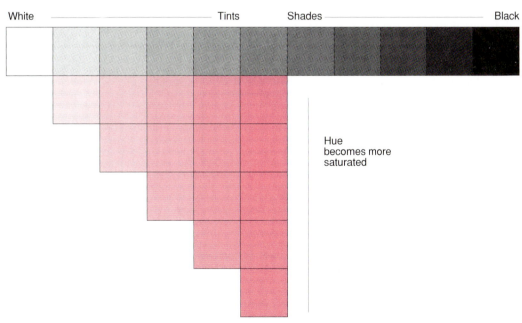

White —————————————— Tints Shades ——————————— Black

Hue
becomes more
saturated

8.9

Figure 8.9 Value and chroma.

HISTORICAL CONCEPTS OF SEEING LIGHT AND COLOR

Concepts of light and color date from before Christ. Frans Gerritsen effectively outlines the different historical concepts on this subject in *The Theory and Practice of Color*. As illustrated in Figure 8.10, he indicates that there have been four main directions of thought throughout ancient history as to how color is perceived: "1. No physical phenomenon takes place between the eye and the object observed, 2. There is radiation from the eye in the direction of the object, 3. Sight is an interaction between images ejected by the object and something like a fire from the eye, which sees as a spirit or soul, and 4. Objects we perceive send out 'rays' to which our eyes are sensitive" [Frans Gerritsen, *The Theory and Practice of Color* (New York: Van Nostrand Reinhold, 1975), pp. 14-16]. This historical overview is important because it clarifies four different directions of thought brought down through the ages, which gives an appreciation for the different concepts and theories about the nature of color.

Another historical concept, promoted by Euclid, was that light rays travel from the eye to the object in order to form an impression of the object's form. In addition, Aristotle declared that simple colors are the proper colors of the elements, those being fire, air, earth, and water (Gerritsen, p. 15). Many of these theories continued into the sixteenth century; it was not until Isaac Newton's experiment with the prism, in which he separated a beam of sunlight into its component hues, that the true nature of light and color became known.

Figure 8.10 Historical concepts of light and color as outlined by Frans Gerritsen in The Theory and Practice of Color.

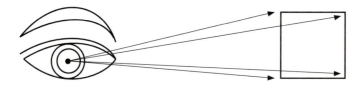

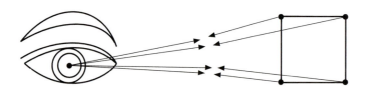

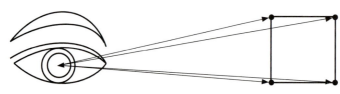

8.10

COLOR NOTATION SYSTEMS AND THEORIES

As color theories developed, scientists and artists designed different types of two- and three-dimensional diagrams to illustrate the relationships and dimensions of color. Historical references tell us that in the seventeenth century Sir Isaac Newton was the first to devise a color wheel (see Figure 8.11). Earlier research by Franciscus Aguilonius was based primarily on differentiating between chromatic and achromatic mixing.

As mentioned previously, Newton proved that light is composed of different colors by projecting a beam of sunlight through a glass prism. When he arranged the spectral hues in a linear band, he noticed the resemblance between the red-violet on one end and the blue-violet on the opposite end. Newton found that by connecting the two ends of his linear color band, a circle was formed

that allowed him to illustrate the relationships among the hues. The connecting color link became "purple," which has no specific wavelength, but occurs when red and blue pigments are combined (see Figure 8.12).

Various color theories and color notation systems have been developed and modified since Isaac Newton's time. The primary developers of color theories and notation diagrams have been scientists, artists, and philosophers, with contributions by physicists, chemists,

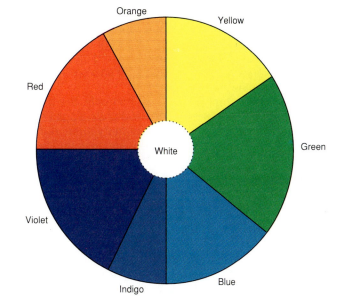

8.11

Figure 8.11 Isaac Newton's color wheel (ca. 1660). The sections in the color wheel are varied in size, depending on wavelengths of the seven hues visible in the spectrum.

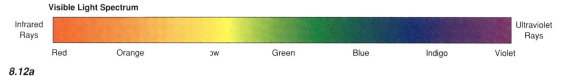

8.12a

8.12b

Figure 8.12 Newton's linear band illustrating (a) the visible light spectrum and (b) the band connected to create the color circle.

psychologists, and physiologists. In other words, color theory and notation have evolved from various scientific and perceptual discoveries.

The physicist theoretically relates to the light primaries, red, green, and blue, used in additive color mixing. Color physics is the study of electromagnetic energy vibrations and particles involved in the phenomena of light, such as the chromatic dispersion of light, mixtures of chromatic light, and measurement and classification of hues. Generally the chemist relates to the pigment, or subtractive, primaries of red, blue, and yellow. Color chemistry, used primarily in industrial research and production, is concerned with the molecular structure of dyes and pigments, problems of color fastness, and the preparation of synthetic dyes and pigments.

Studies show that the human eye does not report the qualities of color in an absolute sense like laboratory equipment used by the physicist or chemist. Vision is highly adaptive to the relative qualities of color, so that the hue reported to the brain is an apparent color based on the surrounding color areas and light source.

Commonly, the psychologist and physiologist relate to four primary hues: red, blue, green, and yellow. These primaries are sometimes referred to as the visual, or **me-dial**, primaries, meaning that if they are spun together, a medium gray will result. The psychologist describes color in terms of symbolism, subjective perception or meaning, and emotional or expressive effects.

A color notation system can give those who work with color both a visual and verbal means by which the dimensions of color can be structured. A verbal notation system offers a descriptive terminology for naming and organizing the hues. A visual notation system can show the relationships among the hues as well as among the other dimensions of color.

There are two types of color notation: two-dimensional color wheels or diagrams, and three-dimensional color solids or diagrams. Because pigments are tridimensional, having characteristics measured according to hue, value, and chroma, many theorists have chosen to represent their ideas in the three-dimensional form called a color solid. A color solid provides a means for representing the three dimensions of color in a structure or framework. Often the color wheel represents a view of a cross-section of a color solid, so the two- and three-dimensional notations are combined within one system.

Moses Harris

English engraver and entomologist Moses Harris developed the first color wheel based on the pigment primaries (see Figure 8.13).

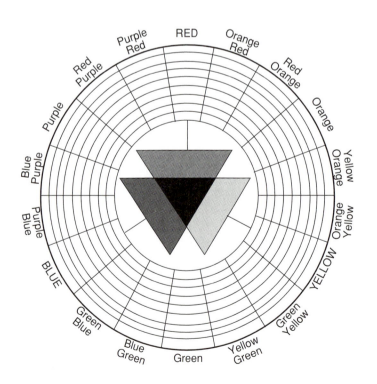

Figure 8.13 Moses Harris's color circle, ca. 1766, is based on pigment primaries.

8.13

Earlier, in 1756, a Frenchman, J. C. LeBlon, had published a treatise discussing the nature of pigment primaries and their resulting mixtures. Harris's was the first color circle to be published in full color and appeared in a book entitled *The Natural System of Colours*. This book was reprinted in facsimile with an introduction by Faber Birren in 1963.

Moses Harris discussed prismatic or primitive colors as the pigment primaries of red, blue, and yellow—the same as named today. Mediate hues orange, green, and purple are now called secondaries, and the compound hues olive green, slate, and brown (or russet) are now called tertiaries.

Johann Wolfgang von Goethe

The color circle in Figure 8.14 is based on the pigment or subtractive primaries. The structure consists of two overlapping equilateral triangles. The apexes of the upright triangle form pigment primaries while the apexes of the upside-down triangle form the secondaries.

German scientist and poet Johann Wolfgang von Goethe, following in the footsteps of Aristotle, refuted Newton's color theory. Goethe felt that blue and yellow were primary. Aristotle believed that yellow came from lightness and blue came from darkness. All other colors, including red, resulted by blending yellow and blue.

Philip Otto Runge

Philip Otto Runge was the first to develop a color theory represented by a color solid (see Figure 8.15). The basic colors used to create this system are red, yellow, and blue pigment primaries. White and black are achromatic values placed at the top and bottom of the sphere, respectively. The gray progression from white to black results on the vertical axis between these two points. The purest hues are arranged about the equator of the symmetrical solid. This three-dimensional organization allowed for equal steps between all the hues and intermediates. The spherical configuration also organized the possible tints, tones, and shades of each hue.

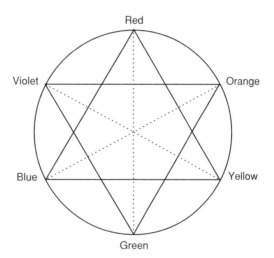

8.14

Figure 8.14 Johann Wolfgang von Goethe's color circle diagram, ca. 1793, showing three primary hues and three secondary hues.

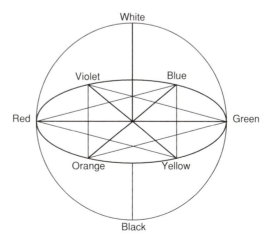

8.15

Figure 8.15 Philip Otto Runge's color solid, ca. 1810, was the first color theory represented as a three-dimensional color diagram.

Figure 8.16 (a-b)
Michel-Eugene
Chevreul's color cir-
cle and color solid,
ca. 1861, are based
on pigment pri-
maries.

Michel-Eugene Chevreul

Chevreul published a book entitled *The Principles of Harmony and Contrast of Colors and Their Application to the Arts* in France around 1839 and in Britain around 1854. His color theory influenced many of the French impressionists and neo-impressionists of that time and is believed to have provided the foundation for teaching color in many art schools. His color circle (see Figure 8.16) was published in the early 1860s and is based on pigment primaries. Although Chevreul was an important and influential colorist, his color model was abandoned when it proved to be impractical.

James Clerk Maxwell

Physicist James Clerk Maxwell developed a triangular system of notation based on the light primaries red, green, and blue (see Figure 8.17). Maxwell is popularly known for research with light primaries and the development of the "Maxwell Disk." These colored disks are spun to obtain different spectral light mixtures. Practice Exercise 8.2 on page 263 illustrates this phenomenon.

Wilhelm von Bezold

The color circle developed by Wilhelm von Bezold (see Figure 8.18) is also based on the additive primaries of red, blue, and green. It was published in his book *The Theory of Color.* The center triangle points to vermilion (red-orange), green, and bluish-violet. All other colors placed around the circle are spaced according to their visual differences. The opposites, known as complements, are vermilion and bluish-green, orange and turquoise, yellow and ultramarine, yellowish-green and purplish-violet, and green and purple.

Figure 8.17 James
C. Maxwell's color
triangle, ca. 1872, is
based on the light
primaries. This sys-
tem is still used
today by physicists
to analyze pure light
or spectral hues.

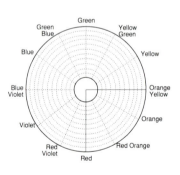

8.16a

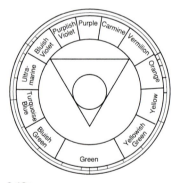

8.17

8.18a

Figure 8.18 (a-b)
Wilhelm von Be-
zold's color wheel
and solid, ca. 1876,
is based on the ad-
ditive primaries red,
blue, and green.

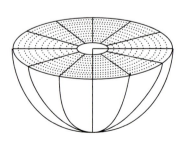

8.16b

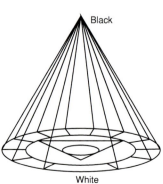

8.18b

Ewald Hering

German psychologist Ewald Hering based his color circle and studies on the human perceptual system (see Figure 8.19). The primaries in this system are red, yellow, green, and blue, because he believed that these four colors, in addition to black and white, formed the basis of all human vision. These four colors are unitary, meaning they have no visual resemblance to each other.

Hering's triangular model is based on the assumption that all possible variations of a hue can be included within a triangle. The pure color is on one angle, white on the second angle, and black on the third angle.

Ogden Rood

In the late 1870s American physicist Ogden Rood developed a color circle and color solid based on the red, green, and blue light primaries (see Figure 8.20). In the color circle, the center is white and pure hues are located on the outer circumference. Rood's symmetrical double-cone solid placed the pure colors around the center. White is located at the top, gray in the middle, and black at the bottom. All hues between these points are intermediate shades or tints.

A. Höfler

Höfler developed a three-dimensional diagram to illustrate color organization in terms of human visual experiences (see Figure 8.21). This symmetrical pyramid model is used widely in psychology. Each of the four corners of the center section relate to one of the visual (medial) primaries, red, yellow, green, and blue. These primaries mix to create gray, located in the center. All tints moving toward white are located above the center section. All shades moving toward black are located below the center section.

Figure 8.19 (a-b) Ewald Hering's color circle and triangle, ca. 1878, are based on the vision primaries red, yellow, green, and blue.

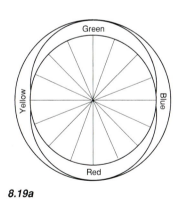

8.19a

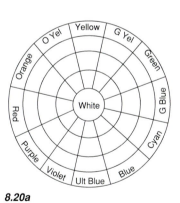

8.20a

8.21a

Figure 8.20 (a-b) Ogden Rood's color circle and color solid, ca. 1879, are based on the light primaries red, green, and blue.

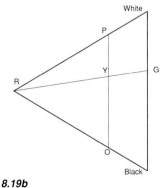

8.19b

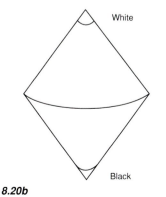

8.20b

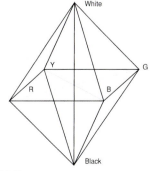

8.21b

Figure 8.21 (a-b) A. Höfler's three-dimensional pyramid diagram and center section illustrating his color theory, based on the medial primaries, red, yellow, green, and blue.

Figure 8.22 Albert Munsell's color wheel, ca. 1898 and first published in 1921, was based on five primary hues and five intermediate hues (courtesy: Munsell Color, Baltimore, MD and Newburgh, NY).

Albert H. Munsell

American painter Albert H. Munsell developed a color circle and color solid notation system that organizes colors visually, instead of by a physical measurement or chemical makeup of the pigment (see Figure 8.22).

There are five primary hues and five intermediate hues, based on the perceptual afterimage phenomenon. When the viewer stares at an area of strong chroma yellow for a few minutes, then looks at a neutral gray surface, an afterimage of purple-blue will be experienced. The purple-blue is the visual opposite of yellow.

The hue names are abbreviated in the Munsell system: R = red; YR = yellow-red; Y = yellow, GY = green-yellow; G = green; BG = blue-green; B = blue; PB = purple-blue; P = purple; RP = red-purple. The one hundred intermediate hues are designated by a decimal number system: 5 is the principal hue, and 10 is the intermediate hue. For example, 5R is the principal red; 2.5R is slightly purple and 7.5R is slightly yellow.

Wilhelm Ostwald

Physical chemist Wilhelm Ostwald developed a complete color system including a color circle and color solid based on combinations of black, white, and four primaries (see Figure 8.23). Most of Ostwald's research and development in this area was based on Hering's discoveries.

There are four primaries and four intermediates in the Ostwald color circle: yellow, orange, red, purple, blue, turquoise, seagreen, and leafgreen. The circle contains a total of twenty-four different hues resulting from three hue variations of each of the eight primary and secondary hues. Each principal hue is the center color within each division. For example, the principal primary hues are numbers 2, 8, 14, and 20. The intermediate or secondary principal hues are numbers 5, 11, 17, and 23.

Michael Jacobs

American painter and teacher Michael Jacobs published a book entitled *The Art of Color* in which he explained the complex color theory of harmony based on primaries of red, green, and violet (see Figure 8.24). The violet he used was close in hue to the blue-violet described by theorists such as Helmholtz and von Bezold. The color harmonies described by Jacobs are in terms of pigments, as in the subtractive color mixing process. He also mentions the technique named scintillating, the visual intermingling of dots of color, which is additive mixing.

Figure 8.23 Wilhelm Ostwald's color circle, ca. 1916, based on combinations of black, white, and four primaries, forms the center of equator for Ostwald's color solid (see Figure 8.37).

Figure 8.24 Michel Jacobs developed a color circle based on red, green, and violet primary hues, ca. 1923.

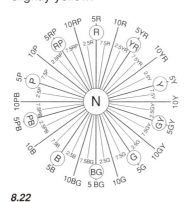

8.22

8.23

8.24

Paul Klee

Paul Klee was a Swiss artist and Bauhaus instructor who organized a spectral color circle of six hues: red, orange, yellow, green, blue, and violet (see Figure 8.25). In addition to the color circle, Klee developed a diagram called the "canon of totality" (see Figure 8.26) to demonstrate the infinite number of hues that can be created from the three pigment primaries. Each primary is represented by a half-moon shape and is arranged in rotation around a center point. Each primary hue spans two-thirds of the circle circumference to illustrate the continuous, never-ending progression as the colors merge from one to another.

C.I.E. Chromacity Chart

C.I.E. is a French acronym for the international Commission on Illumination. This color triangle (see Figure 8.27) is a two-dimensional diagram based on a coordinate system, which makes it possible to identify any color by specifying two coordinates (X and Y). The light primaries red, green, and blue are located at the three corners of the triangle. Intermediates occur as these colors overlap. In the center of the chart is pure white light (X = 0.333, Y = 0.333).

Faber Birren

In his book *Principles of Color* Faber Birren diagrams his color theory called "The Rational Color Circle." Birren explains the asymmetrical structure of his color circle (see Figure 8.28) relative to the distribution of warm and cool colors: "Most artists will give more importance to warm colors than to cool ones because of their more dynamic qualities and their stronger chroma or intensity. Indeed, as far as the facts of vision go, the eye can see more warm tones than cool ones! If a color circle were to be made rational, if its steps around the circumference were to be neatly ordered and smoothly perceptible, one to the next, such a circle would need to include more warm hues than cool ones, even if this sequence threw the central complementation off balance" [Faber Birren, *Principles of Color* (New York: Van Nostrand Reinhold, 1969) p. 25].

Figure 8.25 Paul Klee's color circle, ca. 1924, based on six spectral hues.

Figure 8.26 Klee's "canon of totality" visually explains the infinite number of possible hue combinations as the colors merge from one to another (courtesy of Whittenborn Art Books, Inc.).

Figure 8.27 C.I.E. chromacity chart, ca. 1931, is based on green, blue, and red additive primaries and is internationally accepted for scientific use. (Paul Zelanski/Mary Pat Fisher, Color, © 1989, p. 55. Reprinted/Adapted by permission of Prentice-Hall, Englewood Cliffs, NJ.)

Figure 8.28 Faber Birren's color circle, ca. 1934, emphasizes the quantity of warm hues over cool ones, and uses the first letter of the hue name as an abbreviation. L stands for leaf-green and T stands for turquoise.

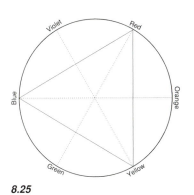
8.25

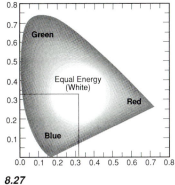
8.27

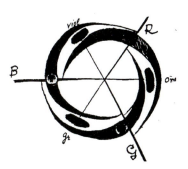
8.26

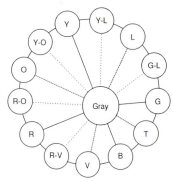
8.28

Johannes Itten

Johannes Itten's color wheel (see Figure 8.29) was first published in *The Art of Color*. His twelve-hue circle was influenced by Adolf Hölzel's "Theory of Color." Hölzel, a German painter and color theorist, developed two different color wheels of six (called diatonic circle) primary and secondary hues, and twelve (called chromatic circle) hues.

Itten's color circle is based on divisions from an equilateral triangle where the pigment primaries are located. The secondary hues of green, orange, and violet are located within the hexagon. All other intermediates are located between the points of the triangle and hexagon. Itten placed yellow at the top of the circle because it is the brightest color and is visually closest to white. The colors in the color circle are equidistant because the intermediate hues are created by mixing equal proportions of two adjacent hues.

Figure 8.29 Johannes Itten's color wheel, ca. 1961, based on yellow, cyan, and red primaries, is commonly used to teach color mixing (© 1973 Ravensburger Buchverlag Otto Maier GmbH).

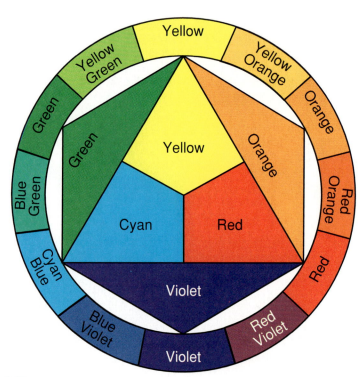

8.29

THE MUNSELL COLOR SPHERE

In 1898 Albert Munsell created the well-known color sphere or color tree. As a teaching aid, he developed a three-dimensional solid, within which visible colors are organized. This three-dimensional system is arranged so that the three dimensions of color (hue, value, and chroma) are organized into equal visual steps (see Figures 8.30 and 8.31).

The Munsell solid is asymmetrical; its configurations are determined by the limited strength of each particular hue. Munsell outlined two reasons for the shape of his color model. First, he noted, "Colors differ by nature in their chroma strength, some being much more powerful than others" [Albert Munsell, *A Grammar of Color* (New York: Van Nostrand Reinhold, 1969), p. 25]. Compare the red and blue-green arrangements on the Munsell color solid: The most intense red pigment is twice

as strong as the strongest blue-green pigment. For this reason, red pigment requires more equal steps to reach the neutral gray axis, whereas the blue-green pigment requires fewer steps.

The second reason for the shape of the model is that not all hues reach the maximum range possible at the same gray value. This is evident when looking at yellow and purple-blue on the solid. Yellow reaches its maximum chroma at the seventh value step, while purple-blue reaches its maximum chroma at the fourth value step. Yellow is also perceived as a much lighter hue, or higher in value, than purple-blue. Because of this, these two hues intersect the neutral axis at different values.

There is a code or color symbol for each specific hue in the Munsell system, so that a color can be easily identified and located. The code describes the color dimensions as follows: A hue name is represented by a letter code, as previously explained in the Munsell color notation; the first number represents the value of the particular hue within the nine possible neutrals from black to white; and the second number represents the chroma or saturation scale, measuring from the central axis outward. For example, R5/12 would refer to a red hue of medium value (halfway between 1 and 9) and high chroma (extended out from the center core).

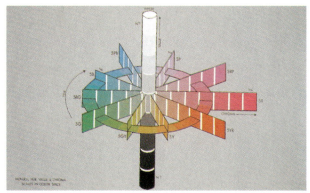

8.30

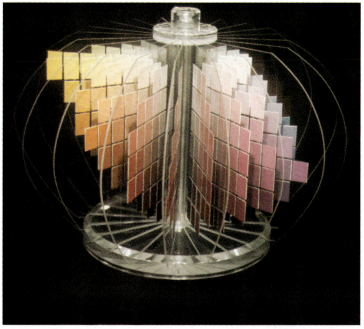

8.31

Figure 8.30 Munsell's color solid or color tree structure. The neutral axis in the center has nine values, with black on the bottom and white on the top. The chroma scale increases as it moves outward from the center axis (courtesy: Munsell Color, Baltimore, MD and Newburgh, NY).

Figure 8.31 Munsell's color solid with the hues arranged around the central axis at equal intervals (courtesy: Munsell Color, Baltimore, MD and Newburgh, NY).

After Albert Munsell died in 1918, a number of his colleagues formed the Munsell Color Company and published his work. It has been continually updated since that time.

The Munsell Student Charts include pages of the ten principal hues and are available from the company for further exploration and study. An extensive color notation system is explained in the forty charts in the *Munsell Brochure of Color*, available through the Munsell Color Company.

..................................

✍**Practice Exercise 8.1: Munsell Student Color Chart Study**

Refer to the example page from the Munsell Student Color Chart (see Figure 8.32). To help you understand the Munsell notation system, select several different hues on the chart. Write down the specific code for each hue selected. Once this is complete, label each part of the Munsell code to identify the hue and its location within the system.

Figure 8.32 (a-d) (a)The first page from the Munsell Student Chart package outlines the value and chroma scales, as well as the ten basic hues at their strongest chroma. (b) Diagram of constant value. (c) Constant hues. (d) Contrast in chroma (courtesy: Munsell Color, Baltimore, MD and Newburgh, NY).

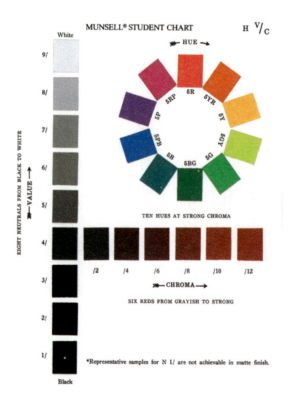

8.32a

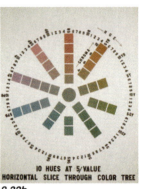

8.32b

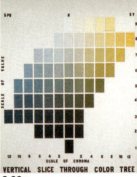

8.32c

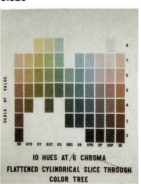

8.32d

THE OSTWALD SYSTEM OF COLOR NOTATION

Scientist and Nobel prizewinner Wilhelm Ostwald created a color system based on human sensation and vision. Ostwald wrote *Die Farbenfibel* [*The Color Primer*, translated into English with a forward by Faber Birren (New York: Van Nostrand Reinhold, 1969)] in which he explains the basis of the notation system: "Everything we see consists directly of colors which are spread out in the field of vision as larger and smaller parts of areas. Where two or more areas meet, borderlines are created, the continuity of which brings about the forms or figures from which we sense the presence of objects seen. The colors are, therefore, the basic components or elements of our sensation of vision. Because of our inexact use of language, the word color is also being used for materials and processes through which colored sensations or colors are created. . ." (Birren, p. 17).

The Ostwald system is based on two categories of color: the achromatic colors (white, gray, and black); and the chromatic colors of yellow, red, blue, and green, and all colors in between them or adjacent to them.

Achromatic Colors

The achromatic colors form a linear sequence from white (top) to black (bottom). Ostwald describes the visual sensations attributed to achromatic colors as "brightness." Brightness is described as "the amount of light falling on a surface that is reflected back" (Birren, p. 23). If all the available light is reflected, it is called *full white*. If none of the light is reflected, it is called *full black*. The gray or achromatic scale used in the Ostwald system is based on a geometric progression to obtain an equal visual progression of eight steps (see Figure 8.33).

The original progression ranged twenty-six steps according to the amount of white in the mixture. A corresponding letter was assigned to each gray. In practice Ostwald determined that the differences between these steps were too narrow and skipped every other step to widen the visual margin. The resulting grays were called "norms." This was defined by Ostwald: "If one enjoys sufficiently free choice (and this is almost always the case), one does not use just any assortment of grays, but rather, one or more out of the series a, c, e, g, i, l, n, p, r, t, v, x, z, which are in an orderly arrangement. From this, very great advantages are to be derived as to achromatic color harmonies" (Birren, p. 29).

Chromatic Colors

Chromatic colors can only be altered according to their relative lightness or darkness and are therefore referred to as one-dimensional in this notation system. According to Ostwald, chromatic color can be altered in four ways:

1. The hue can be altered; for example, red can be made yellowish by adding yellow, or bluish, by adding blue.
2. The specific hue can be maintained, but be lightened by

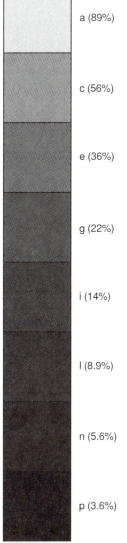

a (89%)

c (56%)

e (36%)

g (22%)

i (14%)

l (8.9%)

n (5.6%)

p (3.6%)

8.33

Figure 8.33 Ostwald's gray scale. The percentage figures refer to the white content, and the black content is the sum that remains equal to 100. The letters refer to a particular gray between 0 and 100 percent, as determined by the geometric progression established by Ostwald. The selected steps are arranged in order, even though the total gray range is not represented here.

adding increasing quantities of white; colors of this type are called light clear colors.

3. The specific hue can be maintained, but be darkened by adding increasing quantities of black; colors of this type are called dark clear colors.

4. The specific hue can be altered by adding both white and black, which is the same as adding some gray of corresponding brightness; these are called muted colors (see Figure 8.34).

Variations of any hue can be plotted within the Ostwald color triangle system (see Figure 8.35). Series of colors containing equal amounts of white are parallel to line CB. Series of colors containing equal amounts of black are parallel to line CW.

The complete Ostwald triangle shows the norm steps included in the color system. The grays from white to black are located along the right vertical axis. Each gray can be differentiated as the code indicates, allowing for ideal visual relationships (see Figure 8.36).

Figure 8.34 (a-c) Relationship of light clear colors, dark clear colors, and muted colors in the Ostwald system.

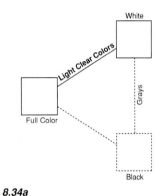

8.34a

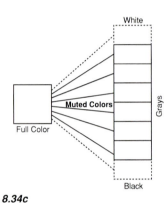

8.34b

8.34c

Figure 8.35 (a-c) Colors within the Ostwald system may be plotted if the black and white contents of a particular hue are known.

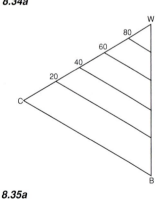

8.35a

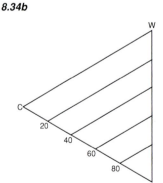

8.35b

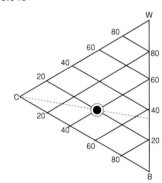

8.35c

Figure 8.36 Norm steps included in the Ostwald color system.

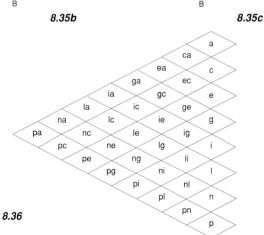

8.36

The Ostwald color solid includes all the dimensions discussed so far: the color circle defines the different hues and their relationships to each other; and the Ostwald triangle shows the relationship between the achromatic colors. These two aspects are combined to create a symmetrical solid (see Figures 8.37–8.39).

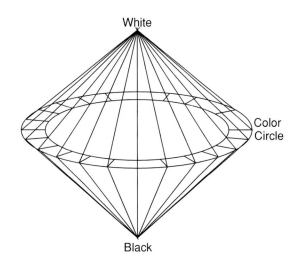

White

Color Circle

Black

8.37

Figure 8.37 Ostwald color solid, showing the location of the color circle at the center and the achromatic colors located through the center.

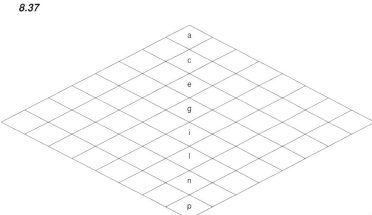

a

c

e

g

i

l

n

p

8.38

Figure 8.38 Ostwald color solid, showing opposite colors are located across from each other on opposite sides of a center core.

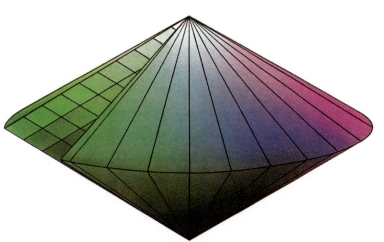

8.39

Figure 8.39 The Ostwald color solid with a section removed. The hues are located around the equator, with white at the top and black at the bottom. (Paul Zelanski/Mary Pat Fisher, Color, *© 1989, p. 61. Reprinted/Adapted by permission of Prentice-Hall, Englewood Cliffs, NJ.)*

COLOR PIGMENTS AND PRODUCTS

Generally speaking, paint pigments, dyes, and inks are not coded according to a formal color system such as the Munsell or Ostwald systems. This makes it difficult to select pigments for projects with any certainty that the visual results will be favorable when the pigments are mixed together. Outlined below are two types of color systems that may have more accurate results in color exercises.

Winsor & Newton Designer's Gouache

Many of the Winsor & Newton gouache series are pure, brilliant pigments that work well for most color mixing and painting. Student kits are available which include the spectrum colors, or selections can be made from a wide variety of single tube hues.

One of the reasons gouache is commonly used is because it is water-based, and the pigments are fairly permanent. Gouache can be mixed to different viscosities, so that it can be used as paint with a brush, as ink with calligraphy pens, or as pigment with an airbrush. Winsor & Newton is readily available and the colors are classified according to color permanence, opacity, and staining (the tendency to bleed through other colors). The codes are as follows:

Permanence

AA = Extremely permanent

A = Durable

B = Moderately durable

C = Fugitive

Opacity

O = Completely opaque

R = Reasonably opaque but will not completely obliterate a dark color

P = Partly transparent

T = Wholly transparent

Staining

N = Nonstaining

M = Moderately safe but tends to bleed through light colors

S = Colors that will stain to some degree

SS = Strongly staining colors

The PANTONE® Library of Color

The PANTONE MATCHING SYSTEM was originally developed to specify ink colors for production printing in graphic and commercial art in the early 1960s (see Figure 8.40). Before the PANTONE MATCHING SYSTEM was widely used for specification in the printing industry, artists, architects, and designers had little control over selecting and specifying colors with the confidence that the colors in the final, printed piece would actually look the way they were intended. Many larger ink companies and printers developed and used their own specification systems, which were commonly based on the Ostwald or Munsell notation systems. Unfortunately, this seldom allowed the users to communicate color specification outside their personal businesses.

Since 1963 the PANTONE MATCHING SYSTEM has expanded to include a variety of specification manuals and color formula guides for printing inks, papers, architectural colors, and textile colors. A few of the PANTONE Color Publications are described in the following section.

The PANTONE Color Specifier

The PANTONE Color Specifier is the basic means for selecting and specifying colors for artwork and printing.

The PANTONE by Letraset Color Papers are available through most art supply stores and are used for mock-ups of actual printed pieces. Papers are available in coated and uncoated stock, adhesive-backed film, and markers. Selected colors are available in graduated paper and film sheets from white to pure color, to be used for an "airbrushed" look.

These paper and film supplies are easy to use and can be adapted to almost any color exercise. However, be careful when selecting colors for a problem solution

that is based on a specific harmony or contrast. Specific values and hues in this system are not matched to a theoretical system of notation; therefore, it may be difficult to reproduce the desired color phenomenon using papers and films. However, with a good understanding of color, it is possible to select the desired hue.

The PANTONE Process Color System

The PANTONE Process Color System is a series of reference charts which illustrate combinations of the standard process colors on coated paper.

The PANTONE Color & Black Selector 747XR

The PANTONE Color & Black Selector 747XR illustrates the result of combining different percentages of a PANTONE color and black (printed shades of a hue). Also included are sample halftones and duotones.

The PANTONE Color Tint Selector 747XR

The PANTONE Color Tint Selector 747XR illustrates the actual color when screen tints (percentages of the pure, opaque ink color printed as small dot screens) are used in printing. The size and density of the dots regulate screen tints from 10 percent to 90 percent.

The versatility in the PANTONE MATCHING SYSTEM allows accurate communication of color among different disciplines and professions.

Figure 8.40 PANTONE® Color Formula Guide 747XR (PANTONE® is a registered trademark of Pantone, Inc.).

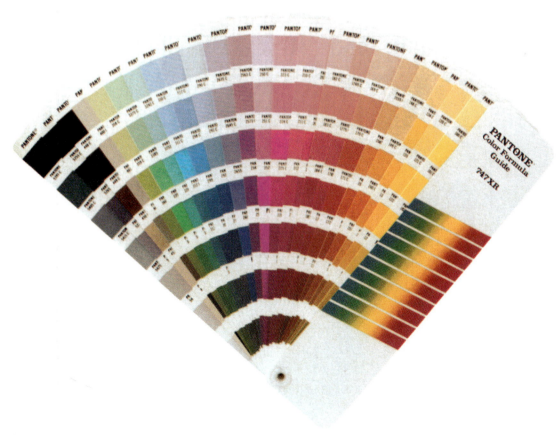

COLOR MIXING

As mentioned earlier, the combining of light hues is called additive mixing, and the combining of pigment hues is called subtractive mixing.

Additive Mixing

When the light primaries are combined in equal amounts, the result is white light. An easy way to illustrate the ex-perience of how additive color mixing works is to set up three slide projectors. Each projector should show a slide of one light primary, that is, a red, blue, and green slide. Begin by project-ing two of the slides simulta-neously so that the images overlap slightly. Add the image of the third color. The intermediate colors created where two projections over-lap are the light secondary hues. Where all three images overlap, the result will be white (see Figures 8.41 and 8.42).

One use of additive color mixing occurs in television. The television image consists of red, green, and blue phos-phor dots on the surface of a cathode ray tube. These phosphor dots are made fluo-rescent by a varying stream of electrons.

Figure 8.41 Additive color mixing using light primaries.

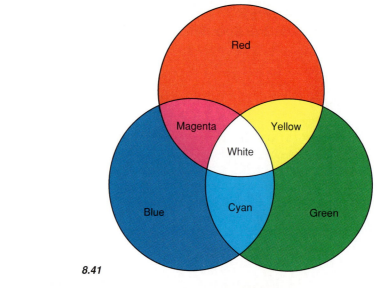

8.41

Figure 8.42 (a-c) Additive color mix-ing to achieve light secondary hues.

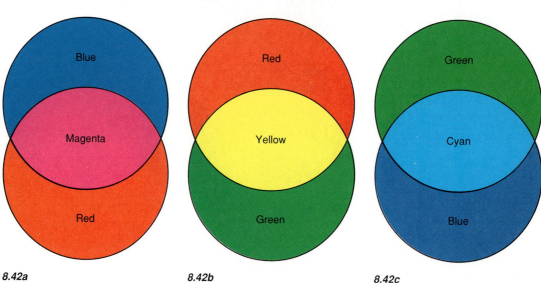

8.42a 8.42b 8.42c

Subtractive Mixing

Subtractive color mixing is the combining of pigments. Subtractive color mixing is called such because all hues are filtered out or subtracted from white light except one. The remaining visible hue is reflected and seen as the surface color of a figure or form. For example, if an object is painted with blue pigment, all other light wavelengths besides blue are filtered out so that the only remaining wavelength (blue) is reflected and perceived.

The pigment primaries are magenta (blue-red), yellow, and cyan (green-blue). Generally these pigment primaries are referred to as red, yellow, and blue. Theoretically, when these pigment primaries are combined, black is the result, but a muddy brown color usually results (see Figures 8.43 and 8.44).

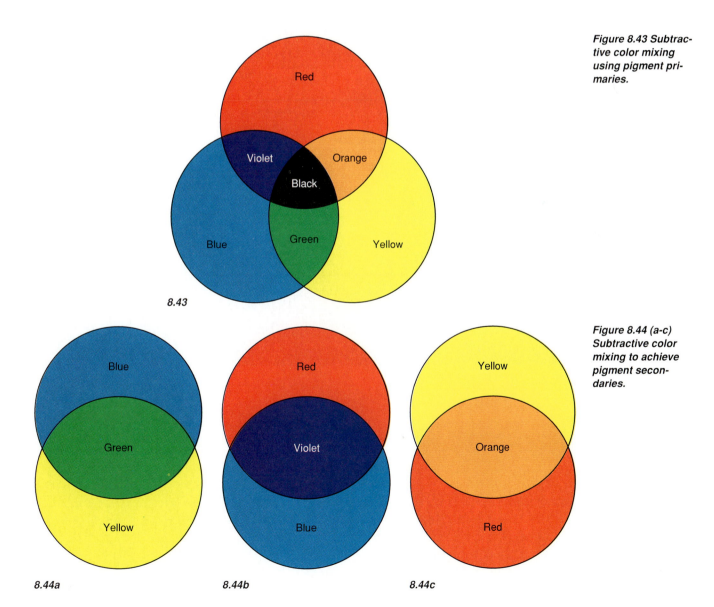

8.43

8.44a 8.44b 8.44c

Figure 8.43 Subtractive color mixing using pigment primaries.

Figure 8.44 (a-c) Subtractive color mixing to achieve pigment secondaries.

Optical Color Mixing

A type of additive color mixing called optical or visual mixing occurs when two or more colors are closely juxtaposed. When these combinations are viewed at a distance, they appear to blend optically to produce colors other than those seen when viewed separately. When colors are positioned closely together, they are perceived simultaneously, and visually mix to create a new color. The effect is attributed to rapid changes in eye focus. The color impression experienced by the viewer is comparable to the intensity achieved by actually mixing the pigments. This type of additive color mixing was used by many of the nineteenth-century French neo-impressionist painters, such as Seurat, Monet, Signac, and Pissarro (see Figures 8.45 and 8.46).

Figure 8.45 Sunday Afternoon on the Island of La Grande Jatte *by Georges Seurat, 1884. Seurat introduced the painting technique called pointillism. This technique employs small dots of color to achieve visual color mixing. (Photograph © 1991, The Art Institute of Chicago. All Rights Reserved.)*

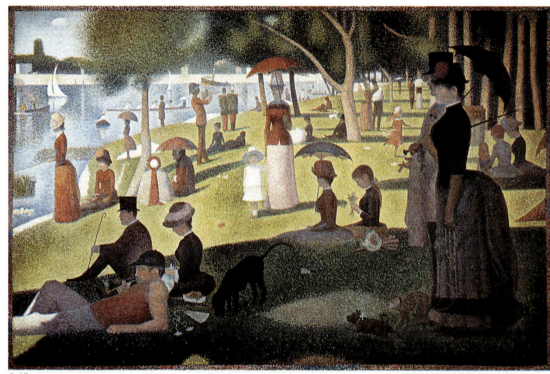

8.45

Figure 8.46 A close-up detail of Seurat's painting illustrates that the viewer's eye blends the small points of color, creating intermediate hues and values. (Photograph © 1991, The Art Institute of Chicago. All Rights Reserved.)

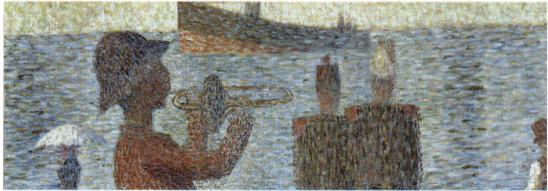

8.46

✍ Practice Exercise 8.2: Visual Mixing of Color

A wooden dowel rod and a Bristol board disk can be used to construct a top, which will illustrate visual mixing phenomena.

Cut a 1/4" dowel into a 2-1/2" length. Shape one end of the dowel into a point as the axis (shaft) for the spinning top. Use a 3" x 1/4" disk for the base of the disk.

Construct a 3" circular color disk from Bristol board like the one illustrated in Figure 8.47. Apply color in proportional combinations using colored paper or gouache. Using a paper hole punch, cut a 1/4" hole in the center of the color disk. Assemble the pieces and experiment spinning the top; adjust the vertical location of the base to achieve a balanced spin. Glue the base to the axis shaft. Paint the top white.

Predict what the visual results will be when the top is spinning. Experiment with different color combinations and surface patterns to achieve a variety of interesting results.

8.47a 8.47b

Figure 8.47 (a-b) Illustration of color top construction.

✍ Practice Exercise 8.3: Visual Color Mixing Compositions

The phenomenon of visual or optical mixing was first described by Wilhelm von Bezold and consequently named the "Bezold Effect." He discovered this effect while planning color combinations for rug designs. By changing only one hue within the whole color scheme, the entire rug color was changed. When the rug was viewed at a distance, the yarn colors mixed visually to create new intermediate hues. The overall effect was the same as that created by Georges Seurat in his pointillist paintings.

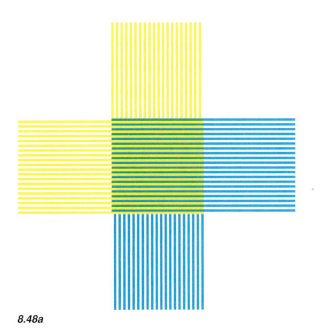

8.48a

Figure 8.48 (a-c) Example of visual color mixing compositions (illustrated by: a, Lee Willett; b, Cynthia Busic-Snyder; c, Tammy Tormasi).

Figure 8.48 (b-c) (continued).

This effect can be created by alternating thin lines, dots, or squares of two or more hues. As the colored elements are viewed, the rapid changes in the viewer's focus cause the alternating areas to appear as a single, intermediate hue. The distance of the viewer and the size of the composition affects the extent to which the colors mix.

Create a compositional structure that complements the concept of visual color mixing. Select two or more different hues. Color the composition using thin lines of tape or dots of colored paper or film. Mount or apply them on hot press illustration board (see examples in Figure 8.48).

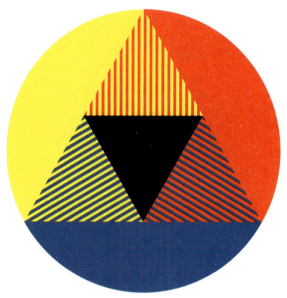

8.48b

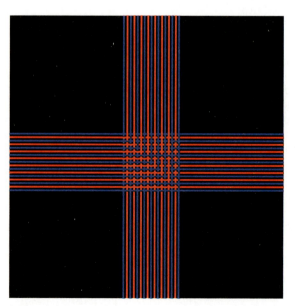

8.48c

Subtractive Color Mixing and Color Circles

The overview of the different color circles and solids and their notation systems presented earlier should help give an understanding of the historical origins, varying concepts, and differences in the sets of primaries. Overall, the different color circles and their primaries are generally acceptable for studying color relationships and harmonies. (Color harmonies are an organized combination of colors resulting in an aesthetically pleasing outcome). Since this text is intended as a general approach, it is preferable that the paint pigment primaries be used for the color mixing exercises. However, the arrangement of hues on the color circles varies from system to system.

Figures 8.49–8.51 show three variations of color circles used in art, architecture, and design studies. Notice the arrangement in the number of primary and secondary hues which affect the differences in the color harmonies.

In the following color mixing and color harmony exercises, study the diagrammed color relationships of the circles. Using tracing paper, draw over the circles and plot the color relationships to compare differences between notation systems. Note how the number of primaries (three, five, or eight) affect the quantity of color harmonies that can be diagrammed in each system.

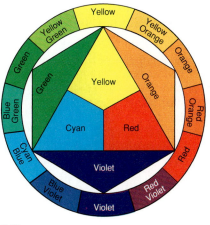

8.49

Figure 8.49 Itten's twelve-hue color circle based on three pigment primaries, yellow, cyan, and red (© 1973 Ravensburger Buchverlag Otto Maier GmbH).

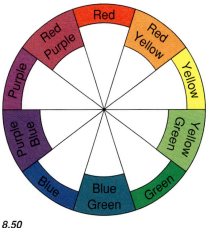

8.50

Figure 8.50 Munsell color circle based on five medial primaries, red, yellow, green, blue, and purple.

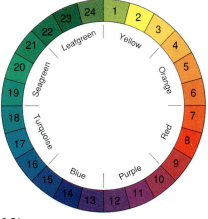

8.51

Figure 8.51 Ostwald's color circle based on four principal hues, yellow, red, blue, and seagreen, with orange, purple, turquoise, and leafgreen added, creating eight principal hues.

✍Practice Exercise 8.4: Constructing a Color Circle

The objective of this exercise is to become familiar with mixing secondary and tertiary hues, and to understand their relationships within a color circle structure.

Recommended materials include an HB pencil, hot press illustration board, watercolor paper, designer's gouache, a 3/4" flat brush, and a no. 10 round brush.

With a compass or circle template, construct a 6" diameter circle, and divide it into twelve equal parts with the HB pencil. Paint in red, blue, and yellow areas using pigment primaries. These colors may be painted directly on the hot press illustration board or they may be painted onto smooth watercolor paper, cut out, and assembled on the illustration board. Next, mix the primaries and paint in orange, green, and violet areas. Upon completion mix the tertiary hues using equal parts of the primary and secondary hues. Continue around the circle until all areas are filled with color as described. Compare the results with the examples illustrated in Figures 8.52 and 8.53. Note the differences between the hues in the printed color circles and those in the one constructed in this exercise. Determine whether they differ due to variation in pigments or due to differences in mixing combinations.

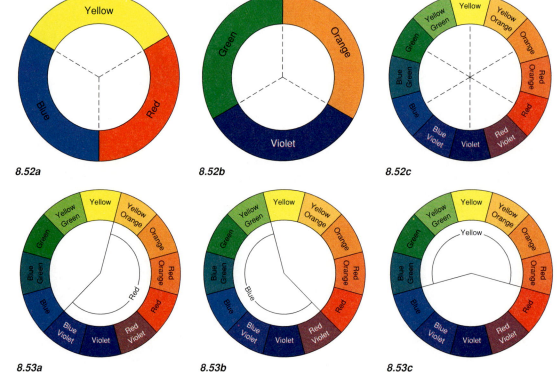

Figure 8.52 Color circles illustrating (a) primary hues, (b) secondary hues, and (c) a combination of primary, secondary, and tertiary hues.

8.52a 8.52b 8.52c

Figure 8.53 All secondary and tertiary hues contain percentages of the three primary hues as follows: (a) hues that contain red; (b) hues that contain blue; and (c) hues that contain yellow.

8.53a 8.53b 8.53c

COLOR HARMONIES AND MAJOR TYPES OF HUE RELATIONSHIPS

The basic color harmonies and their relationships are related to sensory perception and a perceived balance between colors. Visual balance between hues can be achieved through the way in which colors are selected and combined as well as through the differing proportions of one hue to another. The organization of a harmonious color scheme relies on visually pleasing relationships of the three dimensions of color: hue, intensity, and value.

Harmonic schemes are created through a conscious grouping of hues relative to a formal visual structure or composition. As previously discussed, the illustrations in the text are based on a three-pigment primary circle.

The general color harmonies will remain the same no matter what color notation system is used; however, the exact hue configuration and the number of hue configurations will increase or decrease depending on the complexity of the hue circle selected. Refer to the previous three, five, and eight primary color circles illustrated.

Color harmonies may be studied relative to the four hue harmonies: complementary, triadic, analogous, and monochromatic. *Complementary* relationships deal with opposite hues. *Triadic* hue harmonies include three (usually equally spaced) colors on the color circle, used in combination. *Analogous* color schemes include two or more similar hues, commonly positioned next to one another on the color circle. *Monochromatic* harmony is created through variations in the value and intensity of a single color.

8.54

Figure 8.54 Nine-step gray scale.

Neutral or Achromatic Colors

Achromatic means without hue or colorless. White, gray, and black are achromatic or neutral because they lack color quality or hue. Black is absent of any color; therefore, it cannot reflect light. In additive mixing theory, white is thought of as the total accumulation of all color in the spectrum; thus, light is the source of color.

The mixing of black and white pigments creates numerous tonal contrasts or gray values. This range of grays is important because it can indicate depth and relative distance within the visual field.

✍Practice Exercise 8.5: Mixing Achromatic Colors

The objective of this exercise is to mix paint pigments and visually distinguish between equal gray steps from white to black, which will help in detecting differences in chromatic and achromatic colors.

Begin this exercise by mixing a nine-step gray scale, using black and white gouache. It is important to experiment with the paint consistency to achieve a smooth, even coat. Paint fifteen to twenty different swatches of gray tones on watercolor paper, then cut out two sets of 1-1/2" squares from each gray swatch.

Select one black, one white, and seven gray areas to create a consistent, even progression from white to black (see Figure 8.54). For visual comparison, refer to the eight neutrals from black to white (value) included in the Munsell Student Color Charts. Carefully mount the color swatches on hot press

Figure 8.55 (a-b) Achromatic compositions using 1-1/2" gray squares.

Figure 8.56 (a-e) Achromatic compositions (student work).

illustration board so that the edges align and touch.

With the remaining set of gray squares, create an achromatic composition. The pattern can be symmetrical or asymmetrical. Neat technical skills are important for an effective composition. When the compositional arrangement is determined, arrange and mount the squares on hot press illustration board (see Figure 8.55).

✍Practice Exercise 8.6: Formal Compositions in Achromatic Colors

The emphasis of this exercise is on developing skills in mixing achromatic colors while exploring different types of formal compositions. Formal compositions have an underlying structure, which can be created mathematically by planning the position and orientation of chosen compositional elements.

Establish a gray scale within a formal compositional structure. Once the composition is determined, experiment with the placement of grays within the allotted areas by laying tracing paper over the composition and sketching on it with gray markers.

Next, carefully draw the composition on hot press illustration board. Complete the exercise by masking around each area with frisket or tape, or painting separate color swatches as in the previous exercise (see Figure 8.56).

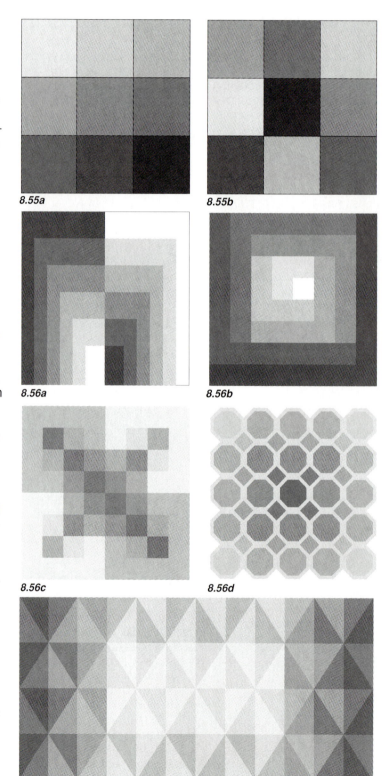

8.55a

8.55b

8.56a

8.56b

8.56c

8.56d

8.56e

Monochromatic Harmony

Monochromatic refers to the use and variance of one hue within the color circle. Different harmonies are created by altering and combining different values and intensities of the same hue within a single composition. There are many monochromatic harmonies because of the subtle and closely related values possible within one hue scheme.

✍Practice Exercise 8.7: Mixing Tints and Shades of a Single Hue

This exercise provides experience in mixing the tints and shades of a single hue. Color mixing experience helps to develop the ability to distin-

guish between the subtle changes available with one hue. Tints are created by the subtractive mixing of white with a hue; tones by the subtractive mixing of gray with a hue; and shades by the subtractive mixing of black with a hue.

A middle gray added to a hue lessens its saturation. If there is an absence of white or black in the color, then the hue is perceived at its highest saturation or intensity (see Figure 8.57).

Construct a 7" x 7" matrix of 1" square units on hot press illustration board. Select one hue of gouache; white and black gouache will also be used. Paint the monochromatic hues on

smooth, white watercolor paper, cut out 1" squares, and mount them on the board. From the top right corner begin with white, and mix a series of evenly spaced tints, tones, and shades of the selected hue. The pure hue will be placed in the center diagonal area of the matrix. Shades are located from the bottom left to the center diagonal. Tonal progressions are from the top right and bottom left toward the pure hue in the center square (see Figures 8.58–8.59).

Figure 8.57 Relationship of tints, tones, and shades relative to a pure hue in the subtractive color mixing process (adapted from Principles of Color by Faber Birren, © 1969 by Litton Publishing).

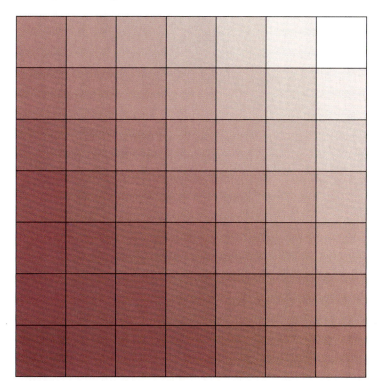

8.59

8.57

Figure 8.58 Diagram of the location of the tints, tones, and hues within a 7" matrix.

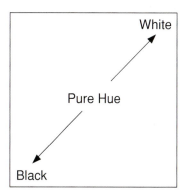

8.58

Figure 8.59 Example of mixed tints and shades of a single hue.

Figure 8.60 Various monochromatic schemes using (a) white to hue (chroma), (b) gray to white (tint), and (c) gray to black (shade) in six steps.

Figure 8.61 Example of a 6" x 6" composition using a monochromatic scheme.

✍Practice Exercise 8.8: Monochromatic Compositions

Refer to the Munsell Student Color Charts in Figure 8.32 and study the way in which the monochromatic scheme changes chroma or saturation as the steps move away from the central neutral axis. Also examine the visual changes as the hue moves from the top to the bottom of the page and compare tints, tones, and shades.

Design a systematic and visually balanced composition using a square matrix as in the previous exercise. Using gouache or acrylic pigments, mix a series of 1" square swatches on smooth watercolor paper illustrating variations within a hue. Cut out the 1" squares and arrange them within a 6" x 6" matrix on hot press illustration board (see Figures 8.60 and 8.61).

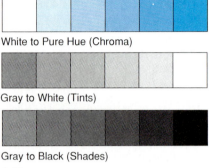

White to Pure Hue (Chroma)

Gray to White (Tints)

Gray to Black (Shades)

8.60

8.61

Selecting Analogous Harmonies

Analogous color schemes are based on the combination of several hues located adjacent to each other on the color circle. Analogous color harmonies can be extended in both value and brightness to create a wide variety of interesting compositions.

There are many ways analogous color schemes are diagrammed. The color circle can be divided according to the warm and cool hues (Figure 8.62). Generally speaking, warm hues refer to red, yellow, and orange. Cool hues refer to blue, green, and violet. Warm or cool distinctions may be within a specific hue as well as the distinction between specific hues. For example, a "warm red" may be slightly yellow or orange, while a "cool red" may be slightly violet or purple in appearance. The perception of warm and cool hues is relative.

Analogous color schemes do not have to be selected according to the warm and cool hues; they can also be diagrammed by selecting one principal hue for a composition. This doesn't necessarily need to be a primary or secondary hue, but rather the hue that will dominate the final composition. In addition, one or more hues on each side of the principal hue will give an analogous scheme (see Figures 8.63–8.65).

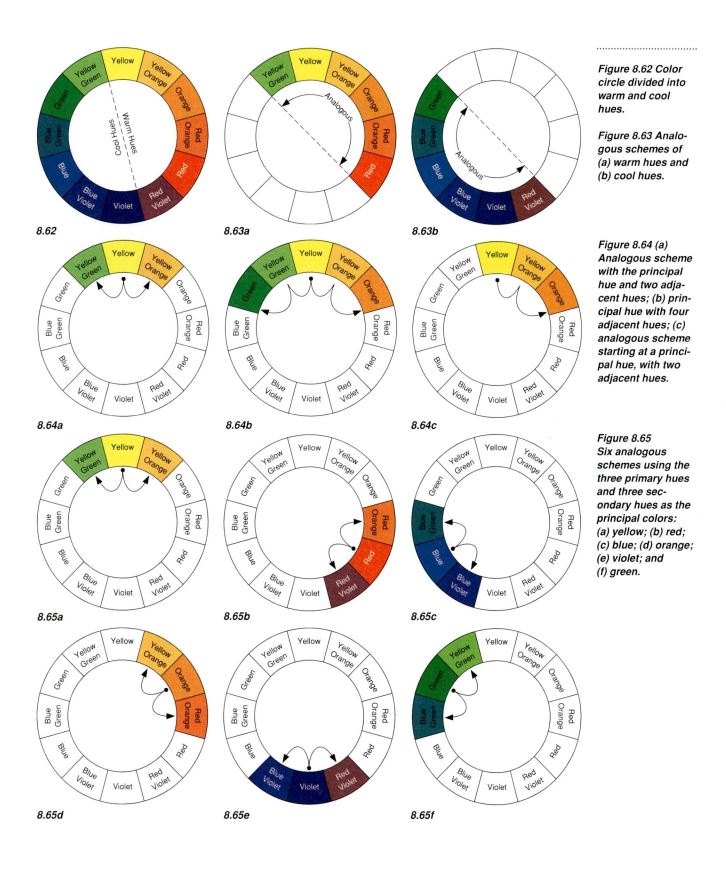

8.62

8.63a

8.63b

8.64a

8.64b

8.64c

8.65a

8.65b

8.65c

8.65d

8.65e

8.65f

Figure 8.62 Color circle divided into warm and cool hues.

Figure 8.63 Analogous schemes of (a) warm hues and (b) cool hues.

Figure 8.64 (a) Analogous scheme with the principal hue and two adjacent hues; (b) principal hue with four adjacent hues; (c) analogous scheme starting at a principal hue, with two adjacent hues.

Figure 8.65 Six analogous schemes using the three primary hues and three secondary hues as the principal colors: (a) yellow; (b) red; (c) blue; (d) orange; (e) violet; and (f) green.

Figure 8.66 (a-b) Schematic plan for a progression of tints on the side of a cube.

✍Practice Exercise 8.9: Color Mixing Applied to a Three-Dimensional Form

Construct a three-dimensional geometric form such as a tetrahedron, a decagon, or a cube. Select a principal hue for the composition. Construct and assemble the selected volumetric form from 3-ply Bristol board. Assign each side of the form a color scheme—that is, tints, tones, shades, or analogous progressions. On each side, represent the assigned scheme in a six-step progression, beginning with the principal hue on the outside larger area and moving to the new hue or value in the center. Paint the color areas for each scheme using gouache on watercolor paper, cut out, and mount to the polygon sides of the polyhedron form (see Figures 8.66 and 8.67).

Figure 8.67 (a-b) Examples of a progression of tints and shades on each side of a cube (illustrated by Susan Hessler).

8.66a

8.66b

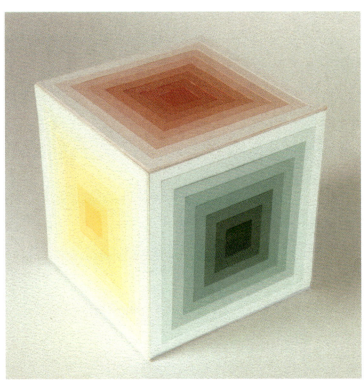

8.67a

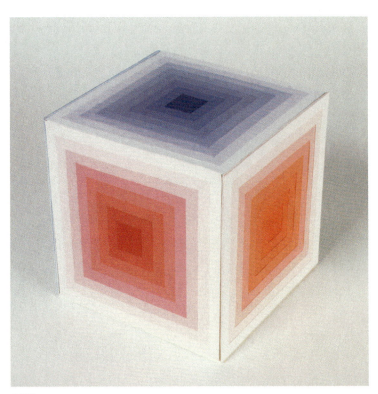

8.67b

Complementary Color Harmonies

Complementary hues are located directly opposite each other on the color circle (see Figure 8.68). When these pigments are mixed together in equal amounts, the result is a gray or achromatic color because the pigments absorb the primary light rays. If complementary hues are mixed in unequal proportions, they lessen the tone and intensity (create shades) of the principal hue. Complementary hues are so named because when they are placed next to each other, they appear brighter, or of greater intensity, than when viewed alone or with an analogous hue.

Contiguous complements share a common border or are placed next to each other so that they touch. When contiguous complements are organized in a pattern and are of equal value and intensity, an illusion of vibration between the hues occurs. Unlike a camera that can easily focus on one point in the pattern, the human eye tends to change its focus rapidly from one color area to another when high chroma complements are used.

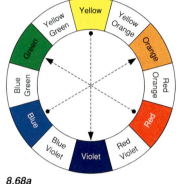

8.68a

Figure 8.68 (a-g) Complementary hues are located opposite each other on the color circle.

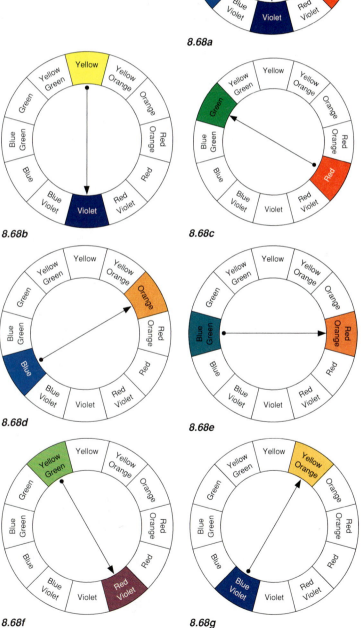

8.68b

8.68c

8.68d

8.68e

8.68f

8.68g

Figure 8.69 Color composition illustrating vibration using complementary colors.

Figure 8.70 Typographic color vibration composition using complementary colors.

✍Practice Exercise 8.10: Creating Color Vibration Using Complementary Hues

The color areas can be painted separately on paper, then cut out and applied to the illustration board. Another construction option is to select PANTONE® or Color Match® paper, and cut out each area to be applied to the board.

Begin by designing a pattern using two different color areas. It can be a simple grid pattern, or it can be a geometric progression (see Figure 8.69).

Complementary color schemes can be used in compositions to enhance the meaning of the communication, or to bring greater attention to specific elements in the message. However, in typographic compositions, the use of high chroma complements makes the message difficult or even impossible to read (see Figure 8.70).

Lightly construct the pattern on hot press illustration board in HB pencil. Select a complementary color scheme to fill the pattern area, and experiment with color placement through marker sketches on tracing paper. Once the final design is determined, use gouache or acrylic pigments to complete the final artwork.

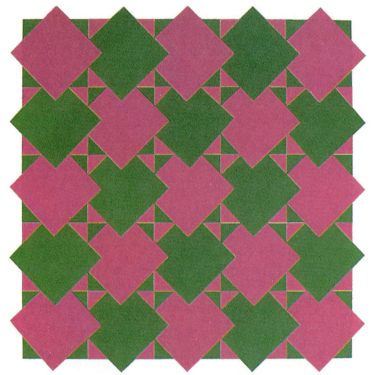

8.69

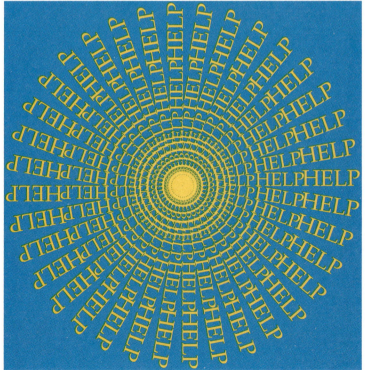

8.70

Selecting Split Complements

Split complement color harmonies consist of three hues: a principal hue, and two secondary hues located adjacent to the direct complement of the principal hue (see Figure 8.71).

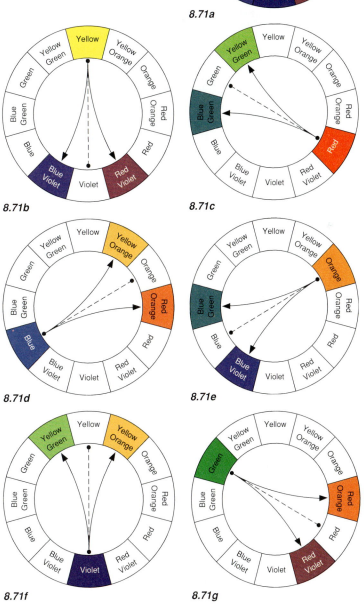

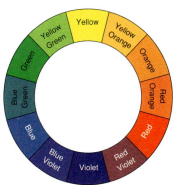

Figure 8.71 (a-g) Split complement schemes of (b) yellow, (c) red, (d) blue, (e) orange, (f) violet, and (g) green.

8.71a

8.71b

8.71c

8.71d

8.71e

8.71f

8.71g

Afterimage Phenomenon

The afterimage phenomenon occurs through the use of complements. In the eye there are color receptors on the retina called cones. These cones can adjust to a specific hue when a viewer looks at an area for one minute or more and then looks at a blank, neutral field. The viewer then sees the complement of the original hue. For example, if the hue is blue, the viewer will experience an afterimage of orange. The complementary color also appears when the eyes are closed.

Figure 8.72 (a-c) Complementary colors and neutral field or ground create the afterimage phenomenon.

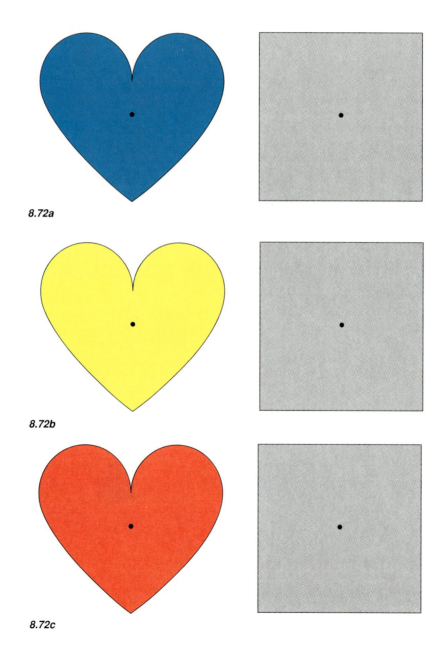

8.72a

8.72b

8.72c

Successive contrasts occur in the after-image phenomenon when the viewer looks at a colored ground instead of a neutral ground. For example, if the viewer looks at a blue heart and then at a light gray field, an orange heart will appear as the afterimage because it is the complement (see Figure 8.72). In a successive contrast, when the viewer looks at the red heart, then looks at the yellow ground area, the afterimage will appear yellow-green instead of green because it is influenced by the color of the ground area (see Figure 8.73).

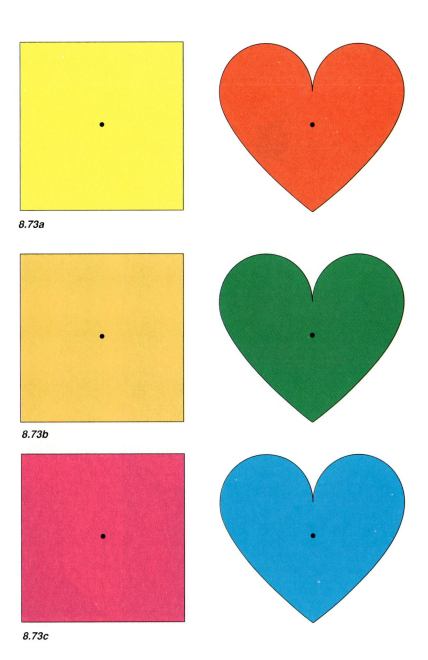

8.73a

8.73b

8.73c

Figure 8.73 (a-c) Successive color contrast phenomena created by the afterimage phenomenon.

Figure 8.74 (a-d)
Triad color harmonies are composed of three hues spaced equidistantly on the color circle.

Triad Harmony

Three hues spaced equidistantly around the color circle are called triads. By rotating an equilateral triangle in the center of the color circle, the hues of triad harmony can be determined. Since the primary and secondary pigments are equidistant from each other on the color circle, they combine to create color harmonies (see Figures 8.74 and 8.75).

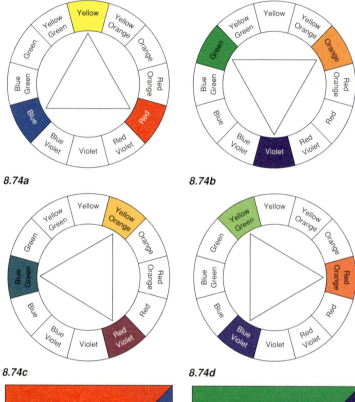

Figure 8.74 (a-d) *Triad color harmonies are composed of three hues spaced equidistantly on the color circle.*

Figure 8.75 (a-d) Compositions using triad color harmonies.

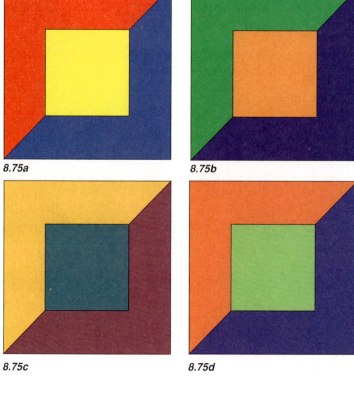

Tetrad Harmony

Tetrad harmonies are composed of four hues that are two sets of complements. A tetrad can be diagrammed as a square or as a rectangle inside the color circle (see Figures 8.76 and 8.77).

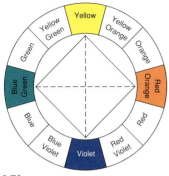

8.76a

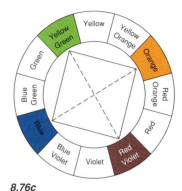

8.76b

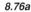

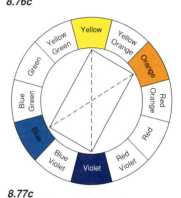

8.76c

*Figure 8.76 (a-c)
Tetrad harmonies
composed of four
hues that are two
sets of comple-
ments.*

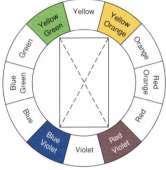

8.77a

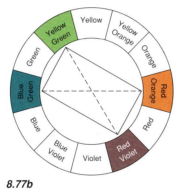

8.77b

8.77c

*Figure 8.77 (a-c)
Tetrad harmonies
composed of two
sets of split com-
plements.*

FIGURE/GROUND AND COLOR RELATIONSHIPS

As will be discussed in Chapter 10, the figure/ground relationship is important to a composition. The legibility, communication, and recognizability of the figure relative to the ground area assists the viewer in perceiving, synthesizing, and understanding the visual information being presented. Other figure characteristics, such as the figure's size, dimensions, texture, pattern, and value, also affect the perception and understanding of the overall composition. Knowledge of how colors affect one another also assists

in controlling how a viewer perceives a composition, object, or man-made environment. It is important for artists, architects, and designers to understand the positive and negative visual effects and uses of color in the figure/ground relationship.

Size, Color, and Luminosity

The appearance and sizes of figures and forms are altered by the colors applied to them. In the example of black and white line art in Figure 8.78, a white figure placed on a black ground appears larger than a black figure placed on a white ground. This effect is called *irradiation*.

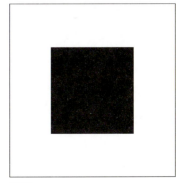

8.78a

8.78b

*Figure 8.78 (a)
When a white
square is placed on
a black ground, it
appears larger and
brighter. (b) In con-
trast, when a black
square of the same
size is placed on a
white ground, the
black square does
not appear as large
or as bright.*

Figure 8.79 (a) When a yellow square is placed on a black ground, it appears more brilliant. (b) When a yellow square is placed on a white ground, the yellow square appears darker.

Figure 8.80 (a) When a red square is placed on a black ground, it appears brighter and radiates luminous warmth. (b) When a red square is placed on a white ground, it appears to recede and become darker.

Figure 8.81 (a) The light blue square placed on the darker blue ground appears brighter compared to (b) its complement, orange, where the same light blue square appears darker. (c) The light magenta square placed on the dark blue ground appears brighter than (d) the same light magenta square on a dark magenta ground.

Irradiation deals with size and luminosity of figures and forms. Each hue has a specific luminosity that is unique to that particular color. The overall luminosity and intensity of colors appear differently on different ground colors. For example, on a white ground, colors decrease in luminosity, but appear to increase chromatically. On a black ground, light colors appear to have a higher chroma whereas dark colors appear to have less chroma and greater luminosity.

These changes in luminosity and chroma affect how the viewer perceives the size and depth of figures within the composition. On a black background, the light colors appear larger and seem to advance toward the viewer. On a white ground, the darker hues will appear larger and will seem to advance toward the viewer (see Figures 8.79–8.81 for illustration of this concept).

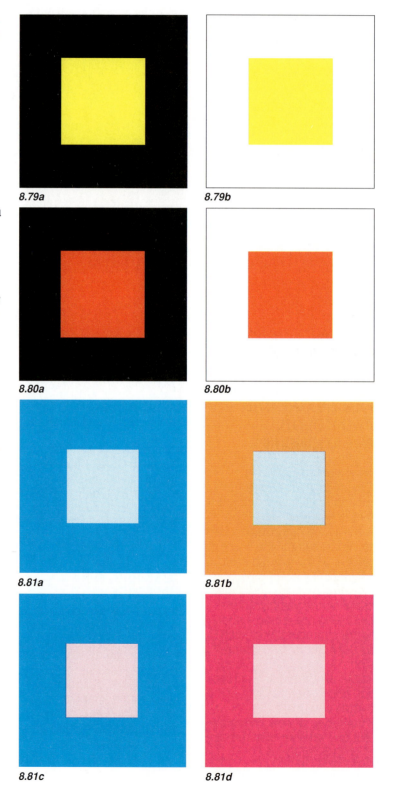

8.79a

8.79b

8.80a

8.80b

8.81a

8.81b

8.81c

8.81d

Simultaneous Color Contrast

Simultaneous color contrast refers to the visual influence of one color on another color when they are placed next to or upon each other. There are different types of simultaneous color contrast or relationships categorized according to the dimensions of color: value, saturation, and hue, or any combination of these. The proportion of one hue to another is also important in creating the simultaneous color contrast.

Simultaneous Contrast with Value

The value of an achromatic or chromatic color is affected by the surrounding ground area. For example, a medium gray will appear brighter on a solid black ground than it will on a solid white ground (see Figure 8.82). The larger black ground area makes the eye less sensitive to the lower value, causing the gray center to appear brighter. The larger white ground makes the eye less sensitive to higher value; therefore, the gray center appears darker.

Simultaneous Contrast with Saturation

A hue of medium saturation can be placed on a ground of the same hue, but of a different saturation level. For example, if the medium hue is placed on a ground of the same hue and tonality, but of higher saturation, it will appear less saturated than when placed on a back-

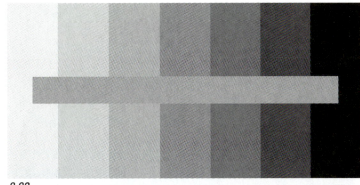
8.82

8.83

8.84

Figure 8.82 Simultaneous contrast illustrated using value.

Figure 8.83 Simultaneous contrast illustrated using saturation.

Figure 8.84 Simultaneous contrast illustrated using hue.

ground of the same hue and tonality of lower saturation (see Figure 8.83).

Simultaneous Contrast with Hue

As with value and saturation, a figure will appear differently when placed on an achromatic ground than it appears on a colored ground. If or-

ange is placed on a white ground, it will appear brighter than it would on a black ground because the orange is influenced by the color of the ground area. Likewise, if a hue is placed on the ground of a complement, it will appear brighter than when placed on the ground of an analogous hue (see Figures 8.84 and 8.85).

Figure 8.85 (a-b)
Simultaneous color
compositions
(student work).

8.85a

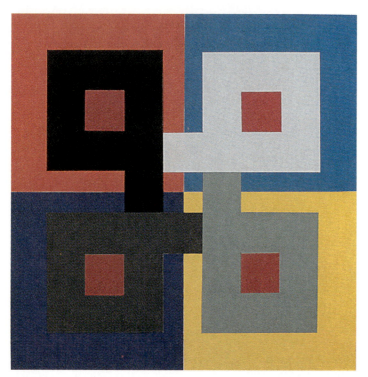

8.85b

Color as a Depth Cue

Color can create the illusion of depth and distance on the two-dimensional picture plane. When color harmonies, contrasts, and phenomena are used in combination, they can create the illusion that compositional elements appear to advance or recede (see Figure 8.86).

Architects and interior space designers can use color and value change to visually increase or decrease the apparent size of an enclosed space within a building. For example, using light colors or white will make a room appear larger whereas using darker colors or dark gray tones will make it appear smaller. In addition, the use of color within a composition or space can be used to minimize details.

Aerial Perspective

Aerial, or atmospheric, perspective creates the illusion of depth through differences in the color and value of panoramic views within the visual field. At certain times of the day from an aerial perspective, colors and values in the foreground are more saturated and darker in value, while the background becomes lighter in color and more neutral in value. Forms seen in the distance appear to lose their color before they lose their shape. This phenomenon or depth cue can be applied in drawing and painting (see Figure 8.87).

Aerial perspective is usually seen or used in conjunction with a number of other depth cues, such as size, linear perspective, and detail perspective.

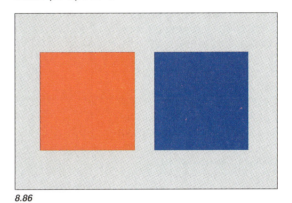

8.86

Figure 8.86 Warm colors advance while cool colors recede on a neutral background.

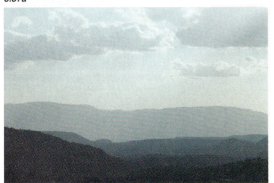

8.87a

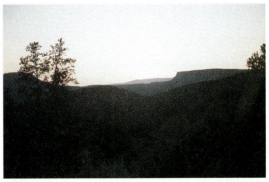

8.87b

Figure 8.87 (a-d) Aerial perspectives (photographed by the author).

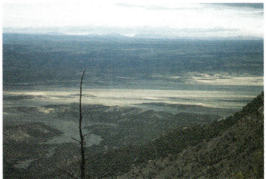

8.87c

8.87d

Figure 8.88 Primary hue ratio—yellow: blue: red = 3:6:8.

Figure 8.89 (a-c) Complementary conversion ratios for color balance are (a) yellow:violet = 1/4:3/4, (b) orange:blue = 1/3:2/3, and (c) red:green = 1/2:1/2.

COLOR BALANCE AND PROPORTION

Because colors are applied on various surfaces, a knowledge of pigments and their attributes is required. When placing colors within or on specific areas, it is necessary to consider the proportions of each hue required to create visual balance. This consideration is important to all compositions, regardless of what color harmony or color contrast scheme is selected. Johannes Itten, in his book *The Art of Color*, reviews some of the studies by Goethe that indicate simple numerical ratios that can be used to approximate light values for the primary and secondary pigment hues. Goethe converted the complementary and secondary light values into harmonious percentages of area, to produce a static or counterbalanced effect (see Figure 8.88).

The numerical ratios should be used only as a general guideline to help develop color sight discernment and sensitivity skills in combining and applying colors.

The conversion ratio creating color balance for secondary hues is: orange = 4; violet = 9; green = 6. For primary and secondary hues the conversion ratio creating color balance is: yellow = 3; orange = 4; red = 6; violet = 9; blue = 8; green = 6. Complements are also balanced but in different proportions (see Figure 8.89).

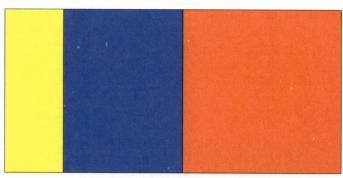

8.88

8.89a

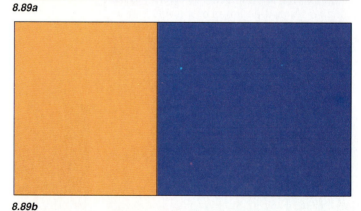

8.89b

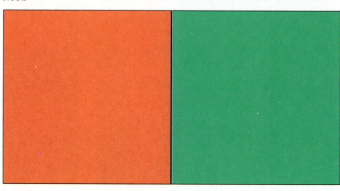

8.89c

✍Practice Exercise 8.11: Color Balance and Proportion

Compose a number of symmetrical and asymmetrical compositions using Goethe's color proportions as a guideline for color application. Assign colors to the different areas of the composition so that the cumulative size of the color areas for each particular hue is close to the proportions and visual balance outlined.

Remember that color balance within the composition doesn't depend entirely on the size of the color areas in the format. The purity or saturation of the hue, and its value level, will affect the final composition as well (see Figure 8.90).

After completing the exercise, try an intuitive approach to develop a composition. Create other types of color balance allowing one or two hues to dominate the composition. Experiment with different color schemes, such as split complements, triads, and tetrads, for more complex visual solutions.

PSYCHOLOGY OF COLOR

At this basic level of color study there should be an awareness regarding the psychological effects of color. Color strongly influences a viewer's moods, feelings, associations, and choices. It is not understood how or why this phenomenon exists. Nevertheless, it is an important factor to be considered because the choice of color used for products, graphics, and interior and exterior environments does influence a response.

It is well known that colors can affect and create moods. There is a general assumption among behaviorists that many people have similar reactions when exposed to a specific color. There is a suggestion that color choice is instinctive or innate, but the process of early learning cannot be completely eliminated.

There have been many interesting studies exploring color preference. For example:

In 1941 a survey concluded men like blue best, followed by red, green, violet, orange and yellow. Women chose the same order, but reversed yellow and orange. Another survey in 1969 placed orange first, blue second, red, and green last. It was suggested that results were influenced by the fact that orange was a fashionable color at that time. To reduce this factor, tests were carried out among students in Botswana and Kenya (on the highly questionable ground that they would be less "fashion conscious"). In Botswana, blue was favorite, followed by green, with red and yellow the least favorite; the Kenyans preferred green over blue, but otherwise agreed. The results showed that in color preference much depends upon what the color is wanted for—we do not choose the same green for our kitchens as we do for our cars. The tests ignored saturation, which according to a West German study, is the most important criteria for preference [Faber Birren, Color *(New York: Leon Amiel Publisher, 1980), p. 44].*

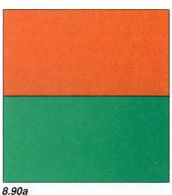

8.90a

8.90b

8.90c

8.90d

Figure 8.90 (a-d) Compositions illustrating color balance and proportion.

Figure 8.91 (a-h) Selected color schemes and their meanings associated with words and forms (illustrated by: a-d, Bryan Wright; e-f, Tracy Bellomo; g-h, Jeff Debord).

✏Practice Exercise 8.12: Color Association

This exercise relates color associations to specific words such as alert, relaxed, tense, and so forth. Select words that refer to emotions, such as despair and sadness. Using these words, select four colors that best express each word and its visual association. The colors can be selected as harmony or contrast schemes, depending on the desired visual results. Also experiment with tints and shades. As a reference, record the color choices and reasons behind them.

Paint or select swatches of the appropriate color from either PANTONE or Color Match sample books. Trim 1" squares of each hue, and mount them together as a group on hot press illustration board. Compare the selections in terms of hue, saturation, and value. Note how the dimensions of color affect the "feeling" attributed to each selection (see examples in Figure 8.91).

✏Practice Exercise 8.13: Color Association and Music

Select two or more different types of music, such as rock, jazz, country, classical, or chamber music. Repeat the previous exercise, selecting colors that you associate with the selected types of music. Mount them on hot press illustration board.

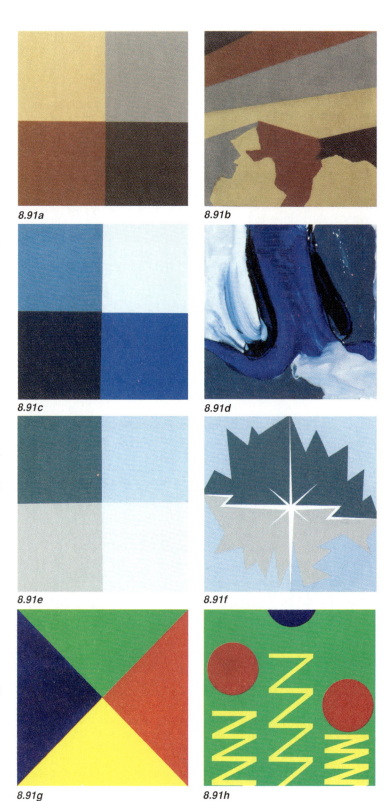

8.91a 8.91b 8.91c 8.91d 8.91e 8.91f 8.91g 8.91h

TWO-DIMENSIONAL COLOR STUDIES

✍Practice Exercise 8.14: Two-Dimensional Color Study

Begin this exercise by reviewing the color harmonies and phenomena previously presented, such as simultaneous contrast, optical color mixing, color vibration, and analogous, monochromatic, and complementary harmonies. Create a color composition using one of these phenomena. The composition should be constructed of colored paper, film, or gouache and mounted on hot press illustration board (see Figures 8.92 and 8.93).

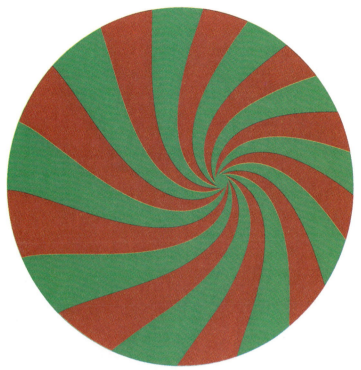

8.92

Figure 8.92 Color vibration composition (student work).

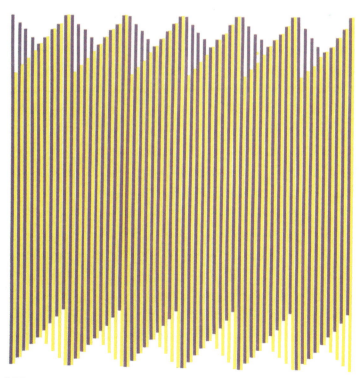

8.93

Figure 8.93 Optical color mixing composition (illustrated by Kathy Stern).

✍Practice Exercise 8.15: Color Relief Composition

Develop a relief composition by dividing a 16-1/4" square into twenty-five 3" squares. Leave a 5/16" margin between each square, and a 1" margin around the outer edge of the pattern. Create a pattern by repeating a simple geometric shape, centered within each 3" square area. Cut out part of the geometric shape to create a folded flap. Score all flaps with a stylus, then fold neatly.

Apply color to the model by painting areas of designer's gouache on smooth watercolor paper, or select colors from PANTONE or Color Match. Place the colors behind the relief cuts. Build a box out of 5-ply Bristol board or 1/8" foamcore and apply the relief upon it (see Figure 8.94).

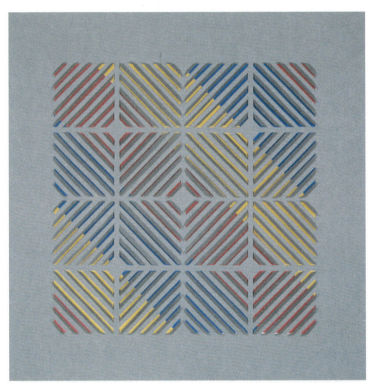

8.94a

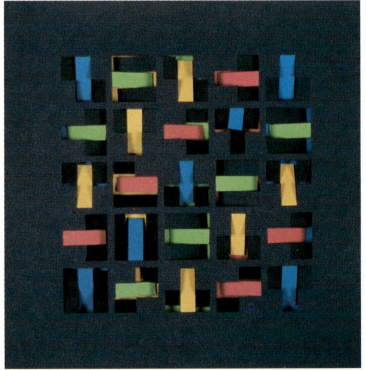

8.94b

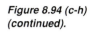

*Figure 8.94 (c-h)
(continued).*

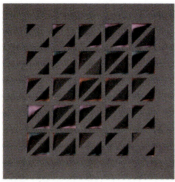

8.94c

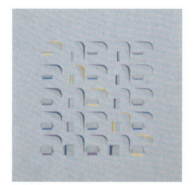

8.94d

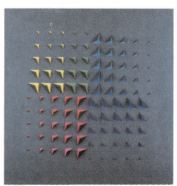

8.94e

8.94f

8.94g

8.94h

*Figure 8.95 (a-b)
Types of free-stand-
ing model configu-
rations.*

✍Practice Exercise 8.16: Color Related to a Free-Standing Model, Using a Proportional System

This exercise emphasizes visual exploration of proportion using a selected color harmony.

Begin the exercise by sketching and building small cardboard models of free-standing (self-supporting) planar configurations. Study the diagrams in Figures 8.95–8.98 for proportional constructions, or refer to Chapter 12 for more information on proportional systems. The use of proportional ratios and constructions will establish a rationale for the panel size and area dimensions. Each panel or plane within

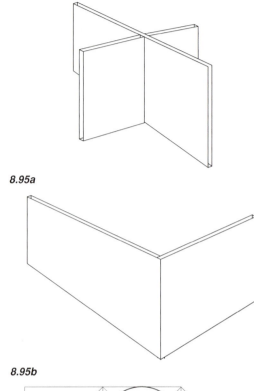

8.95a

8.95b

*Figure 8.96 (a-b)
Golden mean com-
positions based on
a progression of
proportional
squares and in-
scribed circles.*

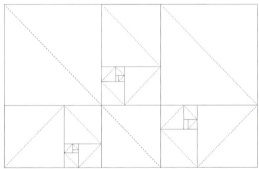

8.96a

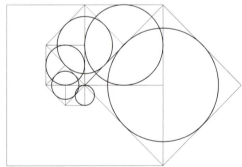

8.96b

*Figure 8.97 Propor-
tional line progres-
sion.*

*Figure 8.98 The
golden mean can be
subdivided into
smaller proportional
units. Compositions
can be created by
separating these
units and arranging
them into a new
configuration (illus-
trated by Shane
Lewis).*

8.97

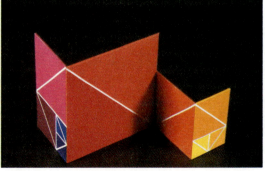

8.98

the design should be proportional to the other panels or planes in the configuration.

After the proportions of the planar panels are established, subdivide each plane into two-dimensional proportional areas that complement and align themselves within the whole form. Through marker sketches, experiment with different color harmonies and planar compositions. Select one solution for the final model.

Build the final model from medium-to-heavyweight board that is white on both sides. This allows for application of color to both sides of each plane in the model. Separate panels can be joined by various cutting, slotting, and gluing methods. The weight of the board should be determined by the type of configuration designed. For example, if the planes are folded, use a medium-weight board. If the planes are cut and slotted, use a heavyweight board. Use designer's gouache to apply color to the final model (see Figure 8.99).

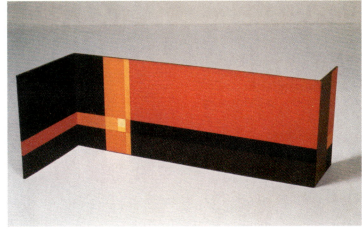

8.99a

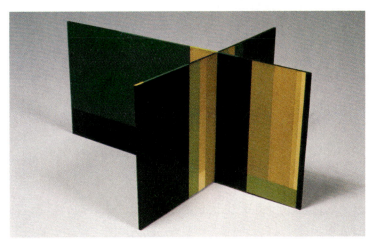

8.99b

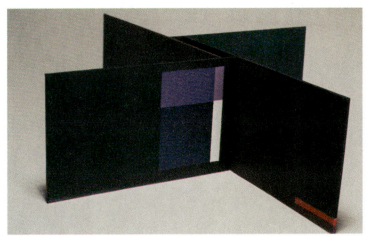

8.99c

Figure 8.99 (a-c) Examples of free-standing models illustrating a proportional system using color (student work).

.....................................

Figure 8.100 (a-d) Three-dimensional cubes created by using set theory and the symmetry operations rotation and reflection (illustrated by Robert Spica).

Figure 8.101 (a-d) Three-dimensional cubes created by using set theory and symmetry operations (illustrated by Robert Spica).

Figure 8.102 (a-c) Set of transformed cubes and their relative relationships (illustrated by Robert Spica).

Figure 8.103 A planar net (illustrated by Robert Spica).

THREE-DIMENSIONAL COLOR STUDIES

✍Practice Exercise 8.17: Volumetric Paperforms Emphasizing Color Harmonies and Symmetry Patterns

Design a set of four volumetric paperforms that can be moved or rotated to create a number of different color harmonies and pattern relationships. Develop the forms using a transformation subtractive process, beginning with a cube. Through sketching, subtract areas from each cube to create new volumes, relating the vertices, edges, and surfaces of each; that is, adjacent forms will have the same or similar shape. Note: The cube must maintain its identity even though a portion is removed. In addition, the formal symmetry of the set is important and must complement the overall grouping of the volumetric forms and selected color harmony.

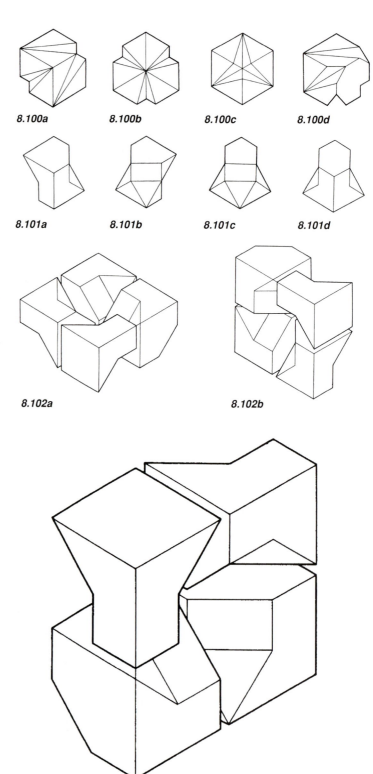

8.100a 8.100b 8.100c 8.100d

8.101a 8.101b 8.101c 8.101d

8.102a

8.102b

8.102c

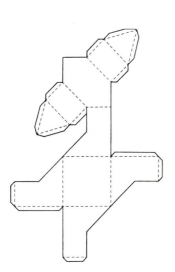

8.103

Once the shape of the cube forms are determined in concept sketches, construct three-dimensional Bristol board models. Develop a planar net of each volume, adding glue tabs and scoring folds. Each form should measure approximately 3" to 3-1/2" on the sides. Apply color to the surfaces of the forms using designer's gouache or colored paper before folding and gluing each volume (see Figures 8.100–8.104). This exercise also relates to set theory, which is the total relationship among a set of three-dimensional forms that relate vertices, interior/exterior line angles, and planes to the given condition, as shown in Figures 8.100 and 8.101.

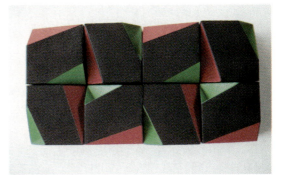

8.104c

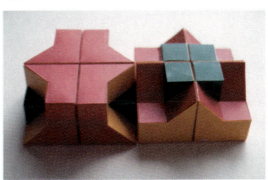

8.104d

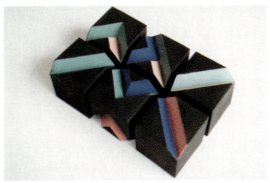

8.104e

Figure 8.104 (a-f) Examples of color cube models (designed by: a, Robert Spica; b, Gail Baker; c, Jon Fehrman; d, Greg Bonnell-Kangas; e, Mary Lynn Shaw; f, Gail Baker).

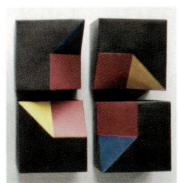

8.104a

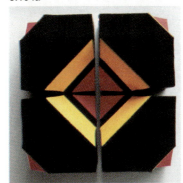

8.104b

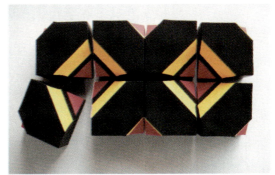

8.104f

✍Practice Exercise 8.18:
Three-Dimensional Color Study Using a Proportional System

The emphasis of this exercise is on gaining additional experience in the application of color harmonies in conjunction with the creation of a three-dimensional model. The exercise uses fifteen to twenty-five dowel rods. The length of each rod is based on a proportional progression system—in other words, the golden mean or root rectangles.

Develop concept sketches in 1/2"=1" scale using the conventions of orthographic drawing (see Figure 8.105). Use markers to indicate color choices in the sketches. Select a color scheme for the three-dimensional model based on color harmony studies in this chapter such as analogous, monochromatic, complementary, and so on.

Figure 8.105 (a-d) Sketches illustrating the design of a model using proportion and color (illustrated by Robert Buckingham).

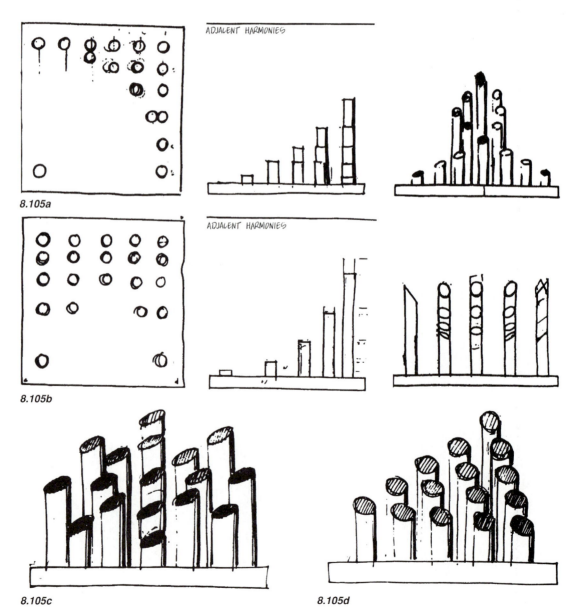

8.105a

ADJACENT HARMONIES

8.105b

ADJACENT HARMONIES

8.105c

8.105d

The dowels can be organized and positioned as a symmetrical or asymmetrical grouping. The top of each dowel should be cut on a diagonal, and the opposite end positioned into an 8" x 8" x 3/4" base. Drill 3/4" holes in the base and place the dowels into the holes. Use wood primer to paint the dowels and base so that the finishing coat of paint will be smooth. Use only one color, either white or black, to paint the base and shaft of each dowel. The diagonal top of each dowel is then painted according to the selected color harmony scheme using acrylic paint (see Figure 8.106).

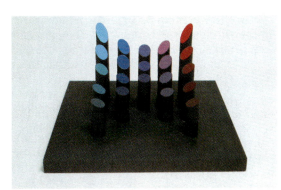

8.106a

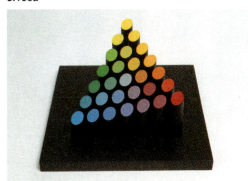

8.106b

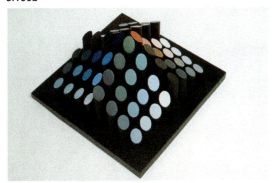

8.106c

8.106d

Figure 8.106 (a-d) Photographs of color models (designed by: a-b, student work; c, Paul Henninge; d, Robert Buckingham).

⚐**Practice Exercise 8.19: Three-Dimensional Color and Shape Transformations**

Design and develop a three-dimensional form transformation from a two-dimensional shape transition transformation, as shown in Figures 8.107 and 8.108. The transformation is based on changes in the size or shape of planes, or a combination of these attributes. Once the transformation sequence is established, using Bristol board and spacers, review different ways the planes can be combined to create three-dimensional forms. The form organization should complement the shape transformation sequence. Then select a color scheme using achromatic and monochromatic color transformations.

Build the final form by cutting the series of planes from white 4-ply Bristol board. Paint each plane using gouache before constructing the model. Select a thicker board material, such as foamcore, to make a base and spacers between the planes (see Figure 8.109).

Figure 8.107 A shape transition, transformation of a triangle.

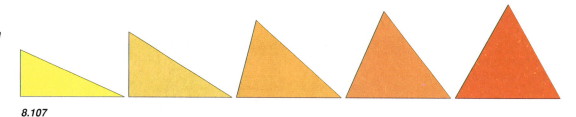

8.107

Figure 8.108 Diagram illustrating the assembly of the model inserting foamcore spacers.

8.108

8.109a

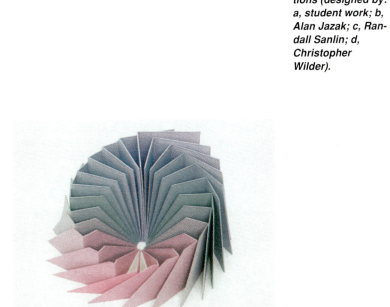

Figure 8.109 (a-d)
Planar models illus-
trating shape and
color transforma-
tions (designed by:
a, student work; b,
Alan Jazak; c, Ran-
dall Sanlin; d,
Christopher
Wilder).

8.109b

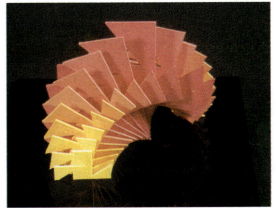

8.109c

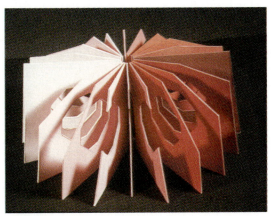

8.109d

Figure 8.110 Scoring, folding, and gluing the 1" x 1-1/16" color planes.

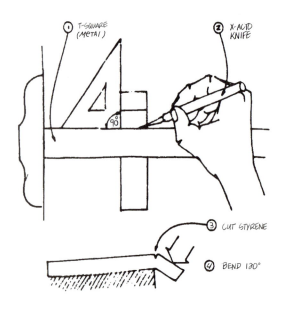

8.110

Figure 8.111 Assembling the color cylinder.

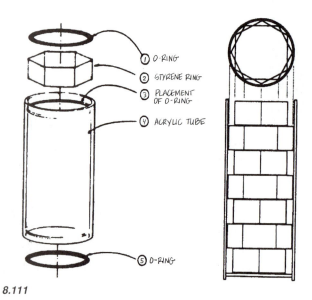

8.111

✍**Practice Exercise 8.20: Designing a Color Cylinder**

This playful color study emphasizes the interaction of different color harmonies and is an opportunity to plan complex color progression schemes.

Begin by developing a number of achromatic and chromatic schemes. Refer to color harmonies and major types of hue relationships in this chapter. Use gouache on smooth watercolor paper or select colored paper to experiment with color mixing and to create different color schemes. Choose the best achromatic and/or chromatic scheme. From the painted swatches or colored paper, cut out rectangular planes 1-1/16" in length. The height of each is determined by a mathematical ratio, following the selected schematic plan (see Figure 8.110).

Using either 1/16" styrene or 2-ply Bristol board, construct and assemble six prismatic hexagonal rings. Dimensions of the planar pieces are the same as the pre-cut color pieces. Note that the construction process is based on scoring, folding, cutting, and taping or gluing the pieces together (see Figure 8.111).

Purchase a 2-1/2"-diameter by 6-7/8"-high clear acrylic cylinder from a plastics distributor. From a hardware store, purchase four 2-1/2"-diameter O-rings. Assemble the six colored hexagonal prismatic rings within the cylinder, placing an O-ring at the top and bottom of the cylinder to hold the prismatic rings. This construction method allows the hexagonal color rings to be rotated within the cylinder (see Figure 8.112).

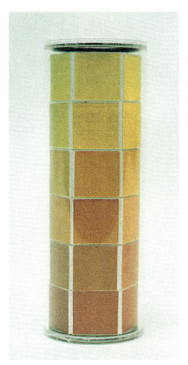

8.112a

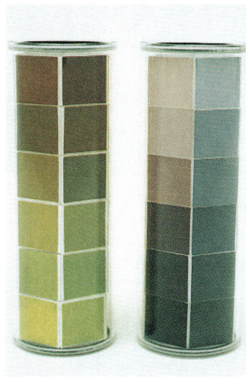

8.112c

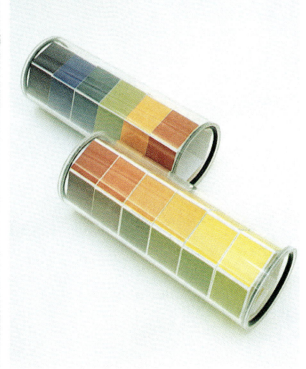

8.112d

Figure 8.112 (a-d) Completed color cylinder models.

8.112b

Figure 8.113 (a-b)
Concept sketches
of play structure
and application of
color (student
work).

Figure 8.114 (a-c)
Final scale models
of play structures
(student work).

✍Practice Exercise 8.21: Designing a Play Structure for Children and the Application of Color

The emphasis of this excercise is to relate color associations to simple geometric forms for a children's play structure.

The play structure can be letter, numeral, or geometric forms and should have interior/exterior access so that the child can climb in, on, and around the forms.

The design process requires concept drawings and three-dimensional sketch models. The model can be constructed from a variety of materials, such as Bristol board, lightweight illustration board, or balsa wood. The color considerations for the model should be related to visually complementing both the inside and outside of the structure, in addition to visually communicating a playful association.

Once the concepts have been finalized, select the best solution and prepare an orthographic drawing of the model. Construct the final model using materials mentioned. Choose a color scheme that best complements the play structure and apply it to the model using gouache or acrylic pigments. Prepare a base for the model that represents its intended ground. Include a child figure that shows the scale of the model (see Figures 8.113 and 8.114).

8.113a 8.113b

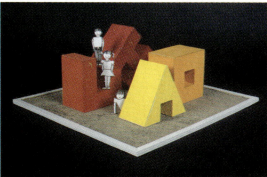

8.114a

8.114b

8.114c

REFERENCES AND RESOURCES

Albers, Josef. *Interaction of Color*. New Haven, CT: Yale University Press, 1963.

Birren, Faber. *Munsell: A Grammar Book of Color*. New York: Van Nostrand Reinhold, 1969.

————. *Principles of Color*. New York: Van Nostrand Reinhold, 1969.

————. *Creative Color*. New York: Van Nostrand Reinhold, 1961.

————. *Color*. Edited and designed by Marshall Editions Limited. New York: Leon Amiel Publisher, 1980.

Chigiiwa, Hideaki. *Color Harmony: A Guide to Interactive Color Combinations*. Rockport, MA: Rockport Publishers, 1987.

De Grandis, Luigina. *Theory and Use of Color*. Englewood Cliffs, NJ: Prentice-Hall, and Harry Abrams, Inc., 1986.

Duttmann, Martina, Friedrich Schmuck, and Johannes Uhl. *Color in Townscape*. San Francisco: W. H. Freeman and Co., 1981.

Ellinger, Richard G. *Color, Structure, and Design*. New York: Van Nostrand Reinhold, 1980.

Gerritsen, Frans. *The Theory and Practice of Color*. New York: Van Nostrand Reinhold, 1975.

Gerstner, Karl. *The Spirit of Colors*. Cambridge, MA: MIT Press, 1981.

Hickthier, Alfred. *Color Mixing by Numbers*. New York: Van Nostrand Reinhold, 1970

Hochberg, Julian. *Perception*. Englewood Cliffs, NJ: Prentice-Hall, 1964.

Itten, Johannes. *The Art of Color*. Translated by Ernst van Haagen. New York: Van Nostrand Reinhold, 1973.

Jacobson, Egbert. *Basic Color. An Interpretation of the Ostwald Theory*. Chicago: Paul Theobald, 1948.

Judd, Deane B., and Gunter Wyszecki. *Color in Business, Science and Industry*. 2d ed. New York: John Wiley & Sons, 1963.

Kuppers, Harald. *Color*. New York: Van Nostrand Reinhold, 1972.

Linton, Harold. *Color Model Environments*. New York: Van Nostrand Reinhold, 1985.

Marx, Ellen. *The Contrast of Colors*. New York: Van Nostrand Reinhold, 1973.

Munsell, Albert H. *A Color Notation*. Baltimore, MD: Munsell Color Company, Inc., 1961.

————. *A Grammar of Color*. New York: Van Nostrand Reinhold, 1969.

Rainwater, Clarence. *Light and Color*. New York: Golden Press, 1971.

Rood, Ogden N. *Modern Chromatics*. New York: Van Nostrand Reinhold, 1973.

Sloan, Patricia. *Color: Basic Principles and New Direction*. New York: Van Nostrand Reinhold, 1965.

————. *The Rainbow Book*. Edited by F. Lanier Graham. Berkeley, CA: Fine Arts Museums of San Francisco in association with Shambhala, 1975.

Vernon, M. D. *The Psychology of Perception*. Baltimore, MD: Penguin Books, 1963.

Weintraub, Daniel, and Edward L. Walker. *Perception*. Belmont, CA: Brooks/Cole, 1966.

Wong, Wucius. *Principles of Color Design*. New York: Van Nostrand Reinhold, 1987.

Zakia, Richard D., and Hollis N. Todd. *Color Primer I & II*. New York: Morgan & Morgan, 1974.

Zelanski, Paul, and Mary Pat Fisher. *Color*. Englewood Cliffs, NJ: Prentice-Hall, 1989.

Chapter 9

Space, Depth, and Distance

CHAPTER OUTLINE

- Chapter Vocabulary
- Introduction to Space, Depth, and Distance
- Depth Perception
- Binocular Depth Cues
- Two-Dimensional Space and the Picture Plane
- Monocular Depth Cues
- Gradients
- Other Depth Cues
- Practice Exercises
- References and Resources

CHAPTER OBJECTIVES

On completion of this chapter, readers should be able to:

- Understand some of the perceptual theories and concepts used to communicate depth and distance in two- and three-dimensional space.

- Understand the binocular depth cues and how they affect the perception of depth and distance.

- Identify and illustrate the monocular depth cues that can be portrayed on a two-dimensional picture plane.

- Understand the importance of using the monocular depth cues in creating two-dimensional drawings, paintings, and graphic designs.

- Select and use depth cues that can enhance man-made environments, products, and artistic forms.

Figure 9.1 The gray area (Space, Depth, and Distance) denotes the subject matter described in this chapter.

Perception Theory

Space, Depth, and Distance

Organizational Principles in 2 and 3 Dimensions

Visual Perception Concepts/Principles

Prescriptive Principles of Organization

2- and 3-Dimensional Form Perception

Light/Brightness
 contrast threshold
Illusions
Monocular Cues
 size
 partial overlap
 value
 color
 aerial perspective
 detail perspective
 linear perspective*
 texture gradient
 shadow
 blurring of detail
 transparency
Binocular Cues
 muscular cues
 parallax cues
Position
Orientation
Motion
Time

***Drawing/Projection Systems**
Orthographic
Paraline
 axonometric
 oblique
Perspective

Gestalt Theory
Figure Laws
Grouping Laws

Figure/Ground
Distinguishing Figure
 from Ground
Ambiguous Figure
Stability/Instability
Figure Closure
Figure/Ground Reversal
Pattern & Figure/Ground
 Reversal
Figure Overlap

Composition/Visual Organization
Balance
 symmetrical
 asymmetrical
Repetition
Harmony
Rhythm
Variety
Contrast
Dominance

Acquired Associations
Free Association
Familiarity
Reading Order
Hierarchies of
 Information
 general to specific
 specific to general
 chronological

Spatial Organization
Centralized
Linear
Radial
Clustered
Grid/Lattice Systems

Symmetry Groups
Identity
States of Being
Operations
 translation
 rotation
 reflection
 glide reflection
Symmetry
Transformations
 affine
 perspectivity
 dilatative
 topological
 golden section
 root rectangles

Dynamic Symmetry
Proportional Systems
 arithmetic
 harmonic
 geometric
Proportional Theories
 golden section
 renaissance
 the Modulor
 anthropometrics

9.1

CHAPTER VOCABULARY

Aerial perspective A type of perspective achieved through using gradations of color and value "farther back" into the painting or image.

Binocular cues Depth cues which result from using both eyes at the same time, as with a binocular microscope. There are two types of binocular depth cues, muscular and parallax, which allow humans to perceive size, depth, and distance within the environment.

Depth cues Fall into two different categories: monocular and binocular. These depth cues assist in the perception of size, depth, and distance of figures and forms in the environment, as well as on the two-dimensional picture plane.

Distance The amount of space between objects, people, and interior and exterior environments. Artists, architects, and designers re-create the illusion of distance on the two-dimensional picture plane through the use of monocular depth cues.

Gradation The process of change by regular, even steps, indicating a gradual advance. Texture and pattern gradation are types of monocular depth cues used by artists, architects,

and designers to indicate depth on a two-dimensional picture plane.

Linear perspective Formal drawing conventions used to reproduce the image of a three-dimensional form, figure, or environment on a two-dimensional picture plane. The final perspective image is the result of the intersection of projected lines from an orthographic drawing of the actual object in three-dimensional space. Perspective constructions are based on a series of points and lines projected from other views of the figure or form.

Monocular cues Depth cues which result from using only one eye, as with a monocular microscope. Monocular depth cues are used to create the illusion of three-dimensional space on a two-dimensional format or picture plane.

Motion The act or process of changing place, position, and/or orientation. Visual motion can be illustrated by showing starting and stopping points, blurring of the image, and so on.

Parallax The apparent displacement, or direction, of a figure or form as seen from two different points; binocular parallax.

Perspective The art or science of representing figures and forms so that they appear to exist within three-dimensional space on a two-dimensional picture plane or format.

Space perception Involves a number of interacting components that are influenced by previous experiences of the viewer. Space perception consists of three spatial axes (one-, two- and three-dimensional space) and one temporal axis.

Stereoscopic vision Because human eyes are set next to each other, two separate views of the visual field are seen at the same time. Stereoscopic refers to the ability to overlap these two slightly different views into one single image. Stereopsis creates the illusion of three-dimensional space and makes it possible to perceive distance.

Three-dimensional space The total environment perceived by the viewer, which includes length, width, and depth.

Two-dimensional space A plane having length and width; sometimes called the picture plane format.

INTRODUCTION TO SPACE, DEPTH, AND DISTANCE

Understanding how man perceives and responds to the various spatial aspects within the environment is important for artists, architects, and designers. Without this understanding, the process of communicating or creating forms is difficult. To help achieve this awareness it is essential

to learn some of the perceptual concepts and spatial cues as they relate to the perception of depth and form. It is also necessary to know how to visually represent depth and form through the monocular cues used in drawing or painting on a two-dimensional picture plane.

The objective of this chapter is to illustrate how two- and three-dimensional depth cues affect the perception of depth in the environment, as well as how they relate to the practices of art, architecture, and design. Before reviewing these spatial cues, it is important to

recognize that artists and architects have been aware of many of the monocular depth cues as far back as before Christ and in ancient civilizations in Egypt, the Middle East, India, China, and Europe.

In more recent history, Leonardo da Vinci formally studied and identified the depth cues used in perception. In the sixteenth century da Vinci identified the depth cues that could be reproduced in drawing and painting and then went on to identify the binocular cues used to perceive depth and distance in the three-dimensional world. Da Vinci's studies of spatial representation are now listed in some of the psychology textbooks as the monocular depth cues.

In the eighteenth century, Bishop Berkeley's "New Theory of Vision" posed questions about how ideas are formed or how the sense for space, distance, size, and the solidity of objects is formed. Berkeley's theoretical concept, the "Muscle Movement Theory of Visual Space," is presented by Julian Hochberg in *Perception* (1964): "The most influential theory of **space perception** in Western thought has been that distance is not a direct visual sensation at all. Instead the empiricist theory maintains, when the retinal image of some object brings to mind the memories of the grasping or walking motions that have been made in the past in order to reach that object, those memories provide the

idea of 'distance' " [Julian Hochberg, *Perception* (Englewood Cliffs, NJ: Prentice-Hall, 1964), p. 43].

In 1858 P. L. Panum investigated the different phenomena associated with monocular and binocular vision. A major contribution of the Panum study was the discovery of what happens when different images are presented to each eye at the same time. Panum presented an image with a shape contour to one eye and an image of a homogeneous field to the other eye. Viewers consistently reported that the image of the contour was more dominant. This research was summarized by Panum and called "The Dominance of Contours," which provided a basis for describing special examples of figure/ground relationships.

Another influential theory in perception psychology, called "The Classical Theory of Cues," was developed by H. L. F. von Helmholtz almost a century ago. The cue theory is based on a distinction between sensation and knowledge; that is, before the mind can know and interpret sensory information, it must participate in sensory events that form the basis for interpreting depth. In essence, Helmholtz's theory emphasizes that the cues to space must be learned through experience, though he notes that once these cues are learned, the perception of space becomes automatic. However, Helmholtz fails to clarify how

this experience develops, or how it is learned. Helmholtz's theory has fallen out of favor with contemporary psychologists, however, because of his presentation of isolated examples of depth cues; modern psychologists caution that this is not the way depth and distance are perceived in real life.

During Helmholtz's time other German psychologists began to develop interest in this area of study and formulated their own theories. An example is Ewald Hering's "Theory of Depth Perception and Local Signs." His theory suggests that each point on the retina within the eye has specific innate values for perceiving the dimensions of height, width, and depth and that these points have corresponding points of height, width, and depth that relate to figures and forms within the three-dimensional environment.

Although earlier theories and experiments are considered important in the historical research associated with the perception of space, depth, and distance, new research proves that these theories and experiments are not entirely satisfactory. However, this should not detract from the contributions produced by these experiments.

A more recent theoretical approach to space perception was presented by Kurt Koffka in 1935. Gestaltist Koffka explained space perception as a whole pattern composed of interacting

forces rather than separate parts or characteristics. Similarly, in 1950 James J. Gibson theorized that retinal stimulation from the environment is not point-to-point stimulation but is the result of relational patterns and groupings of images on the retinal surface.

DEPTH PERCEPTION

Historically, approaches to the study of depth perception have been directed by the many theories and experiments of the artist and the perception psychologist. These approaches vary according to their respective areas of focus and application. For example, the artist, architect, or designer is interested in relating and applying the depth cues to communicate ideas, forms, and spaces, whereas the perception psychologist is involved in examining the physical and psychological aspects that provide a basis for understanding and distinguishing depth.

The study of space and depth perception is usually approached by first differentiating between two- and three-dimensional space and the various cues that contribute to the perception of depth. Generally, basic visual studies concentrate on the two-dimensional depth cues that relate to the creation of depth on the picture plane. In contrast, researchers in the area of perception psychology study depth perception because it is descriptive of the viewer's visual experi-

There are other philosophical and perceptual theories that contest or verify these observations. However, it is not possible to discuss each theory or observation in this text. The information, as presented, is meant to give the reader

ence of space, depth, and distance within the environment.

Three-Dimensional Space

Three-dimensional space is described as being boundless or limitless in all directions. The visual perception of three-dimensional space involves a variety of interacting mechanisms. These visual mechanisms are based on binocular vision, or seeing with two eyes. Binocular vision allows **stereopsis**, or the illusion of three-dimensional space. Monocular vision, or seeing with one eye, makes it difficult to discriminate between the relative depths of figures and forms within the three-dimensional visual field.

However, in monocular vision the visual field does not appear totally flat or two dimensional to the viewer. The viewer is still able to perceive three dimensions. This chapter primarily emphasizes the monocular depth cues used to create the illusion of depth within a two-dimensional format.

some sense that there is a historical context to this area of study. There are many sources that can be explored for further information in this subject area.

Depth Perception and Constancy

In the process of perceiving the three-dimensional world, it is evident that images of figures, forms, and environments vary in size, shape, and brightness according to their distance from the viewer.

Visual information relayed to the brain from the eye is altered according to distance factors (relative change in size, shape, and brightness according to distance), but the mental image of the figure or form remains the same. An oversimplified explanation of this concept of **constancy** is that past experiences of the viewer will influence what is perceived, since viewers often tend to see what they expect to see rather than what is actually there.

Size, shape, and brightness constancy are important phenomena as they relate to the visual language, since many of the visual concepts within a composition are judged relative to each other. The concept of constancy provides a basis for understanding how the monocular

cues are used in two-dimensional designs and compositions. As long as the artist, architect, or designer represents three-dimensional objects or environments two-dimensionally as they are seen in real life, the viewer will be able to assess size, space, and depth with relative confidence.

Size Constancy

Size constancy is the ability of the mind to maintain constant or unaltered perceptions of figures and forms despite changes in the image on the retina. For example, as the viewer moves closer to or farther away from an object, the retinal-image size decreases or increases. Despite this changing physiological process, viewers still perceive the particular object as "normal" in size, shape, and brightness.

Through testing and experimentation scientists have established the fact that people perceive the change in the size of an object's image as a change in distance, and not as a change in actual size of the figure or form. Children discover at an early age that even though objects appear smaller or larger at different distances, the object's physical characteristics remain the same in reality. The environmental context of the perceived figure or form also influences the perception of its size. People, objects, and environments are not usually seen in isolation but within a context that allows for comparison or contrast to other things.

The perception of size constancy does not apply to situations of extreme distance. From far away, figures and forms no longer seem to be "normal" in size, because

the environmental context of the viewer and that of the distant figure or form are completely different. For example, if an individual looks out the window of a tall building down to the sidewalk below, the people look extremely minute. The distance between the viewer in the building and the people on the sidewalk below distorts the perception of size and scale within the visual field.

Figure 9.2 illustrates the idea that distant objects are often identifiable only because there is a previous learned association to them within their context (location, position within the environment).

Figure 9.2 (a) A helicopter and (b) buoys illustrating object identity relative to association and distance within the environment.

9.2a

9.2b

Shape Constancy

Shape constancy is a phenomenon in which the perceived shape of an object remains relatively unchanged with respect to the actual retinal image seen by the eye. For example, if a coin is rotated so that it lies obliquely to the viewer's line of sight, it is still perceived as circular even though it becomes elliptical (see Figure 9.3). Through experience people know that the coin doesn't actually become elliptical, but only appears to because of its position and orientation relative to the viewer's line of sight.

What constitutes shape constancy? In 1931 Robert Thouless conducted an experiment to learn more about shape perception. Viewers were asked to view a circle at a slant, and then to select the shape that most accurately matched their perception. The illustration in Figure 9.4 shows that the shape presented was elliptical, but the viewer's perceptions were close to a regular circle. Thouless named this *phenomenal regression to the real object* because the observer's perception "regresses" from the actual retinal image to the true shape of the circle. Thouless concluded that people automatically perceive the orientation of figures and forms, and the mind compensates for the differences according to what is known about its actual shape. According to Thouless's research, viewers are able to compensate for the differences in the retinal image and still perceive the actual shape, as illustrated in a road sign (see Figure 9.5).

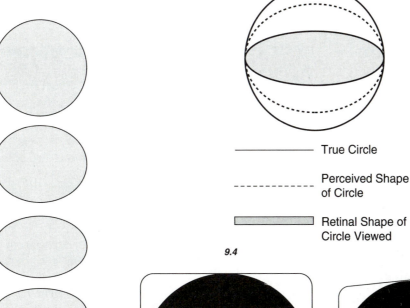

——————— True Circle

- - - - - - - - - - Perceived Shape of Circle

▭ Retinal Shape of Circle Viewed

9.4

9.5a 9.5b

9.3

Figure 9.3 Circle rotated until it lies obliquely to the picture plane, illustrating shape constancy.

Figure 9.4 Robert Thouless's model of the "phenomenal regression to the real object."

Figure 9.5 (a) Road sign front view; (b) road sign trapezoid shape but perceived as view (a).

Brightness Constancy

Brightness constancy occurs when light is reflected off an object and off the comparative objects within the same environment. The effect is proportional to the object, light, and reflections. For example, if an object's color contains white, gray, or black, the object remains relatively brightness-constant in spite of the light source.

Color Constancy

Brightness constancy is a part of what is called color constancy. Color constancy refers to the phenomenon that figures and forms appear to retain similar hue and saturation levels under different lighting conditions. Color perception is based on the perception of relationships within a total context; that is, even though the actual color of objects changes according to the lighting conditions, the relativity of the colors remains the same. To a great extent, adaptation in color perception is influenced by memory and environmental context, because reference to past experience often dominates over visual information actually perceived and relayed to the brain.

If the eyes and mind were not able to adapt color perception, then the visual results would be similar to those of color photographs taken under different lighting conditions. Unlike the human eye, color film cannot adapt to subtle color changes caused by different types of light sources. For example, when "daylight" film is used under tungsten or incandescent lighting conditions, a yellow-orange cast appears in the photograph. This is because "daylight" film is color-corrected to compensate for the color (wavelength) of light produced by the sun. Tungsten film is color-corrected to compensate for the color (wavelength) of light produced by lights having a tungsten filament.

BINOCULAR DEPTH CUES

In order to understand how depth and distance are perceived in the three-dimensional environment, it is necessary to outline factors that influence the ability to see figures and forms in the environment. There are two types of **binocular depth cues**: the muscular cues of depth and the parallax cues of depth.

Table 9.1 identifies the muscular and parallax depth cues.

Muscular Depth Cues

There are two types of muscular depth cues, as shown in the table: convergence and accommodation. Because of the distance between the eyes, the closer an object is to the viewer, the more the eyes must turn toward each other to focus. This turning inward of the eyes is called *convergence*. Convergence provides subtle cues to the viewer about the distance of the object. As convergence occurs, tension in the muscles of the eyeball sends sig-

| Table 9.1 Binocular Depth Cues | |
| --- | --- |
| **Muscular Depth Cues** | **Parallax Depth Cues** |
| Convergence | Binocular parallax |
| Accommodation | Binocular disparity |
| | Seeing behind near objects |
| | Crossed and uncrossed images |
| | Head-movement parallax |
| | Movement perspective or parallax |

[From Daniel J. Weintraub and Edward L. Walker, *Perception* (Monterey, CA: Brooks/Cole, 1966), p. 33.]

nals to the brain. The closer the object is to the viewer, the greater the convergence and tension (see Figure 9.6).

The muscular movement called *accommodation* occurs when the ciliary muscle surrounding the lens of the eye expands or contracts to focus on an object. In theory this muscular action provides subtle depth cues for the viewer; however, this effect cannot be clearly isolated for scientific experimentation.

Parallax Depth Cues

Parallax is defined, in a general sense, as an apparent change in the view of an object resulting from a change in position of the viewer, which creates a new line of sight of the object.

Binocular parallax is based on the fact that humans see with two eyes positioned two to three inches from each other. There are three different types of binocular parallax phenomena: binocular disparity, seeing behind near objects, and crossed and uncrossed images. Some of da Vinci's studies of perception of three dimensions in the sixteenth century were concerned with these phenomena.

Binocular Disparity

Binocular disparity occurs because each eye views objects or images from slightly different locations. We often assume that both eyes are looking at the exact same scene or object; we are not consciously aware of the differences between the two

views of the eyes. Binocular disparity can be proven by a simple experiment. Close one eye and carefully observe the details within a visual field, paying special attention to its boundary. Then close the other eye and notice that the visual field shifts to the side slightly, and the scene is not exactly the same as the scene experienced using the first eye.

Binocular disparity results in **stereoscopic vision**, or the ability to see forms three-dimensionally. Binocular disparity is not depth perception, but an important cue for depth perception.

Seeing Behind Near Objects

In his depth perception studies, Leonardo da Vinci described how it is possible to see behind near objects because of binocular parallax. The two different views seen due to binocular disparity combine to produce an image that reveals visual information behind a close object. This information is visible because the visual field of each eye becomes wider as the field extends away from the viewer.

As seen in Figure 9.7, when an object is placed close to the viewer, the direct line of sight converges at the object's surface, but the angle of vision encompasses an area as wide as or slightly wider than the object. The areas seen by the left and right eyes combine to allow the viewing of visual information beyond the object.

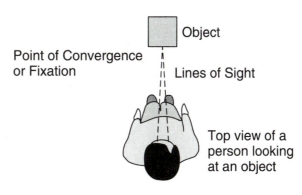

9.6

9.7

Figure 9.6 Top view of a person viewing an object, illustrating convergence.

Figure 9.7 Object close to the eyes where the lines of sight converge.

Crossed and Uncrossed Images

Images of objects located closer than the point of convergence (sometimes called the fixation point) are seen as crossed whereas images of objects located farther than the convergence point are seen as uncrossed.

Head-Movement Parallax

When one eye is closed and the head moves from side to side approximately two to three inches, the images within the visual field normally seen with two eyes will be reproduced in succession rather than at the same time. The successive viewing of these images allows the perception of depth. By increasing the distance of the head movement, an exaggerated version of binocular disparity results.

Movement Perspective or Parallax

Movement perspective, as in head-movement parallax, does not require the use of two eyes. Objects in **motion** that are located close to the viewer appear to move across the field of vision more quickly than objects in motion located farther away. The viewer is able to make judgments about the relative distance of objects based on the rate with which objects move across the field of vision.

TWO-DIMENSIONAL SPACE AND THE PICTURE PLANE

Two-dimensional space is defined as a flat plane that has only length and width. A two-dimensional plane is a picture plane or format that has no depth except for the illusion of depth created through the monocular cues (see Figure 9.8). The monocular cues create the illusion of forms advancing or coming forth from the picture plane. This can also be reversed so that forms recede from the picture plane.

The picture plane can be described as having two major axes or coordinates (horizontal and vertical) upon which shapes and forms can be placed and organized. The two-dimensional picture plane also has boundaries, whereas the three-dimensional environment has none.

MONOCULAR DEPTH CUES

Figure 9.8 The two-dimensional picture plane assumes a center spatial field, which can advance or recede according to how depth cues are applied within it.

Figure 9.9 (a) Same size squares positioned within the center of the page visually assume a static position without the utilization of depth cues. (b) Two squares in juxtaposition, one to the other, create a sense of depth through size change.

The **monocular depth cues** are defined and illustrated on the following pages. In most of the visual examples shown, only one cue is discussed; however, many of the figures include more than one monocular cue. These cues seldom appear in isolation; they are usually interacting forces in the visual field.

Size

The relationship of size of figures and forms within a composition can be used to communicate the sense of depth (see Figure 9.9). The combination of size and position create a strong depth cue resulting in the illusion of three-dimensional space (see Figure 9.10).

9.8

9.9a

9.9b

Figure 9.11 illustrates how a contrast in size can be used to reinforce a verbal message.

The examples in Figure 9.12 illustrate how the size of a figure or form is judged according to the size of its format. The fingerprint appears extremely large when it fills the whole format, as compared to the example where there is white space left around the fingerprint.

9.10a

9.10b

Figure 9.10 (a-b) Two squares positioned within the picture plane; size and position used to visually create the illusion of depth and distance.

Large.

Small.

9.11

Too Small?

Figure 9.11 Contrast in size can reinforce a verbal message.

9.12a

9.12b

9.12c

Figure 9.12 (a-c) The size of an image can be changed, influencing how it may be perceived and interpreted.

.....................................

*Figure 9.13 (a-b)
Contrast in size and
position within the
picture plane visu-
ally creates an illu-
sion of depth and
distance (illustrated
by: a, Louise Ut-
gard; b, Susan
Hessler).*

9.13a

9.13b

*Figure 9.14 Paper-
clip and clothespin,
actual size.*

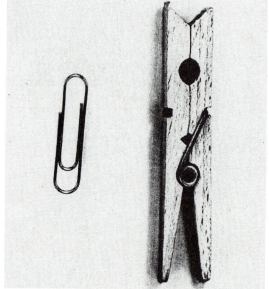

9.14

The combination of size and position with-
in a picture plane creates the illusion of depth
and distance (see Figure 9.13).

Because of past experiences and learn-
ing, judging size, scale, and distance correct-
ly is seldom difficult (see Figure 9:14).
Familiar size relationships are predictable.
When familiar objects are organized in combi-
nations and sizes that are contradictory to re-
ality, then more complex visual messages are
created (see Figures 9.15 and 9.16). The
photograph in Figure 9.17 illustrates how a
change in size can be used to create a rever-
sal in size expectation. The context in which
an object is viewed is an important influence
on perception of size and distance.

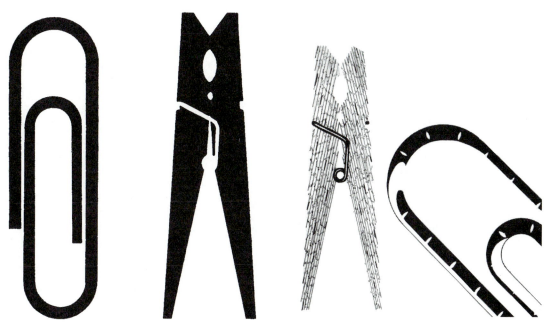

9.15a 9.15b

Figure 9.15 (a) Paperclip and clothespin, made the same size when realistically the paper clip is smaller, creating an exaggeration or a misrepresentation. (b) Paperclip and clothespin. A change in size, surface treatment, and position can create a visual exaggeration (study exercise by Heike Goeller, associate professor, Department of Industrial Design, The Ohio State University).

9.16

Figure 9.16 Visual pun, Les Valeurs Personnelles (Personal Values) by René Magritte, 1952, private collection, Yorktown, New York. (Copyright 1991 Charly Herscovici/ARS, N.Y.)

Figure 9.17 Size exaggeration creating a reversal in size concept and perception (photograph by Professor Richard Roth, Department of Art, The Ohio State University).

9.17

Position

Position is generally defined as the specific location where figures and forms are placed or arranged on the picture plane with reference either to the relative position of other elements or images or to the relative position of other figures and forms. Position within a format can affect the viewer's perception of depth and distance within a composition (see Figure 9.18).

The perception of depth within the visual field is influenced by the relative location of the object to the horizon line. The horizon line, whether visible or assumed, provides a context for the location of objects relative to the viewer. The horizon line also helps the viewer judge

Figure 9.18 (a-b) The square at the bottom of the picture plane is perceived as closer to the viewer, and the square at the top is seen as being farther away. (c-d) The horizon line, whether visible or assumed, provides a context for the location of objects or images relative to the viewer's position, (c) perceived closer, (d) perceived farther away. (e) If an object is positioned above the horizon line and is the same size, it is perceived with ambiguity. (f) If an object is positioned close to the horizon line and is smaller in size than other figures or elements, it is perceived as being farther away.

9.18a

9.18b

horizon line

9.18c

9.18d

9.18e

9.18f

distance, scale, and size when there is more than one similar figure in the composition. The perceived distance of figures and forms is affected by the size and vertical position of the figure relative to the horizon line. If a figure is positioned above the horizon line, but is large in size, it is perceived as being close to the viewer, but floating in the air. If a figure is located close to the horizon line, and is smaller in size than other compositional elements, then it is perceived as being farther away.

Overlap

The depth cue of overlap, also called interposition, occurs when a figure or form partially obscures the view of another figure or form within the visual field. The perception of overlap involves spatial judgments on the part of the viewer, such as "in front of," "on top of," "behind," and "between" (see Figure 9.19).

In the observation of overlap, the more complete figure is perceived as being in front of or on top of the less complete figure or form. The judgment of what is a complete or incomplete figure is based on past experiences or learned information as to what the whole shape "most likely" looks like. It is often difficult to perceive depth or overlap within a set of irregularly shaped figures and forms.

Figure 9.19 (a-b) Compositions illustrating overlap creating the illusion of depth and distance (illustrated by: a, Regina Vetter; b, student work).

9.19a

9.19b

Figure 9.20 Visual compositions using a combination of depth cues, i. e., overlap, size change, and linear perspective: (a) a feeling of depth is conveyed by overlapping representational shapes of houses (using line) along a street; (b) overlap and size change create the illusion that the viewer is slightly above and in front of the series of semicircular planes (illustrated by: a, Dirk Van Nederveen; b, Robert Geary).

9.20a

9.20b

The difference in line weight used to illustrate figures affects the perception of depth in overlap situations. A heavier line weight usually indicates the top or closest figure.

The examples in Figure 9.20 illustrate the depth cues of overlap, size, and linear perspective used in combination. Similar compositions can be created using representational or nonrepresentational shapes and forms.

Attached and Cast Shadows

Shadows help viewers perceive volume, solidity, texture, and the overall form of objects. The shape of a shadow is determined by a figure's position, orientation, and distance relative to the light source. Surfaces that face the light source are light in value and hue; surfaces facing away are in shadow and darker.

An attached shadow is the surface or surfaces of an object opposite the light source. The cast shadow is visible on the ground plane in the area where the object blocks the light rays from reaching it.

The gradual progression of shade from the lighted to the shadowed areas of an object communicates information about the overall shape and surface characteristics of the form. For example, an even, gradual change from light to dark implies that the surface is curvilinear.

Sudden changes in light to dark communicate a sharp corner or change in planar surfaces. Dark shaded areas are perceived as being farther away from the viewer whereas highlighted areas are perceived as being closer to the viewer (see Figure 9.21).

Tone or Value as Depth Cues

Darkness and lightness in visual perception are divided into color or chroma, and value or achroma. The term achromatic is synonymous with tone and value, and describes the lightness or darkness of objects seen within the environment.

In visual studies it is important to remember that colors have value (light and dark), as well as hue (color) and chroma (intensity of the hue). If the environment were reduced to black, white, and gray, then the depth and distance would be judged according to relative value changes. Usually depth and distance are indicated by the darker values in the visual field, whereas nearness is indicated by the lighter values in the visual field.

The position and orientation of figures and forms relative to the available light source results in a range of different values within the visual field. Through changes in value, depth, distance, volume, and mass can be illustrated as they appear three-dimensionally.

9.21a

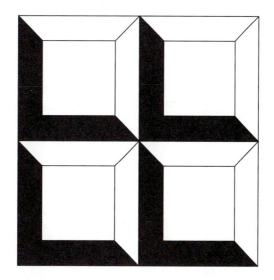

9.21b

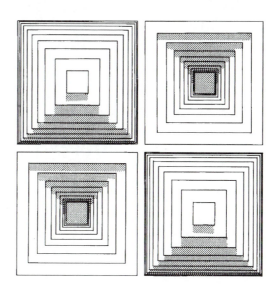

9.21c

Figure 9.21 (a-c) Visual compositions using the depth cues attached and cast shadow (illustrated by: a, Tim Hershner; b, Jeff Chandler; c, Paul Peirce).

Tone can be represented in a variety of ways using different combinations of points, lines, and planes (see Figure 9.22). Also spatial relationships can be manipulated in a composition by altering these value relationships between the elements.

Value changes can convey types of surface materials, pattern, and texture, as well as depth and distance. Sharp changes in value indicate corners and reflections, whereas subtle changes in value indicate bends or rounded forms. Value changes are also used to indicate cast and attached shadows of forms. The value and shape of shadow indicates location, intensity, and relative distance of the light source (see Figures 9.23–9.28).

Figure 9.22 (a-b) Visual compositions using point and line to produce tone creating the illusion of depth and volume (illustrated by: a, Dirk Van Nederveen; b, Tim Hershner).

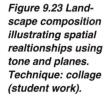

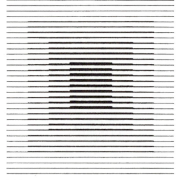

9.22a

9.22b

Figure 9.23 Landscape composition illustrating spatial realtionships using tone and planes. Technique: collage (student work).

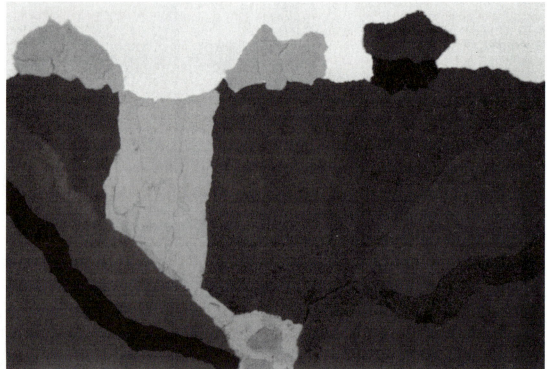

9.23

Other important depth cues that complement the perception of depth and distance are the use of color (warm and cool) and serial perspective. Refer to Chapter 8, page 283.

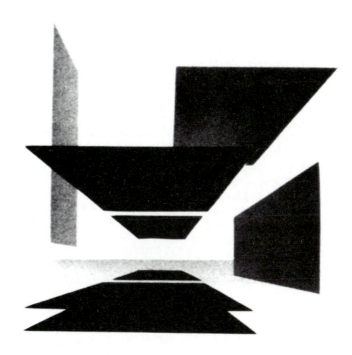

9.24

Figure 9.24 Abstract composition illustrating spatial relationships (depth and distance) using tone and planes (student work).

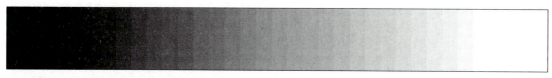

9.25

Figure 9.25 Gradual change in value from black to white.

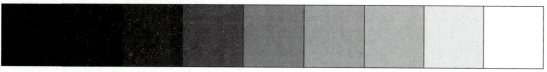

9.26

Figure 9.26 Incremental change in value from black to white.

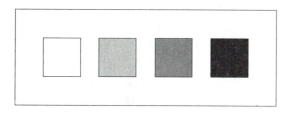

9.27

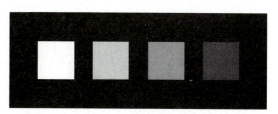

9.28

Figure 9.27 The background value of a composition affects how other values are perceived.

Figure 9.28 Light areas on a dark background appear to advance.

Linear Perspective

Linear perspective is one of the more important depth cues used on the two-dimensional picture plane. The concept of linear perspective, sometimes called vanishing point perspective, is based on a two-dimensional, mathematical system that represents objects and space as they would be seen in the three-dimensional environment. Perspective drawing is based on the principle that parallel lines converge to a point or points that create the illusion of depth on the picture plane or format.

Euclid, Brunelleschi, and Alberti's Methods of Linear Perspective

The empirical method of perspective is attributed to Euclid, who developed the concept for the empirical methods of perspective in Greek and Roman times. These methods are also known as the geometry of natural vision and deal in general terms with rays of light in space converging to a point at the viewer's eyes. The artificial or scientific method of perspective, which is based on a plan and elevation view, is attributed to Brunelleschi and Alberti during the Renaissance. The scientific method of perspective is based on the following points:

1. The viewer stands at a fixed point for the observation.
2. In perspective, parallel lines converge to a single point.
3. The picture plane intercepts the visual cone.
4. Two planes running at 45° to the picture plane converge at two points on the horizon.

Alberti's contribution to scientific or linear perspective is outlined in *The Della Pittura* (1436), in which he describes the construction of a checkered ground in perspective (see Figure 9.29). In summary, Brunelleschi invented the distance point method and Alberti supplied the scientific proof. Alberti should also be given credit for comparing the picture plane to a window frame.

Leonardo da Vinci's Method of Linear Perspective

Leonardo da Vinci's contribution to linear perspective, "Leonardo's method," was based on using the drawing techniques in reverse order. He wrote: "If you draw the plan of a square (in perspective) and tell me the length of the near side, and if you mark it within a point at random, I shall be able to tell you how far is your sight from that position of the selected point"

Figure 9.29 Alberti's "best method": (a) SP is the spectator or station point; V is the vanishing point; OO is the line where the plane containing V and SP intersect; (b) DP is the distance point produced by the diagonals. The intersections on the given horizontal co-ordinates, and intersections give or-thogonal coordinates [illustrations from Fred Dubery and John Willats, Drawing Systems (New York: Van Nostrand Reinhold Co., 1972)].

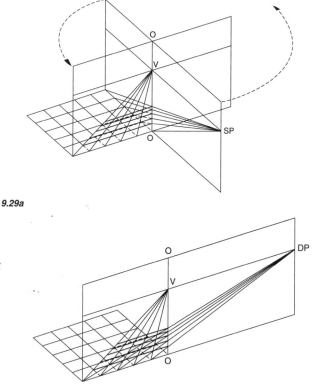

9.29a

9.29b

[quoted in Fred Duberty and John Willats, *Drawing Systems* (New York: Van Nostrand Reinhold Co., 1972), p. 55]. (See Figures 9.30 and 9.31.)

Leonardo da Vinci made notes and illustrations of drawing techniques using drawing machines. Many historians speculate that Albrecht Dürer learned about these drawing machines from da Vinci. The drawing method shown in the woodcut by Dürer in Figure 9.32 allows for long-distance projection and requires two people for operation: One person with a string line establishes points on the lute while the other coordinates and plots each point on the drawing.

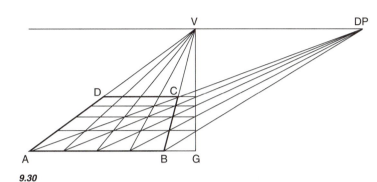

9.30

Figure 9.30 "Leonardo's method" of linear perspective [illustrations from Fred Duberty and John Willats, Drawing Systems *(New York: Van Nostrand Reinhold Co., 1972)].*

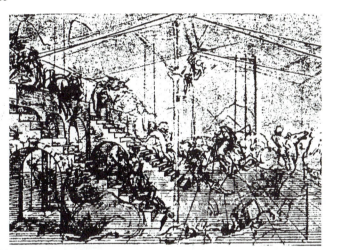

9.31

Figure 9.31 Leonardo da Vinci's drawing Adoration of the Magi *illustrates the perspective construction lines used to create the drawing [illustration from Kurt Kranz,* Art: The Revealing Experience *(New York: Shorewood Publishers, Inc., 1964)].*

9.32

Figure 9.32 Albrecht Dürer, A Man Drawing a Lute; *woodcut 5-1/8" x 7-1/4",* Underweysung der messung Nurnberg, *1525.*

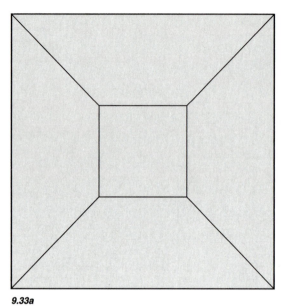

9.33a

Figure 9.33 (a) Regular or symmetrical forms drawn in one-point perspective have a tendency to fluctuate. (b) The same form drawn in a two-point perspective with a different orientation alleviates fluctuation.

One-Point Perspective

Often, forms drawn in one-point perspective can convey unclear visual information about a shape or form. Without value or the use of another perspective view, it becomes difficult to determine whether some forms advance or recede (see Figures 9.33–9.36).

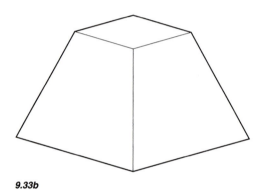

9.33b

Figure 9.34 A front view of a series of overlapping diminishing planes alternating between dark and light areas. This visual technique creates the effect of depth and dimension within the picture plane.

Figure 9.35 An angular view of the same compositional design. Note the visual difference between the two views.

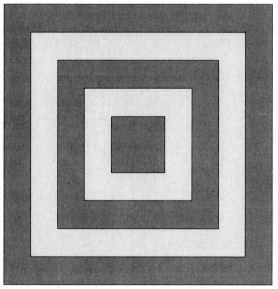

9.34

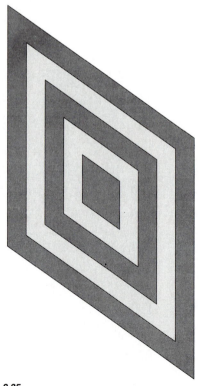

9.35

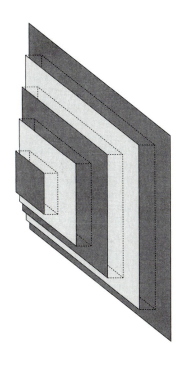

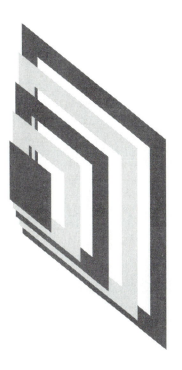

Figure 9.36 The compositional design has been modified once again through a change in angle or orientation using one-point perspective to create the illusion of depth and dimension. The dotted lines indicate where each plane is located within space.

9.36a 9.36b

GRADIENTS

Gradients form a category of depth cues that do not exist in the physical environment. For example, a highway or railroad tracks that appear to converge at a point on the horizon do not do so in reality. When objects appear to decrease in size farther in the distance, it is known through experience that the actual physical size does not change. This phenomenon reinforces the concepts of shape, size, brightness, and detail constancy.

According to James Gibson, author of *The Perception of the Visual World*, the concept of **gradation** means that there is an increase or decrease of something along a specified axis or dimension. Gibson defines the concept of gradation (or gradient, in Gibson's usage) as being based on two rules of perspective: visual angle and the longitudinal dimension (see Figure 9.37).

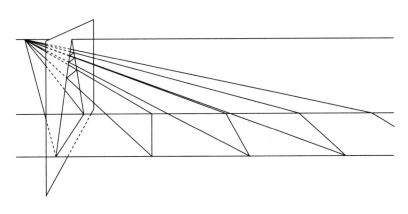

Figure 9.37 Gradients drawn in perspective on the picture plane [illustration from James Gibson, Perception of the Visual World (Cambridge, MA: The Riverside Press, 1950)].

9.37

Gibson continues to define perception of depth and distance as seeing the visual world as an array of physical surfaces reflecting light upon the retina. These surfaces are frontal and longitudinal. A frontal surface is transverse to the line of sight, and a longitudinal surface is parallel to the line of sight.

Figure 9.38 shows three different gradient arrangements that can be used within a composition to create the illusion of depth. Gradients are usually experienced in combination with other depth cues such as size, shape, color, and so on.

Gradation is the process of gradual change by regular steps or stages. Gradients are a form of monocular depth cue used by artists, architects, and designers to indicate depth on a two-dimensional picture plane.

Gradients may be used as perspective techniques in different ways than previously learned. That is, conventional perspective is applied to the edges and boundaries of forms; gradient linear perspective is applied to the texture and pattern of a surface.

James Gibson also describes the difference between gradients; that is, frontal, or zero gradient, which does not produce the illusion of depth on the picture plane. Gradient lines positioned closer together at the top of the picture plane and longitudinal lines positioned closer together with greater density at the left-hand side of the format both create the illusion of depth and distance (see Figure 9.39). Research indicates that the direction of the line's gradient does not affect the perception of depth and distance but rather the density of the line gradient.

Figure 9.38 (a) Linear gradient; (b) logarithmic gradient; (c) radial gradient.

Figure 9.39 (a) Gradient of zero frontal view with lines equally spaced; (b) lines positioned closer together at the top of the picture plane creating depth and distance; (c) lines positioned longitudinally to the picture plane creating visual depth and distance (illustrations from Gibson).

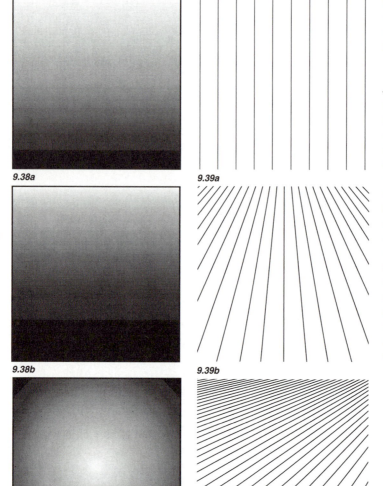

9.38a

9.38b

9.38c

9.39a

9.39b

9.39c

Figure 9.40 shows how a change in the gradient can illustrate a corner or different surface direction. Geometrically, a corner is the intersection of two planes with different slants or orientations.

Figure 9.41 illustrates staggering between two gradients to define an edge between two surfaces. The density of the gradient changes, but the gradient remains constant on either side of the edge.

Density Gradient

Gradients can be produced on the two-dimensional picture plane through the use of the density or interval between compositional figures. In Figures 9.42 and 9.43 dots become more densely concentrated in the distance; therefore, the spaces between them become smaller. Gradient patterns create the illusion of depth. Geometric patterns can be mathematically controlled to show more dramatic illusions of depth (see Figure 9.44).

Detail Gradient

The concept of detail gradient, sometimes called detail perspective, states that objects closer to the viewer will appear in greater detail than objects or figures located farther away. In translating this concept to the two-dimensional picture plane, the figures and forms closer to the horizon require less detail than those closer to the "front" of the composition. Leonardo da Vinci referred to detail gradient as "perspec-

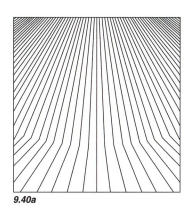

9.40a

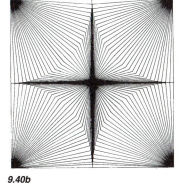
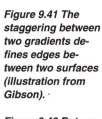

9.40b

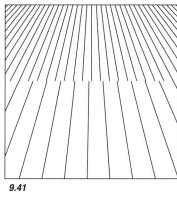

9.41

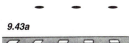

9.42

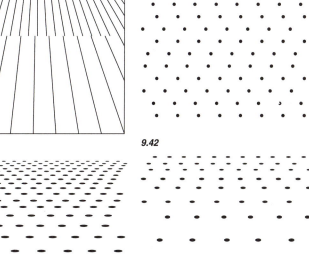

9.43a

9.43b

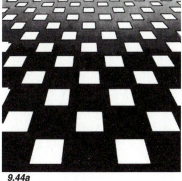

9.44a

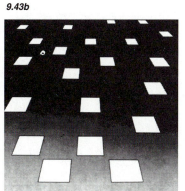

9.44b

Figure 9.40 (a) Change of gradient corresponding to a corner (illustration from Gibson). (b) Gradient change from a corner (illustrated by Tom Stahl).

Figure 9.41 The staggering between two gradients defines edges between two surfaces (illustration from Gibson).

Figure 9.42 Dot gradient, frontal view pattern perceived as being flat (illustration from Gibson).

Figure 9.43 (a-b) Dot density gradient patterns. With greater density and smaller intervals between dots, the illusion of depth and distance is created (illustration from Gibson).

Figure 9.44 (a-b) Square density gradient patterns (student work).

tive of disappearance" and defined it as how objects in a picture "ought to be less finished in proportion as they are remote."

Color Gradient

Colors appear less intense, paler, and more bluish gray as they recede into the distance. Bright colors appear to be located closer to the viewer. Often color gradients can not be separated from light and shadow over short distances and are more evident over great areas, such as in landscapes. (See Figure 8.87 in Chapter 8, page 283, for examples.)

Texture and Pattern Gradient

The distribution of regular and irregular elements and their placement affects the perspective of depth within a composition.

OTHER DEPTH CUES

Transparency

Transparency can be used to indicate depth when compositional figures overlap one another. In transparent forms, viewers see overlapping areas of the shape at the same time as the whole form. This is because transparency is the property of a figure that allows the viewer to see other shapes or forms through it. The concept is similar to seeing through a glass or plastic object, but is represented on the picture plane.

Transparency is illustrated in volumetric forms by showing lines that are "behind," or lines that would be hidden if the form were opaque. Often these lines behind are indicated by thinner or lighter lines than those in front of the figure or form (see Figures 9.45–9.48).

Figure 9.45 Letter A drawn to illustrate transparency (illustrated by Louise Utgard).

Figure 9.46 When transparent color shapes overlap, the overlapping area becomes a new color created from the combination of the first two shapes.

Figure 9.47 When a dark color is placed on top of another color, it negates transparency.

9.45

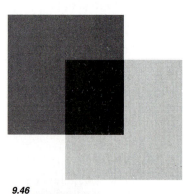

9.46

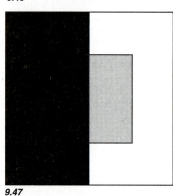

9.47

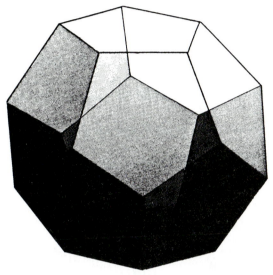

9.48

Blurring

Visual blurring results when figures and forms are too close to the viewer. This is evident in photography when objects are photographed at a close distance (see Figure 9.49).

Blurring can also be a result of motion. In photographs the moving figures or forms can become blurred while the background or stationary forms remain in focus. If the viewer is in motion and the visual field is stationary, then the whole image will be blurred, rather than the elements (see Figure 9.50).

Figure 9.48 The combination of the different values and overlapping lines of the surface shapes create the illusion of transparency and depth (illustrated by Paul Leighton).

9.49

Figure 9.49 Photograph of a tree (at a close distance) causing blurring (photograph by Charles Wallschlaeger).

9.50

Figure 9.50 The illusion of motion and blurring created by moving an image across a photocopy machine.

Filled Versus Unfilled Space

The depth cue of filled versus unfilled space and its effect is considered difficult to demonstrate. It is based on the theory that when the same size figure or object is filled with lines, color, or texture, the object will appear closer to the viewer than the unfilled figure or form (see Figures 9.51 and 9.52).

✍Practice Exercise 9.1: Identifying Depth Cues

Select an image to analyze. It can be an advertisement from a magazine, a photograph, a painting, a drawing, or an object. Study the selection and identify and list the depth cues. Define each cue and briefly explain how it functions within the selected example.

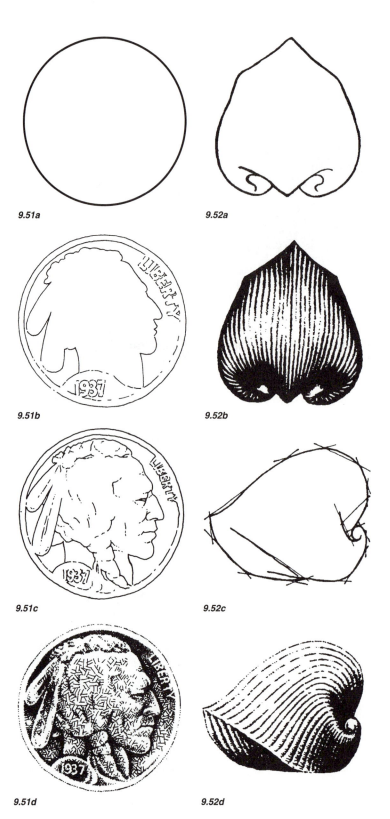

9.51a 9.52a

9.51b 9.52b

9.51c 9.52c

9.51d 9.52d

REFERENCES AND RESOURCES

Bloomer, Carolyn M. *The Principles of Visual Perception*. New York: Van Nostrand Reinhold, 1976.

Dember, William N. *The Psychology of Perception*. New York: Holt, Rinehart & Winston, 1960.

Forgus, Ronald H. *Perception*. New York: McGraw-Hill, 1966.

Frisby, John P. *Illusion, Brain and Mind*. Oxford: Oxford University Press, 1980.

Gibson, James J. *The Perception of the Visual World*. Boston: Houghton Mifflin, 1950.

Goldstein, E. Bruce. *Sensation and Perception*. Belmont, CA: Wadsworth, 1980.

Gregory, R. L. *Eye and Brain, The Psychology of Seeing*. New York: McGraw-Hill, 1966.

Hochberg, Julian E. *Perception*. Englewood Cliffs, NJ: Prentice-Hall, 1964.

Koffka, K. *Principles of Gestalt Psychology*. New York: Harcourt, Brace and World, 1935.

LeGrand, Yves. *Form and Space*. Indianapolis, IN: Indiana University Press, 1967.

Uhr, Leonard, ed. *Pattern Recognition*. New York: John Wiley & Sons, 1966.

Weintraub, Daniel J., and Edward L. Walker. *Perception*. Monterey, CA: Brooks/ Cole, 1966.

Welford, A. T., and L. Houssiade, eds. *Contemporary Problems in Perception*. London: Taylor and Francis Ltd., 1970.

CHAPTER OUTLINE

- Chapter Vocabulary
- Introduction to Perception of Figure and Form
- Perceiving Shapes and Forms
- Shape Perception
- Gestalt Psychology and Visual Perception
- The Law of Pragnanz
- Shape Identity
- Maintaining Regularity and Symmetry in Simple Shapes
- Law of Closure
- Creating New Shape Configurations
- Two- and Three-Dimensional Forms and Their Orientation on the Picture Plane
- Geometric Illusions
- Ambiguous Figures
- Ambiguous Patterns
- Perceiving Three-Dimensional Figures
- Ambiguous Figures in Three Dimensions
- Impossible Figures
- Distinguishing Figure and Ground
- Embedded Figures and Camouflage
- Brightness Contrast in Figure/Ground Relationships
- Brightness Contrast and Just Noticeable Differences (JND) in Figure/Ground Compositions
- Figure/Ground Reversal
- Figure/Ground Reversals (Pattern Fluctuation)
- Types of Patterns
- Overlapping Figures
- Moiré Patterns
- Practice Exercises
- References and Resources

CHAPTER OBJECTIVES

On completion of this chapter, readers should be able to:

- Determine the differences between simple and complex shapes.

- Understand and apply the law of Pragnanz in creating shapes and forms.

- Apply the law of closure in creating figures, forms, and compositions.

- Create and construct new shape configurations.

- Orient shapes and forms on the picture plane so they can be perceived as being stable.

- Understand what attributes make a figure fluctuate.

- Create a fluctuating figure or pattern.

- Understand what attributes make an impossible figure.

- Understand and list the differences between figure and ground.

- Apply the concept of embeddedness within a composition.

- Understand and apply the concept of brightness contrast within a composition.

- Create a figure/ground reversal within a pattern composition.

Perception Theory

Space, Depth, and Distance

Organizational Principles in 2 and 3 Dimensions

Visual Perception Concepts/Principles

Prescriptive Principles of Organization

2- and 3-Dimensional Form Perception

Light/Brightness
 contrast threshold
Illusions
Monocular Cues
 size
 partial overlap
 value
 color
 aerial perspective
 detail perspective
 linear perspective*
 texture gradient
 shadow
 blurring of detail
 transparency
Binocular Cues
 muscular cues
 parallax cues
Position
Orientation
Motion
Time

***Drawing/Projection Systems**
Orthographic
Paraline
 axonometric
 oblique
Perspective

Gestalt Theory
Figure Laws
Grouping Laws

Figure/Ground
Distinguishing Figure
 from Ground
Ambiguous Figure
Stability/Instability
Figure Closure
Figure/Ground Reversal
Pattern & Figure/Ground
 Reversal
Figure Overlap

Composition/Visual Organization
Balance
 symmetrical
 asymmetrical
Repetition
Harmony
Rhythm
Variety
Contrast
Dominance

Acquired Associations
Free Association
Familiarity
Reading Order
Hierarchies of
 Information
 general to specific
 specific to general
 chronological

Spatial Organization
Centralized
Linear
Radial
Clustered
Grid/Lattice Systems

Symmetry Groups
Identity
States of Being
Operations
 translation
 rotation
 reflection
 glide reflection
Symmetry
Transformations
 affine
 perspectivity
 dilatative
 topological
 golden section
 root rectangles

Dynamic Symmetry
Proportional Systems
 arithmetic
 harmonic
 geometric
Proportional Theories
 golden section
 renaissance
 the Modulor
 anthropometrics

CHAPTER VOCABULARY

Ambiguous or fluctuating figure A figure with more than one dominant shape, which causes the viewer to visually switch back and forth from one shape to another.

Camouflage To reduce visibility of shape or form; conceal.

Embedded figure A figure or form incorporated into a ground area in such a way that it is difficult to perceive what is figure and what is ground.

Figure Outline or contour of an object, shape, form, image, and so on.

Figure goodness qualities Simplicity, regularity, symmetry, and ease of being remembered.

Form Shape and structure of an object, building, etc.

Gestalt "Whole" configuration or form.

Ground That which is behind a figure, without dominant form.

Illusionary figure Misleading visual clues within a figure.

Impossible figure A figure that converts two sets of contradictory clues, causing the brain to make conflicting spatial interpretations.

Irradiation (brightness contrast) Amount of light or luminance within the visual field.

Law of Closure Visual continuity.

Reversal A change causing a move in an opposite direction; turned backward; inverted.

Shape Contour of form, figure, object, etc.

INTRODUCTION TO PERCEPTION OF FIGURE AND FORM

Perception psychologists, theorists, and aestheticians have long been involved in research concerning the ways in which two- and three-dimensional shapes, forms, and objects are perceived. This chapter describes some of the concepts, laws, and principles of visual perception as well as figure and form qualities, preferences, goodness, and perceived relationships.

PERCEIVING SHAPES AND FORMS

Visual testing of adult subjects by perception psychologists has revealed a great deal about the way individuals perceive and identify **shapes** and **forms** in two and three dimensions. (Distinction is made between the perception of children and adults, because although a child may receive the same visual information as an adult, the perception of the information will be different. Among many factors, interpretation of visual information is based on experience; in perceiving and interpreting an image or form, the brain draws upon its memory store of past experience.

Therefore, testing of small children only indicates that sensory data have been relayed to the brain and not necessarily perceived or processed in the same way as they would be in an adult.)

Although it takes less than a second, the perception process is complex. A great number of theories exist that describe shape and form perception. Generally speaking, when an individual is confronted with a shape or form, a contour shape and the primary features are seen before interior features and other details such as color, value, and texture are seen.

After receiving the visual information, the viewer begins to classify and identify the image, relating it to familiar shapes, forms, or objects previously experienced or learned. If the form is unfamiliar, additional time is required to observe it, and finally, an attempt is made to name or describe it. Identification can be specific if the individual can relate the form to past experiences or perceived images, or general if the identification attempt is only a description relating it to a similar known shape or form.

The visual form recognition process requires the

presence of light so that the eye and brain can perceive contrast between the form and the background. Perception of form is partially achieved through the identification of certain structural and surface characteristics, such as contour or shape, color and/or value, spatial position, and movement, or lack thereof. If a form is perceived frequently enough, individuals "learn" what the form is through the formation of a mental image. It is also known that form perception takes place more quickly if the object is identified verbally, through the naming and defining process, as well as visually. An example that relates to this perception process is Practice Exercise 3.17: Writing a Visual Description to Assist in Drawing an Object in Chapter 3.

The visual form recognition process varies among different people not only in relation to past experiences, but also in relation to individual differences in culture, education, and learning environments. In other words, different perceptions or conclusions may be drawn by different people using the same visual information because each person's past experiences and perceptions vary. In addition, different conclusions may be drawn by the same individual from the same visual information at different times, depending on ongoing learning experiences.

SHAPE PERCEPTION

Through testing, perception psychologists have found it is likely that a simple shape will be viewed more accurately or easily than a complex one. For example, simple geometric figures such as circles, triangles, or squares are perceived more easily than complex shapes such as ellipses, dodecahedrons, or trapezoids. Some experiments indicate that circles and squares are the easiest shapes to perceive because they are considered the simplest and most familiar. Other studies argue that triangles are the easiest to perceive because they are simple and angular.

Perception psychologists study shape perception and measure the degree of accuracy with which observers perceive figures. In these studies individuals are asked to match specific shapes to others within a series of varied shapes. This research concludes that there is a general tendency to better perceive shapes that are simple, regular, and symmetrical.

This information can be helpful to those who design symbols and forms intended for the public, such as informational signs that require quick identification or identifications for businesses or corporations that should be easily identified and remembered.

GESTALT PSYCHOLOGY AND VISUAL PERCEPTION

The Gestalt movement began in Germany in the 1920s, and intense experimentation and discovery took place over approximately a twenty-five year period. Gestalt theory is concerned with issues in visual perception, memory and association, thinking and learning, social psychology, and the psychology of art. This chapter emphasizes the Gestalt concepts of visual perception, illusions, figure and ground, memory and association, and psychology of art.

The Gestalt theory regarding figure perception evolved from the study of perceptual organization problems and generated a series of experiments and demonstrations involving perceptual phenomena. **Gestalt** does not translate exactly into English, but it loosely means "whole," "configuration," or "form." The primary aim of the Gestalt psychologist's research was to analyze and define the way humans per-

ceive. The emphasis of the research dealt with the configural aspects of perception in order to understand how and why configurations of form are perceived differently when seen in totality than when seen as individual parts. The tendency to perceive shapes and forms not as they actually exist, but in a modified form, is verified by studies of Gestalt psychologists Max Wertheimer, Wolfgang Köhler, and Kurt Koffka.

A major premise in Gestalt theory is that visual perception experiments and research need to consider more than just the separate elements that make up an experience, because the total effect of a visual experience is different from the effect of the accumulation of all the separate parts.

There are a number of areas of visual perception that can be used to create good design shape or form using Gestalt research. Figure laws and figure ground laws, which are discussed in this chapter, and grouping laws, which are discussed in Chapter 11, are examples. In determining how individuals perceive forms, several generalizations have been made and described by perception psychologists. First, when a form cannot be seen clearly these formless fields are described as being "misty" or "foggy." Second, the form or shape configurations perceived are influenced by the physical shape characteristics of the form in a given field of view. Third, individuals have a tendency to modify the actual qualities of perceived forms, especially when the field of view consists of so-called "meaningless" or abstract shapes (forms that do not represent another form or image). Fourth, in the process of differentiating, describing, and classifying forms, the observer will perceive only the details necessary to perform the task of seeing and interpreting and will ignore the rest of the details.

THE LAW OF PRAGNANZ

The law of Pragnanz is a basic law that governs the "breaking down" of the perceptual field into separate image areas that are easier to identify. First described by Wertheimer, the law states that shapes are perceived in as "good" a form as possible. "Good" constitutes the simplest and most stable structure; therefore, the resulting units of form in the perceptual field are stable and require a minimum amount of energy for the viewer to perceive them. In general, a figure or form has a particular shape, solid appearance, and color or value that is distinguishable from other figures or the background in the visual field. According to Gestalt psychologists, some of the qualities for describing **figure goodness** are simplicity, regularity, symmetry, and ease of being remembered. The basic premise presented in the law of Pragnanz is that shapes or forms that exhibit these qualities are more easily perceived. Shapes and forms that do not possess these qualities tend to become more difficult to perceive or remember. In addition, two important factors that contribute to the perception process are the viewer's energy or desire to scan and identify the shape and the amount of time available for viewing and perceiving of an image.

Along with figure goodness, the accuracy and amount of detail perceived depends on the length of time available for viewing the image. The required length of time for correctly identifying a shape is related to its size, orientation, and brightness. Many in-depth studies are available on this subject (see References and Resources at the end of this chapter). This information can be particularly useful in the designing of directional and informational visual communication.

Figure 10.2 A visual comparison (from left to right) of simple to more complex shapes and their identities.

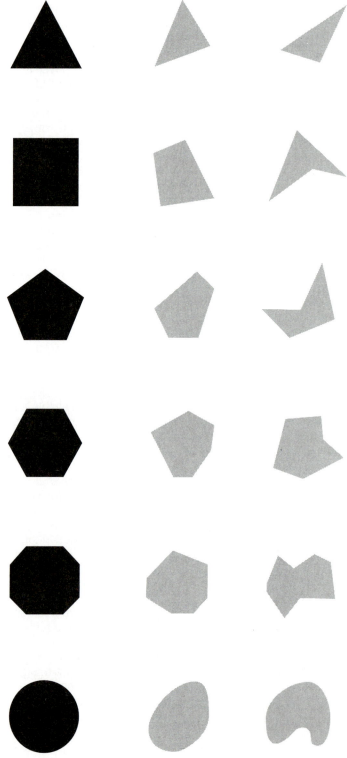

Figure 10.2 A visual comparison (from left to right) of simple to more complex shapes and their identities.

SHAPE IDENTITY

Perceptual studies indicate that regular polygons are more easily recognized and remembered as compared to polygons that become more complex when angles and side lengths are modified. The regular polygons and several modified shapes in Figure 10.2 illustrate this concept.

Simple Versus Complex Shapes

The degree of simplicity of a shape is determined by the number of line segments defining its contour and the regularity of its outline. For example, the regular triangular polygon shown in Figure 10.3a is a simple shape composed of three equal line segments and is called a triangle. In contrast, it is difficult to recognize a complex irregular form or relate it to something familiar. The more complex figures are difficult to identify, remember, or reproduce.

The similarity of shapes affects the way that they can be combined. If two similar shapes are put together (see Figure 10.3b), they can appear as a new, whole figure with different characteristics, whereas dissimilar shapes do not combine well and appear as separate figures (see Figure 10.4).

10.2

A simple square figure possesses the qualities of simplicity, symmetry, and balance; therefore, it is a "good" figure and easy to remember (see Figure 10.5a). The other two solutions (see Figure 10.5b – c) become more complex, irregular shapes that are difficult to perceive and identify.

10.3a

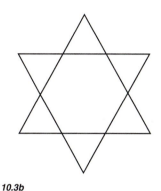

10.3b

Figure 10.3 (a) Simple triangular shape. (b) Two of the same shape combined to make a new figure.

10.4a

10.4b

Figure 10.4 (a) A complex polygon shape is difficult to visually identify and remember. (b) Dissimilar shapes appear as separate entities or figures.

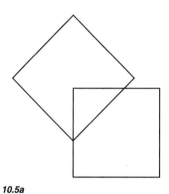

10.5a

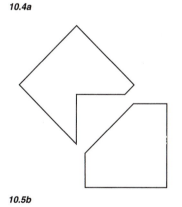

10.5b

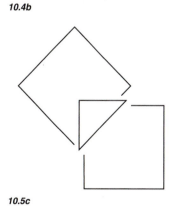

10.5c

Figure 10.5 The law of Pragnanz illustrates that: (a) two overlapping squares are easy to perceive and are considered to have "good" figure; (b) two irregular shapes are more difficult to perceive and identify; (c) three irregular shapes are more difficult to perceive and identify because of their complexity.

MAINTAINING REGULARITY AND SYMMETRY IN SIMPLE SHAPES

There can be different degrees of simplicity within a shape. A regular polygon shape (two-dimensional flat shape with equal interior angles and equal sides) can be added to or subtracted from, creating concave and convex equivalents. As illustrated in Figures 10.6 –10.9, the different shapes that result through change remain relatively simple and are symmetrical. Notice that the number of sides and angles increases, but because the shape is simple and symmetrical, it is easy to remember or reproduce from memory. The logos and symbols are examples illustrating regularity and symmetry of simple shapes derived from the triangle, square, pentagon, and hexagon.

Figure 10.6 (a-c) Regular, concave, and convex triangles. (d) Symbol for Mitsubishi Companies. (e) Symbol design (designed by Charles Wallschlaeger).

Figure 10.7 (a-c) Regular, concave, and convex quadrilaterals or squares. (d) Symbol derived from square by subtracting a triangle shape from each side. (e) Logo for Metropolitan Life (designed by Sandgren & Murtha, Inc.; USA).

Figure 10.8 (a-c) Regular, concave, and convex pentagons. (d) Five-pointed star drawn by connecting the points of a pentagon with straight lines. (e) Symbol for Chrysler Corporation (designed by Lippincott & Margulies; USA).

Figure 10.9 (a-c) Regular, concave, and convex hexagons. (d) Six-pointed star drawn by connecting the points of a hexagon. (e) Symbol for Instructional Systems, Inc. (designed by Charles Wallschlaeger).

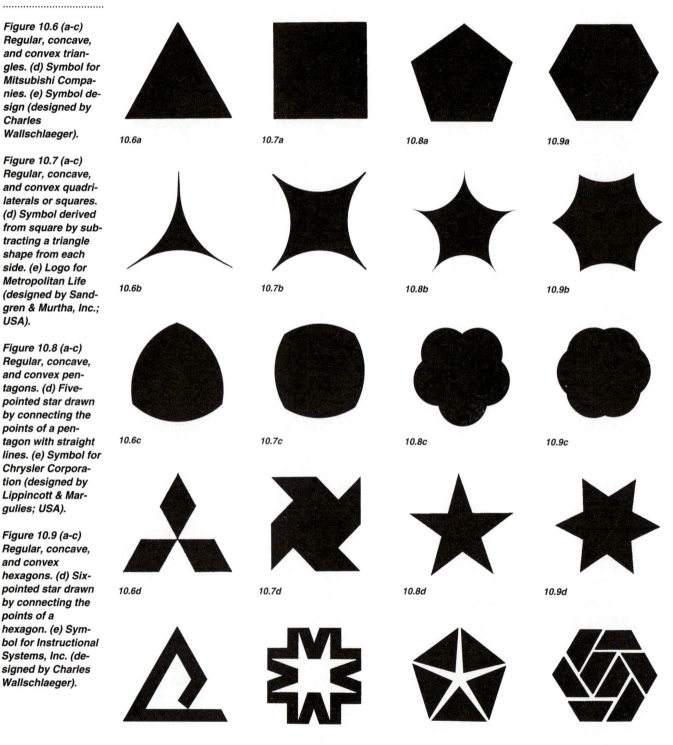

10.6a 10.7a 10.8a 10.9a

10.6b 10.7b 10.8b 10.9b

10.6c 10.7c 10.8c 10.9c

10.6d 10.7d 10.8d 10.9d

10.6e 10.7e 10.8e 10.9e

LAW OF CLOSURE

The figure **law of closure** is related to visual continuity; that is, a shape with a broken or discontinuous contour is perceived as a whole figure. The law is based on the inclination of the viewer to perceive an incomplete figure as complete. In other words, if a viewer sees an incomplete square, the law of closure asserts that there is a pattern in the brain that completes the square (see Figure 10.10).

✍Practice Exercise 10.1: Understanding the Law of Closure

Select a letter, number, or word and, through sketching, experiment with subtracting different sections from the figure. Note how much of the image can be deleted before it becomes difficult or impossible to recognize. Select several sketch examples of the figure and render them on hot press illustration board using dry transfer lettering or pen and ink for the final artwork (see Figure 10.11).

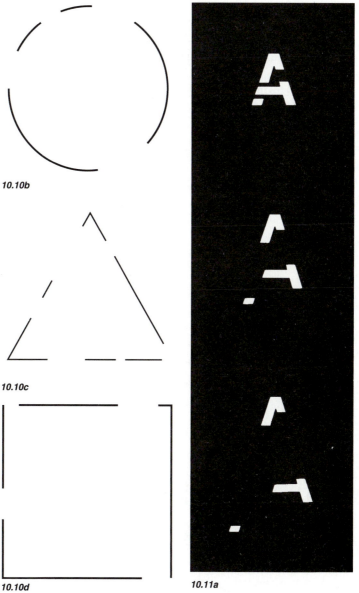

10.10b

10.10c

10.10d

10.11a

10.10a

10.11b

10.11c

Figure 10.10 Law of Closure: (a) four vertex points perceived as a square; (b) interrupted line perceived as a circle; (c) interrupted line perceived as an equilateral triangle; (d) interrupted line perceived as a square.

Figure 10.11 (a-c) Examples of subtracting from a figure until it is impossible to recognize (illustrated by Ann Dickman).

✍**Practice Exercise 10.1: (Continued)**

Select a shape such as a square. Use a minimum number of elements to create a perceived closure of the square. Continue to add elements in order to form a continuous contour of the shape. Finally, fill in the shape, creating a plane (see Figure 10.12).

Repeat the above steps using value or texture within a pattern of squares and create a contrast in which shape is designated by a minimum of four squares, creating a closure recognition of the square. Continue to add value and texture to the remaining four square elements, finally filling in the squares to create the square planes.

An additional option is to incorporate a new element within the pattern, such as a pattern of triangles within the series of squares, creating a shape (see Figures 10.12 and 10.13).

Figure 10.12 (a) A minimum of geometric elements of the same shape and size can be grouped to create a visual closure resulting in the perception of a figure. Adding more elements of the same shape and size will help the viewer perceive the figure; (b) figure becomes a shape contour; (c) figure becomes a shape or plane.

Figure 10.13 Tone and texture applied within a pattern create a square: (a) four points; (b) contour; (c) square pattern. (d-f) Incorporating a new shape (a triangle) within the pattern.

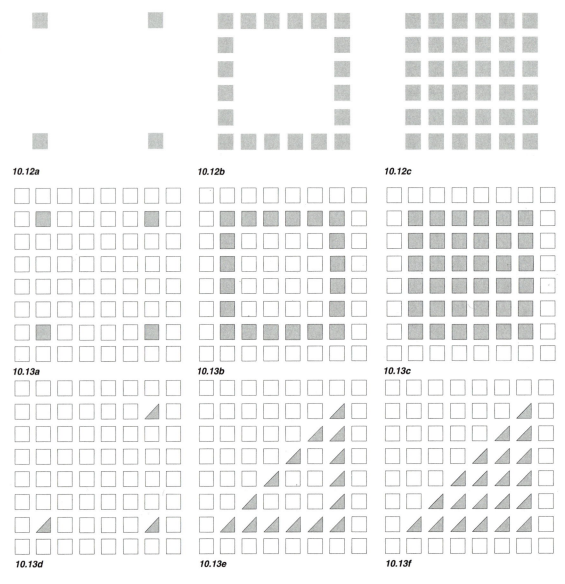

10.12a 10.12b 10.12c

10.13a 10.13b 10.13c

10.13d 10.13e 10.13f

✍**Practice Exercise 10.2: The Role of Association in Shape Perception of Letter Symbols and Type Styles**

The recognition or perception of letterforms can be affected by the quality of figure goodness of the typeface, as well as by previous association or familiarity with the learned letterform. The letter "G" may not be recognizable when presented in the German typeface shown in Figure 10.14a because its unique shape is not commonly known. The letterforms used in the word "up" in Figure 10.14b are taken from a stylized typeface that has low recognition characteristics. It is important for graphic designers and typographers to consider legibility when selecting a typeface (see Figure 10.15 for examples of different typefaces).

Choose a letter or number from a type specimen book. In several steps, sketch the figure and modify the original shape. Observe at what point the figure loses its identifying characteristics and becomes less recognizable.

10.14a 10.14b

10.14c 10.14d

Figure 10.14 The typeface affects the legibility of (a) the letterform "g," (b) the word "up," (c) the word "we," and (d) the word "of."

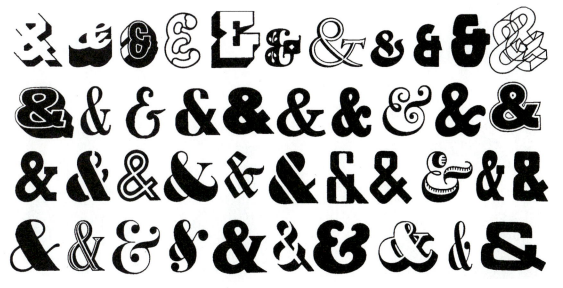

10.15

Figure 10.15 Variations of an ampersand illustrating figure legibility.

CREATING NEW SHAPE CONFIGURATIONS

Original shapes should have "equal strengths" or possess similar or the same shape characteristics in order to combine them successfully. There are several different ways to combine figures; that is, placing shapes so that they are touching, overlapping, or dividing and are perceived as a whole new shape (see Figures 10.16 and 10.17). It is also possible to combine different shapes and manipulate them so the result will be a familiar new shape (see Figure 10.18).

Figure 10.16 (a-g) Transitional sequence of two shapes: diamond shape subdivided into two triangles, shifted and transposed until they become one triangle.

Figure 10.17 (a-f) Two triangles shifted and transposed to form a star.

Figure 10.18 Examples of organizing and combining shapes to make a new composition. (a) A set of familiar shapes (b) used to create a new composition or figure group that becomes familiar, such as a tricycle.

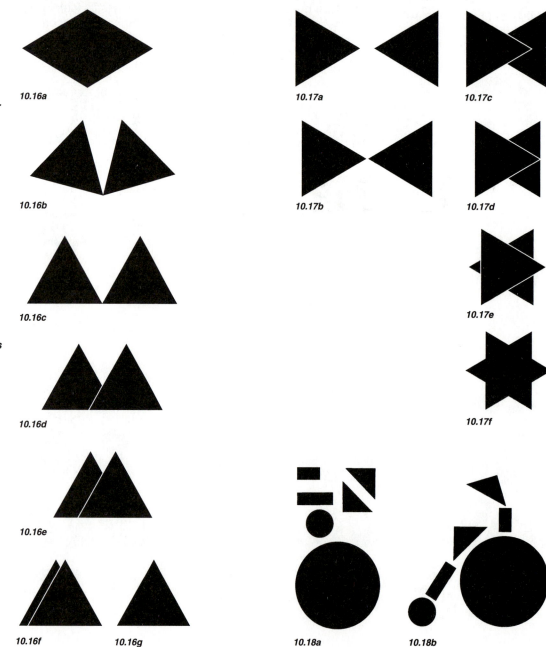

10.16a

10.16b

10.16c

10.16d

10.16e

10.16f 10.16g

10.17a 10.17c

10.17b 10.17d

10.17e

10.17f

10.18a 10.18b

✍Practice Exercise 10.3: Combining Shapes to Create Figures

Select a number of geometric shapes. Through sketching or cut paper explore different ways of combining the shapes to make a figure. Observe how the change of position and orientation affects how the figure is perceived. Select the best solution and glue the figure on Bristol board (see Figure 10.19).

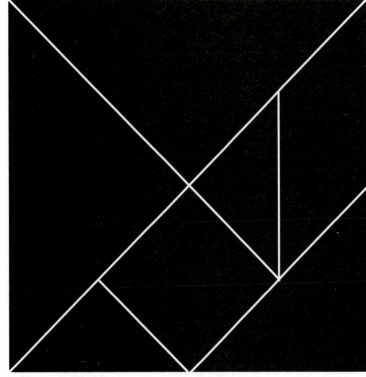

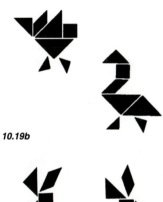

10.19b

10.19a

Figure 10.19 (a) A set of geometric shapes (Tangram Game) that can be reorganized, positioned to create recognizable figures. (b-d) Recognizable figures composed of smaller geometric shapes (from Tangram, 1978).

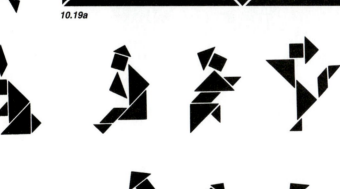

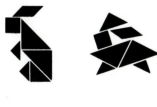

10.19c

10.19d

TWO- AND THREE-DIMENSIONAL FORMS AND THEIR ORIENTATION ON THE PICTURE PLANE

A two-dimensional shape has a specific contour that can be perceived as stable or unstable relative to its orientation within a specific format or picture plane. One of the factors that influences shape stability is the directional axis of the shape. Shapes, whether reg-ular or irregular, possess a dominant directionality as they relate to the ground plane or the horizon line.

Previous visual experiences and learned associations of certain shapes can contribute to a viewer's orien-tation preference. For exam-ple, if a triangle is rotated from a stable position to where it is resting on one point, there is a feeling of in-stability (see Figures 10.20 and 10.21).

Figure 10.20 Geometric construction and orientation study of an equilateral triangle.

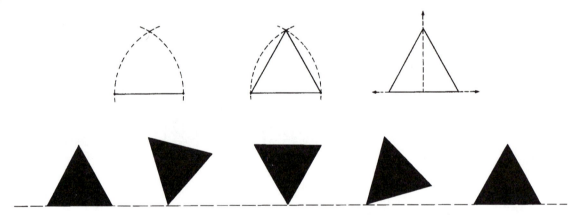

10.20

Figure 10.21 Geometric construction and orientation study of a regular pentagon.

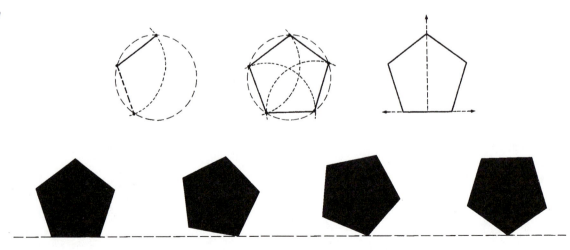

10.21

Just as two-dimensional figures have a stable position and orientation relative to the picture plane, so do three-dimensional forms. Each form has a directional axis that determines its position and orientation relative to the horizon line. If the form's directional axis or preferred viewing position is disregarded, the form or object will be seen as unstable or not at rest with other figures, the picture plane, or the horizon line (see Figure 10.22).

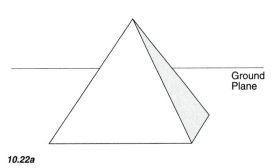

10.22a

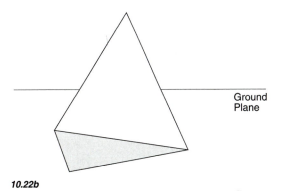

10.22b

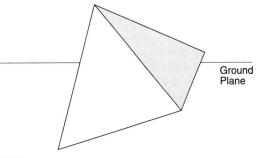

10.22c

Figure 10.22 (a) A pyramid positioned so that its base is parallel to the horizon and its axis is perpendicular to the horizon. This orientation is perceived as a stable form. (b-c) Changing orientation of the pyramid relative to the horizon line creates visual instability.

GEOMETRIC ILLUSIONS

The term *illusion* in reference to a figure implies that there are misleading or unreal visual clues within the figure. In other words, an **illusionary figure** does not give the correct true cues or character of the form or shape being perceived. There are many different types of figure illu-

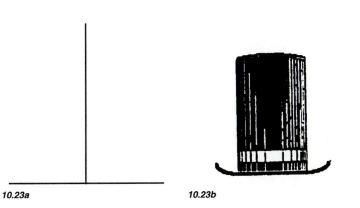

10.23a 10.23b

Figure 10.23 (a-b) Vertical-horizontal illusion: When two equal lines are placed perpendicular to one another, the vertical line appears to be longer than the horizontal line.

······································

Figure 10.24 (a-b) The center circles seem to be of different sizes because the size of the outer circles create the illusion.

sions, but this chapter focuses primarily on geometric illusions. Geometric illusions are line configurations in which the physical dimensions of size, shape, and direction are frequently misinterpreted. Figures 10.23–10.29 are representational of drawn geometric illusions.

Many of these illusions are familiar, but a few require further comment. In Ponzo's illusion (see Figure 10.25) the top horizontal line appears longer than the bottom horizontal line due to their positions within the acute angle. The Poggendorf illusion (see Figure 10.26) creates the illusion of misalignment. If a line is drawn to connect the two diagonal lines crossing the pair of vertical lines it becomes evident that they are aligned. In the Muller-Lyer illusion (see Figure 10.27) the line segments creating the shaft of each arrow are of equal lengths, but do not appear so due to the orientations of the arrow tips. In Hering and Wundt's illusion of direction (see Figure 10.28) the horizontal lines appear concave or convex because the lines and angles in the background create this illusion.

Figure 10.25 Ponzo's illusion.

Figure 10.26 Poggendorf illusion.

Figure 10.27 The Muller-Lyer illusion.

Figure 10.28 (a-c) Hering's and Wundt's illusions of direction.

Figure 10.29 A square superimposed on concentric circles. The illusion causes the sides of the square to bend toward the center of the figure.

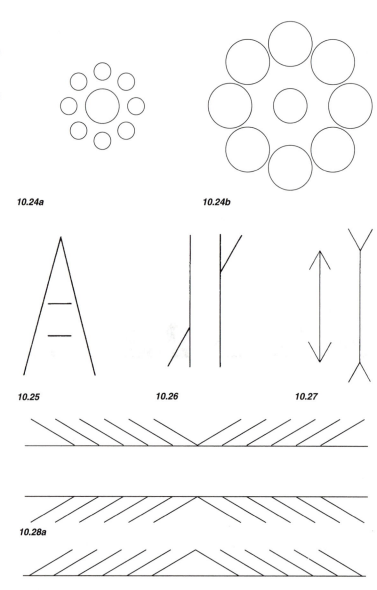

10.24a 10.24b

10.25 10.26 10.27

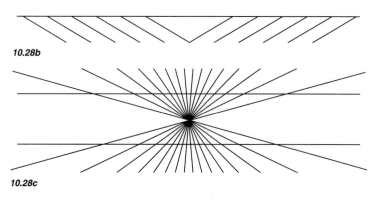

10.28a

10.28b

10.28c

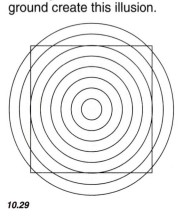

10.29

AMBIGUOUS FIGURES

Ambiguous figures are images created in such a way that they can represent two different figures or a single figure. These figures are sometimes referred to as **fluctuating**, reversible, or equivocal figures (see Figures 10.30 and 10.31).

The phenomenon of a two-sided contour is illustrated by Edgar Rubin's example of a face/vase image in Figure 10.30. The two-dimensional image fluctuates between the profile of two faces and the silhouette of a vase. Notice that the perceptions occur independently; only one or the other can be perceived at one time, not both. When one figure is actively perceived, then the other becomes the ground and vice versa.

There are several explanations as to why these figures fluctuate from one

shape to another. Ambiguous figures exhibit more than one dominant position or figure, so the competition for visual attention causes the viewer to see one image, and then the other, switching back and forth. Figures within the ambiguous image share the same contour line. That is, the contour line is functioning for both figures and tends to

confuse the perception of what is actually being enclosed as the dominant figure. Since ambiguous figures and their contours function for more than one figure, the eye and brain have difficulty assigning the contour to one figure over another; therefore fluctuation takes place between the two figures.

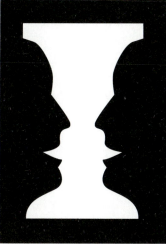
10.30a

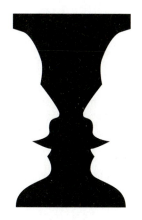
10.30b

Figure 10.30 (a-b) Face and vase fluctuation, a two-sided contour

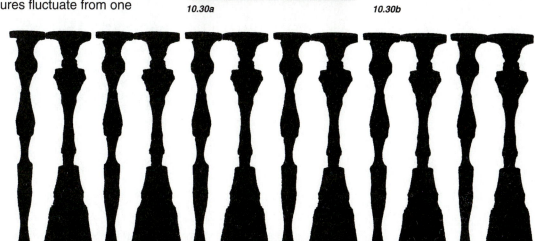
10.31

Figure 10.31 Figures and spindles fluctuation (source unknown).

AMBIGUOUS PATTERNS

Like ambiguous figures, ambiguous patterns are sometimes composed of the same figure facing opposite directions, or patterns are composed of two different figures that have similar shape characteristics and share a common contour line.

In some instances, if a pattern consists of rows of figures that have greater horizontal distance between them, then they are automatically perceived as vertical sets of figures in columns. Likewise, if the figures have a greater vertical distance between them, they are seen as horizontal rows (see Figure 10.32a).

The pattern in Figures 10.32a–c is composed of a set of arrows. As the arrows are moved closer together until they touch, the contour of the first set of arrows

Figure 10.32 (a) Arrow pattern perceived as rows or as columns. (b) Arrow pattern drawn in line creates visual fluctuation due to ambiguity. (c) Positive/negative arrow pattern accentuates the fluctuation.

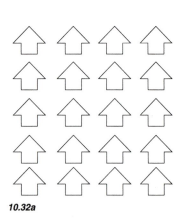

10.32a

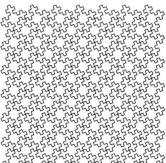

10.32b

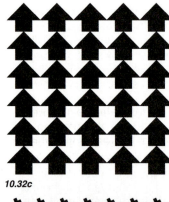

10.32c

Figure 10.33 (a) Symmetrical figure pattern drawn in line illustrating fluctuation. (b) Symmetrical figure pattern, positive/negative reversal, exemplifies fluctuation.

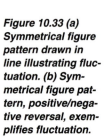

10.33a

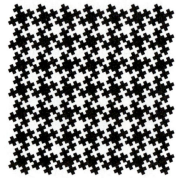

10.33b

Figure 10.34 (a-f) Ambiguous patterns in line (illustrated by: a, John Jay; b, Roger Kamerer; c, Abe Hara; d-f, student work).

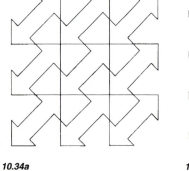

10.34a

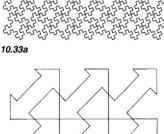

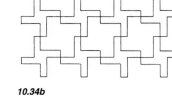

10.34b

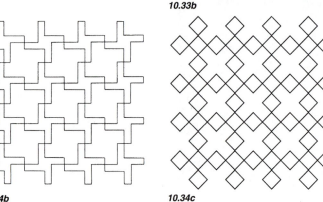

10.34c

forms the contour for the second set of arrows facing the opposite direction. Positive/negative areas can accentuate the double figure phenomenon. Almost any symmetrical figure can be used to create ambiguous patterns. As symmetrical figures become smaller and move closer together as a pattern, they fluctuate or are multistable (see Figure 10.33). The repetition of a line can also create ambiguous figures or patterns. Depending on the focal point within the shape, the enclosed end is perceived as the figure (see Figure 10.34).

Line patterns may be composed of two or more different figures. Notice that, as with ambiguous figures, only one type of figure can be perceived at one time. The dominant pattern figure is usually the figure that terminates or forms the outermost border of the pattern (see Figure 10.35).

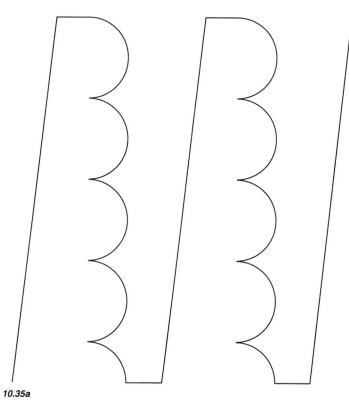

10.35a

Figure 10.35 (a-c) The repetition of a line creating ambiguous figures and patterns (illustrated by Tim Cook).

10.35b

10.35c

10.34d

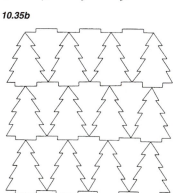

10.34e

10.34f

PERCEIVING THREE-DIMENSIONAL FIGURES

Figure 10.36 (a) This figure can only be interpreted as a contour drawing of a regular hexagon. (b) A regular hexagon subdivided into six equilateral triangles can be perceived as either a two- or three-dimensional form (isometric cube). The fluctuation is caused by having equal angles and the front and back parallel lines converge at the vertices. (c-d) Cubes drawn in isometric and dimetric. The cubes (b-c) can be viewed as either two- or three-dimensional, and they fluctuate between two different orientations because the front and back vertical lines meet at the vertex.

Figure 10.37 (a) Box that can be perceived as having dominant dimensional cues; however, when viewed for a few seconds, there is a fluctuation between two different orientations. (b-e) Varied angles and lines projecting back to a point in space. These figures also fluctuate between two different orientations, one projecting back into space and the other advancing forward.

There are a number of factors and visual cues that contribute to the dimensionality, depth, and stability of figures placed on the picture plane. For example, perspective or paraline drawing conventions can provide effective illusions of dimensionality and depth.

An additional visual factor that influences the perception, stability, or instability of form and dimensionality is the quality of figure goodness. Stated another way, according to how well visual factors and depth cues are applied in the drawing, the resulting figure can be stable or unstable, ambiguous, and so on. (It should be noted, however, that three-dimensional forms can be perceived with the same ease in more than one position or orientation, and their depth relationships can become multistable.)

The visual phenomena of dimensionality, stability, and instability take place when perception of a figure fluctuates between two and three dimensions or between two different depths or orientations (see Figures 10.36 and 10.37).

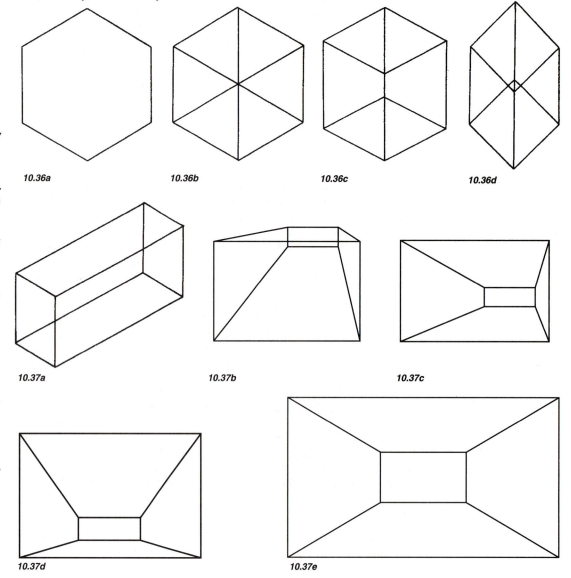

10.36a 10.36b 10.36c 10.36d

10.37a 10.37b 10.37c

10.37d 10.37e

AMBIGUOUS FIGURES IN THREE DIMENSIONS

Three-dimensional ambiguous figures share the same characteristics and explanations as two-dimensional ambiguous figures, with the addition of depth (see Figures 10.38–10.41).

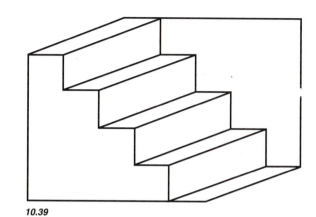

10.39

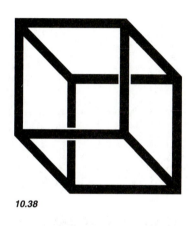

10.38

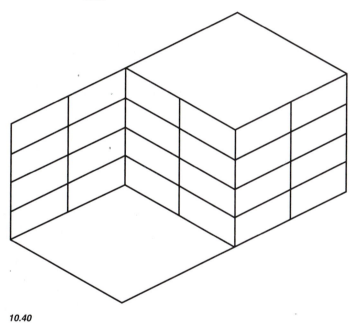

10.40

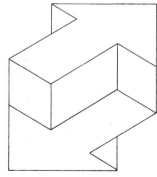

10.41a

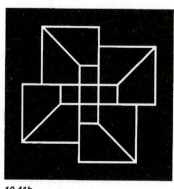

10.41b

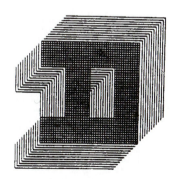

10.41c

Figure 10.38 Oblique wire frame cube, first described by A. L. Necker in 1832, illustrates the fluctuation concept.

Figure 10.39 Schroder's reversible staircase.

Figure 10.40 "Theiry's Figure" fluctuates depending on which plane is the visual focal point.

Figure 10.41 Reversible figures used as symbols or logos. (a) Reversible arrows symbol representing the Ohio Board of Regents (designed by Peter Megert, The Ohio State University/Department of Industrial Design). (b) Symbol for Omni-Plan Environment Service & Development Corporation (designed by Tomoko Miho; USA). (c) Logo for Dufex Publishers (designed by F. H. K. Henrion; UK).

Figure 10.42 "The Impossible Tribar," developed and published by R. Penrose in the British Journal of Psychology, 1958. The three acute angles appear to form a normal triangular figure, but are joined together in a way that is physically impossible in three dimensions (© 1991 Prof. Roger Penrose/Cordon Art—Baarn—Holland).

Figure 10.43 Impossible figure, from The Inquisitive Eye by Mark Fineman.

Figure 10.44 (a-b) A table of computer-generated diagrams used in "An Investigation of the Cues Responsible For Figure Impossibility" by T. M. Cowan and R. Pringle. The figures are ordered from 1 to 27 from what is most probable to what is least probable. The study, published in Journal of Experimental Psychology in 1978, indicates that the judged likelihood of a figure actually occurring with the characteristics shown is determined by the handedness of the twists or "impossible connections." (Copyright 1978 by the American Psychological Association. Reprinted by permission.)

IMPOSSIBLE FIGURES

Impossible figures convey two sets of contradictory spatial cues that cause the brain to make conflicting spatial interpretations. The perceptions are contradictory because they are based on what are seen as impossible connections between the linear members of a single form and what is known to be possible from learned perceptions. An understanding of these figures can help determine inaccuracies in other forms or drawings, and can be used to design visual puns or riddles (see Figures 10.42–10.44).

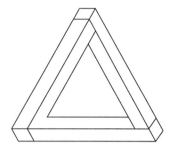

10.42

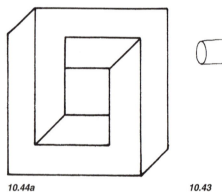

10.44a

10.43

10.44b

✍Practice Exercise 10.4: Developing Impossible Figure Illusions

Explore the concept of impossible figures by changing the vertex and edge alignment of a polyhedron so there are incorrect connections. A polyhedron can be formed by enclosing an area of three-dimensional space with four or more plane polygons (refer to Chapter 6). The exercise can be approached by drawing a number of sketch ideas in line with pencil. Review the concept sketches and select the most effective example. Render it in pen and ink on hot press illustration board. For other options, use color transfer film or gouache (see Figures 10.45 and 10.46).

10.45a

Figure 10.45 (a-d) Examples of impossible figures (illustrated by Reiner Teufel).

10.45b

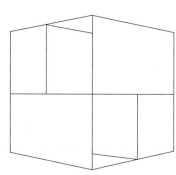

10.45c

10.45d

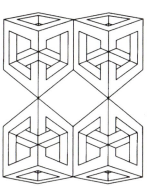

10.46a

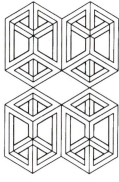

10.46b

10.46c

Figure 10.46 (a-c) Examples of impossible figures (illustrated by: a, Patty Goodburn; b-c, Mark Groves).

DISTINGUISHING FIGURE AND GROUND

This overview presents the differences between **figure** and **ground** as well as the relationships that occur between them. Important early research in this area by perception psychologist Edgar Rubin in 1921 provides a basis for seven differences or differentiations between figure and ground. They are as follows:

1. When two fields have a common border, it is the figure which seems to have shape while the ground does not.

2. The ground seems to extend behind the figure.

3. The figure appears to be object-like (even though it may be an abstract shape) while the ground does not.

4. The color of the figure seems more substantial and solid than that of the ground.

5. The ground tends to be perceived as farther away and the figure nearer the observer even though both are obviously at the same distance.

6. The figure is more dominant and impressive and tends to be remembered more easily.

7. The common border between figure and ground is called a contour, and the contour appears to be a property of figures. [Daniel J. Weintraub and Edward L. Walker, *Perception* (Belmont, CA: Brooks/Cole, 1969), p. 11.]

More recent perceptual studies have found that the recognition of a figure against a background depends on contrast; that is, a contrast in value, color, texture, or depth cues allows for differentiation between what is perceived as figure and what is perceived as background. W. Metzger, a perception psychologist in the early 1930s, identified through experiments "what is the smallest amount of stimulation necessary in order for vision to occur," termed the Ganzfield-describing homogenous stimulation. [Mark Fineman, *The Inquisitive Eye* (New York: Oxford University Press, 1981), p. 14.]

Perception psychologists have also noted other figure properties that influence the perception of figures against a ground. These are figure enclosedness, figure closure, familiarity, size, orientation, and internal detail (see Figures 10.47–10.50.)

Figure 10.47 (a-c) Figure enclosedness: A figure that is completely enclosed by a ground area is more readily perceived as the figure.

10.47a

10.47b

10.47c

Figure 10.48 (a-c) Familiarity: The illustrated letter E is not perceived quickly because of unfamiliarity with the characteristics of the letterform.

10.48a

10.48b

10.48c

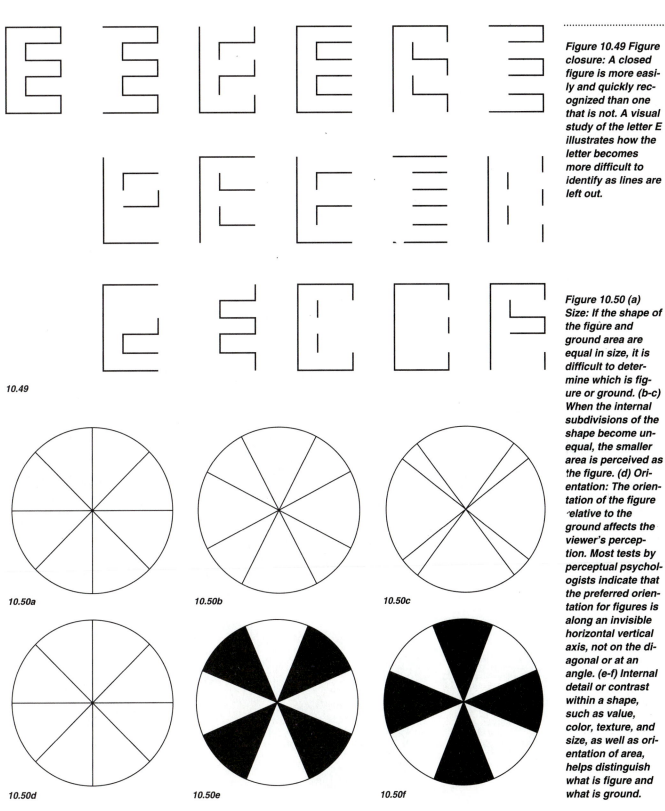

10.49

10.50a

10.50b

10.50c

10.50d

10.50e

10.50f

Figure 10.49 Figure closure: A closed figure is more easily and quickly recognized than one that is not. A visual study of the letter E illustrates how the letter becomes more difficult to identify as lines are left out.

Figure 10.50 (a) Size: If the shape of the figure and ground area are equal in size, it is difficult to determine which is figure or ground. (b-c) When the internal subdivisions of the shape become unequal, the smaller area is perceived as the figure. (d) Orientation: The orientation of the figure relative to the ground affects the viewer's perception. Most tests by perceptual psychologists indicate that the preferred orientation for figures is along an invisible horizontal vertical axis, not on the diagonal or at an angle. (e-f) Internal detail or contrast within a shape, such as value, color, texture, and size, as well as orientation of area, helps distinguish what is figure and what is ground.

*Figure 10.51 (a-d)
The effect of incremental size increases the recognition of the figure until the figure increases beyond recognition relative to ground.*

✍Practice Exercise 10.5: Size and Its Effect on Figure and Ground Relationships

Select a two-dimensional figure, such as a number or letter. Through sketching or the use of dry transfer letters or numbers, study how much of the figure can be enlarged within a specified area on a format before it is no longer seen as a recognizable shape (see Figures 10.51 and 10.52).

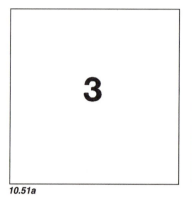

10.51a

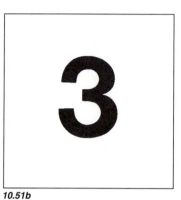

10.51b

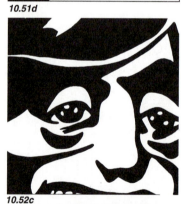

10.51c

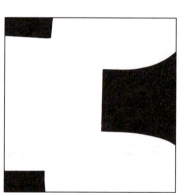

10.51d

*Figure 10.52 (a-f)
The face sequence illustrates important figure/ground considerations when enlarging and extending an image beyond the edges of the format. The last four images in the sequence lose their figure recognition. Also, the quantity of detail and familiar characteristics of the face can no longer be identified, and the shapes become abstract elements (illustrated by Linda Bottenfield).*

10.52a

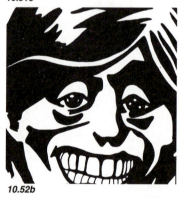

10.52b

10.52c

10.52d

10.52e

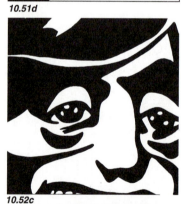

10.52f

EMBEDDED FIGURES AND CAMOUFLAGE

The perceptual concepts of **embeddedness**, or inclusiveness, and **camouflage** refer to figures or forms incorporated into a ground area that makes it difficult to perceive what is figure and what is ground (see Figures 10.53–10.55).

10.53

Figure 10.53 A U.S. Army photograph showing the use of painted dazzle patterns supplemented by camouflage netting.

10.54a

10.54b

10.54c

Figure 10.54 (a-c) Embedded geometric figures (illustrated by Louise Utgard).

10.55a

10.55b

Figure 10.55 (a-b) Embedded figure of Charlie the cat (illustrated by G. Magnus).

Figure 10.56 (a) Various shape subdivisions originating from the first figure drawn in line; (b) the same shapes in positive/negative (illustrated by Alan Jazak).

Figure 10.57 (a) Various shape subdivisions originating from the first figure drawn in line; (b) the same shapes in positive/negative (illustrated by Alan Jazak).

✍Practice Exercise 10.6: Hidden Figures and Their Shape Combinations

Using line, draw a simple abstract or geometric composition, creating several different figure combinations. Also explore positive and negative combinations and compare the resulting figure and the combinations, incorporating the figure laws and figure ground laws previously discussed.

Figures 10.56–10.58 show two different study approaches, a geometric configuration and its combinations created by dividing the format into smaller shapes or areas and a leaf motif form development transformation.

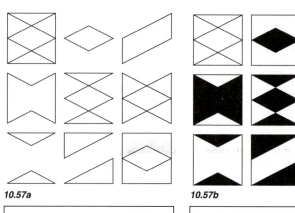

10.56a

10.56b

10.57a

10.57b

Figure 10.58 (a-f) Form development: line and plane leaf motif (student work; Schule Für Gestaltung, St. Gallen, Switzerland. Instructor: Hans Reudi Buob).

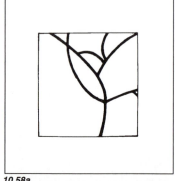

10.58a

10.58b

10.58c

10.58d

10.58e

10.58f

BRIGHTNESS CONTRAST IN FIGURE/ GROUND RELATIONSHIPS

The concept of **irradiation** (brightness contrast) deals with the amount of light or luminance within the visual field and how it changes the viewer's perceptions of images or objects. Irradiation has a direct relationship to visual studies because it can affect the perception of size, brightness, color, depth, distance of figures, and afterimages relative to the ground area or picture plane. For example, a white area or shape may appear larger and seem to advance, whereas a black area or shape of equal size will appear smaller and recede into the picture plane. In typographic design, studies have shown that it is difficult to read white text on a black ground because the text seems brighter and may sparkle or advance toward the reader. This phenomenon is called "the contrast between borders" (see Figures 10.59 and 10.60).

In "phantom figures" (see Figure 10.61) there are imaginary lines called subjective contours, which are perceived within the viewer's mind and define the figure. The two major characteristics of phantom figures outlined by perception psychologist Gaetano Kanisa are: the area enclosed by a subjective contour appears to be brighter than the background even though they are the same; and the figure within the subjective contour appears to be

an opaque surface that is superimposed on the figures in the illustration (see Figure 10.62).

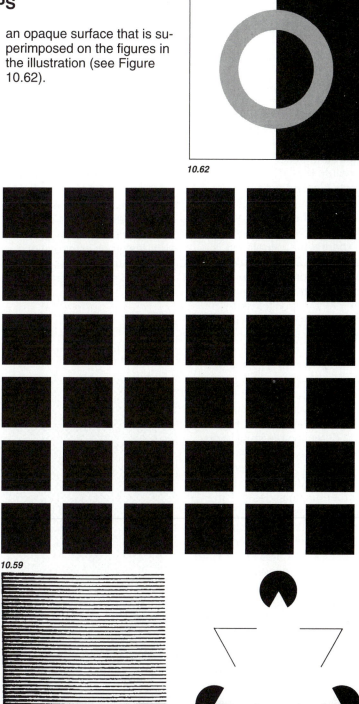

10.62

10.59

10.60

10.61

Figure 10.59 The Hermann grid shows how the contrast of borders causes gray spots to appear at the intersections between the solid black squares.

Figure 10.60 Contours of adjacent areas are more evident when there is a sharp contrast between them. This phenomenon can cause the viewer to see bands called "Mach bands," which appear lighter or darker within a pattern. This information was first reported in scientific literature about one hundred years ago by Ernst Mach, an Austrian physicist and psychologist.

Figure 10.61 "Phantom figures" are created by subjective contours (reprinted courtesy of Roxby Press).

Figure 10.62 Simultaneous contrast in figure/ ground occurs when similar shapes of equal color and value are placed on different grounds. Although the figures are exactly the same, they will appear lighter or darker.

Figure 10.63 (a) A
change in the thick-
ness of a line within
a ground pattern
can visually de-
scribe a figure in a
star. The size of the
overall pattern af-
fects how easily the
figure is perceived.
(b) An image can be
created from small-
er figures within a
pattern. By sub-
tracting a small
area of the pattern
figure, a secondary
figure such as the
diamond figure ap-
pears within the
pattern ground (il-
lustrated by: a, Tom
Stahl; b, Robert
Carr).

Figure 10.63 (a) A change in the thickness of a line within a ground pattern can visually describe a figure in a star. The size of the overall pattern affects how easily the figure is perceived. (b) An image can be created from smaller figures within a pattern. By subtracting a small area of the pattern figure, a secondary figure such as the diamond figure appears within the pattern ground (illustrated by: a, Tom Stahl; b, Robert Carr).

Figure 10.64 The space between elements is altered in a pyramid (illustrated by Rod Johnson).

BRIGHTNESS CONTRAST IN JUST NOTICEABLE DIFFERENCES (JND) IN FIGURE/GROUND COMPOSITIONS

Visual perception in *just noticeable difference* (JND) involves the process of threshold perception, detection, and discrimination. The term *threshold* refers to the minimal amount of information required to accomplish a perceptual task. The simplest task is called *detection*, which requires the viewer to identify when a predefined image (called the stimulus in experimental situations) is detected. *Discrimination* is slightly more complex and requires that the viewer be able to identify specific visual characteristics within a given image area.

In advertising, visual experiments have been performed by perception psychologists to find out more about viewer behavior and the detection of visual information. Most of these tests were accomplished by flashing visual information onto a screen using slides or film. These threshold variability experiments have helped in understanding audience responses. It is also known that the visual threshold varies from one individual to another and that response is affected by other factors such as available light, color, and so on.

There are two categories of thresholds: The smallest amount of information that can be detected, called an *absolute threshold* and the smallest difference between visual information, called a *difference threshold*. JND is a type of difference threshold and can be used to create interesting visual solutions.

The examples in Figures 10.63 and 10.64 were developed to illustrate how these perceptual concepts can be used in visual communication design or compositions and how the visual technique used to create JNDs varies.

10.63a

10.63b

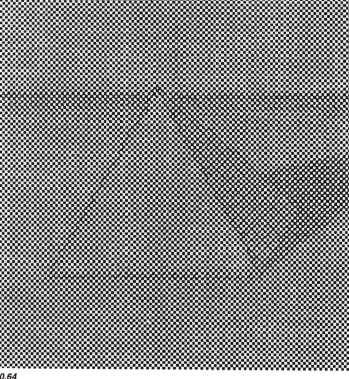

10.64

FIGURE/GROUND REVERSAL

A figure/ground **reversal** occurs when the positive areas of a design become negative and the negative areas become positive. This concept can be illustrated in steps like a transformation sequence, or within a single figure or whole composition.

Figure/ground reversals in a step sequence occur when the figure increases or decreases in size, and the positive becomes negative. This also applies to opposite situations when the ground area increases or decreases in size so the negative becomes positive (see Figures 10.65–10.68).

10.66

Figure 10.65 Compositional sequence illustrating figure/ground reversal by increasing the figure area in increments within the format. (Beginning at top left, read each column in sequence from top to bottom.)

Figure 10.66 Symbol concepts using figure/ground reversals (illustrated by Charles Wallschlaeger).

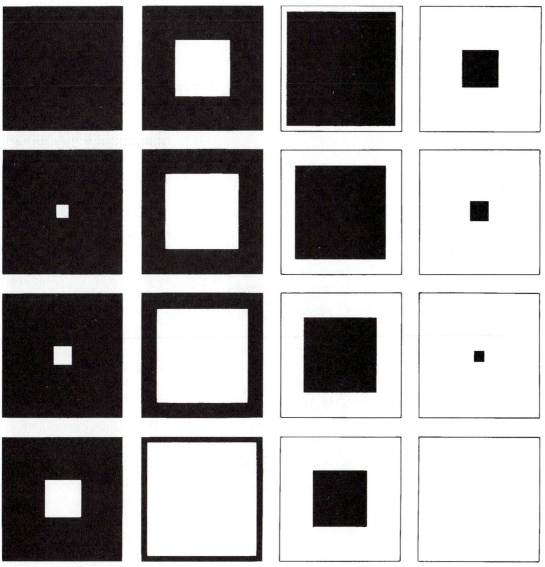

10.65

......................................

Figure 10.67 Figure/ground reversal using a letterform F rotated 180° (illustrated by David Chaney).

Figure 10.68 (a-c) Geometric configuration illustrating figure/ground reversal (student work).

10.67

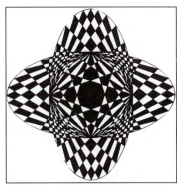

10.68a

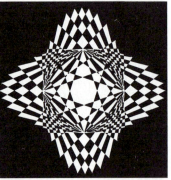

10.68b

10.68c

FIGURE/GROUND REVERSALS (PATTERN FLUCTUATION)

Since figures and forms are visualized within a ground or picture plane, in pattern the smaller visual elements are perceived as figures and the larger areas are perceived as background. By changing the relationship of the figure and ground through positive/negative reversal, the visual perception of the overall pattern is changed. Ambiguous patterns that fluctuate from one figure to another will be enhanced by the addition of positive/negative areas.

The positive or negative ground area affects what pattern shape terminates the pattern composition. A black

ground area surrounding a pattern causes the white figure or space to emerge as the figure in the pattern while the black becomes the ground. A white ground area surrounding a pattern causes the black figure to emerge as the dominant figure in the pattern while the white area becomes the ground. In addition, the outermost shape that creates the border for the pattern area is usually perceived as being more dominant and is called the figure.

As previously explained, a brightness contrast between the white figure on the dark ground and the dark figure on the black ground is encountered because of irradiation and simultaneous contrast. White figures on a black or dark ground will be perceived as brighter and seem to advance from the page (see Figure 10.69).

A pattern is shown in two different sizes in Figures 10.70 and 10.71. How does the overall size of the pattern affect its appearance? When the pattern is enlarged, greater attention is paid to the detail of the figures, so each figure receives more visual attention as a separate compositional element. When the whole pattern is reduced in size, the pattern figures are less noticeable as separate elements (see Figure 10.71). Less detail is perceived and the light and dark areas of the pattern appear as lines or texture.

Dimension and depth within a pattern are created by darkening different areas within a single set of figures. The internal detail contrasts with the plain area, which causes the star to be perceived as the figure and the white area to be perceived as the ground (see Figures 10.72 and 10.73).

10.69

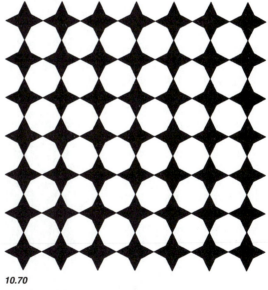

10.70

10.71 10.72 10.73

Figure 10.69 Intersecting points of star and octagon shapes create a new square diamond pattern. The diamond-shaped intersections appear as spots on a white ground because of their size and position to the ground (illustrated by Dennis Couch).

Figure 10.70 When a pattern is enlarged, greater attention is paid to the shape and detail of the figure (illustrated by Dennis Couch).

Figure 10.71 When a pattern is reduced in size, the pattern figures are less noticeable as separate elements (illustrated by Dennis Couch).

Figure 10.72 Internal detail adds an illusion of depth and dimension (illustrated by Dennis Couch).

Figure 10.73 Figure/ground reversal may be achieved by dividing the pattern into two areas, and reversing the positive and negative area (illustrated by Dennis Couch).

Figure 10.74 Fig-
ure/ground reversal
(student work).

Figure 10.75 A cir-
cular figure is trans-
formed into a leaf-
like figure through
figure/ground rever-
sal using an addi-
tive, subtractive
step method (stu-
dent work).

TYPES OF PATTERNS

Figure/ground reversal pat-
terns can be formed or struc-
tured by repeating one or
more shapes to form a pat-
tern and then reversing what
is positive or white area to
negative or black within the
pattern (see Figure 10.74).

Another way to create fig-
ure/ground reversals in pat-
tern is to develop shape
transformation patterns in
which a specific shape, such
as a circle, is changed into a
leaf-like figure through a se-
ries of subtractive or additive
steps (see Figure 10.75).
Then repeat the series a
given number of times to
form a pattern cell. This pat-
tern cell may then be manip-
ulated according to the given
symmetry operations and/or
combinations as presented in
Chapter 12, Symmetry and
Dynamic Symmetry.

A third way to achieve fig-
ure/ground reversals is to de-
sign a figure transformation
that is manipulated using the
symmetry operations, revers-
ing the positive and negative
areas (see Figure 10.76).

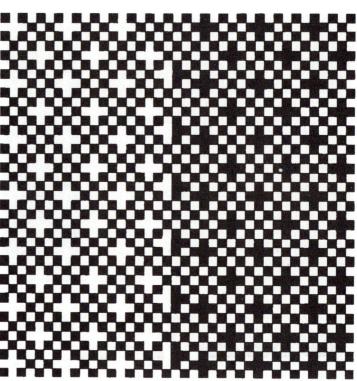

10.74

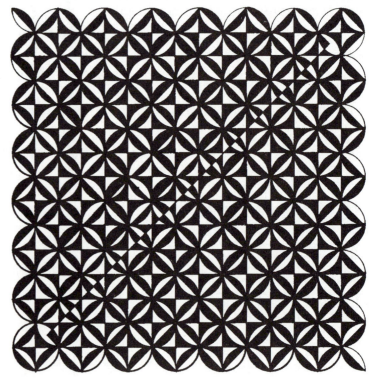

*Figure 10.76 Figure
transformation, al-
ternating the posi-
tive/negative shape
areas (illustrated by
Lee Krendl).*

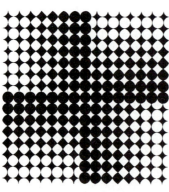

10.76 10.75

OVERLAPPING FIGURES

Overlapping figures can be created by the use of positive/negative reversal; that is, the shape of one figure overlaps another, which reinforces the contour (see Figures 10.77–10.79). An illusion of transparency is brought about by using positive/negative reversal with overlapping (see Figure 10.78).

10.77

Figure 10.77 Emblem for Girl Scouts of America using overlapping and positive/negative reversal (designed by Saul Bass, Herb Yager and Associates, Inc).

10.78a

10.78b

Figure 10.78 (a) Card suit symbols and (b) triangle, circle, rectangle, illustrating the illusion of transparency using reversal with overlapping.

10.79

Figure 10.79 An applied example using overlapping and positive/negative reversal (illustrator unknown).

Figure 10.80 (a) Selected numerals; (b-c) positive/negative reversals and the use of overlapping numerals creating concept compositions; (d) selected composition using numerals 6, 4, 1 (illustrated by Alan Jazak).

✍Practice Exercise 10.7: Overlapping Figures Using Figure/Ground Reversal

Select a simple geometric figure, letterform, or numeral. Through sketching, create several compositions in which positive/negative reversals and overlapping reinforce the contours of the shapes used. Try to fit the shapes together, as in a puzzle, then alternate the white and black area to define the figures. Determine which concept idea is the best solution and render it on hot press illustration board using either pen and ink, gouache, or transfer film (see Figure 10.80).

10.80a

10.80b

10.80c

10.80d

MOIRÉ PATTERNS

When two or more patterns are overlapped at an angle of less than 30°, a moiré pattern is produced. Moirés can be made from patterns composed of any geometric shape, since they depend only on positive and negative areas to be effective.

An example of moiré is seen when line patterns are superimposed on one another. Intersecting angles tend to fill in and create dark areas while the opposite intersecting angles overlap, causing lighter bands within the design (see Figures 10.81 and 10.82).

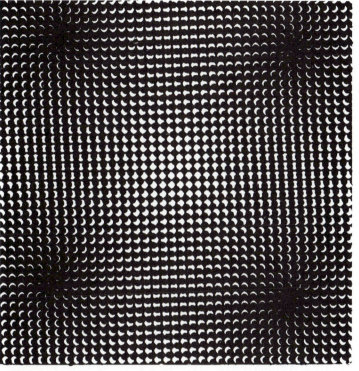

10.82a

10.81a

10.81b

10.82b

Figure 10.81 (a-b)
A simple line pattern superimposed (overlapping) on itself to create a moiré pattern.

Figure 10.82 (a-b)
Examples of moiré patterns using overlapping.

REFERENCES AND RESOURCES

Albers, Josef. *Despite Straight Lines*. New Haven, CT: Yale University Press, 1961.

Beardslee, David C., and Michael Wertheimer. *Readings in Perception*. Princeton, NJ: D Van Nostrand Co. Inc., 1958.

Bloomer, Carolyn M. *The Principles of Visual Perception*. New York: Van Nostrand Reinhold, 1976.

Carraher, Ronald G., and Jaqueline B. Thurston. *Optical Illusions and the Visual Arts*. New York: Watson-Guptill, 1983.

Dember, William N. *The Psychology of Perception*. New York: Holt, Rinehart & Winston, 1960.

Ernst, Bruno. *The Magic Mirror of M. C. Escher*. New York: Random House, 1976.

Fineman, Mark. *The Inquisitive Eye*. New York: Oxford University Press, 1981.

Forgus, Ronald H. *Perception*. New York: McGraw-Hill, 1966.

Frisby, John P. *Illusion, Brain and Mind*. Oxford: Oxford University Press, 1980.

Goldstein, E. Bruce. *Sensation and Perception*. Belmont, CA: Wadsworth, 1980.

Gregory, R. L. *Eye and Brain: The Psychology of Seeing*. New York: McGraw-Hill, 1966.

Gregory, R. L., and E. H. Gombrich, eds. *Illusion in Nature and Art*. New York: Charles Scribner's Sons, 1973.

Haber, Ralph Norman. *Information Processing Approaches to Visual Perception*. New York: Holt, Rinehart & Winston, 1969.

Hochberg, Julian E. *Perception*. Englewood Cliffs, NJ: Prentice-Hall, 1964.

Koffka, K. *Principles of Gestalt Psychology*. New York: Harcourt, Brace and World, 1935.

Köhler, Wolfgang. *Gestalt Psychology*. New York: Liveright Publishing Corporation, 1974.

———. *The Task of Gestalt Psychology*. Princeton, NJ: Princeton University Press, 1969.

Lancaster, John. *Introducing Op Art*. New York: Watson-Guptill, 1973.

Lanners, Edi, ed. *Illusions*. New York: Holt, Rinehart & Winston, 1977.

Leeman, Fred. *Hidden Images: Games of Perception, Anamorphic Art, Illusion*. New York: Harry N. Abrams, 1976.

Luckiesh, M. *Visual Illusions: Their Causes, Characteristics and Applications*. New York: Dover, 1965.

Pirenne, M. H. *Optics, Painting and Photography*. Cambridge, UK: Cambridge University Press, 1970.

Read, Alice Gray, and Peter C. Doo, eds. with Joseph Burton. *Via 6 Architecture and Visual Perception*. Cambridge, MA: University of Pennsylvania and MIT Press, 1983.

Readings from Scientific American. Image, Object, and Illusion. San Francisco: W. H. Freeman, 1974.

Uhr, Leonard, ed. *Pattern Recognition*. New York: John Wiley & Sons, 1966.

Weintraub, Daniel J., and Edward L. Walker. *Perception*. Belmont, CA: Brooks/Cole, 1969.

Perceptual Principles of Organization

CHAPTER OUTLINE

- Chapter Vocabulary
- Introduction to Perceptual Principles of Organization
- Communication Theory
- Planning, Analyzing, and Organizing a Message Within a Visual Field
- Introduction to Aesthetic Principles in Visual Organization
- Grouping Elements Within a Format
- Introduction to Gestalt Grouping Laws
- Practice Exercises
- References and Resources

CHAPTER OBJECTIVES

On completion of this chapter, readers should be able to:

- Understand how the concepts and principles of perception, communication theory, and the theory of signs affect communication and message making.

- Understand how the theories and concepts presented relate to creating visual messages, products, and environments.

- Understand the visual qualities presented and use them to enhance messages and symbolic forms.

- Understand the qualities of two- and three-dimensional fields or formats and how they affect visual messages.

- Understand communication as a theoretical process and describe how it relates to the development of visual messages in two- and three-dimensional space.

- Utilize the theories presented to develop visual messages on two- and three-dimensional formats.

Figure 11.1 The gray areas (Verbal and Nonverbal Communication, Semiotic, and Communication Process and Perceptual Principles of Organization) denote the subject matter presented in this chapter.

Communication Theory

| **Verbal & Nonverbal Communication** | **Semiotic (Theory of Signs)** | **Communication Process** |
|---|---|---|
| **Pattern Recognition** | **Theory by Charles Morris** | **Process by D. Berlo** |
| **Human Communication** Relative to Social/ Cultural Patterns **Visual Language** Codes/Symbols | **Semiosis** Sign Vehicle Designatum Interpretant | Source \| Message \| Channel* \| Receiver |
| | **Syntactics** Formal Concept of Language Syntactical Rules formation rules transformation rules | ***Media** **Hand Graphics** Pencils Pens Markers Film Dry Transfer Tape |
| | **Semantics** Relation of Signs to their Designata Semantical Rule Linguistic Structures Nonlinguistic Structures | **Print** Offset Lithography Silkscreen |
| | **Pragmatics** Relation of Signs to the User Pragmatical Rule | **Film** Still Motion Multi-media |
| | | **Video** |
| | | **Computer** Computer Aided Design (CAD) Computer-Based Education (CBE) computer-assisted instruction (CAI) |

11.1

CHAPTER VOCABULARY

Asymmetry Lack of symmetry, designating an unequal spatial arrangement.

Axis A real or imaginary line through a shape or solid about which a compositional element or group of elements is symmetrically arranged.

Balance The design or arrangement of parts in a whole grouping that creates a feeling of equilibrium or equality.

Closure The tendency of a viewer to "close" or visually complete a form or figure from which some visual information has been deleted; the remaining visual elements are enough for the viewer to perceive the form as a whole.

Contrast A condition achieved by the placement of one or more elements in opposition to each other.

Direction The visual sense of movement resulting from the orientation, position, and arrangement of shapes within a format.

Dominance A condition that occurs when one or more compositional elements within a visual field is emphasized and becomes more visually prominent than the others.

Familiarity An organizational principle characterized by the use of elements that the viewer can recognize and associate with meaning, based on previous personal experience and learning.

Format A two- or three-dimensional field or space in which art forms, visual messages, designs, and environments are created. Two-dimensional formats have length and width; three-dimensional formats have length, width, and depth.

Good continuation A condition characterized by an unbroken, uninterrupted relationship among the visual elements in a format, which directs the viewer's eyes to move through the composition and perceive the relationship.

Good figure A figure or form characterized by simplicity, symmetry, and balance. Good figures are said to be easily recognized by viewers. Stronger and simpler figures generate less ambiguity in their perception.

Harmony A state of visual order or aesthetically pleasing relationships among the visual elements in a two- or three-dimensional composition, form, or structure.

Icon A sign that resembles an actual referent.

Ideogram A sign characterization that expresses the idea but not the letters or sounds of the word that represents the idea.

Orientation The position of a compositional element relative to the format or other elements in a composition or structure. Orientation is the placement of the figure or form within a given space described as "facing forward," "upside down," etc.

Position The location at which a compositional element is placed within the visual field or format. Position commonly is described as relative to other compositional elements and the visual field boundary.

Pragmatics The branch of semiotics that deals with the relationships among signs, symbols, and their users.

Proximity The distance between elements. The law of proximity states that elements that are nearer to each other in a

composition will be seen as "belonging" together.

Randomness A condition characterized by a lack of visual relationships or systematic arrangement among elements in a format.

Repetition A recurrence of one or more compositional elements within the visual field or format.

Rhythm A recurrence or repetition of visual elements in a regular, harmonious pattern.

Semantics The relationships among signs and symbols and the objects they represent.

Semiotics The theory of signs first set forth by Charles Morris. *Semiotic* describes relationships between signs and their referents; *semiology* is the science or art of signs.

Sign A symbol or compositional element that represents thoughts, objects, or events.

Similarity The condition of elements being visually grouped according to like features, contours, or symmetries.

Simplicity A condition characterized by easily recognizable compositional elements or groups of elements. Simple compositions are more easily remembered than complex compositions.

Static Describes a composition of figures or forms that appear to be at rest and visually balanced.

Symbol A sign.

Symmetry The correspondence between opposite halves of a figure or form on either side of an axis or set of axes.

Syntactics The study of the formal properties of signs and symbols and their relationships to other signs.

Unity The condition that exists when visual elements are arranged into a homogeneous whole that exhibits oneness or harmony.

Visual field The picture plane, surface, or space in which compositional elements are arranged. Visual field often is interchangeable with format.

Visual syntax The relation of the sign and its object in terms of "structure" of form (i.e., visual organization).

INTRODUCTION TO PERCEPTUAL PRINCIPLES OF ORGANIZATION

Chapter 10 emphasized the perception of forms and figures, properties of figures, and the distinguishing of the figure from the ground. This was to prepare for the study of organizing and creating figures and forms in two- and three-dimensional formats according to the perceptual principles of organization. The process of organizing visual information or forms into a unified, harmonious whole for interpretation by a given audience is a complex task requiring an understanding of visual structure. This chapter emphasizes the concepts and principles of perception and communication theory and how they affect visual message making.

People daily experience a variety of symbols and metaphors with varying possibilities of interpretation. Living and working environments consist of an infinite number of visual statements and messages found in signs, advertising, television, art forms, products, and environments. These visual cues have meanings that elicit multiple responses from the viewer. The structure, or syntax, used to organize the visual information, as well as the previous experience of the perceiver, contribute to the response of the perceiver.

Thus, the visual principles of organization can be used to organize or create meaningful figures and forms. Because these principles are difficult to comprehend and use in the development of visual messages, art forms, and man-made environments, attempts to understand and use them as separate concepts or rules can be frustrating. Therefore, it is important to understand that each principle or theory is only a small part of the larger concept of organization within the whole visual message-structuring process. Though the concepts and theories are presented in this chapter as seemingly separate ideas, this division is only for simplification.

Overview of the Design Process Using Communication Theory and Practice

The desire to create visual messages and forms implies that there is a concept or message to be communicated. The ability to successfully communicate the visual message requires establishing a hierarchy of the message or form-making process. For example, considerations within the hierarchy are the context of the message or form, its functional purpose, production or construction methods,

visual qualities, and materials and processes. These categories and their considerations are effective in bringing order to the problem-solving process and serve as structuring guidelines to create the intended message or form.

Completed visual communications, art forms, products, and environments consist of a visual context and a message, resulting in some type of physical form. The context is the intended meaning of the message relative to how it is to function or be experienced, and the form is the visual result, or physical structure of the message, product, or environment. By manipulating physical elements, artists, architects, and designers can create and vary a form's message or emphasis, either two- or three-dimensionally.

Organizational guidelines should be established to assist in the creative form generation process. This can be achieved by using visual organizational principles to structure the relationship among the visual elements of form, the compositional elements, and the desired message. There are two types of organizational principles that can be used as visual ordering systems: visual concepts and principles, and prescrip-

tive principles of organization. An understanding of the concepts and principles doesn't guarantee that everyone will be able to create or compose successful, interesting visual messages or forms, but an acceptable solution with visual unity or logic can result. Visual unity, the end goal of the form generation process, is a coherence of the elements, processes, and methods that results in the communication of a message or function of an object or environment. The resulting solutions also are affected by personal ability or talent, motivation, and creativity.

Theories and Principles That Assist in Visual Message and Form Generation

The visual communication process is best understood by taking a broad approach: identifying theories, principles, and techniques that assist in solving visual problems—that is, communication theory, semiotic theory (theory of signs), perception theory (visual organization, perceiving the visual field, figure and form perception), and form aesthetics. Communication theory helps structure the problem relative to the intended message and audi-

ence. Semiotic theory assists in relating and describing relationships between signs and their referents. Form aesthetics are composed of desirable intrinsic form qualities such as size, proportion, and texture. Perception theory assists in laying the structural basis by identifying what viewers may perceive as recognizable figures. Visual organizational principles assist in structuring the relationships among the visual elements of form (point, line, shape, value, color, texture, and so on) to create the desired message.

COMMUNICATION THEORY

This section introduces some of the theoretical aspects of communication theory and how they affect visual message making. The study of visual communication and visual message making is based on scientific principles and empirical research from other academic disciplines, such as human communication, semiotics, information and learning theory, perception psychology, sociology, and aesthetics.

In order to plan, organize, and develop visual communications it is important to relate to and study various communication models. These models outline aspects of the process that are important but not always evident. A model is not a substitute for all possible factors that might occur in a communication situation, however. Generally

speaking, models should be selected, adapted, or developed for specific problems and should consider attitudes, associations, and social or cultural problems.

Types of Models

Models, sometimes called *facsimiles* or *archetypes*, communicate theories, processes, analogies, events, techniques, ideas, and concepts. They can be written, verbal, mathematical, nonverbal, or a combination. Models are referred to as descriptive or functional. *Descriptive models* explain steps in a process identifying categories, components, and actions as they relate to each other. *Functional models* specify relationships or create new relationships among elements, objects, or people. The physical characteristics

of models vary depending on the intent of the communication. Diagrams, charts, maps, and tables are examples of models (see Figure 11.2).

11.2a

Figure 11.2 Examples of types of models illustrating: (a) a trend sequence.

Figure 11.2 (continued) (b) the relationships of components in a system, (c) quantitative relationships, (d) coat pattern diagrams, (e) layout sketch, (f) structure section, (g) map (d-e, student work).

11.2b

11.2c

11.2d

11.2e

11.2f

11.2g

Berlo's Model of Human Communication

The process model of human communication first developed by David K. Berlo has been adapted in outline form (see Figure 11.3) to describe verbal and visual message making that can be used by artists, architects, and designers. This model can provide a logical structure for stages in the communication process as it is applied to visual messages, which increases the probability that the viewer will understand and respond in the desired manner. Following are the steps within the model.

Source/Encoder

The source or encoder is the person or group of persons sending the message. For example, within the context of form generation, the source or encoder would be the artist, architect, or designer. The source is affected by external factors such as cultural values, creativity, knowledge, education, attitudes, visual encoding skills, and associations.

Message

The message is the intended statement, idea, or feeling communicated. The message code is the physical figure or form of the message used singularly or in combination; that is, verbal language or visual language composed of signs, symbols, terms and definitions, structure or syntax, and so on. The visual message can consist of symbols, trademarks, photographs, illustrations, creative images, objects, products, environments, and so on.

Channel

The channel is the mode of sending the message to the receiver, in other words the senses (taste, smell, seeing, touching, or hearing) that are affected by the media and materials (print, film, television, books, magazines, and so on).

Receiver/Decoder

The person or group of persons for whom the message is intended is referred to as the receiver. For example, the receiver of a visual communication could be a general audience including a variety of people, or a more specific group with common characteristics and knowledge. The receiver, like the source, is influenced by external factors such as cultural values, creativity, knowledge, education, attitudes, visual decoding skills, and associations.

Figure 11.4 on the following pages describes the relationship of Berlo's model adapted to a visual model of communication by the authors.

| Source | encode | Message | Channel | decode | Receiver |
|--------|--------|---------|---------|--------|----------|
| Communication Skills Attitudes Knowledge | ▶ | Elements Structure Content Treatment | Seeing Hearing Touching Smelling | ▶ | Communication Skills Attitudes Knowledge |
| Social-Cultural Context | | | | | Social-Cultural Context |

Figure 11.3 Simplified version and outline of David K. Berlo's model of human communication (adapted by the author).

Structuring a Visual Message

The *source* in the visual message-making process is the person or group of persons who actually create the visual statement. In the form generation process, examples of sources are artists such as painters, sculptors, and printmakers; graphic, product, and interior space designers; architects; filmmakers; television producers; photographers; fashion clothing and textile designers; and so on.

Each source or encoder begins with an idea, the *message*, which is to be communicated to others. The message intent may be descriptive, interpretive, explanatory, or persuasive information.

S M

| | | Visual Message | Physical Context of the Message | Visual Elements of Form |
|---|---|---|---|---|
| Visual Model of Communication | Artists
Architects
Designers | | | |
| Components of a Visual Message | Artists
Painters
Sculptors
Printmakers
Photographers
Architects
Interior Architects
Graphic Designers
Product Designers | Idea/Concept Formation | Visual Field or Format | Form Generating Elements

Physical and Visual Attributes of Form |
| Conceptual Components of a Visual Message | Attitudes
Education
Cultural Background
Knowledge
Experiences
Prejudices | **Intent** of the Message:
Informative
Persuasive
Religious
Political
Expressive | Sociocultural Context | Point
Line
Plane/Shape
Volume/Form |
| Physical Components of a Visual Message | Artists
Architects
Designers | Form of the Message:
Media
Paper/Boards
Paint/Brushes
Drawing Tools
Clay and Fiber
Photography
Plastics
Metal
Glass
Brick/Stone
Wood, etc. | Actual **Format** of the Message:

Two-Dimensional Picture Plane

or

Three-Dimensional Volume or Environment | Shape
Form
Color
Texture
Value
Size
Scale
Dimension
Proportion |

11.4

The message content can be instructional, informative, social, political, religious, or persuasive.

The way the message is presented to the receiver can provoke certain moods, feelings, and emotions. *Encoding* is the process of designing the message form and format; therefore, sometimes the source is also called the *encoder*. The success of the visual message may be gauged by the reaction of the audience and depends on the selection of the message code used.

C R

| Organization | Aesthetics | Visual Treatment | Viewer |
|---|---|---|---|
| Concepts and Principles of Organization

Aesthetic Judgment | Personal preferences about the way things "look" | Approach, Method or Style of Communication | Other People

Other Artists, Architects, or Designers |
| Meaning and Association

Syntax Rules

Principles of Organization | Balance
Dominance
Harmony
Contrast
Unity | Skills
Visual Techniques
Creativity/Talent of the Source | Attitudes
Education
Cultural Background
Knowledge
Experiences
Prejudices |
| Spatial Relationships

Size and Quantity of Compositional Elements | | Media and visual techniques result in final communication products:

Drawings
Paintings
Printed Materials
Packaging
Television
Film
Buildings
Interior Spaces
Consumer Products | Individuals or Groups of People |

Figure 11.5 Examples of types of codes.

Human Communication, Messages, and Codes

Human communication is a process in which numerous factors, such as language, attitudes, knowledge, social and cultural influences, and communication skills of the individuals are operating within several dimensions simultaneously. Communication consists not only of the written or verbal language, but also of other sets of codes or code systems. Examples of communication codes would be the alphabet and punctuation for the written verbal language; gestures and hand signs for nonverbal language; semaphore signals and the International Marine code for nonverbal communication; musical notation for reproducing musical sequences; pictographs representing objects, actions, and concepts; and so on (see Figure 11.5).

Types of Codes

Verbal (written)

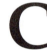

Nonverbal (sign language)

Object Representation

Abstract Representation

Abstract Nonrepresentation

Communication theory states that code systems must consist of a set of significant symbols, and meaningful methods in combining them. Both the symbols and their structural relationships should produce similar interpretations or responses from people who know the code. Artists, architects, and designers also use a language composed of elements and symbols to communicate visual messages.

Verbal codes consist of a specific language (English, French, Spanish, etc.) using certain symbols (the alphabet), grammatical rules, and punctuation. Verbal codes can be used to communicate through writing or speaking. Nonverbal codes consist of pictures or visual elements (sign language for example) that take on symbolic meaning depending on the way they are used or combined.

There are three different kinds of visual nonverbal codes: object representational, abstract representational, and abstract nonrepresentational. The *object representational* or realistic symbol (also called sign vehicle) is referred to as **iconic** or pictorial in nature. This means that it closely resembles the real object or form (called the designatum). These representational symbols and models are created using visual elements, techniques, and media to represent objects, buildings, people, and environments.

Abstract representational images are not literal or realistic visual representations of actual objects, people, or environments. Abstract symbols such as pictographs have a general likeness to the original subject so that viewers associate them with the real object, person, or environment (see Figure 11.6).

Abstract nonrepresentational symbols are images that have no physical likeness to real objects, people, or places. They may represent a concept or idea, summarize an action to be taken, or act as a symbolic code (such as Morse code; see Figure 11.7). These nonrepresentational symbols are assigned meaning and associations by the viewer, based on previous learning and experience.

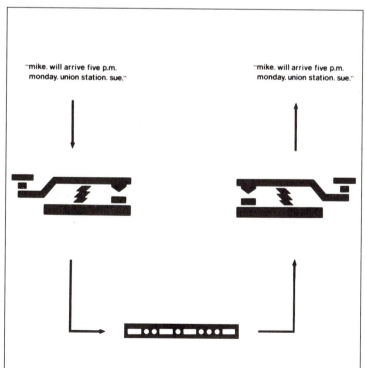

Figure 11.6 Study of codes and symbols and their interpretation (student work; exercise by Professor Peter Megert, The Ohio State University Department of Visual Communication).

Figure 11.7 Design study of the process of representing an action, symbolic code (student work; exercise by Professor Peter Megert, The Ohio State University Department of Visual Communication).

11.6

11.7

Figure 11.8 Types of
graphic signs and
symbols.

Use of Semiotic Theory in Visual Sign Making

An area of study called **semiotics** is important to the understanding of the process of visual message making. Semiotic study explores the relationship of the theory of signs and its effect on the process of creating purposeful signs, symbols, and messages (see Figure 11.8).

Philosophy and communication research have contributed to this area of knowledge by developing a theoretical structure that formally discusses language structure and meaning. Philosopher Charles W. Morris, in

Types of Graphic Signs & Symbols

| Phonograms & Alphabet Codes | Phonetic (Speech) & Typographic Codes | Word Codes | Letter Codes |
|---|---|---|---|
| | a b c d e f g h | Exxon | **RCA** |
| | å ç ´ f © | International Business Machine | **IBM** |
| | *a b c d e f g h* | | |

| Nonphonetic Alphabets & Codes | Morse Code | Semaphore | International Flag Code |
|---|---|---|---|
| | ● ● ● ▬ | | |

| Nonphonetic Graphic Codes & Symbols | The graphic code for artists, architects, & designers consists of the form generating elements: | •••••• Point
—— Line
▨ Plane/Shape
Volume/Form | Types of Pictographs
 |
|---|---|---|---|

| Diagrams are coded signs or types of models that use combinations of signs, symbols, & verbal information to communicate or explain | Coded Signs
& $?
+ = % | Types of Diagram Codes
 | Statistical Diagram
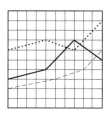 |
|---|---|---|---|

Foundations of the Theory of Signs, Volume 1, has attempted to unify a language of science. He points out the significance of semiotics as a science and creates the foundation for a special science of signs. He defines semiotics as "a science coordinate with other sciences, studying things or properties of things in their function of serving as signs" [Charles Morris, *Foundations of the Theory of Signs, Volume 1* (Chicago: University of Chicago Press, 1938) p. 2].

Typographic Symbols

Sign Language

Braille

Musical Codes

Movement & Dance

High Middle Low

Logomarks used as corporate identities range from representational to abstract representational to abstract nonrepresentational. Abstract symbols often require verbal explanation.

Goodwill Industries

American Telephone Company

Atlantic Richfield Company

Bar Diagram Pictorial Diagram

Figure 11.9 Charles Morris's model of the theoretical structure of signs and their significance [adapted from Foundations of the Theory of Signs Volume 1 (Chicago: University of Chicago Press, 1938)].

Figure 11.10 The relationship between semantics, syntactics, and pragmatics (by John Reinfrank, Assistant Professor, The Ohio State University Department of Industrial Design).

The visual arts and various areas of design have a **visual syntax** and language that are used to designate "things" and their abstractions. The incorporation of semiotic studies provides a basis for understanding the forms of human communication and their interrelationships reflected in the signs used to communicate. According to Morris, semiotic theory is not concerned with the study of a particular kind of object, but with ordinary objects insofar as they participate in semiosis—that is, the process in which something functions as a sign. There are three areas: sign vehicle, that which acts as a sign; designatum, that which a sign refers to; and interpretant, the effect on an interpreter.

Charles Morris's contribution to a theoretical structure of descriptive signs and the defining of a vocabulary can assist in the study and analysis of the nature of signs and their significance. Morris's triadic model (see Figure 11.9) can be utilized to break down the sign process into three basic categories: **syntactic**—signs and their formal relations to other signs; **semantic**—signs and their relations to the objects they represent; and **pragmatic**—signs and their relations to the interpretant.

An understanding of communication processes, codes, and semiotics, and of form perception and visual organizational principles allows for greater command over the visual language. In time, more legible, purposeful visual communications by artists, architects, and designers can result from the processes and theories (see Figure 11.10).

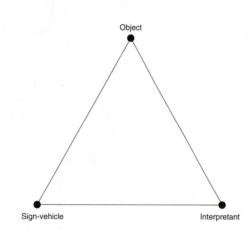

11.9

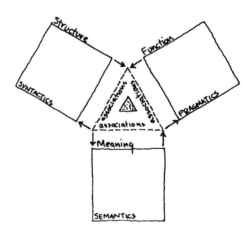

11.10

Developing Signs and Symbols

Visual signs are formed from points, lines, or planes, or combinations of these elements. The basic units of point, line, and plane become structural elements used to form the shape of a sign or symbol. These shapes can then be combined to create visual mes-sage statements and mean-ings.

A basis for structuring signs and symbols depends on the following factors:

- The selected visual elements such as points, lines, planes, and shapes, and the visual treatment of their physical and visual attributes such as color, value, texture, and pattern.

- The way that the visual elements and their attributes are combined to create shapes.

- The way that the signs and symbols are organized within the visual field or format, and the resulting figure/ground relationships that are created by the visual organization (see Figures 11.11–11.15).

Figure 11.11 Abstract symbol configurations created using points: repeated to form a line; repeated to form a plane; and repeated to create abstract shape/symbol configurations.

Figure 11.12 Abstract symbol configurations created using line: singularly; repeated to form a plane; grouped to create abstract shape/symbol configurations.

11.11

11.12

Figure 11.13 Basic compositional elements combined to form a square shape or plane.

Figure 11.14 Series of patterns and textures define and distinguish one plane from another.

11.13

Figure 11.15 Regular and irregular shapes may be used or interpreted as a sign or symbol within a context.

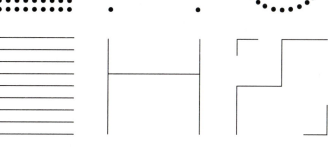

11.14

11.15

Figure 11.16 (a-c) Silhouettes of representational shapes.

Representational figures in silhouette or contour drawings can be used as symbols or signs in visual message making (see Figure 11.16). Visual signs and symbols are also often designed as abstract representations of figures and objects using points, lines, and planes in combination (see Figure 11.17). Henry Dreyfuss in his *Symbol Sourcebook* points out that symbols can be combined to make up new symbols, which is described as a "grammar of semiotics."

Symbols facilitate human communication beyond the limitations of words. Artists, architects, and designers develop symbols as a type of visual shorthand to communicate ideas.

11.16a

11.16b

11.16c

Figure 11.17 Symbols of the human hand developed using (a) point, representing Federation of Enterprises (by Anton Stankowsky, Germany); (b) line, representing Computer Consultants (by Robert Overby, USA); and (c) plane, representing Der Spiegel (a publication, designer unknown, Germany).

11.17a

11.17b

11.17c

As discussed previously, symbols can be representational, abstract representational, or abstract nonrepresentational. The graphic technique used to produce a symbol influences the message being communicated. A symbol can be geometric, illustrative, photographic, or typographic. A nonrepresentational or abstract represen-tational symbol can relay a visual impression of a person, place, or object (see Figure 11.18).

11.18a

11.18b

11.18c

11.18d

Pictographs

Pictographs are simple pictures that represent an idea. They can act as a symbolic representation of an object, person, animal, building, and so on (see Figures 11.19 and 11.20).

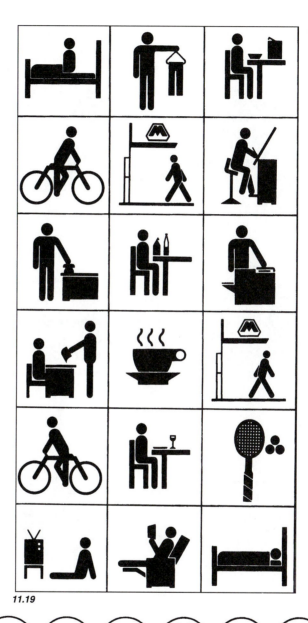

11.19

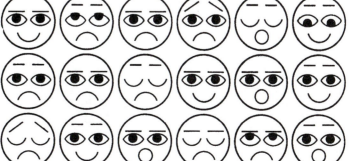

11.20

Figure 11.18 (a-d) Symbols developed to represent the Institute of Polar Studies at the Ohio State University Department of Industrial Design. Exercise by Professors Fred Zimmer and Peter Megert (designed by: a, Jodi Faler; b, Debbie Harris; c, Carlos Rojas; and d, Jim Lustek).

Figure 11.19 Set of pictographs designed and developed to represent the theme "My Vacation" (exercise by Professor Peter Megert, The Ohio State University Department of Industrial Design; designed by Drew Cronewett).

Figure 11.20 The cover of Contemporary Problems in Perception uses pictographs of human facial expressions (designed by Gill Scott).

Symbol: A mark representing a concept used to identify institutions, corporations, etc.

11.21a

11.21b

Pictographs: Symbols which refer to an object, an action, a process, or a concept.

11.22a

11.22b

Combination mark: A symbol and logo used together. Also called a signature.

11.23a

11.23b

The trend in corporate identification has been toward more simplified, abstracted figures and symbols (see Figures 11.21–11.25).

11.24a

11.25a

11.24b

11.25b

An example of a more involved nonverbal message is depicted in Figure 11.26.

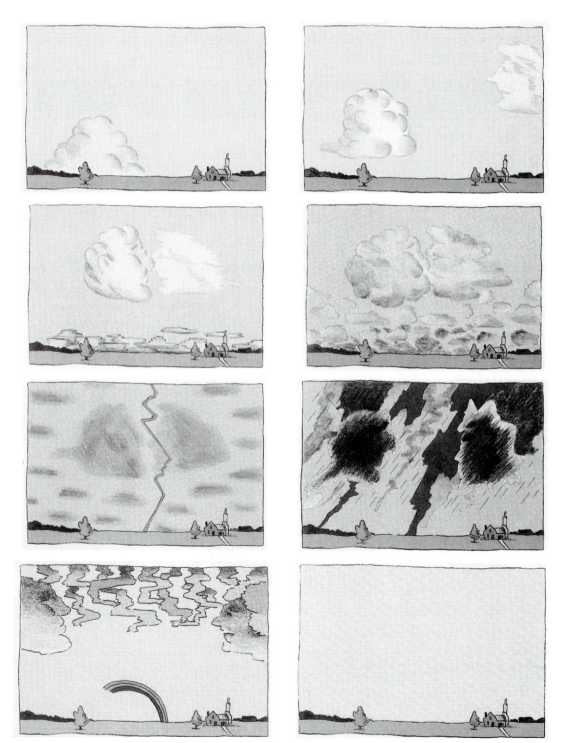

Figure 11.26 Out of the Blue, A Cloudy Romance (a nonverbal message by Seymour Chwast, Push Pin Studios).

11.26

PLANNING, ANALYZING, AND ORGANIZING
A MESSAGE WITHIN A VISUAL FIELD

The next part of this chapter discusses how to plan, analyze, and organize a message within a visual field. Table 11.1 consolidates information on the areas that must be considered in the message-making process.

| Table 11.1 Planning, Analyzing, and Organizing a Message Within the Visual Field | | | |
|---|---|---|---|
| Refer to the models of communication. Review the intent of the message and the characteristics of the intended viewing audience. | Establish a format for the communication that adheres to the constraints of the situation. | Select and design appropriate compositional elements (visual code) and techniques. | Use concepts and principles of visual organization to structure the visual message within the format. |
| **Structuring the Visual Field** | Determine format specifications:

Two-dimensional picture plane | Three-dimensional area or space | Properties of compositional figures and forms

Two-dimensional planes have shape.
Volumes have form.
Form is illusory in two-dimensional space. |
| **Characteristics and Specifications** | Two-dimensional space has length and width and is defined by edges or lines. | Three-dimensional space has length, width, and depth and is defined by surfaces or planes. Forms have size, shape, primary axes, position, and orientation. | Figures and forms have visual and structural attributes such as color, value, direction, texture, and visual weight or mass. |
| **Visual Structure, Function, and Meaning** | The two- or three-dimensional format becomes meaningful to viewers relative to the structure of the subject matter placed within its boundary. | | Function and meaning of each compositional element is gained through the viewer's association or familiarity with known and identifiable referents. |

PLANNING, ANALYZING, AND ORGANIZING A MESSAGE WITHIN A VISUAL FIELD

| Table 11.1 Continued | | | |
|---|---|---|---|
| Explore, test, and analyze different compositional organizations within one or more selected formats. | Produce final artwork, production drawings, or models for the selected communication, product, building, or environment. | Produce and distribute to the intended person or group of people. | Analyze the viewer response and communication effectiveness according to the original constraints of the situation. |

Placement of one or more compositional elements within the visual field:

| Harmony/Repetition | Contrast/Variety | Compositional balance and structural groupings |
|---|---|---|
| Types of stable relationships:

Static, calm, rhythmic, equilibrium, similar, continuous, closure, pattern, repetition, symmetry | Types of active relationships:

Dominance, emphasis, contrast, stress, asymmetry, tension, movement, ambiguous, random, dynamic, gravitational | Types of balance:

Horizontal, vertical, radial, bilateral, symmetrical, asymmetrical, or ambiguous |

| Visual structure, function, and meaning is achieved through a logical and orderly visual organization according to hierarchies of information: | Chronological order
General to specific
Specific to general | Organizational Principles:

Perceptual principles of organization
Prescriptive principles of organization |
|---|---|---|

Figure 11.27 (a-c) A square consists of four sides of equal length and four equal angles and can have a horizontal, vertical, or diagonal axis.

Types of Two-Dimensional Formats

Two- and three-dimensional formats can be any size, shape, or orientation. Each format has a different visual **axis**, stability, and directionality depending on its shape and orientation to the viewer. The most commonly used two-dimensional formats are square and rectangular (see Figures 11.27 and 11.28).

11.27a

11.27b

11.27c

11.28a

Figure 11.28 (a-b) A rectangle consists of four sides and commonly has a horizontal or vertical axis.

The primary axis of each format can be altered by the placement of the compositional elements. The relationship between the compositional elements and the format, as well as the relationship between the compositional elements themselves affects the overall balance, stability, symmetry, meaning, and unity of the design or work of art.

Square formats can easily accommodate a variety of shapes, sizes, and **directions** of visual elements. Figure 11.29 shows the placement of a combination of square elements within a square format, and Figure 11.30 shows vertical elements (matches) within a square format.

11.28b

The most stable position for a compositional element is in the center of the format. If a relatively large, round compositional element is placed within the center of the format it appears to expand within the area, creating tension between the boundary of the internal shape and the boundary of the format (see Figure 11.31).

11.29

11.30

11.31

Figure 11.29
The arrangement and changing value of each of the square elements form a square diamond shape within the format. The horizontal and vertical axes are emphasized.

Figure 11.30
Parallel vertical elements (matches) illustrate how position and orientation can emphasize one direction or axis more than another. Record cover: Bob James and Earl Klugh, One on One. (Columbia Records © 1979 CBS Inc./℗ 1979 Tappanzee Records, Inc.)

Figure 11.31
A large compositional figure (Indian head nickel) within a square format creating dominance. Record cover: Bob James, Heads. (Columbia Records © 1977 CBS Inc./℗ 1977 Tappanzee Records, Inc.)

............................

Figure 11.32 (a-b)
The placement of
the black square in
the middle of the
rectangular format
draws the viewer's
eye to the center,
acting as a sec-
ondary format
where the important
information is locat-
ed (part b designed
by David Collie).

Repetition of the diagonal lines emphasizes the vertical axis in Figure 11.32. The visual weight of the black square in the composition draws the viewer's eye to the center of the format, adding emphasis to the graphic design.

Different formats take on different axis emphases depending on their orientation (horizontal, vertical). Compositional techniques can emphasize or draw attention toward the inherent visual axis of the format (see Figures 11.33–11.36).

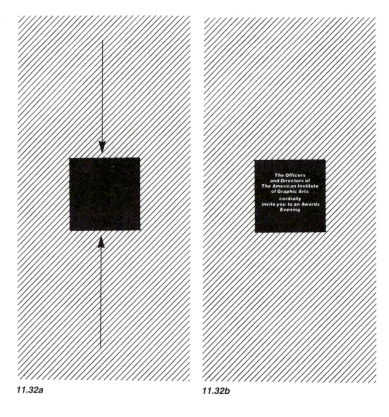

11.32a

11.32b

Figure 11.33 (a-c)
Horizontal format
accentuating the
associative shape
of a stereo system.
Brochure for Braun
Hi-Fi stereo 520
(Germany).

11.33a

11.33b

11.33c

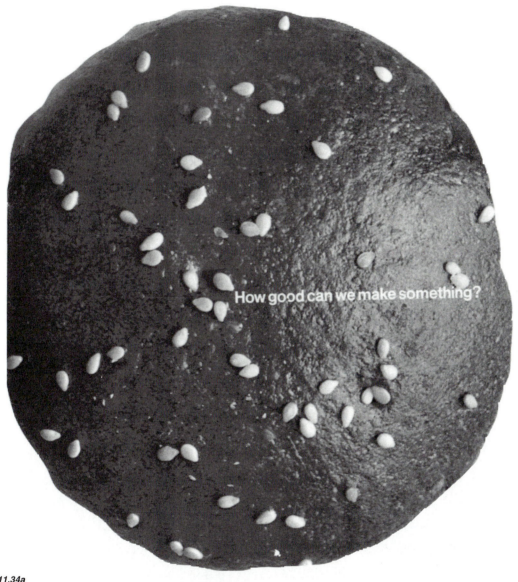

Figure 11.34 (a-b) A circular format accentuating the associative shape of a hamburger bun. Brochure for Champion Papers (Champion Javelin Coated Offset 18016; designed by Miho).

How good can we make something?

11.34a

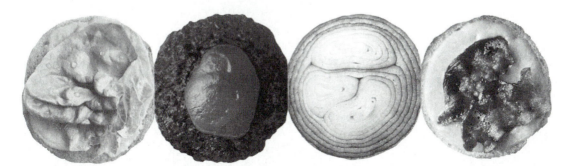

11.34b

*Figure 11.35
Brochure for an art
exhibition entitled
"Calm, Cool, Col-
lected: Selected
Works from the Art
of the Seventies
Collection," The
Ohio State Universi-
ty, College of the
Arts. The irregular
format creates the
illusion of a three-
dimensional cube.*

11.35

*Figure 11.36 (a-c)
Record cover:
Raspberries, Side
Three, produced by
Jimmy Ienner for
Capitol Records,
Inc. The format
takes on the actual
shape of the photo
illustration (design
by Rod Dyer; pho-
tography by Bob
Gruen and Leandro
Correa; art direction
by John Hoemle;
©1973, Capitol
Records, Inc.).*

11.36a

11.36b

11.36c

Creating a Visual Message Within a Format

There are several decisions to be made in the visual message-making process. The first consideration is the shape, size, and orientation of the format or picture plane, which can complement the elements, structure, and placement of the message.

Organizing the Two-Dimensional Format

The format or picture plane can be subdivided into smaller areas; this can influence the message structure and its interpretation. Factors that influence the design of the visual message on a format include the intended reading order or hierarchy, and the compositional structure (see Figure 11.37).

Grids

The grid is a measuring guide used to help ensure consistency in planning a visual message. A grid shows the type and image area di-

mensions, trim, and margins, and is used to define constant dimensions of space. By arranging the compositional elements (images and type) within a grid, the visual message can be presented in a logical manner. Many artists, architects, and designers may not use a grid

because they rely on other organizational tools and an intuitive sense of visual order, scale, and proportion (see Figure 11.38). However, an understanding of grids and proportion can be helpful in dividing space and organizing visual elements within a format.

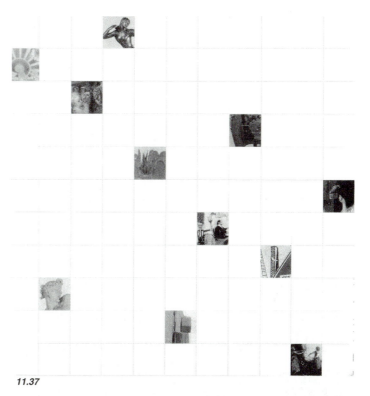

11.37

Figure 11.37 The use of a grid to organize a format area creating a logical and orderly composition (Columbus Museum of Art announcement).

Figure 11.38 Visual organization is achieved by arranging the compositional figures according to their size, shape, and physical attributes (designed by Vance Jonson).

11.38

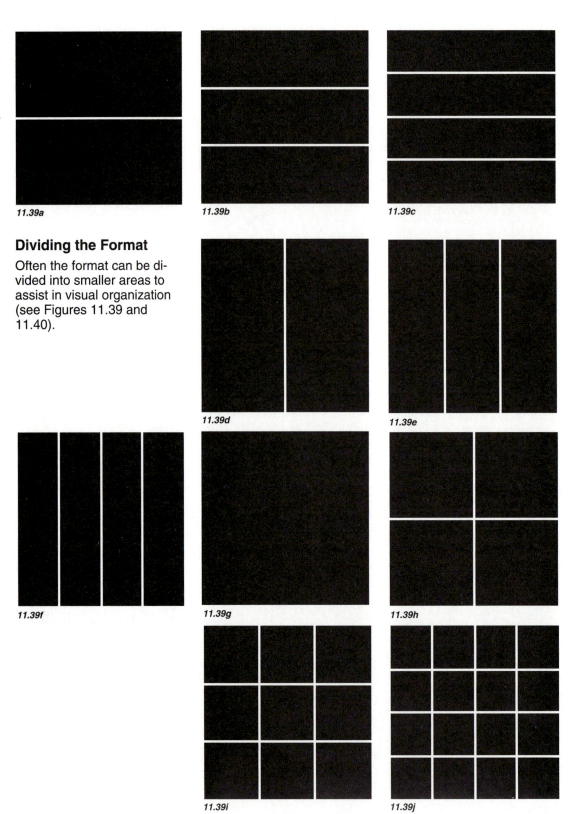

Figure 11.39 (a-j) A square format can be divided vertically, horizontally, or into smaller, equal areas. Each subdivision allows for the placement of information or compositional figures within the format.

Figure 11.39 (a-j) A square format can be divided vertically, horizontally, or into smaller, equal areas. Each subdivision allows for the placement of information or compositional figures within the format.

Dividing the Format

Often the format can be divided into smaller areas to assist in visual organization (see Figures 11.39 and 11.40).

11.39a

11.39b

11.39c

11.39d

11.39e

11.39f

11.39g

11.39h

11.39i

11.39j

First, read this newspaper. Then give it to your dog.

The purpose of this newspaper is to help you train your dog to go to the bathroom indoors, on newspaper, all the time.

The text that follows is excerpted and adapted from

"GOOD DOG, BAD DOG"

This is the center spread. Take three or four sheets of paper right from here and start training your dog today!

How to Paper- Train Your Dog

Don't just read this paper and throw it out. Read it— then give it to your dog. So

it can start training, right away, to "go" on newspaper indoors. Use all the paper.

Figure 11.40 Sixteen-page newsprint brochure for the New York City Environmental Protection Administration. The page format uses a grid to indicate columns and consistent margins (designed by Vance Jonson in collaboration with Lawrence Miller).

11.40

Figure 11.41 (a-c) Sketches of advertising concepts for the holiday season (student work).

✍Practice Exercise 11.1: Grids Used in Visual Organization

Collect samples of various newspaper page layouts and analyze the grid system used to organize the printed information and images.
Determine the standard column width and height units.

Design a holiday advertisement that denotes symbolically the selected holiday, and incorporate it within the newspaper grid. Choose a name of a department store and illustrate it, using a logotype or logomark within the advertisement. Considerations in the exercise should include creativity, drawing techniques, symbol development, figure/ground relationships, and the visual organization of the composition. See Figures 11.41–11.43 for examples of this exercise. Complete the exercise using pen, ink, or mixed media on a good bond paper or Bristol or illustration board.

11.41a

11.41b

11.41c

*Figure 11.42 (a-c)
Sketches of sym-
bols for a holiday
advertisement (stu-
dent work).*

11.42c

11.42a

*Figure 11.43 (a-b)
Concept sketches
for a holiday adver-
tisement using geo-
metric elements
(student work).*

11.42b

11.43a

11.43b

Positioning Compositional Elements Within the Two-Dimensional Format

Compositional stability and instability are affected by the size, position, and orientation of the figure within the format. As previously discussed, each particular shape has its own inherent directionality and stability.

The way that the shape is positioned within the different formats affects the resulting composition (see Figures 11.44–11.46).

Figure 11.44 (a-d) An equilateral triangle placed within a square and square diamond format illustrates stability and instability.

Figure 11.45 (a-d) A square plane placed within a square and square diamond format illustrates variations of stability.

Figure 11.46 (a-d) A pentagon placed within a square and square diamond format illustrates stability and insta-

11.44a

11.45a

11.46a

11.44b

11.45b

11.46b

11.44c

11.45c

11.46c

11.44d

11.45d

11.46d

✍Practice Exercise 11.2: Exploring Format and Compositional Elements in Two Dimensions

Visual **unity** in a composition results not only from the selection and arrangement of visual information, but also from its emphasis within the format. The size and shape of the format relative to the size and shape of the element or elements affect the compositional unity.

11.47a

11.47b

11.47c

11.47d

Figure 11.47 (a-d) Examples of a consistent format sequence, in which the number 3 changes size.

.....................................

Figure 11.48 (a-m) Examples of a constant size number 3, in which the format size changes.

The objective of this exercise is to identify and describe the visual characteristics of a compositional element, in this case, the number 3. The numeral has a vertical shape and orientation, which affects its placement within the format and how it is perceived. Altering the size and placement affects the viewer's perception of the figure.

11.48a

11.48b

11.48c

11.48d

Select a numeral or letter and, through sketching, explore and compare possible visual solutions. First develop a study in which the format remains the same as the numeral or letter changes size. Then produce a visual study exploring compositions in which the size of the typographic element remains the same, but the format changes size. Complete the exercise by using dry transfer letters or numbers on Bristol board (see Figures 11.47 and 11.48).

11.48e

11.48f

11.48g

11.48h

11.48i

11.48j

11.48k

11.48l

11.48m

Compositional Study Relating an Object to Various Formats

The study in Figures 11.49–11.54 illustrates the analysis of an object (in this case, scissors)—its physical characteristics, shapes, and inherent directionality—and relates it to various formats. Other considerations illustrated are how the position, orientation, and size affect the compositional relationship.

The visual problem-solving process in the study began with quick sketches to illustrate different visual options, utilizing positive/negative contrast, figure/ground relationships, and combinations of more than one compositional figure.

Figure 11.49 Comparative studies describing the characteristics of an object (scissors) (illustrated by David Roadcup).

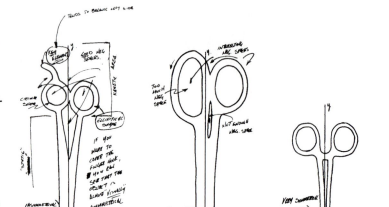

11.49

Figure 11.50 Sketches illustrating the visual thinking process considering the layout of the object in a format relative to size, position, and orientation (illustrated by David Roadcup).

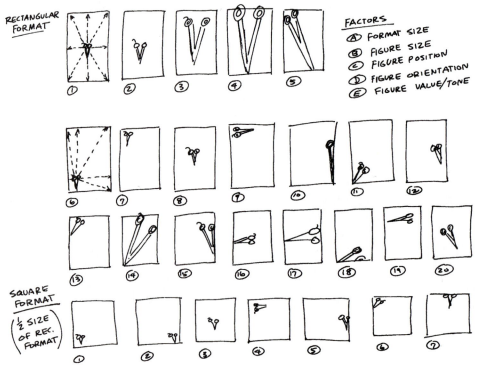

11.50

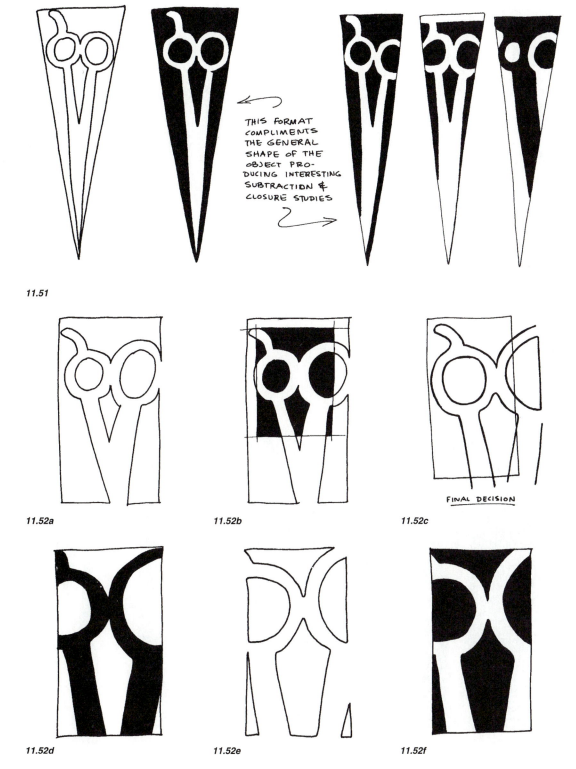

11.51

THIS FORMAT
COMPLIMENTS
THE GENERAL
SHAPE OF THE
OBJECT PRO-
DUCING INTERESTING
SUBTRACTION &
CLOSURE STUDIES

11.52a

11.52b

11.52c

FINAL DECISION

11.52d

11.52e

11.52f

*Figure 11.51
Sketches illustrat-
ing the different fig-
ure/ground relation-
ships when the
compositional ele-
ment is cropped.
The scissors be-
come difficult to
identify because of
the figure/ground
relationship (illus-
trated by David
Roadcup).*

*Figure 11.52 (a-f)
Studies of figure/
ground relation-
ships within differ-
ent types of rectan-
gular formats, relat-
ing to figure recog-
nition (illustrated by
David Roadcup).*

Figure 11.53 (a-h) The format remains constant while the positions and orientations of the object are studied, with consideration to balance and equilibrium (illustrated by David Roadcup).

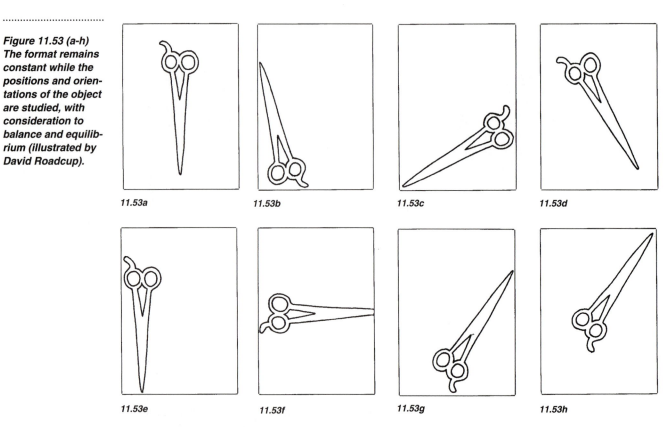

11.53a 11.53b 11.53c 11.53d

11.53e 11.53f 11.53g 11.53h

Figure 11.54 (a-d) The figure remains constant while the size of the format and the figure/ground relationship are altered (illustrated by David Roadcup).

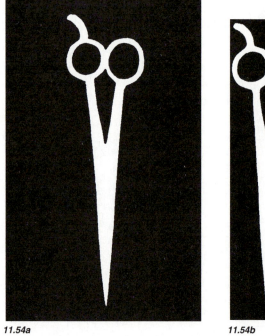

11.54a 11.54b 11.54c 11.54d

INTRODUCTION TO AESTHETIC PRINCIPLES IN VISUAL ORGANIZATION

So far, this chapter has emphasized the various visual communication and perception theories that deal with the process and components of visually communicating messages. Another aspect of creating visual messages is the aesthetic or visual qualities of figures and forms, and their arrangements.

The interpretation of aesthetic qualities relative to compositions may vary according to the background and preferences of the artist, architect, or designer as well as the background and preferences of the viewer. However, aesthetic qualities have been defined as a harmonious whole, or a feeling of completeness, that is referred to as "unity." Unity can be characterized by the following terms: equilibrium/balance, contrast, harmony, emphasis, proportion, simplicity, repetition, dominance, symmetry, scale, rhythm, and variation. Since many of the aesthetic principles and terms are discussed in depth in other references, only a select few are presented here.

The following list includes visual attributes that contribute to shape or form qualities, their organization, and resulting unity.

Properties of Good Figures/Forms

- simplicity
- easy recognition
- easy to remember
- regularity
- familiarity
- symmetry
- balance
- proportion

Refer to Chapter 10 for more information on good figure characteristics.

Visual Qualities of a Message

Contrast between elements or groups of elements in reference to their arrangement or physical qualities:

- size
- weight
- mass
- quantity
- shape
- simplicity
- regularity
- color
- value/tone
- texture
- direction
- orientation
- continuity or rhythm
- repetition

Dominance and Emphasis

The terms **dominance** and **emphasis** relate to the hierarchy of elements within the compositional structure; primary and secondary compositional elements establish visual importance. The hierarchies of order are:

- chronological
- general to specific
- specific to general
- reading order (based on cultural practices)

Placement of Groups of Compositional Elements Within a Format

This refers to information on perception and Gestalt grouping laws.

- proximity
- similarity
- closure
- common movement
- good continuation
- figure/ground qualities
- repetition
- contrast

Figure 11.55 Visual attributes within a composition that contribute to unity: (a) similarity of shape; (b) similarity of shape and proximity; (c) shape, proximity, and value; (d) shape and good continuation; (e) pattern and repetition; (f) color and shape; (g) space, texture, and value.

Types of Groupings According to Compositional Balance

- symmetrical
- ambiguous
- asymmetrical
- neutral

Visual or compositional **unity** can be achieved in a variety of ways through the use of the elements just listed and through the visual treatment and arrangement of these elements within the format (see Figure 11.55).

Unity is the wholeness or completion of the composition or visual statement in harmony with the elements used.

Harmony usually refers to a pleasing consistency among the different parts of a composition that brings visual order to sets of similar or unrelated elements.

Repetition is the use of the same compositional figure or form more than once in the same format (see Figure 11.56).

Rhythm is related to accent and movement and is created by repeating similar compositional elements (see Figure 11.57).

Figure 11.56 (a-b) Repetition established by lines or groups of lines.

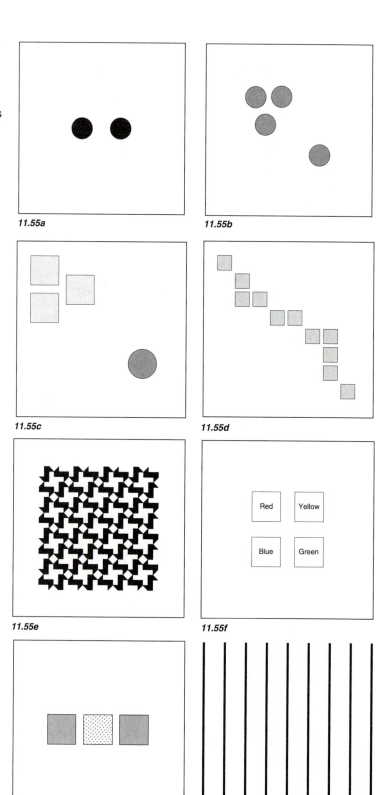

11.55a

11.55b

11.55c

11.55d

11.55e

11.55f

11.55g

11.56a

11.56b

11.57

Figure 11.57 Repetition and varying the alignment and line weight creates a feeling of movement and rhythm.

Pattern refers to the repetition of a figure or the combination of figures and forms that appear more than once in the composition (see Figure 11.58).

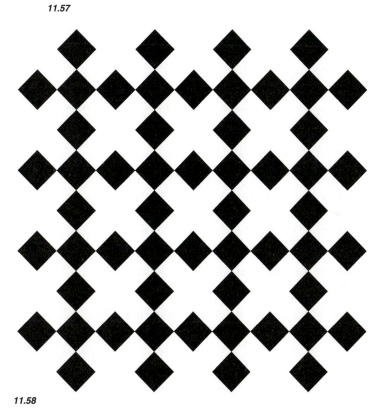

11.58

Figure 11.58 Pattern is the repetition of shape or combinations of shapes.

According to perception theory, **unfamiliar figures** or forms arranged in a random way have little or no recognition factor (see Figure 11.59).

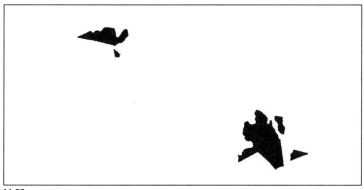

11.59

Figure 11.59 Compositions consisting of unfamiliar figures and forms arranged in a disorderly or random way that have no meaning for and are not recognized by the viewer.

*Figure 11.60 (a)
Symmetrical bal-
ance; (b) asymmet-
rical balance; (c)
ambiguous bal-
ance; (d) neutral
balance.*

Compositional Balance

Equilibrium or **balance** refers to the distribu-
tion of elements within the format. Included in
aesthetics is the need to perceive balance or
equilibrium between figures and forms.
Studies by psychologists indicate that this ap-
peal for balance is related to the sense of
equilibrium within the human body.

The arrangement of the compositional el-
ements can result in visual stability that is ei-
ther static or active. Compositional balance
can be achieved by either symmetrical or
asymmetrical configurations. Balance can be
achieved through the visual treatment of the
compositional figures or forms by varying
their physical attributes such as shape, tex-
ture, color, value, and pattern.

Types of Balance

Symmetrical balance is characterized by a
central axis; the arrangement of a group of
compositional figures and forms may be sym-
metrical relative to their position within a for-
mat (see Figure 11.60a). Symmetrically bal-
anced compositions are characterized by reg-
ularity, congruency, proportion, passivity,
restfulness, static, inactivity, and stability.

Asymmetrical balance is characterized
by irregular or unequal arrangements be-
tween compositional elements relative to a
central axis; it is often referred to as dynamic,
active, stressful, tense, or diverse (see Figure
11.60b).

Ambiguous balance is characterized by a
lack of, or unclear, relationships between
compositional elements; it is referred to as
vague, indefinite (see Figure 11.60c).

Neutral balance is characterized by ran-
domness and ambiguous equilibrium; it is re-
ferred to as nonactive, lacking emphasis or
contrast (see Figure 11.60d).

11.60a

11.60b

11.60c

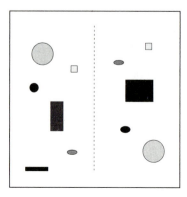

11.60d

Figure 11.60 (a) Symmetrical balance; (b) asymmetrical balance; (c) ambiguous balance; (d) neutral balance.

✍️Practice Exercise 11.3: Exploring Balance Using One Compositional Element

The objective of this study is to present the concept of balance through experimenting with one compositional element before approaching more complex compositions. Emphasis is placed on analyzing the element's position and orientation within the format area.

Begin by selecting a simple geometric shape. Cut it out of paper or film. Compose at least nine different compositions on Bristol board, and label each according to the type of balance created. Note the preferred solutions relative to the type of balance represented in each example (see Figure 11.61).

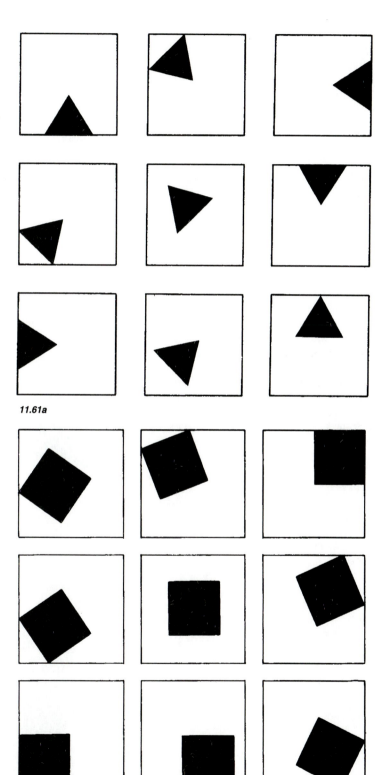

11.61a

11.61b

Figure 11.61 (a-b) Compositional studies exploring differences in visual balance within a square format.

Figure 11.62 Figure groupings illustrating stability and instability (student work).

✍ Practice Exercise 11.4: Understanding Balance Through Grouping and Contrasting Stable and Unstable Figures

This exercise is structured to help in the understanding of stability and instability by utilizing one or more geometric elements in a composition.

Select two or more geometric, compositional elements and cut them out of colored paper or film. Experiment with the arrangement of the elements, creating stable and unstable compositions. Record different compositional arrangements on tracing paper. Select the most interesting idea from each category (stable and unstable). Experiment to see how the visual emphasis changes when color is applied. Place the final composition on hot press illustration board, using colored paper or film (see Figures 11.62–11.64).

Figure 11.63 Figure groupings illustrating stability and instability (student work).

Figure 11.64 Figure groupings illustrating stability and instability (student work).

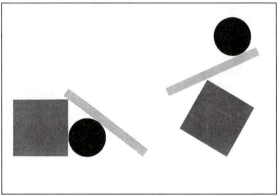

11.62

11.63

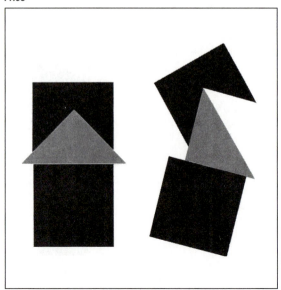

11.64

Visual Contrast

Visual **contrast** can be used to create emphasis and interest through the use of opposing qualities among figures and forms.

✍Practice Exercise 11.5: Using Contrast in Creating a Visual Message

This exercise assists in the understanding of techniques and compositional arrangements used to create contrast between figures and forms in a composition.

Select a numeral, letterform, or figure. Next, select a pair of antonyms from the list below. Develop a visual contrast message with the selected compositional figure, using the antonyms. Through sketching, show two views of the numeral, letterform, or figure, each representing one of the antonyms. Visually record as many examples of contrast as possible, based on the understanding of the words. Select the best compositional illustrations for final artwork. Draw the compositions in ink, or use film on Bristol board. Annotate each illustration (see Figures 11.65–11.67).

11.65a **Large/Small**

11.65b **Smooth/Rough**

11.65c **Transparent/Opaque**

11.65d **Coming/Going**

11.65e **Heaven/Hell**

Figure 11.65 (a-e) Visual contrasts using the letter "h" (illustrated by Mary Jo Sindelar).

Figure 11.66 (a-e) Visual contrasts using a pencil illustration (illustrated by Anne Baker).

Examples of contrasting ideas:

- vertical horizontal
- front back
- left right
- straight curved
- concave convex
- dark light
- heaven hell
- dry wet
- one many
- expanding contracting
- falling rising
- assembled dispersed
- transparent opaque
- little big
- few many
- strong weak
- smooth rough
- stable unstable
- simple complex
- increasing decreasing
- superior inferior
- large small
- hard soft

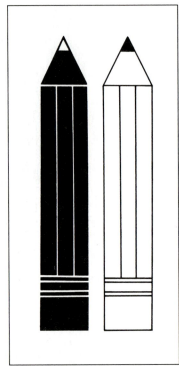

11.66a **Negative/Positive**

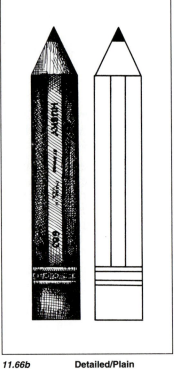

11.66b **Detailed/Plain**

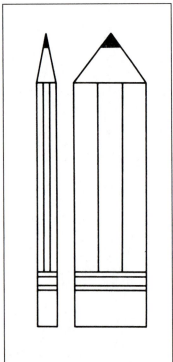

11.66c **Skinny/Fat**

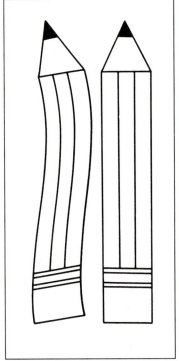

11.66d **Curved/Straight**

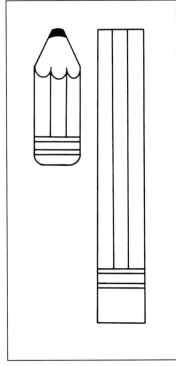

11.66e **Used/Unused**

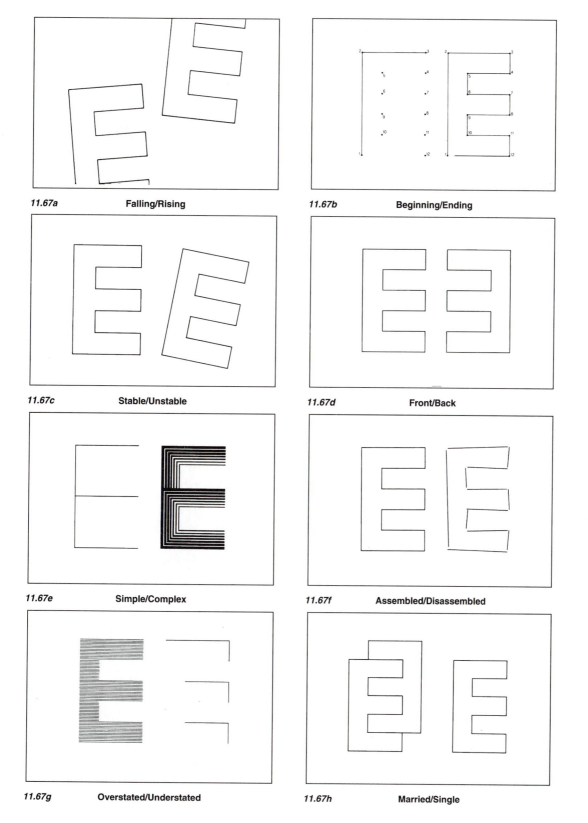

Figure 11.67 (a-h)
Visual contrasts
using the letter "e"
(illustrated by Bret
Kline).

11.67a **Falling/Rising**

11.67b **Beginning/Ending**

11.67c **Stable/Unstable**

11.67d **Front/Back**

11.67e **Simple/Complex**

11.67f **Assembled/Disassembled**

11.67g **Overstated/Understated**

11.67h **Married/Single**

............................

GROUPING ELEMENTS WITHIN A FORMAT

The way elements are grouped within a format affects the way a composition is interpreted. Compositions that are organized in a linear, horizontal, vertical, or diagonal grouping will be perceived as having directionality. Other types of groupings can communicate randomness, isolation, or static balance (see Figure 11.68).

The figure and ground relationship also will affect the composition. Groupings may create new ground relationships. White figures on a black ground appear smaller than black figures on a white ground for example (see Figures 11.69 and 11.70).

Figure 11.68 Grouping organization of elements: (a) random; (b) static; (c) asymmetrical; (d) linear; (e) staggered; (f) grouped and isolated; (g) diagonal; (h) vertical; and (i) staggered.

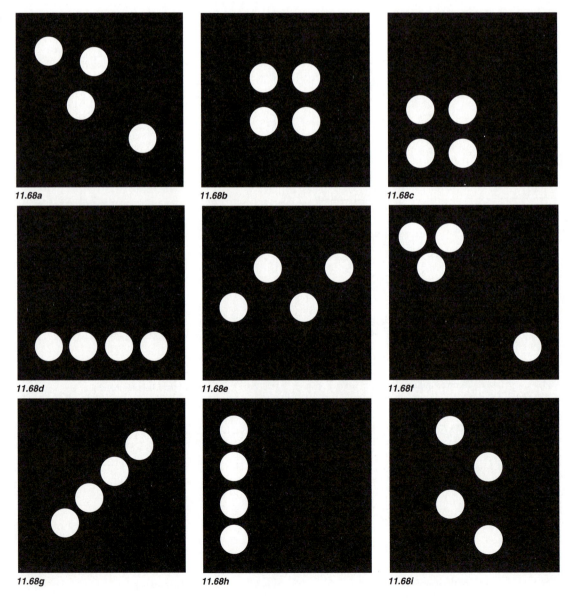

11.68a

11.68b

11.68c

11.68d

11.68e

11.68f

11.68g

11.68h

11.68i

11.69a

11.69b

11.69c

11.69d

11.69e

11.69f

Figure 11.69 (a-f) Study sketches of figure/ground relationships between compositional elements and the format area in positive and negative (illustrated by Alan Jazak).

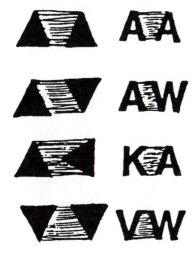

Figure 11.70 Study sketches analyzing the figure/ground relationship between letterforms by comparing their basic contour shapes (illustrated by Alan Jazak).

11.70

INTRODUCTION TO GESTALT GROUPING LAWS

Gestalt psychologists have set forth a number of visual grouping laws that describe visual perception of groups of figures. By understanding the way people see and interpret visual information, artists, architects, and designers can be more successful in bringing meaning to compositions and forms.

Research studies on the perceptual principles, which have been established through viewer response testing, report that the human tendency is to see and remember visual stimuli in the simplest form. As the eye and brain experience an object or environment, they remember the image by grouping visual information.

Mentally grouping visual information according to certain characteristics is known as the Gestalt grouping laws. The most common of these grouping laws are similarity, proximity, closure, and good continuation.

Similarity

According to the law of **similarity**, viewers tend to see

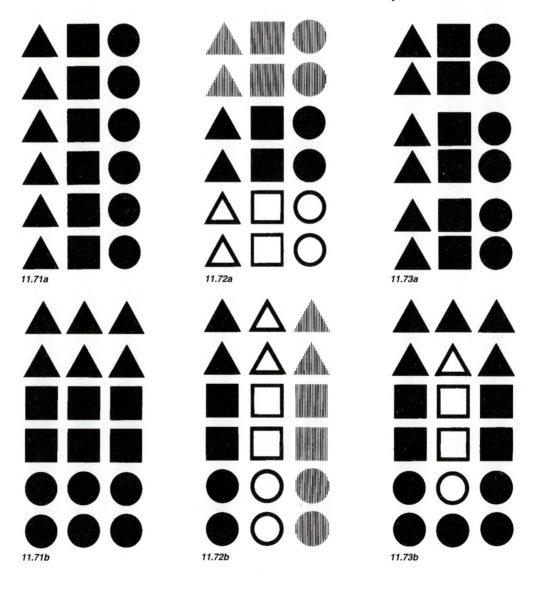

11.71a 11.72a 11.73a

11.71b 11.72b 11.73b

similar shapes as belonging together and similar figures as a group (see Figure 11.71).

When surface variations are added to compositions, figures with color, texture, value, and pattern are more dominant and are perceived as a group (see Figures 11.72 and 11.73).

Proximity

The grouping law of **proximity** states that when similar figures are located in close proximity to each other, viewers tend to see them as belonging to the same group of figures. Because of the visual attraction of mass, viewers relate or connect figures that are located closer together than those that are located

farther apart (see Figure 11.74).

When proximity is used in combination with other grouping laws, such as shape similarity, color, value, pattern, or texture, certain visual information can be emphasized within a group of compositional elements (see Figures 11.75 and 11.76).

Figure 11.74 (a) When figures are repeated at equal intervals to create a pattern, they are seen as a coherent group or plane. When figures are deleted, the sets are perceived (b) as columns or (c) as rows because of their relative location to one another.

Figure 11.75 (a) When more than one shape is repeated in an interspersed manner maintaining an equal interval, an alternating pattern results. (b) When the shapes are aligned according to shape similarity, they are perceived as vertical columns. (c) When shapes are located close together deviating from the pattern, they are perceived as an independent group.

Figure 11.76 When surface texture, color, or value are added to a group of figures, creating a visual dominance within a pattern or grouping, they are perceived as: (a) vertical columns or (b) horizontal rows. (c) Selected shape grouping within a larger pattern.

11.74a 11.74b 11.74c

11.75a 11.75b 11.75c

11.76a 11.76b 11.76c

Closure

Closure is a property of both perceived shapes and the proximity of similar shapes. Viewers have a tendency to "close" or complete incomplete figures and grouped configurations.

The perception psychologist J.M. Bobitt flashed illustrations of incomplete figures through an instrument called a tachistoscope. Through this experiment, he found that viewers would perceive the incomplete figure as complete. Bobitt determined that in the perception process, the brain fills in the necessary information, creating closure (see Figure 11.77).

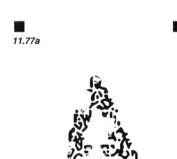

11.77a

11.77b

Good Continuation

In **good continuation**, a figure or group of figures is arranged in such a way as to have direction and seem to continue. This can be a property of figures, or a property of groups of figures (see Figure 11.78).

11.78

Visual Associations

Free association is the learned or acquired ability to assign and change verbal interpretations of a composition by moving from one to many associations.

Familiarity is the ability of a viewer to associate unfamiliar figures with more familiar figures. The most efficient or effective perceptual organization universalizes the familiar (see Figure 11.79).

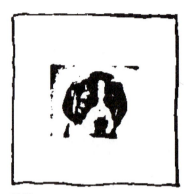

11.79

✎**Practice Exercise 11.6: Using Gestalt Perceptual Organizational Principles in Compositions**

Begin by identifying and collecting a set of shapes, or objects in a related category— for example, shoes, hats, or leaves. After selecting the shapes or objects, draw them in several different positions and orientations.

The compositional arrangements that result in this study should express an understanding of the types of balance, the use of organizational principles, and good figure/ground relationships.

Next, work with the drawings, creating a "family" of compositional shapes. Use eight to ten different shapes or objects. Explore compositional balance, and apply the grouping laws while considering figure/ground relationships. Select the most interesting compositional organization and prepare a final solution using pen, ink, cut paper, or film on hot press illustration board (see Figures 11.80–11.81).

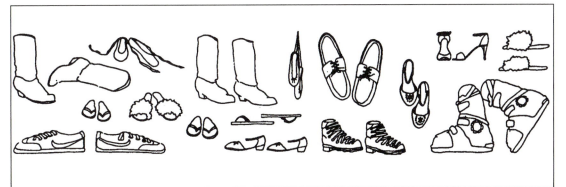

11.80

Figure 11.80 A visual study applying the perceptual principles and laws of visual organization relative to a family of forms (different types of shoes) within a rectangular format.

11.81a

11.81b

Figure 11.81 (a-e) A number of visual studies exploring various compositional considerations—change of figure size, placement within the format, grouping, orientation, and position of pairs of shoes.

11.81c

11.81d

11.81e

✍Practice Exercise 11.7: Package Graphics

This exercise is designed to utilize the grouping laws and figure/ground principles, relating them to a three-dimensional package. Select a product that is packaged in quantity, such as nails. Begin by choosing an existing small cardboard box. Disassemble it and use it as a template for creating a new box.

The production process used for this exercise requires photographic processes using black and white high-contrast photographic paper that is large enough to recreate the box in one piece. The technique used to create the package graphics is called a *photogram*. Photograms are created by laying objects on top of photographic paper and exposing them to light, then removing the objects and developing the paper. Where the objects were positioned, the paper remains white, and the negative areas are black. A test strip of photographic paper that is exposed varying amounts of time will help determine the correct exposure and developing times.

The outline of the original box is transferred onto the photogram by outlining the original package on clear acetate in black or red ink. Use a 00 technical pen. The typography on the package is created by using dry transfer lettering on the acetate sheet. Through sketching and three-dimensional paper models, determine the location of the typography before preparing the acetate overlay.

Place the acetate sheet over the photographic paper, then arrange the objects on top of the acetate sheet. Experiment by manipulating the nails, creating a variety of compositions. Remember that the composition is intended to be viewed as a folded, three-dimensional form, so the composition will be viewed on three adjacent sides at one time.

11.82a

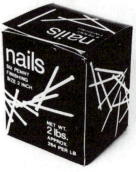

11.82b

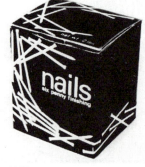

11.82c

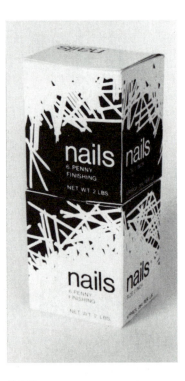

11.82d

Select the most interesting idea and cut it out of the photographic paper according to the guidelines. Using a stylus, score the box along the fold lines on the inside. Assemble the photogram into a three-dimensional box.

Evaluate the results from different viewing points, considering the hierarchical presentation of information, use of the three-dimensional format area, and arrangement of the compositional figures according to the Gestalt grouping laws and figure/ground principles (see Figure 11.82).

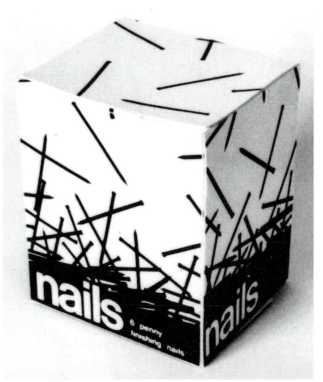

11.82e

Figure 11.82 (a-d) A package design utilizing the grouping laws and figure/ground principles relative to a three-dimensional form. (e-f) Examples of packaging solution alternating the figure and ground from one side of the box to the other (student work).

11.82f

*Figure 11.83 (a-c)
Poster designs il-
lustrating Gestalt
laws, proximity,
similarity, and good
continuation (stu-
dent work).*

✍Practice Exercise 11.8: Design a Poster

The objective of this exercise is to illustrate grouping and figure/ground laws through the use of real objects for a poster. It also introduces the use of photographic equipment and materials (see Figure 11.83).

Select a number of small objects such as nails, pins, paper clips, pushpins, and so on. Experiment with the arrangement of the selected objects to create compositions using the grouping laws. Increasing the size of the object can be achieved by making a film positive (kodalith) photographically, or a high-quality photocopy on acetate, then using the photocopy to produce a photogram. The white area becomes dark and the black area remains white.

The photogram is once again photocopied and enlarged to a poster size. Mount the final design on hot press illustration board.

11.83a

11.83b

11.83c

✍ Practice Exercise 11.9: Visual Organization and Form and Pattern Correlations

This exercise is designed to encourage the discovery of ways in which form and pattern can be integrated to complement each other. There are many objects that have a two-dimensional texture or pattern on the surface, such as a microphone, speaker, or hair dryer.

Begin by selecting three different objects, one with a circular cross-section, the second with a triangular cross section, and the third with a square cross section. Draw the objects with the pattern surfaces so that they constitute a family of forms. The assigned surface patterns should complement the form (see Figure 11.84).

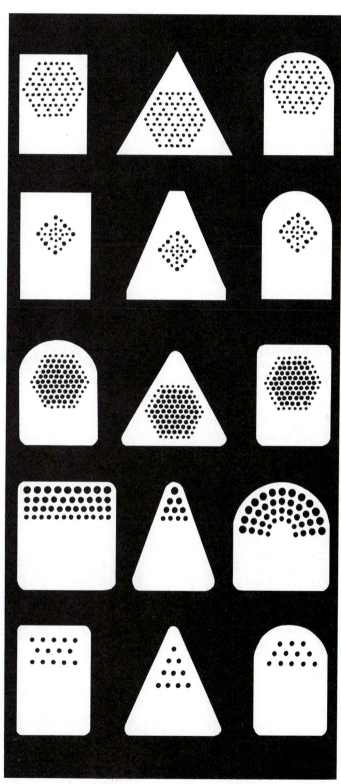

Figure 11.84 Form and pattern correlations related to a family of product surfaces (designs by students at the State Academy of Fine Arts, Stuttgart, Germany; exercise by Professor Klaus Lehmann).

11.84

✍**Practice Exercise 11.10:**
Developing Holiday
Symbols and Posters
Using Simple Geometric
Shapes

This exercise combines and emphasizes a number of principles and concepts learned in this chapter, including the development of symbols and organization of visual information using the figure laws and perceptual principles.

Using the three primary shapes (circle, square, and triangle), create a family of related symbols for Christmas. Select a theme for the holidays, such as food, weather, ornaments, or traditional holiday characters, to develop the symbols (see Figure 11.85). When the set of symbols has been developed and refined, use the visual organizational principles to design a poster.

The poster layout can be organized according to the perceptual organizational principles, and/or through the use of a grid. The final format size and shape should be 18" x 24". The symbols may be drawn, cut from paper, or cut from self-adhesive film and applied to hot press illustration board. They may be annotated using dry transfer lettering (see Figure 11.86).

11.85a

11.85b

11.85c

11.85d

11.85e

11.85f

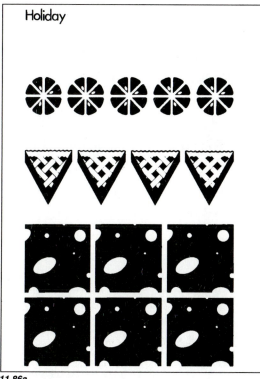

Holiday

11.86a

Joy

11.86b

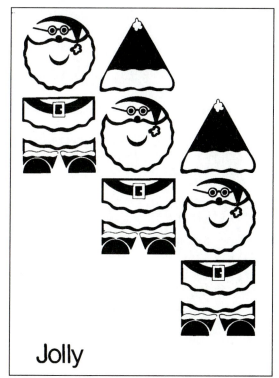

Jolly

11.86c

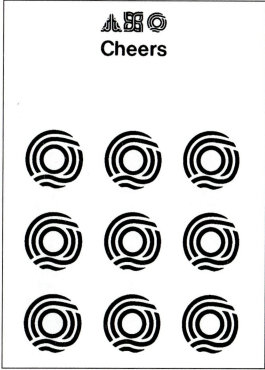

Cheers

11.86d

Figure 11.86 (a-d) Holiday poster designs using different associative symbols based on these geometric shapes (illustrated by a, Paul Henninge; b, Robert Wertz; c, Melissa Rady; and d, Tim Hershner).

Figure 11.87 (a-d) Three-dimensional game designed to emphasize the visual organizational principles (student work).

✍Practice Exercise 11.11: Three-Dimensional Game Using Visual Organization Principles

The purpose of this exercise is to explore the application of visual organization and figure/ground relationships to bring about a greater awareness of multiple pattern combinations. It emphasizes the concepts of basic set theory and good continuation in which interchangeable surface patterns are used along with different figure/ground relationships between cubes. The three-dimensional study uses an interchangeable pattern on each side of a cube (six sides), with sixteen cubes in a set.

Using Bristol board, develop a set of six different square compositions that connect as they meet at the corners and sides of the cube. Through sketching and three-dimensional mock-ups, experiment with different combinations of shapes and lines so that the cubes may be rotated and moved around within the group while maintaining the visual continuity of the whole composition. Silkscreen the solution onto 3-ply Bristol board, score, fold, and assemble each cube (see Figure 11.87).

11.87a

11.87b

11.87c

11.87d

REFERENCES AND RESOURCES

Berlo, David K. *The Process of Communication.* New York: Holt, Rinehart & Winston, 1960.

Bevlin, Marjorie Elliott. *Design Through Discovery: The Elements and Principles.* New York: Holt, Rinehart & Winston, 1985.

Berger, Arthur Asa. *Seeing Is Believing: An Introduction to Visual Communication.* Mountain View, CA: Mayfield Publishing Co., 1989.

Bloomer, Carolyn M. *The Principles of Visual Perception.* New York: Van Nostrand Reinhold, 1976.

Bolian, Polly. *The Language of Communication.* New York: Franklin Watts, Inc., 1975.

Bouleau, Charles. *The Painter's Secret Geometry.* New York: Harcourt, Brace and World, Inc., 1963.

Bowman, William J. *Graphic Communication.* New York: John Wiley & Sons, 1968.

Campbell, James H., and Hal W. Hepler, eds. *Dimensions in Communication.* Belmont, CA: Wadsworth, 1970.

Dember, William N. *The Psychology of Perception.* New York: Holt, Rinehart & Winston, 1960.

Dreyfuss, Henry. *Symbol Sourcebook.* New York: McGraw-Hill, 1972.

Facetti, Germano, and Alan Fletcher. *A Pictorial Survey of Visual Signals.* New York: Van Nostrand Reinhold, 1971.

Forgus, Ronald H. *Perception.* New York: McGraw-Hill, 1966.

Graham, Donald W. *Composing Pictures: Still & Moving.* New York: Van Nostrand Reinhold, 1983.

Jung, Carl G. *Man and His Symbols.* New York: Doubleday, 1964.

Kepes, György. *Language of Vision.* Chicago: Paul Theobald, 1944.

Koffka, K. *Principles of Gestalt Psychology.* New. York: Harcourt, Brace and World, Inc., 1935.

Kuwayama, Yasaburo. *Trademarks and Symbols. Volume 1: Alphabetical, and Volume 2: Symbolical Designs.* New York: Van Nostrand Reinhold, 1973.

McKim, Robert H. *Experiences in Visual Thinking.* 2d ed. Monterey, CA: Brooks/Cole, 1980.

Morgan, Hal. *Symbols of America.* New York: Viking Penguin, 1986.

Morris, Charles. *Signs, Language, and Behavior.* New York: Braziller, Reprint, 1955.

Mulvey, Frank. *Graphic Perception of Space.* New York: Reinhold Book Corporation, 1969.

Ocvirk, Otto G., Robert E. Stinson, Philip R. Wigg, and Robert O. Bone. *Art Fundamentals, Theory and Practice*, 6th ed. Dubuque, IA: Wm. C. Brown Publishers, 1990.

Weintraub, Daniel J. and Edward L. Walker. *Perception.* Monterey, CA: Brooks/Cole, 1969.

Welford, A. T., and L. Houssiade, eds. *Contemporary Problems in Perception.* London: Taylor and Francis Ltd., 1970.

Zettl, Herbert. *Sight, Sound, Motion: Applied Media Aesthetics.* Belmont, CA: Wadsworth, 1973.

Symmetry and Dynamic Symmetry

CHAPTER OUTLINE

- Chapter Vocabulary
- Introduction to the Organization of Form
- Introduction to Spatial Organization
- Introduction to Pattern
- Introduction to Symmetry
- Isometric Symmetry Operations
- Application of Symmetry Operations in Advertising and Graphic Design
- Isometric Symmetry Operations in Combination
- Nonisometric Symmetry Operations
- Symmetry Figures in Three Dimensions
- Lattices as an Organizational Device
- Introduction to Dynamic Symmetry
- Practice Exercises
- References and Resources

CHAPTER OBJECTIVES

On completion of this chapter, readers should be able to:

- Understand the morphology of symmetry; that is, the form and structure of prescribed or mechanical means of visual organization or grouping.

- Understand and utilize symmetry operations, transformations, and terminology.

- Identify the components, purpose, and application of a formal ordering system to solve complex visual organizational problems.

- Apply symmetry morphology and terminology in the analysis and development of patterns.

- Understand and use lattices as an organizational device in the process of form generation.

Figure 12.1 The gray area (Prescriptive Principles of Organization) denotes the subject matter presented in this chapter.

Perception Theory

Space, Depth, and Distance

Organizational Principles in 2 and 3 Dimensions

Visual Perception Concepts/Principles

Prescriptive Principles of Organization

2- and 3-Dimensional Form Perception

Light/Brightness
　contrast threshold

Illusions

Monocular Cues
　size
　partial overlap
　value
　color
　aerial perspective
　detail perspective
　linear perspective*
　texture gradient
　shadow
　blurring of detail
　transparency

Binocular Cues
　muscular cues
　parallax cues

Position
Orientation
Motion
Time

***Drawing/Projection Systems**
Orthographic
Paraline
　axonometric
　oblique
Perspective

Gestalt Theory
Figure Laws
Grouping Laws

Figure/Ground Relationships
Distinguishing Figure
　from Ground
Ambiguous Figure
Stability/Instability
Figure Closure
Figure/Ground Reversal
Pattern & Figure/Ground
　Reversal
Figure Overlap

Composition/Visual Organization
Balance
Repetition
Harmony
Rhythm
Variety
Contrast
Dominance

Acquired Associations
Free Association
Familiarity
Reading Order
Hierarchies of
　Information
　　general to specific
　　specific to general
　　chronological

Spatial Organization
Centralized
Linear
Radial
Clustered
Grid/Lattice Systems

Symmetry Groups
Identity
States of Being
Operations
　translation
　rotation
　reflection
　glide reflection
Symmetry
Transformations
　affine
　perspectivity
　dilatative
　topological
　golden section
　root rectangles

Dynamic Symmetry
Proportional Systems
　arithmetic
　harmonic
　geometric
Proportional Theories
　golden section
　renaissance
　the Modulor
　anthropometrics

CHAPTER VOCABULARY

Congruent Describes a correspondence among figures, forms, and quantities. Congruent figures are alike in every characteristic, including shape, size, color, texture, and value.

Isometric A symmetry transformation that preserves the physical characteristics and measurements of a figure. An isometric transformation allows changes in position, direction, and orientation resulting from the symmetry operation as the figure is repeated.

Lattice or **grid** A visual structure system that can be used in conjunction with symmetry operations and transformations in the creation of compositions.

Map or **mapping** A representation of an object or area, usually on a two-dimensional surface or picture plane. When a figure is repeated through symmetry operations and transformations, the resulting new figure is a mapping of the original. The image created in the mapping process is associated with the actual image, object, or area through relative systems of points.

Nonisometric A symmetry transformation that does not preserve the exact physical

characteristics of a figure or form in terms of measurement or dimensions; only a visual similarity remains.

Pattern Design composed through the repetition of one or more visual elements and attributes within a single composition.

Set A defined group of figures or objects that are similar in their visual and structural characteristics.

Symmetry Consists of a number of concepts, transformations, and operations that describe relationships of parts within a composition and that are used to generate patterns in one, two, and three dimensions. Symmetry relationships provide an important basis for relative grouping and figure organization.

Symmetry operations The specific rules that govern the position, orientation, and action of a figure as it is repeated to create a compositional group or pattern.

Symmetry transformation
The specific rules that govern the change of a figure or form, such as quantity, orientation, position, and shape relative to a mapping process. May be one of

two types: isometric or nonisometric. See **Isometric** and **Nonisometric**.

Symmetry value Refers to the structural composition of a figure: An asymmetrical figure that cannot be subdivided into smaller, congruent parts has a low symmetry value; a symmetrical figure that can be broken down into a number of congruent parts has a higher symmetry value. The numerical quantity of the symmetry value is determined by the number of smaller congruent parts. For example, a hexagon is a symmetrical figure that can be broken down into six congruent triangles; therefore, the symmetry value is six.

Transformation A change in form or structure. It can apply both to a change in quantity (repetition) and a change in quality (shape). Isometric transformations deal with changes in quantity, orientation, and position of figures. Nonisometric transformations change the quality of a figure by altering the point-to-point correspondence in the mapping process.

Visual unity The end composition resulting from the combination of interdependent, related parts, making a logical whole.

INTRODUCTION TO THE ORGANIZATION OF FORM

It is necessary for beginning art, architecture, and design students to understand and be able to use a structural ordering system in resolving form organization problems in order to achieve the primary objective in the design process—visual order or unity.

Designs consist of three major components: subject matter, content, and form. The *subject matter* is the general category of information or topic that is to be communicated, the *content* is the specific message with an intended meaning and func-

tion, and the *form* is the visual and physical structure of the communication itself. By manipulating these three components, artists, architects, and designers are able to vary their emphasis in order to change the communicated message.

Artists, architects, and designers generate forms with an intent to communicate. The level or complexity of the communication varies with the sender. The communication also varies according to the selected format (two or three dimensions) and the controlled arrangement of the visual elements (point, line, plane, value, texture, color, and so on). The principles of organization provide structural guidelines for the ordering and treatment of visual elements so that a predefined audience recognizes and understands the message idea or intent.

Visual unity, the end goal of the form generation process, is a logical integration of form that allows individuals to perceive the form, attribute meaning to it, and derive the intended communication. There are two types of organizational principles used to achieve visual unity: visual perception concepts and principles, and prescriptive principles of organization.

The prescriptive principles of organization are outlined in the design process/form generation model under Perception Theory.

Prescriptive Principles of Visual Organization

Chapter 11 dealt with visual perception concepts and principles in the form generation process. This chapter provides artists, architects, and designers with a prescriptive means to order visual elements. The principles outlined function as formal visual equations or rule sets and are used to logically describe and generate structural arrangements in one, two, and three dimensions.

INTRODUCTION TO SPATIAL ORGANIZATION

Historically, from ancient Egypt, Greece, and Rome until today, basic spatial organizational principles have been evident in architecture and art forms such as tilings, ceramic mosaics, paintings, and sculpture (see Figure 12.2). Often these compositional principles in architectural and painting terminology are dealt with in introductory courses; however, they are appropriate for use in graphic design, product design, and interior space studies as well.

Figure 12.2 (a) Amphitheatre of Flavius, Rome, and (b) half ground plan of the Coliseum illustrating symmetry in architecture (from The Complete Encyclopedia of Illustration by J. G. Heck; Crown Publishers, Inc.).

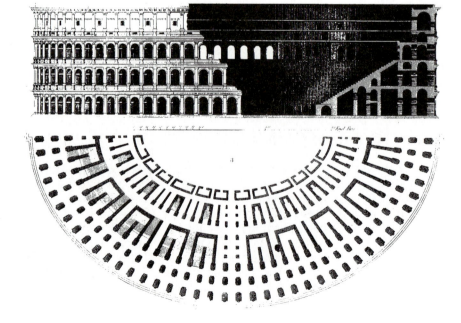

12.2a

12.2b

Although the spatial organizations do fall into the category of prescriptive principles because they are prescriptive ways of organizing two- and three-dimensional compositions and structures, they are not highly formalized. Each of the different types of spatial organizations are characterized by distinguishing compositional factors, but remain relatively informal because a great deal of variety within each category is possible.

Centralized Organizations

Centralized organizations are characterized by a single dominant compositional figure or space, about which a number of secondary and tertiary compositional figures or spaces are arranged (see Figure 12.3). The primary or dominant figure in a centralized organization usually is a simple geometric shape that is larger than the secondary and tertiary forms. The secondary and tertiary figures or

spaces may be similar to or different from the other compositional figures or elements. Figures 12.4 and 12.5 illustrate centralized organization in two famous buildings.

In two- and three-dimensional compositions the primary figure or form attracts the attention of the viewer. For example, traffic patterns will vary in interior spaces and buildings, but usually begin and end in the primary space.

12.3

12.4a

12.4b

Figure 12.3 Centralized organizations are based on a central dominant figure or space.

Figure 12.4 (a-b) Two architectural window details from the Cathedral of Rouen illustrate centralized organization (from Heck).

Figure 12.5 (a) Centralized floor plan of the Pantheon; (b) elevation view (from Heck).

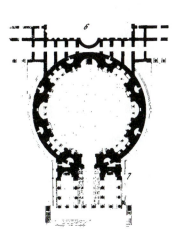

12.5a

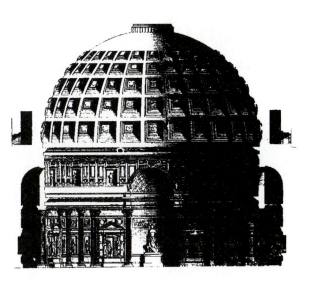

12.5b

Figure 12.6 Linear organizations are based on aligned forms.

Linear Organizations

Linear organizations are characterized by the arrangement of several compositional figures or spaces into a linear sequence or series (see Figure 12.6). Elements relate to one another through the repetition of physical, visual, and structural attributes such as size, shape, color, dimension, texture, and proportion.

Linear organizations convey a feeling of movement. Figure 12.7 gives three examples of linear organization in architecture.

12.6

Figure 12.6 Linear organizations are based on aligned forms.

Figure 12.7 (a) Partial view of the front elevation of the Pagoda at Ho-nang; (b) bridge at Ticino; (c) front elevation and plan of the Louvre, Paris, illustrate linear organization (from Heck).

12.7a

12.7b

12.7c

Radial Organizations

Radial organizations are characterized by a centralized axis and figure. Other compositional figures or forms are positioned so that they are radiating about the central axis or figure (see Figures 12.8 and 12.9).

The "Inflatable Kindergarten" shown in Figure 12.10 is an example of a radial structure. The plan view shows the radial organization of the structure.

12.8

Figure 12.8 Radial organizations are based on forms radiating from a central point.

Figure 12.9 The snowflake illustrates radial organization (from The Bently & Humphrey Atlas*).*

12.9

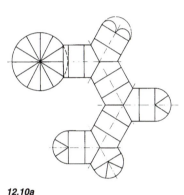

12.10a

Figure 12.10 (a) Schematic plan of the "Inflatable Kindergarten" illustrates radial organization; (b) "Inflatable Kindergarten" (photo from Pneumatic Structures: A Handbook of Inflatable Architecture *by Thomas Herzog, Gernot Minke, and Hans Eggers; Oxford University Press, New York, 1976).*

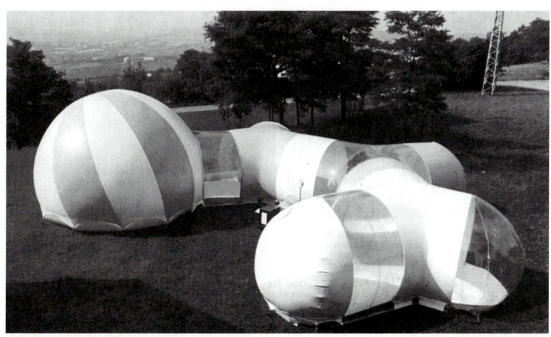

12.10b

Clustered Organizations

Clustered organizations are based on the relationship of space and the relative placement of one compositional figure or form to another (see Figure 12.11). A similar visual perception principle is proximity, discussed in Chapter 11.

A clustered organization is the most flexible grouping because it doesn't require a centralized figure or space that is more dominant than any other. The elements can have a common shape, size, form, or common surface attributes. The Habitat residential settlement shown in Figure 12.12 is an architectural example of a clustered organization.

12.11

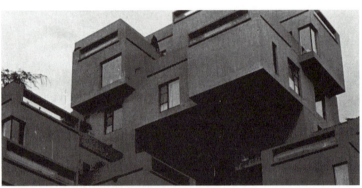

12.12a

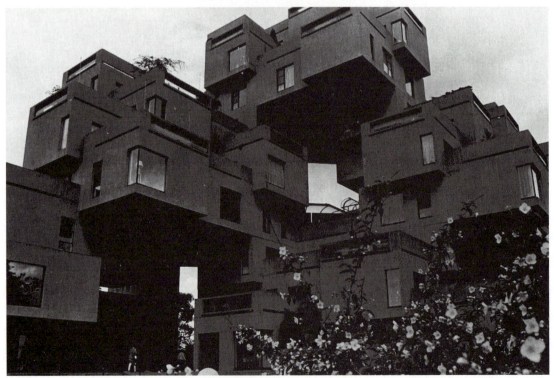

12.12b

Grid/Lattice Organization

A **grid** is a structural system consisting of a series of equal spaces in two or three dimensions (see Figure 12.13). Other terms for grids are **lattices** or *networks*. Grids, lattices, and networks are characterized by the use of congruent spaces or sizes, positions, and orientations. They establish a visual and structural relationship between figures, forms, and spaces. The Dutch Pavilion in Montreal, Canada (see Figure 12.14) was constructed using a grid organization system.

12.13

Figure 12.13 A grid configuration based on a two- or three-dimensional space network.

Figure 12.14 (a-b) The Dutch Pavilion, Expo '67 in Montreal, Canada, illustrates grid organization (compliments of the Royal Netherlands Embassy, Canada).

COUPE D D

12.14a

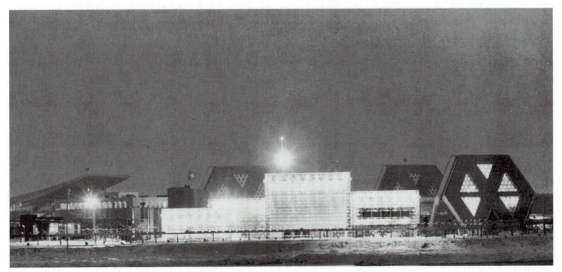

12.14b

INTRODUCTION TO PATTERN

Most compositions have a structure that governs the positions and arrangement of figures and forms to bring about visual order and harmony. Designs that consist of a number of similar compositional figures are called **patterns**.

Patterns result from the repetition of shape, size, color, texture, value, direction, position, and orientation, either singly or in combination. In two dimensions, the compositional figures and their attributes, such as shape, color, and texture, can be selected and organized to create patterns. The specific way each of the visual elements is positioned determines the underlying compositional structure and influences the visual outcome.

The variety of patterns in architecture, textiles, and artisan crafts dating from the first and second millennia before Christ through today are historical evidence that man seems to have a sense for creating pattern. Figure 12.15 shows an example of pattern found in ancient architecture.

Figure 12.15 An example of pattern found in architecture: X shape motif translated across and down (funerary wall, Uxmal, Mexico; photo by Charles Wallschlaeger).

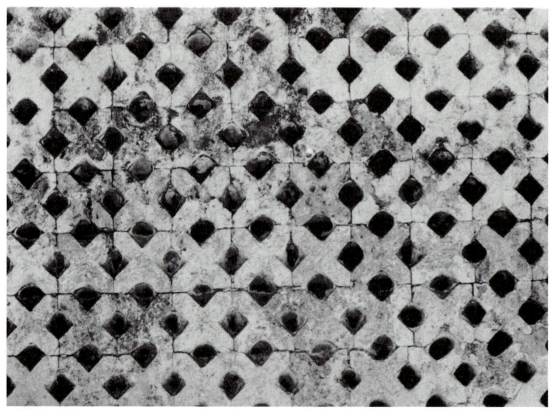

12.15

✍Practice Exercise 12.1: Creating Pattern

This exercise illustrates a formal approach to creating pattern. Begin by developing a compositional element for the exercise as shown in Figure 12.16. Construct a square grid with nine units, three spaces wide by three spaces deep.

Using black gouache or self-adhesive film, fill in some grid areas and leave other areas empty. The configuration created using this process is called the compositional figure. For variation, subdivide grid areas on the diagonal, and fill in some of the triangular areas. Then combine triangular areas with square areas to create a single pattern unit.

Make several compositional elements by photocopying the original, or by hand graphic techniques using self-adhesive film or gouache. Cut out and arrange the additional elements next to each other on 2-ply Bristol board to create a pattern (see Figures 12.17 and 12.18).

Another option for developing this exercise is through the use of the Macintosh computer and software such as Aldus Freehand™ or Adobe Illustrator®. Figures 12.16–12.18 were created on the Macintosh SE® using Adobe Illustrator software.

12.16a

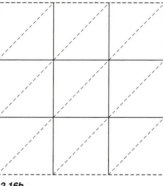

12.16b

12.16c

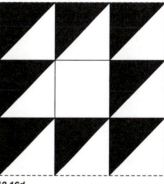

12.16d

Figure 12.16 Approaches to creating figure or pattern figure using an orthogonal grid and its subdivisions: (a-b) illustrates the orthogonal grid and subdivisions; (c-d) selecting and filling in areas to create a figure or pattern figure.

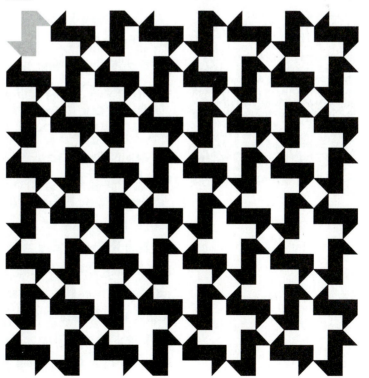

12.17a

Figure 12.17 (a) The figure and pattern in Figure 12.16 repeated to create a larger pattern.

*Figure 12.17
(continued)
(b) Pattern figure;
(c) figure repeated
to create a larger
pattern.*

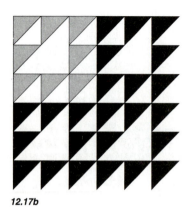

12.17b

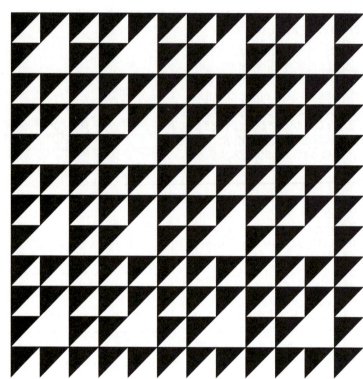

12.17c

*Figure 12.18 (a-b)
As the pattern be-
comes smaller it
reaches a point
where it appears as
a visual texture.
The textural ap-
pearance is created
by the contrast be-
tween the figure
and the ground
area.*

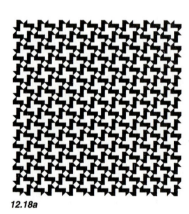

12.18a

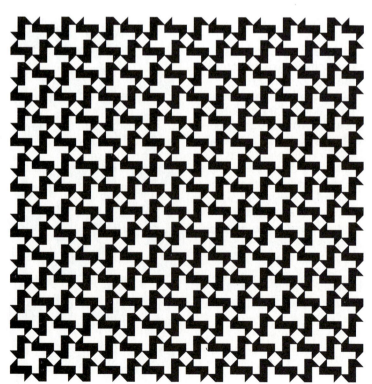

12.18b

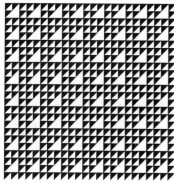

12.19a

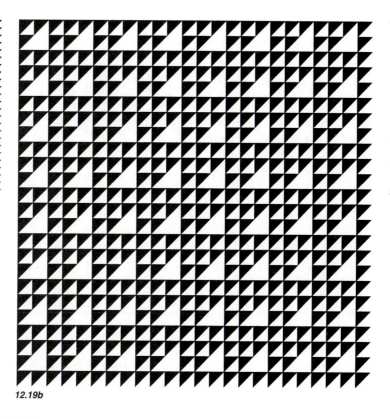

12.19b

Figure 12.19 (a-b) As the pattern becomes smaller it reaches a point where it appears as a visual texture. The textural appearance is created by the contrast between the figure and the ground area.

INTRODUCTION TO SYMMETRY

The term **symmetry** comes from the Greek roots *syn*, meaning with or together, and *metron*, meaning measure. Symmetry deals with the relationship of parts within a group, or, in direct translation, "to measure together." In symmetry studies the relationships of the parts are described in terms of their arrangement on the format, their size, and their measurements or proportions.

Historical Development of Symmetry Studies

Symmetry has been perceived in art and nature since antiquity. Symmetry laws can be traced to Pythagorean times when man consciously sought to establish order within his environment. By the end of the 1700s many realized the structures found in natural forms and crystal configurations could be described by a small number of symmetry operations. Scientists and mathematicians utilized this knowledge within the areas of biology and geometry. The mathematical theory of symmetry was investigated throughout the 1800s in Russia, Germany, and England.

Symmetry studies in science and math deal with the equality and arrangement of parts of a whole in a very formal manner, citing formulas to describe states of order and systematic change. Symmetry in mathematics deals with geometric regularity; forms are geometrically regular if they can be divided into equal parts without a remainder. Geometric laws of symmetry imply identical states of order—that is, compatibly equal (**congruent**) parts or mirror equal (mirror image) parts. The Pythagorean theorem (see Figure 12.20) is an example of a state of order.

In nature, symmetry patterns are seen in the arrangement of honeycomb cells, flower petals, fish scales, tree and plant leaves,

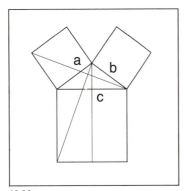

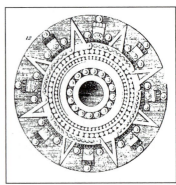

12.20

12.21

12.22

Figure 12.20 The Pythagorean theorem: In a right triangle, the square of the long side (or hypotenuse) is equal to the sum of the squares of the two shorter sides.

Figure 12.21 An example of symmetry in nature, as seen in the crab, thalamita natator (from Heck).

Figure 12.22 An example of symmetry in architecture, as seen in an Aztec altar top design (from Heck).

Figure 12.23 An example of symmetry in a drawn composition (from Heck).

in starfish, in seashells, and so on (see Figure 12.21). On the microscopic level, examples are found in cells of biological tissues and molecular and crystallographic structures.

Symmetry in art, architecture, and design is seen in patterns of textiles, tiled floors, ceramic mosaics, wallpapers, friezes, rugs, and the arrangement of spaces in building structures (see Figure 12.22). It is commonly believed that the use of symmetry in art and architecture originally was derived through the observation and copying of natural form structures and configurations. Complex symmetry patterns and form configurations are evident in ancient art and architecture in Eastern Islamic countries. Conscious application of formal symmetry operations and terminology adopted from geometry, crystallography, and physics is increasingly evident today in the creation of art forms, buildings, and products.

In spite of the considerable amount of research and writing on symmetry that has

evolved from math and science, it has not been used to its full potential by artists, architects, and designers. Often the complex terminology and equations used in mathematics and science discourage individuals from learning about symmetry and its possible visual applications. For this reason, this section emphasizes the visual presentation of symmetry and its prescriptive principles.

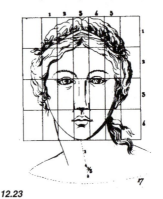

12.23

Symmetry Theory

The theoretical concepts of symmetry deal with group theory and figure **transformations**. In symmetry, figure transformations, or **symmetry operations** as they are called, refer to the movement and repetition (**mapping**) of

a figure in one-, two-, and three-dimensional space. Symmetry provides an important basis for grouping and figure organization in the generation of objects, compositions, and structures (see Figure 12.23). A clearer understanding of symmetry concepts and principles aids individuals in designing more complex pattern compositions, eliminating the need to innately derive these patterns, as has often been done historically. It is therefore important to understand the symmetry terminology, symmetry operations, and symmetry transformations.

Symmetry Terminology

There is a specific terminology for symmetry operations and transformations and their combinations; these vary with the source materials. The theoretical concepts and laws presented here have been defined according to rules and terminology used in mathematic and crystallographic studies. This presentation is an attempt to clarify, simplify, and bring consistency to the terminology used among different professional disciplines. The definitions derived from other profes-

sional areas of study such as art, art history, science, nature, and so on have been simplified and illustrated to complement the visual studies in prescriptive organization and pattern making.

Refer to the chapter vocabulary on page 435 for general terms. Specific symmetry terms are defined below and throughout the rest of the chapter.

Symmetry transformations are the specific rules that govern the change of a figure or form, such as quantity, orientation, position, and shape relative to a mapping process. *Symmetry operations* are the specific rules that govern the position, orientation, and action of a figure or form as it is repeated within a two- or three-dimensional space. *Symmetry states of being* describe the physical and/or visual state of the figure or form as it appears within different symmetry operations and transformations.

Symmetry Morphology

When a figure is repeated in the creation of visual or architectural compositions, groups or visual **sets** become recognizable. In mathematics, chemistry, and physics the concept of a group translates into numbers, sets, or functions. **Symmetry transformations** are groups of figures that are classified according to the invariances. *Invariance* refers to a sameness or congruency in the structure of the figure during the symmetry transformation. This classifi-

| Table 12.1 Symmetry Morphology | | |
|---|---|---|
| **Transformation** | **State of Being** | **Operation (Action)** |
| Isometric | Congruent | Identity |
| | | Translation |
| | | Rotation |
| | | Reflection |
| | | Glide Reflection |
| Nonisometric | Projective | Affinity |
| | | Perspectivity |
| Nonisometric | Dilatative | Dilatation |
| Nonisometric | Topological | Topology |

cation provides the basis for defining concepts of symmetry operations.

Morphology is the study of form relationships. A definition of these relationships encompasses the operations that occur within the morphology of symmetry. Therefore, symmetry can be defined as the relative correspondence in size, shape, and position of points of compositional figures produced by the linear or curvilinear generation of these points in one, two, or three dimensions. This definition leads to the assumption that symmetry transformations bring about motion or the movement of figures in any direction. The concept of symmetry grouping deals with two opposing concepts: transformation (change) and conservation (invariance).

The morphology of symmetry was developed for use as a deductive analysis method to look at structural components of existing forms. These forms have been described in terms of symmetry transformation (a change in the figure), symmetry operation (the specific action governing change), and state of being—that is, the relative state of a figure as compared to a standard or original (invariance) (see Table 12.1).

As defined in the general vocabulary and model, there are two types of symmetry transformations: **isometric** and **nonisometric**. Isometric transformations come about by the repetition of congruent figures or forms. Nonisometric transformations come about by projection, dilatation, or topology.

Symmetry in the Environment

Figure 12.24 shows photographic examples of symmetrical configurations found in the environment. Symmetry examples can be found in architecture, man-made products, and natural objects. An increased awareness of symmetry can be brought about by identifying forms and structures that have a symmetry and photographing or drawing them.

Figure 12.24 Photographic examples of man-made symmetry: (a) folk embroidery, Sweden; (b) silo and barns, Ohio, U.S.A.; (c) house porch, Florida, U.S.A.; (d) balcony supports, Mexico; (e) church entrance, Mexico; (f) observatory, India; (g) farm market, Ohio, U.S.A. (photography by Fred Zimmer, Professor, The Ohio State University Dept. of Industrial Design).

12.24a

12.24b

12.24c

12.24d

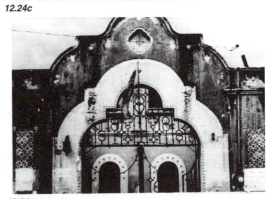
12.24e

12.24f

12.24g

✍Practice Exercise 12.2: Symmetry and Asymmetry in Man

Many natural and man-made forms exhibit symmetry. One example is humans themselves. Imagine a person's face divided vertically down the center. Note the likeness between the two halves; for example, the left half of the nose and mouth look the same as the right half. (This is an example of mirror symmetry, which is the symmetry operation called *reflection*.) Upon closer observation, it becomes evident that even though approximate symmetry exists, there are small differences in the features.

For this exercise, begin by taking a series of black and white photographs of yourself or another person. Once the photographs are developed and printed, make two acetate transparencies of each image. Carefully cut each of the transparencies down the center. Match the two right sides together, and match the two left sides together. (One set of halves will have to be turned over so they will be reflections of the first set.)

Mount the original photographs and two reflections on illustration board and compare the results. Analyze the differences between the photographs. Figure 12.25 shows two examples of this symmetry study.

Figure 12.25 (a-f) Two examples of symmetry studies by students at the Schule für Gestaltung (School of Design) in Luzern, Switzerland, Professors Godi Hofman and Hans Rudolph Lutz.

12.25a

12.25b

12.25c

12.25d

12.25e

12.25f

Selecting a Figure for Symmetry Studies

The compositional figure or element selected for use in symmetry and dynamic symmetry exercises should be asymmetrical or enantiomorphic (which means having specified right- and left-hand sides; see Figure 12.26). If a simple symmetrical figure is used to illustrate the symmetry concepts, it is difficult to identify the particular symmetry transformation or operation used to manipulate the form. The resulting pattern becomes a series of the original figure on a plane, and little variation other than repetition is possible. By creating an asymmetrical figure to use within the exercises, it is possible to compare and contrast the visual pattern. A symmetrical figure can be altered by applying color, value gradation, or line patterns to it, or by subtracting a section from it. Figures 12.27–12.30 show examples of compositional figures used for symmetry studies.

The following section explains and provides examples of symmetry transformations and operations.

Figure 12.26 A pair of mittens illustrates the concept of enantiomorphism, or handedness.

Figure 12.27 (a-b) A symmetrical figure can be made asymmetrical by adding a directional line pattern value gradation indicated in gray.

Figure 12.28 (a-b) Simple geometric shapes can be made asymmetrical by subtracting an area.

Figure 12.29 (a-b) Asymmetrical letterforms can be used for symmetry studies.

Figure 12.30 (a-b) Asymmetrical figures can be created through figure/ground reversals using free-form, typographic, or geometric shapes.

12.26

12.27a

12.27b

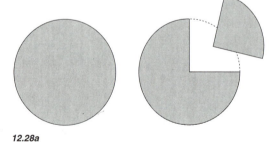

12.28a

12.28b

12.29a 12.29b

12.30a 12.30b

ISOMETRIC SYMMETRY OPERATIONS

Isometric symmetry transformations are categorized as congruent states of being whereas nonisometric symmetry transformations fall into categories of projective, dilatative, topological, or combined states of being. The state of being in symmetry refers to the specific shape of the figure or form that results during a symmetry transformation. The four states of being are illustrated in Figure 12.31.

There are five different basic isometric symmetry operations: **identity**, **translation**, **rotation**, **reflection**, and **glide reflection**. (It should be noted that some theoreticians and writers may not include identity as an operation.) The term "operation" implies action or movement and isometric refers to equality of measurement; that is, each compositional figure or form that undergoes an isometric symmetry transformation maintains the identical shape of the first figure, but it moves in the space as it is repeated.

In a nonisometric transformation that results in a projective state of being, there are two possible symmetry operations: affine and perspective. The affine and perspective symmetries have been included because they are special cases of transformation that can be related to formal drawing and projection systems.

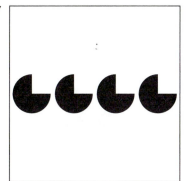

12.31a

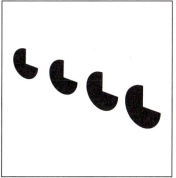

12.31c

In a nonisometric transformation that results in a dilatative state of being, there is one symmetry operation: dilatation (change in size). In a nonisometric transformation that results in a topological state of being, there is one symmetry operation: topology (change in shape due to stretching or compression).

Isometric and nonisometric operations may be used in combination.

Identity

The terminology relative to the formal identity transformation does not imply action and is sometimes a confusing concept. Identity is known as a *unit* operation. According to

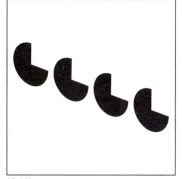

12.31b

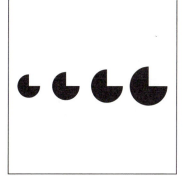

12.31d

12.31e

12.32a

Figure 12.31 (a) Isometric symmetry transformation illustrating a congruent state of being; (b) nonisometric symmetry transformation illustrating affine projection; (c) nonisometric symmetry transformation illustrating perspective projections; (d) nonisometric symmetry transformation illustrating a dilatative state of being; (e) nonisometric symmetry transformation illustrating a topological state of being.

Figure 12.32 (a) Figure within a defined format area.

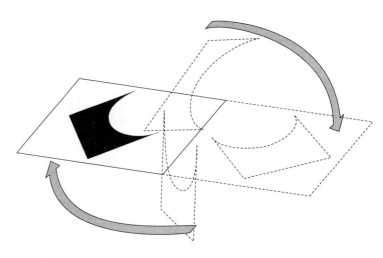

12.32b

Figure 12.32 (continued) (b) The isometric operation of identity is shown reflected/rotated upon itself within three-dimensional space.

Shubnikov and Koptsik in *Symmetry in Science and Art,* "identity is the result of two consecutive reflection operations in the same arbitrary plane, so any new figures will correspond with the original" [A.V. Shubnikov and V.A. Koptsik, *Symmetry in Science and Art* (New York: Plenum, 1974), p. 237]. Identity is a symmetry operation known as an automorph, which leaves every point on the figure visually unchanged because it generates the figure into itself.

Identity reflects the element twice, and it appears as though no movement has taken place. Visually the figure remains at the same place within the format or picture plane area (see Figure 12.32).

Figure 12.33 (a) Translation is an equal one-to-one correspondence of points. (b) The interval includes the figure and the space or area around it. (c-d) Translation creating a linear band, showing the interval.

Translation

As previously presented in the symmetry morphology section of this chapter, both the isometric and nonisometric symmetry operations are mappings. The term *mapping* refers to the point-to-point correspondence between the original figure and the figure that results from the symmetry operation.

Translation is the linear generation of a figure in an equal point-to-point correspondence or mapping (see Figure 12.33a). The area about the figure that creates distance between each element as it is translated is called the *interval* (see Figure 12.33b). The translation of a figure in one dimension creates a linear repetition called

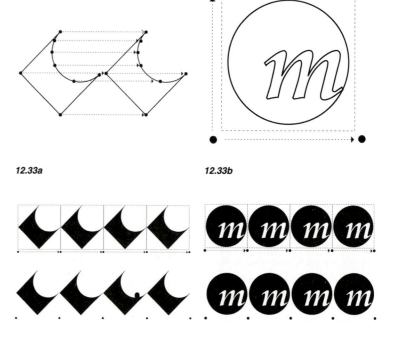

12.33a

12.33b

12.33c

12.33d

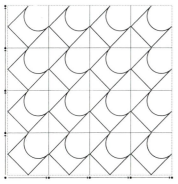

12.34

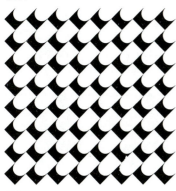

12.35a

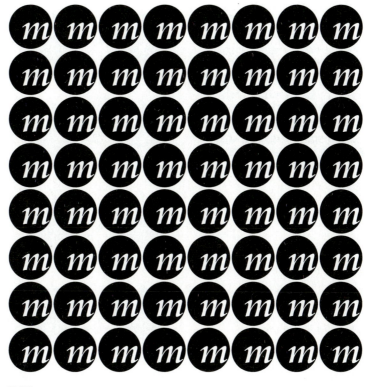

12.35b

Figure 12.34 Translation in two directions, maintaining equal intervals (indicated by dotted lines).

Figure 12.35 (a-b) Translation in two directions (horizontally and vertically), creating a pattern.

a *linear band*, as illustrated in Figure 12.33c and d. Translation in two dimensions creates a planar unit called a *pattern*.

Translation repeats the figure in the same direction the same distance (interval) each time. Translation can be horizontal, vertical, diagonal, or a combination. Figure 12.34 shows translation in two directions.

By varying the shape of the compositional figure, different patterns result using the same symmetry operation. Notice the contrast between the two pattern configurations in Figure 12.35.

Rotation

Rotation is a symmetry operation that turns the figure about a predetermined axis (see Figure 12.36). The figure remains at a fixed distance from the axis. The interval or space between the figures rotated about the axis determines the quantity or **symmetry value** of the rotation—a twofold (twice, or 180°), threefold (three times, or 120°), or fourfold (four times, or 90°) rotation. All equal 360°.

The smaller units created by symmetry rotations can be repeated through translation to form planar patterns as shown in Figure 12.36b–e.

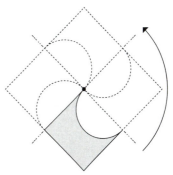

12.36a

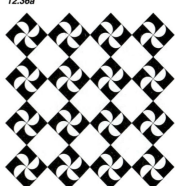

12.36b

Figure 12.36 (a) The figure rotated counterclockwise. (b) The new figure created through rotation is translated horizontally four times, then vertically four times.

Figure 12.36 (continued) (c) Using the figure created through rotation, a new pattern is developed by translating at a 45° diagonal. (d) The figure rotated clockwise. (e) The new figure created through rotation is translated horizontally four times, then vertically four times.

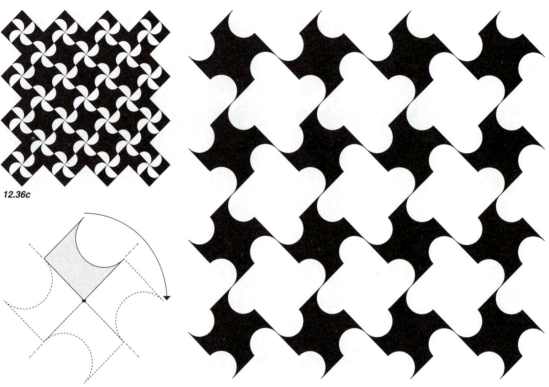

12.36c

12.36d

12.36e

Reflection

Reflection is a symmetry operation that rotates the mapping of the figure out of the plane 180°. The resulting image is the same as an image reflected in a mirror (see Figure 12.37).

There is an axis of reflection that can be placed in any position relative to the figure; that is, it doesn't have to be positioned at right angles (see Figure 12.38). The placement of the axis of reflection determines the resulting pattern and the distance between the figures. The greater the distance between the axis of reflection and the figure, the greater the distance between the figures in the resulting pattern. The smaller units can be re-

flected continuously or translated to create a pattern plane (see Figure 12.39).

The placement of the axis of reflection relative to the figure determines the final pattern cell configuration (see Figure 12.40).

Figure 12.37 A figure reflected about an axis.

Figure 12.38 The reflection operation is a rotation of 180° out of the picture plane onto the opposite plane.

12.37

12.38

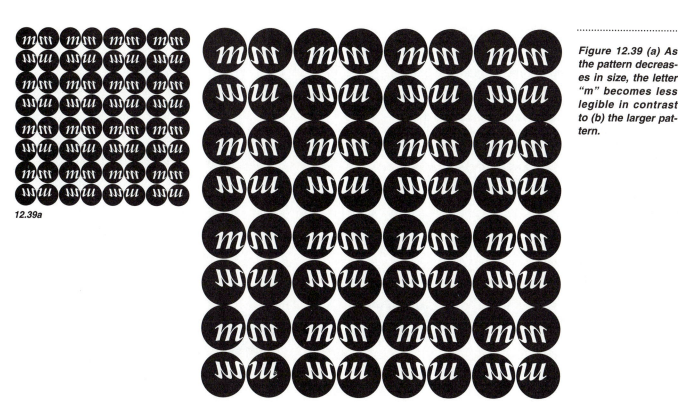

12.39a

12.39b

Figure 12.39 (a) As the pattern decreases in size, the letter "m" becomes less legible in contrast to (b) the larger pattern.

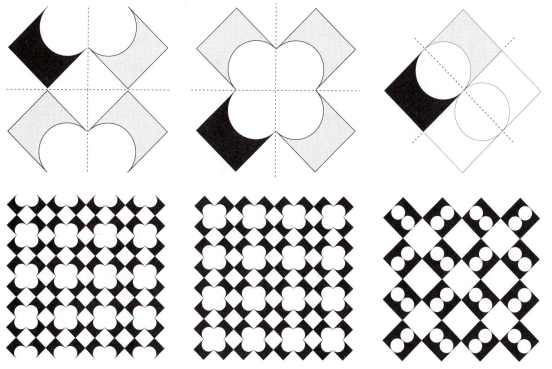

12.40a

12.40b

12.40c

Figure 12.40 (a) The original figure (shown in black) is reflected twice horizontally and vertically to create a cell, then translated to make a pattern. (b) The same figure can be reflected or rotated, creating a pattern similar to (a); however, it terminates differently at the edge. (c) The same figure reflected on the diagonal axis creates closure and appears as a square with two circles cut out. Continuous reflection of the negative square with two circles placed on the diagonal axis creates pattern ares.

Figure 12.41 (a) A figure is reflected across an axis, then glides down into a new position. (b) A three-dimensional view of the figure reflected by rotating it out of the plane 180° and gliding down again. (c-d) Patterns created using the glide reflection operation.

Glide Reflection

Glide reflection is an isometric symmetry operation that rotates the figure image out of the plane 180°, the same as the reflection operation, but then glides or slips the figure into a new position along a predetermined axis of reflection. Figure 12.41 illustrates this process.

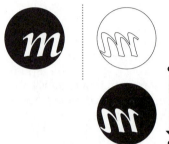

12.41a

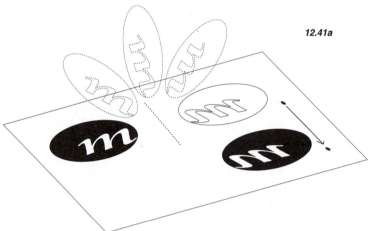

12.41b

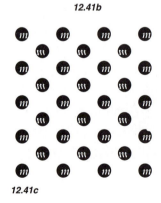

12.41c

12.41d

✍Practice Exercise 12.3: Applying Symmetry

Apply the symmetry operations translation and rotation using a two-syllable word. The word should have a phonetic rhythm that is easily translated into different associative emphases (such as "humdrum") and should be typographically laid out using the translation operation to give a sense of monotonous repetition. Visual contrasts also may be used, such as wholeness to fragmentation (see Figures 12.42 and 12.43).

12.42

Figure 12.42 The word "bookkeep" translated on a vertical axis and then rotated 180° and back again to create contrast and negate the repetition.

Figure 12.43 (a) Use of rotation and translation to create a square shape from the word "humdrum." **(b)** Translation used to create repetition, relating to the word "humdrum". Note the breaking of the rhythmic flow by inserting "humhum." **(c)** The repetition or translation of the word "humdrum" in combination with fragmentation visually changes the redundancy of the word.

12.43b

```
humdrumhumdrumhumdrumhumdrum
humdrumhumdrumhumdrumhumdrum
humdrumhumdrumhumdrumhumdrum
humdrumhumdrumhumdrumhumdrum
humdrumhumdrumhumdrumhumdrum
humdrumhumdrumhumdrumhumdrum
humdrumhumdrumhumdrumhumdrum
humdrumhumdrumhumdrumhumdrum
humdrumhumdrumhumdrumhumdrum
humdrumhumdrumhumdrumhumdrum
humdrumhumdrumhumdrumhumdrum
humdrumhumdrumhumdrumhumdrum
humdrumhumdrumhumdrumhumdrum
hum humhum humhum humhum hum
hum humhum humhum humhum hum
humdrumhumdrumhumdrumhumdrum
humdrumhumdrumhumdrumhumdrum
humdrumhumdrumhumdrumhumdrum
```

12.43a

12.43c

APPLICATION OF SYMMETRY OPERATIONS IN ADVERTISING AND GRAPHIC DESIGN

Symmetry operations and transformations are frequently used in graphic design to accentuate meaning within a graphic or typographic message. The following examples illustrate the application of symmetry operations and transformations to reinforce a message (see Figures 12.44–12.48).

Figure 12.44 Advertising campaign for Total é Total (Italy) by Pino Tovaglia. Use of repetitive elements or the translation operation to reinforce the message.

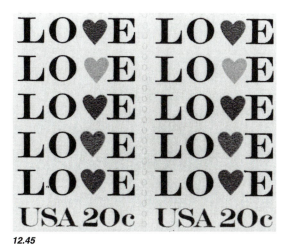

12.45

Glooo
oo
oo
oo
oo
oo
oo
oo
oo
oo
oo
oo
oo
oo
oo
oo
oo
oo
oo
oo
oo
oooria

12.46

Figure 12.45 United States postage stamp using the word "Love"; translation symmetry operation (designed by Bradbury Thompson).

Figure 12.46 Christmas card using the word "Gloria"; translation of the letter "o" to accentuate the phonetic sound of the letter (designed by David Colley).

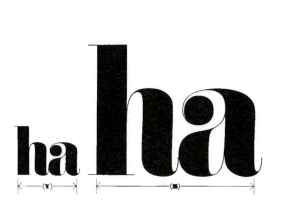

12.47

Figure 12.47 "Psychographics," promotional advertisement for Savitt Studios, New York, using the symmetry operation reflection.

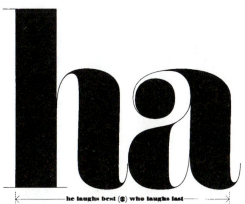

12.48

Figure 12.48 Advertisement for CBS Television Network emphasizing the word "ha," using the symmetry operation translation, and the transformation dilatation or size change (designed by Louis Dorfsman).

ISOMETRIC SYMMETRY OPERATIONS IN COMBINATION

Translation/Rotation

Figure 12.49 (a) A compositional figure translated twice horizontally and vertically, establishing a new figure pattern. (b) The new figure pattern is rotated four times or fourfold. (c) The figure pattern created in (b) is used to create a larger pattern through translation/rotation operations.

Isometric symmetry operations can be used in combination with each other to create more complex pattern solutions. Once the first planar configuration has been generated using a symmetry operation, it is possible to create another pattern solution by using different symmetry operations. Figures 12.49–12.55 are some examples.

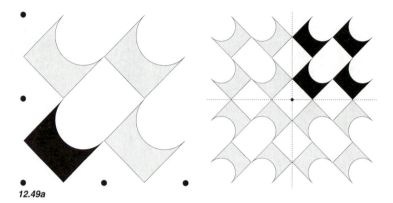

12.49a

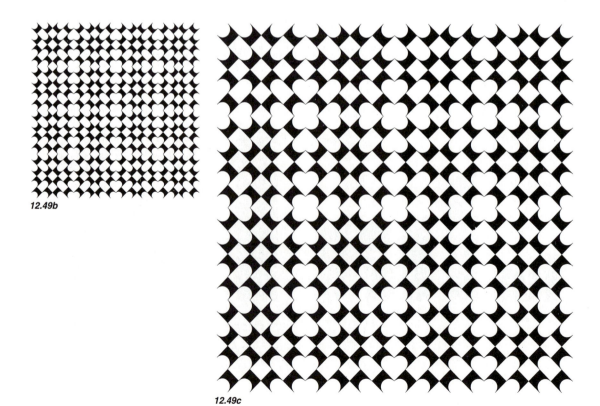

12.49b

12.49c

Rotation/Reflection

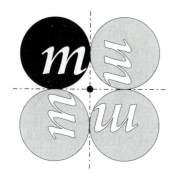

12.50a

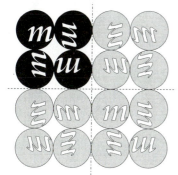

12.50b

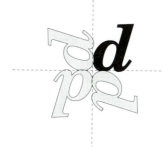

12.51a

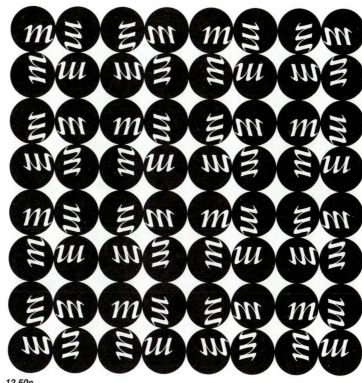

12.50c

Figure 12.50 (a) The circular figure and letter "m" is rotated four times. (b) The new figure pattern is reflected twice horizontally and vertically, establishing a new figure pattern. (c) The new figure pattern in (b) is used to create a larger pattern through the reflection operation.

Figure 12.51 (a) The letter "d" is rotated four times. (b) The new figure pattern is used to create a larger pattern through the reflection operation.

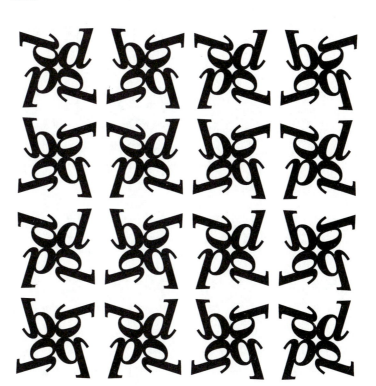

12.51b

Figure 12.52 (a) The original figure translated to create a new pattern figure. (b) This new figure pattern uses glide reflection to create a larger figure pattern area.

Translation/Glide Reflection

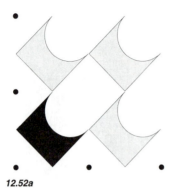

12.52a

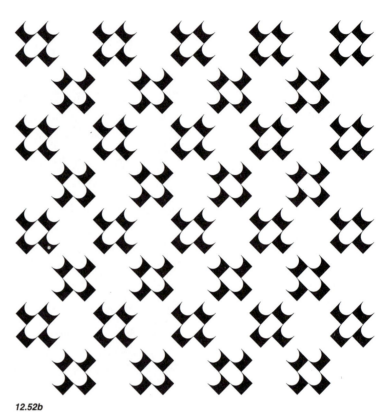

12.52b

Figure 12.53 (a-c) The original figure "g" translated to create different pattern combinations.

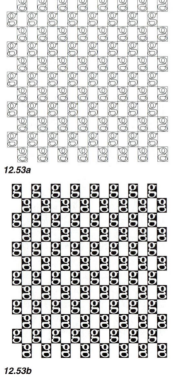

12.53a

12.53b

12.53c

Glide Reflection/Rotation

12.54a

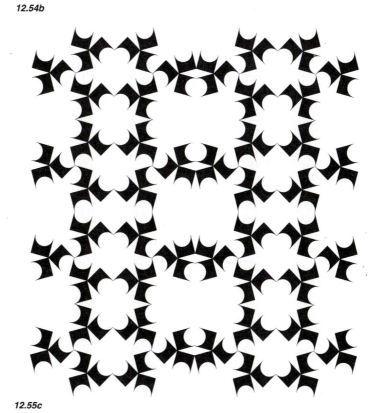

12.54b

Figure 12.54 (a) The original figure undergoes a glide reflection operation and is rotated four times to create a pinwheel configuration. (b) The new pattern configuration is then translated to create a larger pattern.

Rotation/Reflection

12.55a

12.55b

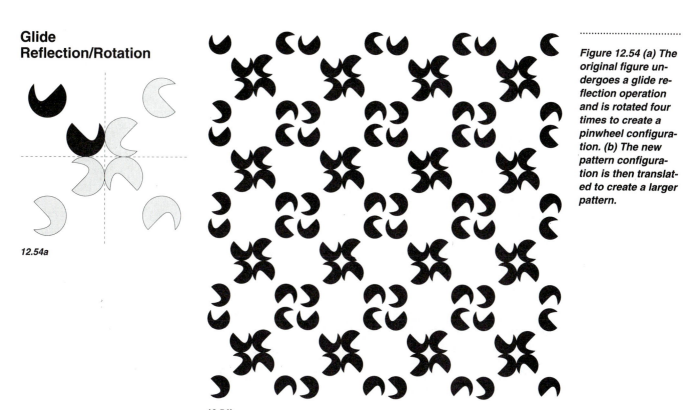

12.55c

Figure 12.55 (a) The original figure is rotated 120° to create a threefold rotation. (b) The new figure pattern is again rotated 120° to create a new configuration. (c) The new pattern configuration is then reflected to create a larger pattern.

NONISOMETRIC SYMMETRY OPERATIONS

Figure 12.56 (a) In an isometric symmetry operation, the figure maintains an equal point-to-point correspondence. (b) Affine operation maps the figure so that all lines that are parallel on the original figure remain parallel in the new figure. (c) Perspectivity causes the parallel lines on the original figure to appear as if they vanish to a system of points in space. (d) The dilatative operation results in changing figure size. (e) The topological operation results in the distortion of a figure in an irregular manner such as stretching.

Nonisometric symmetry operations or transformations occur as three different states of being: projective, dilatative, or topological, and they also can be used in combination with any of the other isometric or nonisometric symmetry operations. There are two projective operations: affine and perspective. The other two nonisometric operations take the same name as their state of being, that is, dilatative and topological.

The difference between the isometric symmetry operations and the nonisometric symmetry operations is the type of mapping. Remember that the isometric transformations maintain an equal point-to-point correspondence when mapped (see Figure 12.56a). The nonisometric transformations do not maintain the same or equal point-to-point correspondence. Depending on the particular state of being, the point-to-point correspondence changes, so a different view, orientation, and figure shape may result. Figure 12.56b–e illustrates these differences. The nonisometric operations only preserve enough visual shape qualities to allow comparison and visual similarity between the original figure and the new figure.

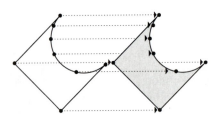

12.56a

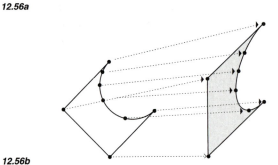

12.56b

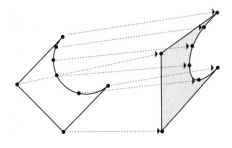

12.56c

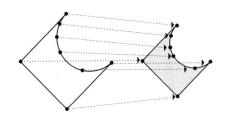

12.56d

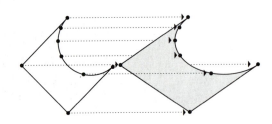

12.56e

Projective Operations

Affine Operations

The affine and perspective operations project the figure into three-dimensional space and are related to the formal drawing or projection systems. In an affine operation, the figure is mapped so that all lines on the figure that are parallel remain parallel in the resulting view (see Figure 12.57). It is called an affine operation because it has an affinity or visual likeness to the original figure. Affine views of figures can be drawn by using the paraline drawing systems discussed in Chapter 4. Figure 12.58 illustrates translation symmetry patterns that were transformed using a nonisometric affine symmetry operation.

Note that the terms isometric and nonisometric should not be confused with the terms isometric symmetry operations and nonisometric symmetry operations. Even though an isometric drawing is an example of an affine symmetry operation, it is not typical; generally, affine transformations do not preserve dimensions or quantities, only parallelism. Isometric symmetry operations preserve all lengths or measurements.

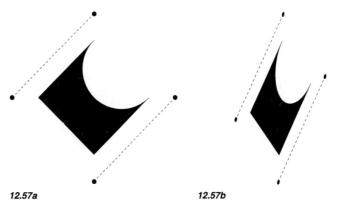

12.57a 12.57b

Figure 12.57 In an affine operation, the parallel lines in the original figure (a) remain parallel in the transformed figure (b).

Figure 12.58 (a-c) Examples illustrating affine and translation operations resulting in a pattern.

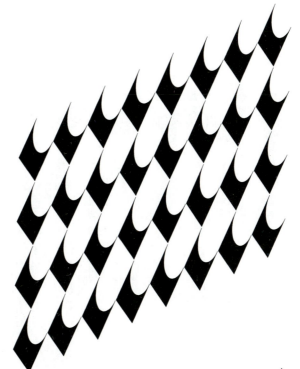

12.58a

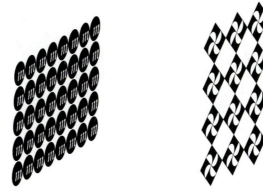

12.58b 12.58c

Figure 12.59 (a) In a perspectivity operation, the parallel lines on the original figure (b) appear to converge at a vanishing point; (c) a perspectivity translation operation resulting in a pattern.

Perspective Operations

In a perspective operation, parallel lines on the figure converge at vanishing points on the visual horizon line (see Figure 12.59).

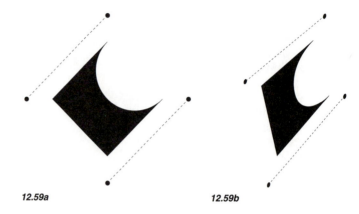

12.59a 12.59b

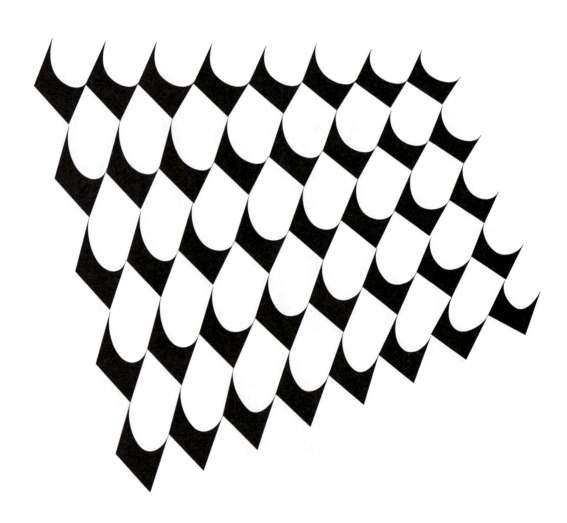

12.59c

Dilatative Operation

The dilatative operation creates a change in size (see Figure 12.60). The size change usually is set at regular intervals or percentages, and can be determined systematically through different proportional systems (dynamic symmetry). Compositions utilizing dilatation in combination with other symmetry operations produce interesting patterns, alternating light and dark areas.

12.60a

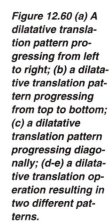

Figure 12.60 (a) A dilatative translation pattern progressing from left to right; (b) a dilatative translation pattern progressing from top to bottom; (c) a dilatative translation pattern progressing diagonally; (d-e) a dilatative translation operation resulting in two different patterns.

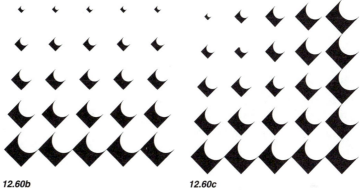

12.60b

12.60c

12.60d

12.60e

Figure 12.61 Examples illustrating topological transformations: (a) a bent plane; (b) a stretched plane.

Topological Operations

Topological changes occur when figures and forms are distorted in an irregular manner, such as through stretching, bending, or twisting, as illustrated in Figures 12.61 and 12.62.

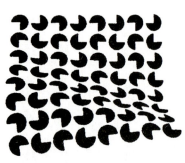

12.61a

Figure 12.62 (a) A topological operation transforming the letter "m" by stretching and bending; (b) topological operation transforming the word "stretch," emphasizing the meaning of the word.

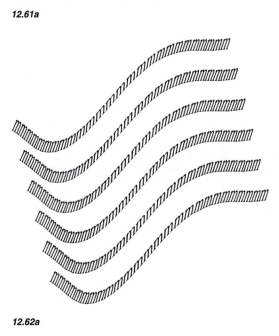

12.62a

12.61b

stretch

12.62b

SYMMETRY FIGURES IN THREE DIMENSIONS

Translation of Three-Dimensional Figures

Symmetry can be used to organize pattern in two- and three-dimensional space. Symmetry operations and transformations may be used in art, architecture, and interior, product, and visual communication design.

Figure 12.63 illustrates the translation of a three-dimensional figure into a linear band, then into a program cell. The figure can be manipulated using symmetry operations horizontally and vertically as in regular two-dimensional patterns, or manipulated along a projected axis in three-dimensional space.

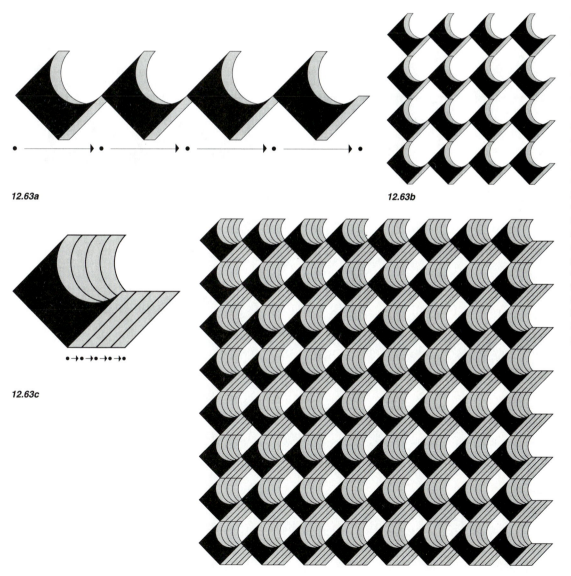

12.63a

12.63b

12.63c

12.63d

Figure 12.63 (a) A three-dimensional figure translated horizontally to create a linear band. The figure is represented by an oblique projection. (b) Pattern created by translating the three-dimensional figure across and down; (c) figure projected back along the Y axis to create a three-dimensional unit made up of four planes through the symmetry operation translation; (d) a pattern composition using the three-dimensional unit.

Figure 12.64 (a) A
figure rotated four
times; (b) the new
figure translated
four times creating
a linear band; (c-d)
the linear band
translated down,
creating a three-di-
mensional pattern.

Rotation Translation of Three-Dimensional Figures

Any of the symmetry operations and transformations can be used to create three-dimensional figures and patterns. Illustrated in Figure 12.64 is a fourfold rotation of the compositional figure and its planar pattern.

12.64a

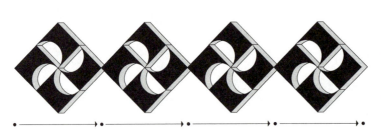

12.64b

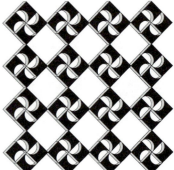

12.64c

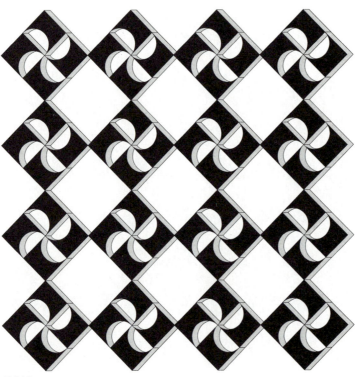

12.64d

LATTICES AS AN ORGANIZATIONAL DEVICE

Structure and Terminology

A *lattice* is a set of points connected by lines that divides an area or space into smaller congruent units, such as a grid or network (see Figures 12.65 and 12.66).

Lattices can be used to organize individual figures or to create figures. Compositional figures can be placed within the cell domain of the lattice, or the cell domain areas can become the figures themselves.

The lattice areas consist of basic geometric shapes such as squares, rhombi, rectangles, or triangles. Each unit of area or space within the lattice is called the *cell domain*. Since each cell domain within a lattice is the same shape and size, the system provides a regular structure within which to organize a pattern. Figure 12.67 traces the development of a pattern starting from a single cell domain.

Square Lattice

The most commonly used lattice is the square lattice. The sides of the lattice are equal in length and are placed perpendicular to each other so each vertex measures 90°

Figure 12.65 Lattices are sets of points used for generating an organizational structure or grid: (a) one-dimensional linear band; (b) two-dimensional plane; (c) three-dimensional network.

12.65a

12.65b

12.65c

Figure 12.66 Lattice points are connected by lines to form cells or domains: (a) and (b) linear bands; (c) planar lattice; and (d) three-dimensional lattice.

12.66a

12.66b

12.66c

12.66d

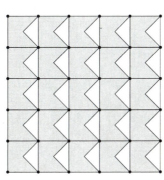

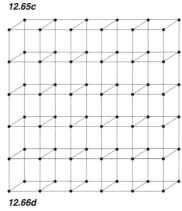

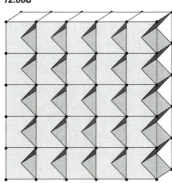

Figure 12.67 Development of (a) a lattice and figure in (b) one, (c) two, and (d) three dimensions.

12.67a

12.67b

12.67c

12.67d

Figure 12.68 Square diamond lattices made up of points: (a) one-dimensional; (b) two-dimensional; (c) three-dimensional.

Square Diamond Lattice

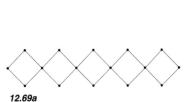

12.68a

The **square diamond** is another type of lattice. The square lattice cells are rotated 45°. Each cell domain remains square even though the orientation is changed (see Figures 12.68–12.70).

12.68b *12.68c*

Figure 12.69 Lattice points connected by lines forming networks: (a) one-dimensional; (b) two-dimensional; (c) three-dimensional.

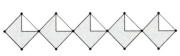

12.69a *12.69b* *12.69c*

Figure 12.70 (a-b) One- and two-dimensional square diamond lattices with figure; (c) three-dimensional square diamond lattice with figure.

12.70a

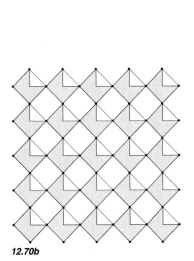

12.70b

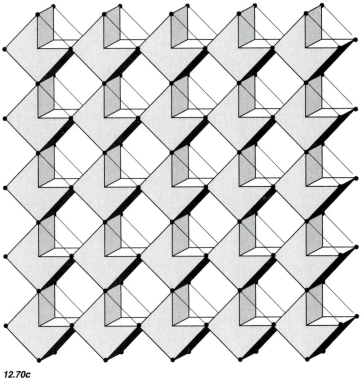

12.70c

Rhombus Lattice

12.71a

A **rhombus** lattice is based on a parallelogram. The angles are oblique and the sides are equal (see Figures 12.71–12.73).

12.71b

12.71c

Figure 12.71 Rhombus lattices made up of points: (a) one-dimensional; (b) two-dimensional; (c) three-dimensional.

12.72a

12.72b

12.72c

Figure 12.72 Lattice points connected by lines to form rhombus networks: (a) one-dimensional; (b) two-dimensional; (c) three-dimensional.

12.73a

12.73b

12.73c

Figure 12.73 (a) One-dimensional, (b) two-dimensional, and (c) three-dimensional rhombus lattices with figure.

Figure 12.74 Horizontal rectangular lattices made up of points: (a) one-dimensional; (b) two-dimensional; (c) three-dimensional.

Rectangular Lattice

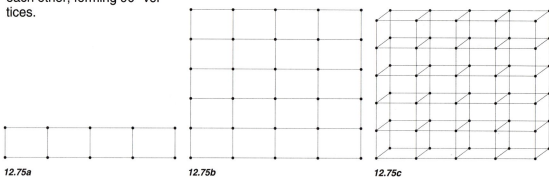

12.74a

Rectangular lattices can be positioned horizontally or vertically, although those illustrated in Figures 12.74–12.76 are horizontal. Like the square, the sides of the rectangle are perpendicular to each other, forming 90° vertices.

12.74b 12.74c

Figure 12.75 Lattice points connected by lines to form rectangular networks: (a) one-dimensional; (b) two-dimensional; (c) three-dimensional.

12.75a 12.75b 12.75c

Figure 12.76 (a) One-dimensional, (b) two-dimensional, and (c) three-dimensional rectangular lattices with figure.

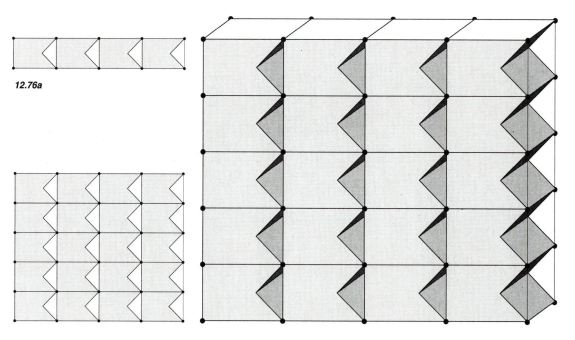

12.76a

12.76b 12.76c

Triangular Lattice

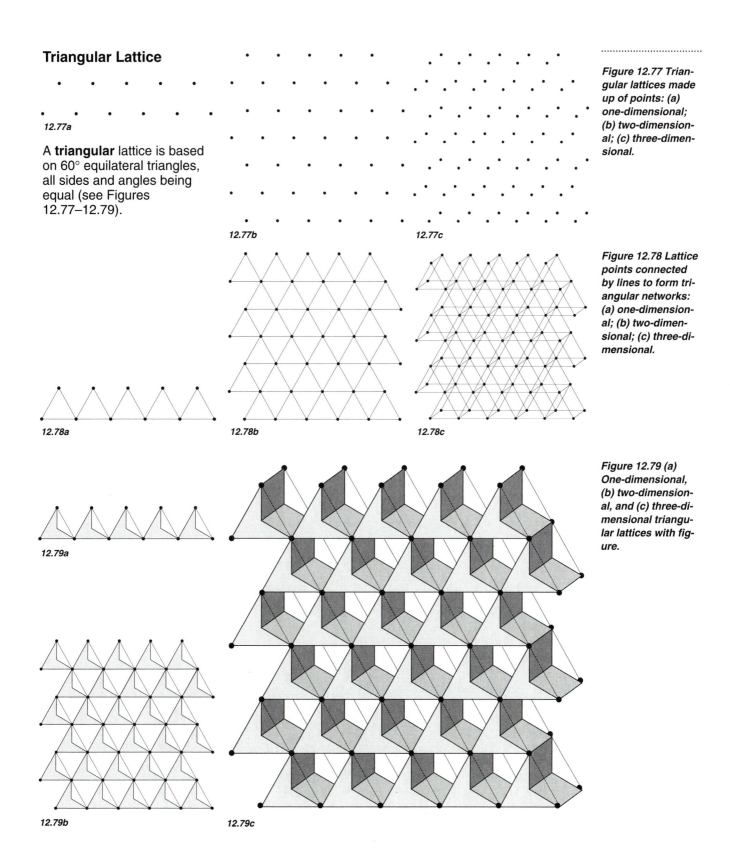

12.77a

A **triangular** lattice is based on 60° equilateral triangles, all sides and angles being equal (see Figures 12.77–12.79).

12.77b

12.77c

Figure 12.77 Triangular lattices made up of points: (a) one-dimensional; (b) two-dimensional; (c) three-dimensional.

Figure 12.78 Lattice points connected by lines to form triangular networks: (a) one-dimensional; (b) two-dimensional; (c) three-dimensional.

12.78a

12.78b

12.78c

Figure 12.79 (a) One-dimensional, (b) two-dimensional, and (c) three-dimensional triangular lattices with figure.

12.79a

12.79b

12.79c

Diamond Lattice

Figure 12.80 Diamond lattices made up of points: (a) one-dimensional; (b) two-dimensional; (c) three-dimensional.

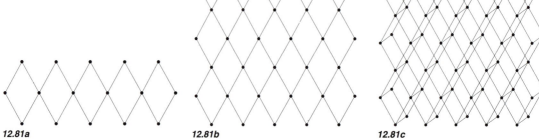

12.80a

A **diamond** lattice is based on four equal lines around two acute angles and two obtuse angles (see Figures 12.80–12.82).

12.80b *12.80c*

Figure 12.81 Latticed points connected by lines to form diamond networks: (a) one-dimensional; (b) two-dimensional; (c) three-dimensional.

12.81a *12.81b* *12.81c*

Figure 12.82 (a) One-dimensional, (b) two-dimensional, and (c) three-dimensional diamond lattices with figure.

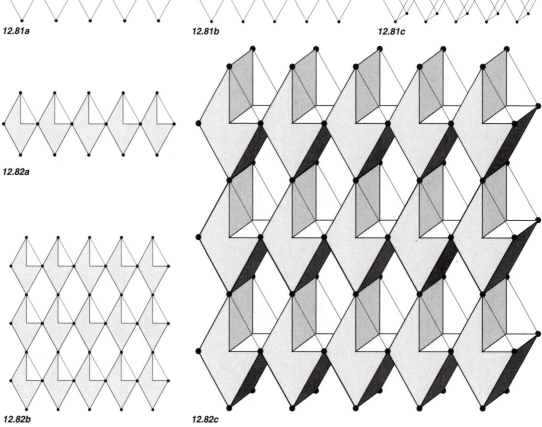

12.82a

12.82b *12.82c*

Hexagonal Lattice

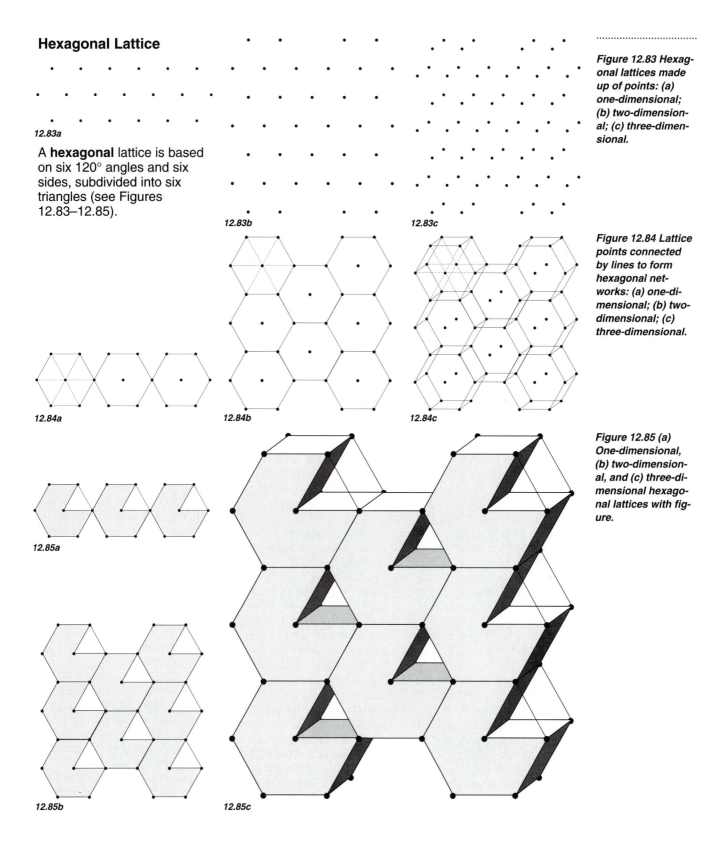

12.83a

A **hexagonal** lattice is based on six 120° angles and six sides, subdivided into six triangles (see Figures 12.83–12.85).

12.83b

12.83c

Figure 12.83 Hexagonal lattices made up of points: (a) one-dimensional; (b) two-dimensional; (c) three-dimensional.

12.84a

12.84b

12.84c

Figure 12.84 Lattice points connected by lines to form hexagonal networks: (a) one-dimensional; (b) two-dimensional; (c) three-dimensional.

12.85a

12.85b

12.85c

Figure 12.85 (a) One-dimensional, (b) two-dimensional, and (c) three-dimensional hexagonal lattices with figure.

12.86a

12.86b

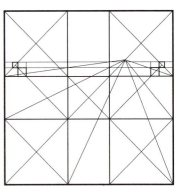

12.86c

INTRODUCTION TO DYNAMIC SYMMETRY

Historically man has observed, analyzed, and rationalized the principles of ratio, proportion, and progression within the environment. These principles have greatly influenced art, architecture, and design. Dynamic symmetry is also concerned with the proportional increases and relationships of parts to a whole through mathematical principles of ratio, proportion, and progression.

The ancient Greeks defined *dynamis* or *dynamic* to mean power, and *symmetria* or *symmetry* to mean the due proportion of several parts of a body to each other. Together these words express the basic function of the proportion principle. In visual studies, it is this concept that governs unity of form.

The value of such a concept to art, architecture, and design is in training the mind and eye to become aware of the structure of form and the relationships between its parts and the entire form. Figure 12.86 gives three examples of geometric construction utilizing proportional relationships.

Through an understanding of dynamic symmetry the principles can be utilized when appropriate. These principles were applied historically in art, architecture, and design and still can be used in creating form. It should be noted that it is not a formula applicable to all form-giving and should be used with proper consideration and context.

Often dynamic symmetry is presented as a mystical concept or is confused with the traditional symmetry transformations and operations previously discussed and illustrated in the chapter. An understanding of the basic principles of ratio, proportion, and progression will help in the study and development of systematic shape transformations, beginning with the proportional increase of similar rectangles known as the square root rectangles. This graphic approach to dynamic symmetry includes step-by-step illustra-

tions of ratio, proportion, and progression, and of how these principles form the basis for root rectangles and other complex figures and forms.

Ratio

Among the geometric principles expressed in Euclid's Elements are those of ratio and proportion. A *ratio* is a comparison of two equal quantities. Ratios are generally expressed as fractions a/b or a:b. Figure 12.87 shows three ways to illustrate ratios.

Proportion

Proportion is a comparison of two or more equal ratios. Euclid defined *proportion* as "magnitudes which have the same ratio."

There are two kinds of proportion: continuous and discontinuous. A *continuous proportion* compares equal ratios that have a common quantity between them. A *discontinuous proportion* compares equal ratios that do not have a common quan-

tity between them. For example, a proportion is continuous when the quantities a, b, c, and d have a common number, and a proportion is discontinuous when the quantities a, b, c, and d do not have a common number. Figure 12.88 illustrates the concept of proportion.

Progression

A *progression* is a series of quantities or numbers in which each term is related to its predecessor by a uniform law (see Figure 12.89). In mathematics, there are three kinds of progression: arithmetic, harmonic, and geometric. These are illustrated in Figure 12.90.

An a*rithmetic* progression is a series of numbers in which the difference between any two consecutive terms is the same. A *harmonic* progression is a series of numbers in which the reciprocals result from an arithmetic progression. A *geometric* progression is a series of numbers in which the ratio of any two consecutive terms is the same.

Unlike an arithmetic or harmonic progression, a geometric progression results in a proportionality of the terms. Rectangles of the same proportion are created using the geometric progression in two dimensions.

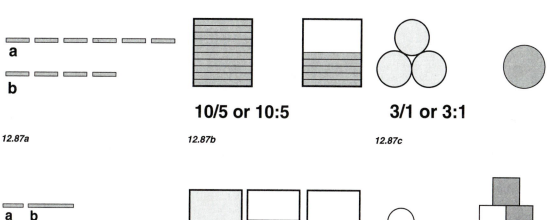

a

b

10/5 or 10:5

3/1 or 3:1

12.87a 12.87b 12.87c

Figure 12.87 Ratio illustrated as (a) linear quantities, (b) volumetric and weight quantities, and (c) numerical quantities.

a b

b c

40/20 = 20/10

1/3 = 2/6

12.88a 12.88b 12.88c

Figure 12.88 The concept of proportion: (a) a is to b as b is to c; (b) continuous proportion; (c) discontinuous proportion.

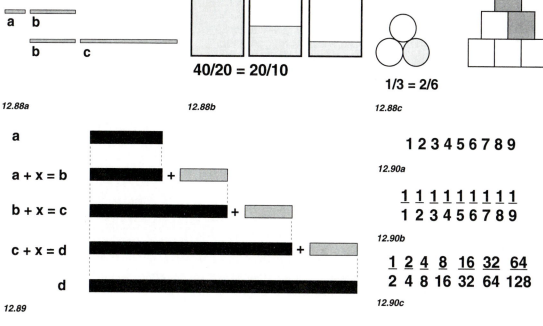

a

a + x = b

b + x = c

c + x = d

d

12.89

1 2 3 4 5 6 7 9

12.90a

$$\frac{1\ 1\ 1\ 1\ 1\ 1\ 1\ 1\ 1}{1\ 2\ 3\ 4\ 5\ 6\ 7\ 8\ 9}$$

12.90b

$$\frac{1\ \ 2\ \ 4\ \ 8\ \ 16\ \ 32\ \ 64}{2\ \ 4\ \ 8\ \ 16\ \ 32\ \ 64\ \ 128}$$

12.90c

Figure 12.89 An example of a progression; each new term is related to the previous term.

Figure 12.90 Numerical values illustrating three types of progressions: (a) arithmetic progression; (b) harmonic progression; (c) geometric progression.

Rectangles are said to be similar when all corresponding angles are equal and all corresponding line segments are proportional. Therefore similar rectangles have either parallel or perpendicular diagonals. Note that any given rectangle can be subdivided into smaller rectangles of the same proportion; however, portions of the rectangle may remain that are not proportional to the original rectangle (see Figure 12.91).

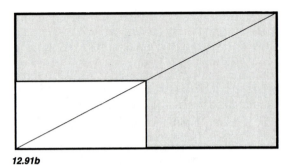

12.91b

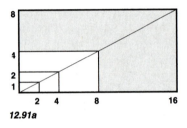

12.91a

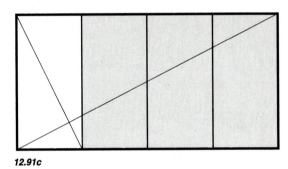

12.91c

Root Rectangles

Certain proportional rectangles can be completely subdivided by similar smaller rectangles. These are called square root rectangles and can be derived from a square.

Constructing Root Rectangles

The ratio of a square is 1:1 because the sides are equal lengths. To construct root rectangles, draw a diagonal within a square. The length of the diagonal is $\sqrt{2}$ or approximately 1.414. Using this diagonal as a circle radius,

construct an arc that intersects the square's baseline. Enclose this figure with a rectangle. Figure 12.92 illustrates this process. The dimensions of the new rectangle are 1:$\sqrt{2}$ and the new figure is called a *root two rectangle* ($\sqrt{2}$).

12.92a

12.92b

12.92c

Subdividing Root Rectangles

According to this definition of root rectangles, the $\sqrt{2}$ rectangle can be subdivided into smaller, similar rectangles that have parallel or perpendicular diagonals. Figure 12.93 shows how to do this.

Draw a diagonal line across the $\sqrt{2}$ rectangle. Perpendicular to this diagonal, construct another line. This line intersects a long side of the rectangle and divides it into two smaller similar rectangles. The same procedure can be used for the smaller rectangles, infinitely subdividing the smaller $\sqrt{2}$ rectangles.

Root Two Rectangle

When a root rectangle is subdivided, a gnomon and a reciprocal are created. A *gnomon* is the area remaining after subdivision and the *reciprocal* is the smaller resulting rectangle. The gnomon will always subdivide into an equal number of reciprocals. In the case of a $\sqrt{2}$ rectangle, the gnomon and reciprocal are equal, since the $\sqrt{2}$ rectangle is halved (see Figure 12.94).

12.93a *12.93b*

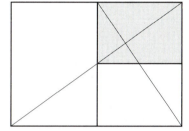
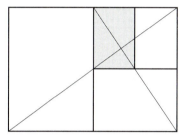

12.93c *12.93d*

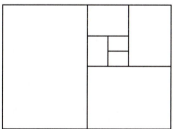

12.93e *12.93f*

Figure 12.93 (a-f) Subdivision of a $\sqrt{2}$ rectangle into smaller rectangles.

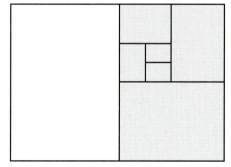

12.94

Figure 12.94 The gnomon (white area) is equal to the reciprocal (gray area) in a $\sqrt{2}$ rectangle.

Figure 12.95 A proportional octagon created using the √ 2 rectangle.

Other unique properties of the √2 rectangle include the creation of a proportional octagon and of the √2 diminishing spiral (see Figures 12.95 and 12.96). The most common use of the √2 rectangle is in the European system of paper sizes, called the DIN System (see Figure 12.97).

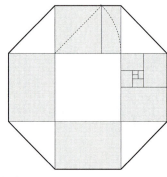

12.95

Figure 12.96 A spiral created by the configuration of the diagonals in a subdivided √ 2 rectangle.

Figure 12.97 A construction of the European DIN System of paper sizes, based on √ 2 rectangle.

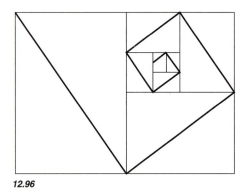

12.96

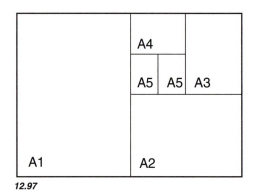

12.97

Figure 12.98 Construction of a √ 3 rectangle from a √ 2 rectangle.

Root Three Rectangle

The √3 rectangle is constructed from the √2 rectangle by drawing a diagonal line across the rectangle and striking an arc to its base (see Figure 12.98). Then the √3 rectangle is subdivided into three equal rectangles by projecting a line perpendicular to the base. The diagonals are drawn as illustrated in Figure 12.99.

12.98

Figure 12.99 Subdivision of a √ 3 rectangle.

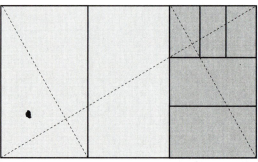

12.99

A regular hexagon can be constructed from the √3 rectangle by rotating the √3 rectangle about a center axis until the corners meet (see Figure 12.100).

The hexagonal prismatic form is found frequently in nature.

Root Four Rectangle
The √4 rectangle is known as the "double square" rectangle because its long side is two units and its short side is one unit (see Figure 12.101). It is constructed from the √3 rectangle, in the same manner as the √2 and √3 rectangles, or by placing two

squares adjacent to each other. Like all root rectangles, the √4 rectangle can be subdivided into an equal number of smaller, similar rectangles, as illustrated in Figure 12.102.

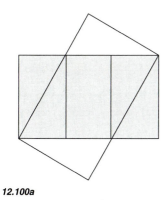

12.100a

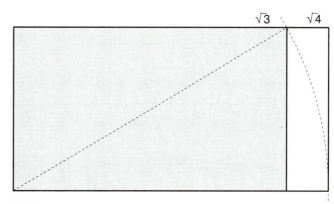

12.101

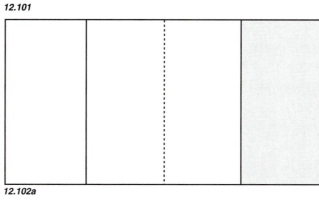

12.102a

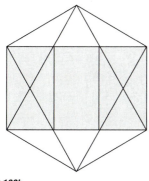

12.100b

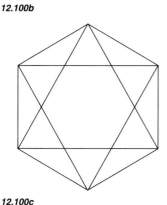

12.100c

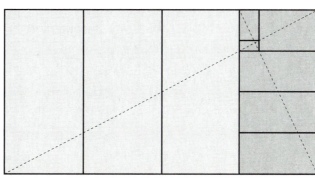

12.102b

Figure 12.100 (a-c) The construction of a regular hexagon by rotating √3 rectangles two times around a center axis until the corners meet.

Figure 12.101 Construction of a √4 rectangle from a √3 rectangle.

Figure 12.102 (a) When divided, the √4 rectangle equals two squares. The √4 rectangle equally subdivides into four congruent parts. (b) The √4 rectangle is subdivided in the same manner as other rectangles, by first drawing a diagonal, then a perpendicular line through a corner.

Root Five Rectangle

The $\sqrt{5}$ rectangle is constructed from the $\sqrt{4}$ rectangle, in the same manner as the other root rectangles (see Figure 12.103).

A $\sqrt{5}$ rectangle can be subdivided into five smaller, similar rectangles. The procedure is identical to the subdivision of other root rectangles. Each rectangle's reciprocal can then be divided into five smaller rectangles, ad infinitum (see Figure 12.104).

A second construction method for the $\sqrt{5}$ rectangle is based on the square. From the midpoint of the base side, strike a 180° arc through the top two corners. Extend the square on both sides to create a $\sqrt{5}$ rectangle. This procedure is illustrated in Figure 12.105.

Figure 12.103 Construction of a $\sqrt{5}$ rectangle from a $\sqrt{4}$ rectangle.

Figure 12.104 The $\sqrt{5}$ rectangle subdivides into smaller congruent rectangles.

Figure 12.105 (a-b) Another method of constructing a $\sqrt{5}$ rectangle from a square.

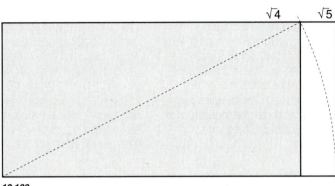

12.103

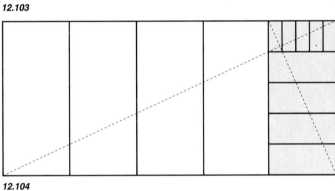

12.104

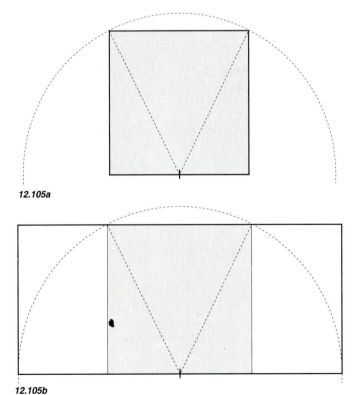

12.105a

12.105b

Root Rectangle Construction

Generating root rectangles from a square illustrates the relationship of the rectangles to each other. Figure 12.106 illustrates how each of the four types of rectangles just discussed can be equally subdivided.

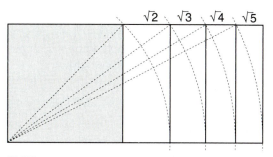

12.106a

12.106b

12.106c

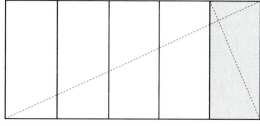

12.106d

12.106e

Figure 12.106 (a) Generating the root rectangle from a square, illustrating the relationship of the rectangles to each other. (b-e) √2, √3, √4, √5 rectangles and their internal subdivisions.

Figure 12.107 (a-h) Sequence illustrating the construction of a regular pentagon from a √5 rectangle.

✐Practice Exercise 12.3: Constructing a Pentagon from a Root Five Rectangle

The √5 rectangle forms the basis for construction of the regular pentagon, which is a figure consisting of five equal sides and angles. This is illustrated in Figure 12.107. Begin this exercise by constructing a square, then divide the base side of the square in half. From this midpoint, draw a diagonal to the top corners of the square. Using a compass, construct a 180° arc tangent to both top corners of the square, and intersect an imaginary line on which the base of the square is established.

The distance between the two intersecting arc points is a √5 rectangle. Measure the distance between point A and C and point B and D. Lines AC and BD should be equal. Draw an arc from point C through point A. Draw another arc from point B through point D.

Point E marks the intersection of the arcs midway over the rectangle and defines the height of the pentagon. Measure the line BC (it should be one unit because it is the dimension of the square). This line is equal to the length of each of the pentagon sides.

From point B swing an arc of one unit radius. Repeat the procedure from point C. Using the same radius, swing arcs from point E so that they intersect the arcs

of equal radius from points B and C. Connecting the intersecting points creates a regular pentagon.

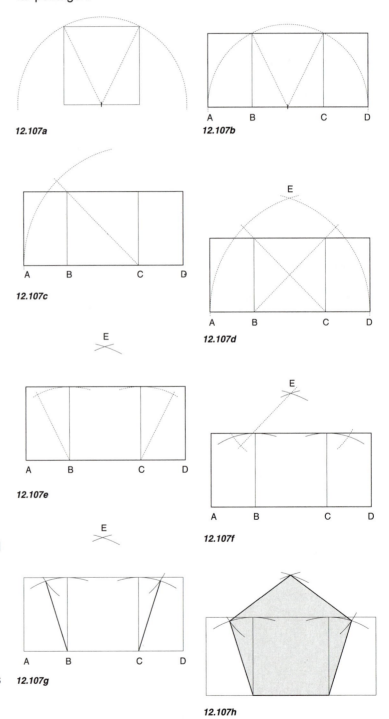

12.107a

12.107b

12.107c

12.107d

12.107e

12.107f

12.107g

12.107h

Golden Mean

The √5 rectangle is closely related to the golden mean rectangle. The golden mean is not a root rectangle because it does not subdivide into an exact number of similar rectangles. What makes the golden mean unique is that its reciprocal is a smaller rectangle and its gnomon is a square. This can best be understood by drawing its construction as shown in Figure 12.108.

The golden mean can be subdivided in the same manner as root rectangles. Note in Figure 12.109 that when subdivided, a golden mean always produces a square and a smaller golden mean rectangle. The golden mean rectangle has a ratio of 1:1.618.

Because of its unique properties the golden mean is sometimes called the "whirling square" rectangle. Proportionally decreasing squares can produce a spiral by using the length of their sides for the radius of a circle as shown in Figure 12.110. Figure 12.111 shows how this technique can result in a proportional spiral.

12.108a

12.108b

Figure 12.108 (a-b) Construction of a golden mean rectangle.

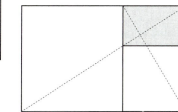

12.109a

Figure 12.109 (a-d) Subdividing a golden mean rectangle.

12.109b

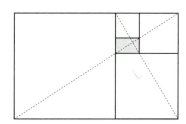

12.109c

12.109d

12.110

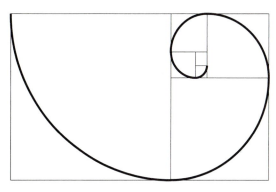

12.111

Figure 12.110 Construction of the "whirling square" based on golden mean proportions.

Figure 12.111 A proportional spiral drawn using the corners of the squares as center points for the arcs.

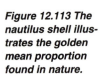

Construction of the Nautilus Shell

Figures 12.112 and 12.113 are an illustration and an analysis of the nautilus shell construction resulting in a diagram of the natural spiral of the shell.

✍Practice Exercise 12.4: Golden Mean Rectangle Construction and Subdivision

Begin by constructing a square and locate the midpoint of one of its sides. From this midpoint view, draw a diagonal to one of the opposite corners. Using a compass construct an arc extending to the base line, creating the golden mean rectangle. The smaller rectangle added to the square is proportional to the entire new rectangle.

Figure 12.113 The nautilus shell illustrates the golden mean proportion found in nature.

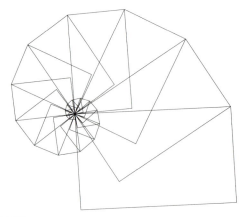

12.112a

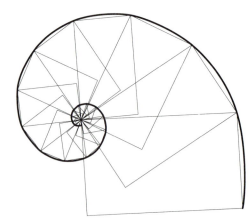

12.112b

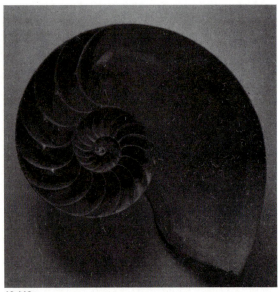

12.113

12.114a

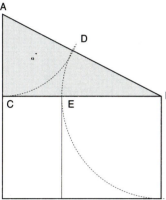

12.114b

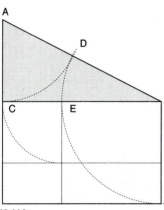

12.114c

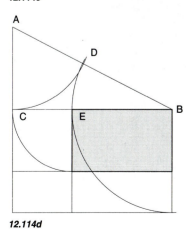

12.114d

✍Practice Exercise 12.5: Constructing Golden Mean Proportions

Begin by constructing a right triangle with the hypotenuse forming the diagonal of a √4 rectangle (double square). This will yield golden mean ratios (see Figure 12.114a).

Construct an arc beginning at point A with radius AC. Intersect the hypotenuse AB at point D. From point B, draw an arc with a radius BD to intersect the baseline BC at point E (see Figure 12.114b).

Draw a line straight down from point B. From point B draw an arc with the radius BE to intersect this line. Draw a horizontal line at the intersection. Draw a line straight down from point E. Draw an arc from point E with the radius EC. Draw a horizontal line at the intersection (see Figure 12.114c). The ratio of BE to EC is the golden mean ratio 1.618. From this triangle, rectangles with the golden mean proportions can be drawn (see Figure 12.114d).

Additionally, using the same right triangle based on the √4 rectangle, proportional circles can be constructed as illustrated in Figure 12.115. From point A draw an arc with radius AE. Where this arc intersects AB and CB, draw two vertical lines. These lines provide the diameter dimensions for the construction of the circles.

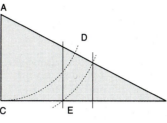

12.115a

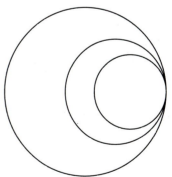

12.115b

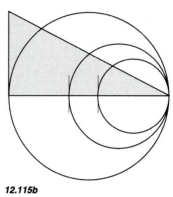

12.115c

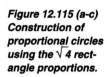

Figure 12.114 (a-d) Constructing the golden mean proportions using the √4 rectangle.

Figure 12.115 (a-c) Construction of proportional circles using the √4 rectangle proportions.

Figure 12.116 (a-c) Sequence illustrating the use of golden mean proportions in Greek architecture: the Temple of Theseus (from Heck).

Golden Mean Proportions in Architecture

The golden mean proportions were used widely in the development and construction of classical Greek and Roman architecture, as shown in Figure 12.116.

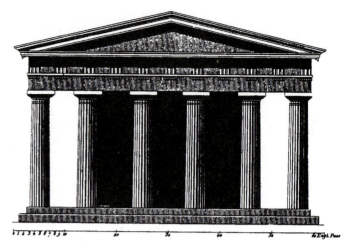

12.116a

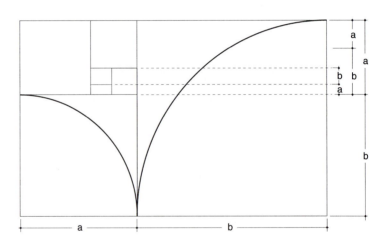

12.116b

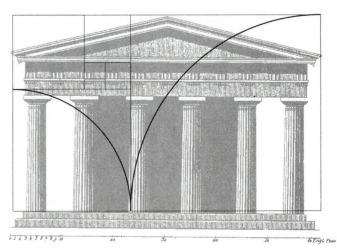

12.116c

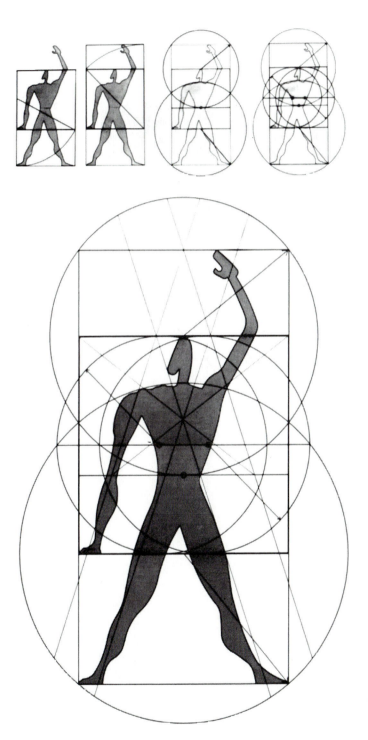

Golden Mean Proportions and Man

The study of the proportion of man (anthropometrics) has been analyzed and documented by artists, architects, designers, mathematicians, and other professionals through the ages. Figures 12.117 and 12.118 show examples of applying the golden mean to the human figure.

Figure 12.117 An exhibition panel illustrating proportional systems of the golden mean applied to the human figure based on Le Corbusier's construction theory (student work).

The Fibonacci Ratio

This phenomenon is illustrated by the Fibonacci mathematical sequence. The Fibonacci sequence is produced by starting with 1 and adding the previous two numbers to arrive at the next, continuing to infinity. The first twelve Fibonacci numbers are 1, 1, 2, 3, 5, 8, 13, 21,

12.117

34, 55, 89, and 144. These numbers have interesting properties and are often evident in nature and art.

The Fibonacci sequence is of interest because of its relationship to the golden mean. The ratio of any two adjacent numbers in the Fibonacci sequence after three is approximately the same as the proportional ratio 1:1.618 found in the golden mean.

This is illustrated in the spiraling of plants. When leaves grow from the stems of certain plants they spiral around the stem. The amount of turning from one leaf to the next is a Fibonnacci fraction of a composite rotation around the stem. The same phenomenon occurs within the spiral of pine cone scales (5:8, 8:13 ratios), and the spiraling configuration of leaves on trees. See the examples in Figure 12.119.

Figure 12.118 Exhibition panel illustrating application of the golden mean to the human figure (illustrated by Mark Groves).

Figure 12.119 Examples of spiraling in nature: (a) larix cedrus (European cedar pine cone); (b) plumbago europaea (toothwort) (from Heck).

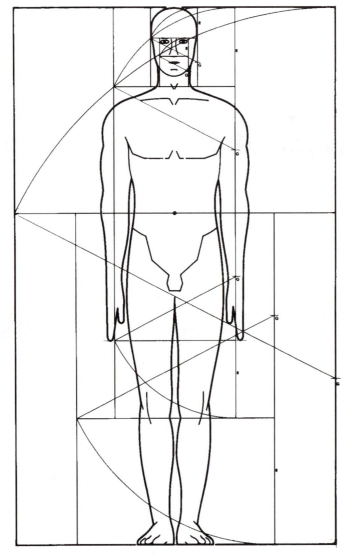

12.119a

12.119b

✍Practice Exercise 12.6: Design a Game to Illustrate the Fibonacci Sequence Ratio

Develop a three-dimensional game to visually illustrate the Fibonacci mathematical sequence. Many variations can be developed using different media, color, and so on. The example illustrated in Figure 12.120 is a model using colored pegs. Arranging the different pegs according to size and spatial configurations can help bring about an understanding of the possible relationships among the numbers.

Relate the number sequence to a unit of measure—that is, centimeters or inches—and use these units to design, plan, and build the model. Other ideas might be to relate the number sequence to sculpture, geometric composition, or architectural structure. In constructing the model, the base should be 12"x12"x3/4" basswood. Use dowel rods 3/8" in diameter, painted with latex acrylic artist color, and insert into the base.

Figure 12.120 (a-f) Peg game applying a proportional ratio based upon the Fibonacci mathematical sequence (student work).

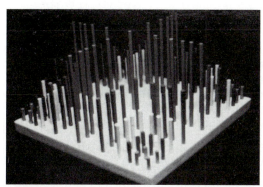

12.120a

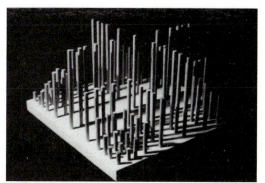

12.120b

12.120c

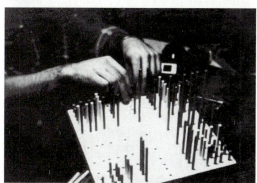

12.120d

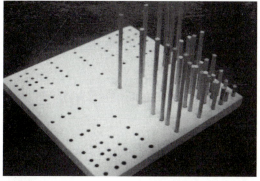

12.120e

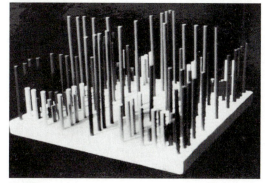

12.120f

REFERENCES AND RESOURCES

Bouleau, Charles. *The Painter's Secret Geometry.* New York: Harcourt, Brace and World, Inc., 1963.

Critchlow, Keith. *Islamic Patterns: An Analytical and Cosmological Approach.* New York: Schocken Books, 1976.

Doczi, György. *The Power of Limits: Proportional Harmonies in Nature, Art and Architecture.* Boulder, CO: Shambhala, 1981.

Dye, Daniel S. *A Grammar of Chinese Lattice.* Cambridge, MA: Harvard University Press, 1949.

Edwards, Edward B. *Pattern and Design with Dynamic Symmetry.* New York: Dover, 1967.

El-Said, Issam, and Ayse Parman. *Geometry Concepts in Islamic Art.* London: World of Islam Festival Publishing Company Ltd., 1967.

Ghyka, Matila. *The Geometry of Art and Life.* New York: Sheed and Ward, 1946.

Hambidge, Jay. *The Elements of Dynamic Symmetry.* New York: W. W. Norton, 1966.

Holden, Alan. *Shapes, Space and Symmetry.* New York: Columbia University Press, 1971.

Huff, William S. *Symmetry: An Appreciation of Its Presence in Man's Consciousness* (booklet series sponsored by a grant from the National Endowment for the Arts, Washington, DC., published in Pittsburgh, PA, 1970–1975). *The Six Isomorphic Coverage Operations, Book 2; The Seven Homeomorphic Coverage Operations, Book 3; Man's Conceptualization of the Universe, Book 4; Man's Observation of the Natural Environment, Book 5; Man's Aesthetic Response: Man's Contemplation on Himself, Book 6.*

Linn, Charles F. *The Golden Mean: Mathematics and the Fine Arts.* New York: Doubleday, 1974.

MacGillavry, Caroline H. *Symmetry Aspects of M. C. Escher's Periodic Drawings.* Utrecht, Netherlands: A. Oosthoek's Uitgeversmaatschappij NV, 1965.

March, Lionel, and Philip Steadman. *The Geometry of Environment.* London: RIBA Publications Limited, 1971.

Schattschneider, Doris, and Wallace Walker. *M. C. Escher Kaleidocycles.* New York: Ballantine Books, 1977.

Scholfield, P. H. *The Theory of Proportion in Architecture.* London: The Cambridge University Press, 1958.

Schröder, Eberhard. *Dürer Kunst und Geometrie.* East Berlin: Akademie-Verlag, 1980.

Shubnikov, A. V., and V. A. Koptsik. *Symmetry in Science and Art.* New York: Plenum, 1974.

Stevens, Peter S. *Patterns in Nature.* Boston: Little, Brown, 1974.

Thompson, D'arcy Wentworth. *On Growth and Form.* London: Cambridge University Press, 1961.

To'th, L. Fejes. *Regular Figures.* New York: Macmillan, 1964.

Weyl, Hermann. *Symmetry.* Princeton, NJ: Princeton University Press, 1952.

Wolf, K. Lothar, and Robert Wolff. *Symetrie.* Cologne: Böhlau-Verlag Münster, 1956.

Approaches to Creating Symmetry Compositions

APPENDIX OUTLINE

- Approaches to Creating Symmetry Compositions
- Nonisometric/Isometric Transformation Compositions
- Practice Exercise
- Dynamic Symmetry Transformation Compositions
- Using the Golden Mean Construction
- Additive/Subtractive Symmetry Compositions

APPENDIX OBJECTIVES

On completion of this appendix, readers should be able to:

- Generate a simple symmetry composition.
- Generate a nonisometric symmetry composition.
- Create a symmetry composition using a shape transformation.
- Create a symmetry composition utilizing an additive/subtractive–positive/negative process.

APPROACHES TO CREATING SYMMETRY COMPOSITIONS

Chapter 12 outlined and graphically illustrated symmetry transformations and operations and dynamic symmetry as they relate to creating two- and three- dimensional compositions. The following examples illustrate the application of the symmetry transformations and how they can be utilized to create a variety of complex patterns that would be difficult to generate without a knowledge of these concepts and principles.

There are a number of different approaches to creating these pattern compositions, some of them simple and others more complex. The most basic approach to generating these compositional patterns is to first select or create an asymmetrical figure (see Figure A.1). This figure then can be repeated, moved, and reoriented on the format by using one or more symmetry operations to create the pattern composition (see Figures A.2–A.5).

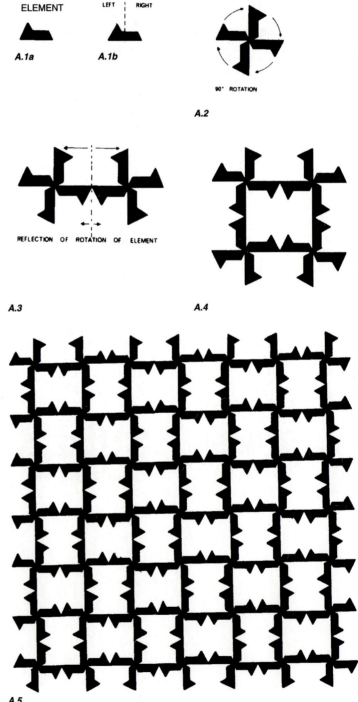

ELEMENT

A.1a

LEFT | RIGHT

A.1b

90° ROTATION

A.2

REFLECTION OF ROTATION OF ELEMENT

A.3

A.4

A.5

NONISOMETRIC/ ISOMETRIC TRANSFORMATION COMPOSITIONS

This approach can be extended and made more complex by altering the state of being of the figure through the use of projective, dilatative, topological nonisometric transformations, or a combination of these, while still using the symmetry operations in order to move the figures on the format (see Figures A.6 and A.7). It should be noted that the various lattice systems outlined in Chapter 12 can be used to create a set of figures or to provide a structure to organize figures within.

Figure A.6 (a-c) Nonisometric projective figure transformation and composition (illustrated by Vickie Marsh).

A.6a

A.6b

A.6c

Figure A.7 Nonisometric dilatative topological transformation (student work).

A different approach to generating symmetry pattern compositions is to create a transformation program—that is, a logical sequence of figures that change within a selected lattice configuration, utilizing the symmetry operations as a means to create the set of figures. This set is then repeated, moved, and reoriented on the format, using, once again, the operations. The success and quality of the transformation program and the cell it creates is determined by the number of different patterns the cell can produce.

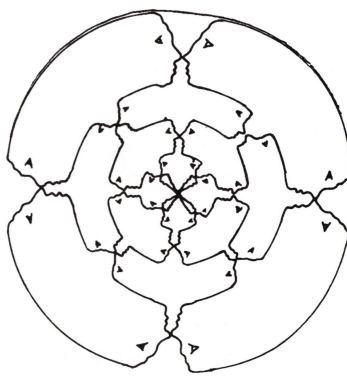

A.7

Figure A.8 (a) A set of figures generated using an orthogonal grid; (b) pattern composition (student work).

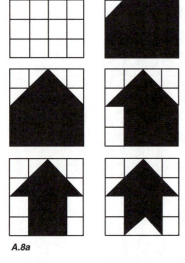

A.8a

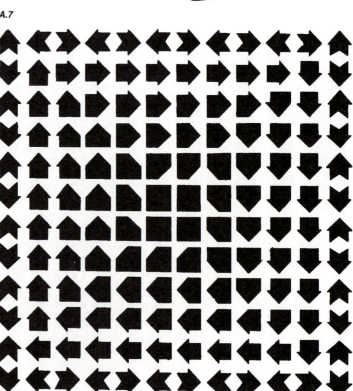

A.8b

✍Practice Exercise A.1: The Process for Generating Symmetry Compositions Using Shape Transformations

Shape transformations are created by changing one shape into another. The transformations in this exercise are illustrated in a sequence to show the transformation and compositional process. Figures A.9–A.19 were created on the Macintosh computer using Aldus™ Freehand® software.

Part 1

Begin by selecting a lattice (square, rhombus, triangle, rectangle, diamond, etc.) to generate and structure the shape transformation into a nine-step sequence—for example, square to circle (see Figure A.9). Once the shape transformation is determined, translate the nine-step linear transformation vertically nine times to create a pattern cell (see Figure A.10). This pattern cell then can be repeated and manipulated by using the isometric symmetry operations translation, rotation, and reflection, creating new and more complex pattern configurations which can be extended into infinity.

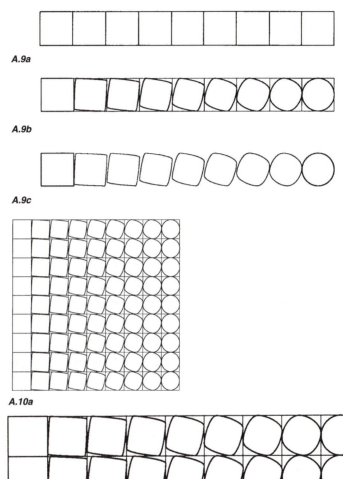

A.9a

A.9b

A.9c

A.10a

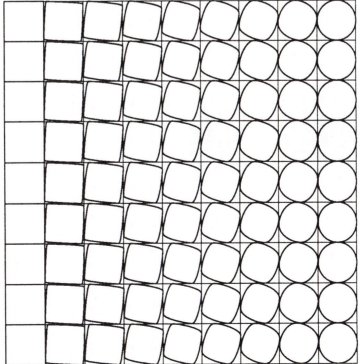

A.10b

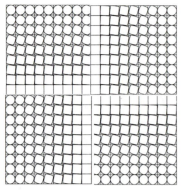

A.11a

Other graphic considerations, such as alternating positive/negative areas within the pattern configuration can be added, creating even more visual contrast and interest (see Figures A.11 and A.12).

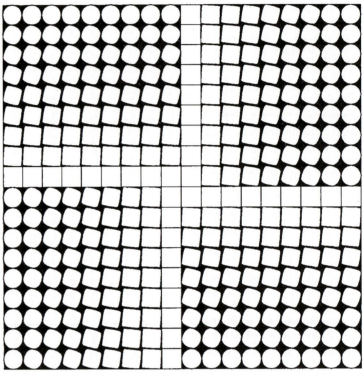

A.11b

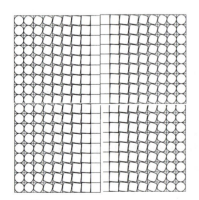

A.12a

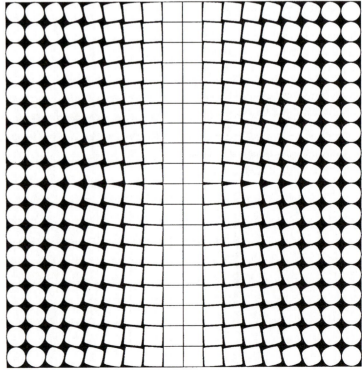

A.12b

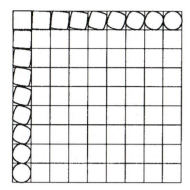

A.13a

The shape transformation may progress both horizontally and vertically within the lattice system. When complete, the progression appears to move diagonally within the composition area. The translation can also be changed to a positive figure with a negative ground or vice versa (see Figure A.13). Figure A.14 is a reflection of A.13c.

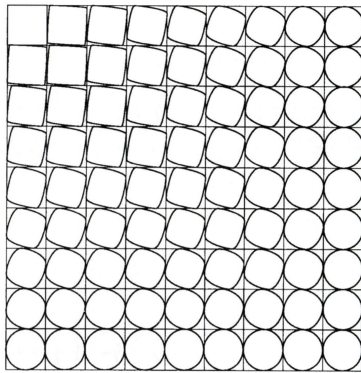

A.13b

A.13c

A.13d

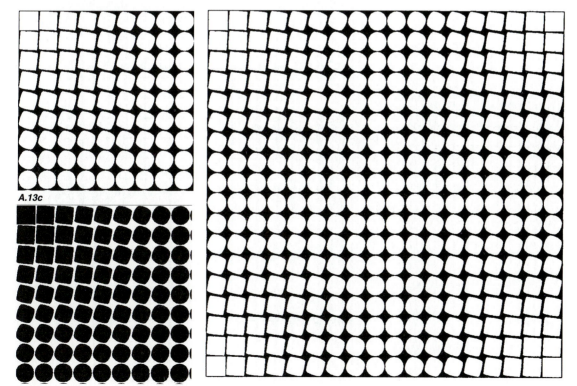

A.14

DYNAMIC SYMMETRY TRANSFORMATION COMPOSITIONS

Shape transformations can also be adapted to the root rectangles and golden mean constructions to create a visual appearance of dynamic movement and topological change within a repetitive pattern.

Part 2
Begin by adapting the transformation created above into a series of root rectangles and repeat the linear transformation vertically nine times to create a pattern cell (see Figure A.15).

As illustrated in Figure A.16, experiment with the program cell and create pattern variations using the isometric symmetry operation reflection. Symmetry programs can be altered using line, value, and positive/negative relationships.

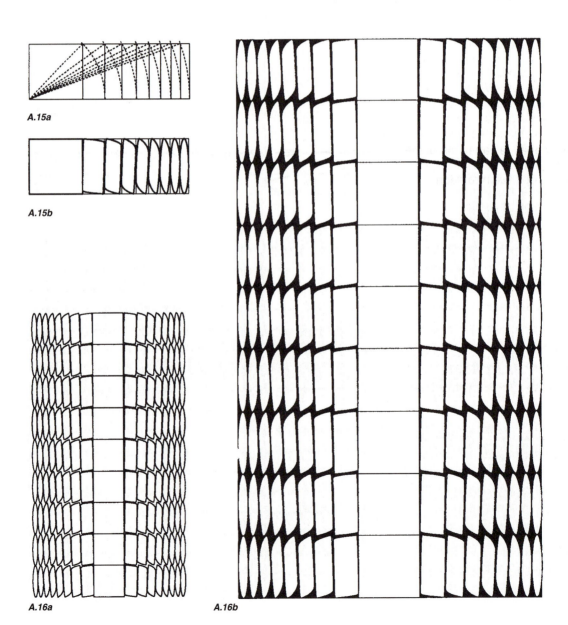

A.15a

A.15b

A.16a

A.16b

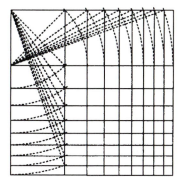

A.17a

As demonstrated above, the shape transformation can be organized across and down within the lattice cell creating different pattern variations (see Figure A.17). Figure A.18 shows positive/negative variations of the program cell using the symmetry operation rotation.

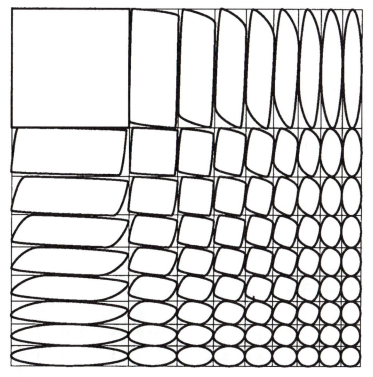

A.17b

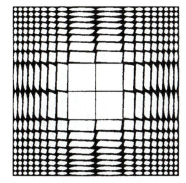

A.18a

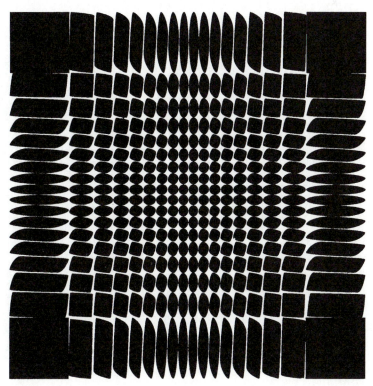

A.18b

USING THE GOLDEN MEAN CONSTRUCTION

In this example (see Figure A.19) the shape transformation has been reduced to seven steps and adapted to the golden mean construction, creating a dynamic shape transformation composition.

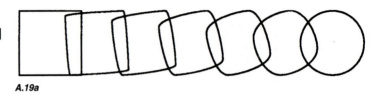

A.19a

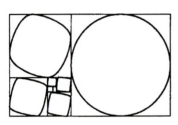

A.19b

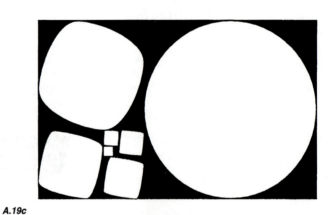

A.19c

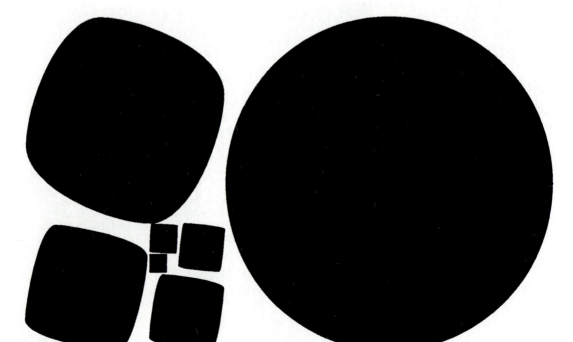

A.19d

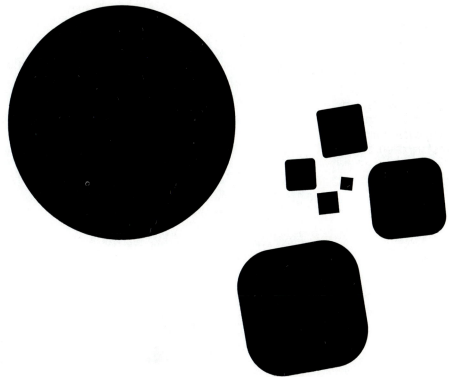

A.20a

Figure A.20 illustrates the dynamic symmetry composition altered using the "whirling square" configuration. The figures appear to recede back into the picture plane because of their orientation, position, and change in size.

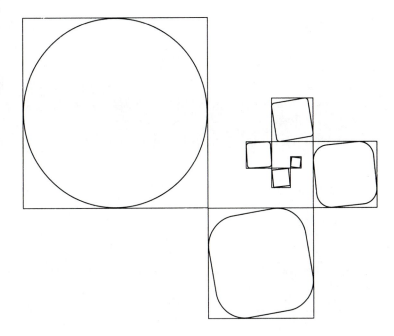

A.20b

*Figure A.21 (a-b)
Subtractive shape
transformation
using orthogonal
grid; (c-d) pattern
compositions
(illustrated by Fred
Hunker).*

A.21a

ADDITIVE/ SUBTRACTIVE SYMMETRY COMPOSITIONS

Another interesting approach to generating a set of figures and transforming them to create interesting compositions is by using the method of additive/subtractive process in conjunction with positive/negative and the symmetry operations (see Figures A.21 and A.22).

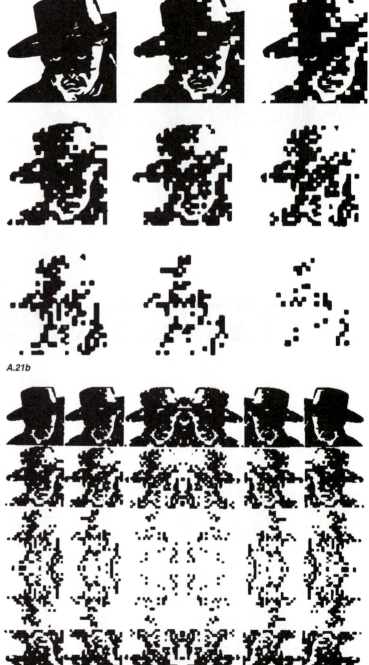

A.21b

A.21c

A.21d

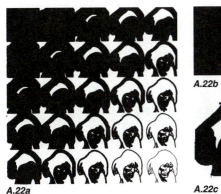

A.22a

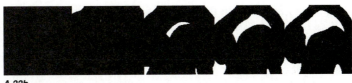

A.22b

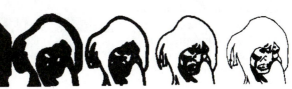

A.22c

Figure A.22 (a-c) Additive shape transformation using an increase in line weight and image size; (d) pattern composition (illustrated by David Fultz).

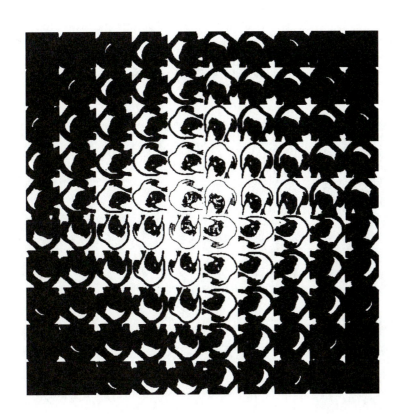

A.22d

Figure A.23 Shape transformation program generated within a square lattice: (a) in line; (b) in positive/ negative; (c) the cell; (d) cell translated into positive/ negative; (e) pattern composition; (f) pattern composition in line (illustrated by Susan Hessler).

Figure A.23 shows an example of utilizing a shape transformation process and symmetry operations generating a number of pattern compositions. Figure A.24 shows the previous shape transformation adapted to a lattice based upon the root rectangles. The symmetry operations once again are used to create dynamic symmetry compositions.

A.23a

A.23b

A.23c

A.23d

A.23e

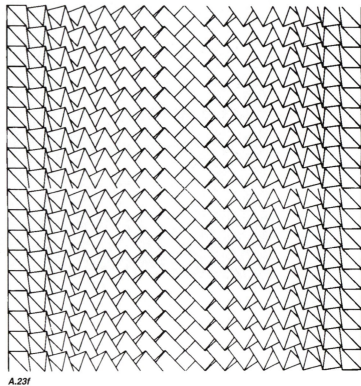

A.23f

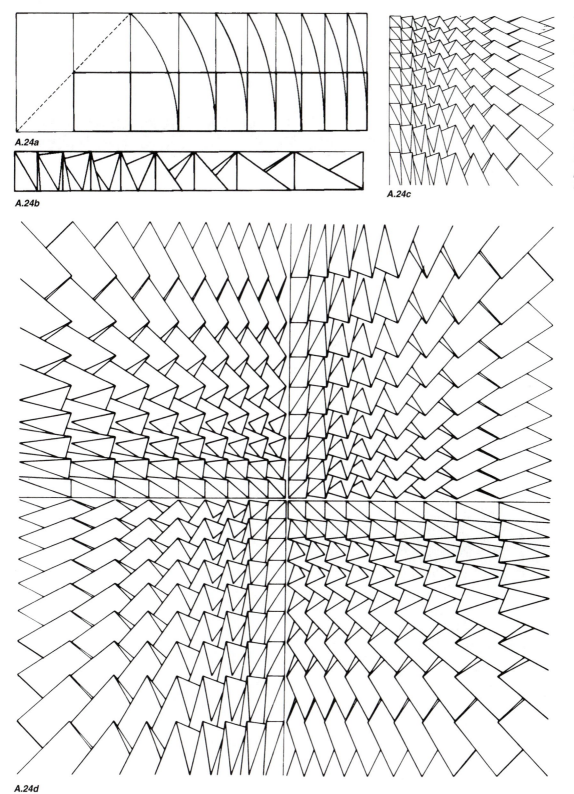

A.24a

A.24b

A.24c

Figure A.24 (a)
Construction of
dynamic symmetry
lattice based on
root rectangle
proportions; (b) the
eight-step figure
transformation; (c)
the cell; (d) dyna-
mic symmetry
pattern (illustrated
by Susan Hessler).

A.24d

Figure A.25 (a-g)
Symmetry program
and compositions
(illustrated by
Richard Miller on
the Macintosh
using Aldus
Freehand software).

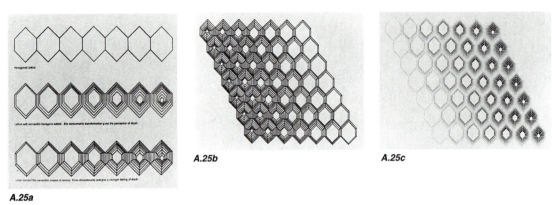

A.25a

A.25b

A.25c

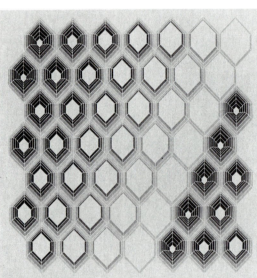

A.25d

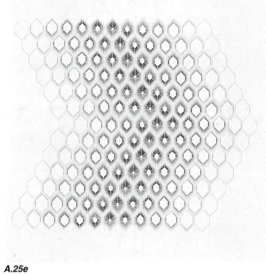

A.25e

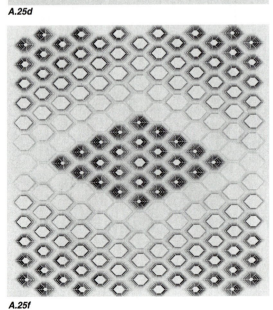

A.25f

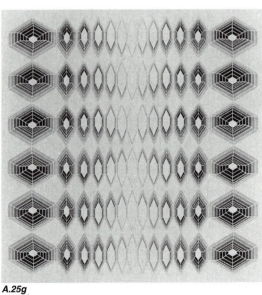

A.25g

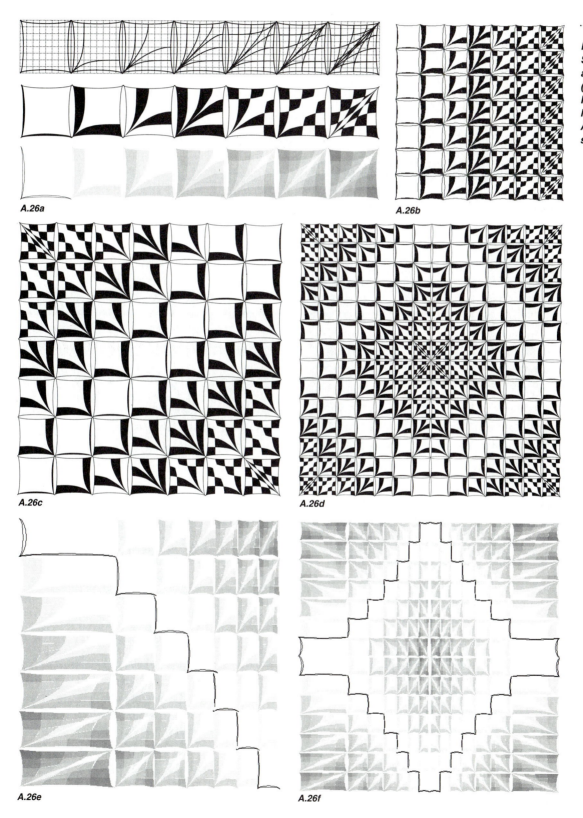

*Figure A.26 (a-f)
Symmetry program
and compositions
(illustrated by Niels
Hansen on the
Macintosh using
Aldus Freehand
software).*

A.26a

A.26b

A.26c

A.26d

A.26e

A.26f

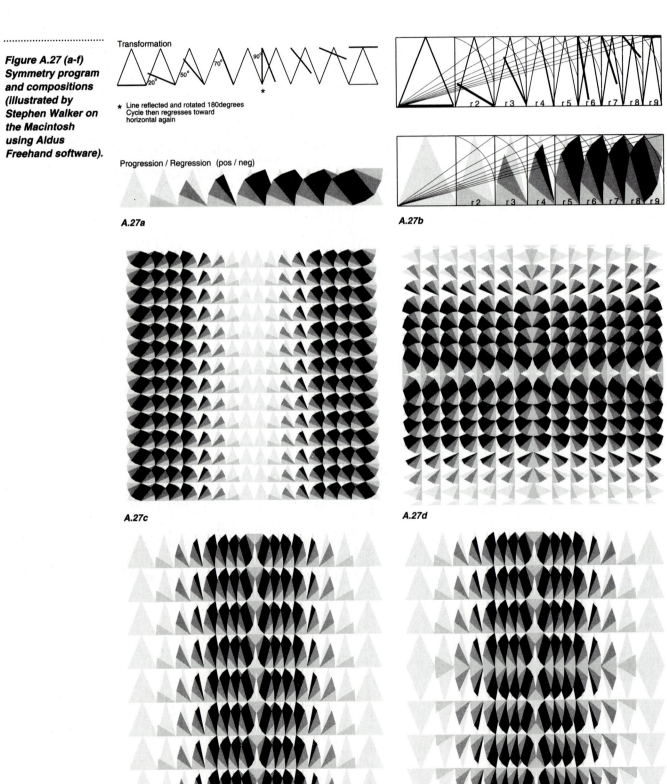

Figure A.27 (a-f)
Symmetry program
and compositions
(illustrated by
Stephen Walker on
the Macintosh
using Aldus
Freehand software).

Transformation

★ Line reflected and rotated 180degrees
Cycle then regresses toward
horizontal again

Progression / Regression (pos / neg)

A.27a

A.27b

A.27c

A.27d

A.27e

A.27f

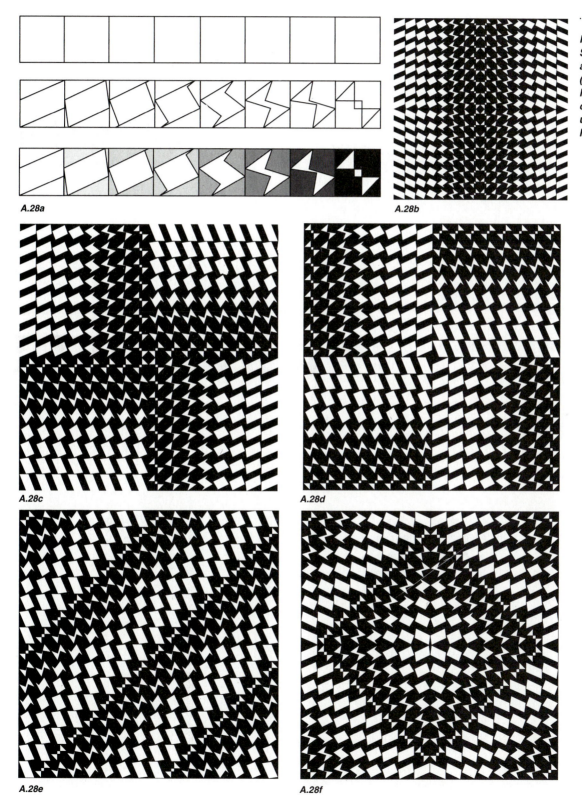

Figure A.28 (a-f) Symmetry program and compositions (illustrated by Richard Stephens on the Macintosh using Aldus Freehand software).

A.28a

A.28b

A.28c

A.28d

A.28e

A.28f

Credits

Figures 5.113, 7.73, 7.74, 7.75, 7.76, 8.27, 8.39, 8.45, 8.46, 9.16, 10.42: Credit appears on the same page as the figures.

Figures 2.1, 2.2, 2.3, 2.4: *The Universal Traveler: A Soft-Systems Guide to Creativity, Problem-Solving and the Process of Reaching Goals* by Don Koberg and Jim Bagnall. © 1972, 1973, 1974, William Kaufmann, Inc.

Figure 2.5: *Art Fundamentals Theory and Practice*, 4th Edition, by Ocvirk, Bone, Stinson and Wigg. © 1981, William C. Brown Co. Publishers.

Figure 5.27: *All Together Now: Happy Birthday USA*, designed by George Tscherny and Robert Davis for Davis-Delaney-Arrow, Inc., 1975.

Figure 5.55: Dakotah, Inc., Webster, South Dakota.

Figures 5.58b, 11.26: Pushpin Graphic #80, p. 17 and #81, p. 25. © 1979. Reproduced with permission.

Figure 5.58: Copyright Container Corporation of America, a subsidiary of Jefferson Smurfitt Corporation.

Figure 5.112: Art Direction and Design by Werner Hans Schmidt.

Figures 6.17a-c, 6.18a-c: Illustrations from *Polyhedra Primer*, Peter and Susan Pearce. Palo Alto: Dale Seymour Publications, 1978. Courtesy Peter Pearce.

Figures 7.37, 9.31: *Art: The Revealing Experience*, by Kurt Kranz, Shorewood Fine Art Reproductions, Inc., © 1964.

Figure 7.40: *Graphic Design: Visual Comparisons*, © 1968 Fletcher et al.

Figure 7.42: Impressum, Gigantisch "Giant Table," illustrated/designed and copyright by Gunter Hugo Magnus, © 1984.

Figure 7.43: Power Broth-Scizzophrenia-Mahnert-Lueg Verlag

Figures 7.56, 7.57, 7.58, 7.59b: *The Geometry of Art and Life* by Matila Ghyka, Dover Publications, © 1946.

Figure 7.59a: *Discovery of the Square* by Bruno Munari.

Figure 7.60: *Proportion: A Measure of Order* (The orders: Tuscan, Doric, Ionic, Corinthian and Composite) Carpenter Center, Harvard University, © 1965. Designed by Eduard F. Sekler in collaboration with Hans H. Buchwald.

Figures 7.70, 7.71, 7.72: M. Steck, *Dürers Gestaltlehre der Mathematik und der Bildenden Kunste*. Max Niemeyer Verlag (1948) Abb. 25, Taf. IX, Abb. 29, Taf. X., Abb. 44, Taf XIV.

Figure 7.77: Courtesy of Delta Design.

Figure 7.78: Anthropometric Study Creating Mannequins, exercise by Professor Reinhart Butter.

Figures 8.2, 8.3, 8.6: *From Light and Color*, illustrated by Raymond Perlman, © 1971 Western Publishing Company, Inc. Used by permission.

Figures 8.10, 8.12b, 8.15, 8.16b, 8.17, 8.18b, 8.21b, 8.25: These figures have originally been published in the edition *Theory and Practice of Color* by Frans Gerritsen (publishers Van Nostrand Reinhold Co., New York). The title is an English translation of the original Dutch edition *Het Fenomeen Fleur* published in 1975 by Uitgeverij Cantecleer B.V., De Bilt (The Netherlands).

Figures 8.12a, 8.13, 8.14, 8.16a, 8.18a, 8.19a-b, 8.20a-b, 8.23, 8.24, 8.28, 8.51, 8.57: VNR Publication/Author: Faber Birren 1969: *Principles of Color*.

Figures 8.22, 8.30, 8.31, 8.32a-d, 8.50: Courtesy: Munsell Color, Baltimore, MD and Newburgh, NY.

Figures 8.29, 8.49: *The Art of Color*, © 1973 "Ravensburger Buchverlag Otto Maier GmbH," © American edition: Van Nostrand Reinhold. New York.

Figures: 8.34, 8.35, 8.36, 8.37, 8.38: Courtesy of Jefferson Smurfitt Corporation.

Figure 8.40: Courtesy of Pantone, Inc.

Figures 9.29a-b, 9.30, 9.32: *Drawing Systems* (a Van Nostrand Reinhold Publication) by Fred Dubery and John Willats, Fig. 40a-b, p. 54; Fig. 41, p. 56; Fig. 45, p. 59. © 1972.

Figures 9.37, 9.39a-c, 9.40a, 9.41, 9.42, 9.43: *Perception of the Visual World* by James Gibson, Houghton Mifflin Co., © 1950.

Figure 10.4a-b: Forgus, *Perception: The Basic Process in Cognitive Development*, © 1966, McGraw-Hill, Inc. Reproduced with permission of McGraw-Hill, Inc.

Figure 10.5a-c: From *Perception* by D. J. Weintraub and E.L. Walker, © 1966 Wadsworth Publishing Company, Inc. Reprinted by permission of Brooks/Cole Publishing Company, Pacific Grove, CA 93950.

Figure 10.6d: Courtesy of Mitsubishi Companies.

Figure 10.7e: Courtesy of Metropolitan Life Insurance Co.

Figure 10.8e: Used with permission of Chrysler Corporation.

Figures 10.23a-b, 10.24, 10.26, 10.27, 10.28a-c: *Visual Illusions: Their Causes, Characteristics and Applications*, by M. Luckiesh, © 1965. Dover Publications, Inc., New York, NY.

Figures 10.25, 10.29, 10.43, 10.59: From *The Inquisitive Eye* by Mark Fineman. © 1981 by Oxford University Press, Inc. Reprinted by permission.

Figures 10.30a-b, 10.38, 10.62: *Optical Illusions and the Visual Arts*, by Ronald G. Carraher & Jacqueline B. Thurston, © 1966, Reinhold Book Corp.

Figure 10.41a: Logotype Ohio Board of Regents.

Figure 10.41b: Omniplan Architects, Dallas. Graphic Designer: Tomoko Miho, New York.

Figure 10.41c: Dufex trademark, designed by F.H.K. Henrion. Courtesy of Marion Henrion.

Figures 10.44a-b: Thaddeus M. Cowan and Richard Pringle.

Figure 10.60: Floyd Ratliff.

Figure 10.61: *Seeing Illusion, Brain and Mind* by John P. Frisby, © 1979, Roxby & Lindsey (Holdings) Ltd.

Figure 10.77: Registered Girl Scout service mark used with permission from Girl Scouts of the United States of America.

Figures 11.2f, 11.29: Reprinted with permission of Champion International Corporation.

Figure 11.3: *The Process of Communication* by David K. Berlo, © 1960, Holt, Rinehart and Winston, Orlando, FL.

Figure 11.8: Courtesy of Goodwill Industries.
Courtesy of General Electric Company.
Courtesy of International Business Machines Corporation.
Courtesy of Eaton Corporation.
Exxon and Exxon Emblem are registered trademarks of Exxon Corporation. The Exxon Emblem is reproduced with permission.
Coca-Cola is a registered trademark of the Coca-Cola Company.
Bell Telephone Companies.
Courtesy of ARCO.
Diagrams by Arthur Lockwood, © 1969, MacMillan Publishing.

Figure 11.9: *Foundations of the Theory of Signs*, University of Chicago Press.

Figure 11.17a: Federation of Enterprises, designed by Anton Stankowsky.

Figure 11.17b: CEBAC, designed by Robert Overby.

Figure 11.17c: Courtesy of *Der Spiegel.*

Figure 11.20: Reproduced from *Contemporary Problems in Perception* (cover art), edited by A.T. Welford and L. Haussiadas, © 1970, Taylor & Francis, London.

Figure 11.21a: Courtesy of Ft. Worth Chamber of Commerce.

Figure 11.21b: The Chase Manhattan Bank, N.A., design by Chermayeff & Geismar Associates.

Figure 11.23a: Courtesy of Eastman Kodak Company.

Figure 11.23b: Courtesy of Unisys Corporation.

Figure 11.24a-b: Courtesy of The Prudential Insurance Company of America.

Figures 11.25a-b: Courtesy of Camp Fire Boys and Girls.

Figures 11.30, 11.31: Album cover artwork from *One on One* by Bob James/Earl Klugh and *Heads* by Bob James used courtesy of Columbia Records.

Figure 11.32b: With permission of The American Institute of Graphic Arts.

Figure 11.33a-c: Courtesy of Braun Electronics, Germany.

Figure 11.34a-b: Published with permission by Champion International Corporation.

Figure 11.36a-c: Album cover artwork from Raspberries' *Side 3* by Rod Dyer, used courtesy of Capitol Records, Inc.

Figure 11.37: Columbus Museum of Art, Ohio: Design by Gene Hite, Design Communications, Inc.

Figure 11.38: Toy Collection: Cari Sanborn, courtesy of Vance Jonson.

Figure 11.40: "How to Paper Train Your Dog" designed by Vance Jonson in collaboration with Lawrence Miller.

Figure 12.9: Weyl, Hermann, *Symmetry*, © 1952. Copyright renewed 1980 by Princeton University Press. Fig. 38, p. 62 by W.A. Bentley. Reprinted by permission.

Figure 12.10a-b: Photos: Gernot Minke, Kussel. Design: Seminal Pneumatische Constructionen, Ulm 1972, directed by Gernot Minke.

Figure 12.12a-b: Habitat designed by Moshe Safdie for 1967 EXPO; photo courtesy of Canapress.

Figure 12.14a-b: Photo: Alcan/M. Morcos. Compliments of the Royal Netherlands Embassy, Canada.

Figure 12.44: Permission given by Pino Tovaglia.

Figure 12.45: © 1984 Stamp Design, USPS. Reproduced with permission.

Figure 12.46: Christmas card (GLORIA), designed by David Colley.

Figure 12.47: Savitt Studios.

Figure 12.48: Advertisement for CBS Television Network, designed by Louis Dorfsman.

Index

DATE DUE